The flip side of p...

Bad Mags

The Strangest, Sleaziest, Most Unusual Periodicals Ever Published!
Volume Two

by Tom Brinkmann

www.headpress.com demon gods of pulp

A HEADPRESS BOOK
First published by Headpress in 2009

Headpress
Suite 306, The Colourworks
2a Abbot Street
London, E8 3DP, United Kingdom

[tel] 0845 330 1844
[email] headoffice@headpress.com
[web] www.headpress.com

BAD MAGS VOLUME TWO
The Strangest, Sleaziest, Most Unusual
Periodicals Ever Published!

Text copyright © Tom Brinkmann
This volume copyright © Headpress 2009
Editor, book design & layout: David Kerekes
Front & back cover design: Tom Brinkmann

A CIP catalogue record for this book is available from
the British Library

ISBN **9781900486705**

Printed in Great Britain by the MPG Books Group,
Bodmin and King's Lynn

A note on the main text

Titles of magazines and tabloid newspapers are
bold/upper case, i.e. **CONSENT**, **WEIRD DETECTIVE**

Titles of films, books, comic books, stageshows and
record albums are bold, i.e. **Vapors**, **5 to Die**

Titles of short stories and articles are italicized,
i.e. *The Harlot Wouldn't Die!*, *Banality of the New Evil*

Sidebar information guide

[magazine title] MONDO GIRLS
[issue number & date] Vol 1 No 1 Dec 1966
[publisher details] Press Arts Inc., 7376 Greenbush Ave,
North Hollywood, CA 91605
[price in US $] 1.50 *[page count]* 72pp

headpress.com

Contents

plus colour plates

Devilish Mags

Monsters and Occult Sex

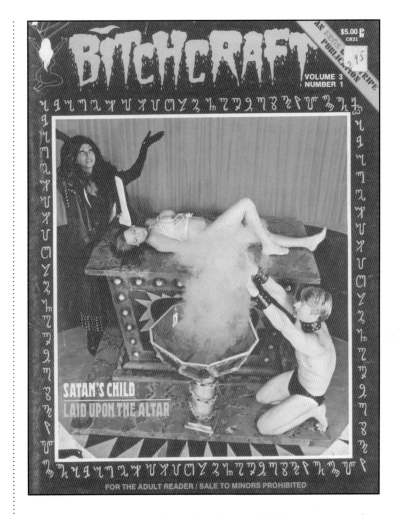

AFTER THE SUCCESS of Hugh Hefner's *Playboy*, some tried to copy its formula and format, which gave rise in the 1950s to the "men's sophisticate" mags. Some of the titles only lasted a few issues, like *Satan* (below), but others such as *Nugget* are still on the stands today. *Nugget* has recently used the cover slogan "In the Fetish Magazine Business Since 1955," although it has changed hands more than once and has definitely mutated from the original *Nugget* of the fifties.

Also in the late fifties monster magazines started showing up on the racks around the country, with James Warren and Forrest J. Ackerman's *Famous Monsters of Filmland* leading the way, with many imitators trailing behind. "Forry" Ackerman had written a few articles for various sexually related mags in the late fifties (see *After Hours* and *Sex & Censorship* below) before starting *FMofF* and continued writing, sporadically, articles and fiction that would appear in men's mags such as *Adam* in the seventies.

The nudist and girlie mags followed the monster craze of the

sixties with monster-and-maiden type layouts, i.e., men dressed in rubber monster outfits, terrorizing naked "teens" or nudists. Layouts of the same type would also show up in the adult slicks on occasion, usually claiming to be stills from a new sexploitation flick.

By the early sixties a few of the adult slicks had picked up the satanic/devilish theme. In 1966 Anton Szander LaVey inaugurated the Church of Satan in San Francisco and not long after, he could be found all over the national media, in such places as the girlie and nudist mags, as well as sleazy tabloids in which he eventually wrote an advice column called "Letters from the Devil."

The later sixties and early seventies saw a rise of interest in the occult, paganism and witchcraft, and publishers in both Britain and America released magazine series' —*Man, Myth and Magic* and in the UK, Gresham published a monthly magazine called *Witchcraft* in the early seventies. In the US, adult slicks and magazines used these same themes for some of their articles and photo layouts.

In the Mar 76 (v8 #4) issue of the newsstand girlie mag *Nymphet*, a letter under the heading "Satanic Sex" features in the editor's column, "The Nymph's Box." Illustrated with a pic of LaVey and a nude woman, a reader wrote the following:

I've been a fan of skin mags for a long time, now and one of the things that bugs me in particular, is the absence of the occult from

sexually oriented material. For a brief spurt about three or four years ago, voodoo, Satanism and the occult were getting a fair amount of play in magazines similar to your own. Now, however, there's little—if anything, appearing on this shadier side of human sexuality.

I find extremely arousing, the rituals and ceremonies involving the symbols of witchcraft and devil worship—especially the idea of sacrificing a virgin and the actual deflowering of the virgin by the Evil One himself. One of the most exciting aspects of that brief period was the popularity of Anton La Vea [sic], occult leader of the 5000-member Satanic Church in San Francisco, California. I thought he was very colorful and the sensual practice of nudity among his worshippers, stimulating indeed!

Other than this, I really have no complaints about your magazine. But I would like to see more kinky types of sex handled visually, as well as in the articles—subjects like necrophilia and bestiality.

The letter is signed "J.L. Jackson, Atlanta, Georgia." Although he seems ignorant on the subject, he makes the point that these articles were a popular theme in the girlie mags—both newsstand and slicks—for a brief time.

Again, what follows is only the tip of yet another iceberg, and is not a complete listing of mags that covered these subjects and themes.

So get out the Black Sabbath tunes—and crank them up!

SATAN

☐ **SATAN** was essentially a lifestyle mag like **PLAYBOY**, but it replaced the Hefner publication's trademark rabbit with "Old Nick," possibly borrowed from a mag that came out slightly earlier in Sep 56 called **MAN ABOUT TOWN**, which used the same type of cartoony Satan on its cover. There were other mags that threw demonic glee into the mix, but **SATAN** led the pack when it came to bachelor pad hipsters with a devilish gleam in their eye. It only lasted six issues, but what great issues they were! Wine, women and song—booze, broads and bravado—Judy O'Day, Tina Louise, Bettie Page and Julie Newmar—oh my!

In the late sixties and early seventies, Stanley Publications published, from the same address as above, some of the shlocky illustrated horror titles on the racks, such as **SHOCK**, **CHILLING TALES OF HORROR**, **STARK TERROR** and **GHOUL TALES**. Stanley Publications also published the men's mag **RUGGED**—"The Entertainment Magazine for Real Men!"—that was advertised in the back of **SATAN**. Theodore S. Hecht was the Managing Editor, who generally worked for Stanley Publications titles, but had also worked with Myron Fass on **SHOCK TALES** (see page 491).

"Devilish Entertainment For Men" was the sub-title and "Abandon All Hope Ye Who Enter Here" was its motto, Dante Alighieri's inscription on the entrance to Hell. **SATAN** was the most quintessential of the men's magazines using the devilish theme that adorned magazine racks in 1957, and was the basic genre of mag which was celebrated and parodied in the trend setting book **CAD: A Handbook for Heels** (Charles Schneider, ed., Feral House 1992).

The first issue of **SATAN** (Feb 57) uses an upper case "S" in its title, which on all subsequent issues changes to the lower case. It opens with this message from the editors:

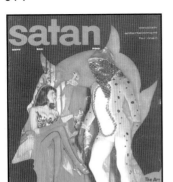

**Page 312 Satan porn! WITCHCRAFT
(v3 #1) Winter 72-73.
This page, above SATAN (v1 #6)
Sep 57. Opposite Classic Betty
Page: front and back covers for
SATAN (v1 #2) Apr 57.**

Here's A Toast…To You the readers…We hope the bubbles in our champagne-flavored pages will titillate your appetite. We, the editors, had a lot of fun putting them together. Satan, himself, that old reprobate, whom we lured back from his devilish playground somewhere down below, was so overjoyed when he saw them, that he promptly made this dedicated magazine his official house organ.

The first issue, with covergirl Judy O'Day "The Devil's Darling", also includes these devilish delights: *Satan Sets Up A Bachelor's Den*, in which this advice was given "A man's relaxing room should be designed to show his trophies;" *The Danger of Being Too Innocent* by Honore de Balzac, reprinted from his **The Droll Stories**; Judy O'Day checking in again with the *Devil's Darling* centerfold layout, in which she dons a pair of purple devil's horns and a tail that looks particularly phallic, red tights, and a pitch fork; a book review of **The Drawings of Heinrich Kley,** with some of his incredible illustrations reproduced; *Satan's Angel*, a Tina Louise layout; *Saucy Satanisms*, the joke and limerick pages; and lots of ribald cartoons!

The second issue of **SATAN** (Apr 57) sports a classic Bettie Page cover and centerfold layout, this time Bettie as *Satan's Angel*. The photos are by Charles Kell and the short text reads:

SATAN had a lot of fun, working with Betty Page. She's such a buoyant girl. Maybe that's why she's in such great demand. Still, when she heard the Royal Command of the Prince of Darkness, she dropped everything and came arunnin'. And wasn't it worth it? It's not every young lady who's showered with jewels, draped in mink, and glorified the way a girl might dream. Still, Old Nick is a canny lad. He knows real beauty, when he sees

it. From the first instant that he saw her, SATAN was enchanted. And—can you blame him!

The third issue (Jun 57) has the cover theme "Wine, Women and Song!" Julie Newmar is featured as the middle of the trio and *The Bride of Satan* is the title of the issue's centerfold layout featuring Rita Dulase.

The cover of the fourth issue of **SATAN** (Jul 57) is a classic, picturing a blond Eve holding the just bitten forbidden fruit, while being seduced by a cartoon serpent Satan, who is smoking and waxing his handlebar mustache whilst sitting on a strategically placed tree branch. Certainly the best cover, next to the Bettie Page cover.

Issue five (Aug 57) shows a cartoon Satan about to take a picture of a posing beauty with an old tripod camera.

The sixth and last issue of **SATAN** (Sep 57) has a very unique looking cover photo from The Art Students League Ball, of a colorfully dressed Princess with a man dressed in a frog mask and costume, reminiscent of the Plague of Frogs scene from the movie **The Abominable Dr. Phibes** (1971). The photo is inset within a silhouette of Satan's head! This graphic eye candy was imitated later by Satan Press on the covers of their line of adult paperbacks in the seventies.

AFTER HOURS

❏ In the fourth, and last, issue of **AFTER HOURS** you get Anita Eckberg (covergirl), Bettie Page, Eve Meyer and Forrest J. Ackerman! What more could you ask for from this James Warren edited mag, which predates **FAMOUS MONSTERS OF FILMLAND.** It is considered by some to be **FAMOUS MONSTERS** #0, in the sense that it has its share of horror monsters and sci-fi movie stills.

Science Fiction Folio is "a monster rally of articles, fiction and humor on the weird, wonderful and ofttimes sexy world

SATAN
Vol 1 No 1 Feb 1957–
Vol 1 No 6 Sep 1957
Stanley Publications Inc., 261 Fifth
Ave, New York 16, NY .50 68pp

AFTER HOURS
Vol 1 No 4 1957
Jay Publishing Co., Inc., 1054
East Upsal St., Philadelphia 50,
PA .50 48pp

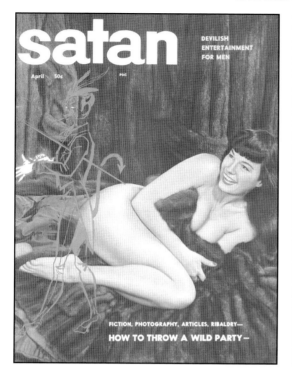

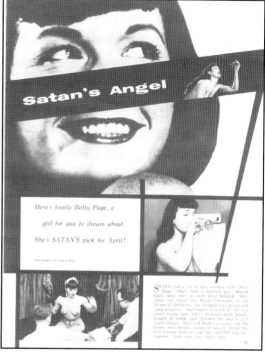

of Science Fiction." The section includes six features and kicks off with an article by Ackerman, *Confessions of A Science Fiction Addict.*

The Ackerman article opens with an *Editor's Note* from Jim Warren that reads:

Recently **AFTER HOURS** *conducted an extensive search to find the country's greatest living authority on Science Fiction, so that we could con him into writing an article for us in return for a free subscription. After months of exploration we found that all roads led to the home of a Forrest J. Ackerman in Hollywood, California. This seemed like a logical place for the habitat of a Science Fiction fan, so we contacted Mr. Ackerman.*

Using his hip turn of phrase, Forry gives us a history of sci-fi mags and films from his childhood, starting in 1926 with **AMAZING STORIES** magazine. Forry also makes the case that sex and sci-fi didn't exclude each

other, and cites examples of sexy sci-fi stories. Six sci-fi pulp magazine covers are pictured and one photo of Forry with a costumed gal at the "Wide Open Interplanetary Spaces Party" in Hollywood.

I Meet My Love Again by Arthur Porges is a two-page story, written in the first person, of the retribution of a research mathematician who is poisoned by his wife and her lover, and dies. His corpse retains the will to live, after death, using his "unique brain, rigorously trained by years of the most exacting research." He remains in the grave, conscious, for three years, until able to break out of his weakening coffin with his decaying corpse and exact revenge on Fred Mason, his wife's lover. He kills him with pure horror, inducing a heart attack, and then awaits the arrival of his wife, Gloria. The last line reads: "I shall greet her as a long-absent husband should—with a lingering kiss on the mouth."

There are two pages of cartoons with space aliens and curvy women, before the next article, the uncredited *Screamoscope*

Is Here!—Beauties & Beasts of Hollywood. It starts with the blurb "Hollywood combines Beauties & Beasts for Box Office Bonanzas . . ." and is illustrated with stills from fifties sci-fi horror flicks like **This Island Earth**, **Dr. Cyclops**, **Earth Vs. The Flying Saucers**, and **Tarantula**—women being threatened by monsters and aliens. There is also a series of six photos of Boris Karlof's transformation in **Abbott & Costello Meet Dr. Jekyll & Mr. Hyde**.

The centerspread—*Out of This World Girl*—is Madeline Castle, who, it informs "graced our centerspread a few issues back." Other vixens in the issue are *The Sensational Swede*, Anita Eckberg, and "the one...the only...the magnificent—Bettie Page" who both have four pages.

Finally, a feature called *Artists Have A Ball* on the New York Art Students League Ball, contains a picture of Tina Louise, who "reigned as Queen of the Ball and was carried into the ballroom astride a huge golden dragon, supported by six costumed 'slaves'."

Above **Stanton logo for SATANA.**
Opposite **Forry Ackerman wrote about Rosaleen Norton in SEX & CENSORSHIP (v1 #2) 1958.**

NOTE From **THE NATIONAL TATTLER** (v2 #8) Feb 21, 65: "CARLSON WADE Noted sexologist, editor-in-chief of **POPULAR MEDICINE**, author of **Transvestism Today**, **Erotic Symbolism**, **Sexual Sadism**, **Sexual Masochism**, **She-Male**, **The Troubled Sex**, **Abortions In America**, **Your Sex Problems In Marriage**, **The Twilight Sex**, **Sex Perversions and Pleasures**, **Sexual Behavior of the Lesbian**, **Sex Power In Marriage**, **Dictionary of Sexual Terms**. Author of over 1000 features in leading magazines and newspapers throughout the country. Syndicated columnist and researcher."

SEX & CENSORSHIP
Vol 1 No 2 1958
Mid-Tower Publishing Co., 693 Mission St., San Francisco 5, CA .50 68pp

SATANA
Vol 1 No 1 No date,
circa 1961
Selbee Associates Inc., 135 West 56th St., New York, NY 1.00 72pp

SEX & CENSORSHIP

☐ **SEX & CENSORSHIP** is a mag dedicated to sexual freedom of speech, and I am only aware of two issues. The second issue begins with a quote from Thomas Jefferson and ends with *Benjamin Franklin's Letter of Advice to a Young Man on Choosing a Mistress*. In between, are articles on *Sex Censorship In Medicine* and *Prostitution Re-assessed* by Harry Benjamin, M.D.; *Is The Vaginal Orgasm A Myth?* by Albert Ellis, Ph.D.; *Monkeys, Movies and Assemblymen* by Lawrence Lipton; and, by the legendary sci fi fan and collector, Forrest J. Ackerman, *Burn, Witch, Burn!* Surprisingly, this is about the New Zealand born artist Rosaleen Norton (1917–79) and her inimitable artwork! None of her artwork features with the article though—partially the point of the piece.

The artwork looks as if it could have been clip-art of the Salem witch trials—a far cry from Norton's magically phantasmagoric satyrs, witches and rituals.

Ackerman's opening sentence introduces Norton, stating:

Rosaleen Norton has been branded a freak, a 20th century witch, a depraved mad-woman and a vehement variety of other slanderous epithets by her contemporary critics and peers. She is an artist of the supramundane.

Forry spins the tale of **The Art of Rosaleen Norton** (1952), a book published in Australia in a limited edition of 1,000 copies, 350 of which were hand-bound in gold-embossed crimson leather. Forry claims only six copies made it into the U.S., two ending up in Hollywood. States Forry:

I once saw a copy in the pale vampiric hands of the late Bela Lugosi. It was fitting that the aged Dracula should be admiring the volume, vocally and volubly, for the original intention had been to bind the book in bat skin.

Forry gives Rosaleen, or "Roey" as he affectionately calls her, the high praise she deserves for her unique artwork that she didn't receive in Australia in the early fifties. She was acquitted of an obscenity charge after showing some of her sexually charged drawings at Melbourne University three years before the publication of her book. The book itself was eventually banned in Australia, and Norton and Gavin Greenlees, whose poetry was used in the book, escaped prosecution by agreeing that the unsold copies of the book were to be destroyed.

Ackerman also notes that Norton's book is dedicated to **The King In Yellow** (1895) by Robert M. Chambers, the same book that inspired the likes of H.P. Lovecraft, August Derleth, Robert E. Howard, and many others. **The King In Yellow** is a collection of short horror stories with excerpts from a supposed play, of the same name, quoted throughout, said to drive anyone who reads it insane.

In one animated description of Norton's artwork, Ackerman writes "In the art appear kaleidoscopic pyrotechnical burgeonings of bodies of birds, beasts, fish and human beings amalgamated with hands, faces, snakes, suns. Gargoyles and gryphons leer and jeer. Cannibalism, lesbianism, bestialism burst birth-naked from the pregnant pages."

Then Forry listed authors and artists that Norton's work "echoes" or resonated with, such as William Seabrook, Aleister Crowley, Arthur Machen, Poe, Beardsley, Virgil Finlay, and others.

He concludes the article with the salute "Charms around you, Rosaleen Norton, wherever, whatever, witch ever you are."

An excellent study of Rosaleen Norton's life and work, **Pan's Daughter—The Magical World of Rosaleen Norton** by Nevill Drury, was published in Australia in 1988, and released again in 1993 by Mandrake of Oxford, UK.

SATANA

☐ The adult slick **SATANA** has a great title and devil doll logo by Eric Stanton, who is the stated art director for issues #4-6, and possibly unstated for the first three issues. Stanton also did most of the artwork inside, including the strip called *Satana* which ran in issues #2-5. Satana—a sultry vixen in Hell—receives a pass from the devil to go "uptop" to tempt some souls into sin to break her boredom, but, once she gets topside, she has a hard time adjusting to the new women's fashions that have come about in the eighty-three years she has been "down below".

Gene Bilbrew, aka "Eneg," was also a regular contributor of incredible fetishistic artwork in the early issues, and contributed cartoons for the *Satanic Sallies* cartoon pages and the sexy cartoon strip *Devil Doll*.

There was another artist whose finely illustrated cartoon artwork could be found in **SATANA**, who simply signed his work "Hank."

The titles of certain pictorial layouts also help give **SATANA** the smell of sulphur: *Princess of Darkness*, *The Devil is a Woman!*, *Devil from Denmark*, and the *Epistles to Inferno* letters column.

Leonard Burtman is listed as "President" in the first three issues. Burtman started the groundbreaking, digest-sized, fetish zine **EXOTIQUE** that lasted thirty-five issues from 1951 until 1959, and contained lots of fetishistic artwork by Stanton and Bilbrew. **SATANA** is similar in subject matter, but larger format with photos used on the covers instead of artwork.

SATANA has many sister publications from Selbee including **EXOTICA**, **DIABOLIQUE**, **PEPPER**, **LEG SHOW**, **HIGH HEELS** and the **FOCUS ON...**series of mags. Some of these titles were picked up by Health Knowledge later in the sixties, and still other publishers after that. Selbee's mags all contain fiction by various pseudonymous writers, articles on diverse

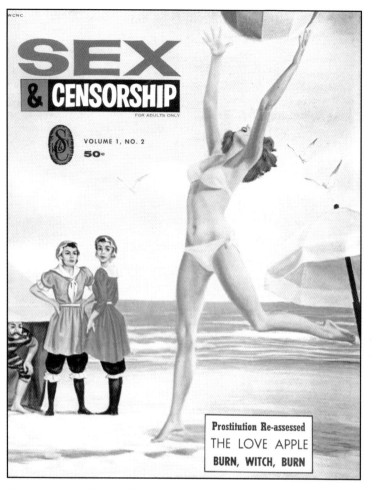

Prostitution Re-assessed
THE LOVE APPLE
BURN, WITCH, BURN

fetishism by Carlson Wade, and lots of b&w cheesecake and fetish photos, including a color centerfold.

Carlson Wade wrote for most of Selbee's mags and authored, with Dr Edward Podolsky, a series of books on sexual behavior and fetishism. Published by Epic Publishing, these were advertised throughout Selbee's mags. It has been rumored that Carlson Wade was a pseudonym of Ed Wood's—that was not the case. Wade, however, did write some interesting articles on the more esoteric aspects of sexuality and fetishism with titles like *Female Sword Dueling Returns* and *The Powerful Beauty of Gloves*. [SEE NOTE]

SATANA issue six (1963), with Lisa Reed adorning the cover and central lay-

out, is one of my favorite covers. It captures something so perfectly that it is useless trying to explain it. You either get it when you see it, or you don't. And I'm not just talking about Ms Reed herself, but the cover as a whole, as a time capsule. Was some guy, somewhere, ejaculating to this issue on Nov 22, 1963 at the exact moment Kennedy's head exploded? Anything's possible. Lisa Reed, the "Satanic Siren," has a cotton candy-like hairdo, heavily painted eyes and eyebrows, and reminds me of a slimmed down version of Divine from the early John Waters films. The issue also features pics of the sultry Laura Vickers.

By issue eight (Summer 65) **SATANA** was being published by Health Knowledge. They did away with the Stanton logo on the

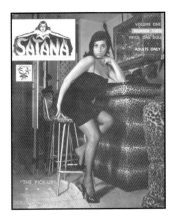

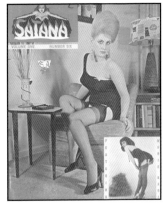

From top **According to the mag, SATANA (v1 #3) covergirl Barry Cole was a native of Tahiti, relocating to NYC and decorating her East Side apartment with leopard skins; Lisa Reed with cotton-candy hairdo in SATANA (v1 #6) 1963.** Right **The letters section of SATANA; this one (v1 #6) was headed by a Stanton rendition of** *Inferno*. Opposite, from top *Devil Doll* **strip by Gene Bilbrew in SATANA (v1 #3); "Miriam Fairfax" with eyeglasses in SATANA (v1 #8) Summer 65.**

BLACK MAGIC
Vol 1 No 1 undated, circa 1963
American Art Agency (A Parliament Magazine), 7311 Fulton Ave., North Hollywood, CA 1.00–2.00 88pp

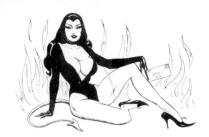

More Epistles to Inferno

"BEST SHOWGAL"

Dear Editor:

The best dancer and showgal in the business is Gilda. I notice that you keep getting requests for news of this exotic beauty, and for new pictures of her. As all your readers know by now, she was once the curly headed little moppet in "Our Gang Comedies."

Enclosed are some unusual pictures of this fabulous woman. The costume and make-up she's wearing are designed by her (she's got all kinds of talents!) and she calls them "Ensemble for the Space Age." If women in the future look like this I hope I live a long life!

Good luck with your magazines.

Yours truly,

N.C.R.
Springfield, Mass.

...SPACE AGE ENSEMBLE by GILDA...
(From N.C.R.)

cover, although they did use a Stanton drawing of a devil doll with a trident, next to the new, flaming, typeset logo, which was only used on that issue.

SATANA v1 #9 (Winter 65–66) has another typeface change to the title logo, but the Stanton devil doll artwork is left on. The artwork on the inside is all Gene Bilbrew. The *Epistles to Inferno* letters column was changed to simply "Letters to the Editor."

The tenth issue of **SATANA** (Spring 66) has a Cher-circa-1966 clone on the cover in leopard print bra and panties. Stanton's artwork is used for the opening pages of the two pieces of fiction, and there are pictorials of Jean MacDonald, "Glorious Glove Model" Laura Vickers and stripper Bonnie Logan,

among others. The feature *Strip for Action* shows a "friendly game of 'Strip Poker'" with Pussy Galore, Crystal, Carmine, and Suzette—"four top strippers from Zorita's famous 'Show Bar' in Miami."

Issue number twelve (Spring 67) has seven nude pictorials, which include Jackie DeWitt, who also features in issue ten with a different set of photos. The redheaded covergirl is Lisa Lang, not featured inside, but in issue seven as *Satana's Seventh Disciple* and the color centerspread.

The two pieces of fiction, and the article *Astrology and Your Love Life*, are all by Carlson Wade, who was back on board after an absence of a few issues.

Woman Leopard Trainer is a pictorial on

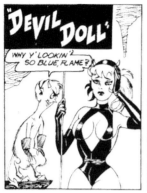

Charlotte Walsh, "the only woman leopard trainer in the world." The pics show the lovely Ms Walsh putting her lively leopard through hoops, having him stand on his hind legs, and licking her hand.

There are at least fifteen issues of **SATANA**, possibly more, but the title seems to have stopped being published in the late sixties.

BLACK MAGIC

☐ **BLACK MAGIC** was a top of the line adult slick from Parliament, that made nylon-covered legs, garters and panties, and of course the lovely ladies that inhabited them, its stock in trade. Or, as the title of one layout aptly put it: "Lingerie Witchcraft." **BLACK MAGIC** also chose to go with the occult sounding title and similar layout themes, as they did with their other boobs-and-bongos title, **SATAN'S SCRAPBOOK**.

The first issue of **BLACK MAGIC** is undated but is most likely from 1962-63, and has two stories under the title *Satan and Silk* by D.B. Lewis. Both stories are concerned with Satan's penchant for silk stockings and his frustration at not being able to see such things in Hell. The first story starts:

The Devil digs silk stockings too. Down in his igneous castle in the southwest corner of Gehenna atop his flaming throne, his Royal Lowness never

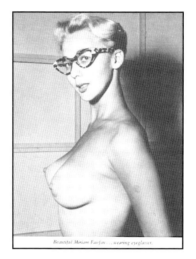

Beautiful Miriam Fairfax . . . wearing eyeglasses.

gets the chance to see a female leg encased in that shining, silken sheath of sex incarnate—the stocking.

The story starts when seventeen naked call girls are transported to Hell via a fire that burns down the house of ill repute that they work in. The patrons go to Heaven while the working girls go to Hell. Satan whisks one of the girls off to purgatory because she looks too young. But Satan is bored with naked women, no matter how lovely, and longs to see "well shaped gams in black nylons." So, when Satan proclaims "Stockings!"—"many millions of silkworm souls were galvanized into action." When the stockings have been made, and are on the sixteen remaining girls, Satan blows his stack when he sees their legs clad in stock-

ings of "a vivid, bilious green—with lavender and pink polka-dots—and crimson seams." An angel from Heaven shows up and as the hellions cover their eyes, the angel says, "Like you're damned too, and don't you ever forget it! You're doing all right for a bum—but nix on the special kicks. I got orders to give you a special reminder, so this's it!" And the Devil's legs are clothed in stockings of "yellow, with blue and purple zebra stripes." He rips them off in a fury, and sends the sixteen lovelies to a pit of lava containing the ghosts of sharks and piranhas!

The second short story in *Satan and Silk* concerns "Joe," a ventriloquist con artist sent to Hell for bilking widows by communicating with their dead husbands for a price; Joe was also a legman. The problem is, Satan doesn't like legmen, as he is jealous of them! So Joe is in for a rough time in Hell. He is whooshed away to a large hall filled with what look like beautiful women wearing nylon stockings, until he lunges at one only to find that they are all "unbelievably beautiful—department-store mannikins." Joe screams, "It ain't fair!" The Devil, from his castle, replies: "It sure ain't. Let's see you make them talk!"

The issue's humor pages, called *The Lighter Side of Black Magic*, feature racy cartoons, jokes and limericks: "There's only one thing slower than your wife getting her clothes on. That's a woman who isn't your wife getting her clothes off."

In **BLACK MAGIC** v3 #1 (Apr/May/Jun

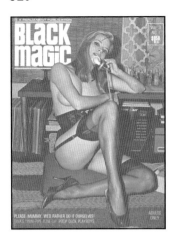

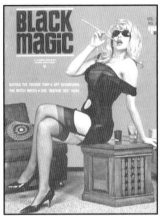

From top **BLACK MAGIC (v3 #1)**
Apr/May/Jun 66 and **(v3 #2) Jul/**
Aug/Sep 66. Right Barbie Conners
performs her mysterious ritual
in BLACK MAGIC (v3 #4) 1967.
Opposite, from top Maggie Conway
charming a rope in *Focus on Hocus-*
Pocus, BLACK MAGIC (v3 #4);
Splash page artwork for *Satan and*
Silk by D.B. Lewis in BLACK MAGIC
(v1 #1) undated.

PAGAN
Vol 3 No 3
Jan/Feb/Mar 1966
American Art Agency, Inc. (A
Parliament Magazine), 7311 Fulton
Ave., North Hollywood, CA 1.50 80pp

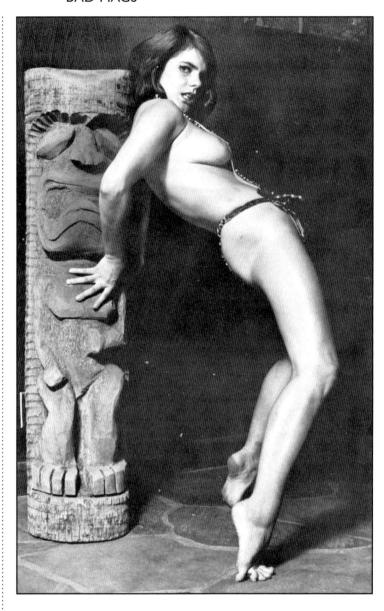

66) there are the usual girlie spreads and a couple of stories, but, there are two features of mild interest. The first, *Please, Mummy, We'd Rather do it Ourselves!* is a photo layout with minimal text that informs you the ghouls "gather together in their secret cavern for another performance of an eerie ritual that has never been photographed in its entirety until now."

"Before long, the fiendish fling is in full swing. The floor show features a supernatural hootenanny, with torch songs by our uninhibited honeys, and choral accompaniment by the Phantom Four." The "honeys" being four women dressed only in panties, and the "Phantom Four" the robed and hooded torch carrying cultists.

Wendy Weaves her Witchery is a girlie layout of a woman, with her cat and bongo drums, who strips before the camera.

This issue, and others, contain an insert advertising memberships in "Jaybirds Anonymous," a nudist club, that states on the form: "I am in favor of individual freedom of expression, including the exposure of total body to sun, air, water, family and consenting friends."

BLACK MAGIC v3 #2 (Jul/Aug/Sep 66) is one of my all-time favorite covers, and is where the cover for this book comes from, which has been digitally manipulated. Seeing the image for the first time—of the haughty, bewigged blonde babe on the cover, smoking through a long cigarette holder, from behind her bug-eyed shades—instantly seemed to me an archetypal image.

Mona Evertsen is the covergirl and her layout on the inside is called *Mona's Manhattan Mystique* in which she sheds her shades and dress, but not her nylons, garters, panties or cigarette holder.

The back cover invites you to purchase the mag:

> **BLACK MAGIC** *is your passport to the wild and way-out world of bewitching women, wondrous wit and superb stories. Light your evening with their eerie delights. Buy it now!*

Some of Parliament's other titles would have the occasional witchcraft and devil themed feature with women, skulls, hooded cultists, altars, etc. For example, in **HONEY** (v1 #2 1962) with its *A Switch on Witches* feature, again written by D.B. Lewis, features photos of two women, one wrapped in a black veil holding a skull, and the other in a white veil, on the floor writhing around with a skull and candles.

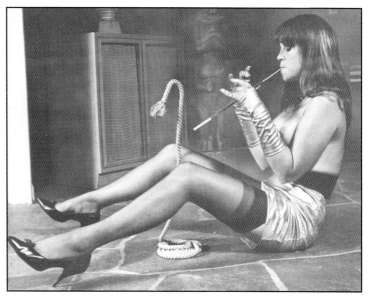

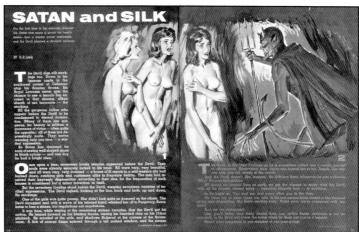

PAGAN

☐ If your cup of tea is sixties erotica exotica, then **PAGAN**, which premiered in 1962, is the mag for you. Most all of the earlier issues were swimming in tikis,

bongos, congas, skulls, women with spears, women in animal skin outfits, witches, pagan idols, and so on.

PAGAN v3 #3 is a prime example of the mag and its penchant for exotica, starting with the idol-clasping covergirl and centerspread model, Moira Henderson. The text accompanying her layout, *Solo Sorceress in the South Seas*, claims Moira is Polynesian, born in Papette, Tahiti, "the only child of an English sea captain and the native Tahitian doll whose beauty dazzled the captain into retirement." Moira is seen posing, in leopard

print panties, with native animal hide shields, a spear, and of course the stone idol from the cover.

The opening layout in the issue, and the back covergirl, *Witch Girl's Broom Zoom*, has a gal posing with witch's cape, conical black hat and broom, clad only in black panties, garter, stockings and high heels! The blurb on the back cover announces:

> *Follow this broom-zooming witch... she's the sorceress who'll be your stewardess on your enchanting flight*

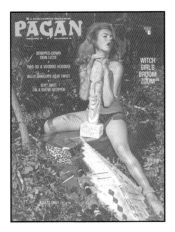

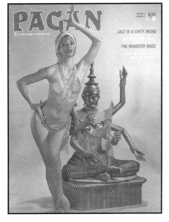

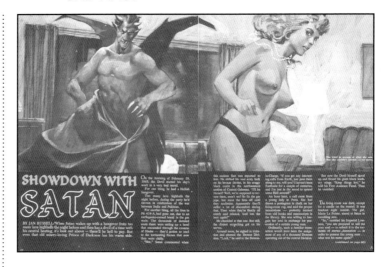

SATAN'S SCRAPBOOK
Vol 2 No 4 Jan/Feb/Mar
1966
American Art Agency, Inc., 7311 Fulton
Ave., North Hollywood, CA 1.50 80pp

over **PAGAN***'s jungle of pictorial
loveliness. You'll soar to the heights of
delight as the fascinating panorama
of pulchritude unfolds before your
fortunate orbs. The primitive package
also offers a man-pleasing selection of
fiction, fact and rollicking good humor.
There's a solid measure of pleasure on
every pulsating page of* **PAGAN***!*

The short fiction pieces always have
great splash page artwork—in this issue for
the stories *Hell Can't Wait* by Neal Neitzel
and *Showdown with Satan* by Jan Russell.
Hollywood's Over-Hexed Helmsmen by
Clete David is a strange article that concerns
itself with famous Hollywood personalities
who had mishaps while boating, some being
fatal. The opening blurb—"Hollywood has
spawned many would-be Leif Ericssons
who itch to sail the seven seas. But too
often when they take the wheel or tiller,
the Viking image fades and tragedy takes
over." The film stars mentioned include
Humphrey Bogart, Steve Cochran, Errol
Flynn, and Jack Barrymore.
Two do a Voodoo Hoodoo is a pictorial
with two "pagan pretties" dancing around
topless in loincloths with a drum and spear.
The first half of *England's Sick-Sick-Sick
Sex Cults* by Russ Gordon rehashes the his-

tory of Sir Francis Dashwood's Hellfire Club,
and claims it has been revived by a group
of Oxford students, who said: "We go light
on the religious mumbo jumbo and we don't
have to use professional prostitutes. Plenty
of local girls are eager to attend the meet-
ing." The article then discusses "London's
famed Suicide Society," in which the twelve
members play dice or cards, with the win-
ner the next to do himself in. Each 20 May,
between sunset and midnight, one of the
members killed himself, or as the article
puts it, "*commits his own murder.*" The
suicide clubs used the legend *Appointment
in Samarra* as their motto of sorts, the title
having become a euphemism for meeting
one's death.

The later issues of **PAGAN** are pretty
themeless beaver mags that occasionally
have an interesting article or two: **PAGAN**
v7 #4 (Jun/Jul/Aug 72) has an article called
Sex on Stage by Cathy West and is "An in-
depth interview with the entrepreneur who
first presented actual intercourse." The writer
talks with Ray "Tiny" Becker, manager of the
New Follies Theatre in San Francisco.

According to the article, the first live
onstage sex show was **Lloyd Downton's
Bedroom Techniques** which played at
the New Follies in San Francisco's Mis-
sion District. Lloyd Downton being "a San

Francisco playboy and man about town who gets busted now and then for making 'obscene' movies." Downton produced the show, which only lasted a month due to poor attendance. Its failure was blamed on the public's confusion in thinking it was a film, and the theatre's location far away from the usual tourist traps.

The thirteen actors and actresses in the show were culled from a newspaper ad. They weren't told, at first, that they would be asked to perform sex on stage. When they were asked, and given the choice of simulating or actually fucking on stage, some of them left and had to be replaced at the last minute.

Bedroom Techniques was a one and a half hour show which included four Adams and four Eves with glowing fig leaves and genitals, engaged in cunnilingus, fellatio and intercourse, under black lights, while a narrator recounted the origins of sex. Then a short film sequence of a totally nude woman riding the cable cars in San Francisco and going shopping. Next was a live demonstration of adult sex toys of the time, with a woman using a variety of dildos and rubber vaginas. Some comedy routines followed, and the final scene was couples demonstrating different sexual positions, which turned into a "mass orgy."

At the end of the piece, manager Tiny Becker makes some prescient predictions about where the sex shows were headed:

> Now that people have seen ordinary fucking, they want to see far-out sex—sadism, masochism, the whole gamut until the theater becomes like the Roman arena. Lloyd Downton made a movie that ended with a group of people encircling a girl and urinating on her. The 'golden shower,' they call it. We're going to see more of that sort of thing.

And on "video-taped stag films" Becker predicts—"People will buy these erotic tapes

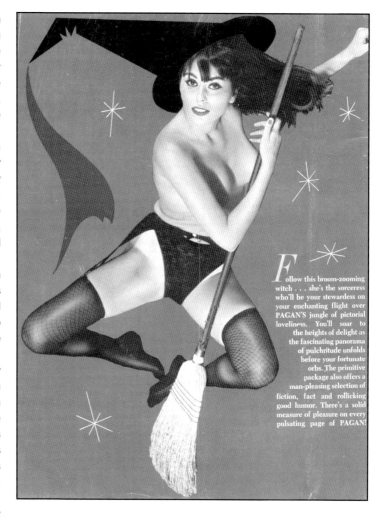

*F*ollow this broom-zooming witch . . . she's the sorceress who'll be your stewardess on your enchanting flight over PAGAN'S jungle of pictorial loveliness. You'll soar to the heights of delight as the fascinating panorama of pulchritude unfolds before your fortunate orbs. The primitive package also offers a man-pleasing selection of fiction, fact and rollicking good humor. There's a solid measure of pleasure on every pulsating page of PAGAN!

the way they now buy phonograph records. That'll bring sex back where it belongs—in the home. What better place is there for erotic entertainment?"

SATAN'S SCRAPBOOK

❑ Another Parliament mag, along the same lines as their **BLACK MAGIC** and **PAGAN** titles, was **SATAN'S SCRAPBOOK**, which premiered in 1963. The Devil was not only in the details but also in the early issues of **SATAN'S SCRAPBOOK**. For example, in v1 #4 (1965) is *Honey from Hades* and the pictorial *How to Tease the Devil*, featuring

a large breasted brunette stripping off her lingerie and hanging it on a lasciviously grinning horned bust of the Arcadian god Pan.

SATAN'S SCRAPBOOK v2 #4 uses a conga-playing nude on the cover, who is also the featured centerfold girl, Audrey Simmons. The contents page headings add to the sulfuric air, with titles like *Devilish Articles, Diabolic Humor, Flaming Fiction* and *Impish Pictorials*.

The pictorials of buxom sixties babes wearing leopard print panties, nylons, garters and high heels—posing with conch shells, ceramic bulls, conga drums, and power drills—are classic.

The fiction offerings are *Blues for a Bare*

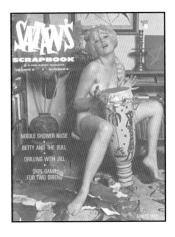

Above **SATAN'S SCRAPBOOK** (v2 #4) Jan/Feb/Mar 66 featuring Audrey Simmons on the cover and in a layout called *Peek of the Week* that uses an animal skin rug, African bongo and face mask as props. Opposite **NATIONAL STAR CHRONICLE** was a tabloid published in New York City from 1962 that ran into the seventies, by which time it was completely given over to sex. This is issue (v8 #7) May 8, 1967, with Anton LaVey on the cover.

NATIONAL STAR
CHRONICLE
Vol 8 No 7 May 8, 1967
Inter-Press Corporation, 64 University
Place, New York, NY 10003 .15 16pp

FATE
Vol 20 No 9 (No 210)
Sep 1967
Clark Publishing Co., 500
Hyacinth Place, Highland Park, IL
60035 .40 132pp

Body by Dale Lester and *McGill's Last Girl* by Jack Barnes, both opened with splash page paintings.

The ads in the back, as with most all Parliament mags, are for Jaybird mags and calendars, nudist mags from Sun Era, and mags and paperbacks from Regent House. There are two subscription ads for the leg lovers mags **TIP TOP** and **BROADSIDE**, interesting for their funny and clever come-on text. For example, the **TIP TOP** ad copy reads:

For the Man Who Has Nothing!
Start him off with a subscription to
TIP TOP...*He'll move up fast in the world—from the tips of the toes to the tops of the hose—with side trips to outlying territories, when he discovers* **TIP TOP***'s Uncover Girls: indoors & out; high-heeled & in sneakers; in nylons or patterned hose or bits & pieces of the latest lingerie; at work or play; in a group or alone. Every 80-page issue features lots of color & motion, as well as informative short articles on what's new in leg watching and underfashions for the gynecomorphous* body.*
In no time at all, he'll be even with the man who's had his **TIP TOP** *for years. Soon, he'll be ready for real, live girls. After that—the world!*
So, to make a 98-pound weakling into a Man Of Distinction, send him **TIP TOP** *today. And, how about a subscription for yourself? It's very educational. $9 for 4 issues—sent in a plain wrapper, 1ˢᵗ class postage.*
*(*Gynecomorphous—having the form or structural characteristics of a woman or female.)*

NATIONAL STAR CHRONICLE

☐ After the formation of the Church of Satan in 1966, Anton LaVey was featured in various magazines and tabloids through the years, such as **UNCENSORED**, the nudist mag **NUDE LIVING**, **LOOK**, **ARGOSY**, **HUSTLER**, **HIGH SOCIETY**, **NOSE**, and so on.

The tabloid **NATIONAL INSIDER** ran a six part series (Oct 27—Dec 1 68) called *Inside the Church of Satan*, written by Mike Resnick, adult novel and sci-fi author. Not long after, LaVey started writing a tabloid column called *Letters from the Devil* which ran at first in the **NATIONAL INSIDER**, and later in the **NATIONAL EXPLOITER**, from early 1969 until sometime in 1971; both papers were published by the Allied News Company out of Chicago. LaVey was occasionally pictured on the covers of other tabloids, as well as inside, usually with the nude altar publicity photos, when the paper needed something sensational to boost sales.

The **NATIONAL STAR CHRONICLE** premiered in 1962, and is an exploitation tabloid that, by the early seventies, had turned to more sexually oriented articles. LaVey is used on several of their covers as an inset in the early seventies, advertising such features as *The World of the Occult—1970 Style* and *Devil Worship Returns*.

This issue has a cover that screams "Four Girls Tied Me Up & Raped Me" and a photo of the "New Sin Cult" i.e., LaVey and crew, which makes this issue of the **CHRONICLE** especially collectible. It is also the earliest tabloid I've found with a LaVey cover story, although there may have been earlier ones.

Special Report on New Sin Cult and *Man Founds Religion to Worship the Devil* are the title and blurb on this one page item by Hugh Bohm, which includes six photos. Bohm gives the usual intro info on LaVey and his various past jobs, some of which have had doubt cast upon their validity since LaVey's death in October 1997.

The following is written about LaVey's pet lion at the time:

Vistors are requested not to enter through the rear door—which is

guarded by a 500-pound lion named Togare. A sign on the door warns: 'Danger, No Trespassing. Survivors Will Be Prosecuted.'
At night, the lion sleeps with LaVey and his wife, Diane, a bewitching blonde whom he calls 'Elysia.'

The short article seems almost a template for the others that would follow in the mainstream media, some of which can be found below. It starts with a description of LaVey's dark, thirteen room Victorian house on California Street in San Francisco, and the warning signs outside to discourage unwanted solicitors. LaVey is seen emerging from a secret passage hidden behind a fireplace. Descriptions of LaVey's *objets d'art* are given, which include human skeletons, various stuffed beasts, a gravestone-topped coffee table, an operating table as a bar, unique paintings, and bookcases filled with arcane knowledge. The Satanic wedding that LaVey presided over is also mentioned.

LaVey has been quoted on some of the fundamental points of his belief such as: "How can somebody be good to his fellow man, if he doesn't know how to be good to himself first?"

And, "Satan has kept religion going for thousands of years, and without due credit. It's about time the forces of evil got all the respect they deserve."

The piece ends with the bottom line:

In return for this and other tidbits of devilish wisdom, LaVey expects his followers to support his 'church' with financial donations.
Unlike the practice of most religions, however, those who don't contribute are asked "not to return."

The headline of a small boxed-in item on the same page as the LaVey article reads *Shot in the Lung—He Coughed up the Bullet.*

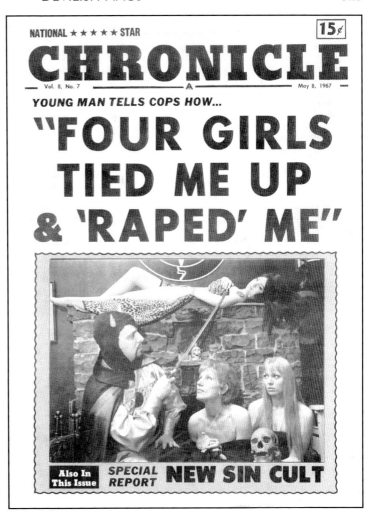

FATE

☐ **FATE** has been around as a digest-sized mag for many years, but this issue is from 1967. **FATE**'s subtitle at the time was "True Stories of the Strange and Unknown" and the issue contains one of the earlier national articles on Anton LaVey and the Church of Satan.

The article *Speak of the Devil*, by Paul R. Jeschke, has the tag line "Speak of the Devil and we'll tell you were [sic] to find him!" And: "Speak of the Devil...in the right place at the right time and this high priest may materialize before your very eyes!"

The article is four pages long, including four photos, and peppered with short quotes from LaVey. Jeschke starts by listing the occupations LaVey tried but "really never made it big as," such as lion trainer, police photographer, magician, etc. But as LaVey himself admits, he "has a perverse showmanship which will not be stifled."

Jeschke offers this assessment of LaVey:

Currently it appears LaVey has found a métier that bodes success. Impersonating the devil, he presides as high mucky-muck in the 'First Satanic

Above **The Canadian tabloid CONFIDENTIAL FLASH was also distributed in the US. This is issue (v31 #49) Dec 9, 1967.** Opposite **The rare JAYBIRD JOURNAL #10 (or v3 #2) Oct/Nov/Dec 67, with a cover featuring Anton LaVey.**

Church of the United States,' founded less than a year ago and already a diabolical success. It is not clear whether he has been influenced by Aleister Crowley whose truck with the devil preceded LaVey's in time and whose stature as a satanic go-between is not likely to be surpassed.

LaVey explains that Satanism is a "great breakthrough in the gray area between religion and psychiatry."

Jeschke concludes the piece with this LaVey quote: "The Seven Deadly Sins actually are virtues. They all lead to physical or mental gratification. How can one be kind and good to anyone else if he doesn't even know how to be good to himself?"

Jeschke admits that LaVey "may have a point there."

JAYBIRD JOURNAL

❑ The **JAYBIRD JOURNAL** began in 1965, the same year that Milton Luros, its publisher and distributor, was set up by the government and bagged under the antiquated Commstock Law for the mailing of adult mags to a newsdealer in Iowa. Luros was found guilty of "conspiring to disseminate obscenity." His tenacious First Amendment lawyer Stanley Fleishman took the case to federal court and got the ruling overturned.

Ed Lange, who had been hired by Luros, put his nudist vision into print with the **JAYBIRD JOURNAL** and thus started what was termed the "Jaybird Philosophy," with multitudes of mags espousing it.

By 1968, with the change of some staff, Jaybird mags ceased using the freelance photographers and nudists from the nudist camps, and turned to hiring staff photographers to shoot hippies and strippers, eager to earn extra money by posing as nudists.

During 1973, after the loosening of obscenity laws that allowed hardcore mags

JAYBIRD JOURNAL
No 10 (Vol 3 No 2)
Oct/Nov/Dec 1967
Jaybird Enterprises, Inc., 7315
Fulton Ave., North Hollywood, CA
91605 2.00 64pp

CONFIDENTIAL FLASH
Vol 31 No 49 Dec 9, 1967
John Blunt Publications and
Enterprises Ltd., 230 Adelaide St.
West, Toronto 1, Canada .25 20pp

in the adult shops and pubic hair in the newsstand girlie mags, the nudist mags petered out.

Anton LaVey and the Church of Satan by Nat Freedland is the cover story of this particular **JAYBIRD JOURNAL**: a six page feature with six photos, one of which shows LaVey naked from the waist down during a ritual. Freedland also wrote the informative book **The Occult Explosion** (1972), which features LaVey and the Church of Satan in one of its chapters.

This article is well written, and LaVey-friendly. Freedland introduces the San Francisco Satanist to Jaybirds at large by putting a nudist spin on it: "In existence for only one year, the Church's membership has zoomed to over five thousand members. Nudity is a vital factor in all ceremonies as depicted in our photos of LaVey's temple."

In the article, Freedland mixes descriptions of the inside of LaVey's house with quotes from LaVey—and occasional plugs for nudism—while relaying the Church of Satan's use of a nude female altar and other info of tabloid interest.

But, as Freedland writes:

Is Anton LaVey for real with his devil-worship and magic spells? The question is somewhat beside the point; it's been said that the main difference between a confidence man and a witch doctor is that the witch doctor really believes in spirits. To succeed at either trade requires a high degree of artistry at practical psychology, and there are a lot of bright San Franciscans who will attest that Anton's magic really works.

After mentioning a nightclub billboard in the North Beach section of the city that advertised "Anton LaVey and His Topless Witches Sabbath," Freedland writes: "And the nude altar girl for the regular Friday Satanic service will be starring in the mamba snake goddess dance before a packed house a little later."

Of his nightclub act, LaVey said: "Of course there's no conflict in presenting a re-enactment of magic rituals in a nightclub, Satanism belongs where people are having pleasure, not being made to learn false guilts."

Concerning the use of LSD by the hippies for enlightenment, LaVey said:

LSD can expand your consciousness to the point where it's a doormat for sensation. The magician's approach is to narrow his awareness into a concentrated beam that will enable him to attain his desires from each moment of living.

Freedland concludes with the observation: "Even in the throngs of downtown San Francisco, Anton LaVey always finds a parking space—just like magic. It's probably Satan realizing he's in good hands and taking care of his own."

The mag also has an article on nude yoga, *Yoga for the Naked Mystics* by Paul Brock, which claims that yoga and nudism go hand in hand, as yoga postures are best achieved in the nude. Tongue swallowing is also discussed.

Also of occult note in this issue is a section called *Nude Frontier*: a gazette type feature that contains small items on the acceptance of nudism. The first item, *Advertising Takes on a Jaybird Look*, is about nudity in advertising, and reproduces several ads. One of them is an ad for **The Book of the Law** by Aleister Crowley from Los Angeles Free Press. The ad has been reproduced quite small, and contains a highly stylized Mucha-type drawing of a nude woman with a large snake entwined around her. The ad's copy reads: "**The Book of the Law** by Aleister Crowley is a rare manifesto of a magical-sexual religion that still flourishes secretly throughout the world." The article goes on to inform the reader that Crowley "wholeheartedly endorsed nudity."

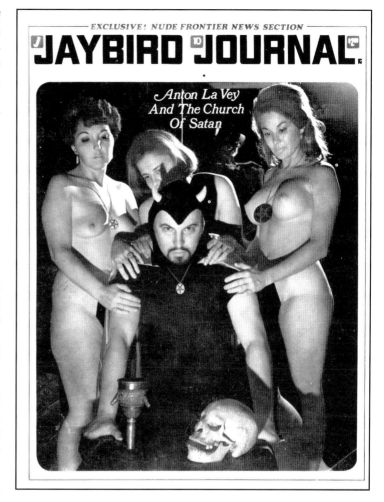

CONFIDENTIAL FLASH

☐ "Satanic Sex Orgies Bared" reads the headline of this **CONFIDENTIAL FLASH** (Dec 9, 67), above a picture of a woman with her arms outspread, wearing a diaphanous gown that displays her underlying nakedness. She stands in front of other men and women, some naked, some in robes, holding swords and daggers aloft. The caption below: "Won't You Come Into My Coven?—Swingers dig new 'kicks' in black mass."

Inside, the article's title blares *There May be the Devil to Pay! Swingers Turn to Satan and all Hell May Bust Loose*. It

is written by Gail Stone and includes two photos of LaVey, one of Sybil Leek and one of a magic circle with nude witches dancing around it—a typical tabloid presentation of such subject matter. A large blurb running across the middle of the article reads: "Ancient Antics Are Greasy Kid Stuff Compared To These Present-Day Oily Sex Orgies."

Stone groups witchcraft into two categories: white and black. She also mentions that Sybil Leek blamed black witchcraft—used for personal gain or destruction—for the bad image of modern witches.

Stone then describes what she calls "the indoctrination of a new member into a big city cult:"

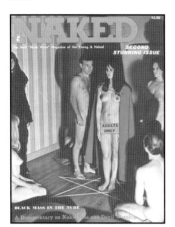

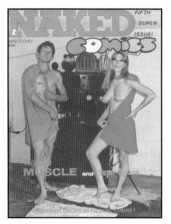

From top **The cover for the "second stunning issue" of NAKED (undated) with a witchcraft theme; the "fifth super issue" (May 68) was a comics themed fifth issue.**
Opposite **Nudist reading a copy of Weird Fantasy in NAKED #5.**

NAKED
No 2
undated, circa 1967
Phenix Publishers, Ltd., 5839
Mission Gorge Rd., San Diego, CA
92120 2.50 68pp

ADAM
Vol 12 No 4 Apr 1968
Knight Publishing Corp., 8060 Melrose
Ave., Los Angeles, CA 0046 .75 84pp

The striking young novice squats on the floor while naked men and women—heavily oiled skin reflecting the eerie glow of flickering candles—dance and weave frantically around her.
In front of her sprawls the corpse of a freshly killed cat, while along her spreading hips are laid cups of mushrooms and wine.
Minutes later she will become a living part of what is described by police as 'the most frightening orgy scene in America today'—Satan Worship!

It continues by claiming that American law enforcement officials looked to the expertise of a former superintendent of Scotland Yard in England for advice as they have a 1,100 year history of dealing with witchcraft.

Reports culled from raids in American cities showed that "swingers" were flocking to witchcraft and Satanism. Or, as one cop stated: "LSD and wife swapping are out and Satan's in!" Sybil Leek labeled these swingers as "pseudo-covens" and "sordid little clubs" that have nothing to do with the "Old Religion."

LaVey had as much disdain for the so-called "white witches" as Ms Leek did for the black witches:

They're tea shop witches, plump little women sitting around threatening to turn each other into toads.
Most of them are neo-pagan Christians and they toy with the same notions other religions have, skulking around under a burden of guilt and afraid of being called evil.

The article points out that the use of modern drugs like LSD in religious rites involving sexual intercourse, as espoused by the likes of Timothy Leary, were not new but date back at least 3,000 years.

The piece concludes:

These 'swingers' who are joining the Satanist circles in droves for sensual purposes are going to find themselves sooner or later in some very sticky business.

NAKED

☐ **NAKED** was another title promoting nudism. The "Second Stunning Issue" has the cover blurbs "Black Mass In The Nude" and "A Documentary on Nakedness and Devil Worship," which don't seem to jive with the cover photo. Discerning readers will notice the cover pic looks like some kind of witchcraft ritual, but not a Black Mass.

NAKED was first and foremost a nudist mag. It's hard to tell whether or not the people in the mag were actual pagans, Wiccans, or just nudists acting the part. It could be argued the difference is slim, as nudists would seem to be defacto pagans just by their free philosophy of nature and naturalism. They certainly don't seem to be Satanists or Devil worshipers, as the text claims, and it's not sexploitation either. Maybe the best way to describe it would be a pagan nudist mag.

There are two layouts inside; the first, *Naked in the Night*, has the short preface:

Conforming to an age-old pattern of ritual, young actors interested in the black rites gather on a high hill at midnight to evoke the presence of Satan through dancing, mystic powders sprinkled on flame, and a chant as old as time.

The photos show nude men and women at night around a blazing bonfire, and in a room with a pentagram drawn on the floor, a blindfolded woman lying in the middle of it. The author of the text, W. Willis-Thomson, discusses the liberalization of America, and the decline in the belief of a benevolent participatory God. He mentions a sci-fi novella

by Lester del Rey called **For I am Jealous People!**, where Lucifer is the benevolent deity and Jehovah a malicious and deceiving deity ruling mankind through paranoia. Sounds Gnostic to me. This leads into a pro-Satanism-as-nudist philosophy rant, in which he misspells LaVey as "LeVey".

The article ends:

> For the interest of its readers, **NAKED** has photographed much of the standard ceremonials of Satanism as posed by a group of interested nudist actors, who have previously organized, directed, produced and acted in their own nudist film.

Between the features is a page that lists nudist clubs throughout the US called *Naked…Nudist Park Guide*.

The second feature, *Naked in the Sun*, is supposed to be naked college kids in California on the only nude beach in the country at the time, but from the looks of them they are a lot older than college age. The text, by F. Anne Zeine (fanzine?), bemoans the Puritan-like lack of sanctioned nude beaches in the US, pointing out that European countries have had them for years. The only beach allowing nudism was an unnamed beach near San Francisco where the pics were taken.

NAKED's "Fifth Super Issue" (May 68), with the title **NAKED COMICS**, has a super-hero theme—naked of course, except for the capes. The two layouts inside are rather crude attempts: a mixture of photos, hand lettered text in word balloons and captions relating the action and story. One pic shows a naked gal reading a copy of the 1950s EC comic book **Weird Fantasy**!

The "Twelfth Tingly Issue" (Jul/Aug 69) touts itself thus: "Page after page in heart-quickening color! Thrill with naked horror at an Old Dark House of bared passions!" The whole mag is one layout and story with b&w and color photos of the "**NAKED** actors and actresses" remaking the classic 1932 horror film **The Old Dark House**.

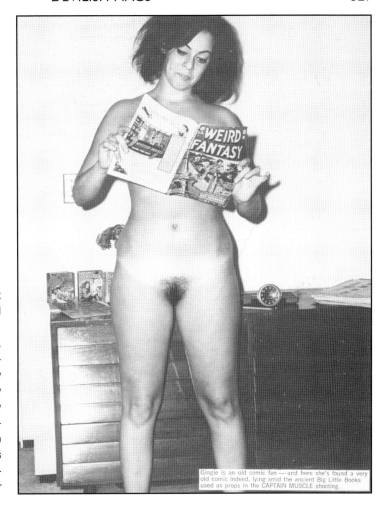

Gingie is an old comic fan — and here she's found a very old comic indeed, lying amid the ancient Big Little Books used as props in the CAPTAIN MUSCLE shooting.

ADAM

☐ *Satan, 1968 Style* is another piece by Paul R. Jeschke (he wrote the piece on LaVey for the Sep 67 issue of **FATE** mentioned above). The article is short, with five photos, and suggests that LaVey and his Church of Satan were just out to make a buck. While it gives the usual list of LaVey's previous occupations and a description of his house filled with macabre *objets d'art*, Jeschke also writes, "Each potential follower of Satan is subjected to LaVey's own financial analysis. The less affluent, he said, 'are simply asked not to return.'" According to LaVey, the Church was supported by

2,500 member's donations "after private consultations."

Jeschke asks in closing, "And how does one go about worshipping the devil?"

The answer Jeschke gives to his own question is the exclamation point to the rest of his article:

> Well, it has something to do with weird symbols, including one LaVey calls a pentagram, which is a five pointed star containing the face of the devil. And that is about all the High Priest is telling until he gets a look at your bank account statement!

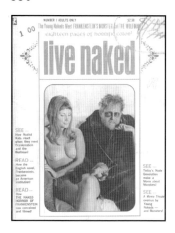

Above **LIVE NAKED #1 Jul 68.**
Opposite **This is the censored
version of the cover of NUDE
LIVING #47 (v7 #5) Jun 68 with
Anton LaVey. Uncensored it did
not have the black strips over the
breasts.**

NUDE LIVING

Vol 7 No 5 (No 47) Jun 68
Elysium, Inc., 5436 Fernwood Ave.,
Los Angeles, CA 90027 1.50 48pp

LIVE NAKED

No 1 Jul 1968
Phoenix Publishers, Ltd., 3511
Camino del Rio South, San Diego, CA
92120 2.50 68pp

KNIGHT

Vol 6 No 8 Sep 1968
Sirkay Publishing Co., 8060 Melrose
Ave., Los Angeles 46, CA 1.00 100pp

NUDE LIVING

☐ **NUDE LIVING** was a long running title
from Elysium and the Jun 68 issue is another
nudist mag with Anton LaVey on the cover
and an article on the Church of Satan inside.
There are two versions of this issue, one with
blurbs covering the nude women's nipples
and another without.

On opening the mag you find a large
b&w photo stretched across the first two
pages of three naked women lounging
on LaVey's altar, a Baphomet emblem
emblazoned on the wall behind. The cover
photo is credited to Leif Heilberg, a nudist
photographer. The mag contains work
by other noted lensmen such as Walter
Chappell, who photographed Sharon Tate
and carried on a platonic relationship with
her through the years; Bill Rotsler, an early
pornster; and Ed Lange, publisher of this
and many other nudist mags from Elysium.

The ten page, photo-filled article *The
Religion of Indulgence* by Jackie Davison,
has a splash page that announces "Re-
gie Satanas!" with a quote from Milton's
Paradise Lost: "Better to reign in hell than
serve in heaven." The article itself starts off
by quoting from the Old Testament—"And
the Lord said unto Satan, Whence comest
thou? Then Satan answered the Lord, and
said, From going to and fro in the earth, and
from walking up and down in it. **Job** 1:7"

The article is illustrated with many pic-
tures of LaVey, as well as a few works of art
that reside in museums. On the stereotypical
assumption that Satanists used virgins as
altars, LaVey points out: "Virginity is a waste
to me, an unfulfilled symbol. Worse, it might
even signify an absence of lust. A woman
should be sexually complete to grace our
Satanic altar." The piece relates the usual
stories of the Satanic wedding and funeral;
LaVey's 500lb pet lion; and his lack of family
portraits on the walls in favor of pictures of
circus freaks: "I have an attraction for the
bizarre things of life. I like circus freaks be-
cause they are proud. They don't want pity;

they prefer to astound the public."

LaVey makes the point that his Satanic
Church disagreed with some of the teach-
ings of Christianity, but "is not actively anti-
Christian" nor a reaction against it. The
article ends with a quote from LaVey:

*The only deity that cares is the one
that has been banished by one name
or another by every religion known;
and he has been cast in an evil role
simply because he is concerned with
enjoying life just as you are—or might
like to! The Satanic Age is upon us.
Why not take advantage of it and
live—evil spelled backwards! Regie
Satanas! Hail Satan!*

The last page of the piece comprises
The Nine Satanic Statements as found in
The Satanic Bible.

Other features in the mag concern
nudism, *Michael McClure: Poet of Meat
and Muscle*, and *'The Beard'—Filth or Art?*,
a commentary by publisher Ed Lange on the
controversial play by McClure.

LIVE NAKED

☐ **LIVE NAKED** uses men dressed as
monsters to romp with young nudists
throughout, not unlike **NAKED** #12 (above)
and **THE SEXORCISTS** (below). The plot in-
volves a group of young nudists looking at an
old mansion to rent for use as a "communal
pad", awakening some dormant monsters in
the process! The text informs us that some of
these pics were taken on set during the film-
ing of **The Naked Horror of Frankenstein**,
and also in and around the Monica Theatre
on Sunset Boulevard, whose marquee can
be seen in a few photos. One blurb tells the
reader that the Frankenstein monster was
played by Chuck Gallo and the Wolfman by
Rance Farraday.

There is also a short article called
Teen-Ager's Terror Tale by Forry Sagehully

Goodfellow—either an obvious pseudonym in honor of Forrest "Forry" J. Ackerman, or most likely Forry himself, as Ackerman did on occasion write articles for certain sexually oriented mags (e.g. **SEX AND CENSOR-SHIP**). It gives the history of Frankenstein's monster's popularity in American popular culture since the James Whale and Boris Karloff film. The article also claims that the Frankenstein story never really caught on in Mary Shelley's home country of England, and that the UK's few Frankenstein related movies were made to cash in on American audiences.

"Forry" gets down to the brass tacks of nudism, in two long sentences:

It is immediately understandable that so powerful a narrative concept and physical image would appeal to the young American nakeds engaged in film-making to promote the common sense and healthiness of nudity on all levels of social life. Since it is the established purpose of these young people to produce films which will cause the general audience to accept the portrayed nudity as casually as the characters in the picture, they tend to select tried and true cinematic themes—such as the private eye flick, the western, the science-fiction thriller—which will almost at once absorb the 'disturbing' impact of the actors' nakedness into the greater impact of the excitement of the movie's story, so that when the picture is over, the departing audience will only then realize, with pleased and impressed surprise, that they have been watching naked people all the time, and rarely had time to even think about this fact from start to finish.

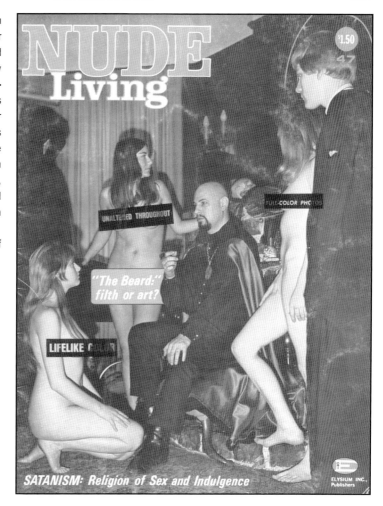

KNIGHT

☐ **KNIGHT** is one of the publications to come from 3060 Melrose Ave., the same address from which men's mags like **ADAM**, **CAD** and the excellent Holloway House paperback originals were published. Ads for many interesting titles from Holloway House can be found all over the back pages of these magazines. Holloway House was first to publish the black writers Donald Goines and Iceberg Slim, among others, and today calls itself "The World's Largest Publisher of Black Experience Paperbacks."

The Church that Worships Satan, by Burton H. Wolfe, is almost six pages and includes two photos. Wolfe was a freelance writer from San Francisco who also wrote a biography of LaVey called **The Devil's Avenger** (1974) and the 1976 introduction to **The Satanic Bible**.

Even if you are familiar with LaVey and his books, Wolfe's article is interesting and amusing, as it includes descriptions of LaVey's house, the story of his career, quotes from LaVey, mentions of Shibboleth rituals, the death of Jayne Mansfield and Sam Brody, and so on. Straight from the early publicity seeking days of the Church of Satan and written by someone who was not hostile towards it, Wolfe was well aware of LaVey's prankster aspect.

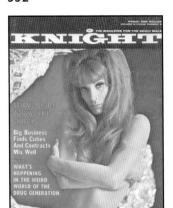

Above **KNIGHT (v6 #8) Sep 68** had the cover blurb "Satanic Orgies In New Church," and inside the work of fiction, *O Ye of Little faith* by Harlan Ellison. Opposite, from left Young nudists encounter the Wolfman and boogaloo with Frankenstein's monster in LIVE NAKED #1 Jul 68.

THE SEXORCISTS
No 1 No date given,
circa 1968
Utopia Publishing Co., Los Angeles,
CA 3.50 64pp

In **ROLLING STONE** #612 (Sep 5, 91), *It's not easy being evil in a world that's gone to hell* by Lawrence Wright, casts doubt on many of LaVey's claims about his early career and employment. But since LaVey's death, the accusations that most all the jobs LaVey listed as having worked were false claims to build up his image, seem to be moot points. Whether or not LaVey was a police photographer, lion tamer, oboe player, or of Gypsy heritage doesn't seem to matter and the controversy only adds to LaVey's persona and myth.

LaVey is quoted:

The Satanic Age started in 1966. That's when God was proclaimed dead, the Sexual Freedom League came into prominence, and the hippies developed as a free sex culture. You could see this trend developing. More and more people are realizing that the Christian churches are based on hypocrisy, that they preach spirituality and morality but practice the same materialism that governs our society. Even the church officials are recognizing it and are trying to change their rituals to accommodate the new mood. But this is trying to patch up a dead horse, and I believe in going with a winner. If God isn't completely dead, I hope at least He's got Blue Cross. Eventually, people will become honest with themselves, recognize the true basis of their lives, and join the one religion based on carnality instead of spirituality.

Wolfe notes an increasing number of incidents reported in American and British papers on the revival of witchcraft and black magic, usually reporting orgies, sex crimes, vandalism, and sadistic/masochistic rituals, all of which the papers tried to link to LaVey and his Church of Satan. LaVey dismissed the charges as nonsense:

We have nothing to do with these things. I doubt if they even exist, but if so, it was just a few individuals on their own. There are no orgies in our church. We're a responsible group with a definite philosophy, and we operate on a formula of nine parts respectability and one part outrageousness—which is why we call ourselves a church.

On the subject of Heaven and Hell:

I really do not believe in any such place as Heaven or Hell. They're both right here on earth. I do believe in eternal awareness for those who wish it. I'll never die because I've arranged it. My conscious ego will survive because I don't want to miss what will happen after my shell dies. I will come back.

Wolfe pointed out that Jesus and General Douglas MacArthur both made the same boast.

Also of note in this issue are *O Ye of Little Faith* by Harlan Ellison; *The Ecology of Dope* by Norman Spinrad; *Witchcraft and Modern Medicine* by Harwood Thompson; and a film review of **The Acid Eaters** (1968).

Tete-A-Tate by Cynan Jones is a four page article on Sharon Tate's career, which came out approximately a year before she was murdered. Sharon Tate's life, beauty, films, and relationship with director/husband Roman Polanski, are related and illustrated with two solo shots of Tate looking characteristically beautiful, Tate and Polanski just married in London and Tate bouncing off a trampoline into the arms of a muscleman from the movie, **Don't Make Waves**.

The piece touts Tate as the biggest sex symbol since Marilyn Monroe. The response from Sharon:

There will never be another Garbo or Harlow—and that's why it burns me up to be called another Marilyn Monroe. There will never be another Marilyn. I

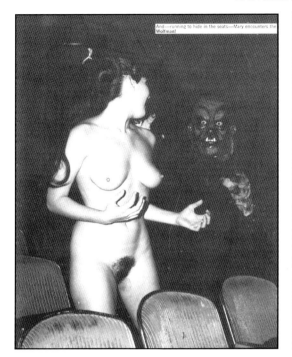

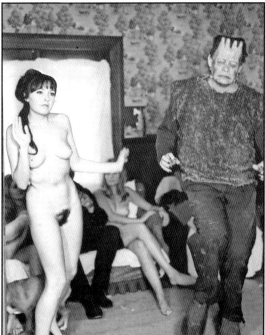

will never be like Marilyn—I will always be me, Sharon Tate.

Tate's "flawless" beauty was always a topic of concern and angst for her. Polanski said of his new wife, "I'm trying to get her to be a little meaner—she's too nice and everyone walks all over her. She's embarrassed by her own beauty."

A quote from Sharon confirms her husband's comment:

I'm really different underneath. All my life I've been told that I'm beautiful. But beauty has nothing to do with me—the real me. Anyway, you can stay covered up to your neck and still be sexy, you know. I would like my image to be somewhat secretive, simple and down-to-earth. I adore the 'little girl look.'

Having said that, the article ends:

...indispensable factors for success for a young actress are brightness, *brilliance, a strong sexual appeal and drive. There must be an aura, a magic, a curious mystique and love affair with the audience. Whatever these intangibles are, Sharon has an abundance of them. She is also equipped with a face of extraordinary beauty and a body that won't quit! Sharon Tate, sex symbol, will be with us for a long time.*

THE SEXORCISTS

☐ "Twelve naked teens are hired to exorcise the evil spirit that haunted a castle." So says the small cover blurb on this Utopia/GSN "Electra Color" mag with nudists spending the night in a haunted castle in San Francisco's swanky Nob Hill. In other words, it was a hokey ghost story, with a pro-nudist moral to it.

The story is titled *Naked Nomads and the Haunted Castle* and the opening blurb describes the scenario: "Being a tale of terror and intrigue in which the Naked Nomads

invade the castle of the long dead Baron Kurt Von Schliegel, where they proceed to frighten the bejeebers out of the ghost who haunted the castle…"

The ghost that haunts the castle is the Baron, who, until 1934, had a wife named Annalee. She was in the habit of sunbathing in the nude in the solarium of the castle, much to the delight and amusement of the neighbors. This eventually made her, and the Baron, laughing stocks of Nob Hill society. Annalee left in the night, hoping it would save face for her husband. The Baron, in despair over his vanished wife, hung himself from the iron railing of the stairs.

Over the years, various tenants would stay for a matter of weeks in the castle and then move out of the seemingly haunted abode. The real estate company boarded it up and offered anyone who could spend the night in the castle $500 for proving that it was not haunted. Enter the Naked Nomads—"a rather unorthodox group of nudists from Los Angeles."

The nudist teens take the offer and

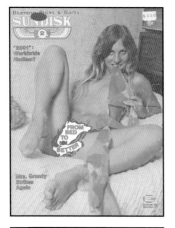

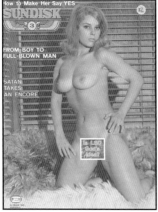

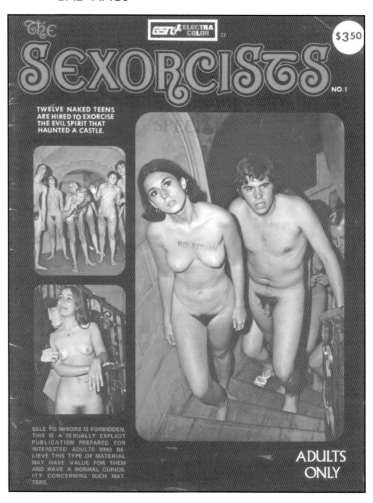

From top **Elysium's SUNDISK #2 Feb/Mar/Apr 69 and #3 had articles by and about Anton LaVey's Church of Satan. The crotch-covering blurb on the cover of #3 asks "Is LSD God's Idea?"** Right and Opposite **The cover of THE SEXORCISTS #1 undated, a Golden State News "Electra Color" mag, featured inside twelve naked teens who tip-toe through a haunted castle as an evil spirit watches.**

SUNDISK
No 2 (Vol 7 No 4)
Feb/Mar/Apr 1969
Elysium Inc., 5436 Fernwood Ave., Los Angeles, CA 90027 2.00 56pp

spend a spook-filled night in the castle until the Baron's ghost shows itself just before sunrise. One of the nudists explains to the apparition:

All right, Baron, we're nudists, and I know you hate nudists. In fact you hate everybody! You're mad at the world for something that happened to you many years ago. If it had happened now instead of then your family wouldn't have been disgraced by your wife's sunbathing activities. You were the victim of an era, Baron, and you've visited your curse upon succeeding generations instead of upon the people who were to blame!

This freaks the ghost out and it dives through a window, shattering it! When the real estate rep shows up to announce that the nudists would get the reward, they lie and say they saw no ghosts in the castle, and that the window was broken by accident. They are informed that the broken window will be deducted from their reward money. The moral of the story, of course, is that had the neighbors of the Baron's wife, Annalee, been more accepting of nude sunbathing in 1934, all of this could have been avoided.

The photos are a mixture of shots of the nudists at play, roaming the castle with shocked expressions on their faces while the pale-faced ghost of the Baron shadows them. The text is minimal.

SUNDISK

☐ The nudist mag **SUNDIAL** was started in 1964 by Ed Lange and changed its title in 1968 to **SUNDISK** while it updated the nudist look, getting slightly psychedelic in the process. As pointed out in **Naked as a Jaybird** (Diane Hanson, ed., Taschen 2003), tan lines are quite evident on some of the models, which nudists wouldn't normally have. This is because the models were not nudists but hired hippies and strippers.

SUNDISK #2 has several photographers of note listed on the contents page as contributors: Ed Lange, also the publisher and editorial director; Ron Raffaelli, who went on to do sexual art photography books and helped launch **PURITAN INTERNATIONAL** in the early eighties; Bill Rotsler, and others.

The issue kicks off with LaVey's fifteen page article. It opens with a color photo of LaVey during a ritual, reddening the buttocks of a naked woman draped over his knee with others watching. The title of the piece, *The Truth—Straight from the Devil's Mouth*, has the subtitle: "A Talk to Novices of the Satanic Church, San Francisco by High Priest Anton Szandor LaVey."

LaVey begins by stating that the success of Satanism is due to the fact that it is "in one way, completely acceptable and in another way, completely outrageous."

LaVey writes to the "potential brethren" about the origins of religious rites involving sex and how they became euphemized and disguised by mainstream religion. He also suggests that the Christian church's recruiting of young people, "creating a physically and sexually appealing force," and bringing rock music into the mass, are signs of it moving in a Satanic direction itself.

As an example of that aspect and a religion that used sexual titillation in its public displays, LaVey mentions Amy Semple McPherson's Angelist temple where the cross-bearing girls wore diaphanous gowns with fans backstage to blow the

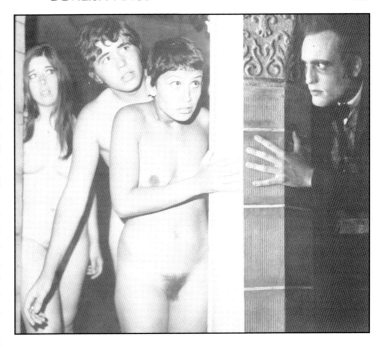

gowns up enough to expose bare flesh to the audience. Having said that, he goes on to explain that: "Anybody who joins the Satanic church for sex orgies is sadly mistaken. We don't spoonfeed sex to people here. We let people feel that sex is a natural adjunct to their lives." LaVey makes it clear that being a member of the Church of Satan might be beneficial to someone looking for a like minded partner, but was not a swinger's club and did not include sex in its rituals other than the nudity which was included for its effect and to represent man's carnal nature.

The bizarre aspect on the cover of **SUNDISK** #3 is the box covering the woman's crotch which reads "Is LSD God's Idea?," relating to the article inside called *LSD is Religion—Religion is Opium* by Eleanore Pagenstecher.

Satan, Take an Encore! by Anton LaVey is the second part of the article above.

The short intro paragraph to the feature reads: "In **SUNDISK** #2, High Priest LaVey described the rites of the Satanic Church. Now he concludes with some historical perspective on the evolution of Satanism and its heavenly applications in modern life. Reported by Leif Heilberg." It is a ten page article, not unlike the previous one in that it uses a mixture of photos of LaVey and his Church, and other unrelated pics of nude women and couples on a couch.

LaVey starts out by expounding the differences between mysticism (internalization) and magic (externalization). Having fun with Aleister Crowley's name, he writes, "Alice de Crowley defines magic as going forward and mysticism as sitting still."

He continues:

One of my parishioners defines mysticism as contemplating your navel, and magic as contemplating someone else's navel! That, I think, is a good definition. Another of my members defines mysticism as applying for a loan, and magic as writing out your own check. It's the difference between waiting for something to come to you (mysticism) and going out and getting it (magic).

LaVey explains that "legitimate" Satanists:

practice their religion unnoticed, and still do, appearing to be completely respectable. These are the ones you never read about, these are the people who are real black magicians, who control societies, governments and entire nations and continents.

The history of the persecution of witches and heretics is touched upon too:

Naturally, these heretics had to be dealt with, so whenever the righteous ones tried to inflame the public's wrath against these heretics, they would use the best propaganda measures imaginable: sex, sentiment and wonder. They would charge Satanists with deflowering young girls on the alter [sic] of shame, taking young boys and performing all sorts of perverse acts with them, and taking babies and boiling them up for fat for the candles. In all these things you're dealing with the sentimental theme and the sex theme and all these very sacred themes in people's lives and blaspheming them, tearing them apart and literally using them as fuel for the fires of outrage. The Black Mass of the Satanist of the Middle Ages was a literary invention, most of it.

Again linking Satanism to psychiatry, LaVey ends with the thought:

From a psychiatric point of view it makes sense, because it's the best form of psychodrama in the world. I have one of my representatives doing a paper on this now, that is beautiful. It has to do with the contention that man, if he were able to practice Satanic therapy would not need psychiatrists or psychologists. Man would be his own psychologist. This man is the head of a large city's mental health department.

The complete text of the article by LaVey, and a few of the photos, have been reprinted by Scott Stine in his adult horrorzine **FILTHY HABITS** #2, Spring 2003.

ESQUIRE

☐ Underneath the **ESQUIRE** logo on the cover is a very close-up pic of Lee Marvin's face with a shadow falling across it. The blurb: "Evil lurks in California. Lee Marvin is afraid." This is in reference to a series of seven articles inside, listed on the contents page under the heading *Honi Soit Qui Mal Y Pense* or *Shame be to him who thinks evil of it*. These should be essential reading for anyone interested in the drugged occult underground of post-Tate/LaBianca/Manson Los Angeles.

The opening article, *California Evil,* is by Craig Karpel. It starts with a list of fourteen people "Dead in California," including those murdered at the Tate house and others, such as Diane Linkletter, Ramon Novarro, William Lennon, and "The Girl in the Polka Dot Dress." A well written commentary questions where California was headed in the wake of LSD, Manson, Altamont, and the Zodiac killer. In the mix are astute observations and wry juxtapositions. The last line of one paragraph is a laundry list of "bad omens" from California: "An oak tag sign fades over one of the eyes of a dead store on Haight Street: 'Closed Due To Hostile Vibes.'"

Charlie Manson's Home on the Range by Gay Talese, subtitled "No deer and antelope. But strange sounds for a blind man's ear," is a short biography of George Spahn and his acquisition of the infamous Spahn Ranch. The first half of the article is on Spahn's early life in Pennsylvania, his eventual move west to California in the 1930s, and his purchase of the ranch that he

Opposite Lee Marvin, not looking too afraid, on the cover of ESQUIRE (v73 #3) Mar 70, the occult filled issue.

ESQUIRE
Vol 73 No 3 (No 436)
Mar 1970
Esquire, Inc., 65 E. South Water St.,
Chicago, IL 60601 1.00 204pp

was to rent out for the filming of Hollywood westerns and children's pony rides.

The second half of the piece starts when Manson, with girls in tow, showed up to save Spahn from what would have been an infinitely more mundane existence. By then, Spahn had grown blind, and the girls liked cooking and cleaning for him, and leading him around. Rumor has it that they were kind to him in other, more physical ways as well.

Princess Leda's Castle in the Air by Tom Burke, is undoubtedly the strangest article included. It relates the comings, goings, and rantings of one Princess Leda Amun Ra, as she went to a Los Angeles city park to steal a black swan with which she planned to conceive!

Under the title is the blurb, "In subterranean Hollywood there lives a witch, an acid goddess. Don't go there without a cross."

Burke travels through the fear haunted, acid drenched, occult nooks and crannies of LA in the months following the Tate-La-Bianca murders. Questioning a freaky Bible salesman on Sunset Strip, Burke is told:

> *But I've been around that scene, man, cats who have given themselves up to the Lord Satan. If you sense an evil here, you are right, and I'll tell you what it is: too many people turned on to acid. If you make a habit of tripping—well, acid is so spiritual, so, uh, metaphysical, that you are forced into making a choice, between opting for good, staying on a goodness or Christian trip, and tripping with the Lord Satan. That's the whole heavy thing about too many people turned on to acid: to most of them, the devil just looks groovier. Acid is incredible—I've been on one hundred and seventy-two trips now—but it shouldn't be available to everybody and anybody.*

Burke's enquiry leads him to a large, private, liquor-free nightclub called Climax, located on La Cienega Blvd. Here, he meets

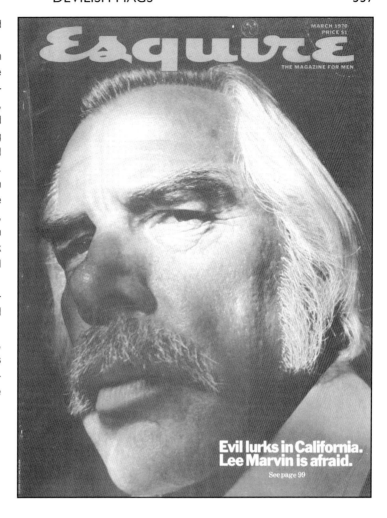

the legendary (to Hollywood acidhead hipsters anyway) Princess Leda Amun Ra and her cohort in psychedelic occultnikism, the King. Burke says of the nightclub: "Climax members lie about on velveteen divans solemnly viewing antique vampire films, or making convulsive movements before the twenty-foot Satan's head, its foolish eyes painted with Day-Glo." The Satan's head mentioned, and shown in the photo, has also shown up as a background prop in a few orgy flicks in adult sexploitation mags.

Then Princess Leda "materializes," dancing alone, clad only in black feathers, her naked breasts held with gold fishnet. She and her dance are likened to Salome

for their lustfulness.

When someone from Burke's table approaches Princess Leda and asks her to join them for a soda, she replies by inviting them to meet her at her "castle" later on and supplies the directions. As it turns out, her "castle" is really a mosque-style house on a hill overlooking Hollywood, surrounded by a high wall and an iron gate.

After knocking with no response, they find the front door to be unlocked, and walk in. What Burke, and apparently his photographer, find inside seems to spook them a bit. Entering through a vaulted foyer, they find themselves looking at wooden dolls dressed in shrouds, a four foot coffin holding another

doll dressed in a blood spattered nightgown, on a bed of rotted flowers, at rest in a circular alcove. They are surprised by a man in a jumpsuit who appears behind them, grabs a cigarette from one, and informs them there is no smoking here, but they are at liberty to come and go as they please. He explains that the doors are never locked as: "Why would a god need to lock her doors?"

As they move through the house, they encounter a dozen or so guests. Burke describes three of them:

a tall, pathetically thin girl, nearly nude, with a helmet of milkweed-pod hair; a dark lovely girl who chatters incessantly to herself; a black boy in green leather pants, who wears two chains, one holding a silver pentagram, or magus medallion, the other holding a silver crucifix on which an agonized Christ hangs nailed upside down.

A blonde girl and a young black man start to verbally accost them with questions and riddles, sometimes talking simultaneously, as if Burke and his companions are taking a trip through Alice's LA Wonderland.

When they finally reach the Princess in her bedchamber, she is spreadeagled on a bed with a black swan between her shapely legs. As the swan honks, Princess Leda proclaims in a loud voice, "I will conceive."

The piece then jumps to Burke interviewing a girl "singer of some note" who warns him that Leda and her crew are "dangerous." She informs him that the secret to Leda's power is LSD and tells him if he wants to meet a real magus, she can get him an appointment to meet Samson de Brier, which she does.

De Brier, who lived not far from Leda, was once a confidant of Anais Nin, and had a role in Kenneth Anger's **Inauguration of the Pleasure Dome** (1954) with Nin. Burke describes De Brier's magically cluttered house:

Opposite Dancers grooving at Climax in LA with the Devil looking on. ESQUIRE (v73 #3) Mar 70.

…the sanctuary of Samson De Brier is a gentle junkyard, a repository of rotting portiers, chipped gilt frames, Regency ball gowns on wooden dress dummies, disintergrating [sic] first editions stacked on floors, tables and love seats; of dusty whorehouse mirrors; of goldplated peacocks with zircon wings; of photographs of Gide, who was Samson's closest companion; of death masks, including one of James Dean, with rouged cheeks and lips, as if it had been executed by a mediocre undertaker; and of Samson De Brier himself, sometimes indistinguishable from his surroundings, a tiny, tremulous man of perhaps seventy-five, swathed in black, with gray bangs and wet, vulnerable eyes.

When Burke asks De Brier if he is familiar with Princess Leda Amun Ra, De Brier gives a surprised response:

Oh, Lord! You're seeing <u>her</u>? Well, I mean, I wouldn't want to be quoted as saying anything against her. I admire her…daring. But you see, you've got to understand the difference between true witches, and people who take drugs. For instance, <u>the murder</u>. No serious witch could have done such a thing as that…

The murder refered to was that of Sharon Tate, whose ghost was hovering over LA at the time. The various people interviewed, including Leda herself, mention Tate's murder several times throughout the article.

One afternoon Burke visits Leda, mourning the death of her black swan and sipping her "private hallucinatory formula" from a silver cup. As Burke tries to get some information on who the real Leda is, she evades questions and claims to have been reborn at her temple two years earlier. She then recounts the history of her various incarnations through the centuries, which

include her namesakes from Greek and Egyptian mythology, a priest in Atlantis, and Sarah Bernhardt. Leda also informs Burke: "I have also considered human sacrifice. I feel more and more, each day, that it is somehow *required* of me, to consummate my rebirth."

When asked if she had considered the legal ramifications, she snaps back: "Listen, I don't think I'm getting through to you, baby! You must understand! I am totally evolved spiritually! Why, baby, should I fear the law? I mean, *how can the fuzz hassle a god?*"

Of Sharon Tate, Leda claims, "Sharon will eventually speak to me of the terror." As Leda paces the floor, she rants about her necromantic abilities and her familiarity with Sharon:

This town is full of stenographers and file clerks trying to call up spirits. The fashionable one this year is Sharon, naturally. Those stupid assholes! I am the manifestation of a deity; I am able both to capture and receive souls. No, I can't explain how, because I don't know myself. But I swear to you, the morning that Sharon died, I got up early, which I never do, and I began rolling on the floor, screaming in pain. Wolf teeth biting into my guts! Sharon had been here just once, while alive, brought here, incidentally, by the worst degenerate homicidal homosexual in the country. She was very sweet and gentle, though; she followed me around this house all evening, and she said, over and over, I swear, 'I'm going to come back here in another life, I'm going to, I know it!' And she has been here constantly since her death. She is not strong enough yet to speak, but I am transmitting strength to her. She is not at rest. Soon she will speak. Sebring's been here too. Whenever he came, the room turned icy cold. I sent his soul on to…to Tom Jones. No, I don't know him, but he's beautiful, and

I sense that he is together enough to receive it, and to deal…

Then, while fantasizing about leading "an army of flower children" against the white Anglo Saxon Christians, and criticizing Timothy Leary as a "plastic messiah" who she claims was a "misuser of sacred chemicals," Leda blurts out—"I give acid to persons who have never dropped it without telling them. I think of this as the administering of Holy Communion."

Burke's photographer arrives, and Leda asks them if they can drive her to the Arcadia arboretum, an LA wildlife reserve, so she can replace her recently deceased swan. When they reach the park and question Leda as to her method of acquiring a swan, she emphatically states, "Leda will have her swan!" Leda is out the car door and headed toward the lake, carrying a large carpetbag, brushing past security guards and visitors. As others look on confused and amazed, Leda and her assistant scoop up a black swan from the water's edge and instruct Burke and the others to go back to the car. Leda announces to the stunned onlookers, who have come to the conclusion that it is a TV commercial in progress, "*I will conceive*

by this bird!"

The article concludes back at Leda's mosque-like temple at midnight, where Burke says "most of underground Hollywood is." Burke finally talks with the King, who believes Leda's power to "capture souls" to be genuine, but isn't sure whose powers are stronger, Leda's or his.

Leda, meanwhile, picks up a knife and wanders into the garden, beyond which is the pool where the new black swan is swimming. The swan is not what Leda is headed for, but the stone bench nearby with a teenage boy tied to it, an imitation of Christ with loincloth, long hair and beard, and a crown of rose thorns. Guests dance around the boy chanting something "mystic-sounding." All of a sudden:

Leda looks up at the moon, as if consulting it. Then, abruptly, she laughs, her wild, unruly, liberated-housefrau laugh. Everyone stops dancing. She drops the knife to her feet, slams the garden door, and runs back through the temple and up the stairs, giggling, and sobbing.

The article is illustrated with four b&w

Above **MCCALL'S** (v97 #6) Mar 70 provided an occult filled read for the female reader, as ESQUIRE from the same month had for men.

MCCALL'S
Vol 97 No 6 Mar 1970
McCall Publishing Co., McCall St., Dayton, OH 45401 .50 160pp

photos from inside Princess Leda's castle, and three color shots of her excursion to capture the black swan. One of the color photos shows Princess Leda's assistant holding open a floral carpet bag, awaiting the swan. A large close-up photo of Leda, holding the black swan to her breast, takes up a full two pages.

Princess Leda Amun Ra was also featured in the Jan 71 issue of **CONFIDENTIAL** magazine (see page 349), complaining about the above article's portrayal of her.

The Art of Evil. Power in the blood is a two page offering on the artwork of Neke Carson, a Texas artist whose works "contain blood, or the image of it." Plastic crosses filled with blood should, according to Carson, "float near all entrances and exits of space stations as warning signals to all astronaut Vampire-Devils."

Banality of the New Evil by William Kloman reproduces a newspaper item from the **WASHINGTON POST** of Oct 31, 1969 on its first page. It is set against a black background with the headline, *Boy Tells of Chaining by Cultists*. The item relates the torture of Anthony Saul Gibbons, a six year old boy, at the hands of communal cultists. The boy had been burned with matches and chained inside a box for fifty-six days in the hot summer sun, because he had started a fire which had injured some goats the commune valued. The cult is named in the article as "Ordi Templar Orientalis," a bastardization of Ordo Templi Orientis. Or, for those unfamiliar with the lore, this was the infamous "Solar Lodge" of the O.T.O., written about by Ed Sanders in his book **The Family**, and regurgitated by many others.

The article itself is made up of vignettes concerning more drug-addled hippies in LA in the late sixties, by which time most of the good vibrations had turned sour.

The Style of Evil starts with a quote from The Rolling Stones' Sympathy For The Devil and is mostly photos, with a little text, explaining the jewelry and body adornments of the occultists and Jesus freaks—devil tat-

toos, crucifixes, amulets, charms, pendants, etc. One of the photos included is the dance floor inside the Climax nightclub, with the large Devil's head overlooking a couple in the midst of their groovy dance moves. Club owner Michael Hewitt says of the crowd:

I proudly boast the greatest collection of freaks in the world. Many of them are heads, but as long as they behave, don't impose, they're welcome. The Climax's exterior was painted with a series of murals depicting the life of a modern-day Buddha. It was a spiritualistic trip that attracted the kids.

Light in the Heart of Darkness focuses on the witches and wizards who proclaim only to work for the good with white magic. There are color photos of Samson De Brier in his magically cluttered home and Frederic Adler, the high priest of a coven of witches, who says: "The forces that we study within the craft, can very potently be used for evil, but it is against our principles to do this. Psychic forces are neutral; it's how you use them that counts."

MCCALL'S

☐ **McCALL'S** is a long running women's magazine that, thirty-three years ago, published the feature *The Occult Explosion*, in the same month the above article ran in **ESQUIRE**. Combined, the two features gave America a glimpse into the world of the occult, its practitioners and concerns.

The series of seven articles on the inside begins with an opening page titled *The Age of Occult*. Underneath the title is a picture of a woman wearing a multicolored turban, holding a smoky crystal ball. The introductory blurb reads, "Housewives hold seances, gurus speak on college campuses, businessmen exploit the zodiac, scientists investigate ESP. Where in the world can the Age of Aquarius be taking us?" "House-

wives" seems to be the operative word, as one of the strangest aspects in reading these articles is that they are all continued in the back of the magazine amongst ads for children's clothes, cake frosting, toilet bowl cleaner, TV dinners, and so on.

The first article, simply called *Occult* by Nicholas Pileggi, is summed up in the opening blurb: "For many of today's young, astrology has taken the place of psychology as the personality decoder of their generation."

There is an article on *The Mysterious Madame Blavatsky* by Kurt Vonnegut, Jr., and pieces by others on *Seances in Suburbia*, *Tarot*, and *Maurice Woodruff—Astrology's Brightest Star.*

Love Among the Rattlesnakes, by Jean Stafford, opens: "A gifted writer ponders the meaning of the Tate murders, and the girls who tried so hard for freedom and won only the most awful kind of slavery." The article focuses on the concerns of the women involved in the murders, appropriately so for **McCALL'S**.

Ms Stafford starts the piece with the premise that the Tate-LaBianca murders were a symptom of an "epidemic" of diabolism infecting the populace, equating Manson and his crew with disease. Stafford then proceeds to point out the similarities between Manson's cult and that of the Assassins, i.e. the Assassins smoked hashish and the crew from Spahn Ranch smoked marijuana, hash and also indulged in LSD, speed and mescaline.

Stafford gives a brief history of Manson's life since his release on parole from Terminal Island in 1967. But the main concern is the girls who were attracted to Manson, why and how they came to be under his influence.

Stafford makes this assessment of Manson's role as father figure:

As God or Satan, Manson was the omnipotent head of 'The Family,' and within this remarkable travesty of the basic—and sometime sacred—so-

cial unit, the young women in his entourage were at once his daughters, his sisters, and his concubines. How many of them bore his children has not been determined. If it were not for the man's sly, albeit mindless, semantic acrobatics, incest could be added to the long list of his torts, misdemeanors, felonies, and aberrations. Manson preached love, but it was an isolated love, embracing only those of his persuasion; tipping the scales heavily on the other side was his unforgiving hatred of the Establishment and his red-neck hatred of blacks.

Making a wrong assumption, possibly based on some of the girls' statements at the time, Stafford writes: "There was no sibling rivalry among God's daughters, no intramural jealousy to disturb the peace of the sorority." She then comments that some of the women came from "squalid backgrounds," others were "vagrants," and some came from "middle- and upper-middle class families."

Citing **The Throwaway Children** (1969) by Lisa Aversa Richette (a District Attorney in Philadelphia's Juvenile Court), Stafford says that no matter what class backgrounds they came from, "these children, in almost every instance, come afoul of the law because they have been unacquainted with familial love."

Ultimately, Stafford concludes:

The sobering thought occurs that the emancipation of women has fallen so far from its ideal that women no longer want it. In clinging with blind fidelity to the Family, those girls, tired of their peregrinations and their search for an unnamed grail, seemed to be looking for lares and penates and for order. The primeval chaos they found was the mirror image of order; as individuals, they are culpable, and atrociously so; but as members of a criminally

permissive (ergo, neglectful) society, they deserve compassion.

The intro blurb for the article by Judith Rascoe reads: "In a silvery-black house, amid skeletons, tombstones, voodoo dolls, and devil's food cake, High Priest Anton LaVey presides over the Church of Satan whose faithful all believe in black magic, curses, and indulgence, not abstinence." It opens with a half page color photo of Anton LaVey, who looks appropriately stern. He points an index finger with a very large ring on it at the camera from under his black, purple lined cape. John Oldenkamp took the four photos that accompany the piece.

The article starts with Ms Rascoe showing up at Dr LaVey's front door and ringing the bell: a sign attached reads "Do not ring unless you have an appointment," which she did. LaVey's wife Diane answers the door, and Rascoe is shown in and introduced to LaVey, seated in an oak chair talking to a "middle-aged lady in a nurse's uniform."

After giving her first assessment of LaVey as "impressive," Rascoe is introduced to Zeena LaVey, the daughter, seven years old at the time, and shown to another room to wait and discuss ponies with her. When the phone rings, Mrs LaVey answers it; it turns out to be "a fellow who was married in the Church of Satan" and was looking to get LaVey to perform a "divorce ceremony."

LaVey shows up for the interview and starts by explaining that Satanism is a philosophy of the will: "We sincerely believe that it will by one name or another be the society of the future....We've just established a philosophy that advocates all of what most Americans practice whether they call it Satanism or not."

LaVey continues: "Magic works, you can call it alpha, beta, delta, or gamma wave energy or whatever scientists are dabbling in now, but I've been practicing it for *years*."

Then LaVey takes Rascoe on a tour through his funhouse. The Ritual Chamber with its decor and paraphernalia is

 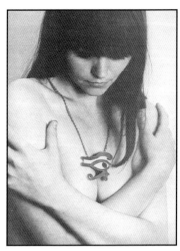

Right **Isaac Bonewits, the first student in the world to earn a diploma in magic, and modeling occult jewelry in WITCH #1, undated.**

NOTE **ROLLING STONE** #61 (Jun 25, 1970; see the Manson chapter) reported that Alex Sanders and Sharon Tate had met on the set of the movie **Eye of the Devil**, amidst rumors that he initiated her into his coven.

WITCH

No 1 undated, circa 1970
Top Sellers Ltd., 95 Great Portland St., London, W1, UK 36pp £0.20

described in detail, at one end of which stands a "gilded mummy case," actually a door into what LaVey calls the Red Room. LaVey apologizes that the room is still in disarray from a previous party, the devil's head ashtray being filled with cigarette butts. While there, LaVey tells the journalist of his fondness for Captain Nemo, the filmed version of **The Black Cat** with Karloff, and societies of the future. He also clues her in to his musical tastes, including Strauss, Verdi, Wagner, Sousa, and Rodgers and Hart, among others, ending with the quip, "I mean, I'm just a cornball."

Weeks later, Rascoe drives through the thick San Francisco fog to show up on a Friday night to attend a Satanic High Mass. She recalls the snippets of conversation overheard from her fellow attendees, such as someone questioning whether or not the crystal ball they just purchased was made of acrylic or not, and another talking about Japanese sci-fi movies.

The congregation is a mix of young and old of both sexes. Finally the lights dim and Wagner is heard, until the pipe organ takes over from another room, at which a door opens and a priestess enters, carrying a candle to lead the others into the Ritual Chamber, which is pitch black.

Black hooded "ministers of Satan" gather in front of the altar occupied by a nude,

redheaded woman, whose nudity, Rascoe points out, "is more suggested than explicit, especially to the obliquely seated congregation." A bell is rung and LaVey steps out of the shadows with his cape held in front of his face, Dracula-style. After some readings from "a Gospel of Satan" and Enochian invocations, LaVey leads the congregation in a chant of the names of Satan.

Members make wishes to Satan to curse enemies and to attract the lust of others, as the group joins in unison with "Shemhamforash! Hail Satan!" The bell rings again and the service ends.

Rascoe says that after this particular service, newly arrived copies of **The Satanic Bible** were handed out and signed by LaVey.

Afterwards, "frank smiles and firm handshakes" are exchanged, welcoming Rascoe to the congregation and bidding her goodnight. Returning home, she contemplates the questionnaire given to applicants. Rascoe concludes: "It seemed to me I could answer all the questions except the first"—*"What do you expect to gain from Satanism?"*

WITCH

☐ As far as I am aware, this is the one and only issue of **WITCH: THE MODERN**

OCCULT MAGAZINE. The magazine was published in Britain by Top Sellers of London, who were responsible for many reprints of American comics, including Superman annuals and an assortment of magazines. It is undated but a review and promotion for Alex Sanders' LP, **A Witch Is Born** (A&M records), would seem to place its publication in 1970. (The release date of the LP was Jun 12, 1970.) Indeed, there is emphasis on Sanders throughout **WITCH**. The self proclaimed "king of the witches" and founder of the Alexandrian Tradition of Wicca is also on the cover and credited as editorial advisor.

The first article, *The Shocking Truth About Ritual Murder* (prefaced by the bold statement 'IT WILL HAPPEN HERE!'), mentions the murder of Sharon Tate within the context of a possible ritual killing. [SEE NOTE] It doesn't mention Charles Manson or the Family (also helping to date the mag), and instead intimates that, "Evidence has been mounting that this murder far from being an isolated instance was just a small part of a world-wide pattern."

A **WITCH** "exclusive" has the Sanders prediction that *Prince Charles will Marry an American*. He also predicts that Charles "will succeed to the Throne before the death of the Queen" and faces a future "marked by immense popular favor." I think it's fair to say, given Charles' marriage to Camilla Parker Bowles in the shadow of Lady Diana—neither wife being American—public favor for the Prince is at an all-time low and it's unlikely he'll ever take to the throne.

Other articles, notably *Forbidden Witchcraft Initiation Rites!* and *Your Occult Guide to Sexual Vigor*, relate the contents of the **A Witch Is Born** album. Reliable sources inform me the record features Sanders initiating a girl into his coven on Side A, while Side B is The Great Rite ceremony—little more than the sexual act—both interspersed with narration that is suitably reverent.

Several pages at the back of the magazine are devoted to extracts from **The**

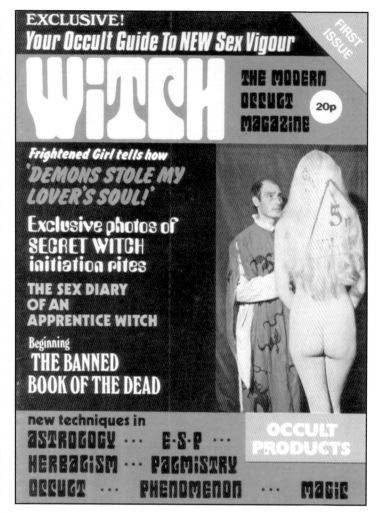

Necronomicon, which is described as *The Banned Book They Never Dared to Print* and awarded this history lesson:

The Necronomicon, *by Hamat'at, is the most feared and revered book in the history of Witchcraft. Handwritten by an allegedly insane Arab priest who discovered the original manuscript after defiling a 3,000-year-old tomb.*
The Necronomicon *consists entirely of the secret rites used by ancient Egyptian priests for raising the dead and breathing the Spirit of Immortality into their souls. For nearly six hundred years* **The Necronomicon** *has left a*

trail of death and destruction in its footsteps. From the fifteenth through to the nineteenth centuries only one copy of the Book of The Dead existed, locked away in a monastery. Rediscovered in 1878, it was hand copied five times, making six copies extant.
One was destroyed in World War I. The Second was moved to Spain, the destruction and massacre of Guernica. The Third copy wound up in Dresden. The following day the city was destroyed in the worst Fire Storm of World War II. Copies number four and five are now in Italy, where they are kept under lock and key.

Top **Calga Publications'**
SEXTROLOGY was slated for twelve
issues, one for each sign of the
zodiac, but the first (Aries) Jun/Jul
70 may have been the only issue.
Above and Opposite **This woman**
appears throughout SEXTROLOGY,
as does the ram's head.

SEXTROLOGY
Vol 1 No 1 Jun/Jul 1970
Calga Publishers Inc., PO Box 35303,
Los Angeles, CA 90035 3.50 72pp

KNIGHT
Vol 8 No 4 Aug 1970
Sirkay Publishing Co., 8060
Melrose Ave., Los Angeles, CA
90046 1.00 92pp

The Editors of **WITCH** *have obtained*
the sixth and final copy.
THE BOOK HAS NEVER BEFORE
BEEN PUBLISHED…UNTIL NOW…

The reproductions throughout the above article are crude, contemporary pen and ink interpretations of artwork dating from the late 1800s.

Given the conservative manner of the British, **WITCH** isn't nearly as salacious as its American counterparts aspired to be. Not that I necessarily think that's the point of **WITCH**—behind it there seems to be a genuine desire to expand on a market the editorial team thought had "an important place in the mental and religious exercises of our modern world." Ultimately that market wasn't there to respond to **WITCH**, or it certainly wasn't big enough to sustain **WITCH** at the time of publication.

Most of the articles in the mag are uncredited, but the emphasis on Sanders leads me to suspect that he either penned them all or Top Sellers produced **WITCH** as a promotional tie in with Sander's album. The stuff that doesn't feature Sanders is just filler. Supposedly true stories, *The Devil Stole My Lover's Soul* by Judy Trenholm, and *Love Sorceress of America*, uncredited, read like second-rate pulp fiction.

The *Occult News* column tells of twenty year old Isaac Bonewits (!) of the University of California: Bonewits is the first student in the world to earn a diploma in magic and "favours a large Sherlock Holmes pipe."

Following **WITCH**, an occult mag published by Gresham in Britain called **WITCHCRAFT** made it to at least issue #4 in 1972. [Review by David Kerekes]

SEXTROLOGY

☐ The first issue of **SEXTROLOGY**, "The Magazine of Astrological Sexuality," concerns itself with the Aries zodiac sign and must have helped to give credence to the stereotypical pick-up line. **SEXTROLOGY** also got some good mileage out of a stuffed ram's head that appeared throughout the mag with the naked models.

You would think there would be twelve issues, one for each sign of the zodiac, but **SEXTROLOGY** looks to have been a one shot. The back cover reads "12 Heavenly Pages of Full Color," and shows a nude model on her knees with one of the horns of the stuffed ram's head playfully positioned near her backside.

Although Calga Publishers was one of Ed Wood's publishers, this mag doesn't seem to have any text written by him and there are no short stories in the mag.

Astrology: A Key to a Woman's Bedroom is an article about using astrology to get laid. The photos show a nude woman rolling around in the middle of the twelve zodiac signs, the ram's head outside the circle.

The Split Sexual Psyche is on what to make of the Aries who doesn't act like one and "astrological schizophrenia" in general.

The Sexual Nature of the Aries Female postulates that she's an aggressive, woman-on-top, take charge kind of gal. The photos for this layout are of the woman from the first feature with a guy, and of course the ram's head, in softcore poses.

The Age of Aquarius and the Aroused Aries is on the dawning of the Age of Aquarius and Carol, "an Aries, with Scorpio rising, and her Moon in Aquarius." The photos are the front and back covergirls rolling around nude together, no ram's head in sight.

Seduction Comes Easy to an Arien is about Burt G., "a double Aries, with both his Sun and rising sign in Aries. His moon is in Leo the sign of kings…"

Aries: The Erotic Sign of the Zodiac is written by "an Aries broad" and features the girl from the front cover posing nude on a shag rug with the ram's head nearby.

Aries and Group Sex concerns "Phil and Barbara S., both fiery and incredibly endowed Ariens, relat[ing] some of their experiences of a group sexual encounter

they helped to instigate." Phil lays it on the line in the last sentence:

Barbara and I really have that pioneer spirit. We'd love to open new territory and the moon looks to be the last wilderness. Besides, can you imagine being the first couple to screw in a state of complete weightlessness. That would really be something. I bet a man could maintain a hard-on for weeks—and wouldn't Barbara and me love that!

The "group" in these photos is the cover-girl and a guy on the shag rug, with the ram's head. A two page photo montage shows the same couple in multiple poses and looks like a Roman orgy in progress.

The inside back cover reveals an uncredited ode to an Arien woman, the background a photo of a woman's crotch hovering over the ram's head. One particu-larly funny verse reads:

Your body proud and warm, dances in men's minds / As if you were a queen from ancient times / And no one man could ever hope to call you his own / In bed, or even in these hackneyed rhymes.

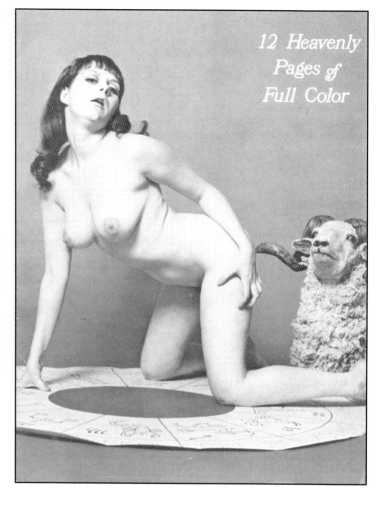

12 Heavenly Pages of Full Color

KNIGHT

☐ **KNIGHT** delivers the goods with this occult filled issue. The first article of occult import is *Tarot: Hanging Men, Crumbling Towers, Death, and the Devil* by George Lafleur, which opens with a full page repro of "La Mort," the Tarot's thirteenth trump card. The article starts in one of LA's occult supply shops run by a Mrs Person, who claims to have been taught to read tarot cards as a child by her "European immigrant parents."

Then the piece informs us of "Frog," an eighteen year old runaway girl "crashing from an acid trip", who had lived on "the streets and crash-pads of San Francisco and New York and now Los Angeles." She is waiting for an "Uncle Don," who turns out to be Don Blyth, head of "the Brotherhood of the Ram—a small, virtually unknown Hollywood satanist cult, its members mainly culled by Uncle Don and his regulars from the sidewalk traffic outside." Frog explains her relationship with the Tarot as follows:

Tarot? Yeah, I've been into Tarot…but I'm way beyond it now. Ask me specific questions. How can I tell you what you want to know unless you ask specific questions? Tarot is a good beginning. I started a couple of years ago, getting readings from a friend of mine to figure out why my head was fucked up. Yeah, it worked…of course it worked. But you get in deeper. I know all those things now. I can tell what the future'll be like without the Tarot telling me…It's a nice game, but I don't have time for games anymore. I need answers—truth—and I'm gonna try everything till I find it.

The article proceeds to explain the seventy-eight card Tarot deck's history, us-ing quotes from Paul Foster Case, author of several well known books on the Tarot and the Rosicrucians, and also an initiate of the New York chapter of the Golden Dawn.

Fiction by Harlan Ellison and Theodore Sturgeon, *Runesmith*, makes the issue highly

WILDEST FILMS
Vol 5 No 1 1970
Classic Publications, 2211 So. Union Ave., Los Angeles, CA 3.50 80pp

SATAN SEX CEREMONIES
1970
S & D Products, PO Box 34474, Los Angeles, CA 90034. National Distributor: Wyngate & Bevins, Inc., 6311 Yucca St., Hollywood, CA 90028 5.00 72pp

collectible. Its strapline reads: "The world lay in hideous ruin…twisted monsters of men pursued him…yet Smith the Runesmith's true danger was the Demon within…"

The strangest of the occult features in the mag is *Weird Harold and the Witches* by Paul Cabbell. He visits the same "satanic cult" mentioned above, LA's Brotherhood of the Ram, headed by Don Blyth, who takes him for a tour. Cabbell encounters a 3,300 year old mummy named Senbi, a hand of glory, a human skeleton crucified on a cross named "Weird Harold," and skulls with lights in the eyes. All the while, Cabbell has inserted his thoughts into the article: "I can always kick him in the nuts and then grab one of the chicks. I could use her as a hostage. The door can't be locked."

The Brotherhood of the Ram's high priestess, Diana, explains to Cabbell:

We don't have rules, regulations, by-laws, or a charter or anything. We're a group of people who've gotten together to pursue the legitimate occult. We're not out to make a name for ourselves or to put on a fantastic display.
We raise certain entities and converse with them. We want to become more attuned to the other plane, the spiritual realm. We're actually sort of a symposium of the occult. We're trying to bring the occult community together.

Then, in an attempt to quell Cabbell's scepticism, Blyth demonstrates his ability to "see without eyes," and to stop his and the heart of one of his initiates at will. All of Blyth's claims appear to be proven true, but Cabbell remains a sceptic.

Another member of the Brotherhood, nineteen year old Lilith, informs Cabbell that she had "a rather intimate relationship with the demon known as Asmodeus," becoming defensive when Diana says of the demon, "he's a rather stuffy individual. He's very hung up on formality."

The lofty aim of the Brotherhood was

"the liberation of the self and the world." According to Blyth, most of society's ills came from Christianity and the "right hand path religions." The established order caused us to be ashamed of our bodies and our genitals, but contrary to rumor, he states that the Brotherhood does not hold orgies or commit human sacrifice. However, like the Church of Satan in San Francisco, they did use a nude woman (Lilith) for their altar.

The strange objects were part of Blyth's Weird Museum, an odditorium on Hollywood Blvd. In the fall of 1970, this piece would seem like an advertisement for it, if not for the fact that the Weird Museum is not mentioned in the article! Legend has it that Dr Blyth was given the odd objects by his father, who had traveled the globe as a sea captain. When a few of his female initiates came to Dr Blyth and asked if they could sell herbs and other goods in a corner of the museum, he agreed, and The Ram Occult Center started in the summer of 1971. Donald R. Blyth died in Jan 1993.

An article called *Zen, Bahai, Palmistry, Astrology, ESP and Now…Phrenology!* by Walter Jarrett is the final occult related piece in the mag, but of little interest unless you plan on reading the bumps on someone's head.

To top off the issue wonderfully, there is an ad for the Holloway House paperback original **5 to Die** by Jerry LeBlanc and Ivor Davis, one of the earlier and more interesting books on the "Exclusive Story of the Charles Manson Cult!"

WILDEST FILMS

❏ This "Arcane Issue" of **WILDEST FILMS** is included here for its focus on occult themed sexploitation films. Most of the layouts are montages of stills from various films with sparse text; Classic Publications doing its usual bang-up job with pseudo-psychedelic layouts and artwork.

Sex Rituals of the Occult is in two parts,

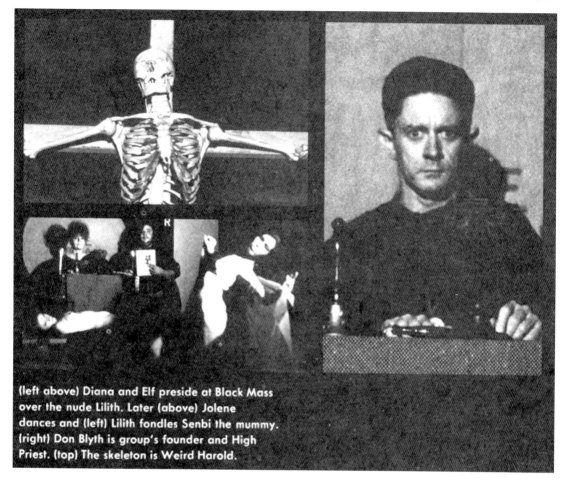

(left above) Diana and Elf preside at Black Mass over the nude Lilith. Later (above) Jolene dances and (left) Lilith fondles Senbi the mummy. (right) Don Blyth is group's founder and High Priest. (top) The skeleton is Weird Harold.

opening and closing the mag:

One of the most factual and revealing films ever made about the supernatural is the exceptional film **Sex Rituals of the Occult**. *With this selection of preview stills from the film, we are also printing some of the actual spells used by witches through the ages.*

The "actual spells" are a toss-up between short blurbs and crudely rendered symbols and sigils that could have been taken from any number of books on the occult.

The blurbs edify the reader:

According to the idolatrous practice of this age, Satan is believed to appear in the form of a black cat or a toad. In this arcane form he demands kisses from his adherents: one abominable kiss under the cat's tail; the other is a horrifying one being placed in the toad's mouth.

Thus by their own power and more so through witchcraft they can do harm to all men.

It more frequently happens that witches are corporeally present at Sabbats and have actual carnal and physical intercourse with the Demon. Witches eat human flesh, especially the flesh of children, and publicly drink their blood. But if they cannot procure children, they exhume human corpses from the grave or take off from gibbets the bodies of hanged men.

The photos are of various orgies and rituals from the film, mixed with close-up vaginal lips and an assortment of objects placed over them, such as Baphomet medallions, flowers, necklaces and chess pieces.

Another layout is *Rosemary's Booby*, "A sensual spoof on a sexy spook film." The photos have word balloons containing minimal and inane dialogue.

I Do Voodoo is supposedly stills from a movie of the same name, again mixed with anonymous close-ups of vaginas and "arcane" symbols.

Ritual of Lust focuses on lesbian witches and claims that, "Many of the old spells and charms required the fluid from the sexual act

Above Rare "Arcane Issue" of **WILDEST FILMS (v5 #1) 1970.** **Opposite** Underground comix-like strip by "D. Barry" from **THE DEVIL MADE ME DO IT.**

CONFIDENTIAL
Vol 19 No 1 Jan 1971
Newsline Publications, Inc., 8060
Melrose Ave., Los Angeles, CA
90046 .75 76pp

between two women."

Sex Spell starts with a full page extreme close-up of a vagina with a large pentagram superimposed, inside which are astrological signs and Hebrew letters. The subtitle: "The way witches get laid."

SATAN SEX CEREMONIES

☐ **SATAN SEX CEREMONIES** is an obscure mag that emanated from 6311 Yucca St., which apparently housed—as well as various publishers of adult material—Wyngate & Bevins, a national distributor of adult magazines, paperbacks and sex aids. The Wyngate & Bevins logo—an Atlas figure inside a circle—was used on the cover of their gay mag **MR. SUN** and rubber stamped on the cover of both copies I've seen of **SATAN SEX CEREMONIES**.

Again the Magus is a magus-by-magus overview starting with Count Cagliostro and moving through to Crowley—with quotes from his **Magick in Theory and Practice** and the last lines from his Hymn To Pan.

The Witches is more on the history of witchcraft: Louise Huebner is quoted from her book **Power through Witchcraft**, while Alex Sanders and his bio **King of the Witches** are mentioned, along with his non-traditional brand of witchcraft

Predictions begins with a quote from H.L. Mencken: "The prophesying business is like writing fugues; it is fatal to everyone save the man of absolute genius."

The Star Science discusses Ptolemy's **Tetrabiblios** being the astrologer's Bible, and the Emerald Tablet is much quoted: "That which is above is like that which is below and that which is below is like that which is above, to achieve the wonders of the one thing."

Cult of the Dead concerns itself with resurrection, ghosts, necromancy, Mexico's Day of the Dead and astral corpses. It ends with the advice:

So if you are tempted by séances and Tarot readings, at least now you know. It's the Cult of the Dead you're tampering with, and the spirit that comes may not be the harmless one you sent for!

Rituals of Magic again quotes Louise Huebner and Richard Cavendish. Ceremonial magic is the concern of the remainder of the piece, with Crowley and the Golden Dawn mentioned in connection to their use of the ritual *The Bornless One*, with some of the incantation included.

Satan, Sex, Ceremonies is the main photo layout weighing in at thirty pages, depicting a ceremony or ritual with arcane symbols, nude initiates, animal sacrifice, human skulls and a man with a face painted on his butt cheeks, presumably to be kissed by the cultists. The text opens with a quote from Houseman: "Have willed more mischief than they durst / And stood and sweated ice and fire / Fear contending with desire."

It then relates the experience of Nicholas, attending a ceremony to call up the Lord Satan and initiate a new witch into the coven. The photos start with a couple who are supposed to be Nicholas and Diana, the woman he has asked to help him "purge his mind and emotions, to exhaust himself through the use of drugs, drink and sex."

A picture of the naked lower torso and crotch of Diana, lying prone on the floor, has the caption: "The invading force of the demon will enter more easily, it is thought, if the sorcerer can put up the least possible resistance to the invading force."

The rest of the coven show up in black robes clutching black candles. There are pics of Nicholas holding over the initiate a knife in his right hand and a bird (possibly a crow) in his left. "The energy let loose by the ceremonial killing is embodied in the blood where the life-force of an animal is found." A few photos later everybody has shed their clothes to writhe around on the floor. A fairly generic description of someone called Virginia being initiated follows.

Then, suddenly, it was over and He was gone in a flashing of scarlet and a whirl of smoke. Virginia lay back in drowsy contentment but…His celebration must go on.

"His celebration" goes on with Nicholas getting sloppy seconds with Virginia after the Lord Satan leaves in a puff of smoke. And an exhausting orgy is had by all. On one of the last pages of the layout was a boxed-in quote from *The Bornless One* ritual.

The Curious Cards is an article tacked on at the end of the mag and a short primer on Tarot cards, with another quote from Cavendish.

There are only three ads in the mag, all for products available from The Store in Canoga Park, CA. One ad is for an inflatable chair, the other two for an inflatable sauna belt and a three-in-one vibrator.

CONFIDENTIAL

❑ The cover of this issue of **CONFIDENTIAL** boasts "All About Witchcraft," "Dennis Hopper's Ugly Past," and "Edy Williams—A Fake Feline With Claws." Inside, there are two articles concerning witchcraft and both seem to have been in response to the articles in the March 1970 issue of **ESQUIRE** on the occult world of California in the wake of the Tate/LaBianca murders.

The first witchcraft feature is *An Interview with Hollywood's Glamour Witch Princess Leda Amun Ra* by Carol Lee. LA acid goddess and witch Princess Leda Amun Ra is also featured in the article *Princess Leda's Castle in the Air* by Tom Burke, in the issue of **ESQUIRE** mentioned above. This article claims that the photographer who went along on the **ESQUIRE** interview, Bud Lee, was fed an LSD-laced apple and nearly lost his mind as a result! A website on Lee, now living in Florida, says of the assignment with **ESQUIRE**:

It was a whirlwind tour of [California's] most deviant residents, including Princess Leda, self-proclaimed Acid Goddess. [Bud] accidentally ate some fruit laced with a whopping amount of LSD and ended up in jail for a night handcuffed to a transvestite.

And speaking of transvestites, I wonder if Ed Wood had heard of Princess Leda Amun Ra as he used a similar name, "Amau Ra," in his horror tale, *Witches of Amau Ra* in **HORROR SEX TALES** (see page 269).

In any case, when writer Carol Lee was assigned this **CONFIDENTIAL** interview, she was a tad wary of the Princess and her minions and invited four friends along

for the ride, two of whom were good-sized males. The article starts with Lee and friends sitting around her apartment smoking joints and discussing the pros and cons of wearing crosses, St. Christopher medals, and garlic to visit the Princess at her "castle in the sky." They leave to pick up the photographer and smoke more dope. They have been told by Leda's "manager"/servant, Osmo, that they should bring dope with them to ingratiate themselves with the Princess.

Their arrival at Leda's place reads like the beginning of numerous horror movies about lost travelers ending up at the haunted house with a discarnate voice leading them up the pathway and the front door seemingly opening by itself. After entering and

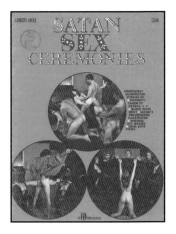

From top **SATAN SEX CEREMONIES**
1970 was an unusual mag from
Wyngate and Bevins publishers,
with a rubber-stamped Atlas that
was the logo for their male physique
mag MR. SUN; Hard-to-find later
issue of CONFIDENTIAL (v19 #1)
Jan 71 in which some of the people
who appeared in the ESQUIRE Mar
70 issue got to comment on it. Right
and Opposite Two page opening
spread for *Rituals of Magic* article in
SATAN SEX CEREMONIES; Opening
page of the *Satan, Sex, Ceremonies*
photo layout.

inspecting the strange, antiquated decor they are informed that Princess Leda is under the weather and that they will have to visit her in her bed chamber, to which they are led through the labyrinthine maze of the house.

Leda Amun Ra's bedroom is decorated in late sixties decadent hippie occultnik fashion:

brilliantly colored peacock feathers cascaded from ceiling to floor, held by a dark bank of some sort, half exposing the huge king-size bed. The room was almost in total darkness. The walls seemed to be painted black. Shapely legs extended from behind the peacock feather drapes. They were encased in sheer black stockings, laced knee-high with black leather thongs. The bed sheets were black satin; pillows of black satin, wild silk prints, fake fur, etc. were piled high against the headboard and there she was—Princess Leda Amun Ra—sprawled out in disarray, a thin strip of silk flung carelessly across her breasts. Her hair was totally wild, teased and frizzed out like a black halo about her sunken cheeks and gaunt eyes. The eyes themselves were compelling, cunning, insane.

After the Princess beckons the group to sit, they light cigarettes, only to be told that cigarette smoking is not allowed in the "Temple." When all the smokes have been put out Leda asks if anyone has a joint. When she is given one, she smokes half of it before starting to talk to her guests, and when she does it is a tirade against **ESQUIRE** for the article they had written about her. She calls the **ESQUIRE** reporters "bastards, cowards and little shits" for their "wretched and false story" which involved her theft of a black swan from a state park to procreate with it, like her mythological namesake. Most of what she talks about is nonsensical to Ms Lee, but, when coherent, she brags about her occult powers (claiming to possess the soul of Hitler) and reincarnations as a male and female, as well as being reborn into each of the twelve zodiac signs (which gave her the ultimate zodiacal power), and having been a high priest of Atlantis. The Princess continues to rail against **ESQUIRE** and other magazines that she believed had wrongly smeared her, mostly using her own words and actions.

Eventually the **CONFIDENTIAL** crew are offered fresh fruit with a bowl of powdered sugar which they initially refuse, remembering Bud Lee's spiked apple. Ms Lee by that point has figured out that Leda is a fake, and braves the fruit with sugar

dip, the others following suit. After more in-comprehensible pontification by their host it is time for the reporter and her friends to leave, which they do as Leda drones on, a pathetic woman addled by drugs and an overblown ego.

As they drive away from the stucco cas-tle of Princess Leda Amun Ra, the friends all agree that Leda is a fake whose occult power is LSD, and is to be pitied more than feared. They also agree that she put on a damn good show.

Late Afternoon, Twilight and Evening at the Timeless Occult Shop is by Emily Allen, who visited Ben Harris, proprietor of the Timeless Occult Shop which had been located on the Sunset Strip for two years when the article was written. Harris was another of those mentioned and pictured in the **ESQUIRE** article, not in an article on him specifically, but as part of *The Style of Evil* piece which included photos of Julius Cae-sar SPQR and the dancefloor of the Climax Club. Harris, not unlike Princess Leda, was not happy with the **ESQUIRE** article and felt it misrepresented the occult scene in Califor-nia. He was of the opinion it increased the flow of "incredibly Evil persons" into his oc-cult shop. He predicted California would fall into the ocean in 1984 because the planet Pluto, the planet of "death and destruction," would enter its own sign of Scorpio.

Writer Allen moves through the shop and its attendant twilight world of channel-ers, mystics, and seers as she and Harris discuss evil, love oils (made by a little old lady in Glendale), astrology, psychology, before going to dinner at Villa Frascati down the street.

At the end of the article Allen states that "Evil" (spelled with the capital "E" throughout the piece) wasn't hippies smoking pot, or swingers at the Sexual Freedom League, nor Black Masses at the Church of Satan, but ultimately "formless" and "drift[s] down from the Hollywood hills and laugh[s] at the movie colony indulging in sadomasochistic revels featuring plenty of props—whips,

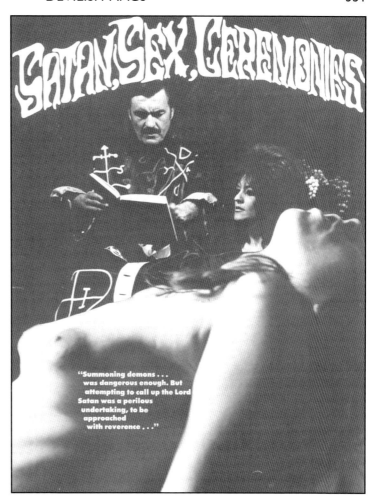

"Summoning demons . . . was dangerous enough. But attempting to call up the Lord Satan was a perilous undertaking, to be approached with reverence . . ."

handcuffs, bloody chunks of raw meat." Which I suppose could have been read as Polanski, Tate, and friends and the way they were portrayed in the media by some.

There is a sidebar feature within the above article called *Witchcraft and Your Medicine Cabinet* by Merlin Mendel, which includes eight questions concerning the reader's knowledge of the medicinal quali-ties of certain plants and the drugs obtained from them; the answers are given at the bot-tom of the page.

Other highlights of the issue are *Edy Williams—Vintage 1964* by Julie McMahon which includes pics of Williams and Russ Meyer's wedding with Hugh Hefner and Barbie Benton in attendance. *Dennis Hop-per: Not So Easy Rider*, by Liz Razzio, is the bizarre and sordid tale of Dennis Hopper's girlfriend Barbara Berkley and her use of heroin to quell the physical and psychologi-cal pain of the doctor-inflicted miscarriage she had of Dennis Hopper's baby. A friend of Barbara's, who had helped during her miscarriage, muses upon seeing the newly released film **Easy Rider**, wishing she had seen it with Barbara, who had left without a trace. Little did the friend know that Barbara had met her end in a cheap motel in Arizona. The last paragraph informs us that she "took part in the murder of two FBI men. It was a 'contract killing' and she needed the money to flee to Europe—for she had no place left to run."

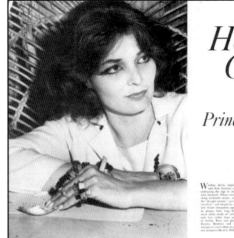

Above **LOOK (v35 #17) Aug 24, 1971.** *Right* **Splash pages for the interview with Princess Leda Amun Ra in CONFIDENTIAL (v19 #1) Jan 71.** *Opposite* **Satan returns for the Canadian edition of TIME magazine's "Occult Revival" issue, dated Jun 19, 1972.**

LOOK

☐ **LOOK** (i.e. mainstream media) includes an occult exposé, *Witches are Rising* by Brian Vachon. And who better to feature on the cover but Anton LaVey holding a human skull!

The article opens with a very magisterial looking LaVey, in a color photo that spreads across the first two pages. In the piece, Vachon reports on three occultist/witches—Anton LaVey, Raymond Buckland and Aden Kelly, all of whom have large color photos in the article, mostly taken by Jack and Betty Cheetham (who also took the **TIME** cover photo below).

On visiting the black Victorian house in San Francisco that LaVey renovated into the first Church of Satan, the first observation he makes is that of a bank check tacked to the door of the "waiting room" that reads: "The Church of Satan, Louisville, KY., sends to Central Church of Satan, for 15 souls." Vachon then describes tombstone coffee tables, gory paintings by LaVey, and his penchant for taxidermy as evidenced by stuffed animals everywhere. LaVey makes his entrance via hidden passageway, from behind the fireplace.

LaVey is quoted: "There is a demon inside man. It must be exercised, not exorcised—channeled into ritualized hatred."

After mentioning that he did not worship or believe in the existence of Satan, LaVey comments: "But there is a force—a Godhead or whatever you want to call it. It is a displacement of the energy of human beings that will become a malleable source of action for the magician—the witch."

Next, Vachon visits Raymond Buckland and his wife Rosemary. Vachon claims Buckland is the "antithesis" of LaVey: Buckland claimed that people like LaVey were the ones that gave witchcraft a bad name. Buckland, at the time, was living on Long Island, New York and had a shortlived Museum of Witchcraft and Magick in Bay Shore, which I visited once as a teenager. Buckland, also a practicing witch, held monthly coven meetings in the basement of his home. Vachon asks if he could attend one, and is refused. Buckland says his wife Rosemary conducts the coven's rituals, and he and the others assisted in the nude.

While visiting "a bevy of witches in the San Francisco Bay area" Vachon met Aden Kelly, "high priest of a coven," who he places somewhere inbetween LaVey and Buckland. Kelly says that what started out as an occult study group of twenty people turned into a coven that practiced ritual ceremonies in the nude every full moon.

There are photos of Lady Judith, "a witch by avocation," hunting for herbs in the woods

LOOK
Vol 35 No 17
Aug 24, 1971
Cowles Communications, Inc., 111 Tenth St., Des Moines, Iowa 50304 .35 74pp

TIME
Vol 99 No 25
Jun 19, 1972
Time, Inc., Rockefeller Center, New York, NY 10020 .50 76pp

with her students.

Vachon concludes his investigation by going to an Esbat at Kelly's apartment where he finds himself dancing in a circle nude. In the afterglow, sitting around eating fruit and cookies and drinking wine, "an uncommonly delectable 16-year-old girl" says, "This really does give me a mystical experience, a feeling of oneness with the universe. This is my religion. For me, it works." Vachon admits to trying not to stare at her nakedness.

TIME

☐ TIME's cover announces "The Occult Revival" and "Satan Returns"—the magazine joining the occult fray with the eyecatching cover photo by Jack and Betty Cheetham of a hooded member of the Church of Satan. The Cheethams also took all the photos for the uncredited article inside, *The Occult: A Substitute Faith.*

Underneath the Baphomet symbol, centered on the opening page, the caption reads: "Satanist's inverted pentagram—A desire for mystery." The four pages of color photos that follow it include LaVey with animal headed adherents in a "ceremony of the beasts"; a naked coven of California witches; Lilith Sinclair in a "ritual of compassion"; a bewitching nineteen year old Karla LaVey with a human skull (probably the same skull her father posed with on the **LOOK** cover); the German born surrealist/occultist Satty in his San Francisco digs; and a photo labeled thus: "In the Santa Cruz mountains, members of the New Reformed Orthodox Order of the Golden Dawn (Aidan Kelly's group) lead a celebration of the spring equinox, an important date for witches."

The nine page article begins by telling the reader how prevalent belief in the occult has become in the past few years, beginning with the astrology boom of the sixties. It cites various meetings and rituals of pagans, witches and Satanists taking place across the country, stressing their normality by the

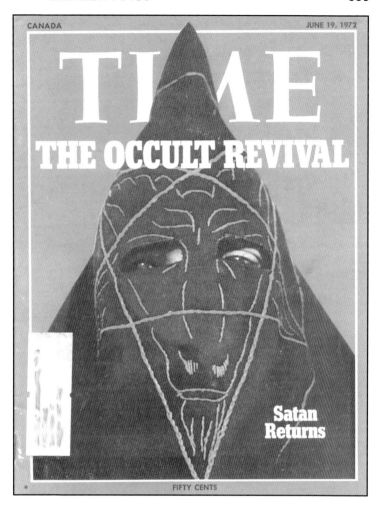

CANADA JUNE 19, 1972

TIME
THE OCCULT REVIVAL

Satan Returns

FIFTY CENTS

jobs they held as computer programmers, nurses, chemists, etc.

It then tallies up the increasing sales of occult related books, checking in with such stores as the Metaphysical Center in San Francisco and Scribner's in New York. The alchemy of it all is demonstrated by a Pan Am Airlines package flight to Great Britain, dubbed the "Psychic Tour" for its astrologically plotted flight and destinations that included visits to Stonehenge, a séance and a psychic healing center.

Owen Rachleff, author, "Occult Debunker" and teacher of a course on the occult sciences at New York University, says: "Most occultniks are either frauds of the intellectual and/or financial variety, or dis-

turbed individuals who frequently mistake psychosis for psychic phenomena." The writer of the piece adds:

Yet for all its trivial manifestations in tea-leaf readings and ritual gewgaws, for all the outright nuts and charlatans it attracts, occultism cannot be dismissed as mere fakery or faddishness. Clearly, it is born of a religious impulse and in many cases it becomes in effect a substitute faith.

A brief history of man's fascination with the occult is given, from the Lascaux caves to seventeenth century France. The occult revivals of the Victorian era and the 1920s

From top **BITCHCRAFT** (v3 #2)
Spring 73 and **(v3 #3) Summer 73.**
Opposite, from top **Layouts from**
the above: *Handmaiden to Damballa*
(v3 #2) and *Satan's Sacrifice* **(v3 #3),**
which features Eric Stanton artwork.

BITCHCRAFT
Vol 3 No 1
Winter 1972–73
Eros Publishing Co., Inc., Wilmington,
DE 5.00 100pp

are also mentioned. The "space age" occult revival—*Satanism*, *Witchcraft*, *Prophecy* and *Spiritualism*—comprises the remainder of the article.

Under *Satanism*, LaVey is the main topic. Also mentioned is an unnamed army officer who was one of LaVey's Council of Nine and editor of the newsletter **The Cloven Hoof**. This was Michael Aquino, who left the Church of Satan in 1975 to start his own Temple of Set.

Mentioned in the last few paragraphs are "quasi-satanists" The Process Church of the Final Judgement (with a reference to an article in the Sep 6, 1971 issue of **TIME**), along with Manson and other occult related crimes across the country.

Witchcraft begins with Margaret Murray and wends its way through Sybil Leek, Aidan Kelly and Gerald Gardner. Of the Gardnerian tradition in witchcraft, Owen Rachleff names it "library witchcraft" as it was mostly "concocted from books."

Prophecy discusses various methods of divining the future, namely astrology, I Ching, and Tarot cards. The power to see the future psychically is also covered, mentioning Nostradamus, Jeane Dixon and Edgar Cayce. (Strangely enough Criswell is not mentioned!)

Last and probably least is *Spiritualism*:

The art of spiritual healing is a gift frequently mentioned in the New Testament in connection with Jesus. Many a saint has since established his credentials with healing miracles, and many an evangelical preacher—and occultist—still tries.

At the tail end of the piece, under the heading *Magician Playmate*, a Jesuit theologian named John Navone is quoted on his assessment of the Devil in modern cults:

[The Devil] is more often a type of magician playmate, the product of a **PLAYBOY** *culture rather than the ma-*

lign personal being found in Scripture. These cults tend to use the Devil for a type of arcane amusement, whereas the unamusing Devil that appears in Scripture manages to use men for his dark purposes.

BITCHCRAFT

☐ **BITCHCRAFT** typified the genre of softcore S&M witchcraft/Satan porn, and was one of many ubiquitous Eros Gold-stripe mags published in the seventies, along with their other popular titles such as **WHIP 'N' ROD**, **BONDAGE QUARTERLY**, **UNIQUE WORLD**, **EXOTIC LIFE**, **B&D**, **HIGH HEELS**, **EXOTIQUE**, and the **FOCUS ON: (SECRETARIES, WOMEN IN UNIFORM, HOOKERS, HOUSEWIVES)** series. Many of the layouts and photos from **BITCHCRAFT** ended up in later titles like **WITCHES & BITCHES**.

Eros Publishing gave its address as Wilmington, Delaware, reportedly for tax purposes, while it was distributed by Parliament News in Chatsworth, California.

BITCHCRAFT, more likely than not, took its title from the chapter of the same name in Anton LaVey's book **The Complete Witch or What to do When Virtue Fails** (1971). (And that is not all that was borrowed from LaVey's book.)

All the issues of **BITCHCRAFT** use the magical alphabet known as "Theban" as a border around the cover photo. The characters are arranged in alphabetical order as found in numerous books on magic and do not spell out anything arcane.

All three issues of **BITCHCRAFT** open with the statement:

The powerful female who exercises her control over man and the world of man has been a subject of attention since remote antiquity, and down through the ages the female witch has come to epitomize that dominatrix.

In conclusion, the mag is characterized as follows:

Intriguing and possibly somewhat frightening, **BITCHCRAFT** *is a journey through the veiled, unknown regions of the universe where the fetishist reigns supreme, where men and women derive pleasure through pain, perform ritual intercourse with occultists and even the Devil himself and worship other ungodly forces.*

Laid Upon the Altar, from which the cover photo is taken, starts on a dark note with the High Priestess raising a large goblet and intoning, "'Oh Satan, Lord of darkness, Father of Evil, touch this potion and make it strong by thy hand. Come to us here tonight and survey all that we do in thy name.'" The piece is mainly a photo layout with text and the supposed sacrifice of a virgin girl to Satan, the "Master of the Universe, Purveyor of Evil." She is forced to drink a "foul smelling brew" and then tied to an "Altar of Satan." The virgin sacrifice then has ritual intercourse with a male slave on the altar as per the High Priestess' orders.

There are two articles in the mag, both by someone pseudonymously named "Hastur," a name used in *Haita the Shepherd* by Ambrose Bierce and mentioned in H.P. Lovecraft's Cthulhu mythos.

Hastur's *Sex Astrology* article is predictable (pun intended), but *A Startling Review of Witchcraft Today* is of more interest as it features "a question and answer forum:" letters from the readers with Hastur's replies. Hastur was also apparently the author of a book called **Sex in Witchcraft**, published by Eros Publications, which he refers to in one of his replies while giving advice to someone who is impotent.

In Hastur's intro to the letters he states:

There is a definite need for an occult 'hot line' to the swinging generation,

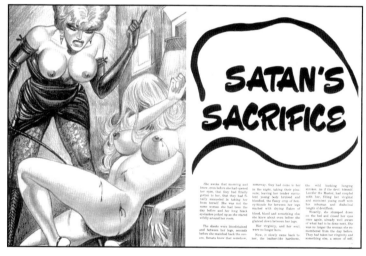

of which you are probably a member. Witchcraft is now an 'in' thing and millions of people throughout the world are investigating this ancient, morally liberating and philosophically enlightening religion.

Hastur gives long winded, detailed answers to queries on impotence, con artist or guru?, sex initiation rites, rape phobia, and witchcraft statistics.

Satan's Child is another photo feature with some text, probably written using the photos as inspiration. The story concerns the wild woman "Guren," rumored to have been sired by Satan and who had run off into the Tennessee swamps at an early age. Michael, Guren's cousin, goes into the forest to search for her as he has heard rumors of her existence in the darkest part of the swamp. Michael finds her, or more accurately, she finds him and knocks him out with a blow to the head. Guren binds his hands behind him and ties him to a tree. Michael awakes to plead with his cousin, but to no avail. Guren gives him another whack over the head. She finally drags him to a stream to wake him up: "Was he to be sacrificed on a forest altar in some bizarre ritual…or was it his destiny to become the

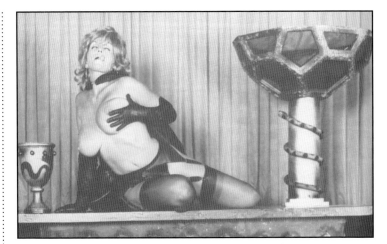

Above **SEARCH had a different
theme for each issue. This one
was the "Witchcraft Erotica" issue,
(v3 #2) Summer 73.** Right and
Opposite **Candy Samples on the
altar in BITCHCRAFT (v3 #1) Winter
72-73; Title page for *Slave of Satan*
in that same issue.**

mate of Satan's Child?"

Sue's Summons to the Coven is a
fictional piece with unsigned artwork by Bill
Ward on its splash page. The other short
story in the mag is the eighteen page *Bride
of Satan*, which starts out text-heavy with a
few pics at the front of the mag, and continues in the back, this section mostly photos
with very scant text. One of the males in the
pics looks surreal, wearing fake sideburns,
eyebrows, moustache, and goatee.

Ritual of Sin, another photo layout with
some text, depicts two women: "Forester" a
dominatrix witch, and "Kathy," a young starlet looking to advance her career through
the magic of Forester. It is one of the many
sets of S&M and B&D photos that utilizes the
ubiquitous wall plaque prop of two crossed
daggers. Forester's help comes with a price,
as the text makes clear: "For the magic she
works involves the person's submitting to
her will in bizarre rituals in which they are
expected to pay homage to Satan; and, in
every ritual, blood has to be drawn." Kathy
is shown kissing a mace, worshipping at
Forester's feet, and submitting to having
an "unholy cross" carved into her butt cheek
with a knife for the bloodletting. Kathy then
dresses up in kinky leather garters, gloves,
and cat mask while praising Satan with Forester who holds a sword over their heads.
Kathy is "allowed to remove her mask, but
then she must kiss the sex of the woman

who has known the body of Satan."

The photo feature *Come, My Lovelies,
Come* uses the Theban alphabet again in
the layout. The pics show Candy Samples,
the "Countess," with a guy dressed in a
Batman-like leather mask, red satin cape,
and red leather gloves: the "Count." The
Count and Countess are busy training two
women—whom they have bought at a Moroccon white slave market—in the Satanic
rituals of Beelzebub. The Count orders them
to worship his wife's ample breasts which the
two do without hesitation. After their display
of loyalty, the Count mounts the altar as the
Countess and two slaves worship him as the
god Priapus. Then it is the Countess' turn for
worship upon the altar as "a symbolic Bride
of Satan." After the Countess climaxes from
her imaginary coupling with Satan, and the
other three pose in various conglomerations
around the hokey looking porn version of a
ritual chamber, they all come together for a
mass group grope. Most of the color pages
in the mag came from this set of photos.

The photo feature *Slave of Satan* is
printed on green, uncoated paper unlike
the rest of the mag that is on the usual,
heavy glossy paper. Rene Bond features
in it as "Jan." With a masked muscleman
named "Butcher," she subdues and chains
a woman to a circular suspended table,
threatening her with a whipping if she
does not drink the concoction she fears is

SEARCH
Vol 3 No 2 Summer 1973
Scandia Productions Ltd., Stockholm,
Copenhagen & New York 5.00 48pp

laced with a "hallucinogenic." After Butcher successfully gets the woman to drink the potion, he tells her to "go to town" on Jan. The last photo shows her about to engage in cunnilingus with Rene/Jan.

The photo-illustrated article *Dressing the Part of the Female Witch* is lifted from Anton LaVey's advice to witches in his **The Complete Witch**, reprinted more recently as **The Satanic Witch** (1989). There is no byline or credit given to the piece and LaVey's original text has been purposefully mis-paraphrased so that it is not outright plagiarism.

It seems doubtful that this was written by LaVey himself in spite of the fact that he was featured in various nudist mags and adult slicks.

A one page ad towards the back of the mag has the banner blurb, "Unusual Magazines On Adult Behavior!" The mags offered are **FEMALE MIMICS**, **HIGH HEELS**, **EXOTIC LIFE**, **FETISH & FANTASY**, **40RTY PLUS**, and **WHIP 'N' ROD**. The order form is from Visual Adventures in Cleveland, Ohio.

The next issue of **BITCHCRAFT** v3 #2 (Spring 73) is 100 pages and features a caped Rene Bond on the cover, clutching a ceramic skull between her bare silicone enhanced breasts. The issue features the articles *Witchcraft and Sexual Freedom* and *What is Sex Magic?* The fiction pieces are *Handmaiden to Damballa* and *The Carnal Curse of the Kahunas*, both of which have uncredited intense pen-and-ink splash page artwork. Some of the photos in the issue can also be found in **SEARCH** v3 #2, below.

BITCHCRAFT v3 #3 (Summer 73) is cut down to seventy pages and has a cover photo similar to **BITCHCRAFT** v3 #1, in that the same hokey altar and oversized goblet can be seen on both. In spite of the page reduction, the Summer 73 issue includes the short story *Satan's Sacrifice*, which starts off with a page of pencil art which, although unsigned, I would say was by Bill Ward, depicting a dominant woman with a riding crop, her breasts hanging over the top of her tight dress as she stands over and reprimands

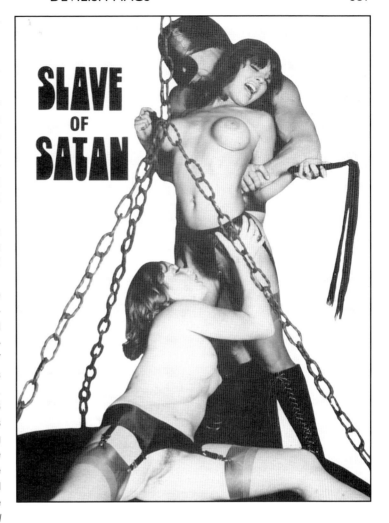

a naked blonde woman with bloody lash marks on her skin. The one article is titled *The Erotic Implications of Witchcraft Partnerships*, while the photo-illustrated article is on *Witchcraft in Italian Films*.

SEARCH

☐ **SEARCH**'s front cover has the subtitle "Witchcraft Erotica" and announces "24 Full-Color Pages Exclusively Photo-Illustrated," while the back cover features the blurb: "**SEARCH** takes you INSIDE the covens and sabbats—in a survey of the EROTIC ARTS OF THE OCCULT." **SEARCH** is an-

other title that changed themes each issue, like the aforementioned **NAKED**.

SEARCH was picked up by a couple of different publishers. **SEARCH** v3 #1 (Summer 73), on "Sex Devices," was published by Capri Publishers. Eventually it was published by Eros Publishing and **SEARCH** v5 #1 (1974) was a softcore pseudo-sex-ed "Sex and the Liberated Woman" issue which had a bibliography in the back.

In **SEARCH** v3 #2 (Summer 1973), the statement of purpose reads:

Because witchcraft and other occultist forms of behavior are currently undergoing a revival in this country,

Above **A demon lover portrayed in SEARCH (v3 #2) Summer 73.** Right **Photo from the article** *Witchcraft Erotica* **in that same issue: "The sacrifice of a virgin upon the altar is actually a sexual sacrifice and not murder."** Opposite **Cover for SEXUAL WITCHCRAFT #1 undated.**

SEXUAL WITCHCRAFT
No 1 undated, circa early seventies
Golden State News, 1636 W. Adams, Los Angeles, CA 4.00 48pp

the publishers of **SEARCH** *felt that a sober examination of witchcraft and the place that sexuality has in occult matters would enlighten the person who is attracted to these rituals. Witchcraft is definitely not for everyone, and sex in witchcraft, we found, is not the glamorous act that it has been purported to be.*

The article *Witchcraft Erotica* runs throughout the mag and is uncredited. The writer does mention a book they published called **What You Always Wanted to Know About Sex in Witchcraft** (Eros 1972), that could have been the **Sex in Witchcraft** book by Hastur, above. The piece is an overview of the history of sexual practices within witchcraft ceremonies and rituals, in which the writer includes the Black Mass. This seems to be one of the problems with the piece, as with many others in the adult mags, the mixing up of witchcraft, ceremonial magic and Satanism as if they all come under the heading of witchcraft. For example, in the section titled *Origins of Witchcraft*, it starts out:

Much confusion presently surrounds the question of what is the 'genuine' magic form. Gardnerian advocates insist that by worshipping Cernunnos and Aradia, they are conforming to the world's oldest religion. Ceremonial Magaicians, Sorcerers and sex magic practitioners also make identical claims. Continental Witches, New Age Occultists and many secret fraternities disagree, claiming they are the true advocates of the Old Religion. Some cults place exceedingly strong interest in sex, others minimize or altogether eliminate erotic emphasis claiming that sexuality is an adverse deterrent of magical potency. For example, the most drastic deviation from ancient initiation ceremonies is seen in the Gardnerian version, where nudity is a frequent requirement but ritual copulation rarely occurs.

On the same page as the above quote are three color photos, of two guys and two women. One of the males wields a paddle and, in another pic, a bullwhip. The caption reads: "Implements of torture have

their place in satanic rituals, used mainly to heighten the energy level of their group sex act. Often initiates are put through the most bizarre and painful forms of torture to prove their obedience to the coven."

The article makes a couple of passing references to Aleister Crowley and to an "R. Kennen" who, it claims, was "the Black magic priest and leader of the Comii Brotherhood, a nation-side [sic] network of covens that participate in the dark rites of Sex Magic." There is a photo of a nude woman on an altar, a skull resting on her pubic mound, with another woman cutting into her nipple with a knife. The incongruous caption reads: "The sacrifice of a virgin upon the altar is actually a sexual sacrifice and not murder."

Witchcraft Erotica is illustrated throughout with a mixture of hard and softcore photos from diverse sources. Most of the photos have captions, the main focus being S&M in a ritual chamber and bedroom. The pics reveal the usual paraphernalia of skulls, whips, black hoods, candelabras, chalices, corsets, devil masks and so on. Rene Bond even makes an appearance in a few of the pics, sometimes wearing a blonde wig. There are no ads in the mag.

SEXUAL WITCHCRAFT

❑ This is one of GSN's "Electra Color" mags, even though there are only six pages of color in it. The cover blurb reads "Nudity In Witchcraft! The True Inside Story" but is really just photos of nude women with skulls, couples with Ouija boards, and minimal text. The back cover has a pic of a nude woman staring at a candle, which reads "Rare Photographs of Mediums In The Raw!"

The first feature, *The Naked World of Witches* by Victor Banis, is mostly pics of nude women, one who has a totally bald crotch and sixties hairdo, posing with a candle and human skull. The other pics are of the nude covergirl in front of a dancing flame.

The text is short and claims that "Witchcraft is one of the earliest forms of organized nudism" and talks about why witches perform their rituals in the nude.

Next, *The Naked Astrologer*:

Insofar as astrology affects nudism, there are certain signs which are more impelled toward nudism than others. For example the 'water signs' of the zodiac are more apt to shed their clothing than say the 'fire signs.'

It goes on to give a "capsule account" of each of the twelve signs of the zodiac and how prone they might be to nudism. Ending the piece with the wisdom, "Take heart, however, if nudism was not in your stars—remember the stars impel, they do not compel."

The Message of the Ouija by Jay Symon starts with some wonderful photos of a nude couple playing with a Ouija board. In one pic the male has his semi-erect penis hovering over the board as if searching for a letter to land on! The text is short and explains the use of the board and its pointer, and how to improvise your own Ouija by using a glass and squares of paper with letters on them. Apparently the last sentence was written before the release of **The Exorcist**: "You may or may not learn what you want to know—but you'll certainly have some good fun while you're at it."

Above **WITCHES & BITCHES** had
many reprinted layouts and photos
from the earlier BITCHCRAFT
mag. This is the cover for (v4 #4)
Spring 77 Right The beautiful
Majeska casting an evil spell on
her sex-slave in the *Satan's Slaves*
layout. Opposite, from top Photo
from the *Devil Doll* layout (note
the ubiquitous crossed dagger
wall plaque that can be found in
any number of S&M adult slicks
from the seventies); Ad for the film
Kinkorama (note the misspelling of
the words "bizarre" and "weird").
All images from **WITCHES &
BITCHES** v4 #4.

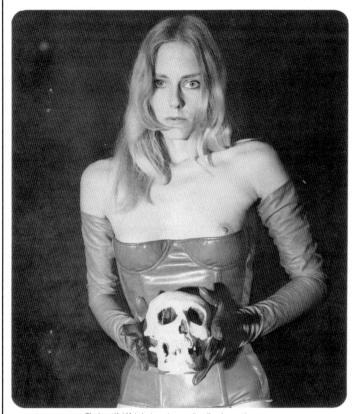

The beautiful Majeska is casting an evil spell on her captive sex-
slave. She summons every ounce of her will; and she reaches her Lord
in an intense moment of total concentration and will-focus. This is a
very special ceremony — a skull must be employed, and one nipple bared.

Numerology & Your Sex Life by Gene
Evans opens with a nude model laying back
and lifting one of her legs high in the air. The
reader is informed: "Numerology is gaining
in popularity among many groups of people,
and nudists are no exception."

The numerology involved is ba-
sic—"your legal name will reflect your Life
Number when properly worked out." A chart
gives the numerals one through nine, with
the letters of the alphabet underneath them.
After you boiled your "Life Number" down
to one digit, you could consult the last nine
pages of the piece which correspond to the
numbers one through nine again, but each
page is mostly taken up by a picture of
nudists engaged in various activities, with
a short paragraph on each numeral.

A full color page at the tail end of the nu-
merology feature uses a photo of a woman
dressed in only stockings and garter, sitting
on the corner of a bed with her legs spread.
The retro vibes kick in with the rainbow
colored "Peace & Love" poster hanging on
the wall in the background, alongside a small
painting of a small dog with very large eyes,
made popular in the sixties by Walter and
Margaret Keane.

WITCHES & BITCHES

❏ **WITCHES & BITCHES**, along with
its predecessor **BITCHCRAFT**, typify this
genre of occult porn, filled with all the occult
props from altars to skulls. It comprises six

WITCHES & BITCHES
Vol 4 No 4 Spring 1977
Eros Publishing Co. Inc., Wilmington,
DE 5.00 56pp

"photo features" and one "photo-illustrated article" called *Erotic Bitchcraft*. A lot of the elements from **SEARCH** can also be found in this mag, as is pointed out below.

The issue starts with an editorial that reads:

> *Dominant females have tremendous powers—they can subjugate the male of the species in every way. They know how to make whimpering, whining sex-slaves cringe and crawl, and plead with their supreme Mistress for mercy—of which she has none. And when the powers of the domina are harnessed to and augmented by the Devil himself—then the results are incredible. Just turn the following pages of this special issue of* **WITCHES & BITCHES***, and see if that is not true. You'll find that we are, if anything, understating the case!*

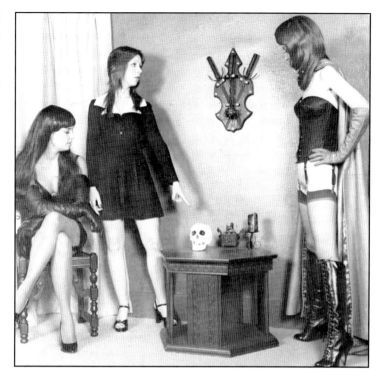

That is all fine and dandy, but the problem is that only one of the six layouts shows females dominating a male! Four of the features are all female and the remaining pic shows a male helping women to subjugate another woman!

The first feature, *Sex Spell*, has two women: "Wanda," a blonde, and "Gloriana," a brunette, both dominas. All the layouts have minimal but fairly humorous text. For example: "The beautiful blonde lovifies Gloriana's bountiful body; and the dark dominatrix swoons with pleasure." Or "The dusky damsel closes her eyes and wills her captive to minister to her." The layout ends with the two women worshipping a metal skull with a lit candle on top: "Gloriana converts the will-weakened Wanda to the worship of Satan. Now she will know supreme power."

The next feature is a seven page article called *Erotic Bitchcraft* that is continued in the back of the mag. It is based on a supposed book called **Kennen on Sex Magic**; Kennen being "founder and controller of a

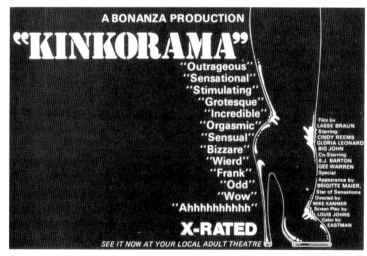

nationwide Black Magic cult known as the Comii Order." The same book and author are mentioned in the *Witchcraft Erotica* article in the above **SEARCH** magazine.

Sex Magic starts out by saying: "Majeska has powers which cannot be denied—she is a Bitch-Witch who conjures up sex-spells to overpower her vassals. Her cohort, Evila,

helps her out." One of the two women is the same blonde from the first *Sex Spell* layout. This layout is shot on the porn set version of a ritual chamber that can be found in shoots in various other mags, including **SEARCH** mag.

Chalice of Evil shows a guy dressed in paisley pants, being tied up and sub-

Above **Splash page for** *Sex Spell* **from WITCHES & BITCHES (v4 #4) Spring 77.** Opposite **Ad featuring Maxine Sanders for the "collector's edition"** *Witchcraft Today*, **that may have been a book or a magazine, offered by Superb Sales in York, Pennsylvania.**

jugated by two females dressed in black leather capes, stockings and garters. The text reads:

Vanessa and Andrea have stirred up such a malevolent mixture, and now they have fed it to Art, who is about to go reeling under its impelling influence—he will be their abject vassal: he will do their bidding now.
Overcome with depraved lust, the sex-crazed man does as he is told. The two Satanic women have him minister to their wanton desires; and he most willingly acquiesces, unable to control himself—he now has no free will. He is theirs.
An orgiastic free-for-all ensues, and the three revelers cavort with depraved abandon, mindless of the world outside. They are lost souls; devil dolls.

Captives Curse was shot on the same set as the *Sex Magic* layout, except, lo and behold, the captive is the ubiquitous Lynn Harris! The story goes:

Poor Paula was just walking down the street, minding her own business, when all of a sudden the startled sexpot was captured by witches.
They scurried her off to their den, and then they proceeded to torture and torment her in various ways (some of which we cannot even show you!). The dazed chick buckled under their assault. Then they put a curse on her, poor thing.
A sexual free-for-all ensued, and the poor girl was made to minister to the depraved and debauched wishes of the evil group.
Paula swooned as the demi-demons attacked her from all directions, taking their evil way with her, and forcing her to perform all sorts of naughty sex acts with them.

Satan's Slaves starts with an interesting photo of two women sitting at a table, séance-like, with their eyes closed. A lit candle burns on the tabletop and an image of another woman, "Majeska," is superimposed on the curtains behind them, only to materialize on the next page with a whip in her hand and the other two witches kneeling at her feet.

Devil Doll has an unusual title page: a silhouetted photo of a woman's pelvis with spread thighs, wearing nylons and no panties. Two pairs of hands, coming from opposite sides of the photo, simultaneously caress each of her thighs and hold a skull on top of her pubic mound. Witches "Tanya" and "Maybelle" threaten and torment "Holly," a newcomer, all to please their master Satan.

The layout uses a prop of note: the wall plaque display, of crossed daggers and a morning-star mace, can be found throughout the early porn mags in all sorts of layouts. It can even be found on the covers of many mags, particularly of the S&M and domination variety.

There is a nicely designed, half page ad for the X-rated movie **Kinkorama**, and a full page color ad with Rene Bond advertizing sex aids and toys such as Pet Cocks, Joy Jelly, Jungle Love capsules, Motion Lotion, French ticklers and more.

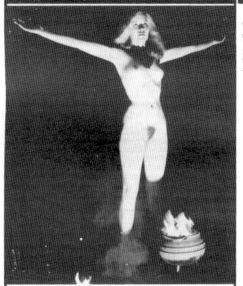
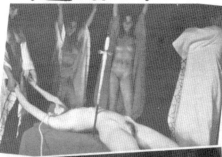
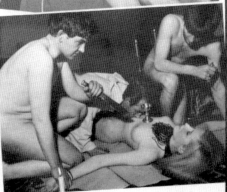

Sharon Tate

Sixties Sex Goddess in Print

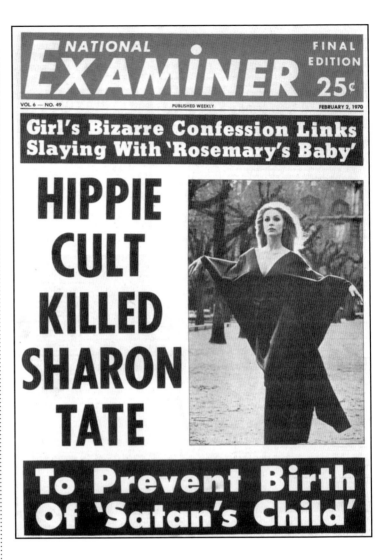

NATIONAL Examiner

FINAL EDITION 25¢

VOL 6 — NO. 49 PUBLISHED WEEKLY FEBRUARY 2, 1970

Girl's Bizarre Confession Links Slaying With 'Rosemary's Baby'

HIPPIE CULT KILLED SHARON TATE

To Prevent Birth Of 'Satan's Child'

MY MEMORIES OF THE MURDERS of Sharon Tate and the others in the summer of 1969 are foggy, as I was fourteen at the time and had other concerns. The long-haired hippie image that Manson projected at the time of his arrest confused a lot of people on the left and helped them come to the conclusion that it was the establishment blaming hippies for the slaughter in Los Angeles. Manson was held up as a martyr by some on the extreme left who portrayed him on a cross, and others who celebrated the slaughter of the "pigs."

My memory of the arrest of those concerned and the publications that came out shortly thereafter is a little clearer. I certainly remember the Sharon Tate layout in the Mar 1967 issue of *Playboy*—having just gone through puberty around that time—but that was the extent of my familiarity with Tate (I first saw *The Fearless Vampire Killers* a few years later on TV).

The three publications I distinctly recall are: *The Killing of Sharon Tate* by Lawrence Schiller—the first book on the murders which I vividly remember seeing on the desktop of a fellow student at Junior High School, Manson's piercing eyes staring out from the cover; the infamous cover of the Dec 19, 1969 issue of *Life* magazine, which contains the first article I actually read on the case at the time; and finally *Rolling Stone* #61, which features Manson as coverboy and includes an extensive article on the case.

One incident that brought the whole thing closer to home, literally, was the surrender of Linda Kasabian in Concord, New Hampshire—her home state as well as mine at the time. Concord was the state capitol, and Kasabian was brought there from Nashua to give herself up.

Kasabian was summarily shipped back to LA to be charged in connection with the murders. She eventually testified for the prosecution in exchange for immunity from the charges against her.

Sharon Tate remains more or less a mystery, even in light of the books and media coverage that her murder precipitated. A recent book about her life and murder, *Sharon Tate and the Manson Murders* by Greg King, helped to put certain aspects of her personality in focus, but didn't completely shatter her aura of mystery.

This was what led me to search for the magazines and tabloids she featured in. Sharon Tate can be found in small items in movie and TV magazines as early as 1963, such as the Nov 63 issue of *TV Radio Mirror* where Max Baer—who played Jethro in *The Beverly Hillbillies*—and Sharon are pictured together.

While alive Tate was mainly featured in the movie, TV, gossip and scandal mags, but because of the sensational nature of her murder, true crime detective mags and sleazy tabloids started to feature her posthumously.

Reading through the material you inevitably come across the occasional quote by Sharon, or an article about her—published while she was alive—that in some eerie way foreshadowed her fate. Even certain photos of her seemed to take on a new meaning after her murder, as I have discussed in relation to the photo in the Mar 67 issue of *Playboy* below.

Sharon Tate had a classic beauty, flooring both men and women who would encounter her in person for the first time. This of course launched her career and ultimately took its toll, as Hollywood came to think of her as just another pretty face. She was one of the few American "sex goddesses" of the sixties, along with the just as mesmerizing Raquel Welch, another classic beauty. Both battled to be taken as serious actresses. Raquel Welch was more or less successful with her battle. Sharon Tate gave it up to become a wife and mother.

Some of the other concerns of the day in the Hollywood gossip mags, which can be found throughout the mags listed below, were the murder of William Lennon, the father of the famous singing Lennon Sisters, Teddy Kennedy and Chappaquiddick, the Lawrence Welk Show scandals, Mia Farrow, Elvis, Glen Campbell, and so on.

Before as well as after Sharon Tate's murder, numerous magazines from Europe, Mexico and South America featured her on their covers, especially in the last days of August 1969. Tate's early movies having been made and released in Europe got her more magazine coverage there than was the case in America. The American mags that concerned themselves with her murder generally didn't put her picture on the cover—or if they did it was as a small inset—as they seemed more concerned with the murder of William Lennon, which took place two days after the Tate murders. The interest in the Lennon Sisters was attributed to the fact that they "grew up on TV" in front of America and were a well known popular act—via *The Lawrence Welk Show*—unlike the little known Sharon Tate at the time.

Roman Polanski, being a European director, had more notoriety there from his early films and married Sharon in London in 1968. In more than one of the mags listed below, interviewers have stated that upon meeting Tate they got the feeling that she was European, to the extent that they expected her to have a foreign accent when she spoke. Her father, Paul Tate, was an Army Intelligence Officer, affording Sharon the opportunity to attend high school in Italy. Her views on marriage and fidelity were admittedly more European, whether she was just parroting Polanski's views or not. Sharon was also intimidated by the intellect

Page 364 **Interesting theory posed by this cover and inside article of the NATIONAL EXAMINER, Feb 2, 1970.** This page, above **Mar 67 issue of PLAYBOY. Its feature,** *The Tate Gallery,* **consisted of stills taken by Polanski on the set of** *The Fearless Vampire Killers.* Opposite **A still from** *The Fearless Vampire Killers* **that is fairly bizarre in hindsight, given the Devil's horns held over Tate's head.**

PLAYBOY
Vol 14 No 3 Mar 1967
HMH Publishing Co., Inc., 919
N. Michigan Ave., Chicago, IL
60611 .75 194pp

THE SATURDAY
EVENING POST
240th year, issue No 9;
May 6, 1967
The Saturday Evening Post, 641
Lexington Ave., New York, NY
10022 .35 110pp

of some of her husband's friends and acquaintances. Her shyness around them was mistaken for aloofness by some.

Reading these articles and looking at the photos gives one a more complete understanding of the way in which the people involved were seen by the public through the media at the time—as rich, jaded, jetsetting hippies who would do most anything for a new thrill. The articles that were written before Susan Atkins' spilling-of-the-beans were particularly interesting for their wealth of misinformation, rumor, innuendo, speculation, and the fear that they helped spread throughout Hollywood's hip community like the plague.

In *Eye* magazine's Jan 69 issue (v2 #1) there is a two page feature called "Who I'd Like To Be In My Next Life," that has twelve luminaries in their respective fields give short quotes on exactly that.

The twelve included Sly Stone, Peter Townsend, Ravi Shankar, Andy Warhol, Arthur C. Clarke, Roy Lichtenstein, Jacqueline Susann and Sharon Tate among others. Tate's response to the query was as follows:

I'd like to be a fairy princess—a little golden doll with gossamer wings, in a voile dress, adorned with bright, shiny things. I see that as something totally pure and beautiful. Everything that's realistic has some sort of ugliness in it. Even a flower is ugly when it wilts, a bird when it seeks its prey, the ocean when it becomes violent. I'm very sensitive to ugly situations. I'm quick to read people, and I pick up if someone's reacting to me as just a sexy

blonde. At times like that, I freeze. I can be very alone at a party, on the set, or in general, if I'm not in harmony with things around me.

PLAYBOY

❑ *The Tate Gallery: Pictures by Polanski* was my first conscious encounter with Sharon Tate in print: for a twelve year old with a love of horror movies, this layout was quite a turn on.

The feature consists of six still photos taken by Polanski on the set of his film **The Vampire Killers**, later renamed **The Fearless Vampire Killers**. A red haired, sudsy Sharon Tate played the innkeeper's daughter. She is bathing in a tub when Count Krolock appears out of the shadows with fangs flashing. The text is brief and tells of Sharon's half-million dollar, four year grooming process by Martin Ransohoff, and her three upcoming films in 1967, **Don't Make Waves**, **Valley of the Dolls**, and **The Vampire Killers**, the latter being the best of the three.

The last photo in the layout is eerie in hindsight: Count Krolock (looking particularly contemplative) stands behind Ms Tate with one hand held in front of her as if to fend off the camera lens, while his other hand is held behind her head making the 'devil horns' gesture with forefinger and pinkie upraised, the standard salute at heavy metal concerts these days. This is one of the more blatant oddities I have found foreshadowing her fate; some of it is more subtle.

This issue of **PLAYBOY** also contains an interview with Orson Welles by Kenneth Tynan; occult-horror writer Ray Russell's story *Comet Wine*, which precedes the Tate-Polanski feature; the Bunnies of the "Show-Me" state of Missouri, and the usual highbrow articles, fiction, cartoons, and concerns of **PLAYBOY**.

THE SATURDAY EVENING POST

☐ Following the five page cover feature *Rush to Judgement in New Orleans*—on Jim Garrison's attempt to uncover a plot to kill JFK—is a six page feature on starlet Sharon Tate called *'Sexy Little Me'* by John Bowers. The cover blurb: "How an unknown beauty becomes a movie star."

This piece starts with the writer sitting in Sharon's apartment that she shared with Polanski, at 95 Eaton Mews West, London. Sharon puts on her eyelashes with a hand mirror as she complains about the sunlamp treatment cracking the skin on her face. Bowers describes the "transient look" of the place with stereos on boxes and empty walls, with the exception of a framed Academy Award nomination citation for Polanski's **Knife in the Water**.

Bowers makes an interesting observation about Tate: "As Sharon reached for a folder of still photographs from **The Vampire Killers** to show a male visitor, she stuck up her bottom in a way she has; as she went through the photos, she pooched out her bosom. But she did it by reflex." Sharon can be seen in that *exact* pose on the cover of the Jun 68 **CONFIDENTIAL** mentioned on page 372.

Despite her physical attributes, Tate was insecure when amongst Polanski's film crowd. According to Bowers:

> She wondered if tonight she would be thrown with people who would overwhelm her with their wit, their awesome knowledge, their self-confidence. When she was out in public with Roman, she never felt adequate enough to open her mouth. She could only talk to him alone. Her problem was that she had always been beautiful, and people were forever losing themselves in fantasy over her—electing her a beauty queen, imagining her as a wife, dreaming of a caress. Most people had fantasies. But a few people, like Polanski, took charge.

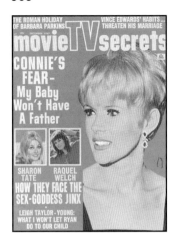

Above Connie Stevens as the main story, with Sharon Tate and Raquel Welch inset on the cover of MOVIE TV SECRETS Dec 67. **Opposite** Sharon Tate as the central, and sexiest, doll in the valley on the cover of LOOK Sep 5, 1967.

LOOK
Vol 31 No 18 Sep 5, 1967
Look Building, Des Moines, Iowa
50304 .50 94pp

MOVIE TV SECRETS
Vol 8 No 1 Dec 1967
Countrywide Publications, Inc.,
150 Fifth Ave., New York, NY
10011 .35 66pp

SCREEN STORIES
Vol 66 No 12 Dec 1967
Dell Publishing Co., Inc., 750 Third
Ave., New York, NY 10017 .35 84pp

The article proceeds to tell the tale of how Sharon Tate went from a six month old Miss Tiny Tot in Texas to being "discovered" aged twenty by Martin Ransohoff, resulting in her brief stardom. Ransohoff had a contract drawn up the instant he saw her, reportedly shouting, "Draw up a contract. Get her mother. Get my lawyer. This is the girl I want!" Tate, not long after, signed a seven year contract with Ransohoff.

Her agent, Harold Gefsky, said:

Everywhere I took her she caused a sensation. I would take her into a restaurant and the owner would pay for her meal. Photographers kept stopping her on the street. I've lived in Hollywood since the mid-Forties, but I've never seen anything like it before or since.

The article is filled with the minutiae of Tate's early acting career: mostly bit parts on TV sitcoms and commercials. Also well covered is the story of Ransohoff's playing cupid for Tate and Polanski, who didn't really hit it off at first.

Bowers writes about Polanski and Tate going to Alvaro's restaurant in London; Tate and Ransohoff at La Scala in Beverly Hills; Tate redoing a scene from **Don't Make Waves** at Malibu Beach; Tate visiting her parent's home; and finally, Tate out and about at a Beverly Hills disco called The Daisy where she spied fellow actresses Suzanne Pleshette, Patty Duke, Linda Ann Evans and Carolyn Jones gyrating on the dancefloor. Bowers writes as if he were there, which he undoubtedly was, but never mentions so.

LOOK

☐ *The Dames in the Valley of the Dolls* is Sharon Tate's first major magazine cover exposure and she certainly is the most central, slinkiest looking and sexy of the three **Valley of the Dolls** actresses pictured on this **LOOK** cover, photographed by Stanley Tretick.

The article starts with an intro piece that mentions the movie's origin, the mega-novel by Jacqueline Susann, and notes, "it has been callously abbreviated" to 'VD' by its critics.

It explains which real life stars the characters were loosely based on i.e. Anne Welles played by Barbara Parkins on Grace Kelly; Neely O'Hara played by Patty Duke on Judy Garland; and Jennifer North played by Sharon Tate on Marilyn Monroe. It devotes a page or two of color photos and text to each of the three actresses, starting with Sharon Tate.

Sharon Tate Plays Jennifer, Doomed Sexpot reads the title above a large picture of Tate standing in a short red dress, one foot resting on the edge of a bed. The photo's caption reads: "Sharon, whose father is a colonel in Army Intelligence, frolics here in the California beach house rented by her friend, the Polish director Roman Polanski."

The piece states that Tate "was just another Hollywood cupcake" when she was discovered by Ransohoff at an audition for the TV series **Petticoat Junction**. The writer gives a backhanded compliment when talking about the role she plays opposite Tony Curtis, saying "Sharon isn't crazy about [**Don't Make Waves**] (she's very good in it) because the character she plays is, of all things, a body queen with shredded wheat between her ears instead of brains."

After complaining about being "just a piece of merchandise" because of her sex symbol status, Tate ends by saying: "If you just take it down to bare facts, the reason for living is the reason you make it. I mean the brain was made to create. I'm trying to develop myself as a person. Well, like sometimes on weekends I don't wear makeup."

Patty Duke Plays Neely, Nice Kid Turned Lush refers to Duke as "yesterday's moppet,

today's sewer mouth" which she readily admits to. Having started acting at age seven, as an extra and doing commercials, Duke says: "I hated it…Yeah, I went to that professional children's school. All you do in that place is sit around for three years."

Duke said she tapped into her character's loneliness because that was what she identified with most, even though all the other actresses trying out for the part of Neely O'Hara played her as a "hard-nosed bitch."

The last of the three, *Barbara Parkins Plays Anne, Good Girl with Bad Breaks* includes two photos of the actress looking into a mirror: the writer points out that Parkins is in love with herself. Parkins seems like she would have been a willing candidate for a porn-star-gang-bang-queen with comments like: "I'd love to go live with a tribe of Indians sometime and find out what makes them tick," or, "Of course, when I heard I had two nude scenes in this movie, I was *terribly* excited. I couldn't wait! I would like all people to be attracted to me—especially men. Like Marilyn Monroe. Everyone loved her." Parkins was disturbed when Tate was cast as Jennifer North, the Monroe-like character with the sexier role that Parkins had originally wanted.

The three actresses may have cringed reading the piece if they had realized the dynamic at work in it. While Tate and Parkins appear vain and fairly idiotic, Patty Duke comes off as a foulmouthed tomboy from Brooklyn—a real "tough cookie."

MOVIE TV SECRETS

☐ The ubiquitous Myron Fass of Countrywide Publications published **MOVIE TV SECRETS**. Fass was the kingpin of sleazy illustrated horror magazines published by Eerie Publications, and myriad other pulp curiosities.

The magazine has a great Connie Stevens cover with the blurb "Connie's

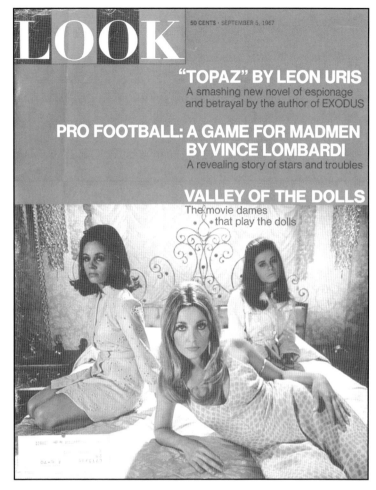

Fear—My Baby Won't Have A Father," with an inset below of Sharon Tate and Raquel Welch, a double-barreled knockout of sixties sex goddess beauty! An article by Ann Howard, *Raquel Welch/Sharon Tate—How they Face the Sex Goddess Jinx*, follows the two sexy actresses and their respective battles for credibility beyond the valley of sex goddess status.

The article starts out with a comparison of Jean Harlow, Marilyn Monroe and Jayne Mansfield (killed earlier that year in a car accident) with their two sixties counterparts. The "jinx" the article discusses is the two sixties starlets dying an untimely death like their three predecessors, another weird coincidence in hindsight, given Tate's

subsequent murder. Raquel Welch on the other hand, went on to win her battle with credibility in several movies and is still a knockout in her sixties.

SCREEN STORIES

☐ *Sharon Tate—Sex isn't Everything!* by Wallace Edwards opens with the text wrapping around a sexy photo of Sharon sitting on a stool wearing a psychedelic body stocking that shows off her curvy contours.

On the page opposite is an ad for "fine art prints" of "4 Irresistible Wide-eyed Puppies" from original oil paintings by "Gig," who specialized in big-eyed animals—usu-

Above **Again, Sharon Tate as the
central and sultry doll; the cover of
TV AND MOVIE PLAY Apr 68.**

TV AND MOVIE PLAY
Vol 2 No 6 Apr 1968
Stanley Publications, Inc., 261 Fifth
Ave., New York, NY 10016 .35 68pp

MAN
Vol 63 No 2, Apr 1968
Man Magazine Pty Ltd, 142 Clarence
St., Sydney, 2000, Australia (UK price)
4/9 104pp
Distributed in Great Britain by Atlas
Publishing and Distributing Co. Ltd,
334 Brixton Rd., London, SW9

MODERN SCREEN
Vol 62 No 5 May 1968
Dell Publishing Co., Inc., 750 Third
Ave., New York, NY 10017 .35 92pp

ally kittens and puppies—in less than ideal surroundings. The puppies in this ad are named "Bucky," "Potato Chip," Golden Boy" and "Snuffy," all of which have been painted in landscapes and situations designed to tug on your heartstrings. The "big-eyed" painting craze was started by Margaret Keane's paintings of big-eyed waifs and harlequins in San Francisco and caught on in department stores across the country.

The Tate article starts off with Martin Ransohoff's discovery of her on the set of the sitcom **Petticoat Junction**, which she had a bit part in. Ransohoff said that, "I have this dream where I'll discover a beautiful girl who's a nobody and turn her into a star everybody wants. I'll do it like L.B. Mayer used to do, only better." That was exactly what he did with Sharon Tate.

In the May 68 issue of **MODERN SCREEN** mentioned below, Tate was interviewed in the commissary at Twentieth Century Fox and here Edwards reports on her meeting with that interviewer. He gives a description of the effects Sharon unwittingly had on the surrounding males as she walked through the cafeteria to sit with the reporter:

Every male head within viewing range swiveled in her direction as if she were pulling invisible strings; forks stayed at half-mast long after she had passed the table; bus-boys in her wake suddenly developed a clattering case of butterfingers.

Edwards then describes her meeting with the interviewer, giving quotes from the exchange in which Tate talks about her attitude towards sex and nudity in films:

In **Valley of the Dolls** *I have a nude scene and I have no qualms about it at all. I don't see any difference between being stark naked or fully dressed—if it's part of the job and it's done with meaning and intention.*

I honestly don't understand the big fuss made over nudity and sex in films. It's silly. On TV, the children can watch people murdering each other, that is a very unnatural thing, but they can't watch two people in the very natural process of making love. Now, really, that doesn't make any sense, does it?

On hippies Tate says:

I love love-ins. They're fascinating…they're fun. I think the hippies are great; they just want to be left alone and they want everything to be nice and peaceful. That's my philosophy: live and let live. But I'm not just a hippy. I'm not just a anything.

The article ends with Tate commenting on how her relationship with Polanski had helped her "grow tremendously," saying: "I guess I kind of lived in a fairytale world… looking at everything through rose-colored glasses. I probably always will, to a certain extent."

TV AND MOVIE PLAY

☐ This issue of **TV AND MOVIE PLAY** contains three separate articles on the **Valley of the Dolls** actresses pictured on the cover, not unlike the **LOOK** mag above. The article *Sharon Tate: Why she Prefers Love without Marriage!*, by Joan Selig, ponders why Tate and Polanski wouldn't wed when they seemed to be so in love and inseparable.

The answer Selig has come up with is that Sharon wanted to become a sex goddess superstar! As evidence of this she mentions Sharon going out *sans* underwear, wearing nothing but a "clinging dress." The fact that Tate had recently appeared nude in the **PLAYBOY** spread is also mentioned.

Today, it might seem trite but at that time it was not common for two people to live

together without being married, especially in Hollywood circles where it would have been kept a secret for fear of a career damaging scandal. Tate and Polanski were open about their relationship and the press were fascinated by it, painting Tate as an "unconventional, uninhibited hippie living a free life with no restraints."

But a friend of Tate's said this about her: "Sharon is a one-man woman if there ever was one. She's the most faithful 'wife' in Hollywood but she's afraid it would ruin her sex goddess image if she got married."

At the end of the article Selig covers some weird territory by writing: "Will Sharon learn her lesson in time? That being a woman is more important than being a sex symbol. That the love of one man is more important than the adoration of millions of fans."

These types of articles may have had an effect on Tate who undoubtedly read some of them. In the end, she did give up her career to become a wife and mother. But contrary to Selig's statement— "…there are many years ahead for Sharon. Years in which she could be famous but lonely, or years which she could share with a loving husband and family," Sharon Tate's tragic fate was decided for her by someone other than herself.

MAN

☐ **MAN** offers an Australian slant on the world of the men's mag, containing the obligatory, for the time, article on the subject of hallucinogens: *A Portrait in Blood* tells of the anonymous author's own experience with LSD.

> She spoke again. "What's your name?"
> "Godfrey.'"
> "May I call you God for short."

More interesting is a piece on self-trepanation. *Greater Awareness…Or Just Plain Holes in the Head?* by Richard Jules, tells

the story of Bart Huges, a mild mannered thirty year old Dutchman, who recently "gave himself the 'third eye.'" A medical student, Huges performed the operation in his Amsterdam home. It took forty-five minutes and was achieved with the use of a local anesthetic and a dentist drill. The resultant hole—a third of an inch diameter by a sixth of an inch deep—landed Huges in a mental ward for a spell; doctors saw no scientific value in the operation and couldn't "leave at large somebody who subjects himself to such weird experiments." Unrepentant, Huges claimed that the hole in his head had cured his depression, was a good alternative to marijuana and LSD, and left him in a constant state of bliss. The story is accompanied by some alarming pictures.

Elsewhere in **MAN** is *tete-a-Tate*, a two page illustrated article on Sharon Tate by Michael South. Its byline is a rather glum one for the actress: "The Eliza Doolittle of a corporate Henry Higgins has hit the big time in a fairy-tale nightmare called Hollywood" it states, in relation to the movie **Don't Make Waves** (1967), and her starring role in it alongside Tony Curtis, having been kept "top secret for 30 months" by film producers Filmways.

The rest of the piece comprises a fluff interview with Tate, which concludes with South's observation:

> Surprisingly, she shows quite a talent for acting—not that this appears to be any great advantage to an actress these days. Still, it's comforting to know she has it to fall back on.
> [Review by David Kerekes]

MODERN SCREEN

☐ Mia Farrow and Barbara Parkins, both friends of Tate, grace the cover of this issue below the blurb "How the Men They Loved Have Hurt Them!"

The feature *Sharon Tate's Strange Ideas*

About Married Love, by Leslie Steele, starts with the "turned on wedding of the year"—the Polanski/Tate wedding at the registry office in London and reception at the Playboy Club. The two newlyweds then went to see The Supremes' opening night gig at the London nightclub, Talk of the Town. They then made their way to Paris for a "secret" honeymoon, and while there took in the premiere of **The Fearless Vampire Killers**.

Polanski is quoted as saying of his new bride, "I want a hippie, not a housewife!"

Steele had interviewed Sharon before her marriage to Polanski—over lunch at Twentieth Century Fox after completing **The Valley of the Dolls**. For the most part, the rest of the piece is quotes from Tate taken from that interview.

Tate's European outlook on life and her "strange ideas about married life" are reflected in her statements to Steele concerning her relationship with Polanski and his "European" attitudes when it came to seeing other women. Sharon explained:

> My dad was stationed in Europe for a number of years and I went to school there and grew up there…so naturally, I have the European attitude towards sex…and life in general…
> In Europe everything is so much more realistic. Absolutely! The whole freedom outlook over there is just fantastic. People aren't worried about what society is going to think—as long as the feelings are there…and the feelings are honest. Men in Europe cry and in airports they kiss their sons right on the lips. And it's a beautiful thing: this freedom of emotion makes them real men!
> Now, I've begun to think there's something wrong with a man who doesn't have the drive to want to go out and see another girl. Even after he's married—oh, yes! Any man who lets his wife tie him down or take him to task for following his natural instincts

From top **Mia Farrow and Barbara Parkins face off on the cover of MODERN SCREEN May 68; MAN Apr 68.** Opposite **To me, the cover of CONFIDENTIAL Jun 68 shows Sharon Tate in her sexiest pose with sixties hair.**

CONFIDENTIAL
Vol 16 No 6 Jun 1968
By-Line Publications, Inc., 315 Park Ave. South, New York, NY 10010 .35 76pp

VIP—THE PLAYBOY CLUB MAGAZINE #18
Summer 1968
Playboy Building, 919 N. Michigan Ave., Chicago, IL 60611 .35 40pp

is a very meek man. He wouldn't be the man for me.…Just because a man gets married doesn't mean he should stop operating like a man. I would want my husband to hold down the other front as well. It's the only honest way. No, I don't believe a woman can do the same things. Mentally, she isn't created to do the same things in that area, as the man…Roman has probably been the biggest influence in my life.

Steele has also written of her first impression upon meeting Tate, before the interview: "Up close, she has a decidedly European flavor, so much so that you expect a French or Swedish accent—not the carefully-rounded speech class tones, with just a tiny tinge of her native Texas."

Tate's affinity to the "European way of life" could have been nothing more than Polanski brainwashing her into regurgitating his one-sided swinging desires for their marriage. As Sharon's friends stated more than once, she did *not* like finding out about Polanski's many affairs behind her back, usually finding out from a friend or acquaintance not long after.

The European magazines loved her too: she made more covers in Europe than in her home country even before her death, but especially after her murder.

Of her future husband Tate says: "When I'm with Roman, I'm not concerned with, Is he going to marry me or not? I just enjoy being with him…I really think that if you live for today, tomorrow takes care of itself."

Steele ends the piece:

For Sharon Tate—whose ideas about love and marriage may well seem strange to many Americans—'tomorrow' had a good, old-fashioned Hollywood happy ending on Jan 20 at the Chelsea Registrar's office.

CONFIDENTIAL

❑ Originally **CONFIDENTIAL** was publisher Robert Harrison's baby and was selling millions of copies per issue in the mid fifties, thanks in part to Walter Winchell's on-camera hailing of it on his TV show and the column he ended up writing for it. Harrison sold the mag in 1958 after many lawsuits and much controversy, although he claimed the reason was that many stars were publishing their own tell-all biographies, taking the punch out of **CONFIDENTIAL**. Much of the celebrity gossip and scandal that had made it a bestseller was given to the mag by the stars themselves.

The cover of the 1968 issue of **CONFIDENTIAL** features a b&w shot of Sharon Tate in a most provocative pose, kneeling in tight sweater and pants, with big hair, arched back and rear end curvaceously stuck out—a pose mentioned by John Bowers in the **SATURDAY EVENING POST** on page 367. Although Tate appeared on the cover of the Sunday newspaper supplement **Parade** of Sep 18, 1966, most of her other cover appearances had been with her **Valley of the Dolls** co-stars Barbara Parkins and Patty Duke, or as a small cover inset. The exception was the Dec 66 cover of Jim Silke's mag **CINEMA** that also featured Tate.

Sharon Tate: Was she Forced to Marry her Lover? by Mary Ellen Teague opens with a full page photo of Sharon and Roman descending stairs after their wedding in London in Jan 68. Sharon was wearing what is described as a "mini-mini skirt," which the photographer was obviously trying to peek up.

Martin Ransohoff's dream of taking a beautiful 'nobody' and turning her into a 'somebody' came true in the form of Sharon Tate. Ransohoff did admit that once the starlet became a star, he lost interest.

While still single, Sharon Tate was quoted as saying: "If I ever do decide to get married, I guarantee I'll give up my career. It's almost impossible to have a happy mar-

riage and a successful career at the same time. You have to give so much to both."

The rest of the piece goes on to give the story of Sharon and Roman's going out on a date at the behest of Martin Ransohoff. At their first two dinner dates Polanski reportedly ignored Sharon for most of the dinner, and suddenly, on the walk home, passionately kissed her out of the blue, knocking them both to the ground. This was too much for Sharon, who told Ransohoff that she would not work with Polanski. She thought better of that, gave it one more try and the couple ended up in the dark at Polanski's flat, tripping on LSD (not mentioned in this article). Polanski scared her to tears by sneaking up on her with a Frankenstein mask covering his face. One thing led to another and they became an item.

At the end of the article the writer speculates as to why the two married—was it because they were living together and afraid of a scandal ruining Sharon's career? Or was it Sharon figuring it was her only shot at keeping Roman home at night? The last line reads: "Even the sexiest doll in the Valley may not be enough to keep Roman from roamin'."

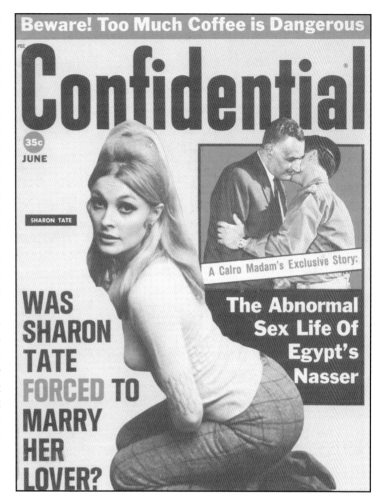

VIP—THE PLAYBOY CLUB MAGAZINE #18

☐ **VIP** was essentially a high-end newsletter, in magazine format, for those who belonged to and swung at the nineteen Playboy clubs listed in it. Typically, it contained news and events for each club and resort as well as articles with photos of notable celebrities, such as Wilt Chamberlin, Carl Yastrzemski, Bill Cosby and Stan Getz—surrounded by Bunnies at the various locations.

The golf themed cover of the issue was to announce the opening of championship golf courses at the Playboy Club-Hotel in Lake Geneva, Wisconsin.

VIP was used to introduce the *New Bunnies in Town* to prospective custom-

ers who could peruse the color photos of each new Bunny and find out which club she worked at.

Noted Newlyweds cut up at London Club is a single page announcing: "Sharon Tate and Roman Polanski celebrate wedding reception at 45 Park Lane", i.e. the Playboy club of London. The reception was attended by such stars as Anthony Newly, Laurence Harvey, Barbara Parkins, Michael Caine, Leslie Caron, Warren Beatty and Candice Bergen, to name but a few. One of the four photos that accompanies the item shows the Polanskis cutting their wedding cake, a wedding cake that, because of an "innocent goof" had the message "Happy Retirement, Hilda" written across it.

THE NATIONAL INSIDER

☐ In the regularly featured gossip column *Under Hollywood Skirts* by Rita Romaine, there is a small picture of Sharon in a bikini and a paragraph that reads as follows:

Don't believe that rumor about Sharon Tate eye-scratching and hair-pulling and bosom-beating with a young starlet at a Hollywood party when the girl started to feel up Sharon's escort—who wasn't her recent bridegroom, Roman Polanski. Ridiculous! What really happened was that the fellow was making a pass at 42-34-36 Sharon while Polanski was in another

Above **Bunnies and golf were the themes of Playboy's VIP mag dated Summer 68, with a page reporting on the Tate-Polanski wedding in London.** Opposite **Sharon Tate was used on the cover of NATIONAL BULLETIN Dec 23, 1968, but was not found inside.**

THE NATIONAL INSIDER
Vol 13 No 5 Jul 28, 1968

RAW FLIX
Vol 1 No 4 Summer 1968
Health Knowledge, Inc., 119 Fifth Ave.,
New York, NY 1.50 72pp

NATIONAL BULLETIN
Vol 7 No 29 Dec 23, 1968
Summit Publishing Co., 234 Fifth Ave.,
New York, NY .25 20pp

REAL
Aug 1969
Bee-Line Books, Inc., 386 Park Ave.
South, New York, NY .50 136pp

LIFE
Vol 67 No 9 Aug 29, 1969
Time, Inc., 540 N. Michigan Ave.,
Chicago, IL 60611 .40 64pp

room discussing business, and Sharon gave him a push and he landed right in the lap of his date. She was drunk and started making remarks right back and soon the two girls were really battling, naked bosoms and all…

RAW FLIX

☐ **RAW FLIX**—"Featuring sizzlin' scenes from the adult reelers"—was published by Health Knowledge: one of the myriad of sexploitation film slicks published in the late sixties. The issue contains scenes from such diverse films as **The Initiation**, **French Honeymoon**, **Tony Rome** with Frank Sinatra, **Planet of the Apes**, the French film **Little Girls**, **Once Upon a Knight**, **The Secret Society**, and **The Girls on F Street** with a young Kellie Everts.

The short three page feature on *Sharon Tate, Star of the Month,* starts:

Don't Make Waves isn't the first movie that lovely Sharon Tate has starred in, but it is perhaps the one that best shows the Tate-alizing curves of this talented blonde.
Her latest flick, a spoofy exploration into the lives and half lives of some of the Southern California beach fauna, also stars Tony Curtis and Claudia Cardinale.
The movie is based on the Ira Wallach novel, Muscle Beach, is produced by John Calley and Ransohoff and directed by Alexander Mackendrick. Robert Webber co-stars in the Metrocolor, Panavision epic from MGM.

The piece is mostly b&w pics of Sharon posing in revealing bikinis and clothing with a few stills from **Don't Make Waves**, and a smaller photo of Sharon poking the pecs of muscleman David Draper.

In another shot of Sharon—in a feature called *Selected Short (Pot) Shots* from the

Valley of the Dolls—she sits on a bed emptying a bottle of pills into her hand. The blurb reads: "Sharon Tate pours out a few bedtime pills to help her sleep in **Valley of the Dolls**. We have a much better suggestion for a doll as well 'valleyed' on top as she is!"

NATIONAL BULLETIN

☐ "Sex In The Movies—See Today's Nude Stars Perform Complete Act Uncensored!" screams the headline on this early Tate tabloid cover, as she stands sideways in a bikini and looks at the camera sucking her forefinger!

The corresponding centerspread article, called *Sex is Mounting in the Movies*, nestles amongst other journalistic gems as *I Was Held Captive by 20 Enemy Girls!*, *Bride Kidnapped & Raped*, *Stripper has Male Sex Organs*, *Raped by a Snake*, *Hubby Grinds Nympho Wife into Pizza!*, *Missionary Discovers New Jungle Sex Rites*, and *Badly Burned Boy Crawls 50 Miles*.

Although Tate is labeled on the cover, neither she nor any of her movies are mentioned in the article.

The same photo of Tate has been reversed and used on the cover of the **NATIONAL INFORMER**'s Oct 12, 1969 (v16 #16) issue with the headline: "'Tinseltown' Is Utopia For Killers—Hollywood Weirdos Freak Out At Murder Orgies!"

REAL

☐ **REAL** was a digest-sized, sold-at-the-checkout type women's magazine, and another strange blast from the past. Concerning Sharon Tate's subsequent murder, the issue in question contains more material on her which seems bizarre in hindsight. Being the Aug 1969 issue it could still have been on newsstands at the time of the murders or shortly before. The cover model is a Sybil Shepherd clone in a bikini standing waist

deep in the ocean, with a picture of a young Dustin Hoffman as one of *6 Men Who Turn Women On*.

The blurbs read: "Meet America's First Official Witch"—"'Should I Give My 16-Year-Old The Pill?'"—"California's Dying Days: What The Prophets Said"—"Your Child Is Probably Brain-Damaged."

Sharon Tate shows up twice in photos. One appears in *Women Men Admire: 7 Profiles*. The other women listed are Jean Shrimpton, Gloria Steinem, Suzanne Farrell, Marion Javits, Joan Baez and Barbara Jo Rubin. What is wrong with this picture? The text with the photo reads:

> She looks, walks, and talks a little like Marilyn Monroe…but there the comparison ends. Sharon Tate does not want to be treated like a slab of beef. As an actress, she is definitely her own woman. The turnabout is remarkable since Sharon was custom-made for stardom by careful producers. Then, at the apex of her rise, she turned her back on the whole ball-game, married highbrow filmmaker Roman Polanski, and now serves as a sort of Mother Superior for Hollywood's 'Thinky' set.

The other photo of Sharon, in this confusing issue, is at the beginning of another piece called *Women Who Turn Men On* that lists (1) Raquel Welch, (2) Sharon Tate, (3) Jean Shrimpton, each illustrated with a photo but no text. It continues with a page of text and photos each of Grace Kelly, Hope Cooke, Barbara Parkins, Faye Dunaway, and Diana Rigg.

LIFE

☐ This particular issue of **LIFE** seems an all too perfect time capsule of 1969, with Norman Mailer writing on the moon mission and a long feature on the Woodstock music festival. Also, *The Old Smut Peddler*, written

by Albert Goldman, is a profile on Barney Rosset, head honcho at Grove Press and major force in the hip sixties underground press.

The article of concern is *A Tragic Trip to the House on the Hill* by Thomas Thompson, illustrated with color photos of the still bloody Tate crime scene. In the feature, Thompson visits the Polanski/Tate house on Cielo Drive, with Polanski in tow, a week after the murders when the police had finished but the bloodstains were still intact.

Peter Hurkos—the famed psychic— tagged along to give the police any details from his psychic impressions. He is pictured

in a bizarre photo getting the vibes from the murder scene in the living room, squatting next to the couch with Tate's blood at his feet and the "jumble of oddities" on the floor. The pull-quote along the top of the page: "The sudden stillness of their swinging world."

Polanski wanders sadly dazed, room to room, through his lonely blood stained house, as he describes Sharon's preparations for the birth of their child, pointing out books, clothes and even the floating pool ring she had bought to support her swelling belly in the water. Polanski is asked "Why?" and answers: "Sharon…was…the supreme moment…of my life…I knew it

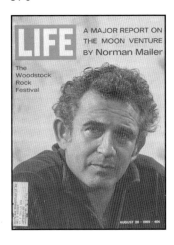

Above Quite an historic issue of LIFE from Aug 29, 1969, that covered Woodstock, the moon landing, and the murder of Sharon Tate. **Opposite** Early reportage of the Tate murders in THE NATIONAL TATTLER and THE NATIONAL INSIDER, both tabloids dated Sep 7.

THE NATIONAL TATTLER
Vol 11 No 10 Sep 7, 1969
Publishers' Promotion Agency, Inc.,
2717 N. Pulaski Road, Chicago, IL
60639 .15 24pp

THE NATIONAL INSIDER
Vol 15 No 10 Sep 7, 1969
The National Insider, Inc., 2713
N. Pulaski Road, Chicago, IL
60639 .15 24pp

would not…last."

The article then summarizes Polanski's childhood and early career, which is juxtaposed with Tate's: "While Roman was fleeing from the Nazis, Sharon was growing up first in Dallas—where her father, an Army officer, had been stationed in 1943—then a dozen places around the country."

The article describesPolanski moving through the Cielo Drive house, speculating about what went on the night of the murders, looking for clues overlooked by the police and finding reminders of his wife and their unborn child.

Coming to the bedroom that Frykowski and Folger had been using, Polanski says of Frykowski: "I should have thrown him out when he ran over Sharon's dog," referring to an incident several weeks previous. An interesting point of note is that in the article Frykowski is referred to as "Frokowski."

Polanski apparently learned from John Phillips of the Mamas and the Papas that Frykowski was "into a harder drug scene than just pot."

It is explained that Folger and Frykowski had been staying at his house that spring when both he and Sharon were in Europe, and when Sharon returned by herself they stayed to keep her company until Roman returned.

A friend of Polanski's is quoted:

Roman didn't know what the hell was going on at his house. All he knew was that one of his beloved Poles was staying there. Sharon probably knew, she had to, but she was too nice or dumb to throw him out. If any creeps and weirdos went up, it wasn't by Sharon's invitation.

After discovering an armoire filled with baby items and books on naming babies, teaching your baby to read, and having healthy children, Polanski eventually breaks down, weeping uncontrollably. He leaves the bloody house in a hurry, never to return.

THE NATIONAL TATTLER

☐ Less than a month after the slaughter in LA, the uncredited article *Sharon Tate Executed in Real Life Horror Plot! Bizarre Cult-isms Link 7-Plus-7 Slayings, Hollywood and Michigan* tried to link "elements of ritualistic murder" in the Tate murders with seven sex slayings of young women near two Michigan universities.

The article relates Polanski's hard childhood in Poland; his escape from the Nazis; the violent deaths of his parents; and examines his earlier, psychologically disturbing films where evil seemed to triumph over good.

The writer lists the similarities between the murders of the Michigan women, which in these forensically correct times would immediately point to a lust driven serial killer, not unlike Ted Bundy. But, the "ritualistic" aspects of the crimes got them thrown together with the slaughter in Hollywood.

The piece ends with this info: "Seven weird deaths in Hollywood—seven in Michigan…the mystical numeral of demonology."

THE NATIONAL INSIDER

☐ *Behind Sharon Tate's Weird Murder—Her Mate Provided the Death Pattern in his Films!* by Saunders Appleby is an article that starts on the last page of this tabloid and continues inside. It tries to tie in the subject matter of Polanski's films to the murder of his wife and friends. Or, as the cover asks: "Did Sharon's Mate Inspire Her Death?" It doesn't succeed with that premise though, as it briefly mentions **Knife in the Water**, **Repulsion**, **The Fearless Vampire Killers**, **Cul de Sac** and, of course, **Rosemary's Baby**:

Each film was based on a series of terrifying killings, many of them done in weirdly ritualistic fashion.

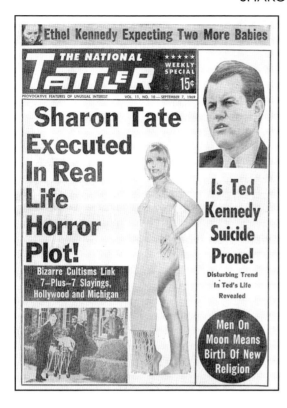

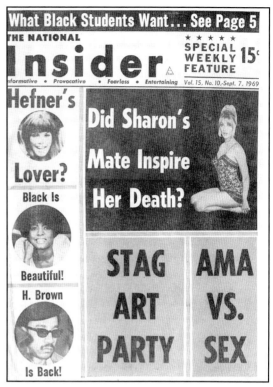

The similarity between the pattern of the killings in Polanski's dramatic presentations and the real-life murders of Polanski's pregnant bride and four other persons, three of them members of the so-called 'Rich Hippie' jet set, is all too vivid to ignore.

Although Polanski dealt in dark, psychologically disturbing films, the premise set forth in the piece doesn't work. Not to say there weren't uncanny connections to some of his films, particularly **Rosemary's Baby**, but these are not mentioned, some because they had yet to occur, such as John Lennon's murder in front of the Dakota apartments in NYC where the film was shot.

It mentions that Polanski was in London at the time of the murders and also the bizarre and disturbing foresight in a discussion of "sudden deaths" he had with an acquaintance. He apparently said: "Eeny meeny miney mo, who will be next to go?"

The phone rang at that moment with the news of the murders, and Polanski was devastated.

The article claims after the murder Polanski had two haunting thoughts to struggle with: that he would never be able to deal with such dark subject matter again in his films, and that his previous films didn't in any way inspire the killing of his wife and friends.

The piece ends with a sympathetic wish for Polanski, that he "finds within himself the strength to live with that burden and that terror."

The issue also contains Anton LaVey's column *Letters from the Devil*, in which he answered letters from enquiring minds on such topics as aphrodisiacs, incantations to get rid of evil spirits, and cannibalism:

Dear Dr. LaVey:
I have had a strange craving to taste human flesh. Are there any rites in your Church that involve cannibalism?
I am not joking, but very serious. Ed G., Plainfield, Wis.

Dear Ed:
No, there are no ceremonies in the Church of Satan that involve cannibalism, but another very well-known religion practices a form of it when they symbolically eat the body of their savior in the form of a wafer and drink some of his blood in the form of wine. I'm sure, Ed, that the 'long pig' of the South Seas provides a better feast with far less hypocrisy. Until you can find a suitable tribe, however, it looks like you'll have to make do with lamb chops.
All you sinners will find your confessions well received if you will write to me at The Church of Satan, Letters to the Devil Dept., 6114 California Street, San Francisco, Calif. 94121.

The National Insider

VOLUME 15, NO. 10 — SEPTEMBER 7, 1969

BEHIND SHARON TATE'S WEIRD MURDER

Her Mate Provided The Death Pattern In His Films!

NATIONAL EXAMINER
Vol 6 No 37 Nov 10, 1969
Beta Publications Ltd., 234 Fifth
Avenue
New York, NY 10001
and
1440 St. Catherine Street W., Montreal,
Canada .25 20pp

NATIONAL EXAMINER

❏ This is a quintessential example of what the sleaze tabloids come up with when that window of opportunity—between the crime and its solving—was opened. The tabloids used it back in 1969 and they still use it to this day with cases such as the Laci Peterson murder. Before the crime was solved or the perpetrators arrested or convicted, all sorts of speculation and false info from dubious sources rose to the surface like scum. It gave the tabloids grist for their mill and helped sell papers to those who were desperate enough for an immediate answer to some of the more disturbing aspects of human nature.

"Drug Pusher Who Was There Reveals…What Really Happened…The Night Sharon Tate Was Killed" is the cover blurb advertising the article inside, *Eyewitness to Sadistic Slaughter Tells Terrible Story of what Really Happened on that Night of Horror in the Sharon Tate Home.*

The article is uncredited because it was supposed to be a letter from a Hollywood drug pusher sent to the **NATIONAL EXAMINER**. It is prefaced by an editor's note that reads in part:

Though there have been suspects, there have been no convictions, as of the printing of this article.
It arrived in letter form at the offices of **NATIONAL EXAMINER** *and has been published intact with not one word changed.*
The sender of the letter refused to identify himself; but the facts he reveals make it clear that his claim to be an eyewitness of the mass murder could not be a lie—Ed.

The pusher tells the story that at about six o'clock that night he scored a kilo of pot, a couple ounces of hash and some coke. He then called Jay Sebring to ask if he'd be interested in anything; Sebring said he would and told him to come on over.

When he got to Sebring's house he found a note on the door telling him to go to Roman Polanski's house to deliver the goods. This made him nervous in that he said that the Polanskis were straight as far as he knew. He called Sebring at the Polanski's, who said it was okay and to come right over.

The dealer went to the house in Benedict

Canyon to be greeted at the door by Sebring. All the while he got increasingly paranoid from being around that house, and didn't want to go in. He entered anyway, against his "sixth sense" warnings.

When he entered, Sebring, Frykowski, Folger, and Tate were inside having a conversation. He handed over the dope to the two males who paid him, wanting to leave quickly, but Sebring told him to hang around for a little party and started rolling joints. After getting stoned the dealer's paranoia got worse. Sebring went out to stash the dope in his Porsche. When he returned, the pusher got up to leave because he was climbing the walls with fear at that point.

As Sebring was trying to convince him to stay, they heard a car pull up and then "the lights go down." The dealer took the opportunity to duck into the next room to escape through a window. The front door opened "and this cat comes in looking mean all over. I know him. Not personally. Just I've seen his face around, and he's seen mine."

The intruder's name was "Bugsy" as far as the hidden dealer knew:

The word running around about this guy is that he once burned Sebring and Frokowski [sic] on a coke deal, and they humiliated him sexually in front of a lot of people, after beating him and tying him down.

Bugsy yelled at Sebring—who didn't look happy to see him—and pushed Sharon into a chair when she tried to leave; the dealer realized that Bugsy was "flying on speed and maybe a little acid." Bugsy was screaming that Sebring and Frykowski had raped him, and was not leaving until he did the same to them. As Frykowski tried to laugh it off Bugsy pulled a gun on him and told him to strip; Sharon complained and was told to strip at gunpoint. Folger tripped into the room, saw the gun being held on Sebring and bolted out the door with Bugsy in hot pursuit: she was shot

on the front lawn.

Sebring attacked Bugsy from behind and ended up getting a knife in his gut for his efforts. Sebring and Sharon were both stabbed to death as Frykowski tried to make a break for it, and got bagged by Bugsy.

When the killing was over, Bugsy wandered around drooling and mumbling to himself until he broke into maniacal laughter. Then came the "strange things" Bugsy did to the corpses, such as carving Xs on Tate's belly and stabbing Sebring in the genitals a few times.

As Bugsy readied to leave, another car

pulled up and its driver greeted by a bullet in the head, courtesy of Bugsy.

The observant dope dealer concluded:

Well, that was that, except for a few more weird stunts like putting Sebring's head in a black hood, and tying ropes around both their necks—it wasn't nice to watch, the way he played with their corpses and their blood like a kid in a mud puddle.
I'm sure the narco boys must know who this guy Bugsy is.
I hope they get him and put him away,

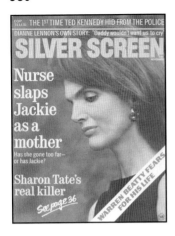

Above and Opposite Cover from
SILVER SCREEN Nov 69, and splash
pages from that same issue.

MOTION PICTURE
Vol 57 No 706 Nov 1969
Macfadden-Bartell Corporation,
205 East 42nd St., New York, NY
10017 .50 92pp

SILVER SCREEN
Vol 39 No 11 Nov 1969
Macfadden-Bartell Corporation,
205 East 42nd St., New York, NY
10017 .50 68pp

*because he's nuts. He's so crazy that I
wouldn't be surprised if it just happens
again and again.*

SILVER SCREEN

☐ *The Other Side of Sharon's Story…Ro-
man Polanski Talks About the Woman He
Loved* is an article at the beginning of the
mag that quotes from Polanski's press
conference at the San Souci Room in the
Beverly Wilshire Hotel in Hollywood. There,
Polanski attempted to put the kibosh on all
the rumors of his wife's drug taking and
partying. He claimed they had numerous
parties where pot was smoked, but that
Sharon didn't take drugs or alcohol, nor
did she smoke cigarettes. Actually, she did
smoke cigarettes on occasion, but hid the
habit from Polanski.

After Polanski admitted that Sharon
was the only person who ever loved him,
he said:

> *[Sharon's] name has been spread
> all over the papers—mostly foreign
> papers—because I must say that
> the local press has seemed more
> understandable…more understand-
> ing…forgive me my English.*

The same could be said of the foreign
magazines that plastered Tate's photo on
their covers in the last weeks of August
1969.

After praising the police for showing
him "the most heart and understanding,"
Polanski left the room and the press in
"dead silence."

The last line of the piece reads: "For the
full story and a different point of view turn to
page 36." On page thirty-six you find *Sharon
Tates Real Killer!* by Chrys Hyranis. It is filled
with photos, many of a scantily clad Sharon,
seemingly from the same set of pics used in
HORROR FANTASY (see page 123).

Hyranis writes the piece with his typical

sensational verbiage:

> *They say it was a Hollywood love
> cult, reveling in weird sex rituals, that
> caused the grisly death of Sharon Tate
> and her four friends.*
> *They say it was the Hollywood thrill-
> seekers—the pot-smokers, the drug-
> takers, the dabblers in witchcraft—who
> were responsible.*
> *And some will tell you that it was just
> Hollywood—with its strange combina-
> tions of unknown hangers-on and super
> stars, envious screwballs and genuine
> geniuses—that killed Sharon Tate.*

One point of interest in the article is
the mention of the police looking into the
possibility—a "far-fetched notion even to po-
lice"—of the involvement of a Black Panther
hit squad in the massacre. This, of course,
was one of Manson's many motives, but it
didn't pan out for him.

> *Investigation of the way-out Panther
> hired-killer theory, however, produced
> almost no positive leads and authori-
> ties were inclined to rule out any
> connection between the Panthers and
> the ghastly murders.*

Tate's close friendship with Mia Farrow,
star of Polanski's Satanic extravaganza
Rosemary's Baby, was also cause for
investigation using the cult angle, which
Polanski firmly denied both his or his wife's
involvement in. Polanski didn't subscribe
to the cult-ritual murder theory either: he
thought it was the work of a "maniacal mur-
derer who just happened on the scene." Of
Mia and Sharon's relationship we are told:

> *Mia has demonstrated a bent for
> mysticism, and she and Sharon
> would reportedly meet frequently for
> meditation sessions, sitting at a table,
> séance-style, to contemplate on Hindu
> philosophy.*

It is alleged that Abigail Folger also joined them and

They would often sit in Mia's digs overlooking Malibu Beach, it was reported, all of them dressed in hippie attire and chatting enthusiastically about 'the cosmos' and 'universal love,' in a room heavy with the fragrance of burning incense.

In Hyranis' final analysis, Hollywood was the killer—"the town that makes them prey to the envy of every stranger, vulnerable to the fantasies and hatred of every undetected psychotic."

The Tate murder coverage continues with *Why Warren Beatty Fears for his Life!*, in which the actor "talks about the threats he's received" with Christopher Wright, following the Tate and Sebring funerals.

Beatty was living in a penthouse suite in the Beverly Wilshire Hotel and says of his home and country:

It's the only place I feel I need protection.
There is such a climate of violence in America lately that I frankly feel a little scared. I can handle myself if I know from where it's coming, but it's that uncertainty that's scary.

Beatty had recently starred in **Bonnie & Clyde** (1967), originally unrated because of its graphic violence. He continues:

Look at Jay Sebring, one of my best friends and my barber, who was killed with Sharon Tate. Jay held a black belt in karate. I've seen him, small as he was, put his hand through a stack of two-by-fours.
He never would have been killed if he had known from where his attacker was striking. I am sure he was completely surprised. It's the only way he could have been taken.

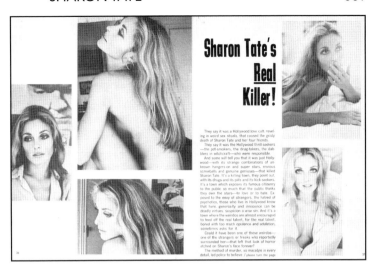

Sharon Tate's Real Killer!

Sebring wasn't the only one who had martial arts training. Sharon had taken some instruction from Bruce Lee, appearing in **BLACK BELT** magazine with him.

We can only guess as to whether or not Beatty was sporting a Sebring hairdo in the opening photo of him in a suit and tie, shades and a beard.

The lion's share of the article deals with all the other Hollywood stars who had a bad case of the heebie-geebies that affected their need for security. The stars said to have beefed up their security were Marlo Thomas, Milton Berle, Frank Sinatra, Dean Martin, Elizabeth Taylor, and Debbie Reynolds.

MOTION PICTURE

☐ The cover photo on this issue of **MOTION PICTURE** is truly bizarre as it shows two of the Lennon Sisters sitting graveside at their father's burial with the corner of his coffin seen on the left. The people standing in the background are all looking directly at the cameraman taking the picture, who could almost be accused of trying to get a shot up the sister's skirts. The blurb: "Daddy Will Live Through Us…"

The top banner blurb on the cover

announces: "Hollywood Party Girl Reveals 'I Was At the Sharon Tate Cult Parties' Sex—Drugs—Whips—Whiskey." The story is a lurid account of the unnamed writer's friendship with Jay Sebring—whom she had known for several years—and a strange night she spent with the junkie-turned-men's-celebrity-hair-salon-owner only one month before his murder.

As Sebring fondled an ampoule of amyl nitrate, he tried to sell the female writer of the article on its pleasures:

It accelerates your heartbeat. Opens you up so the blood roars. For a few seconds you are on the precipice, a step away from death. If you dig Amies, you'll really dig dying. That's the next stop.
I've been on the edge so many times. One day I think I'll go over—the whole trip. Maybe soon. I don't think I'll really mind.

That conversation took place at the Factory:

…the ultra-elegant former machine shop that currently serves as Hollywood's escape hatch for the jades who sleep on satin and drive to their

From top **Graveside photo of the Lennon Sisters at their father's funeral on the cover of MOTION PICTURE Nov 69; SCREEN STORIES** that same month.

SCREEN STORIES
Vol 68 No 11 Nov 1969
Dell Publishing Co., Inc., 750 Third Ave., New York, NY 10017 .40 76pp

RONA BARRETT'S HOLLYWOOD
Vol 1 No 1 Nov 1969
Laufer Publishing Co., 2nd and Dickey Streets, Sparta, IL 62286 .50 84pp

restless occupations on kid leather in their Porsches and Rolls-Royces.

The "party girl" writer claims Sebring would have loved the publicity surrounding the murders as his "greatest social deficiency" was that he was a namedropper.

It's no wonder that the police focused on Sebring as a drug dealer/user, as this article claims he had been a heroin addict for many years, and tried cures in various cities before settling in Hollywood and got off the habit by trading it in for haircutting.

After Sebring and the writer left the Factory, he invited her back to his Moorish-style Benedict Canyon home. There, the two snorted coke, smoked joints and drank an "exotic and obviously rare liqueur" in front of Sebring's gas fueled fireplace.

More coke, weed and liqueur follow, and Sebring introduces his writer friend to the head-spinning amyl nitrate. A lengthy description of the "intoxicating, churning, vacillating, mind-blowing high" of the amyl nitrate leads to Sebring disclosing some of his dark desires to her:

I wasn't shocked when he painted pictures of girls bound and straining against their bonds as he caressed their half-nude bodies. I was fascinated with the picture and asked to hear more and wanted him to tell me why he dug it. But he couldn't tell me. He could only suggest that I try it and see for myself.

Standing up, she let Sebring undress her. After admiring her scantily clad form Sebring left the room to return with a "vest of gold chains" which he adorned her with, then added a belt of gold chains, making her look like a belly dancer or harem denizen.

Sebring showed his own colors, leaving and returning once again, this time dressed in

...a black silk Japanese robe that

stopped where his thighs started. A wide black leather belt accentuated his ridiculously small waist; high heeled black leather boots hugged his calves and stopped at his knees, standing away from his thin legs.

Then, after correctly guessing the brand of perfume his guest was wearing, Sebring left once more to appear again carrying a "hand-carved mirrored tray edged in gold," covered with different bottles of perfume which he uncapped to captivate his female friend with a "potpourri of scents."

Disappearing again he returned with some rope and asked if he might tie her up while rubbing her down with the oils and perfumes, to which she consented.

As Sebring tied her wrists to two beams on either side of the fireplace, his willing partner explained to him that she wasn't into pain; Sebring replied "I understand."

Sebring had to untie her when she complained that the heat from the fire and the smell of the perfume was overwhelming her. Sebring asked her if perhaps she would do it again after he turned the fire down and she had rested, to which she agreed again.

Tying her up a second time, both her wrists and ankles that time, so as to spread-eagle her, Sebring didn't seem to be able to sit still as he was constantly disappearing and reemerging with another "toy" to use on her, such as a small gold bell that he attached to her waist to hear ringing when he left the room. Then he came out in a black satin hood, carrying a whip.

As the captive female writer protested the whip, Sebring assured her that he wouldn't hurt her, but his voice had changed: "It was hoarse, deep, and his breath came fast from behind the satin folds of the hood."

Sebring whipped her harder in spite of her protests until he finally broke down and cried: "Don't...don't...oh, God, don't!" He tore off the hood and untied the frightened woman, and she noticed: "There on the floor, gleaming dully in the dim light was a long,

curved butcher knife!"

After that shocking sight, she grabbed her clothes and "fled out of that dark house."

She saw Sebring a few times after that and talked with him on the phone, but refused all his offers to visit the house again. Even when he claimed she cheated him and owed him "a couple of hours."

She next saw Sebring in person at a wild swinging party attended by some of Hollywood's biggest stars. When she arrived at the party she was sucked into its vortex, passed around to meet one acquaintance after another: luminaries such as Tommy Smothers of the Smothers Brothers comedy team, Richard Dawson of **Hogan's Heroes** and **The Family Feud**, and Dean Martin, who was surrounded by "would-be" starlets.

After bumping into Sebring a few times during the night, they found themselves alone as Sebring tried to get her to stick around for the real fun, telling her she should meet Sharon Tate. The writer didn't want that sort of fun and again refused his offers.

Lastly, she claims Sebring called her early in August and asked her, "Remember what I spoke to you about the last time I saw you?"

"What?" she asked.

"Sharon. She's got a great pad. Lonely. Safe. Great people. Only small groups and nobody talks. Won't you come? Please? I promised you would," Sebring pled.

The writer said of her response to Sebring's queries:

I hesitated. It was the small boy asking for the sweet again. I looked toward my kitchen. My maid was cleaning up the dishes. She held a butcher knife high in the air and shook water from it and the lights flashed brilliantly along the curved blade. I shivered in fear, remembering the knife near the ropes at his house. I hung up the phone without even saying good-bye.

SCREEN STORIES

❑ *Behind the Bizarre Murder of Pregnant Sharon Tate—Why her Husband will Never Forgive Himself!* by Felicia Linnay, starts with Sharon Tate's funeral on Aug 13, 1969, attended by the likes of Yul Brynner, Warren Beatty, Steve McQueen and Peggy Lipton, among others.

Of Tate's funeral, Linnay says: "There were the curious, too. And the sick. One movie star told friends, 'The people there were the greatest bunch of freaks I've ever seen.'"

It also mentions the police being there to keep an eye out for potential suspects in the still unsolved murders amongst the crowd.

The piece contains three photos, one of Polanski and Tate on the beach together, another of Polanski standing between Sharon's parents leaving the funeral service, and the last of Polanski and Mia Farrow on the set of **Rosemary's Baby**.

After the account of Tate's funeral, the piece delves into Polanski's film career and his penchant for dark, offbeat and violent subject matter. It mentions Polanski's pooh-poohing of the accusation that violence on the screen was partly responsible for the violence in the streets. Of his attitude towards it:

'The bloodier the better' was [Polanski's] motto in regard to film making. But his blood was ketchup or raspberry jelly. The blood in which the word 'Pigs' was scrawled across his front door, however, was the real thing. And it just might have been the blood of the woman he loved more than anything in life—or the blood of his baby due to be born in just a few short weeks.

Then, starting with Winifred Chapman's discovery of the bodies the morning after, the piece relates the events that took place in the wake of the murders and police efforts to solve the crime. To its credit, this article refutes the rumors of mutilation of the victim's

bodies, apparently "emphatically denied by the police."

The highlights of Tate's career, meeting Polanski, their courtship, wedding, and fame from **Rosemary's Baby** are all included. It also discusses the emotional torment and guilt Polanski had to wrestle with:

Why didn't he insist that Sharon remain in London with him until he completed his work? Why wasn't he more choosy in selecting the people with whom he had surrounded himself and his wife? Were his pictures in any way responsible—if not for his wife and baby's murder—for the indiscriminate and violent murders that are frighteningly commonplace in the world today?

The last paragraph sums it up:

For with an ironic twist no scriptwriter could ever imagine, murder and horror have come home to haunt him—possibly for the rest of his life—and he will never be the same man again.

An editor's note is tacked on the end of the article:

As we go to press an international search for four men involved in drug traffic is going on in Canada. One of these men was reportedly a guest at Sharon's party. By the time you read this the murderer may have been apprehended, but no matter how the case is resolved by the police, the effect on Roman Polanski's life will remain the same.

RONA BARRETT'S HOLLYWOOD

❑ "Sharon Tate Speaks From Beyond the Grave! Eerie Séance! Weird Occult Rites!

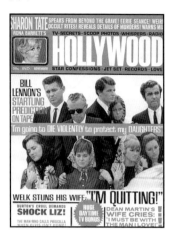

From top **The premiere issue of Rona Barrett's HOLLYWOOD, dated Nov 69. It features an interview with Sharon Tate from beyond the grave via a medium.**

MODERN SCREEN
Vol 63 No 10 Nov 1969
Dell Publishing Co., Inc., 750 Third Ave., New York, NY 10017 .50 92pp

CONFIDENTIAL
Vol 17 No 11 Nov 1969
Newsline Publications, Inc., 8060 Melrose Ave., Los Angeles, CA 90046 .50 84pp

Reveals Details of Murders! Warns Mia" reads the top banner blurb on the cover of the premiere issue of **RONA BARRETT'S HOLLYWOOD**.

The mag starts with a "Sizzling 10 Page Bonus" called …*Rona Barrett's Hollywood*, written by Rona herself. It starts:

BLOOD AND TEARS…THE TRUTH ABOUT SHARON TATE…As we go to press, Hollywood is still shaking in their beds over the brutal slaying of actress SHARON TATE, hair stylist JAY SEBRING, coffee heiress ABIGAIL FOLGER, and two other victims at the Roman Polanski estate.

A paragraph discusses the other murder story of the time: Bill Lennon, father of the Lennon Sisters. Returning to the Tate murder, it is claimed that **RONA BARRETT'S HOLLYWOOD** had "one of the first reporters on the death scene."

She writes of Sharon's rise to stardom through the likes of Richard Beymer, her former boyfriend; Hal Gefsky, Beymer's agent; Phillippe Forquet, another boyfriend; and Marty Ranshohoff, who, after eyeing Sharon, would not let her or Gefsky leave his office until they signed a long term contract for $200,000. After the fling with Forquet, Sharon met Jay Sebring at the Whiskey-A-Go-Go and Ms Barrett points out the irony of the two being tied together, literally and figuratively, in death. The piece briefly examines the rest of Sharon's career and the change in her personality after hooking up with Polanski: "She was still beautiful, still warm, still kind, but somehow she had become *different*." It ends on this note:

We wish to say no more. The house on Cielo Drive, originally built in the 1940s by Michelle Morgan, will never be erased from our memory. Nor will it probably be erased from the memories of former occupants, such as Henry Fonda, Terry Melcher, Candice Bergen,

and others. Many Hollywood stars had rented the Cielo Drive Estate. Fortunately, they lived under luckier stars than Sharon Tate, Jay Sebring, Abigail Folger, Steven Parent and Voytchek Frokowski [sic].

After that, Barrett's column reverts to the usual name-dropping Hollywood gossip everybody was familiar with.

The title of the article emulates the cover blurb: "*EXCLUSIVE Eerie Séance—Weird Occult Rites—Sharon Tate Speaks from Beyond the Grave—Her Warning to Mia: 'Your life is in danger, too.'*" The article has no byline, and is based on a "conversation" with Sharon Tate's spirit at a séance with a medium named Zorina Andretz, which the writer had attended with two friends. The writer of the piece was the one who apparently "spoke" to Sharon Tate from beyond the grave.

As the séance began the group meditated on pictures of the victims from Cielo Drive, and it took half an hour before the writer got dizzy and went into a trance: "Everyone else in the room ceased to exist as far as I was concerned and I was aware of nothingness." The writer heard a voice, presumably Sharon's, and went on to question the spirit about what had happened that night concerning hard drugs, Jay Sebring, a Black Mass, the "hoods" that Tate and Sebring were found wearing, Sharon's expected child, and so on.

The story went something like this: Sebring brought along hard drugs that night to enable them to "open other worlds" despite Polanski's protestation. Sebring was jealous of Sharon carrying Polanski's child and showed her a "new world" through the use of drugs and the occult. Tate's spirit went on to explain they were having a Black Mass that night and that Sebring brought the black hoods found around their heads, the white cord connecting Tate and Sebring. It was the way they "made contact." According to the spirit, Sebring and Folger made love in

front of Sharon, to get her excited as she watched, but unable to join in because of her baby. There is mention of a book Sebring had, filled with names of "special friends" that society called strange "but we thought they were groovy."

The slaughter began as Sharon was clubbed on the back of her head and things went black. She only came to briefly to see a man in a "uniform" and someone "who looked familiar" with him, while someone else swung a knife around. After her death, she looked down as if "standing on a platform" at the murder scene, seeing her own body lying bloody amongst the dead. She then related, "I think they were trying to carve my heart out. And they kept flicking blood off their fingers. I don't know what stopped them. They seemed disappointed that I had ceased struggling." The séance ended with a warning to Mia Farrow from her friend from beyond the grave:

Tell them. Warn them. Mia. Especially Mia. She's in danger. She's searching, but she's heading the same way, and her search will end the same way if she doesn't stop. We spent a lot of time together. I know how she thinks.

The article ends with an editor's note:

It is important that the reader keep in mind that this story is not based on material gathered from newspaper or police files. It is a taping of an actual séance and is a 'Conversation' between Sharon Tate and the author who was present at this eerie gathering.

Starting in the Jan 70 (v1 #3) issue of **RONA BARRETT'S HOLLYWOOD,** is a three part series—*The Sharon Tate Case*—on the murders and victims that concluded in the Mar 70 (v1 #5) issue mentioned below.

MODERN SCREEN

☐ **MODERN SCREEN** had a regular gossip column at the front of each issue by Dorothy Manners. The first item in this issue's column is *Pray for Sharon's Baby*, with eight photos from her funeral with shots of Polanski, Yul Brenner, Peggy Lipton, Peter Sellers, Steve McQueen, Warren Beatty and members of the Tate family. The last two lines read:

How ironic that the advertising on Polanski's **Rosemary's Baby**—*the slogan 'Pray For Rosemary's Baby'—seems these days. Pray for Sharon's baby, a little boy who never lived to know how desperately his beautiful mother wanted him.*

The article *Sharon Tate's Horrible Death* by Ruth Waterbury asks the question: "What went on at the 'swinging' party that led to mass-murder! Will the killings stop now?"

The answer to what went on, apparently, is drug taking. The article dwells on the drug angle in the murders as evidenced by this sensational sentence:

Then there has been the slimy underbelly of Hollywood, its dazed-eyed small coterie of film people who crawl at night into those shrubbery-hidden homes in the hills and smoke pot, have their 'fixes,' dream their crazy, mad dreams induced by hallucinatory drugs.

Waterbury briefly explains what the murder victims were doing with their lives just prior to their deaths and speculates on the possibly drug-addled state of the killer. Explaining how a rope had been looped around Sebring's neck, over a beam in the ceiling and around Tate's neck, but not tight enough to hang either, Waterbury writes: "That was really the first clue that alerted the detectives to the fact that the killer was very likely an 'acid head.'"

After writing of caretaker William Garretson's arrest and release and his guest that night, Steven Parent (shot to death while leaving), Waterbury moves on to relate the fear that enveloped Hollywood immediately after.

At the article's end, Waterbury wraps up with some rhetorical questions:

So—those infamous Hollywood parties have calmed down somewhat. Not many of the 'swingers' seem to feel like swinging lately. And they're wondering. Was it the 'drug scene' that led to the murders? If it was, are the joys of those drugs sufficient to make possible murder worthwhile?

CONFIDENTIAL

☐ Newsline Publications shared their address with several other related publishing companies, notably Knight Publishing (**ADAM**), Sirkay Publishing (**KNIGHT**), and the paperback publisher Holloway House that would later publish the paperback original **5 to Die**, on the Manson Family, in 1970. Newsline Publications had taken over the title **CONFIDENTIAL** from By-Line Publications in New York sometime in late 1968. In other words, this incarnation of **CONFIDENTIAL** was several publishers removed from Robert Harrison's original brainchild of the fifties.

The blurbs on the cover are a sign of their times—"Sharon Tate Murders—Predicted by Satanists, Cultists, Astrologers & Mystics," "Nancy Sinatra Got Her Boobs Blown Up," "Black Student Union Breeds Hate On Campus," and "A Monkee Made Me Pregnant."

The mag starts off with a column called *From the Desk of Tracy Cabot*, in which editor Cabot contemplates one of the most violent summers in Hollywood's history, and the Tate murders specifically. She states that the whispers in Hollywood likened the

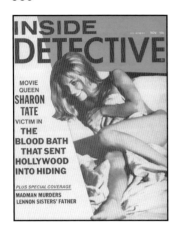

Top **Classic cover of INSIDE
DETECTIVE Nov 69 featuring the
recently murdered Sharon Tate.**
Opposite **CONFIDENTIAL Nov 69
with Polanski and Tate on the cover
and more mystical and astrological
interpretations of Tate's murder.**

INSIDE DETECTIVE
Vol 47 No 11 Nov 1969
Detective Publications, Inc., 750 Third
Ave., New York, NY 10017 .50 84pp

murders to the unsolved murder of Karen Kupcinet in Chicago. Pointing out Sharon Tate's belief in astrology, Cabot discusses the malevolent "highly violent" astrological configuration between Mars, Venus and Saturn at the time of the murders. Cabot also mentions Peter Hurkos' feeling of evil when in the Tate/Polanski residence a week after the murders and ends by saying that Hollywood has "come a long way since Errol Flynn's two-way mirrors."

The article *Sharon Tate Murders*, also written by Cabot, starts with an "Editor's Note" in which she explains that the murders may have been solved by the time the magazine hit the stands, which they weren't. Cabot then mentions that **CONFIDENTIAL** had gone into the world of Hollywood dope deals, depravity and devil worship to bring the reader the inside scoop on what the witches and astrologers "in-the-know" were saying about the murders, and what they had predicted before they occurred. The opening spread uses a large headshot of Tate wearing a fashionable scarf around her head in imitation of a hippie headband.

The article starts by giving a brief description of the five Tate murder victims as well as groundskeeper William Garretson, who was found alive in the guest house and detained by the police until cleared of having any connection to the murders.

An unidentified friend of Sharon's—who had been her neighbor when Tate lived on Summitridge Drive—unleashes some bizarre gossip about the fad of rich Hollywood hipsters using chastity belts on their mates, both male and female, as well as handcuffs, and points out that both items required keys kept by one's mate. The friend relates the antics at a party she had attended at which Tate and Polanski were present: party goers filed through an upstairs bedroom where the host was tied naked to a bed, taking turns to tickle and torment him.

The locals interviewed for the piece are: Louise Huebner, the official witch of Los Angeles county; Maria Graciate, astrologer

and mystic; Helen Owen, from the Temple of the Tarot and the Caballah; Anton LaVey, of the Church of Satan; and Jim Slaten, an astrologer.

Louise Huebner claims that Tate and Sebring had at one time engaged in erotic strangulation games during intercourse that ended in orgasm only seconds before death.

Maria Graciate says Sharon's astrological chart was "one of the bad charts of Aquarius" and felt that the murders were premeditated. Graciate also claims Sharon told her about receiving phone calls telling her the baby would not live, which Graciate speculates was revenge for **Rosemary's Baby**, and that the murder of Rosemary LaBianca was another clue supporting that theory.

Helen Owen observes that many unbalanced personalities were attracted to the occult and drugs, leaving them open to attack by adverse psychic entities.

Anton LaVey praises Polanski as a genius, claiming he was spared the slaughter in LA because he had given the Devil his due, i.e. he wasn't a hypocrite. The murdered had all "played the devil's game but didn't use the devil's name" says LaVey. He claims: "They were the objects of a lust murder. The penetration knife wounds duplicate the sex act."

Astrologer Jim Slaten makes the most absurd claim, saying that Tate was thrown out of a "devil worship, black magic cult" because she was involved in animal sacrifice which the cult felt would attract unwanted attention.

Many of the quotes, gossip, and claims made by the above personalities surface again and again in the lurid tabloid reports on the murders, usually uncredited. This article seems to be the original source.

The mag also contains a full page ad for the Universe Book Club which I, like many others, joined at the time and received my first books on magic, witchcraft, Tarot cards, ESP, astrology, etc.

INSIDE DETECTIVE

☐ This issue of **INSIDE DETECTIVE** is a real collectible as Sharon Tate's smiling nude form, wrapped in bed sheets, occupies the cover nicely, and the article of concern, *Sex Queen Sharon Tate Victim in the Blood Bath that Sent Hollywood into Hiding* by John Montgomery, starts with a two page montage of photos of the beautiful starlet. The rest of the long article is heavily illustrated: the Polanski house with bodies coming out on stretchers, the victims while alive, Sebring's haircutting salon, and so on. One photo taken at the scene has the caption: "Coroner Thomas Noguchi supervised removal of 'rich hippie's' corpse."

Montgomery is a good writer, exceptional even, as far as most of the movie and scandal mags go, blending accurate information into the mix of facts and speculation.

The piece starts with the discovery of the bodies by Winifred Chapman, the Polanski's maid, at the Cielo Drive estate at 8:30 on the morning of August 9 and continues with a description of the crime scene as Ms Chapman and the police found it. It details the discovery and booking of William Garretson, caretaker and sole survivor of the massacre, who later brought a $1.25 million false arrest suit against the LAPD.

The events are recounted as they unfolded: from the identification of the bodies to Polanski's notification, his flight to Los Angeles, and press conference not long after his arrival.

In describing the wounds of the victims, Montgomery states that an "informed source" claimed the bodies of Tate and Sebring were mutilated, although the police denied it. The police noted the "cool precise planning" needed to cut the phone wires, in juxtaposition to the chaos of the murder scene.

The cutting of the phone wires indicated premeditation, and showed that the person had to climb eighteen feet up a

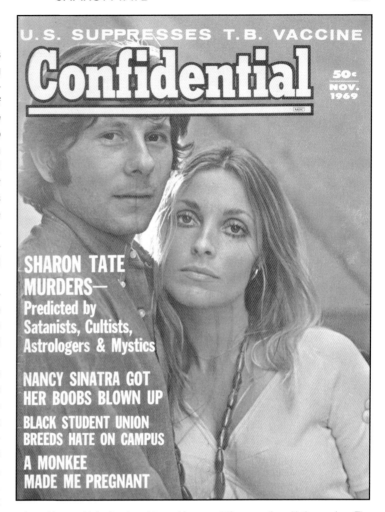

pole and know which wires to cut to avoid electrocution.

The murders of the LaBiancas the following night were mentioned as being "apparently unrelated" by the police, despite the similarities.

There are brief but interesting descriptions of the five Tate victims, Tate's funeral, the fear spreading through Hollywood, Frykowski's involvement in narcotics, and an exchange of gunfire between a security guard at the home of Rona Barrett and a prowler in her bushes. It is pointed out that Ms Barrett lived in the same area as the Cielo Drive house.

Also covered in more detail than elsewhere are the potential suspects being

sought in connection with the murders. The police were "keeping under close guard" a man, a Polish émigré, who informed them that Frykowski was the target of the killings because of his "deep involvement with narcotics distributors." The informant gave the police the names of three people he believed took part in the killings and told them he had been invited to the "party" that night, but had to work late and didn't go. The gathering of three guests, seemingly close friends, at the Tate residence on the night of the murders was constantly referred to as a "party," not only in this piece but in many other articles.

This is a good article for anyone interested in the news coverage at the

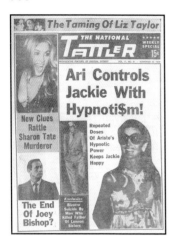

Above Sharon Tate inset on the cover of THE NATIONAL TATTLER Nov 23, 1969. **Opposite** Excellent juxtaposing of images on the splash pages of this feature in TV RADIO MIRROR Nov 69.

TV RADIO MIRROR
Vol 69 No 12 Nov 1969
Macfadden-Bartell Corporation,
205 East 42nd St., New York, NY
10017 .50 100pp

NATIONAL TATTLER
Vol 11 No 21
Nov 23, 1969
Publishers' Promotion Agency, Inc.,
2717 Pulaski Road, Chicago, IL
60639 .15 24pp

SCREENPLAY
Vol 71 No 12 Dec 1969
Smifty, Inc., 9000 Sunset Blvd.,
Hollywood, CA 90069 .50 84pp

time, as it is informative and well written. Montgomery also wrote the Manson cover article for **INSIDE DETECTIVE** Mar 70, mentioned in the next chapter.

TV RADIO MIRROR

☐ The feature *Inside Story! How Mia Farrow Escaped being Murdered with Sharon Tate* by Jim Shaw, opens with a close-up still from **Rosemary's Baby** in which Rosemary holds her hand to her mouth, shocked at the discovery of her demon baby.

On the opposite page is a photo of Sharon Tate lying with her eyes closed as though dead. The two photos together look as though the surprised expression on Rosemary's face was at the discovery of Sharon's corpse.

The article explores Mia and Sharon's relationship—both had an interest in mysticism and the occult, and mentions Mia's trip to meet with the Maharishi Mahesh Yogi along with the likes of the Beatles, Marianne Faithful, and Kenneth Anger. Tate and Abigail "Gibby" Folger explored mysticism together, and after all, Mia met Sharon while filming **Rosemary's Baby**. Farrow left Frank Sinatra at that time after he gave her an ultimatum to quit work on the movie and come back to him; she stayed. One of the writer's friends who claimed to have been invited to the Tate house the night of the murders told him that Farrow and Tate had both moved beyond transcendental meditation into more occult interests. When Shaw asked his friend if he could rule out witchcraft as one of those interests, the friend hesitated before answering "No," and added: "There are a lot of people who represent themselves to be warlocks or witches. They mixed with this group on occasion."

Also discussed are psychic Peter Hurkos, his visit to the murder scene with Polanski, his personal impressions of what happened, who committed the crime and the information he gave the police. Hurkos

actually gave them three names but told them no occult rites were taking place when the murders occurred. It mentions Hurkos reaching under the couch—that Sharon died next to—and pulling out some contraband item, most likely drugs, that the police had missed because they had not moved the furniture.

The article, not unlike others, tries to find significance in the nylon rope that connected Tate and Sebring in death. One of Shaw's "informants" told him that no real witches or occultists would use a nylon or synthetic rope in a ceremony, only ones made with natural fibers.

Louise Huebner, official LA witch, astrologer and psychic, said that the rope was not used for witchcraft, but for "weird love-making that produced an emotional crisis something like strangling."

All of the Tate murder victims and their friends' brushes with the occult are related, e.g. Sebring's spooky card reading; Sharon and the ghost of Paul Bern; Peter Sellers moving because of poltergeist activity in his home, etc.

Mia Farrow was in London at the time of the murders with her new beau, Andre Previn, and preparing to return to LA when she received the news of Sharon's death. Frightened, she quickly canceled her plans to return to Hollywood and her brother, writer John Farrow, went to Sharon's funeral while Mia stayed away.

The piece wraps up with:

A number of prominent Hollywood persons who could have been there but were not said prayers of thanks that they were still alive the following day. Among them, no doubt, was adventurous Mia Farrow, who this time possibly escaped an adventure that might have cost her her life.

If the numerous covers shown in this chapter featuring the Lennon Sisters aren't enough proof of their popularity, then the

feature *The Lennons Through the Years* surely is. The opening blurb of the piece explains why: "The girls became young women, brides and mothers right before your eyes, on TV and the covers of **TV RADIO MIRROR**, the magazine that 'discovered' them."

So, it wasn't just the media circus over William Lennon's murder that got his daughters on the covers of TV and movie gossip mags, as they had been there all along.

To show how popular the Lennon Sisters were with their readers over the years, **TV RADIO MIRROR** reproduced all the covers of the magazine that the Lennon Sisters had graced, starting with the Mar 57 issue. In all there were thirty-seven covers ending with the Jul 69 issue. Many more were added after their father's tragic murder.

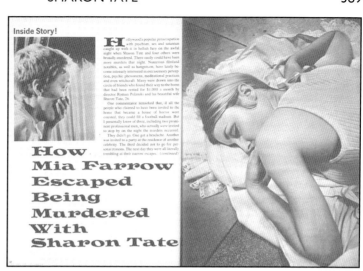

NATIONAL TATTLER

☐ "New Clues Rattle Sharon Tate Murderer" or *The Tate Murder Clues—How they add up* is how this uncredited article is blurbed on the cover and inside respectively.

The piece inside includes a cropped version of the cover photo of Sharon laughing with the bizarre caption: "Sharon Tate was a beautiful girl full of the joy of living, but she will never laugh no more." Beneath a smaller photo of her body being taken from her house in a body bag, the caption reads: "The corpse that was Sharon Tate, is wheeled away after her brutal murder."

The still relatively recent and unsolved Tate murders had "undisclosed clues" that would eventually fit together, according to Robert Houghton, assistant chief of the Los Angeles police department. The article tries to tie various clues and aspects of the crimes together.

Linking the LaBianca murders with the Tate crime, the article suggests that Mrs LaBianca's first name, Rosemary, added to the fact that Sharon was eight months pregnant, in the light of Polanski's Satanic

movie **Rosemary's Baby**, equaled: "A satanic ritual with an unexpected ending?"

The piece proffers the scenario of the murder victims picking up some Hollywood freaks and weirdos and bringing them back for fun and games—games that turned into a deadly reality for the Hollywood jetsetters. The fact that the perpetrators knew the victims would be murdered, while the victims themselves did not, is explained thus: "This element of secret knowledge is an essential part of the cult of black magic and sorcery. And imagine the secret delight at knowing their ritual will end in death!"

In spite of the LAPD's optimism that the crimes would be solved, the writer of this piece ends by saying:

*A purposely senseless ritual murder, designed to dig into Polanski's psyche with the macabre **Rosemary's Baby** signature, using corpses for words. And a murder that will never be solved, since the slayers are but chance acquaintances of the victims, and have no real motive for the killings except the satisfaction of their own unnatural desire for shared secret knowledge—in this case the most soul-shaking kind, shared blood-guilt.*
Is it any wonder that ordinary, 'square'

policemen are having difficulty solving the Tate murders?"

SCREENPLAY

☐ In this issue of **SCREENPLAY**, in the gossip column *Hollywood Blabber Mouth*, there is a full page photo of Sharon Tate and the caption, "Sharon Tate's love for Roman Polanski was real and tender. They may have been an unorthodox couple, but they never did anybody any harm. Not anybody."

The uncredited article *Hollywood's Reign of Terror! The Tate-Lennon Murders* delves into the murders of Sharon Tate and friends on Saturday Aug 9, 1969 and that of William Lennon, father of the Lennon Sisters, the following Tuesday. A crazed ex-mental patient who had delusions of being married to Peggy, one of the Lennon Sisters, had shot Mr Lennon to death in the parking lot of the Marina del Rey golf course where he worked as an instructor.

The Lennon Sisters had become famous from their many appearances on the Lawrence Welk Show starting back in 1955. Both William Lennon and Sharon Tate were buried in Holy Cross Roman Catholic Cemetery.

The bulk of the article relates the facts

Above This Dec 69 issue of SCREENPLAY was one of the few movie gossip mags to carry Tate on its cover after her murder. **Opposite** With all the blurbs on its cover and the fact it was a low distribution title, TV RADIO MOVIE GUIDE Dec 69 is a rare curiosity.

TV AND SCREENWORLD
Vol 4 No 4 Dec 1969
Stanley Publications, Inc., 261 Fifth Ave., New York, NY 10016 .35 68pp

TV RADIO MOVIE GUIDE
Dec 1969
Ramey Publications, Inc., 6404 Hollywood Blvd., Hollywood, CA 90028 .35 68pp

MOVIELAND AND TV TIME
Vol 27 No 8 Dec 1969
K. M. R. Publications, Inc., 21 West 26th St., New York, NY 10010 .35 84pp

of Polanski and Tate's careers and how they met in 1965. The Lennon Sisters' career is also discussed at the tail end.

But, the point of interest is that after mentioning Polanski's denial of any romantic relationship between Sebring and his wife at the time of the murders, it says that Sebring almost brought his "own girl"—Connie Kreski—to the Tate house that night. Kreski was the Jan 68 **PLAYBOY** centerfold and 1969 "Playmate of the Year." Kreski was a stunning, longhaired blonde, not unlike Tate. Kreski went on to get parts in unsuccessful movies like Anthony Newley's **Can Heironymous Merkin Ever Forget Mercy Humpe and Find True Happiness?** in which she played Mercy Humpe.

Strangely enough, Polanski was pictured on the cover of the Oct 18, 1970 issue of the **NATIONAL ENQUIRER**, Kreski at his side, with the caption: "Polanski's New Girl Friend Is Sharon Tate Lookalike" (see page 405).

Continuing with the **SCREENPLAY** article, Polanski's friend Gene Gutowski compared the Tate murders with those of the Clutters in Kansas—made famous by Truman Capote's **In Cold Blood**—to make the point that the Tate victims were not "hippies or cultists" and that it could have happened to anyone.

The article is one of many that claims the police had finally admitted that Sharon Tate's baby was cut from her belly, and that Sebring had been castrated, details that were initially withheld from the public for the families' sake. However, it was not the case: even though they were stabbed numerous times, they were not mutilated as claimed.

At the end of the piece, two addresses are given to send condolence letters to both Polanski and the Lennon Sisters.

TV AND SCREENWORLD

❑ In this issue of Stanley Publications' **TV AND SCREENWORLD**, in the article *Behind the Tate Killing—The Savage Murders that Haunt Hollywood*, Floyd Thursby weighs the impact of the murders of Sharon Tate and Bill Lennon on Hollywood and compares them to other high profile Hollywood murders in the past.

In the second paragraph Thursby makes the curious statement: "The death of Mr. Lennon was particularly staggering since he had been considered so well-liked." Which is to say that Sharon Tate and the others murdered were not well liked? It is true that the Lennon murder was covered by the movie mags more extensively than the Tate murders and, when opting for cover space and cover photos, it was the Lennon murder that got it.

Thursby didn't elaborate though, he just moved on to the murder of Johnny Stompanato by Lana Turner's daughter Cheryl, and to Ramon Navarro's sensational, unsolved murder. The murder of Alain Delon's bodyguard—who had been having an affair with Delon's wife Nathalie—is also discussed.

By adding more details of mutilation that weren't true, Thursby ups the horror ante, if we are to believe the morgue photos and autopsy reports of the Tate victims. Thursby wrongfully claims Tate's left breast was sliced off and that she had a large "X" carved across her belly.

He reiterates: "While the Lennon murder wasn't as spooky, it was at least as tragic. Bill Lennon was extremely well-liked."

In conclusion: "Where will it end?"

TV RADIO MOVIE GUIDE

❑ *The Killers of Sharon Tate are Known!* is the cover blurb as well as the title of the uncredited article inside. This mag was probably on the stands slightly before the LAPD announced that Manson, Watson and the girls were charged with the murders. So in spite of the blurb on the cover, Manson and Family are not mentioned in the piece. It claims that the LAPD knew who the killers were but were waiting for an airtight case

against them before making any arrests or releasing names to the public. Interestingly it mentions that some women were also under suspicion.

The mysterious circumstances of Tate's murder are likened to the deaths of Marilyn Monroe, Dorothy Dandrige and starlet Karen Kupcinet. Psychic Peter Hurkos is quoted as saying that he gave the police the identity of the murderers and that they were taking his extra-sensory perceptions seriously.

Tate's haunted nature and her belief in the supernatural are mentioned, as is her eerie ghost-seeing experience at Paul Bern's old house (see **FATE** mag on page 403).

There are also bizarre quotes from Tate given to freelance journalist Enrico di Pompee in what it claims was her last interview: "I feel that I am evil and I sometimes grow so depressed that even the thought of death is ecstasy." She continues:

Roman leaves all his monsters at the studio when a picture is finished. I'm the one who sees the real ghosts. I am possessed by fears of the underworld, not the criminal underworld, the mystical one. I live with monsters and so I shall die with them.

The article does not depict Tate favorably as it repeats the "black magic" rumors, and ends with quotes from Cher accusing Sharon of trying to hit on her husband, Sonny Bono.

MOVIELAND AND TV TIME

☐ *Terror Strikes the Stars!* by K.V. Burroughs starts with the intro blurb, "The longer the Sharon Tate case goes unsolved the more the stars worry about whom to trust!" The article features six photos, including one of a grieving Polanski, and another of a dazed and confused William Garretson.

Peter Hurkos' psychic investigations of the Tate case are again related in this article,

but it says of his past experience:

Mr. Hurkos first used his extrasensory 'vibrations' during WWII when he was able to pick one of his supposed friends as a Nazi spy. He then helped Scotland Yard with one of their most famous cases. Since then he has worked on the Boston strangler mystery and the slayings of the seven Michigan coeds.

Burroughs mentions the $25,000 reward offered by Peter Sellers and others for information leading to the capture of the killers, and included a PO Box number at the Terminal Annex in Los Angeles to send

information to.

Another point of note is the tone the article takes concerning drug use by the stars. Burroughs quotes Steven Roberts of the **NEW YORK TIMES** talking about Polanski's friends:

Many of them preferred marijuana to Scotch, but as one of them put it, 'So does everybody else these days, this is speakeasy time for pot.' Some of them might have dabbled in cocaine, but there is a limit when you have to be on a movie set at 7:00 a.m.

Also noted: "The murder house has now become a big point of interest as visitors

Above **MOVIELAND AND TV TIME
Dec 69.** Opposite **SCREENLAND
Dec 69** claimed that this picture
was the last taken of Sharon Tate
alive—untrue, as film was found
in a camera at the Tate/Polanski
house containing pics taken the day
before she died.

MOVIE WORLD
Vol 14 No 7 Dec 1969
Magazine Management Co., Inc.,
625 Madison Ave., New York, NY
10022 .40 100pp

MODERN SCREEN
Vol 63 No 11 Dec 1969
Dell Publishing Co., Inc., 750 Third
Ave., New York, NY 10017 .50 84pp

SCREENLAND
Vol 69 No 12 Dec 1969
Macfadden-Bartell Corporation,
205 East 42nd St., New York, NY
10017 .35 68pp

to Los Angeles flock out to see 'where it happened.' The Polanskis paid $200,000 to rent the house and now it is supposedly up for $300,000."

Strangely Barbara Streisand is quoted on her move back to New York as an example of the extent of fear in Hollywood. Streisand said: "Imagine rushing back to New York and feeling safer on the west side there than out in Hollywood."

The article ends on the skeptical note:

Of course in time this feeling of panic will ease up but right now most of the stars would feel much better if the case were solved. They are worried that it will be another Karyn Kupcinet case—which has never been solved and looks as if it never will be.

Karyn Kupcinet was an actress and claimed by conspiracy theorists to be the first murder victim in the "clean-up" after the John F. Kennedy assassination. She had apparently been heard by a phone operator saying, "The President is going to be killed" twenty minutes before his assassination. Kupcinet was found strangled to death in her West Hollywood apartment on Nov 30, 1963, although the coroner said she had died three days earlier. The case was never solved.

MOVIE WORLD

❑ *The Man Who Saved Mia from Sharon Tate's Horrible Fate* by Steffi Harlow takes the long way round to tell us that Andre Previn was the man who saved Mia from Sharon's horrible fate.

The first half of the piece is the usual story of the murders, Sebring's drug use and Tate's discovery and career. Then it states of Mia Farrow:

And part of the crowd that the Polanski's ran around with included Mia Far-

row. She was just far-out enough for their taste, and she responded eagerly to their friendship. Mia, too, has always been fascinated by the absurd, the offbeat. "A real happening" is how she refers to a gift surrealist artist Salvador Dali gave her—a bottle containing a lizard and a rat fighting to the death. She recently told a reporter she can't help imagining "war—DEATH—with all the nerves flashing, everything blowing out like a shooting gallery."

The article explains that if Mia had not gone to London with Andre Previn, "she could easily have attended that party at the Polanski house."

Sharon and Mia's friendship is discussed: "Both were fascinated by the bizarre, and both loved men who were not the average run-of-the-mill American boys. Both had meditation sessions with the Maharishi."

An example of Mia's quirkiness: she had recently hitchhiked alone from New Orleans to New York, "a dangerous, foolhardy thing for any young girl to do."

The moral of the story according to Harlow, who blames the victim, is that Sharon Tate might have been able to better control her circumstances had she been more careful. Sharon's death had taught Mia a "very valuable lesson—one every woman should heed."

MODERN SCREEN

❑ *How Sharon's Death is Changing Hollywood* by Bethel Every, starts out with the blurb, "Months have gone by since the ghastly crime, but no one there will ever forget. For no one there will ever be the same!"

It recounts Polanski's return visit to his Cielo Drive home that had been kept intact, down to the bloodstains, since the murders.

It then takes a look at various Hollywood celebrities and their paranoia since the murders, admittedly looking at some who were not part of the Polanski's "large coterie of friends and acquaintances—the hippie set."

Such megastars as Charlton Heston, Steve McQueen, Tony Curtis, Red Skelton, Robert Vaughn, Don Adams, Julie Andrews, and Frank Sinatra are mentioned concerning the security measures they took with their houses and telephone numbers: "as guarded as the entrances to their homes."

The article then proceeds to say that the Bel Air neighborhood that Tate lived in was patrolled by a private subscription police force, to which the Polanskis apparently did not subscribe.

It ends on this note:

So all the protection money can buy is not enough. And Hollywood will never be the same.

Not as long as there is a memory of the lovely mother-to-be who lost her life in such a brutal and terrifying manner will the residents of Hollywood be able to sleep peacefully through the night.

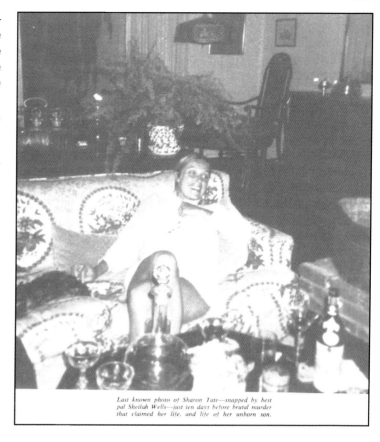

Last known photo of Sharon Tate—snapped by best pal Sheilah Wells—just ten days before brutal murder that claimed her life, and life of her unborn son.

SCREENLAND

☐ You wouldn't know it from the cover, but inside this issue of **SCREENLAND** is *Scoop! Sharon Tate's Friends Talk About Her Killer—'It was someone in our crowd'* by George Carpozi, Jr, a writer of mass-market paperback biographies of celebrities and many other books.

On the first page of the piece is apparently the last photo taken of Sharon Tate; her best friend Sheilah Wells took it ten days before she was murdered. In the picture she is smiling, pregnant and sitting slouched down on a couch petting a cat. Other photos were found undeveloped in a camera at the Cielo Drive house that were actually the last pics taken of Tate. They show her pregnant in a bathing suit by her pool.

The article begins by stating that many of Tate's and Polanski's friends had claimed they thought the killer/s would be someone they knew, someone from their "crowd." Polanski himself was quoted saying, "I know of many wild and cruel people in the group with whom we've associated these last five years since I met Sharon. Some I wouldn't trust as far as I could throw them."

But Polanski did "make it clear" that his friends were incapable of the violence meted out to his wife and the others. It was the "weirdos and freaks," the hangers on—or more to the point—the "envious that existed on the fringes of their group."

The police had found Sebring's address book in which they recognized a number of "sex deviates, drug addicts or occultists."

Paul Newman commented: "I hold to the theory that Sharon and the other four knew their killer. But I don't pretend to know who he was."

Mia Farrow—Polanski's Rosemary and good friend of Sharon—is also quoted, saying:

Yes, it could have been someone in the crowd. But the question is who? The killer must have been demented and I know of no one personally who completely fits that bill. It is a frightening crime and much too complicated to figure motive.

At least, I know of no one who would have wanted Sharon—or the others—dead.

Michael Sarne, writer of the movie **Myra Breckenridge**, says:

Above **MOVIE LIFE YEARBOOK 1969.** Opposite **Interesting illustration from the Tate/Manson article in the NATIONAL EXAMINER Feb 2, 1970, the cover of which is pictured at the start of this chapter.**

MOVIE LIFE YEARBOOK
No 46 1969
Manton Publishing Corp., 295 Madison Ave., New York, NY 10017 .50 92pp

NATIONAL EXAMINER
Vol 6 No 49 Feb 2, 1970
Beta Publications Ltd., 234 Fifth Ave., New York, NY 10001 .25 20pp

Just thinking about those ghastly murders is sickening. But what makes it worse is that I had been invited and, only for a stroke of fate, didn't go to the party. It's chilling when you think how lucky you were to escape that awful butchery. Of course, I have no idea who could have done it. Except that whoever did it was mad.

Actor George Maharis chimes in with:

Not a day goes by that I don't think about this terrible blood bath. No fictional plot can rearrange the saturnalia of murder in this case without lessening the impact one feels.

Attorney F. Lee Bailey uses his experience and knowledge of psychotic killers—he had defended the Boston Strangler and others—to profile the killer:

The type who can commit mass murder is usually quiet, sensitive, even pleasant outwardly. But he is psychotically subject to slights and what he considers affronts to his dignity. Any remark or gesture he figures as putting him down can bring an explosion in his brain. Yet he is capable of speaking very softly, even smiling, just before he fires the shot or stabs with the knife. And he can return to that covering almost immediately following the crime. Which makes him very hard to detect.

Carpozi ends by saying that the killer "must also bear a fear of the vengeance of this world—when, and if, the moment of truth comes."

MOVIE LIFE YEARBOOK

☐ *Sharon Tate—How Hollywood Destroyed Her* is one of five uncredited articles under the title *Horror Over Hollywood—How 5*

Shocking Tragedies Spread Sorrow and Fear. The other four focus on Ted Kennedy, the Lennon Sisters, Robert Taylor and Judy Garland.

The Tate article states: "It's so difficult to refer to Sharon Tate in the past tense. She was so much a 'now' person—young, beautiful, talented, hip—that her death seems more like the ending to a horror movie than a reality."

It also claims that Hollywood was to blame for the "real tragedy" in Tate's life: Sharon became a personality because she had flair and flaunted it. But being a quick learner of Hollywood's prime lesson—how to 'sell' yourself—she became a commodity and began to lose her identity in the process. It continues:

So wrapped up had she become in her Hollywood image and her desire for stardom that somewhere along the line she may have begun to lose sight of her real self. Perhaps Sharon's lack of selectivity in choosing her friends and her great need to have as many of them as possible was her way of demonstrating her worth as a human being and compensating for the false and one-dimensional image Hollywood had created for her. Sharon's friendships apparently gave her what she desperately needed—the sense of reality and identity Hollywood had robbed her of. In the end though, they may have contributed to her death

The article's premise—as written before the arrests—is that it wasn Abigail Folger and Voityck Frykowski who were the targets of the murderers because of their involvement with "the underground world of drugs."

NATIONAL EXAMINER

☐ The eerie cover of this issue of the **NATIONAL EXAMINER** reads: "Girl's Bizarre

Confession Links Slaying With 'Rosemary's Baby'—Hippie Cult Killed Sharon Tate To Prevent Birth Of 'Satan's Child'"—and it is a keeper!

The two page spread *Bizarre Slayings Linked to 'Rosemary's Baby'—Hippie Cult Member Reveals why Sharon Tate was Killed* by Larry Bell, is supposed to be the revelations of former Manson "cult" member Mary Ann Porter. The twenty-four year old Porter claimed that Charlie Manson and his Family went to see the movie **Rosemary's Baby** and the end of the movie reportedly left Manson in tears. Porter said it caused Charlie to have an epiphany of sorts, that the birth of Satan's child would mean the end of the world, and he, 'Jesus,' would have to prevent it.

After Sharon became pregnant, Manson and Family "got themselves convinced that Sharon was involved in a heinous pact with the LaBiancas, similar to Rosemary of the novel." According to Porter, "Each member swore a solemn oath to discover the nest of vipers and root out the Antichrist."

Apparently Manson went to Terry Melcher's house one day and when he came back he looked "as though he had seen his mother's belly slit open." He then told the others at the ranch that Melcher's house had a pregnant woman and four others living in it. Manson claimed he listened outside a window at the house and overheard a conversation with the recurring themes of "the Antichrist, the child of Satan, the Beast of Evil." The writer speculated that Manson undoubtedly heard talk about the film **Rosemary's Baby**.

To thwart the birth of the Antichrist and save the world, Manson sent out his band of "chosen elite" to kill those in the house. The article claims that Manson had learnt of a dinner date that the Polanskis had with the LaBiancas right before Sharon conceived; he likened the LaBiancas to the "Castavets" in the movie version.

The former Family member said that before the killers left on their mission of slaughter, Charlie warned them to only stab the woman but leave the baby untouched by the knife, as the child had to die a "natural death." If the child had died from a stab wound, its ghost would haunt the world.

Porter ends by saying: "No one will ever understand the beauty of our life with Charlie. He was Jesus to us—our Savior."

MODERN MOVIES
Vol 3 No 2 Feb 1970
Magazine Management Co., Inc.,
625 Madison Ave., New York, NY
10022 .35 100pp

CAD
Vol 2 No 7 Feb 1970
CAD Publishing Co., 8060
Melrose Ave., Los Angeles, CA
90046 1.00 100pp

MODERN SCREEN
Vol 64 No 2 Feb 1970
Dell Publishing Co., Inc., 750 Third
Ave., New York, NY 10017 .50 92pp

RONA BARRETT'S
HOLLYWOOD
Vol 1 No 5 Mar 1970
Laufer Publishing Co., 2nd and Dickey
Streets, Sparta, IL 62286 .50 84pp

MODERN MOVIES

☐ The first page to this mag's Tate feature reads *Exclusive! Photos of the Movie that can't be Shown for a Year—Sharon Tate Nude in her Last Film!* The piece consists of seven b&w stills from **One Among 13** (aka **Thirteen Chairs**) and four short paragraphs of text. The text is uncredited and curiously written:

> *Sharon Tate's tragic death left her fans disconsolate. Not only did they feel grief for her sake and sympathy for her husband Roman Polanski—they were heartbroken also because they had nothing to remember her by. As far as anyone knew, Sharon left only old films, such as* **Valley Of The Dolls** *and* **The Vampire Killers**, *as her claim to movie fame.*
>
> *But just recently* **MODERN MOVIES** *found out that Sharon had starred in a film a year or so prior to her death, and luckily we were able to procure some photographs taken of Sharon and her co-star Vittorio Gassman while they were filming* **One Among 13**. *Made in Italy, the film was directed by Vittorio De Sica.*
>
> *As these photos show, some of the highlights of* **One Among 13** *take place in bed. Word has it that Sharon's widower, Roman Polanski, is upset because this film exposes so much of his late wife's gorgeous body—and also shows her in bed with one of Italy's sexiest male stars. Roman has come to think of his dead wife as some kind of a saint these days. We all know she was flesh and blood—a warm, loving woman—as these revealing pictures show, and there is no reason for Polanski to be ashamed of her appearance in her last movie. Nowadays, many of Hollywood's finest actresses take roles that call for nudity and sex scenes. To her fans, Sharon was a goddess,*

> *and seeing these pictures—and* **One Among 13** *when it is released—may help assuage some of the pain and horror of her death.*

What the text doesn't mention is that Sharon Tate was pregnant during the filming of the movie.

CAD

☐ **CAD** was one of the mags published from 8060 Melrose Ave., along with **ADAM**, **KNIGHT**, **PLAYERS**, **PIC** and others, not to mention the Holloway House line of paperbacks.

Our Life is our Jungle, by Bruce Harper, starts with his reflections on talking with Roman Polanski in "the private inner sanctum of the studio commissary at Paramount," while Polanski was busy editing **Rosemary's Baby**. In their discussion, Polanski stated that he purposefully left the ending of **Rosemary's Baby** ambiguous as to whether it was happening in reality, or just in Rosemary's "psychotic consciousness." The two were joined by Krysztof Komeda, a doctor who gave up his practice to compose music, and had composed the score for **Rosemary's Baby**. He later died in April 1969 from injuries received in an accident.

Polanski pointed to a cut on his lip that he received while in Paris a few days earlier, when he had gotten into a fist fight with three street thugs, one of whom had stuck his hand up Sharon's dress. Polanski hit him in the face and was left cut by the ring of the man who hit him back. Later, Komeda pulled the stitches out for Polanski.

The article relates the tale of Polanski's childhood in Nazi occupied Poland, his escape from the concentration camps and fast rise in the international film community. Tate's career and meeting of Polanski were briefly touched on.

Included are two long quotes from

newspaper articles. One appeared in the **EAST VILLAGE OTHER**, by Allen Katzman, who related the story of the drug dealer/suspect, William Doyle, allegedly whipped and sodomized at the house of Cass Eliot of Mamas and Papas fame. He has claimed that Frykowsky and Sebring sodomized Doyle while Tate and Folger whipped him. Doyle apparently then swore he would get revenge.

The second newspaper quote is from the **LOS ANGELES TIMES** film critic Charles Champlin: "The last tragedy would be if the exotic enclave in the hills were thought to have existed in total isolation, irrelevant to all except those who died so hideously."

The article plays up the "black magic" and Satanic angle, evidenced by the cover blurb, "Roman Polanski: Satanic Terror." The title of the piece has been taken from a quote by Polanski, "We are rational like the jungle—our life is our jungle…"

The observation is made that Rosemary LaBianca shared her first name with Polanski's Satanic Madonna played by Mia Farrow. The question:

Could the choice not have been at 'random,' and could some outlandish devil sect have chosen to punish the Polanskis for capitalizing on the satanic conception in Rosemary's Baby?

Several incidents from around the country are cited as evidence of devil worship afoot. Harper writes: "These may be unrelated incidents, but could some sect of Satan be taking seriously the concept that God-Is-Dead-and-This-Is-the-Year-One-of-the-Satanic-Era?"

As Polanski said, "It looks like there is more and more evil, but better and better dressed."

MODERN SCREEN

❑ In the short piece *Tate Murder Suspects Caught! Hippie Murder Cult Revealed*, writer James Thornton muses on the various motives and the "finger pointing" that went on in the three months after the murders, and before the arrests and Dec 1 police conference announcing the apprehension of the suspects.

Upon learning that it was a band of hippies—"members of a sinister cult…weirdos who might have killed anybody"—who committed the crimes, Thorton blasts Hollywood and its culture of drugs and sex: "Yes, it could have happened again in Hollywood, because that town, which once idealized all that was glamorous, had lost its direction, had opened its arms to drugs, had welcomed the weirdos."

Thorton describes the Manson Family as "a militaristic, kill-crazy cult that robbed, mugged and stole…"

The motive given is that the murderous "slippies" were looking for Terry Melcher. Not finding him at home they decided to kill everyone there anyway, unaware of their victims' identities until hearing it on TV the next day.

The article mentions—what then was rumor, but turned out to be fact—that the killers were high on either LSD, speed, or both.

RONA BARRETT'S HOLLYWOOD

❑ "Kill! Kill! Kill! He allegedly ordered! And they followed his command without flinching, without question…thus Sharon Tate and her companions became the victims of Satan's blood-thirsty messengers!" This is the opening blurb of part three of *The Sharon Tate Case* by Judith Wieder. The first three paragraphs are just as strange:

An explanation as mad as the monstrous murders themselves—that's

what the world was treated to last month when 21-year-old Susan Atkins, a member of a wandering mystical commune called 'The Frigate Family,' suddenly decided to tell all.
Her grotesque tale of a half-demented criminal 'guru,' Charles Manson, and his satanic influence over the empty, childish lives of his hippie converts, has shattered almost beyond repair everything the idealists in this country have longed to believe about the young. When the 'love generation' hates… when 'peace children' carve war on the bodies of their victims…where are we—all of us? Because no matter how easy it is to point to this pathetic band of misfits and say: 'Yes, well, of course, but they were all just insane, an isolated case of villainy!—the inescapable point is that 'The Frigate Family' is a perverted product of our own American society.

Where the term "The Frigate Family" came from I don't know. I can only assume that somebody said to the writer "the friggin' Family," which she misinterpreted.

In the remaining article, Wieder concludes that Manson was able to carry out "his sexual and philosophical insanities" by filling the "empty minutes" of his follower's lives. Wieder says the Family's unifying force was "fear, sex and crime."

In trying to understand the murders, Wieder emphasizes the physical effort it took to carry out the crimes:

Susan, Patricia, Linda, and Tex were involved, deeply, physically involved, in a long and exhausting struggle for life and death. Their victims did not die without a fight. …Was the fear of disobeying Charlie Manson's orders enough to supply his 'gang' with the kind of moment to moment physical energy they needed to carry out the Tate bloodbath?

Atkins made the bizarre claim that when she said to Tate, "Woman, I have no mercy for you," as the actress pleaded for the life of her baby, she was really talking to herself! As did Katie Krenwinkel when talking to Folger as she stabbed away.

Wieder concludes that if the heavy hand of the law was brought down on the long-hairs and hippies as a result, then Manson would have won: "Manson knows that any concentrated authority leveled at today's youth out of fear rather than concern, will make the 'generation gap' permanently un-crossable!"

PHOTO TV LAND

☐ The article *Will Sharon Tate's Killer Strike Again?* opens with the blurb, "At this writing, Sharon Tate's killer is still at large—and fear is sweeping across Hollywood: Will it happen again?"

The straightforward article focuses mainly on the only clue the Los Angeles police had to go on at the time in their search for the killers: a pair of odd eyeglasses supposedly left by one of the perpetrators. The glasses, the police surmised, belonged to someone with an unusually small, round head, very poor eyesight and possibly with one ear higher than the other. Obviously not mentioned in the article are the theories that popped up after the Manson Family's arrest, speculating that Charlie had gone back to the scene of the crime later that night to see his handiwork firsthand, and planted the glasses as a false clue for the police. To my knowledge, these glasses have never been accounted for.

Since the killers had not yet been found, the concern of some of Hollywood's in-crowd was high. Specifically mentioned are Elke Sommer and her writer husband Joe Hyams, and their moving to a high-rise apartment in downtown LA, hiring armed guards and dogs to keep strangers away from their secluded home in the hills.

INSIDE TV

☐ *Doris Day in Shock over Son's Tie with Accused Tate Killers!* by Reed Stuart opens with a quote from Doris Day to her TV show's press agent Billy James: "No more interviews. I feel sick."

The reason Doris Day felt sick was that in the morning's paper was the revelation that her son, Terry Melcher, was the intended target of the Tate murders. Doris Day went into seclusion and refused to talk with the press; Melcher had twenty-four hour police protection, as did his mother.

It mentions that Doris herself could have been slain had the killers struck the summer before when she visited Terry at his Benedict Canyon house. Melcher had leased the house with an option to buy when he and Candice Bergen had planned to marry, but after their break up he found the estate too big for his purposes and moved to an apartment in Beverly Hills.

The piece—like all others since the Dec 1 press conference—is based on information from the testimony of Susan Atkins, which she finally gave after her attorney Paul Caruso persuaded her to, in spite of an ESP death threat she claimed to have received from Manson.

In the conclusion, the article theorises that when Melcher's adoptive father, Marty Melcher, died, Terry took over the reins of his business, Arwin Productions, at CBS Studios. This, it claims, left Melcher with little time for his "hippie musician" friends, including Charlie Manson.

As an interesting aside, at the beginning of the mag in the gossip column *Set Hopping with the Stars* by Jack Bradford, there is an item about Barbara Parkins, Sharon Tate's co-star in **Valley of the Dolls**. It mentions her move into a Georgian house in London's Mayfair district and Bradford writes:

Haven't had time to talk with Barbara since one of her constant Hollywood companions, Steve Brandt, succeeded

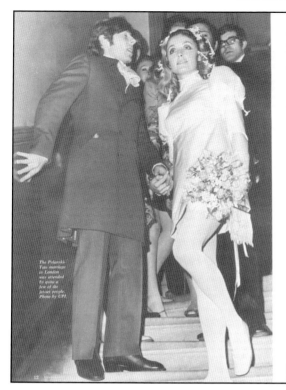

OUR LIFE IS OUR JUNGLE
by Bruce Harper

The Polanski-
Tate marriage
in London
was attended
by quite a
few of the
jet-set people.
Photo by UPI.

When I encountered vibrant and intense Roman Polanski at Paramount Studios he was in the midst of editing *Rosemary's Baby*, the brilliant film on satanism and witchcraft in our time that was to bring him world-wide acclaim. Was it also to bring him that dark night of ritualistic murder and personal tragedy at the Benedict Canyon estate he shared with his beautiful young wife Sharon Tate?

We knew nothing of the evil that lay ahead of him as we lunched in the private inner sanctum of the studio commissary at Paramount. It was the spring of 1968 and the slight, intense, lean, yellow-haired young man who sat next to me at the small table was as happy as he possibly would be in his life.

He was thirty-four and looked ten years younger. He was already a world renowned festival prize winning film director, of Polish origin but now very mobile in the farflung film world – Paris, London, Rome and now the heart of the industry, Hollywood.

But above all Roman Polanski had just wooed, won and married the unbelievably beautiful and talented young film star, Sharon Tate. If there was one young couple among the "beautiful people" who had everything going for them – love, immensely successful talent, exciting careers and the unlimited admiration of their peers – it was Sharon and Roman.

That this idyll would be shattered in a short year could be known to neither of us as we ate cabbage rolls and Roman rapped with me about his personal cinematic art, about Mia Farrow whom he had picked as his star in the picture he was then editing – *Rosemary's Baby*. This film he told me was nothing less than a tantalizing dramatization of a Black Nativity – the Devil conceiving a Hell-Child in the body of a woman named Rosemary, creating the Year One for the Satanic cultists bent on taking over the world in the name of evil.

Now I know – in the lurid light of the demonic destruction that took place on Polanski's Benedict Canyon estate that August night in *turn the page*

with an overdose of sleeping pills. Steve was much too involved with the Sharon Tate crowd, which may have been one of the reasons Barbara pulled away.

SCREENLAND

☐ *Step-by-Step Confession of the Killing: 'I Wanted to Cut Sharon Tate Open and Take the Baby'*, by Hillary Hope, is a dramatic account of the murders rehashed from Susan Atkins' testimony. There are b&w pictures of Sharon, her father Paul Tate, Katie Krenwinkle, Manson, Watson, Terry Melcher, Spahn Ranch, and a strange photo of mattresses out in the woods under some trees that the caption claims were slept on by members of the accused "family."

At the end of the article is an aside about a conversation Ms Hope had with Sheilah

Wells—Sharon's best friend—whom Sharon had originally planned on spending the night with on Aug 8, 1969.

Wells made the point that the killers could not have known Sharon, because if they had they could not have killed her. In the last few months of Sharon's life, says Wells: "She never really cared about being beautiful or acting. She just wanted to love and be loved…and have her baby."

TV RADIO SHOW

☐ *Doris Day: The Nightmare that Threatens her Life!* by Sarah Hart, relates a day in the life of Doris Day. She was having some morning tea before getting ready to go to the studio and read the blaring headline of the **LOS ANGELES TIMES**: "Grudge Against Doris Day's Son Motive For The Tate Slayings." She involuntarily shuddered and got a sick feeling in her stomach, realizing how

close her son and possibly even herself had escaped the slaughter. Just then the phone rang: it was Terry Melcher, hip sixties record producer and tangential target of the Tate murders, offering to drive his mother to the studio knowing she had just seen the shocking headline and wanting to talk to her about it. He claimed to have met Charles Manson only twice: once at the mansion of Dennis Wilson of the Beach Boys, where Manson and his traveling harem were living for a short while, and later when Dennis had brought Manson over to Melcher's secluded Cielo Drive digs so he could play some of his tunes for the producer in hope of scoring a record deal. Melcher told him to keep practicing, to try to get some gigs playing in public and to come back in six months. The article quotes Melcher as saying of Manson: "Who could have ever *known* he'd turn out to be insane…the leader of some weird cult." Not mentioned in the article is the story that Manson reportedly did come back one

Above **PHOTO TV LAND was one of Myron Fass' many titles. This is the Mar 70 issue.** Opposite, from top **PHOTO TV LAND Mar 70 had these dramatic splash pages for its article on the Tate murders; Splash pages from SCREENLAND Mar 70 containing some of Susan Atkins' "confessions."**

TV RADIO MIRROR
Vol 70 No 4 Mar 1970
Macfadden-Bartell Corporation,
205 East 42nd St., New York, NY
10017 .50 104pp

NATIONAL INSIDER
Vol 16 No 12
Mar 22, 1970
National Insider, Inc., 2713 N. Pulaski
Road, Chicago, IL 60639 .15 24pp

NATIONAL BULLETIN
Vol 8 No 44 Apr 6, 1970
Summit Publishing Co., 234 Fifth Ave.,
New York, NY .25 20pp

day to discover Sharon Tate at the door, as Melcher had moved and leased the house to the Polanskis.

The article relates Doris Day's thoughts after reading the news of Susan Atkins' ghoulish testimony to the Grand Jury: that Manson had picked that particular house because he wanted to send a message to Melcher, whose current location he didn't know. He apparently instructed Atkins et al to kill everyone in the house, which could have included Doris Day had her son still lived there.

On the drive to the studio, mother and son comforted each other and discussed the horror and tragedy of the whole thing, while contemplating God moving in mysterious ways. Doris reassured Terry:

We can pray for Sharon Tate and her friends, and we can thank God that he saw fit to spare your life.
We can't live in the past. You can't spend your time brooding over something you couldn't control, or worrying about something you can't change. Be thankful, and make the most of every hour of every day. That's what the gift of life is for.

At the end of the piece is the c/o address for CBS-TV for readers to write to Doris.

TV RADIO MIRROR

☐ *Sharon Tate Murder Story Breaks Doris Day's Heart*, "The strange, unsuspecting role her son played in the tragedy!," by Bill Franz, is a much lengthier account of the same territory covered in the above article. This article, however, recounts the murders and goes into more of the revelations contained in Atkins' testimony, which was, at the time, the only source for the 'facts' of the case and also spawned the first instant paperback on the murders: **The Killing of Sharon Tate**.

This article is accompanied by an intense photo of Manson looking Rasputin-like while sitting in court, along with pics of Atkins, Kasabian, Krenwinkel and Watson. Above it the blurb: "Satan and the four who are accused of killing Sharon: 'He instructed us to get our knives…'"

The piece relies on Atkins' testimony, saying that Melcher had made promises to Manson that he did not fulfill and that the Tate house was chosen because Melcher used to live there. Even though Manson knew Melcher had moved, he wanted to send a message to him.

The article is broken up by small bold headlines giving you a taste of what follows, using titles such as: "Long-building hatred" for Manson's history of incarceration; "Senseless, symbolic slayings" for the discussion of Tate and the others' deaths being connected to Melcher having lived there; "Object of hate unaware" describes how Melcher slept peacefully as the Tate victims were slaughtered; "How many more Manson slaves?" asks if Hollywood feels safe because Manson was arrested; "Claims tie-in with Deity" points to Manson's claim to be God and Satan at once; "Still fears for life" looks at Linda Kasabian who feared Charlie's thought waves; "Others marked for death" discusses stars who were randomly marked for death by the Manson clan; "A trial for Doris, too" discusses Doris Day's agony over her son's connection to the Manson trial.

NATIONAL INSIDER

☐ "Hypnotism Did Not Kill Sharon Tate!" claims the cover. Inside the related article is *Hypnotist Explodes Sharon Tate Murder Trance Alibi* by Lee Hewitt Witten, although the piece is mostly quotes from Ginger Court, PhD, who was a "medical hypnotist on call to prominent surgeons."

Some of Dr Court's statements are rather confusing, or at least ambiguous,

starting with her opening statement: "The Sharon Tate murders were not committed under hypnotism, although a similar situation is theoretically possible."

And:.

> Now as to the Sharon Tate killings. Could they be committed under hypnosis? They could, but not under normal conditions. They could not take place under conditions of stage hypnotism, nor even by a professional hypnotherapist under laboratory or hospital conditions.

What does that mean? Manson wasn't a stage hypnotist, nor was he practicing under laboratory conditions, and certainly not under normal conditions.

NATIONAL BULLETIN

☐ "Hippie Witness Confesses…Sharon Tate Gave Manson An Hour Of Love For Drugs" touts the cover with a photo of Sharon Tate superimposed next to Manson, made to look as if they are in the same photograph.

The concocted story, *Sharon Tate & Charles Manson Met One Month Before Murders* is the title of the centerspread feature by Sam Pepper. It alleges that someone called Rudi Cohen said he met Manson in the Haight eighteen months earlier and lived with the Family for approximately six months. Cohen claimed he witnessed Sharon Tate drive up to the ranch in a limo and go into Manson's "cabin" for an hour. He also said that one of the Manson girls told him that Tate was there "for her dope and some of Jesus' fine loving." The girl told him that she considered Tate "a member of the cult."

The writer asks, "What kind of man was Charles Manson?" The answer from Al Adamson, "a film producer who encountered Manson and his clan while shooting scenes

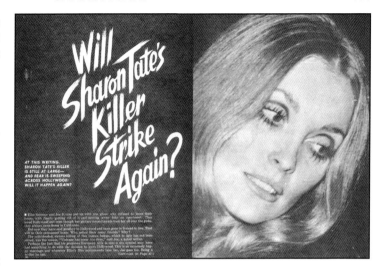

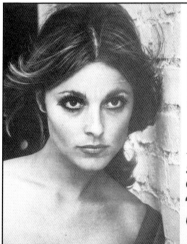

EXCLUSIVE!

Step-By-Step Confession Of The Killing: "I Wanted To Cut Sharon Tate Open And Take The Baby!"

near their California ranch," was: "He's a little man. We had to kick them off the set. They were bothering our actresses. These were literally little people. Dirty types. You see them all around southern California and you don't think much about it."

The rest of the piece purports that Manson's small stature drove him to impose his will on other people, especially his women. One of the actresses on Adamson's set is quoted as saying: "[Manson] was playing his guitar and singing to about a dozen starry-eyed and dirty looking young girls with long straggly hair who were squatting in a circle around him on the grubby ground."

The most amazing piece of incredulity is a hokey photo of twelve hippies sitting around (some dressed, some nude) on posh rugs and couches, the caption claiming: "Charles Manson talks to his brood while in movie ranch. Rudi Cohen joins in lecture." Two of the males in the pic have been circled, supposedly Manson and Cohen.

It ends with the observation: "It will be an irony of history if Cohen's story is proven to be true."

Above **TV RADIO MIRROR Mar 70.**
Opposte, from left **THE NATIONAL INSIDER Mar 22, 1970,** put Tate and Manson together on the cover, seemingly looking at each other; **NATIONAL BULLETIN Apr 6, 1970,** went one step further in putting Manson and Tate in the same picture and incredulously claiming they had known each other through drugs and sex.

UNCENSORED
Vol 19 No 2 Apr 1970
Nutrend Publications, Inc., 4806 Bergenline Ave., Union City, NJ 07087 .35 68pp

FATE
Vol 23 No 5 (issue No 242)
May 1970
Clark Publishing Co., 500 Hyacinth Place, Highland Park, IL 60035 .50 164pp

UNCENSORED

❑ This title gets your attention: *How Hitler's Murdering Nazis Haunt America's Kill for Kicks Hippie Cults*. Almost every word in the article has some sensational value. The opening page of the piece, by Antony James, features a large swastika and a photo of goose-stepping Nazis. On the next page is the blurb, "Sharon Tate Bloodbath Climaxed Orgy of Sex, Dope, Sadism & Devil-Worship." Underneath is a pic of a Spahn Ranch shack with inset pics of Krenwinkel and Watson.

A blurb running across the next two pages announces: "'Satan's Slaves' Saw Themselves as Founders of New White Master Race" with pics of Atkins, Manson, Sebring and Tate.

James pays tribute to Sharon Tate's breasts in the first sentence of the piece: "In **Valley of the Dolls** Sharon Tate played a beauty whose enormous assets that carried her to screen stardom were two incredibly large and beautiful breasts."

The article is filled with typos, and reprints a shoddily reported article by Paul Caruso, Susan Atkins' lawyer, from the Feb 70 issue of **UNCENSORED**—incorrectly sourced to the Feb 69 issue, which would have been before the murders even took place.

The reprinted text from the Caruso article is filled with inaccuracies about the crime and claims Tate and Sebring had been mutilated beyond the multiple stab wounds and gun shots, and that Sebring had a "sadistic streak" and "was also given to homosexual practices." The piece attempts to tell the story of Manson and his desert tribe roaming California, possibly leaving bodies in their wake, and quotes two writers: Max Lerner from the **NEW YORK POST** and William Federici from the **NEW YORK DAILY NEWS**.

Lerner comments:

The accused are all members of a "strange family," counting more than a score and held together by a reportedly hypnotic leader. They became a mobile cult-commune, moving on a converted school bus through Southern California and holding up in encampments from which they spread terror.

Federici's contribution:

It is not as though the 20th Century Nomadic tribe of mystical kill-oriented dropouts from society were unknown to Californians. They are the real hippies—the prototype. The others are pale imitations. The Nomads exist on what they can get from stealing, killing, blackmail.
Their existence has been known to California authorities for years. They have been feared by Californians for years. So stories of mass murders and weird, sadistic sex rites began to unfold as the result of the arrest of cultists for the murder of Sharon Tate and six others, Southern California police began a search for "untold graves of other victims of this tribe."

Not until the end of the article does the Hitler connection come into play:

But for every Munson [sic] there are others standing in the wings—and out of them will come what the Hippie world has been promising for a long time—an American Hitler.
The parallels are all too obvious. Hitler's early legions were as bedraggled as today's Nomad hippies. They were the social rejects of the time—homosexuals, drug addicts, the discontented. They had one common bond—hatred of the Establishment. And when they turned their energies toward anti-Semitism, they had it made.
Like the Nomads from the desert, Hitler's Storm Troopers caught the fancy of Germany's 'beautiful people.' The rich industrialists, the divorcees,

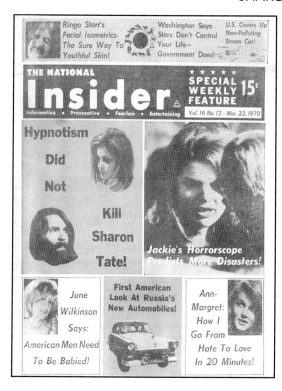

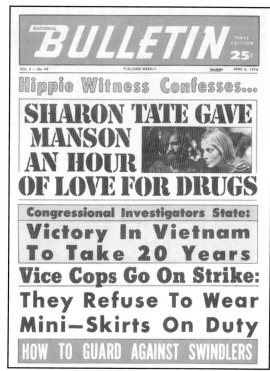

the widows with money—yes, even the movie people.

Hate is a popular commodity, and these strange young people appear to have realized it.

Living only for themselves, for their special self gratification they pose a threat to an orderly way of life as profound as any in the hands of science or in the minds of what might be considered, falsely, more sophisticated people.

FATE

☐ *Sharon Tate's Tragic Preview of Murder!* by Dick Kleiner relates the tale of Sharon Tate's run-in with the ghost of Paul Bern. The piece claims Sharon told him about the experience a year before her murder, when he interviewed her on a movie set. Kleiner said he made it a practice to ask all the celebrities he interviewed if they had ever

had a psychic experience. In response to the question, Sharon told him of an experience she didn't understand. He only understood it in hindsight after Tate's death.

About a year earlier, she had still been dating Jay Sebring who was living in Benedict Canyon—about one mile south of Cielo Drive—in a house that had once belonged to Hollywood agent Paul Bern, who entered the limelight when he married sexpot Jean Harlow. Harlow later walked out on him and he committed suicide in the house, although some have cast doubt upon whether it was suicide or homicide. Bern had reportedly beat Harlow and caused her liver damage that led to her death. There were also rumors that Harlow had died from a botched abortion.

At the time, Tate was inbetween apartments and didn't have a place to stay; Sebring had to go to New York to work out a franchising deal for his hair salons, and offered Sharon the use of his house, which she accepted.

The first night she stayed in the house

she had trouble going to sleep because of a "funny feeling," something internal. When she turned on a lamp she noticed "something stirring outside her bedroom door."

Sharon explained, "I saw this creepy little man. He looked like all the descriptions I had ever read of Paul Bern." The figure entered her room, moving rapidly and bumping into things, then left. Sharon put on her robe to go downstairs. She was shocked to find a figure—she couldn't tell if it was her or Jay Sebring—tied to the stairs with its throat cut. She "flew past" the gruesome sight and made it into the playroom, intuitively knowing where the bar was located, and found a button that revealed a hidden bar behind the bookcase. She poured herself a stiff drink and pinched herself to make sure it wasn't all a bad dream.

Starting back to bed, she still had to avoid the thing gurgling blood on the stairs and the "creepy little man" flitting about upstairs. Once in bed she immediately fell asleep.

Above **FATE May 70 told of Sharon Tate's encounter with the ghost of producer/screenwriter/director Paul Bern.** Opposite **UNCENSORED Apr 70 had a wonderful conglomeration of cover blurbs and Sharon Tate.**

NATIONAL BULLETIN
Vol 9 No 4 Jun 29, 1970

Summit Publishing Co., 234 Fifth Ave., New York, NY .25 20pp

NATIONAL ENQUIRER
Vol 45 No 7 Oct 18, 1970

Best Medium Publishing Co., Inc., 210 Sylvan Ave., Englewood Cliffs, NJ 07632 .15 32pp

NATIONAL TATTLER
Vol 13 No 16 Oct 18, 1970

Publishers' Promotion Agency, Inc., 2717 N. Pulaski Rd., Chicago, IL 60639 .15 20pp

NATIONAL TATTLER
Vol 13 No 20 Nov 15, 1970

Publishers' Promotion Agency, Inc., 2717 N. Pulaski Rd., Chicago, IL 60639 .15 20pp

Sharon awoke late the next morning to someone yelling, "Hey, Sharon, are you home?" which turned out to be Sebring, whose trip had been cut short.

Kleiner ended by saying, "Now it seems obvious. What could it have been but a preview of the horrifying drama to come?"

NATIONAL BULLETIN

❑ *Sharon Tate is Alive—Close Friend Sees her with Polanski in Brazil* by Tristan Pool claims that a "close friend" of Polanski and Tate, David Leyava, encountered the couple in Rio de Janeiro with a baby carriage! At first, Polanski ducked down a side street after recognizing his friend, but Leyava continued to pursue them to ascertain whether he was seeing ghosts or not. He finally cornered Polanski and the woman, who Polanski told him was Sharon's twin sister Carla!

Polanski explained that the murders shook them both up and that they had been spending time together since. Carla/Sharon didn't say anything.

Later, Leyava saw them again, eating dinner in a hotel dinning room, and when he asked the waiter to invite Polanski and friend to his table, the waiter replied:

Ah, you mean Mr. Polanski and his wife. They're regular customers of ours since moving into the hotel last year. They booked in here last June and have been staying here ever since. Mr. Polanski often has to go away on business trips but he always leaves his wife and son behind with us. We look after them well. After all, their young baby was born in this hotel!

Leyava gave up and left, with his head spinning, but without talking to the couple again. And, as the last sentence said, "Perhaps when Sharon decides to make an appearance the mystery will be solved."

This article may have been sparked by Polanski's relationship with Tate lookalike and Playboy playmate, Connie Kreski, not long after his wife's murder.

NATIONAL ENQUIRER

❑ Sharon Tate morphs into Connie Kreski on the cover of this **NATIONAL ENQUIRER** as the blurb under the pictures read "Polanski's New Girl Friend Is Sharon Tate Look-Alike."

In the half page item Polanski is pictured in the back of a car with Kreski, along with Hugh Hefner and his main squeeze at the time, Barbie Benton. It says: "Polanski has been seen dating a girl who looks enough like his slain wife to be her twin sister." Polanski had apparently been seen jetsetting all over Europe with Ms Kreski on his arm. The piece, written by Jim Whelan, informs us that Kreski told the **ENQUIRER** reporter she met Polanski through Hefner, and mentions nothing of her relationship with Jay Sebring (see **SCREENPLAY** v71 #12 Dec 69).

Polanski's globetrotting with a Sharon Tate doppelganger on his arm might have inspired the incredulous tabloid story that he had been seen in Rio de Janeiro with Tate and their new baby boy (see the **NATIONAL BULLETIN** v9 #4 Jun 29, 1970 above).

Kreski, it claims "was quite obviously entranced by and devoted to Polanski," not unlike Tate herself. She later became James Caan's girlfriend for a while. Kreski died of lung cancer in 1995; she was forty-eight.

NATIONAL TATTLER

❑ "Cops Goof On Sharon Tate Case—Coroner's New Twist Sharon Died By Hanging" is the pertinent cover blurb next to a photo of a pregnant Sharon Tate. Inside is one page with three items on Tate.

The first—*Cops Goof in Tate Case* by Paige Martel (who apparently wrote all three Tate items)—rightfully takes the LAPD to

task for their botching of the identification of the .22 caliber handgun found by ten year old Steven Weiss in the underbrush near his house. The gun remained in possession of the LAPD while they desperately looked for the murder weapon and any other clues to the identity of the perpetrators.

They finally got the message after Weiss saw a troop of Boy Scouts on the TV news, looking for the weapon in the hills near the Tate house, and called the police station to remind them of what they had all along. When the ten year old asked if they still had the gun, he was told they did and that he could have it back! Weiss explained that he thought the gun he found was the very gun they were looking for. It turned out to be the gun Watson had used in the murders but the police had smudged the prints on it.

The bottom line is it took the LAPD three months to figure out they had the murder weapon, and wouldn't have if not for ten year old Steven Weiss.

The second item on the page—*Now Coroner says Sharon's Death Caused by Hanging*—is a short piece concerning Coroner Thomas Noguchi, who changed his opinion about how Tate died. Originally he claimed the sixteen stab wounds had something to do with it, then changed his opinion due to the rope burns on Tate's neck and cheek, claiming she died from hanging. It is mentioned that Noguchi found MDA—"a potent amphetamine, known as a 'love drug'"—in both Frykowski's and Folger's bodies.

The third item—*2 Film Makers Rush Tate Movies*—informs the reader that two European producers—Mario Vincenti in Italy and Michel Garcon in France—had each rushed to put out movies on Sharon Tate's life and were in competition over it. Polanski refused to grant permission to either, but the producers simply changed the names of the characters. The tentative title of Vincenti's movie was **Magic Love** while Garcon's was **Night of Flowers**. The two apparently tried to stop each other's movies being released.

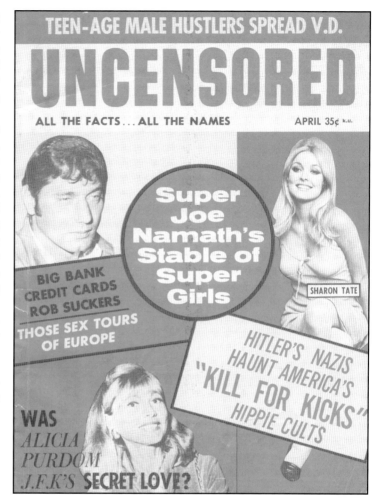

The item ends: "And no matter who wins, the public will have two awful movies to remind them of what happened to Sharon Tate."

NATIONAL TATTLER

☐ "Sharon Tate's Beauty Was Her Downfall" is the blurb on the cover inset. The issue has two articles of interest.

The first is *Next on Manson's Kill List—Tate Witness' Eerie Tale of Plot to Slay Liz, Dick, Frank* by Evart Alimine. It is another version of the revelations told by Susan Atkins to her cellmate—that Manson had a hitlist of celebrities to be tortured and murdered in an insane fashion.

Virginia Graham—Atkins' cellmate and blab recipient—is quoted relating the disfigurement of Liz Taylor's face as told to her by Atkins, who made it sound like some dreamy cosmic event:

She told me she knew how to gouge out people's eyes. She said she was going to take her knife and burn the end of it until it was glowing hot. She wanted to take it and put it on the side of Miss Taylor's face. Then she commented about the smell of disintegrating flesh, that it [the flesh] was going back to the elements, back

NATIONAL TATTLER
Vol 13 No 21
Nov 22, 1970
Publishers' Promotion Agency, Inc., 2717 N. Pulaski Rd., Chicago, IL 60639 .15 20pp

PHOTOPLAY ANNUAL 1970
Macfadden-Bartell Corporation, 205 East 42nd St., New York, NY 10017 .50 84pp

NATIONAL BULLETIN
Vol 9 No 29 Dec 21, 1970
Summit Publishing Co., 1199 Broadway, New York, NY 10001 .25 20pp

to infinity.

The piece ends on this noir note:

And now, in jaded Hollywood there's a new status symbol: if you aren't on the Manson-Atkins death list, you're a nobody.

The second feature of interest is *Tragedy of the World's Most Beautiful Girl!—Sharon Tate: In the Beginning!* which is uncredited and the first of a series of articles the **TAT-TLER** ran on Tate's life. Most of the first part relates her murder and the arrest of Manson and Family. The last few paragraphs give the details of Sharon's life, from her early beauty contest days in Texas to her time abroad in Italy.

It concludes with her finding an apartment in Hollywood and the agent Harold Gefsky, who was beside himself with Tate's beauty. Gefsky described the youthful Sharon as follows: "She was so young and beautiful I didn't know what to do with her. I think the first thing I did was to take her to a puppet show. Everywhere I took her she caused a sensation."

The next week's installment is advertised as: "Sharon becomes an actress and meets the father of her child Roman Polanski."

NATIONAL TATTLER

☐ "Sharon Tate's Road To Stardom—And Death" is the cover blurb for this second part of the above **TATTLER** series. Neither this nor the previous article mention how many parts the series was to be. At least three can be discerned from the "next issue" add-on at the end of this piece advertising the coming installment, *Sharon's love life and her romance with horror master Roman Polanski*.

The article inside is called *Sharon Tate: 'This is the Girl!'* by Kurt Steffen. The title refers to what Martin Ransohoff, head of Filmways, Inc., said upon seeing Sharon Tate for the first time on the set of **Petticoat Junction** when Tate was just eighteen years old. Ransohoff wanted to put some life back into the dying, if not dead, "grand old star system" by finding the right girl and turning her into a star; that girl turned out to be Ms Tate.

The writer, Steffen, tells it like it was, pointing out that Tate thought little of herself and that, "Strangely enough for a girl who had always been so exceptionally beautiful, Sharon just didn't believe in herself. So many people had told her she was beautiful that she placed no value on it."

There are quotes from two of Sharon's early acting coaches that shed light on how others saw her. One said of Tate: "She was an incredibly beautiful girl, but a fragmented personality." Another added: "Such a beautiful girl, you would have thought she had all the confidence in the world, but she had none."

Lloyd Shearer, a writer who had interviewed Tate, said of her: "Sharon Tate was a sweet, ambitious, under-educated, untalented girl." Shearer had also suggested to Tate that since she had been raised as an army brat, she should "consider giving up her career in favor of marriage to some hard-working second lieutenant..." At which, Tate scoffed.

Tate likened herself to her character, Jennifer, in **Valley of the Dolls**, fending off all who would think of her as nothing more than "a sexy thing."

The piece concludes with a kind assessment of Tate by movie critic Rex Reed:

Her honesty, her desperate drive to be herself, even if she sounds immature, has caused some writers to make a fool out of Sharon in print. I find her refreshing.

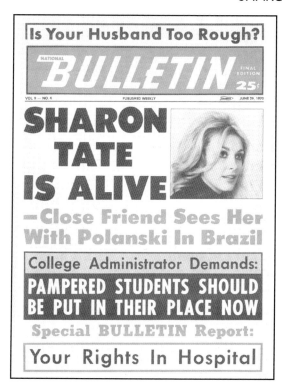

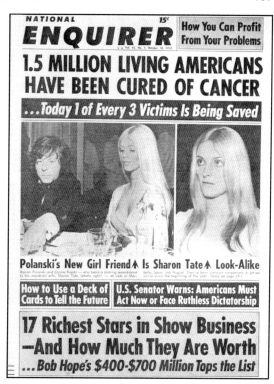

PHOTOPLAY ANNUAL 1970

☐ The cover of this 1970 Annual has pictures of the Lennon Sisters, Mia Farrow, Joan Kennedy and Mary Jo Kopechne, all the top stories of late 1969, and one of the blurbs reads: "Behind Sharon Tate's Tragedy: Group sex among the stars."

The World of Sex & Sin that Murdered Sharon Tate is nicely laid out, as is the entire mag, and includes some great pictures, but does not have a lot to say. It asks the question, "What kind of girl was she?"

The answer given:

Warm and friendly. A girl who used to laugh it off when men were stopped dead by her beauty. A woman who didn't think it a sin to have an affair provided it was for love. An intelligent but not intellectual person who trusted all and everybody. This last quality could have been her downfall.

After breaking it off with one time lover and fellow victim, Jay Sebring, and marrying Polanski, "Sharon was in the big time of blasts, drug parties, pot smoking and open house sessions. Perfect strangers were often invited to join in. In their world of 'love' they could see no evil and no hate."

Lastly, it is noted that after Sharon Tate's murder:

…it was obvious that her way of life was already too strong for her or that she was too weak for it, too innocent, too trusting, and perhaps, a shade too daring to know life even in its most forbidding aspects. A pall fell over Hollywood and the most jaundiced residents say it will be long before it's lifted.

The issue also has an article on Mia Farrow, *Married She Can Always Get*, which includes a shot of Sharon, Roman, and Mia walking along, side by side, in the

dark. It is a strange trio—Roman Polanski who brought us **Rosemary's Baby**, Mia Farrow who played the pregnant Satanic Madonna, and Sharon Tate, Polanski's new wife, murdered in her eighth month of pregnancy.

NATIONAL BULLETIN

☐ In the editor's column, *From the Editor*, the heading is "Susan's Tragic Story:" an explanation of why the **BULLETIN** was running the two part series on Atkins. The editor concludes:

Perhaps in reading this, you may recognize a little of your own daughter in Susan Atkins. And perhaps, by better understanding this tragic child of destiny, somewhere, somehow, a concerned parent may save his child from becoming another Susan Atkins.

Above **PHOTOPLAY ANNUAL 1970.**
Opposite, from left **THE NATIONAL TATTLER reveals that "Sharon Tate's beauty was her downfall" and deliberates on "Sharon Tate's road to Stardom—and death." Issues dated Nov 15 and Nov 22, 1970.**

NATIONAL BULLETIN
Vol 9 No 30 Dec 28, 1970
Summit Publishing Co., 1199 Broadway, New York, NY 10001 .25 20pp

THE NATIONAL CLOSE-UP
Vol 6 No 51 Dec 28, 1970
Beta Publications Ltd., 1440 St. Catherine Street, West, Suite 625, Montreal, Canada .25 20pp

*Manson Clan's 'Ugly Duckling' Susan Atkins tells her Story: 'I Can't Kill Sharon—You do it!' The Gushing Blood made her Sick, but not too Sick to Scrawl 'Pig' with it…*was Part One of *Susan Atkins' Story* by Sam Pepper.

Susan Atkins' words were used for the title of the article—*Tex, I Can't Kill Sharon… You do it*—on the vampiric murderess. Atkins changed her story more than once; she at first confessed that she did kill Tate and then changed the story to blame Watson. Atkins is pictured on the cover, as is Sharon Tate, posing in front of a Rolls Royce.

The article claims that Atkins was the misfit of the Manson Family, the "ugly duckling." It said this was the reason Manson nicknamed her Sadie Mae Glutz.

In the piece you are treated to quotes from Atkins, Manson, and Edward John Atkins, Sadie's biological father—as opposed to Manson, her self-adopted daddy guru.

It opens with Atkins' shocking description of the murder:

I held on to Sharon's arms and said, 'Tex, I can't kill her. I've got her arms. You do it.' So Tex stabbed her—in the heart. Again and again.
I could hear the blood gurgling inside her. It wasn't a pretty sound. I reached down and turned my head away. With the towel I touched her chest to get some blood and I went to the door and wrote "pig" in blood.

Then the piece quotes Atkins explaining her feelings for Manson: "He gave me nothing but love, complete love, and he gave me answers to all the questions I ever had in my mind."

The quotes from Manson on Atkins aren't so kind:

She was the kind of girl who wanted to be something she wasn't. And I told her, 'Sadie, you got to be yourself.' But all those pretty girls were with me, making love to me, and she felt that if she made love with me she would be pretty like they were.
I only made love to her three times. She was pregnant most of the time I knew her and once a girl is pregnant, there isn't any use to make love to her, dig?
Anyway, she had these breasts that hung down to her waist and I'd look at the line of girls waiting for me and I just couldn't do it with Sadie.

Edward J. Atkins said of his daughter: "I loved her, I still do. My daughter did some very beautiful things. But that was a long time ago. I don't know what went wrong. I guess I never will."

Apparently things started going wrong for Atkins at age fifteen when her mother died of cancer. Atkins wandered around the Northwest and was arrested for car theft in Oregon at eighteen. She headed south and became a go-go dancer in San Francisco, until she met Manson in Haight-Ashbury in 1967. The piece ends with a quote from Atkins talking about the night of the murders: Manson's reason for having them committed was "to instill fear into Terry Melcher."

Sam Pepper concludes: "And before the night ended former choir girl Susan Atkins would become a principal in one of the most bizarre and brutal mass murders on record."

NATIONAL BULLETIN

☐ *Susan Atkins' Story—Part 2—'Let Me Have My Baby,' Sharon Tate Pleaded 'Kill Her!' Snarled Tex* is again by Sam Pepper. This second part picks up from the first with a quote from Atkins about the night of the Tate murders when Tex Watson shot Steve Parent right after the four Mansonites went over the fence.

Atkins said of the inhabitants of the Tate house that night: "God's game ended for them."

The rest of the one page article is Atkins describing the unfolding of events that night. It would seem that Manson had good reason to be concerned, after tying up the LaBiancas, as this quote from Atkins demonstrates:

One of the ladies cried, "What are you going to do with us?" and Tex said, "You're all going to die."
This caused immediate panic. Tex ordered me to kill the big man on the couch. I went over to him and raised my knife—and I hesitated.
And, as I hesitated, he reached up and grabbed my hair and started pulling it. So I had to fight for my life. I remember thinking, wow! I'm actually fighting for my life.

Here, Atkins changed the reason for the murders slightly, not mentioning Melcher and saying it was "to instill fear in the Establishment" and "To show the black man how to go about taking over the white man."

THE NATIONAL CLOSE-UP

❑ "Manson Trial Defendant Brags 'I Drank Sharon Tate's Blood'" screams the cover headline, appropriately juxtaposed with the story *Life Inside a Female Penitentiary*, a harbinger of things to come for Susan Atkins.

The article, *Susan Atkins Brags...I Drank Sharon Tate's Blood* by Jay Warren is another rehashing of her story told to cellmate Virginia Castro aka Virginia Graham. Again, the quotes are taken from the book **The Killing of Sharon Tate** as in the two issues of **NATIONAL BULLETIN** above. All these articles seem to stem from the release of that book in 1970.

Here, Atkins is quoted saying, "I decided to snitch because my conscience wouldn't let me keep quiet." But the article gives Atkins' original story she told cellmate Graham,

which differed in the fact that at first she said *she*—not Tex—had killed Sharon Tate.

Susan Atkins:

Sharon was the last one to die. When Tex came back he said 'Kill her,' so I took my knife and plunged it into her stomach, again and again.I bet I can tell you something that will blow your mind. It was like a drug. The more I did it, the more I liked it. I couldn't stop. Wow! I was really into it. It was better than having a climax. What a crazy trip. It was life and death mixed up together.

Atkins on drinking Tate's blood: "I put my fingers in it. The blood was warm and sticky. I could hear it gurgling. Wow! That's what they call a death rattle. I drank it. It was salty. What a trip!"

Wrapping it up, Atkins said, "We going to teach a lot of people a good lesson. Because they have to be purged. They have to learn. Charlie said so. So it must be so."

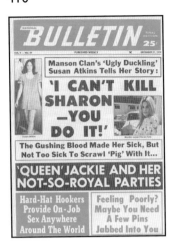

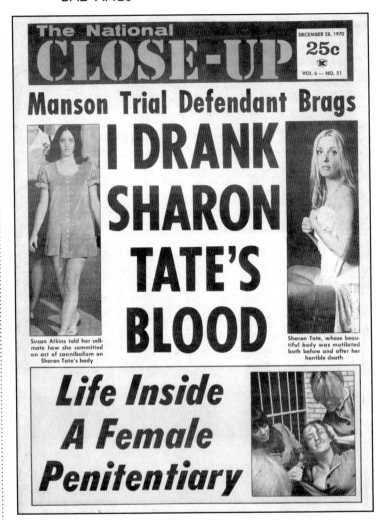

Susan Atkins told her cell-mate how she committed an act of cannibalism on Sharon Tate's body

Sharon Tate, whose beautiful body was mutilated both before and after her horrible death

Above **Susan Atkins was dubbed the Manson family's "Ugly Duckling" on the cover of NATIONAL BULLETIN, Dec 21, 1970.** Right **The cover of THE NATIONAL CLOSE-UP Dec 28, 1970, leaves little to the imagination.** Opposite **Two foreign language magazines featuring Sharon Tate: O SECULO ILUSTRADO (#1651) Aug 23, 1969 and PLATEIA (#420).**

W

W

Vol 30 No 8 Aug 2001
Fairchild Publications Inc., 6300
Wilshire Blvd. Suite 720, Los Angeles,
CA 90048 3.95 214pp

❑ "Exclusive—The Long-Lost Photos of Sharon Tate." Sharon's beauty again haunts us in the Aug 01 issue of **W** magazine with a feature entitled *Tate Gallery*, a collection of never before published intimate portraits taken by the late, eccentric nudist photographer Walter Chappell. The feature brings Tate's image full circle from the initial Mar 67 **PLAYBOY** feature, *The Tate Gallery*, which brought her to the attention of so many.

The story behind the photos and Chappell's long, platonic relationship with Tate—and his eccentric nudist tenden-cies—is actually of more interest than the portraits themselves. For the most part, the portraits were close-up studies of Tate's intensely beautiful face.

In 1964, Chappell was an obscure, reclusive photographer who had done some photos for various nudist mags published by Elysium. Then he was hired to take still photos on the set of the Martin Ransohoff-directed film, **The Sandpiper** (1965), starring Liz Taylor and Richard Burton, in which Tate had an uncredited bit part. At that time, Ransohoff had hired Chappell to shoot some photos of Tate for a publicity portfolio.

Chappell spent a few days with Tate in

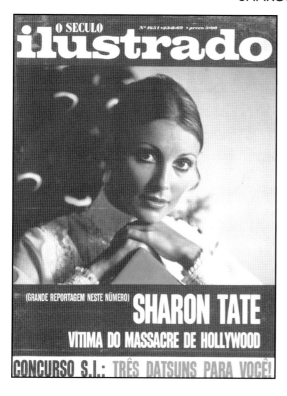

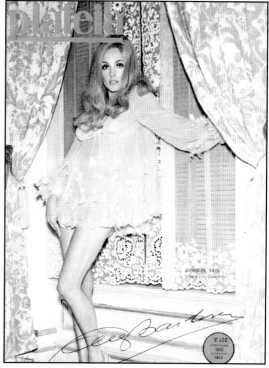

Big Sur—she was twenty-one—and shot the photos that acted as time capsules of the early sixties. Chappell and Tate reportedly bonded instantly, and their rapport was such that she felt at ease taking her clothes off for Chappell's lens. When Ransohoff told Chappell to hand over the negatives, he refused, which was probably the reason they were never used. Chappell put them away and told virtually no one about them.

Chappell kept in contact with Tate through the years, though how closely was not exactly clear. He was summoned again to photograph her in February 1969 by Sharon herself, to capture her happiness after finding out she was pregnant. Of the photos that resulted from that shoot, art dealer Andrew Roth said, "It's like she's turning into a star, and she's posing. She's controlling how she wants to be seen, so he couldn't make good pictures."

Chappell was a nudist and, according to Linda Piedra, his companion for the last years of his life, his nudism was a result of an experience he had had in the army at age nineteen when he was a prisoner of war and kept in solitary confinement, naked. This, he claimed, opened his senses to "the altered states of consciousness that are possible to achieve directly through the skin." Diving naked into the snow every morning for his "snow bath" was one of his many eccentricities. Chappell was also a follower of the Armenian philosopher and spiritual teacher, George Ivanovitch Gurdjieff.

When art dealer Roth showed up at Chappell's home in New Mexico in 1999 to look over his work, he was shocked when Chappell met him at the front door naked. Roth's description of the photographer:

He was a very tall guy. He had long white hair, like an old hippie. The flesh was just hanging on his skeleton—he was at that age. And he had a big, sort of woman's butt, kind of funny, and the only thing he wore were these cock rings, and little slippers when he went out into the woods.

Chappell would meditate during which he would sometimes take self portraits of his genitals in various states of repose. In 1962 one of these self portraits, in which he had an erection while holding his small son, was confiscated in both California and Maine and he was brought up on obscenity charges that were, however, not upheld by the court.

But for all his quirks, Chappell stayed loyal to his platonic love, Sharon Tate, and kept her photos from public scrutiny even after her murder. After his death from complications due to lung cancer in August 2000, his heirs finally consented to let the photos of Tate go on exhibition for sale, fetching up to $15,000 for single prints and $90,000 for the portfolio of fourteen prints.

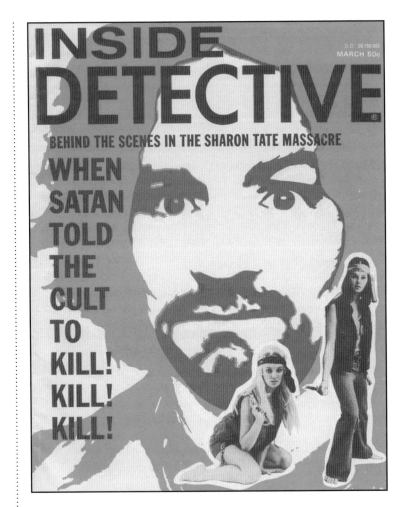

THIS IS A DIVERSE LISTING OF SOME of the many features and articles on, or related to, Charles Manson and his "Family" and their crimes as reported in the magazines and tabloids, including a few obscure publications, spanning thirty years. It is by no means complete, and is limited to the publications I am aware of and/or had access to copies of. Hopefully it will act as a guide for those interested in the subject matter and will inspire others to fill in more information on other publications not listed.

Manson was commonly referred to as "Satan" by some of his followers and the press, as can be seen on the *National Enquirer*'s earlier covers, as well as local papers around the country such as the *N.Y. Daily News*, and in some of the tabloids and mags that follow. Some of Manson's girls referred to themselves as "Satan's Slaves," also the name of an outlaw motorcycle club with a San Fernando

Valley chapter that Manson was supposed to have set his sights on for enlistment in his apocalyptic desert attack battalion, a plan which didn't pan out. The Satan's Slaves MC was formed in 1960 and was friendly with the various Hell's Angels MC chapters in California, which led to the club becoming the San Fernando Valley chapter of the HAMC in the later part of 1977.

It is interesting to note that Manson and Family lived in Canoga Park at 20910 Gresham St. in January and February 1969, which put them within blocks of many of the larger publishers of the adult slicks at the time. It's a wonder that some of Manson's girls didn't end up posing for some of the magazine photographers as they were known to turn tricks and dance topless on occasion when money was tight. Catherine "Gypsy" Share did play a nude Indian squaw in the sexploitation film *The Ramrodder*, in which Bobby Beausoleil also had a part playing an Indian brave.

In Ed Sanders' book, *The Family*, he mentions that Manson tried to get his girls into the topless clubs as dancers through Jack Gerard and his Gerard Agency who were to act as their agents. Gerard was not impressed with the scant breasts of the girls and offered to get them silicone injections, which they refused. This may have been the John Gerard listed as editor of *Adam* magazine in the late sixties.

It is also ironic that Manson and crew were living in Canoga Park when the Jan 69 issue of *Movies International* (#7) titled *Horror Fantasy* was published, also from Canoga Park. The irony being that it featured Sharon Tate on the cover and inside posing in provocative semi-nude shots on a bed.

In Bugliosi's book *Helter Skelter* he quotes Paul Watkins as saying:

...we all moved into the Gresham St. house to get ready for Helter Skelter. So we could watch it coming down and see all of the things going on in the city. [Charlie] called the Gresham St. house 'The Yellow Submarine' from the Beatles' movie. It was like a submarine in that when you were in it you weren't allowed to go out, you could only peek out of the windows. We started designing dune buggies and motorcycles and we were going to buy twenty-five Harley Sportsters...and we mapped escape routes to the desert...supply caches...we had all

these different things going on.

In the book's infamous "Sleazo Inputs" chapter, he writes:

Manson used to hang out on the Sunset Strip using the name Chuck Summers. There were a bunch of sleazo bars and cafes on or near the Sunset Strip with names like the Galaxy Club, Omnibus and The Melody Room that Chuck Summers frequented in 1968. Bikers, prostitutes, petty criminals and porn models flocked to these clubs.

The house band for the Galaxy Club at the time was Iron Butterfly.

Seven Seventy Publications and Press Arts often used photos of the hippies and bikers from the Sunset Strip/San Fernando Valley area, taken out on the street in the environment from which they came. In fact, some of the same outlaw biker clubs mentioned by Sanders were among the clubs pictured in many of the photos from these exploitation mags, identifiable by their jacket patches or "colors," or named in the text itself. Pendulum and Gallery Press culled some of their nude models from the same Sunset Strip scene, using the hippies and bikers in posed softcore photos.

Sanders goes on to write:

The Galaxy Club was located up the street from the Whiskey A Go-Go. Manson probably met the bike club, Jokers Out of Hell, at the Galaxy. Some of Manson's lesser-known girl friends, with names like Mouse and Venus, were also frequenters of these establishments. ...Sunset Strip seems to be where Manson first made contact with the satanic variety of bike groups, with names like The Satan Slaves, The Jokers Out of Hell, The Straight Satans, The Coffin Makers and other snuff oriented groups of young men. It is undeniable that an increasing contact with some of these clubs with hellish names would create great violent 'reflections' in Manson. With some of the groups like Straight Satans and particularly The Satan Slaves, Manson had deep association during the following year of violence.

Sanders seemed to be saying these clubs were "Satanic" just because of their names and didn't seem to be able to get the names quite right either: "The Coffin Makers" were actually The Coffin Cheaters. The Satan's Slaves turned down

Page 412 **A good Manson cover on INSIDE DETECTIVE Mar 70.**

This page, above **Ralph Nader, Black Panthers and Manson in TIME Dec 12, 1969.**

TIME
Vol 94 No 24
Dec 12, 1969
Time, Inc., Rockefeller Center, New York, NY 10020 .50 112pp

NEWSWEEK
Vol 74 No 24
Dec 15, 1969
Newsweek, Inc., 444 Madison Ave., New York, NY 10022 .50 124pp

LIFE
Vol 67 No 25
Dec 19, 1969
Time, Inc., Rockefeller Center, New York, NY 10020 .40 88pp

Manson's advances and offers of willing young ladies in exchange for their enlistment in his apocalyptic desert army. Manson had slightly better luck with the Straight Satans, a smaller, less well known club. Only a few of the Straight Satans regularly hung out at the Spahn Ranch; the mainstay was Danny De Carlo. To what extent Manson convinced the motorcycle club as a whole of his philosophy of an impending apocalypse has been somewhat clarified by De Carlo who said:

My club brothers—they'd come up there to visit and Charlie would sit down there and run this thing down to them about tearing society apart, and they thought he was nuts and figured he was brainwashing me and they came up here that night to get me, and they were going to take him and wad him up in a rubber ball.

Obviously, Manson and the tangential concerns of the crimes, trials and tribulations of those involved, were covered in hundreds of newspapers and magazines worldwide; I have focused on the American magazines and tabloid newspapers, with a few from Europe thrown in. The articles and features in these diverse publications range from the well written highbrow, to the scurrilous, and some just plain funny tabloid drivel; most of them fall somewhere inbetween.

Taken chronologically, the magazines and tabloids give a better view of the press reaction to, and coverage of, Manson and the trials and his grow-ing mythos through the later decades.

If you'll notice the dates below, 1970 was *the* year for Manson in print. Even though Manson was arrested in October 1969, he and the Family were not exposed to the public at large as the suspects in the Tate/LaBianca murders until December 1, 1969; therefore, most publications didn't get him into print until the early months of 1970. The weekly magazines, *Time*, *Newsweek*, and *Life*, got out issues in the middle of December 1969 but only *Life* chose to use Manson as coverboy, as did a few of the tabloids. The earlier magazines and tabloids on the murders, before the arrests of Manson and crew, are listed in the preceding chapter on Sharon Tate.

TIME

☐ Ralph Nader and "The Consumer Revolt" is featured on the cover of this issue of **TIME** magazine. Strangely enough the article preceding the Manson piece in *The Nation* section is on "Race" and subtitled *Police and Panthers at War*: the "lethal undeclared war between the police and the Black Panthers."

Since the beginning of 1968 twenty-eight Panthers had been killed in shoot-outs with the police, the latest two being Fred Hampton and Mark Clark, shot in an apartment on the West Side of Chicago. After the raid that killed the two and wounded four other Panthers, the police claimed the Panthers had fired at them first; the evidence suggested otherwise.

The Demon of Death Valley is the main, uncredited, article on Manson and Family, and presents the facts of the case

as known at the time, courtesy of Susan Atkins' jailhouse gossip/confession and the police press conference held a week before this article came out.

To quote the article:

Last week Los Angeles police announced that they had solved the five murders and three others as well. If they are correct, the alleged murderers were even stranger and more bizarre than their crimes. The police case was based on the tale of an accused murderer, Susan Denise Atkins, 21. She sketched out a weird story of a mystical, semi religious hippie drug-and-murder cult led by a bearded, demonic Mahdi able to dispatch his zombie-like followers, mostly girls wearing hunting knives, to commit at least eight murders and, police say, possibly four others.

There is a boxed-in feature at the end called *Hippies and Violence*, also uncredited. It is illustrated with a page of Manson's courtroom doodles, or "disoriented scribblings," which psychiatrists then went on to explain were indicative of "a psyche torn asunder by powerful thrusts of aggression, guilt and hostility."

In the first part of the piece Dr Lewis Yablonsky says of the hippie movement: "Hippiedom became a magnet for severely emotionally disturbed people'" and called them a "lonely, alienated people."

Yablonsky also comments:

They have had so few love models that even when they act as if they love, they can be totally devoid of true compassion. That is the reason why they can kill so matter-of-factly. There has always been a potential for murder. Many hippies are socially almost dead inside. Some require massive emotions to feel anything at all. They need bizarre, intensive acts to feel

alive—sexual acts, acts of violence, nudity, every kind of Dionysian thrill.

Manson's doodles are discussed by psychoanalyst Dr Emanuel F. Hammer, who saw them *without* knowing they were drawn by Manson, and psychologist Dr Harry O. Teltscher, who knew Manson had drawn them.

Dr Hammer claims the drawings reflect "an inner tension that is jampacked with jarring elements. The drawings hit you like chaos on the part of the mind that drew them." The drawings also show "a lack of respect for the integrity of things" and "attempts at control over aggression." Dr Hammer says of Manson's "armless beings," they "are goonish and ludicrous, which may show a demeaning and devalued view of people."

Dr Teltscher says of the drawing: "This whole drawing looks like part of the universe. Ofttimes, paranoid-schizophrenics identify themselves with cosmic situations." Dr Teltscher also found "repressed anger and hostility against all mankind" in Manson's artwork, and states that the murders were Manson's "way to express his anger."

NEWSWEEK

☐ In this issue of **NEWSWEEK** with "The Dazzling New York Knicks" on the cover, the mag chooses to characterize the Manson case as the *Case of the Hypnotic Hippie*. It seems appropriate enough, although Manson claimed he was not a "hippie" but a "slippie." In the uncredited article, Manson is also referred to as "a silken-voiced nouveau guru with an Old Testament beard, the eyes of Rasputin and a line of mystic patter that mixed the Beatles with Scientology" and as "a bearded, wild-eyed Svengali" who headed a "mystical traveling commune, 'The Frigate Family.'"

The **NEWSWEEK** writer makes an interesting observation when he writes: "The tale

seemed a cross between Nathanael West and **Easy Rider**, an incredible yet compelling vision of the darker side of contemporary American life." The piece perceptively characterizes the motive as being Manson's "perverse desire to punish the affluent." The have-nots against the haves.

The piece is illustrated with photos of Manson being led to court, a pregnant Sharon Tate, Atkins, Krenwinkel, Kasabian, Tex Watson before (clean cut Texas lad) and after (crazed wild-eyed hippie), and the Spahn Movie Ranch.

In the article it claims Manson referred to himself as the "hymie" of the Family, a leader who was not a leader, typical Charlie-speak, as no sense made sense.

The eight subheadings in the article: "Rasputin," "Submerged Father," "Dropouts," "Movie Ranch," "Purged Pigs," "Creepy Crawlers," "Sidewinders," and "Angel's Voice." All of which are fairly self explanatory for those familiar with the case, and the "Angel's Voice" referred to a quote from Sandy Good who had said of Manson: "He would write songs for us and he would sing all the time. He had the voice of an angel."

The article right after the Manson piece in the *National Affairs* section of the mag is *The Panthers: 'Shoot it Out'*, and is basically the same info as in the previously mentioned **TIME** magazine article, *Police and Panthers at War*.

LIFE

☐ This was the first magazine cover to feature Manson's hypnotic stare, captured in a mugshot taken on Apr 22, 1968 for a car theft charge, some claiming that Manson was on LSD when it was taken. In any case, it became the quintessential portrait of him for the country and the world at the time, and was also used on the cover of his LP **Lie**, recordings that were pressed and sold to help fund his legal defense, which they

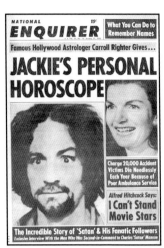

NATIONAL ENQUIRER 15¢ What You Can Do to Remember Names

Famous Hollywood Astrologer Carroll Righter Gives...

JACKIE'S PERSONAL HOROSCOPE

Charge 20,000 Accident Victims Die Needlessly Each Year Because of Poor Ambulance Service

Alfred Hitchcock Says: I Can't Stand Movie Stars

The Incredible Story of 'Satan' & His Fanatic Followers
Exclusive Interview With the Man Who Was Second-in-Command to Charles 'Satan' Manson

Above **NATIONAL ENQUIRER Jan 11, 1970, was Johnny-on-the-spot with Steve Dunleavy reporting on the Manson case early on.** Opposite **LIFE magazine Dec 19, 1969, featured this most famous Manson cover and was where most Americans first read the story of the "hippie" Svengali and his teen girl "slaves."**

NATIONAL ENQUIRER
Vol 44 No 19
Jan 11, 1970
Best Medium Publishing Co., Inc.,
210 Sylvan Ave., Englewood Cliffs, NJ
07632 .15 32pp

didn't as the album sold poorly.

"The Love and Terror Cult" announces the cover blurb, while the contents page lists the article as *The Monstrous Manson 'Family'*. Turning to the feature itself, the title is *The Wreck of a Monstrous 'Family'* by Paul O'Neil, but also has an opening paragraph of credits for reporting done by nine **LIFE** correspondents and stringers from California, Chicago, Texas, Alabama and Boston.

"Flattery, fear and sex lured his girls into a sisterhood of exploitation," reads the first heading. The article starts with two dramatic full page b&w photos, one of Susan Atkins leaving court and the other of Charles Manson in court, the blurry images of "Squeaky" Fromme and another girl, possibly Nancy Pitman, seen smiling over his shoulder in the gallery.

When reading the article it is important to keep in mind that it was the first, and most widely read, national account of the people charged with the mass murders in Los Angeles. It is well written and informative, and includes many photos, several of which were rare—three girls in Manson's command dune buggy in 1968; Susan Atkins in a flowered bikini top laughing, taken by an amateur photographer, also from 1968; and various shots inside the Spahn and Barker Ranches of which Manson and Family were denizens.

The article wastes no time in revealing Manson's techniques of "flattery, fear and sexual attention" as "methods used by every pimp in history." This explains Manson's successful assimilation into the hippie milieu that was Haight-Ashbury in 1967, after his release from prison. It also explains the childhood that led him there.

"A 'roving minstrel' from reform school," is the heading on the next page, which juxtaposes photos of a clean cut Manson in suit and tie, taken in 1949, with the bearded, wild eyed Manson dressed in handcuffs and a jailhouse jumpsuit twenty years later.

Short descriptions of Watson, Kasabian, Atkins and Krenwinkel, who they were and

where they came from, are included. The article concludes with Manson's apocalyptic visions fueled by LSD and biblical revelations—but the Beatles are not yet mentioned as an influence. Also not mentioned in the article is the second night of murder at the LaBianca's, which is only alluded to in the caption accompanying a photo of "Leslie Van Houghton [sic]."

The end of the article discusses the lifestyle of Manson and his crew at Barker Ranch, their plans of escaping into the desert when Armageddon arrived, and the group's capture not long after they moved there. It states that the Manson women, once jailed, had to be forced to wear clothes in their cells and would yip like coyotes in reply to Manson's own yips from his cell.

There is also a sidebar within the article, "A doctor and a parole officer remember Manson," in which Dr David Smith, founder of the Haight-Ashbury Free Clinic, and Dr Roger Smith, Manson's parole officer at the time, relate their firsthand knowledge of Manson and his girls. Dr David Smith offers the opinion that the "common denominator" of Manson's hold on the women was, "Sex, not drugs." He also states that Manson "would probably be diagnosed as a schizophrenic, but ambulatory schizophrenics were very much looked up to in Haight-Ashbury because they could hallucinate—without drugs." Dr Roger Smith says of Manson: "They talk about the hypnotic kind of state he was able to produce. Always in the back of my mind I felt he was a con man. Charlie's rap was always a little bit too heavy, a little bit too polished."

NATIONAL ENQUIRER

☐ *The Incredible Story of 'Satan' & his Fanatic Followers—Exclusive Interview with the Man who was Second-in-Command to Charles 'Satan' Manson* by Steve Dunleavy—the same Australian-born Steve Dunleavy who currently writes a column for

the **NEW YORK POST**, and helped create the genre of "tabloid TV"; he was also a well known inebriated carouser around town, known for being willing to go to any lengths for a story, who some have dubbed "the Keith Richards of tabloid journalism."

The two page centerspread, one of the earliest tabloid pieces on Manson, includes some rarely published photos. It is based on an interview that Dunleavy conducted at the Barker Ranch with a nineteen year old Paul Watkins, who "revealed the innermost secrets of the grotesque cult" and is quoted throughout. Watkins said he met Manson in April 1968 when he "was wandering in the Malibu mountains and found a hippie house," inside which was a "wild-eyed" Manson standing behind six naked girls. Manson told him to "Take any of these girls. They're all yours."

Watkins claims to have saved his own life by escaping Manson's control just in time, along with Brooks Postin, and the help of Paul Crockett, all three of whom are pictured. Crockett had studied Scientology and used some of its techniques to free Watkins and Postin from Manson's mind control. Dunleavy points out that the three of them were added to a "list of 11 future murders" that included Warren Beatty and Julie Christie.

In the article, Manson is referred to as "Satan" and the girls as "Satan's Slaves," also the name of the outlaw motorcycle club often connected to Manson, rightly or wrongly.

Watkins told of bringing "five or six young girls a week, aged anything from 15 to 21," usually using stolen cars to transport them to Charlie. Watkins also discussed Manson's fondness for animals over humans:

While the women were treated like dirt in the camp, the dogs were given the real good treatment. ...First the dogs would eat, then the men would eat whatever was left over from the dogs, then the women would get whatever

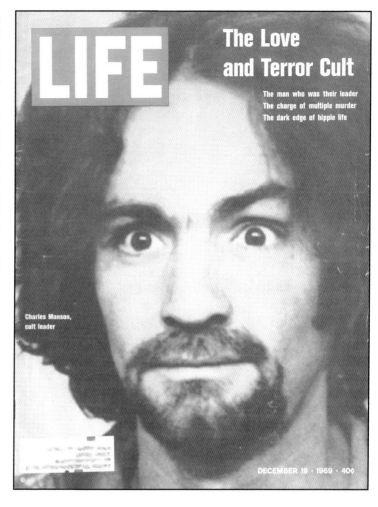

The Love and Terror Cult

The man who was their leader
The charge of multiple murder
The dark edge of hippie life

Charles Manson, cult leader

DECEMBER 19 · 1969 · 40¢

was left over from the men. ...I remember sometimes for an hour at a time Charlie would look into the face of his dogs, feeling their teeth and saying crazy things.

Of Manson's power over others Watkins said:

Everywhere he went he got this suicidal loyalty from everyone: He was big on Scientology and black magic.He picked it all up in San Francisco. It was pretty powerful stuff. He was continually hypnotizing us, not the way they do at nightclubs but more like mental thought transference.

Watkins eventually wrote his own book, **My Life with Charles Manson**, and went on to make appearances on **Larry King Live** and various other TV tabloid shows in the late eighties. Watkins died on August 3, 1990.

Another small item of interest in the issue is *Psychic's Tate Murder Predictions were Accurate* by Thomas Knowles, which concerns itself with the psychic predictions that Chicago hairdresser Joseph DeLouise made about the Tate murderers two weeks after the crime occurred. DeLouise reportedly had made other prescient predictions about train wrecks and plane crashes before they happened. DeLouise can also be found in the **NATIONAL INSIDER** Aug 1,

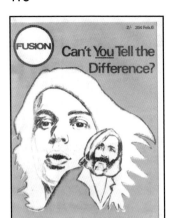

Above **FUSION** was a hip local Boston underground paper that featured articles by "acid-fascist" Mel Lyman on occasion. The cover of FUSION #26 Feb 6, 1970, juxtaposed Mick Jagger and Manson. Opposite Heading for *His Satanic Majesty?* article by Peter Beren in FUSION #26.

MIDNIGHT
Vol 16 No 28
Jan 26, 1970
Midnight Publishing Co., 1440 St., Catherine St. West, Montreal, Canada .15 20pp

FUSION
No 26; Feb 6, 1970
New England Scene Publications, Inc., 909 Beacon St., Boston, MA 02215 .35 36pp

NATIONAL INSIDER
Vol 16 No 6 Feb 8, 1970
National Insider, Inc., 2713 N. Pulaski Rd., Chicago, IL 60639 .15 24pp

1971 (see page 448), in a series of articles excerpted from his book **Psychic Mission**.

The predictions DeLouise made concerning the Tate murders were originally made to a reporter from the Long Beach, California, newspaper **PRESS-TELEGRAM** and ran in their August 21, 1969 issue, DeLouise having predicted that: "This was a thrill murder…their joy was killing…they have no conscience. They don't feel sorry about it. They are excited about it."

MIDNIGHT

☐ **MIDNIGHT** started out as a local tabloid in Montreal in 1954 and by the 1960s was the **NATIONAL ENQUIRER**'s largest competitor.

"Hushed Up By Authorities: Names of 9 Hollywood Stars Marked For Death By Sharon Tate's Murderers" is the headline on this issue, but the names are not hushed up by **MIDNIGHT**: they name six of the stars and include pictures of the threatened performers, including John Wayne, Bob Hope, Raquel Welch, Joey Heatherton, Bing Crosby and Nancy Sinatra.

The article *Authorities Reveal Gruesome Plan…Tate Killers Plotted to Murder 9 More Hollywood Personalities* by Stephan David, claims the beef that Manson and his "hippie cult" had with the named stars was over their support of the Vietnam War, showing pics of Bob Hope and Raquel Welch entertaining the troops, and a pic of a solo Nancy Sinatra doing the same.

The article adds to the general paranoia:

The names of the intended victims were not to be released because of the recent arrests, but police fear that other members of the hippie-type gang may still be at large and attempt to carry out the additional executions that were planned despite the arrest of their leader.

Also mentioned is an unspecified reward offered by three Hollywood stars—Yul Brynner, Peter Sellers and Warren Beatty—for the arrest of Sharon Tate's killers.

FUSION

☐ This semi-underground rock music tabloid from Boston has a drawing on the cover of a large Mick Jagger and a smaller Charles Manson, asking: "Can't You Tell The Difference?"

Editor Robert Somma, in his editorial, links the Tate/LaBianca murders and Altamont, as well as Manson and Jagger. The question posed: "Interested in the self-righteous and the pious? Try this: 'Are Mick Jagger, Sam Cutler, Emmit Grogan and Rock Scully any less guilty of that black man's death than Sheriff Madigan of the death of James Rector?'" Then: "Is Mick Jagger any less guilty of the murder of that black man than Manson of the death of Sharon Tate?" Somma himself answers:

I don't think Jagger is a murderer any more than I think that he really understands what this country is all about. And I doubt very much the parallel between Sheriff Madigan and those responsible for Altamont occurring when it did and how it did really holds much water.

This obviously came out before the rest of the world would see **Gimme Shelter**, the documentary film of the Rolling Stones' 1969 Tour. Helter Skelter and **Gimme Shelter**, hell, it even rhymed! The one person who never got blamed for the death at Altamont is the one who died: Meredith Hunter—the black man waving around a handgun in front of the stage! What did he expect, a welcoming committee?

The article titled *His Satanic Majesty?* by Peter Beren, is a good example of the counterculture's reaction to Manson, who

had caused it to stop, look, and listen.

The intro blurb reads:

Charles Manson has been invariably described as a natural product of the culture, what you get when you cross a groovy subculture with a brutalizing system. Our national press feeds on images borrowed from our popular entertainment. Did the Stones supply a way to explain away this current horror?

At first, Beren argues that the sixties produced two "perverted geniuses" or "arch-villains" in the Zodiac Killer and Manson, as counterpoints to such geniuses as Dylan and the Beatles. Beren makes the point that both had been used to sell newspapers, and that he doesn't consider them "monsters" as the press had termed them, but as human beings.

Beren calls Manson a psychotic: "Manson was a prototype street person. During the ducktail fifties, he was supporting himself by hustling at age fourteen. Early public street hustling has usually been reserved for blacks in our society, not for whites." But, by the time Manson hit the streets again in 67, the street people had changed into: "White middle class dropouts who had forsaken their martini homes and economic security for something more humane and spiritual. Manson soon learned how to hustle them."

Next, Susan Atkins' three different motives behind the murders are discussed. The first being "to instill fear in man himself, man the establishment." The second, to "promote interracial warfare," and the third was revenge against Terry Melcher—who is not named—for not getting Manson a recording contract. Beren has used the last "petty" motive to launch into a diatribe on the commercialization of the record industry: "Executives may have sideburns and long hair—but H.L. Hunt in bell-bottoms is still an exploitative capitalist."

George Orwell's **Nineteen Eighty**

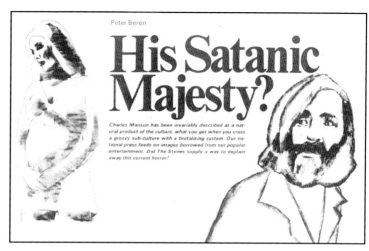

Peter Beren

His Satanic Majesty?

Charles Manson has been invariably described as a natural product of the culture, what you get when you cross a groovy sub-culture with a brutalising system. Our national press feeds on images borrowed from our popular entertainment. Did The Stones supply a way to explain away this current horror?

Four, Zappa's Who Are The Brain Police, Vietnam, Nixon and Agnew, all added up to Beren momentarily aligning with Charlie and commenting: "This is the climate of our times and the sense of urgency that I share with Charles Manson."

Beren also treats us to his own interpretation of Manson's astrological chart:

He is a Scorpio with four planets in Scorpio: Mars, Venus, the Sun and Jupiter. This all adds up to psychic power, the ability to draw people to him, genius and the occult. Saturn squared his Sun, indicating a certain amount of sadism. The words used to describe Manson by people who knew him show a remarkable similarity, 'magnetic, mesmerizing, powerful psychically, hypnotic…etc.' One's lunar position tends to rule one's relationship with women. His moon was in Capricorn triand with Mars and Neptune. This forecasts his forceful, hypnotic relationship with women. The chart also showed that, due to the Scorpio triand with Mars and Neptune, he had the power to possess and obsess others.

Lastly, after noting the legal authorities' attempt to keep publicity as low as possible

for the trial, so as to keep the jurors unprejudiced, Beren asks:

…are they trying to keep future mesmerization on the part of Manson (say the jury, witnesses etc.) a secret?Or, rather, are they trying to keep Manson with his powers out of the media because he might hypnotize the country?

Manson was on the cover of **FUSION** at least three times, if not more, the next cover being the Oct 2, 1970, issue and later the Dec 24, 1971, issue (see page 452).

NATIONAL INSIDER

☐ "Have Hippie Cults Spawned Killers?" asks the cover's banner blurb. Clayton Mills tries to answer that question inside with a half page piece accompanied by Manson's picture.

Mills begins by examining Manson's power over other people by using other people's descriptions of him, as a "mass hypnotist" who had "a strange mystical power of suggestion over other people."

Part of the answer, Mills concludes, is drug use, particularly LSD because it "suggests the realm of religion, mysticism, and the occult."

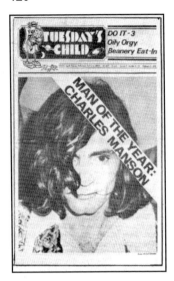

DO IT - 3
Oily Orgy
Beanery Eat-In

MAN OF THE YEAR:
CHARLES MANSON

Above Hard to find issue of Los Angeles' TUESDAY'S CHILD Feb 9, 1970, the cover of which proclaimed Manson to be "Man of the Year." **Opposite, from left** Manson was reportedly paid $50,000 for this interview in the ENQUIRER Feb 15, 1970—money that it claims Manson did not share with his family; Manson, Jackie O and Tiny Tim share the cover of the NATIONAL TATTLER Mar 1, 1970.

TUESDAYS CHILD
Vol 2 No 5 (issue No 13)
Feb 9, 1970

NATIONAL ENQUIRER
Vol 44 No 24 Feb 15, 1970
Best Medium Publishing Co., Inc.,
210 Sylvan Ave., Englewood Cliffs, NJ
07632 .15 32pp

NATIONAL TATTLER
Vol 12 No 9 Mar 1, 1970
Publishers' Promotion Agency, Inc.,
2717 N. Pulaski Rd., Chicago, IL
60639 .15 24pp

The rejection of their parents' materialistic middle-class values had caused young people to search out the spiritual through the use of drugs and, by joining cults like the Universal Church of the Grape, an "order" in California that laced their sacramental wine with LSD according to the County Sheriff's office. Scientology—"One of the most extensive cults to come out of California"—is also given as an example of a cult that has a "tendency to see even the simplest things through a veil of religious gobbledygook."

Mills paints this picture of the situation:

Twentieth-century warlocks stride the streets of L.A.'s Strip and Chicago's Old Town wearing ancient talismanic charms and fingering magical objects under their ponchos and floppy hats.

The bottom line is that the young were running away from their parent's way of life into the arms of cults and, as Mills concludes: "It's questionable whether they'll ever realize that this is the very game they're running away from!"

TUESDAYS CHILD

❑ As of writing I have not been able to locate a copy of the underground tabloid **TUESDAY'S CHILD**, but it was a Los Angeles based paper thought to be hipper than the **LOS ANGELES FREE PRESS** and obviously had a different take on Manson than the rest of the media. The Feb 9, 1970 cover is pictured in the book, **Helter Skelter**, and carries the banner, "Man of the Year: Charles Manson." The subsequent issue depicts Manson as a crucified hippie on the cover, and ran free ads for Manson's LP **Lie**, as did the **LOS ANGELES FREE PRESS**.

NATIONAL ENQUIRER

❑ *Exclusive—1st Interview—A Revealing*

Look into the Mysterious Mind of Charles 'Satan' Manson by Joe Hyams—the title sums it up, as this early interview with Manson is interesting for that very reason. The **ENQUIRER** and Hyams laid claim to this first interview with Manson since his arrest; it was conducted at the LA County Jail through bulletproof glass. As mentioned below in the **NATIONAL TATTLER** of Mar 1, 1970, in the article by George Fields, Manson reportedly got $50,000 for his interview with the **ENQUIRER**.

The article opens with a small pic of Joe Hyams, forty-six, and a short bio on his career as an investigative reporter. It states: "…his talk with the hippie leader is perhaps one of the most fascinating interviews he has conducted." No doubt.

Hyams "found [Manson] to be more of a combination of James Dean and the Maharishi," partially due to the crowds of young people lining the streets and cheering when Manson was transferred from one place to another, which Hyams points to as a sad commentary on the morals of the youth.

The interview begins with Hyams wishing Manson a "Merry Christmas," to which Manson replies "Happy Birthday;" Hyams interprets this as Manson referring to himself as "Christ-like." Manson starts by revealing that, "My first crime was being born without a father," studying Hyams' reaction to his statement. Manson then goes into how we were all programmed by our parents as if we were computers, but then comments: "You spend 20 years in jail with rough people who know what's going on in the world and you learn." He goes on to talk about his like of solitary confinement and his ability to create symphonies in his head.

Manson then informs Hyams: "Man, I had it made there on the ranch. We were all love people. We were with ourselves. We had become one with each other. There wasn't any need to say anything."

Manson goes into an explanation of Susan 'Sadie' Atkins' testimony concerning her being at the murder scenes. Manson

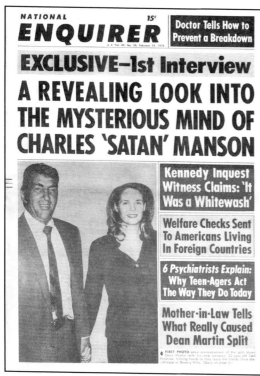

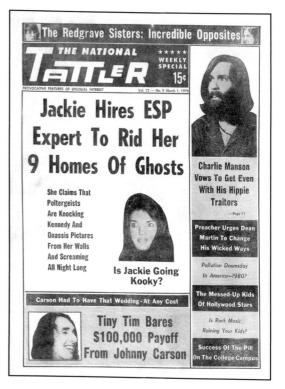

says she "projects herself into what's happening around her" and that, "She just sat there watching TV and the Tate case and she tuned in on it, man. But I don't believe she was there." Concerning Atkins' claim that Manson was at the LaBianca's home the night of the murders, Manson claims she dreamt it, and that "there's no line in her mind between reality and dreams."

NATIONAL TATTLER

☐ Jackie O and Tiny Tim share this cover with Charles Manson. The cover blurb reads: "Charlie Manson Vows To Get Even With His Hippie Traitors." *Hippie Leader Manson Vows Reprisals!* is the article in this **TATTLER** "Exclusive Jail Interview," conducted by George Fields in the attorney's room at the Los Angeles Central Jail with a smelly Manson. The latrine-like stench was caused by mastermind Manson's "silent protest" of not washing or eating. He was protesting

that the judge had refused to let him have a tape recorder.

A quote from Manson kicks it off: "There's a large hole in the desert. Soon a whole lot of people will disappear into it." A few paragraphs later Manson vows, "The motherfucking establishment's gonna pay for this, and soon." This seems to be the "reprisals" mentioned in the title.

Manson claims the press were "lying through their genitals about everything" and the reason they got caught was Sadie's (Susan Atkins) fault. He says she should die for telling lies, then quickly changes his opinion, saying it was not her fault and that the attorneys talked her into it because: "She's a crazy dame, says anything you want her to."

When asked if he wanted to be his own attorney Manson said he did. Fields informs the readers Manson could certainly afford to pay for "top flight legal talent" having received $50,000 from the interview he did with Joe Hyams for the **NATIONAL**

ENQUIRER, above.

Fields also points out that Manson's girls were out on the sidewalk begging for money and wondered if they knew that Charlie was holding out on them. After Manson tells Fields: "Now get outa here, man, you bug me," the reporter leaves and finds the girls outside; he tells them Charlie got the $50,000 which they know nothing about. The girls waste no time going inside to find out from the horse's mouth. Later, one of them is heard muttering, "He got it all right, but he won't share it."

Fields couldn't get the girls to talk about their sex life with Manson, but he did get Paul Crockett to comment that Manson was making up for lost time in prison without women. Crockett also mentioned how Charlie would punish his girls by making them orally copulate with him, saying: "Yeah, they'd line up in front of him and take turns being punished for hours on end. It made me sick."

The article claims Manson fathered

Above Rare issue of RAMPAGE Apr 5, 1970, another sensational sleaze tabloid from Vince Sorrentino in Chicago.

INSIDE DETECTIVE
Vol 48 No 3 Mar 1970
Detective Publications, Inc., 750 Third
Ave., New York, NY 10017 .50 84pp

RAMPAGE
Vol 17 No 14; Apr 5, 1970
The Informer Publishing Co., Inc., No
address given .25 24pp

CRIME DETECTIVE
Vol 16 No 2 Apr 1970
Pontiac Publishing Corp., 201
Park Avenue South, New York, NY
10003 .50 76pp

twelve children in two years, including Sandra Good's son, Ivan Satan Manson, who was born two weeks after the Tate murders.

The piece ends with a quote from a clinical psychologist from Haight-Ashbury's free clinic: "There are thousands of Charlie Mansons wherever the flower children gather, thousands of men with no other purpose in life but to deflower a flower child."

INSIDE DETECTIVE

☐ The cover of this **INSIDE DETECTIVE** with Manson and two threatening "hippie chicks" on it can be seen for a fleeting moment, along with the **ARGOSY** mag listed below, in the documentary film **Manson**, by Robert Hendrickson. The article inside, *Behind the Scenes in the Sharon Tate Massacre: When Satan Told the Cult to Kill! Kill! Kill!* by John Montgomery, is lengthy and laden with pictures, some of which are rare. This is the post-arrest follow up to Montgomery's piece in the Nov 69 issue of **INSIDE DETECTIVE** that featured Sharon Tate on the cover (see page 387). This article is dated "Los Angeles, Cal., Dec 19, 1969" at the beginning—the same date as the **LIFE** magazine cover article on Manson.

The opening two page spread has large photos of Tate and Manson facing each other. On the Tate side are smaller pics of Frykowski, Folger, Sebring and Parent, labeled, "The Victims," and Kasabian, Watson, Atkins, and Krenwinkle on the Manson side, labeled, "The Accused."

Starting before Thanksgiving that year, before the murderers had been revealed to the public, Montgomery runs down the info on the victims and their murders: the Tate/Polanski house, the LaBiancas, and Gary Hinman. Also pointed out is that Sharon Tate's close friend Mia Farrow did not attend her funeral, as she herself was in fear for her life, thinking she would be the next victim. Not mentioned is that Farrow was in Europe

at the time. Another unnamed actress friend of Tate is quoted: "I travel in the same circles as she did, but I don't know who the nuts are. You're sitting around having a few laughs and boom. It's nightmare time. For the first time in my life I bought a gun."

The many ramifications of the murders that rippled through the Hollywood community are discussed in detail, such as a Beverly Hills gun dealer claiming he sold 200 guns in the two days since the murders, his norm being two or three a day. The paranoia of stars such as Steve McQueen, Tony Bennett, and Jerry Lewis is touched upon as they took extra precautions for their safety.

One of the points of interest here is the psychic and occult aspects of speculation before Manson was apprehended. Mentioned are Peter Hurkos' prediction that three men killed the people in the Tate house and that he had informed the police of their identities. Hurkos also claims they were "frenzied, homicidal maniacs" high on LSD.

Truman Capote, author and self proclaimed expert on criminal psychology, predicted that the crime was committed by one man who had been at the residence earlier and, insulted in some way, had left and come back to kill everybody in sight in a moment of "instant paranoia."

Louise Huebner, LA County's official witch, believed they were having "a sadistic-masochistic orgy" that got out of hand.

Anton LaVey, founder of the Church of Satan, is quoted: "They were all the objects of a lust murder. The penetration knife wounds duplicate the sex act."

Astrologer Jim Slaten goes out on a limb, stating:

My friend and I...said that there would be some kind of bloody murder in Hollywood because of the position of the planet Mars. Sharon Tate was a member of a black magic cult, but she was thrown out because she was getting too involved with animal sacrifice and

they were afraid that she was going to draw too much attention to them

The article seems centered on the Dec 1 press conference in Los Angeles that gave the media and public their first clue as to who was responsible for the mass murders. It had been over a month since the last press conference that had shed any light on the case and the media was salivating for more info: they got it in spades.

On Monday Dec 1, 1969, LA Police Chief Edward M. Davis announced, just after two pm, that warrants had been issued for the arrests of Watson, Krenwinkel, and Kasabian for the Tate murders. All three were arrested in other states: Watson in Texas, Krenwinkel in Alabama, and Kasabian in New Hampshire. Just as momentous was the second revelation that the same three were also named as the prime suspects in the murders of Leno and Rosemary LaBianca, which had originally been considered a "copycat" crime by the LAPD.

The biggest surprise came when Police Chief Davis said the three belonged to a hate-filled hippie commune that claimed Charles Manson as its leader, who was interchangeably referred to as "Jesus," "Satan," and "God" by the members of the cult. Police disclosed that none of the accused knew the victims and that five young women, known as "Satan's Slaves," who obeyed all Manson's commands without question, were being held as material witnesses in the case.

The initial motive given for the crimes was that they were to punish the affluent victims for their lifestyle and liberate them through death. Later, Susan "Sadie" Atkins confessed that the Tate house was picked because record producer Terry Melcher, son of Doris Day, had lived there at one time. Manson had been to the house when Melcher lived there and been rejected by Melcher, who was not interested in recording Manson's music. Melcher had been introduced to Manson through Dennis Wilson of the Beach Boys.

The last part of the article relates the details of the crimes as confessed by Atkins to her fellow inmates and the Grand Jury; this was the first glimpse the public got into the convoluted motives for the murders.

Also mentioned are the mysterious deaths of Doreen Gaul and James Sharp, two teenage Scientologists who were found murdered in LA on Nov 5, thought to have been killed by Manson followers.

Montgomery gives the reader an almost day by day account of the events from the Dec 1 press conference to Dec 16 when Atkins received her court date from Judge Keene.

This article is an important, early sample of what was being reported at the time and boasts several pages of photos, including one page of photos and bio info on Sharon Tate.

RAMPAGE

☐ "He Could Have Prevented Tate Murders! Scientist Discloses Method of Discovering Sex Killers" states the cover while the article—*Psychopathic Killers have Tell-Tale Fingerprints* by Richard Wolff—is a strange piece of tabloid journalism that uses Sharon Tate and Charles Manson together on the cover to sell papers.

The centerfold article has pics of Manson, Atkins, Polanski, and Tate, and postulates the theory that sex killers have different fingerprints from normal people and the murders could have been prevented. The problem is that the writer starts with the wrong premise—that the Tate murders were sex killings, which they were not—so even if this theory were correct, it couldn't have prevented the slaughter.

The article quotes from a speech given by a Dr Lawrence Razavi of the Department of Genetics at Stanford Medical School, at a symposium on violence at the American Association for the Advancement of Science's annual meeting: "Violent sex criminals, a study shows, have on the average, 35 times the incidence of sex-chromosome abnormalities in their body cells as the general public."

It proceeds to state that because men and women have different ridge counts on their fingerprints, someone with abnormal sex chromosomes will also have different fingerprints from the norm, therefore making the prevention of sex crimes a possible application of this science. The reason the author came to the sex crime rationalization was because he believed, wrongly, that Sharon Tate had a breast sliced off, a large X carved on her pregnant belly, and that Jay Sebring had been castrated and similarly mutilated. This was not the case if you read the credible sources or see the morgue photos. The same "sexual mutilation" story is printed in several of the magazines listed below as the *real* scoop on the murders that the police did not want the public to know. The facts were gruesome enough as is; they didn't need any added rumor and speculation.

CRIME DETECTIVE

☐ My copy of **CRIME DETECTIVE** Apr 70 is a remainder copy that has the top part of the cover ripped off by the distributor as proof to the publisher of unsold copies.

You Can't Run from Murder—The Strange Twist of Fate Behind the Sharon Tate Massacre by Dick Halvorsen in this issue is well written, if slightly sensational, in that it sticks to facts as they were known at the time and doesn't veer off into rumor as some articles did.

The opening blurb reads: "Destiny revels in a host of deadly jests, but none more cruel than senseless hate." It has three photos on the opening pages, one of Susan Atkins being led from court, a headshot of Manson, and a very sexy pic of Sharon Tate who stands half in shadow, half in light, wearing a

Above **RAMPARTS Apr 70** had interesting cover art, radical politics and a contemplative piece on the Manson phenomena by Marshall Singer. Opposite **Manson triptych in RAMPARTS Apr 70.**

short, tight dress, cinched at the waist with a wide belt, and braless, as her nipples can be seen though the fabric. Her hands are haughtily placed on her angled hips as she stares into the camera.

The photos continue on the next four pages. There is one of Bugliosi holding a photo of the rope used in the Tate murders, but the caption wrongly identifies him as LA Deputy District Attorney Aaron H. Stovitz!

The intro paragraph is a vignette of Susan Atkins leaving the Tate residence:

As the pale moon bathed the hillside estate of the director and his movie-star wife in soft light and stark shadow, the last of the uninvited guests wrote 'The End' to the script for the evening's entertainment in a weird and woeful way. While a couple of others wrote their own graffiti on the walls, she dipped a towel in the blood of one of the vengeance victims inside the mod mansion and scrawled an unsightly crimson 'PIG' on the front portal. The others scrambled out of the place but she had one more act to improvise. She went back upstairs and wrapped the bloody white towel like a ritual hood around the fifth victim's head and then fled downstairs and past the blood-daubed door to join her high and hippie friends outside.
For them, the party had been a success, their weird cravings fulfilled…

The article goes on to describe the events following the discovery of the murder scene that morning by housekeeper Winifred Chapman, and the reaction of the first police officers to witness the carnage.

In an interesting aside, the article mentions a reporter who drove up to the Polanski/Tate house on that Sunday, less than thirty-six hours after the murders took place. He was turned around at the gate by police, but interviewed one of the neighbor's teenage daughters who happened to be walking down the street. Concerning the Tate house she said:

They used to say that there was so much pot around that if the house ever burned up everybody in the neighborhood would be high for years. But we never really saw anything. There were a couple of noisy parties with hundreds of cars, but just what went on inside we don't really know.

The article points out there were really six victims that night because someone could have saved Sharon Tate's baby had they tried immediately after her death.

This piece caused some of the confusion regarding the use of the name "Satan's Slaves," which it claims was what Manson's girls called themselves. But, as already noted, it was also the name of one of the motorcycle clubs Manson supposedly had contact with.

The break came when a pretty young 21-year-old known as Susan Atkins decided to turn police informant. Her story was that she was a member of the cult known as Satan's Slaves and/or The Family…

Among those netted was Charles Miller [sic] Manson, 34, alleged leader of Satan's Slaves.

The writer has suggested any future movie about the case should be named **Death Valley of the Dolls**, pairing the irony of the title of Tate's biggest movie with the "desolation of location and spirit and absence of hope" that Death Valley conjures up.

The article ends by stating that all the accused must still be considered innocent, in spite of the shocking testimony heard at the indictment, as the trial by their peers had yet to have happened.

RAMPARTS
Vol 8 No 10 Apr 1970
Ramparts Magazine, Inc., 1940 Bonita Ave., Berkeley, CA 94704 .75 66pp

MOVIE TV CONFIDENTIAL
Vol 1 No 6 May 1970
Stanley Publications, Inc., 261 Fifth Ave., New York, NY 10016 .35 68pp

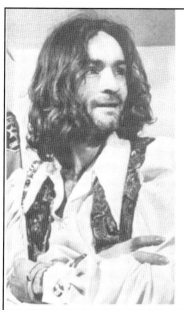 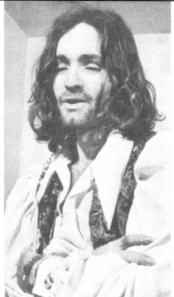 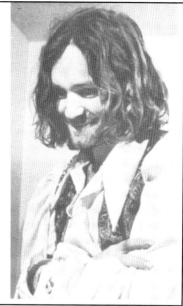

RAMPARTS

❑ **RAMPARTS** began in 1962 as a liberal Catholic quarterly magazine but in 1964 Warren Hinckle III took over its editorial reins, and transformed it radically with slick, hip graphic design and good investigative reporting, not to forget "radical chic," which he invented. Later, after he left **RAMPARTS** in the late sixties, Hinckle was the co-editor of **SCANLAN'S MONTHLY** magazine.

This issue came out after Hinckle had left, and **RAMPARTS** was again being edited by David Horowitz and others. It lists Eldridge Cleaver as the international editor, as he was on the run internationally after a shoot-out with the Oakland police, though he had been the senior editor at one time.

Amongst the ads for the Black Panther Party newspaper, psychedelic posters, and peace and love paraphernalia is the article *Fragments from the Shooting Gallery* by Marshall Singer. It is an introspective meditation on Manson and his relationship to us, the audience/society that created him, which Manson in turn reflected upon.

The piece is broken into twelve short numbered sections, each having a different theme of inquiry. Three sequential b&w photos of Manson across the two opening pages are of interest, as three more of Manson's infinite facial expressions. Manson is seen dressed in top of the line hipster shirt and vest, with two claw-like fingers resting in the crook of his arm.

Singer describes Manson as "Equal parts of Chaplin and Jack the Ripper" and says of his theatrics: "it's hard to tell if it comes from the Stanislavsky method popular in the '50s, or the freer style of the Yippies." Undoubtedly, it was a combination of the two.

He also writes:

A hippie in Topanga Canyon tells of Manson's occasional trips into town to find new subjects for hypnosis and to put his ear to the ground. He says that his commune was put off, not so much by Manson's frenzied eyes, as by his far-out plans, one of which was to assemble a fleet of dune-buggies, place gun mounts on their dashboards, and then launch this armada against the pigs.

People say there is a new mood spreading over the hip populace of Southern California, on the communes in the Valley and among panhandlers on the Sunset Strip. They say there is a pogrom coming against the hippies, and that Manson, not a hippie at all, but a crazy ex-con, has fucked it up for everybody. It was possible, but, as Peter Fonda says, 'We blew it.'

MOVIE TV CONFIDENTIAL

❑ The feature in this Stanley Publications mag is *The Real Reason for the Satan Slave Slaughter*, written by Mary Culver. It opens with the blurb: "Los Angeles is a strange place, according to those who live there, and with new interest in cults, it's getting stranger."

The article itself is short and starts by recounting the Hollywood tragedy of Ramone Navarro, a film star whose mysterious death went unsolved. The connection, or segue, into the Manson case was that both went unsolved until loose lips shed some light upon the crimes.

THE REAL REASON FOR THE SATAN SLAVE SLAUGHTER

MOVIE TV CONFIDENTIAL

TED'S TORMENT: "IS DAD'S DEATH THE FINISH?"

Joseph P.: The Beginning of the Line– And The End of Kennedy Power!

THE HOT & HEAVY DEMANDS LIZ & JACKIE PUT ON THEIR MEN
WHY STARS FIGHT THE ESTABLISHMENT–FROM THE PRESIDENT TO THE POPE
Cops Ask: "Was That Guy Out To Get The Sister Acts?"

Above A tormented Ted Kennedy, underneath the blurb "The Real Reason for the Satan Slave Slaughter." MOVIE TV CONFIDENTIAL May 70.
Opposite ARGOSY May 70, with Manson looking particularly Mephistophelian on the cover.

ARGOSY
Vol 370 No 5; May 1970
Popular Publications, Inc., 205 E. 42nd St., New York, NY 10017 .60 100pp

NEW TIMES
Vol 1 No 4 May 25, 1970
E-M Publishing Corp., 377 Park Ave. South, New York, NY

Again, when referring to the perpetrators in the Tate/LaBianca murders, they are repeatedly called "Satan's Slaves." The "real reason" for the crimes, the article claims, is that when Terry Melcher had lived at that residence, Manson and his "slaves" had visited the house with a warm reception from Melcher. When the Polanski/Tate crowd moved in, they had laughed at Manson and had a "devil-may-care attitude" towards him. It argues this was why "Angel/Devil Charles Manson" sent his "Satanic Slaves to come on the scene—and destroy everyone on it."

The murderers are referred to as "another bunch of butchers," "self appointed angels of vengeance," "unmerciful angels," and claims "They descended like birds of prey, like vultures…"

The article emphasizes the cult angle, using words and phrases like "purified them," "tainted by all that money," and "better off dead," which are in quotation marks in the text, though it is unclear who is being quoted. If anyone, I'm guessing it was Susan Atkins.

In the end statement, it seemingly confuses Manson with Tex Watson:

And so, as someone who once was close to Charlie Manson told us, someone who knew him when fans cheered his feats at high-school football, the Slaves were sent to carry out their ungodly undertaking.
And so…the 'unrepentant sinners' died, proclaiming their innocence.
All because Charlie tried to play God. They say GOD has no sense of humor. Neither had Charles Manson.

ARGOSY

☐ The devilishly grinning Manson on this cover has been made to look slightly more Mephistophlian, as the picture is silhouetted against the background, making his hanging

hair look more like a pointed goatee.

The cover asks "Could This Man Control You?" The article inside is *I Lived with Charlie Manson's 'Family,'* and is by Y. Lee Freeman, a freaky hippie with a degree in philosophy, who had lived at the Spahn Ranch from May to October 1968 courtesy of his friend 'Crazy Jake' who was a mechanic there. Describing the ranch as "nowhere, a place not of this world" and "not even a ghost town, but the ghost of a ghost town", the article opens with Y. Lee relating some of his life experiences:

My life experience has ranged from killing screaming animals in a funky slaughterhouse to winning a degree in philosophy three blocks away. I was a wiper on a merchant ship and a teacher in a little red school, lived in Haight-Ashbury communes, loved more women and tried more drugs than I remember, but I have never been married to a woman or done a murder.

But he did get bound up in a spell that ultimately led to him giving Manson and his Family all his worldly possessions.

Y. Lee drove his '48 Chrysler into the Spahn Ranch one evening in May 68 and was greeted at the door by his friend Crazy Jake. He noticed the abundance of young girls serving dinner culled from garbage runs in the San Fernando Valley. Garbage tastes pretty good when it's being spoonfed to you by beautiful hippie girls. He awakened the next morning to look up and find three lovely young ladies, clad only in bikini bottoms and sunshine, offering to buy him a set of new tires for his Chrysler, via a credit card from Charlie. As the girls took his car to go get the tires, he and Jake contemplated their good fortune at having a friend like Charlie Manson, but Y. Lee had not yet met this "cat" named Charlie and went to look for him. Seek and ye shall find.

Looking in the school bus that had

been painted flat black, Y. Lee found two nude women lounging on pillows, but no Charlie. He then headed off to the ranch house, where he ate a "garbage lunch" and finally met the thirty-four year old head of the Family. As Manson walked in, Y. Lee thanked him for the tires. "We all have to help each other," Manson told him, sounding like an "old country preacher."

The next day, Charlie and company headed north with the school bus, promising to come back to Spahn Ranch, because they dug it. They didn't return for three weeks.

On his return, Manson put his plans to take over the ranch into full motion, which included Y. Lee and his friend Jake's pad. Jake didn't trust Manson but Y. Lee still remembered his kindness with the tires and thought everything would be fine, until Charlie started rapping to him and getting him nervous with talk of the coming race war and non-whites being exterminated. Manson smoked a joint with Y. Lee and then offered to trade his tent for the house he and Jake were renting from Spahn for forty dollars a month. Y. Lee regretfully told Manson he would think about it.

The softening up campaign began with the girls cooking and cleaning for him and inviting him into the back of the bus for a "pot party." Then one day while tinkering with the engine on his car, Y. Lee was approached by a biker named "Jingles" who laid a hit of acid on him that he suspected was really PCP.

As Y. Lee stumbled around in a drugged stupor, he ran into Charlie and twenty-five of his slaves listening to tapes of Manson singing. Charlie turned off the tape and said to him, "I knew you would come, Y. Lee. We have been waiting for you. Why have you tried to resist us? Why won't you give me your Chrysler? You know I want it—and *everything* belongs to me."

Still in a drug induced haze, Y. Lee noticed the girls taking his books from the house while Charlie told him, "You don't need your books any more, Y. Lee. You're one of us. All you need to know, you'll learn

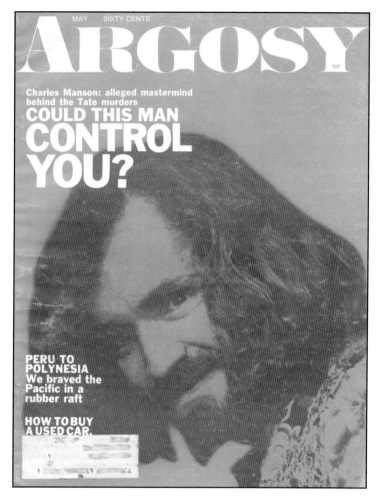

from us." Y. Lee started to throw his own books in the fireplace one by one. He also took the only money he had—thirty-eight dollars—and handed it to Charlie, who in turn threw it in the fireplace, though Y. Lee noticed him retrieve it later.

After this incident Y. Lee stayed away from the house and Manson until he and Jake split the Spahn scene for good, "never to see Charles Manson or his slaves again."

The article is illustrated with two color photos of Y. Lee Freeman at Spahn Ranch wearing a paisley shirt, along with smaller b&w pics of Manson and Tate.

NEW TIMES

☐ **NEW TIMES** billed itself as "A National Bi-Weekly Alternate Culture Newspaper," and in the back cover, a **NEW TIMES** subscription ad notes that:

Beginning with this issue, all proceeds from subscriptions above the costs of printing and mailing will be donated to a united 'Holding Together' fund for the legal defense of America's political and cultural prisoners, i.e., Tim Leary, The Panther 21, John Sinclair, The Conspiracy, and the others that will undoubtedly follow.

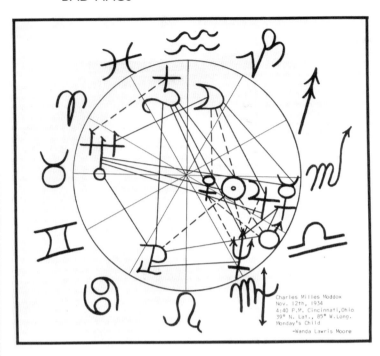

Charles Milles Maddox
Nov. 12th, 1934
4:40 P.M. Cincinnati,Ohio
39° N. Lat., 85° W.Long.
Monday's Child
-Wanda Lawris Moore

They could have added Charles Manson to the list, but his defense fund had its own paid ad on page fifteen.

Manson is on the front cover in magenta monotone, surrounded by a black border. The back cover features an ad for the Electric Circus rock venue on St. Mark's Place. A quote printed in large, white point type on a black background reads: "The DEVIL made me go to The Electric Circus." At the bottom of the ad in tiny, almost unreadable type: "THE ELECTRIC CIRCUS. You'll sell your soul, for one more bowl. You'll even take down your pants."

The first half of the paper is taken up by news items from across the country concerning civil unrest in Berkeley and Boston, campus protests, riots, yippie marches, KKK Kapers, the rock establishment vs. rock culture, ads for rock albums, wigs, hippie boutiques on St. Mark's Place, and the Charles Manson Defense Fund.

On arriving at the centerspread, you find a large two page b&w spread of Manson's eyes staring out at you! Manson is the subject of the next three articles, which take up

almost all the second half of the paper.

Charlie Manson: The Apocalyptic Emergence of a New American Archetype is by Wayne McGuire who wrote for the **AQUARIAN JOURNAL**, from which this article quotes liberally—possibly McGuire quoting himself. In fact, the piece is rife with other quotes from various sources with McGuire's commentary inbetween. He hasn't taken a position on Manson's guilt or innocence, as the implications of the murders and Manson's mystery were enough to suggest that the "Aquarian Age" might not be what everybody was expecting. "Are we going to build the City of God or the Fourth Reich?" is one of the many quotes from the **AQUARIAN JOURNAL**, and, "Is Charlie Manson the foreshadowing of a psychedelic Hitler?" McGuire compares aspects of Manson in such people as Ken Kesey, Andy Warhol and especially Mel Lyman.

He claims to have been warned about Manson through the writings of William Burroughs, C.S. Lewis, and Charles Williams and felt "Charlie [Manson] as a powerful presence lurking at the heart of the collec-

tive unconscious of America."

Manson's Chart: Four Planets in Scorpio by Wanda Lawris Moore is yet another look at Manson's astrological chart. It would have been interesting to see what these same astrologers would have said about Manson before the facts, instead of after them. The piece is illustrated with his chart as drawn by Moore and a reproduction of his birth certificate from the Ohio Department of Health.

The bulk of the piece is the usual astrological lingo that is all Greek to me so I won't try to untangle it here. The more unusual aspect is that the "Postscript" at the end of the piece jumps off the Aquarian Age diving board into Atlantis and reincarnated Atlanteans. Moore claims: "As we enter the Aquarian Age, we are witness to the initial manifestations of an Atlantean Brotherhood that has been predicted for centuries." She calls the reincarnated Atlanteans "Brothers of Light who are being sent back to earth to enlighten, teach and guide the Children of Aquarius." Moore also claims Donovan, Tim Leary, Baba Ram Dass, Alan Ginsberg, Julian Beck, Bob Dylan and John Lennon all belonged to this Brotherhood of Light, and that Manson "is shown to be a strong Atlantean by his astrological chart."

Moore concludes:

> *The savagery with which Manson is being attacked by the media is perhaps due to a dim and no doubt frightening realization that, aside from the ultimate decision of the courts, Manson is plainly guilty. Guilty, that is, of being a powerful, albeit flawed, representative of a new species of man whose appearance on earth foreshadows the arrival of a new age, and the demise of the old.*

A Last Interview from Jail originally ran in the **LOS ANGELES FREE PRESS** and **THE BERKELEY BARB** of Feb 13, 1970. Here, it has the introductory part

ACME MAY 25 1970 35¢

new times

The Media Assasination of Charlie Manson: Last Interview from Jail
Civil War Hits Boston and Berkeley
Jagger & Goddard · The Revolt of Woodstock Nation · Brown Rice · and more

of the article and the *Afterword* written by Michael Hannon, a writer for that paper. The interview itself—sandwiched between Hannon's commentary—was conducted by Steve Alexander and Fred Hoffman and originally ran in **TUESDAY'S CHILD**, an underground paper from LA that had the cover with Manson's picture, declaring him "Man of the Year."

In the first part of the article, Hannon starts:

> *The image of Charles Manson created by the media is a lurid fantasy of*

sexual prowess, drug involvement and magical power, vested in a depraved killer. No motive for the murders has been offered by the District Attorney, and Manson has not been placed at the scene of the crime. How the killer's ferocious behavior towards the victims was caused by Manson remains unclear, but the media's image of Charles Manson is based on the assumption that he is the guilty one.

After that, Hannon has reprinted Manson's letter to District Attorney Evelle

Above **MOVIE TV SECRETS**
was a mag published by **Myron
Fass' Countrywide Publications.**
**The cover of the Jun 70 issue
commemorated the onset of
menstruation in Caroline Kennedy
as well as the Manson case.**
Opposite **Iconographic Manson
cover of ROLLING STONE (#61) Jun
25, 1970, with an exhausting six
chapter piece on the case.**

MOVIE TV SECRETS
Vol 9 No 9 Jun 1970
Countrywide Publications, Inc., 222
Park Ave. South, New York, NY
10003 .35 52pp

ROLLING STONE
No 61; Jun 25, 1970
Rolling Stone Magazine, 625 Third St.,
San Francisco, CA 94107 .50 64pp

Younger in which he complained he was not getting a fair trial because he was representing himself and didn't have the same resources available to him that the court did; he seemed to make some valid points. Manson claimed he was harassed psychologically by being shuffled around from his cell to the library, and by the noise, which interrupted his attention span. Bodily searches, lack of fresh air and sunshine, and hour-and-a-half lines to make a phone call were all mentioned by Manson as reasons for his belief he was getting an unfair trial. The Court responded to Manson by issuing an "Order. Re: Publicity" that prevented Manson from having any contact with the media. The interview with Steve Alexander was held the day before the order went into effect, but the interview was not picked up by the straight press because it "did not conform to the stereotype of Manson-as-Monster."

In the interview, only three questions are asked; the first, "What's your birth sign?" to which Manson answers "Scorpio." The second, "Do you know your rising sign?," gets the brief response, "You know, you wake up every morning and there's another rising sign." And then Manson lurches into a long rant—the bulk of the interview—without giving Alexander a chance to ask another question he didn't know the answer to. It is too long to go into fully here but Manson talks of man's destruction of the environment, his history of incarceration, Haight-Ashbury, and the mark of the beast on the helmets of California police officers that had the state seal of a bear on the front of them.

The last "question" is really only a statement by the interviewer letting Manson continue his talk. Manson wraps it up by saying: "I realize everybody's got their own message, dig? But I can't tell anybody nothing they don't already know. But I can sing for them and I got some music that says what I like to say if I ever had anything to say."

In the *Afterword* Hannon questions the justice system's handling of Manson and his lack of constitutional rights to defend himself. The last exchange with Manson was the bottom line, figuratively and literally, when Manson claims:

"You know, they can't do anything to me."

"They can kill you. That's what they're trying to do," the interviewer responds.

"They can't kill me. They can destroy my body, but they can't kill me," is Manson's reply. Hannon ends the piece wondering, "What can you say to a man who believes in God?"

MOVIE TV SECRETS

☐ *Hollywood Hate Murders—Why Mia Farrow Fears for her Baby—Why Barbara Parkins Lives in Terror* are two separate articles relating to the actresses having a connection to Sharon Tate and how her murder affected their lives.

The Mia Farrow piece is mostly conjecture about her feelings on the death of her close friend and her pregnancy at the time. The writing is wonderfully wacky, but would you expect anything less from a Myron Fass publication? The writer's assessment of Mia:

> She looks like a child herself, Mia. A lost child with large, melancholy eyes, looking up at you sad and sweet and filled with hurt and wonder. Like a child that has suddenly found itself in the wrong world altogether and steps up hesitatingly to the ticket booth as if to buy a ticket to the faraway planet she was born on. And she smiles, but her smile can be sadder than someone else's crying.
> She must have come from a place that is peopled by elves and hopgoblins [sic] and dragons, because there is something fairylike about her, something not quite human, for human beings were never magical like this.

The Barbara Parkins piece is just as wacky and probably written by the same uncredited writer as the Mia article. The subject of speculation here was Parkins' move to a high rise apartment in London after the murder of Sharon Tate with whom Barbara had become close on the set of **Valley of the Dolls**. Also discussed is the suicide of Parkins' good friend Steve Brandt, a Hollywood gossip columnist who had been depressed since the Tate murders. The following is a good example of the writing style: "For Barbara has reached out for superstardom since she was a little girl and now she has that star in her hand at last. Didn't anyone ever tell her that stars are made of fire and they burn?"

ROLLING STONE

☐ This extensive article, divided into six "books" or chapters, was written by David Felton and David Dalton, co-authors with Robin Green of the book, **Mindfuckers** (1972), published by Straight Arrow Books, **ROLLING STONE**'s book imprint. **Mindfuckers**' subject matter is "acid fascism" as used by Manson, Mel Lyman and others. This article was reprinted in **Mindfuckers** "in slightly altered form" and constitutes its Manson chapter. The twenty-one page long extravaganza is filled with rare photos of Manson and the people and places he knew.

Book One—Year of the Fork, Night of the Hunter takes its title from two sources: a supposed Weatherman bumper sticker that read "Manson Power—The Year of the Fork!" and the title of the book and film **Night of the Hunter** that features Robert Mitchum as a con man preacher with "Love" and "Hate" tattooed across his knuckles. The article is concerned with the publication of Susan Atkins' "confession" by the **LOS ANGELES TIMES** and the Lawrence Schiller book, **The Killing of Sharon Tate**, which followed. Both the article and the book, it

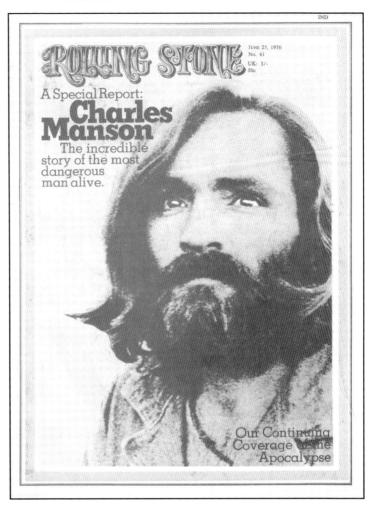

claims, were really written by Jerry Cohen and Dial Torgerson, two former **LOS ANGELES TIMES** journalists. Discussed are how these published pre-trial revelations would effect the impartiality of the jury and the perception of Manson's guilt or non-guilt, along with the way that Manson was being covered by the extreme left in LA underground papers such as **TUESDAY'S CHILD** and the **L. A. FREE PRESS**. The piece gave directions for a circuitous three hour, eighty mile drive from the Spahn Movie Ranch to the home of the LaBiancas in Los Feliz, with all the other stops at Manson-related locations inbetween.

Book Two—Porfiry's Complaint, is told

in the words of an unnamed prosecutor for the District Attorney's office, referred to as "Porfiry," after Dostoevsky's character in **Crime and Punishment**. The first half of this section recounts Gary Hinman's death, and how it ultimately led to the arrest of Bobby Beausoleil and others in the Manson fold, and the theory that the following murders, right after Beausoleil's arrest in early August, were "copycat" crimes carried out to extricate Beausoleil from the original murders.

Book Three—The Most Dangerous Man in the World—is the only section in the article that had its title changed in **Mindfuckers** (to *So I'm Here for Stolen Dune Buggies,*

Above **Cover of Straight Arrow's rare 1972 book, *Mindfuckers*, on "acid fascism."** Opposite **"Manson declares Nixon guilty" announces the cover of THE EAST VILLAGE OTHER Aug 11, 1970. This paper started on New York's Lower East Side in 1965 and by the end of the decade was NYC's seminal underground newspaper.**

both being quotes taken from Manson in the interview). The subtitle, which stays the same in both versions is, appropriately, *An Audience with Charles Manson AKA Jesus Christ*, an interview with a very animated Manson, conducted while he was in the LA County Jail. In interviewing Manson for print, the writer wisely notes descriptions of Manson's body movements, hand jive and facial expressions throughout. Of Manson's convoluted mind games: "Charlie is a super acid rap—symbols, parables, gestures, nothing literal, everything enigmatic, resting nowhere, stopping briefly to overturn an idea, stand it on its head, then exploit the paradox."

Book Four—Super Ego vs. the Id—pits Manson and his belief in apocalypse and divine law against the rigid court system and its multitude of narrow laws.

In *Book Five—The Book of Manson*, three former associates of Manson give their thoughts, memories and opinions of him in their own "According To" sections. The three are Phil Kaufman, Gary Stromberg, and Lance Fairweather (a pseudonym); each part is prefaced by some introductory info on each.

While at Terminal Island prison for a drug conviction, Kaufman met Manson, liked his singing and songwriting abilities, and kept in touch after they were released. Kaufman also lived with Manson and the girls for about two months in 1968, and produced Manson's **Lie** album.

When Manson was released from prison, Kaufman sent him to see Gary Stromberg to record his music and possibly start his career in showbiz. Apparently, Manson didn't get along with the recording engineers, or they with him. After recording three hours of music Manson left and didn't return.

The pseudonymous Lance Fairweather "was some kind of producer in Hollywood and an intimate friend of Beach Boy Dennis Wilson, producer Terry Melcher and, of course, Charles Manson." After Manson's arrest for the murders Fairweather sold his

house and moved his family "to a secret location in the San Fernando Valley." In hindsight Fairweather said of Manson: "I don't think he's sane. He's a danger to society. He represents a danger to life. Charlie himself has no fear of death. I've seen him do some wild things."

Book Six—In the Land of the Mindless, takes the reader on a visit to Spahn Ranch to meet some of the people still living there months after the arrests. Clem played games with Sandy's baby Ivan, and Gypsy ranted Manson's philosophy—some of which is quoted in the article—for an hour into a tape recorder, until Sandy put the nix on the tape ever leaving the ranch. Sandy (Sandra Good) had just visited Charlie that morning who had given her a letter to take to the **L. A. FREE PRESS** so they could print it, in the hope of gaining some followers and possibly selling some copies of his record.

Also, in the *Random Notes* section at the front of this issue, there is an item from London by Bob Greenfield called *Sharon Tate had One Question*, in which Alex Sanders and his wife Maxine, both high profile witches at the time, talk about Tate and her participation and initiation in their coven when she was filming **The Eye of the Devil**. Sanders had been an advisor on the film and met Tate on the set. He describes the first time they met as follows:

> *...she came walking through all the grips and cameras, makeup men, quite the grand dame you know, but scared to death, like a little girl. She came up to me and the first thing she said was "Do you fuck?" Sanders seemed to misunderstand the question by commenting, "I understood immediately...she thought we were celibate, some kind of divine murderers...Well I told her, yes we do...*

EAST VILLAGE OTHER
Vol 5 No 37 Aug 11, 1970
East Village Other, 20 East 12th St., New York, NY 10003 .25 NYC .35 Outside 24pp

EAST VILLAGE OTHER

❑ **THE EAST VILLAGE OTHER** was New York City's main underground newspaper between 1966–72, and gave many underground cartoonists a boost by publishing covers and centerfold comix pages featuring the artwork of Robert Crumb, Spain, Yossarian, Kim Deitch, and many others. Paying for original artwork and getting some through the Underground Press Syndicate, **EVO** filled many of their issues with funny head-trip strips. They also published eight issues of the comix-only tabloid, **Gothic Blimp Works**, the East Coast's answer to **Zap Comix**, and started their own hippie sex tabloid **KISS**, in the wake of Al Goldstein's **SCREW**.

This issue of **EVO** has Manson on the cover, a political comment on, and satire of, the front page of the **LOS ANGELES TIMES** that had the headline, "Manson Guilty, Nixon Declares" (Manson held it up in court in an attempt to gain a mistrial). The paper's name here has been changed to **LESS ANGELS TIMES** and the headline reads: "Manson Declares Nixon Guilty." The same photo of Manson as the **ROLLING STONE** cover above is used, but here he has a "Nixon Guilty" button pasted to his chest.

Strangely, the only mention of Manson inside the paper is on his upcoming album on the record reviews page by Charlie Frick. The typos in this piece are a feature in themselves as they are so prevalent, and give an idea of what to expect of many underground papers. Here, I leave it completely as it was printed:

Speaking of the anti matter galaxy Charles Manson courtroom wiz kid will have his first record coming out in a little while. the masters were obtained from some of his earlier recording sessions in various west coast studios between 1967 and 1969. They are all original compositions written and sung by charlie and additional instruments and vocal by the girls of the Manson Family The record company to take

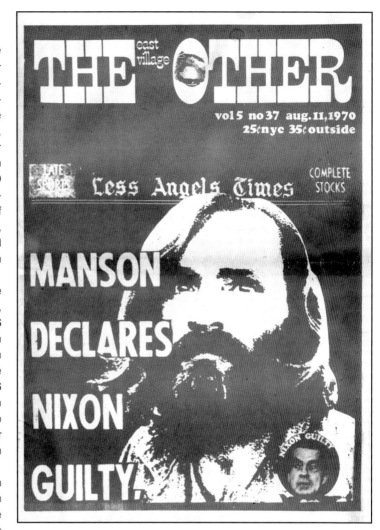

a chance with this new and quite unknown artist is ESP-DISC, an a new york based record company with such fine preformers in their catalogue as Albert Ayler, Sun Ra and His Heliocentric world, The Fugs early albums, The only record ever put out bu the East Village Other called The Electric Newspaper, Pearls before Swine, William Burroughs readings, and a whole mess of other unknowns un recogniseables. Chales Mansion, the record industry will welcomes you with open arms. ESP-DISC can be contacted at 300 West 55th st n.y.c..

THE NATIONAL INSIDER

❑ "Minister's Looks Stun Congregation!" reads the blurb in the inset next to a picture of "Robert Moor Sylvester de Grimston," looking Christ-like, on the cover of this **NATIONAL INSIDER**. The **NATIONAL INSIDER**'s slogan is: "Informative—Provocative—Fearless—Entertaining."

The corresponding article, *Expose Cult for Suckers* by Avery Kidd, shares the tabloid-sized page with two inset pieces, one about a bikini clad gas station attendant.

Although the article does not mention Manson a year after the Tate/LaBianca

Above and right **THE NATIONAL INSIDER** Aug 16, 1970, with inset of Robert de Grimston, head honcho of the Process Church of the Final Judgement. Opposite, from top **SCANLAN'S** Aug 70 has a Robert Crumb cover lifted from the back cover of *Zap Comix* #0 but with new words in the voice balloon; Clever illustration from that same issue of **SCANLAN'S**.

THE NATIONAL INSIDER
Vol 17 No 7 Aug 16, 1970
The National Insider, Inc., 2713
N. Pulaski Rd., Chicago, IL
60639 .15 20pp

SCANLAN'S
Vol 1 No 6 Aug 1970
Scanlan's Literary House, Inc.,
143 W. 44th St., New York, NY
10036 1.00 72pp

TRUE DETECTIVE
Vol 93 No 4 Aug 1970
TD Publishing Corp., 206 East 43rd St.,
New York, NY 10017 .50 84pp

murders, and before any books had yet to emerge detailing the similarities between Manson and the Process, this little exposé about "Robert de Grimston" and his Scientology spin-off, the Process Church, provides a glimpse into the *modus operandi* of the infamous and influential cult.

The article starts with the observation that "Jesus Christ is alive and well and living on London's fashionable West End."

Under the larger pic of de Grimstone is the caption, "Why do wealthy jet-setters believe that this man is Jesus Christ?" Strangely enough, the only clue given in the piece as to the Process philosophy is one quote from de Grimston himself—"You've got to go through Satan to reach God."

Having joined the London branch of Scientology in the early sixties, and seeing how wealthy L. Ron Hubbard was becoming, the then thirty-five year old de Grimston and his thirty-seven year old wife Mary Ann decided to start their own money-making cult. Borrowing heavily from both Scientology and Aleister Crowley, they added their own personal revelations after weathering a hurricane on the Yucatan peninsula in Mexico and gained the epiphany to go forth into the world. The de Grimstons, commonly referred to as "God" and "Goddess," managed to become wealthy enough from their own mystic stew that they could globetrot, with several other members, recruiting new

disciples from Europe, Canada and the USA. They did this by having new recruits "renounce" all worldly possessions to the cult, i.e. the de Grimstons.

The piece ends on this note:

Two thousand years ago, a simple Man of Galilee told a bunch of unemployed fishermen, 'Come follow me, and I will make you fishers of men.'
Today's jet-set Jesus has a slightly different message: 'Follow me, and I promise you all the suckers you can land.'

SCANLAN'S

❑ The Robert Crumb cover on this issue has been taken from the back cover of **Zap Comix** #0, where the text in Mom's word balloon originally read: "I want you should stop wasting your time reading these cheap comic books!" Here it has been changed to refer to the contents of this issue of **SCANLAN'S**:

This dirty magazine is only about POT and DOPE SMUGGLING and POONTANG MOVIES and LEFTWING INDIANS and PENTAGON FRAUDS and CHARLIE MANSON!! So don't hand me any of that crap about Winnie

the Pooh (p. 28).

An Astrological Portrait of Charles Manson, by Gavin Chester Arthur, gives Manson's time and date of birth as 6:30 am on Nov 12, 1934, along with his place of birth: Cincinnati, Ohio (39 North, 84 West); he was a Scorpio.

Gavin Chester Arthur had also written for the occult psychedelic underground paper, the **SAN FRANCISCO ORACLE,** that started in 1966 and lasted until 1968.

The article includes a color reproduction of his astrological chart, which means nothing to me as I'm not an astrologer, but it looks impressive. There is a b&w illustration of a scorpion with a small photo of Manson's head pasted on it.

Manson's "case history" is boiled down into four short paragraphs, then Arthur gives the details, and his interpretation of, Manson's horoscope. Apparently Manson had what is known as a Grand Cross or Grand Square in his chart. Arthur states that this contains a "great deal of strength because it connects the four elements of fire, earth, air and water. It can produce an individual with great strength and power." That is if it is used "correctly." But, "If used incorrectly, the power contained in the Grand Cross took over the individual and would frequently drive him insane."

Arthur concludes that Manson is of a schizophrenic nature, which "shows up time and again in his chart."

In the interpretation of Manson's chart, Arthur offers: "Manson is playing the role of a villain but is really a loving person by nature." He also claims Manson is "endowed with psychic powers and intuition—leading to ESP. He is able to hypnotize people and get them to do his bidding."

Robert Heinlein's sci-fi novel **Stranger in a Strange Land** is mentioned as having had a great influence on Manson and, like the alien hero in the book, Manson "thinks nothing of obliterating anyone who stands in the way of what he wants."

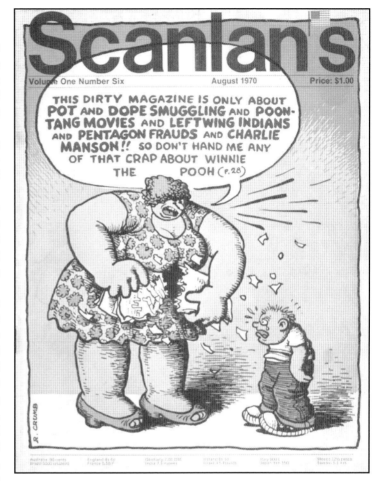

The bottom line, Arthur concludes: "Obviously Manson is mad as a hatter."

Most of Arthur's conclusions about Manson are what the general public was led to believe anyway, without the use of astrology.

TRUE DETECTIVE

❑ The cover deceptively reads "Extra-Length Special! From court records, weirder-than-fiction facts revealed for the first time! Astonishing Preview of The Sharon Tate Murder Trial." But this article focuses on the details of the murder of musician Gary Hinman, the testimony of those involved, and witness Danny De Carlo. The Hinman

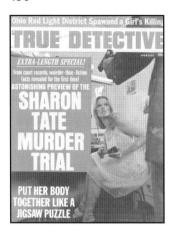

Above **Hokey posed photo on the cover of TRUE DETECTIVE Aug 70, an issue with an "Extra-Length Special" on the Tate murder trial.**
Opposite, from left **Magazine ad for Charlie perfume by Revlon; Early sixth issue of NATIONAL LAMPOON dated Sep 70, with a spoof on the Manson media circus.**

NATIONAL LAMPOON

Vol 1 No 6 Sep 1970
National Lampoon, Inc., 635 Madison Ave., New York, NY 10022 .75 84pp

murder, and its resulting arrests, were the real genesis of Helter Skelter.

In the title that appears inside the mag the word "Astonishing" from the cover has been replaced with "Uncensored Preview of the Sharon Tate Murder Trial." It is the first of two articles written by Chris Edwards on the Manson murder trials. The other appears in a later issue of **TRUE DETECTIVE** from Apr 71 (see below). This article was also reprinted in the UK mag **MASTER DETECTIVE** from Nov 70, with added photos.

The rather long piece starts off:

Except for the victims, the murder of musician Gary Hinman featured virtually the same cast of characters and could have been a dry run for the massacre, only a short time later, of sex-pot film star Sharon Tate and her offbeat friends. Here was the blueprint for the bloodbath of the century…

Gary Hinman, thirty-four, was a musician who befriended Bobby "Cupid" Beausoleil and at one time played in a musical combo with him, even sharing his home with Beausoleil for a time. Beausoleil later introduced Hinman to Manson and the Family.

The story goes that a rumor had made it to Manson that Hinman had inherited $20,000 and kept it at his home in cash. Manson was trying to raise the money to move his crew into the desert for the beginning stages of Helter Skelter, so he sent Beausoleil, Susan Atkins and Mary Brunner to get the cash from the ill-fated Hinman. When confronted by the three, Hinman claimed he had no money to give them and all they got was twenty dollars from his wallet. Beausoleil called Manson to inform him of the developments. Later, Manson would show up with Bruce Davis and ended up slicing Hinman's face, nearly severing his ear with a sword he had received in trade from the outlaw motorcycle club, the Straight Satans.

Manson and Davis eventually left with the pink slips to both of Hinman's cars, taking one of the autos with them. Davis soon disappeared after the murders and was being sought when this piece was printed. There are two mugshots of Davis included in the article, one with moustache, one without, and it asks: "Have You Seen This Man?"

Beausoleil continued the torture of Hinman until Manson allegedly gave the order to kill him over the phone. Hinman was polished off by Beausoleil with help from the women, who held a pillow over his face when he was making too much noise. Hinman received five stab wounds, and when found a week later was swarming with flies. Beausoleil had apparently revisited Hinman's house a few days later and commented to Mary Brunner that "he could hear the maggots eating Gary."

NATIONAL LAMPOON

☐ The banner across the cover of this classic early issue of **NATIONAL LAMPOON** reads: "Show Biz: John and Yoko Unmasked—Raquel Welch Undressed—Charles Manson Onstage," and sits above Minnie Mouse exposing her breasts complete with flower pasties!

The **NATIONAL LAMPOON** takes a first stab at Manson humor with *Cashing in on Charlie* by George Trow, a fairly funny take on the media circus around Manson in 1970 with the subtitle, "You're A Good Man, Charlie Manson." It is a three page feature that starts out with a full page color cartoon by Larry Ross of Charlie Manson sitting in the guest chair on **The Johnny Carson Show**, handcuffed, with flies buzzing around his head, halo-like! The article starts:

Show Biz insiders know that Charlie Manson has that special something, that indefinable je ne sais quoi, that unfakable [sic] charisma that's known as Star Quality. Like Mick Jagger, Mae West and Andy Warhol, Charlie

Manson has the ability to make others sit up and take notice. More than that, he has a fabulous-funky wickedness that is all 1970, something very, very NOW.

It goes on to quote **ROLLING STONE** magazine on the sale of the Manson LP **Lie**, of which only 300 copies were sold of the 2,000 that were pressed. Its "miserable failure" apparently because, "Manson has been *Badly Managed*."

The next section of the piece is a guide on how to rectify the situation, *The Cash-in-on-Charlie Campaign—The Funk Threshold Concept—Put it to Work and Make Big $,* and comes with a graph chart and cartoon illustrations by Peter Bramley.

After a hilariously convoluted explanation of the "Funk Threshold" and "Funk Continuum," Manson's predicament is explained:

Manson, due to bungling mismanagement, has crossed the Funk Threshold. This is why his record is a bomb. Manson must be placed on an auspicious position on the Funk Continuum so that he can EMBRACE the Funk Threshold, slide it further down the Funk Continuum WITHOUT ACTUALLY CROSSING IT. Tricky, but

not impossible. Manson will not be as difficult to promote, for instance, as Personal Feminine Hygiene Deodorant Spray.

It then lists the game plan for marketing Manson under the headings: "Vulnerability, Endorsements," "Cash In On Charlie at the Theater," "Cash In On Charlie in Films," "Cash in On Charlie on Wax." The last sentence presciently observes:

Finally, as the period of Charlie's Maximum Hipness begins to wane, as he becomes more and more an accepted (if slightly controversial) figure,

we Cash In On Charlie on the Tube. And…HERE'S CHARLIE.

Someone on Madison Avenue must have read this and taken it to heart, because didn't we get: **Charlie's Angels** TV jiggle-action drama; the women's perfume, Charlie; the TV sitcom, **Charles in Charge**; and briefly a magazine called **CHARLIE**, not long after? What was that all about? And in a different category, the directly linked **Legion of Charlies** underground comic by Greg Irons and Tom Veitch.

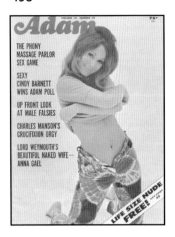

THE PHONY
MASSAGE PARLOR
SEX GAME

SEXY
CINDY BARNETT
WINS ADAM POLL

UP FRONT LOOK
AT MALE FALSIES

CHARLES MANSON'S
CRUCIFIXION ORGY

LORD WEYMOUTH'S
BEAUTIFUL NAKED WIFE—
ANNA GAEL

Above ADAM Oct 70 with the cover blurb "Charles Manson's Crucifixion Orgy" and a cute hippie chick with tie-dyed pants. **Opposite** Splash page spread from Manson article in the same issue—basically excerpts from the Holloway House paperback book *5 to Die* by Jerry LeBlanc and Ivor Davis.

MOVIE TV CONFIDENTIAL
Vol 2 No 2 Sep 1970
Stanley Publications, Inc., 261 Fifth
Ave., New York, NY 10016 .35 68pp

ADAM
Vol 14 No 10 Oct 1970
Knight Publishing Corp., 8060
Melrose Ave., Los Angeles, CA
90046 .75 84pp

NATIONAL TATTLER
Vol 13 No 15
Oct 11, 1970
Publishers' Promotion Agency, Inc.,
2717 N. Pulaski Rd., Chicago, IL
60639 .15 20pp

MOVIE TV CONFIDENTIAL

☐ *Manson's Monsters Revisited* by Pat Bustamante starts out contemplating Manson's voice and musical talents in light of Family Jams, Inc.'s pending release of an album of Manson ditties to help with his defense fund. It quotes Susan Atkins several times on Manson's voice and how it had "hypnotized" and "mesmerized" her. Atkins said of Charlie: "We belong to him, not to ourselves." She also gave the motive for the killings as the fact that Terry Melcher used to live in the house, which 'Tex' Watson told her he and Charlie had visited at one time. The article mentions the poor taste nickname, "Terry the Target," given by some to Melcher since the murders. Melcher admitted that he did know and encourage Manson at one time.

The piece has a paragraph on the Manson related movies already coming out:

Satan's Sadists, *which was quickly rushed to the screen with advertising that said—'Just like the Tate murders!' Jackie Susann is steaming, and no wonder, at 20th-Century Fox's* **Beyond the Valley of the Dolls**. *It has nothing to do with her own* **Valley of the Dolls**. *It's just that the title makes money, and it's rated X and simulates the Tate murders. Another in the works is simply called* **The Family**.

Manson's failed attempt to represent himself in court is mentioned, with a rather interesting bit of banter between Judge George Dell and Manson. After Manson told the Judge, in response to an interjection, "Don't cut me off," the Judge replied: "I'm not cutting you off—I'm opening you up, Mr Manson."

The article mentions Manson's connection to Dennis Wilson and the Beach Boys, and claims: "Manson nearly joined the Beach Boys to sing in Texas, except that parole restrictions kept him home."

Susan Atkins then becomes the main subject of discussion and is quoted on the murders, how she couldn't kill Sharon Tate, and how she told 'Tex' he would have to do it. After relating the brutal crimes, she goes on to say: "My lawyer is coming soon, and he's bringing me vanilla ice cream. Vanilla ice cream really blows my mind."

The writer makes the point that it seemed Ms Atkins' mind had already been blown—by drugs. This is the theme the article ends on, asking if the accused were just 'monsters,' or was it drugs that were ultimately responsible for Manson and crew turning to violence?

ADAM

☐ The cover of this issue of **ADAM** lists "Charles Manson's Crucifixion Orgy", but the title of the feature inside is called *The Crucifixion of Charlie* by Jerry LeBlanc and Ivor Davis, a verbatim excerpt of chapter five of their book, **5 to Die**. The book was published in 1970 by Holloway House Publishing, the paperback imprint from Knight Publishing, who published the **ADAM** and **KNIGHT** mags. The Holloway House paperback originals are hard to find and sought after by collectors.

Holloway House also published books by popular black writers Ice Berg Slim and Donald Goines, as well as biographies of black entertainers, classic erotica, books on gambling, the burgeoning porn film industry, and Hollywood. Ads for these books can be found throughout their magazines: **ADAM**, **KNIGHT**, **CAD** and **PIX**, among others.

The article starts with a two page spread, the first being a full page shot of Manson—the same pic is used on the cover of **5 to Die**. The intro blurb reads:

Manson's identity as Christ was irrevocably established in the minds of his followers through the reenactment of dying on the cross. Other rituals were

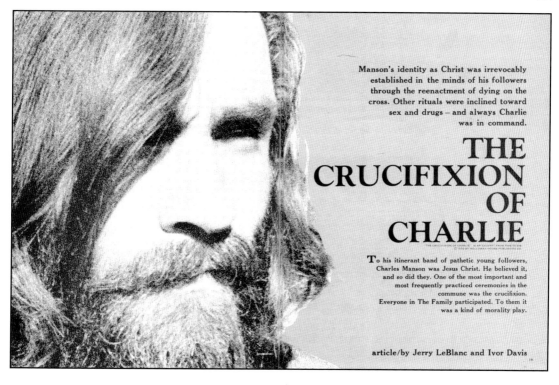

Manson's identity as Christ was irrevocably established in the minds of his followers through the reenactment of dying on the cross. Other rituals were inclined toward sex and drugs – and always Charlie was in command.

THE CRUCIFIXION OF CHARLIE

To his itinerant band of pathetic young followers, Charles Manson was Jesus Christ. He believed it, and so did they. One of the most important and most frequently practiced ceremonies in the commune was the crucifixion. Everyone in The Family participated. To them it was a kind of morality play.

article/by Jerry LeBlanc and Ivor Davis

inclined toward sex and drugs—and always Charlie was in command.

LeBlanc and Davis piece together scenarios of orgies with Manson as puppeteer, from conversations with Family members, and hearsay, almost as if they have firsthand experience of it all. At the end of the piece, they write of Manson's association with the Fountain of the World religious commune, located down the road in Box Canyon.

They claim:

Manson was a frequent visitor to the religious cult in Box Canyon and took his band along to Saturday night skits and for 'musical sessions,' although Foundation members were terrified of him and his girls. ...In the past, Foundation members had fed Manson and his girls, but in Aug 1969, three girls, including Susan Atkins and Patricia Krenwinkle, asked if they could move in and abruptly were turned away.

As they left, the girls were heard singing a song about "piggies," undoubtedly from the album **The Beatles** aka the "White Album."

Lastly, Manson's "dying games" are touched upon:

...in which members were asked not just to play but to actually die for Charlie, who then in his Christ role promised to "resurrect" them. For Manson laid claim not only to the name of Christ, but also that of Satan. Family members were told, 'They are the same.'

NATIONAL TATTLER

☐ The blurb on the cover—"Linda Kasabian's Mother—Don't Let Your Daughter Drift Away"—and corresponding back cover article, *Linda's Mom Takes all the Blame* by Chad Viking, isn't about Manson but is

interesting all the same.

It starts off:

Linda Kasabian—a name to conjure up nightmares.
Nightmares of rebellious, wayward hippies. Of pot and LSD-colored sex orgies. Of the Manson 'family' foraging for food, stealing cars, terrorizing their Topanga Canyon neighbors.
And finally—the ritual blood-letting at the Polanski-Tate estate. The grisly LaBianca murders.
Linda Kasabian. A name to contend with.

The writer then asks, "But who's heard of Joyce Byrd?" That would be Linda's mom, a New Hampshire housewife, who took a trip down memory lane by wracking her brain for answers to how her "kindest and gentlest of girls," Linda, had been charged in the century's most shocking bloodbath.

Mrs Byrd tells of Linda's search for un-

Above **NATIONAL TATTLER Oct 11, 1970**, with Linda Kasabian's mother spinning the tale of her daughter's long and winding trip to Spahn Ranch and Helter Skelter. Opposite Chaotic Manson-themed illustration from **EAST VILLAGE OTHER Oct 27, 1970**.

EAST VILLAGE OTHER
Vol 5 No 48 Oct 27, 1970
East Village Other, 20 East 12th St., New York, NY 10003 .25 NYC .35 Outside 24pp

NATIONAL TATTLER
Vol 13 No 19 Nov 8, 1970
Publishers' Promotion Agency, Inc., 2717 N. Pulaski Rd., Chicago, IL 60639 .15 20pp

derstanding that she wasn't getting at home, as she had five younger siblings that sapped her mother's energy and attention.

Ma Byrd attributed the beginning of Linda's path to Manson starting at a communal house of hippies—or "hippie pad"—in Milford, New Hampshire, where Linda ended up staying.

Linda eventually made her way back home and worked different jobs to save enough cash to get her to Miami, Florida, where her estranged father lived. There, she worked as a switchboard operator for a high-end Miami Beach resort hotel. She also went from a chunky 140 lbs. to a svelte 107, with the aid of diet pills. She started wearing "mod" clothes and became a lot more sophisticated while working around the wealthy patrons of the resort.

Linda eventually went back home to New Hampshire and, not long after, left for Boston where she was busted in a "bad drug scene." This was where she met her future husband, Bob Kasabian, whom her mother did not approve of and forbade Linda to see. But, as was to be expected, Linda and Bob eloped and moved to California.

Once they made it to Venice, California, they had a child, Tonya. The marriage turned sour and Linda made frequent trips home, only to be lured back by Bob with promises of exotic trips to South America that never materialized. After a particularly "bitter squabble," Linda left Bob for good and ended up in the orbit of Charles Manson and Helter Skelter.

As the piece states: "The rest is history. Grisly, odious history."

After the murders, Linda spent a month in Florida with her dad, then moved back to New Hampshire where she was living when the news broke of her participation in the country's most bizarre and horrific crime. Linda heard the news on the radio and her mother saw it in the paper.

Mrs Byrd remembered Linda as a child, loving animals, avoiding stepping on ants, and shooing flies out the door to save them

from being swatted. This, Mrs Byrd said, was the irony of her daughter's involvement in a bloody mass murder.

After Linda handed Tonya over to her mother—and was being led away by New Hampshire State Police—she turned to her mom and said, "Mum…all I ever wanted was what you've got—a husband, love, a home and children."

EAST VILLAGE OTHER

☐ An *Open Letter to Tim Leary from Charles Manson* is Manson at his most stream-of-consciousness-like and therefore hard to follow. In the truth is stranger than fiction department, Leary landed in a Folsom Prison cell next to Manson years later (see **OUI**, Aug 76). The full page feature is illustrated with a b&w collage of Tate, Manson, his girls, Jesus, the moon, a gun, and a coin. The piece starts with a quote taken from Manson's letter: "Revelation brings blood, love knows no sin."

"General Tim Leary (Sunstone)" is to whom it is addressed. The letter is not broken into paragraphs, but is one long rambling sermon into which Manson drops occult, mystical love and fear mumbo-jumbo with bad grammar included.

The letter's flavor is apparent in this initial excerpt:

So I hear your call to arms to face the fears mad dog of suppression. My soul cries from a misty grave as I've always lived in this tomb of living dead. I've cried so long for freedom until becoming one with self is like to unwinding a top. I see only through the madness of mad men who try to kill soul and trap freedom in the name of peace, misusing the words love and god. Must I lay in giving again, I have always gave all for my loving and now as you see the grave will open. Will I stand alone, face myself and bring an unjust world to

justice. I have cried for you brother. Guns are what people get killed with. Their fear is your strongest weapon. People who are afraid of dying carry guns because they are afraid to face death. When a man can face his own death and looks in the face of some man who can't face his own death, strange power is no power had love to stand and reflect no fear and all who are afraid will fall as fear brings to now awareness completing one with itself. Love will look at death and welcome a look into itself. Love will stand in their courtroom and judge its own for all to witness. The truth is as it has always been 'my' love can get out of this coming slaughter, by looking at it and learning to live with and welcome fear. My fear is my awareness.

The letter continues, mentioning "judgment day," and I guess what amounts to Manson's convoluted advice to Leary, to buck up and get ready for the coming apocalypse.

The last lines read: "Love is as it's always been the beginning and the end. Complete your circles, make ready to face me. All words are without meaning. The thought has always been yours as I am. MANSON."

NATIONAL TATTLER

☐ "'It Must Have Been God's Will'—Manson Cult's Hideout Is Wiped Off The Earth" is the banner cover blurb. The center-spread article inside by Claude Baker (*With Charles Manson at Spahn Ranch—Drugs and a Flaming Inferno!*) starts:

Satan was alive in the desert that day. Bare-chested save for a ragged vest of many colors, he sat on a low rock and watched the writhing nude girl lying on the ground before him.

"Satan" of course was none other than Charlie Manson and the "writhing nude girl" was Susan Atkins about to give birth. The rest of Atkins' birthing experience is recounted as the Family gathered round and a baby boy was born, whose umbilical cord was bitten off by one of the girls, while "Satan" Manson tied it off with a guitar string. After it was over, Manson told Atkins to crawl to him through the dirt. The new mother crawled to him and laid her newborn at Manson's feet. It mentions the Family had been "tripping out on mescaline for the past three days" when this birth occurred.

As the article says: "the devilish Family of Charles Manson was one member stronger."

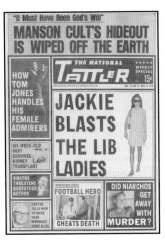

Above **THE NATIONAL TATTLER**
Nov 8, 1970, considers "God's will"
as the cause of the fire that burned
Spahn Ranch to the ground.

MOVIE MIRROR
Vol 14 No 13 Nov 1970
Sterling Group, Inc., 315 Park Ave.
South, New York, NY 10010 .35 84pp

REAL DETECTIVE
Nov 1970
Rostam Publishing, Inc., PO Box 1374,
New York, NY 10022 .50 84pp

MASTER DETECTIVE
Nov 1970
Argus Press Ltd., The Illustrated
Publications Company Ltd., 12 Paul St.
London, EC2 2s. 6d. 52pp

ASTROLOGY TODAY
Vol 1 No 2 Dec 1970
Hewfred Publications, Inc., 444
Madison Ave., New York, NY
10022 .60 68pp

There is a description of a Family LSD group-grope session, told by a girl who "participated in many of these orgies."

According to the girl, one night Charlie was dancing around naked except for his colorful ceremonial Family vest and a cowboy hat, and the girls were all naked with the exception of the new redheaded girl. Tabs of acid were passed out and incense lit.

The new girl was visibly nervous as Charlie stripped her of her clothes. By the time the others had followed Charlie's lead and had started groping each other, the new girl was kissing Manson's feet, literally, and only minutes away from giving Charlie oral stimulation. As the orgy lasted through the night, Manson arranged the participants in various combos, guy/girl, girl/girl and guy/guy.

The eyewitness says: "I tell you, it was beautiful. I can get turned on just sitting here talking about it. Those nights were the wildest, most wonderful times of my life!"

The brush fires that burned down the Family's Spahn Ranch movie set digs on 26 and 27 September 1970 are touted as a cleansing punishment from God. George Spahn was questioned about the family of hippies he let stay at his horse ranch, and what he thought about them now that several had been arrested for murder.

Spahn says:

I don't condone murder, but neither do I want to judge all the kids because of charges against a few.
You know, I really like some of these kids. And by God, don't think some of them ain't real nice people.
It's just, well, I don't know, they just got these funny ideas sometimes.

On refusing to kick the Family off his ranch since the arrests:

I don't like the notoriety of all this, but to tell the truth, these young people, including Manson, have been mighty

good to me.
It's awfully hard to believe these things about them, and I'm not going to kick them out like some people think I should.
The people were scared of the kids. The ones who were still here had all been cleared by the police, but people still didn't feel easy around them.

In the middle of the article is an inset item from the **TATTLER** staff advertising the fact that in the next week's issue they were to start a series of articles exploring Sharon Tate's life in which they would "take a hard look at Satan—Charles Manson himself."

MOVIE MIRROR

❑ The cover photo of Elvis and Priscilla Presley is emblazoned with the headline banner "Mystery Girl Charges—Elvis Is The Father Of My Baby!" Down in the corner of the cover is the blurb, "Is Hollywood Hiding The Real Manson Secret?," which is a "Special Insider's Report!" by Felicia Lawrence.

This piece is a good example of a Hollywood gossip mag's coverage of the case—dramatic, with little attention to detail.

Writer Lawrence was apparently in the courtroom when Manson suddenly stood up waving a copy of **THE LOS ANGELES TIMES** with the headline "Manson Guilty, Nixon Declares." This incident threw the courtroom into a tizzy, and Lawrence into a reverie about other secrets Manson and Hollywood had up their sleeves, as she writes:

How many more hidden truths would be kept undisclosed? we wondered. How many more secrets are there in this murder trial? And why, we had to know, had Hollywood suddenly stilled its wagging tongue whenever the names of Sharon Tate, Charles Manson, Roman Polanski or Susan Atkins

were brought up? Is there, in fact, some secret that Hollywood wants to keep locked up?

After referring to Manson as "a satanical hippie type," Lawrence gives a brief rundown of Manson's under-privileged childhood. Lawrence then juxtaposes this with Tate's life of relative privilege, starting at six months of age with her winning the title of "Miss Tiny Tot."

The piece ends by trying to answer the question of what secrets Hollywood may have divulged as a result of the murders and the arrest of Manson and the Family.

At first, Lawrence blames it all on boredom when she states:

Both Charles Manson and Sharon Tate were so turned on to the jaded lifestyle that they couldn't be turned off. Tragically, each pursued their glamour in separate ways. But the fatal meeting was a horrible culmination of all that has been kept secret in Hollywood.

Lawrence then quotes a detective who told her a "complete exposé of this murder would blow the lid off the happenings in Hollywood."

Tate's interest in mysticism, Lawrence claims, *made* her say "the thought of death is ecstasy." Where she got this out of context quote from she doesn't mention.

Another quote Lawrence gives is from "one knowing actor" who confirmed the ennui aspect, saying:

There is in this country, and especially in this city of movie stars, a great many people who suffer from a fatal disease. Boredom. After receiving so much attention and money, there is little left to give these people thrills. So they become jaded. And when there is nothing else left to excite them, they kill themselves.

Lawrence concurs and concludes with this thought from Paul Newman: "The secret died with Sharon and the others, and that's what makes it a classic mystery."

REAL DETECTIVE

❑ "The Weird Kind of Sex Behind the Sharon Tate Murder!" blasts across the front cover with an inset picture of Manson, who looks more like Steve Railsback playing him than himself.

When Charlie Manson Looked at a Girl, she Became his Love Slave! is the title of the uncredited article inside, which has been reprinted, photos and all, at least twice—once in a later issue of **REAL DETECTIVE** (Jan 77), and again in **POLICE DETECTIVE 1977 ANNUAL** (see page 465).

The intro blurb reads:

Using his incredible hypnotic powers, Charlie Manson looked at a girl once and she became his love slave. He initiated them into his 'way out' kind of sex, beginning with a full day's instruction. Then came group sex! And when Charlie was finished 'teaching,' the girl belonged to him—totally!

The article spends significant time focusing on the girls and where they came from, and includes many quotes from Manson's loyal love slaves expressing their adoration for their master. Sandra Good insists: "It's not hypnotism, it's making good love to the girls." Susan Atkins drives the point home saying, "We belonged to Charlie, not to ourselves."

The writer makes the point that most all the girls came from broken homes and that Manson came from "no home at all," contributing to their mutual neediness. The girls needed a father figure and Manson needed the family he never had.

Manson's wanderings since his release from prison in 1967 are briefly related,

including the use of Dennis Wilson; Manson's conversion of a Methodist minister, Dean Moorehouse, from outraged father to Manson advocate through the miracle of LSD; and George Spahn's terrifying ordeal with Manson trying to prove the blind could see.

The last paragraph concludes:

Charlie Manson was also a god. A father, a lover, a leader, a friend. But most of all, a god. A god of evil and death. And his girls now are lost. Souls who will never be the same, can never go back to what they were before Charlie. They've looked on the face of eternity, known the taste of blood and seen destruction.
All in the name of love.

MASTER DETECTIVE

❑ *Astonishing Prelude to the Sharon Tate Massacre* by Chris Edwards is a reprinting of the article that originally appeared in the Aug 70 issue of **TRUE DETECTIVE** seen above; although it includes many of the same photos, there are added photos not in the American version.

The excellent cover photo of Manson appears again on the cover of the UK crime mag **MURDER MOST FOUL** #13 in 1994.

ASTROLOGY TODAY

❑ "The Beatles—Conflict In the Stars," is the main topic on the cover. They are pictured inside apples with their respective sun signs printed above. The other blurbs—"Revealing Horoscope—Cult Leader Charles Manson by Zodiactronics' IBM Computer" and "How Uranus Changes Your Life" complete the cover.

The pen and ink line drawings in the mag that illustrate the twelve signs of the zodiac have a typical hippie flavor to them.

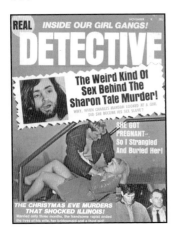

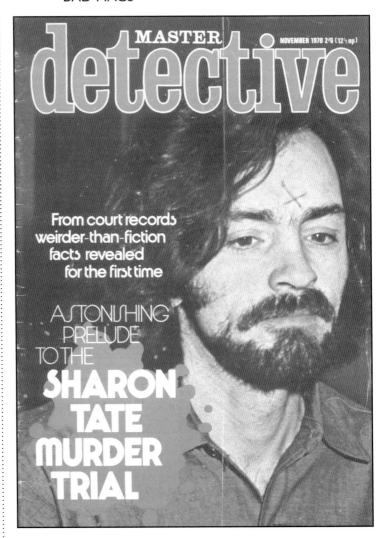

Top **The inset on the cover of REAL DETECTIVE Nov 70 has Manson looking more like Steve Railsback doing Manson.** Above and Opposite **ASTROLOGY TODAY Dec 70 used an IBM computer to give Manson's astrological info; Manson's famous mugshot is a design element.** Right **MASTER DETECTIVE Nov 70 has an excellent cover with Manson wearing a bloody "X" on his forehead and a complex beard design.**

SAGA
Vol 41 No 5 Feb 1971
Gambi Publications, Inc., 333 Johnson Ave., Brooklyn, NY 11206 .60 100pp

Other features include *Rapping with Sally Kirkland*, a *Special Feature on Scorpio*, *Fashion: Earth Animals*, *Computerized Astrology*, and an *ESP Exercise*.

Revealing Horoscope—Cult Leader Charles Manson is yet another Manson astrological reading, this time his chart calculated by a computer. The opening artwork is a Warhol-like page of multicolored versions of Manson's infamous mugshot with a central close-up of his eyes.

Manson's astrological chart is pictured and gives the data for his birth as "4:40pm Nov 12, 1934, 84 degrees 31' W and 39

degrees 6' N," which differs slightly from the data given in the **SCANLAN'S MONTHLY** article on page 434.

The piece is written as if Manson had submitted his data to a Zodiactronics computer and it was sending his calculated horoscope back to him. It starts: "Here is your individualized horoscope calculated with mathematical precision from the same formulas used in charting planetary positions for space flights."

Most of what the computer has to say, as far as the astrological aspects are concerned, is not understandable to a layman.

There are, however, occasional interesting assessments of what it all means:

The Sun in Scorpio is powerful. It can make you a master of men and nature or a prisoner of your secret fears. You have all the awesome strength of Pluto, but whether you use it to build or destroy is entirely up to you. No one can guide you better than yourself with your uncanny self-knowledge and incredible self-discipline. Your personal magnetism figuratively hypnotizes people into doing what you want. This ability stems from the piercing intensity of your inner feelings and emotions, which are seldom displayed. You prefer to disguise them beneath a cool, poised, outward calm. You are capable of independent and unorthodox methods, and have a good imagination, intuition, and inventive mental ability. You like creating ideas and implementing them. If you have any adverse planetary aspects to your Aquarian moon, it usually indicates an eye problem. The women (mothers, sisters, friends) in your life will be much above aver- age—loyal, broad-minded, intelligent and somewhat idealistic. They could be of the greatest practical assistance to your career.

Under the section titled "Your basic personality, a capsule summary," it says of Manson:

…you are the strong and silent type, but there are wells of unexpressed emotion just below the surface. You are receptive and psychic, impression- able. Your desires are keen, but tinged with suspicion and mistrust. Your emotional level is high, but feelings tend to become trapped within you. Then come resentments, jealousies and insecurity.

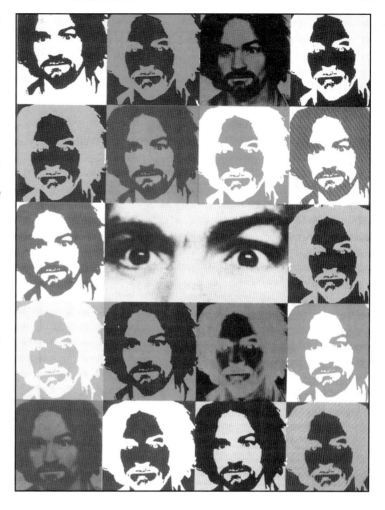

The planets in conflict on Manson's birthday are listed as the Moon and Pluto, Mercury and Uranus, the Sun and Saturn, the Moon and Mercury, the Moon and Jupiter, the Moon and Uranus, Venus and Saturn.

Of the planets in conjunction, it claims that, "Many conjunctions indicate you have an extraordinary drive to be famous."

SAGA

☐ **SAGA** was another long-winded men's mag and a competitor of **ARGOSY** and **TRUE**. The cover of this issue pictures

the underwater skeleton of an SS officer covered in a hoard of Nazi treasure.

"Charles Manson's Deadly Stars," is the pertinent cover blurb, and the article of concern is the *Inside Astrology for Men* feature by Joseph F. Goodavage, who also has a second article in the mag, *The Moon is Alive!*

Inside Astrology for Men is broken into four sections—"Future Headlines," "The Time Machine," "Astro Portrait," which is on Manson, and lastly "And The Final Word."

The "Astro-Portrait" starts by calling Manson "The Demon of Death Valley" and the "hippie 'Rasputin.'" The first being the title of the **TIME** magazine piece on Manson,

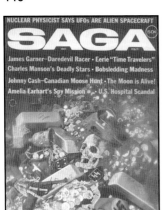

NUCLEAR PHYSICIST SAYS UFOs ARE ALIEN SPACECRAFT

SAGA 60¢

James Garner–Daredevil Racer • Eerie "Time Travelers"
Charles Manson's Deadly Stars • Bobsledding Madness
Johnny Cash–Canadian Moose Hunt • The Moon is Alive!
Amelia Earhart's Spy Mission • U.S. Hospital Scandal

MISSING BILLION DOLLAR HOARD OF HITLER'S HENCHMEN

Above The cover of SAGA Feb 71 with a drowned skeletal SS officer covered in looted Nazi gold, and another Manson astrological interpretation inside.
Opposite NATIONAL EXAMINER Apr 12, 1971, had an "exclusive" given to them by girls who claimed to possess intimate knowledge of Manson's sexual prowess.

NATIONAL INSIDER
Vol 18 No 8 Feb 21, 1971
National Insider, Inc., 2713 N. Pulaski
Rd., Chicago, IL 60639 .25 20pp

NATIONAL EXAMINER
Vol 8 No 7 Apr 12, 1971
Beta Publications Ltd., 1440 St.
Catherine St. W., Suite 625, Montreal,
Canada .25 20pp

in which the phrase "hippie Rasputin" is also used. He is also referred to as the "Cincinnati Kid" a few lines later.

The Manson reading continues, stating that "Saturn, the 'celestial taskmaster' was in extremely adverse aspect to Manson's Capricorn Moon at the time of his birth."

It also says of Manson:

This drifter, fancying himself some kind of super-commando out to right imaginary wrongs, never got beyond the seventh grade. He never knew his father; his mother was a prostitute; his criminal record is two decades long and—despite the fact that he played 'guru,' 'god,' and 'Satan,' in a crudely dictatorial manner, he had a deep life-long sex problem—i.e., he hated women. One disgusted rancher told of an incident in a garbage heap 'commune' when one of Manson's girls performed a sex act on the 'guru' while his majesty discussed 'business.'

The column ends by saying: "Look for a sensational bestseller about this incredible hippie leader…followed by a multi-million dollar flick by a major motion picture company."

NATIONAL INSIDER

☐ The headline on this tabloid reads: "Doctor Says Parents To Blame—Twenty Million Charlie Mansons Running Loose," which corresponds with the article inside, *Charlie Manson: The Angriest Child of all* by Barclary Wilson, accompanied by a photo of Manson at the age of fourteen. The piece claims that at fourteen Manson was renting a room by himself, paid for by delivering Western Union telegrams and engaging in petty theft.

The piece uses as its basis a new book at the time, **I Hate My Parents** by Dr Anita Stevens, a nationally known specialist in adolescent psychiatry. Dr Stevens used

Manson as one of her case studies, a classic example of how not to raise a child.

Dr Stevens' theory is that Manson's childhood, with no father and an alcoholic prostitute for a mother, had such an adverse effect on him:

that he vows undying revenge on those who brought him up, often taking this revenge, however, on the innocent who only symbolically represent his parents. ...Children give up primitive impulses because they want a parent's love and approval. Otherwise, they would probably remain as they are born—selfish, savage, greedy, egotistical.

The article mentions Manson's early criminal career and his path through many correctional institutions that taught him life was hard. Reading about Manson's childhood it doesn't take a brain surgeon to figure out that his unique charismatic/antisocial personality was formed by being passed around to relatives who had little use for him. The browbeatings, physical beatings, and sodomy at the hands of reform schools and adult correctional facilities also obviously had an impact.

The article ends by saying that Manson vented his anger at his parents, or lack thereof, by trying to destroy "The Establishment" which symbolized them. Claiming that Manson had seen the pregnant Tate on at least one occasion before the murders, Wilson writes: "She became the symbolic 'pig mother' and that must have finally made him decide to seek revenge at her house."

NATIONAL EXAMINER

☐ *Exclusive! Girls who were his Love Slaves Reveal: Charles Manson's Strange Sex Secrets—Why they Willingly Gave their Bodies for his Pervert Desires* by John Samson is the two page centerspread.

After comparing Manson to Rasputin, the **EXAMINER**, "In an effort to solve the mystery of Charles Manson's sexual prowess…spent weeks seeking out former members of the Manson clan and interviewing them."

The article claims: "One woman murdered her husband in order to go to him. Another gave $10,000 just to sleep with him."

The three girls on the cover are interviewed, along with Paul Watkins and Mike Armstrong, a Spahn Ranch foreman, about Manson's sexual habits and powers.

The first is Allison Whitaker, "who insists that her real name is 'Zulu Red' because that is what Manson once called her." She is quoted:

I can still close my eyes and feel him making love to me. He was such a powerful man. He could hurt me and be so gentle all at the same time. He was cruel and kind. I can still have an orgasm just by remembering his hands on my thighs.

The next girl refused to give her real name, calling herself "Caroline Kennedy," again, named such by Manson because she "was so prim and proper." She painted this picture of life with Charlie:

> NATIONAL
> **EXAMINER** 25¢
> PUBLISHED WEEKLY
> VOL 8 — NO. 7 *Facts the Others Are Afraid to Print* Ⓕ APRIL 12, 1971
>
> **EXCLUSIVE!** Girls Who Were His Love Slaves Reveal:
>
> # CHARLES MANSON'S STRANGE SEX SECRETS
>
>
>
> **Why They Willingly Gave Their Bodies For His Pervert Desires**

We would start out with twelve girls and six men in a circle. Charlie would get in the middle of the circle. When he gave the signal, the girls would move in very slowly and fall at his feet. We would kiss his toes and then his ankles and tell him how much we loved him. We would shove and push each other just to touch him with our lips—and we'd work our way up and up until…Wow! Charlie would just stand there—so powerful—until he made you feel like nothing and everything. Then, when he gave the signal, the men would come and caress our bodies and we would all make love. When he gave another signal, we would change partners. He was in such total control until no matter who you were doing it with, you felt as though you were being loved by Charlie himself.

The third girl interviewed was Gloria Carson, a runaway who was fifteen years old when she met Paul Watkins, who took her to meet Manson:

When we got to the ranch, Paul took me to see Charlie. He was dressed in a cape and his eyes were real eerie—like he could look right through my skin and see inside my body. Charlie sat down beside me and began talking in a gentle voice. I can't even remember what he was saying, but the words made me feel like I was taking a warm bath. While he caressed my body with one hand, he made funny little motions with the other. I was fascinated by the motions. We did not look at one another, but I had never felt so close to a man.

The article gives a brief history of Man-

TWO SEXY BEAUTIES WERE MARKED FOR DEATH

TRUE DETECTIVE

APRIL 50¢

The KEY testimony that did it:

'JESUS' MANSON & HIS GIRLS— GUILTY OF MURDER!

Special Book-Length Feature

PASSION KILLING OF A TEXAS BLONDE

Above A typically posed photo for the cover of TRUE DETECTIVE Apr 71, which refers to Manson as Jesus, as opposed to Satan. Opposite UNCENSORED Aug 71 with Manson in buckskins next to Princess Margaret and Ryan O'Neal.

TRUE DETECTIVE
Vol 94 No 6 Apr 1971
TD Publishing Corp., 206 E. 43rd St., New York, NY 10017 .50 84pp

NATIONAL INSIDER
Vol 19 No 5 Aug 1, 1971
National Insider, Inc., 2713 N. Pulaski Rd., Chicago, IL 60639 .25 20pp

UNCENSORED
Vol 20 No 4 Aug 1971
J.K. Publications, Inc., 227 East 45th St., New York, NY 10017 .50 68pp

son and how he had gathered his Family from San Francisco to LA. Paul Watkins is quoted on Charlie's tutoring in how to pick up girls and bring them back to him.

In the last paragraph, a Dr Charles D. Jarrell relates how it was possible for "a skinny ex-convict who never finished high school" to wield such power over people. He says: "These girls were lost and lonely. At one time, he filled two great needs in their lives—as a father and a lover rolled into one!"

TRUE DETECTIVE

☐ *The Key Testimony that did it: 'Jesus' Manson & his Girls—Guilty of Murder!* is the second long article written for **TRUE DETECTIVE** by Chris Edwards, a "Special Book-Length Feature."

At the beginning of the article Edwards mentions Susan Atkins' case-breaking, loose-lipped, jailhouse tales of murder, mayhem and blood tasting in the Hollywood hills, and her subsequent Grand Jury testimony—which she recanted later—from which the instant book **The Killing of Sharon Tate** was written.

But the article really centers around the testimony of Linda Kasabian—"The only female member of the Manson family to smash this slavish mold"—who cut a deal for immunity from prosecution for murder if she testified against the other defendants.

The last part of the article includes a lot of the transcript of Bugliosi's questioning of Kasabian, and her testimony. Her direct questioning by Bugliosi lasted three days. Covered in Bugliosi's questioning was Kasabian's arrival at Spahn Ranch, her indoctrination by Manson, and the two nights of murder she was involved in.

When asked if she was under the influence of anything the night of the murders, Kasabian answers: "I was under the influence of Charlie." She adds:

When I first saw Charlie dressed in buckskins and with his long hair and beard, he looked beautiful. And I think that is when I started to believe he was Jesus Christ. But I began to doubt when I saw him beat up some of the girls.

When interviewed in her New Hampshire home about the guilty verdicts that were handed down in the case, Kasabian comments: "I am not surprised, but my heart still grieves for them. I knew it in my heart."

The editor's note at the end of the piece informs us:

On February 4th, Charles 'Tex' Watson, who had been in a hospital for the criminally insane undergoing tests, was certified as 'restored to legal capacity' and was to be returned to Los Angeles to stand trial for murder.

NATIONAL INSIDER

☐ Sean Connery's James Bond and Liz Renay share the cover slots on this issue and inside you find the feature *The World of Joseph DeLouise, Psychic—Part Three of Psychic Mission—DeLouise's Mind Haunted by Visions of Manson's Thrill Killers.*

This is the third part in an ongoing series of articles by DeLouise taken from his book **Psychic Mission** (1971), and the only one that concerned the Tate murders.

If DeLouise's crystal clear predictions were made on Aug 19, 1969, a week after the Tate murders, as he claims, they are impressive, but, appearing in this Aug 71 article, they seem a bit after the fact. His predictions are also mentioned in a small item in the back of the **NATIONAL ENQUIRER** Jan 11, 1970 (see page 416), again after Manson and crew had been arrested.

DeLouise's visions included: a hand wielding a knife, the name "Linda," a plane writing "Texas" across the sky, vertical bars

on windows and doors, a man in an institution, a woman in an arched doorway holding a cat, greasy hands working on a motor, disassembled auto parts lying around, a clean-shaven face with long hair and a jagged scar on its cheek, and a link between money, black magic and movies.

From the beginning, DeLouise asserts that: "a bitter taste came into my mouth and I felt a dryness in my throat which to me is a sure psychic indication of narcotics." He mentions a "quinine-like taste" in his mouth again later while relating his visions.

When the visions finally stopped, DeLouise got a call from a Miss Neiswender, a reporter who had also interviewed Peter Hurkos, and was writing an article called *Psychics Give Tate Case Ideas* that ran in the Aug 21, 1969 issue of the Long Beach **INDEPENDENT PRESS-TELEGRAM**. The article is reprinted in the text of DeLouise's story.

In it we learn that DeLouise, a father of six who was a hairdresser then living in Chicago, had come to the US from Italy at the age of six with money he found in a box he was led to via ESP.

DeLouise told Neiswender that the Tate murders were committed by three "thrill killers" who were acquaintances of, but not close to, the victims. The three had no remorse for the murders, felt joy in their killing and were probably high on drugs.

After Susan Atkins' confession, Neiswender was spooked by DeLouise's seemingly accurate visions and wrote a follow-up piece called *Psychic Described Tate 'Thrill Killers'* which reveals more of his original predictions that she hadn't used in her first article.

As an added bonus, the centerspread in this issue is Part Six of the continuing series the **NATIONAL INSIDER** had been running on *The Confessions of Liz Renay*. Here, she explains that she was arrested because of her mob-connected boyfriends.

UNCENSORED

❑ **UNCENSORED**'s roots went back to June 1953 when its first issue was published by Feature Story Corp., and it remained a quarterly series of exploitation mags until the Oct 54 issue, when it became another scandal mag in the shadow of **CONFIDENTIAL**. It eventually went monthly, and changed publishers a few times, but survived until 1971, which makes this one of its last issues. By the end of its run, **UNCENSORED** had started to fill its back pages with ads for sex films, adult books, sex aids, marriage manuals, and so on.

Not so strangely, Myron Fass resurrected the title briefly in 1975, publishing it under his National Mirror, Inc. company, also the listed publisher of his sleaze-fest mag **CONFIDENTIAL SEX REPORT**.

Preceding the Manson juror article are others of interest, such as *Motor Monsters,* about the violent and deadly clash between the Hell's Angels MC and Breed MC at a Motorcycle Custom and Trade Show in Cleveland, Ohio. It also tells of other turf wars between various outlaw clubs around the country. There are a few photos of processions of motorcycles taken at biker funerals.

Other articles featured in the mag are: *Vietnam's Dragon Lady*, *Dangerous*

Above **Appropriate cover painting for ESQUIRE Nov 71 with the topic of "Garbology" and an article on Manson largely taken from Ed Sanders' book *The Family*.**
Opposite **An amazing discovery courtesy of the NATIONAL BULLETIN Nov 29, 1971.**

ESQUIRE
Vol 76 No 5 (whole No 456) Nov 1971
Esquire, Inc., 65 E. South Water St., Chicago, IL 60601 1.00 292pp

NATIONAL BULLETIN
Vol 10 No 26
Nov 29, 1971
Summit Publishing Co., 1440 St. Catherine St. West, Suite 625 Montreal, Canada .25 20pp

Psychos in Government, *Proven Cure for Homos*, and *I am a Call Girl for Lesbians*.

Sex Capers of the Manson Jury by Jeanne Voyeur purports to tell the behind the scenes story of the eleven men and women chosen for "the most important jury of the twentieth century," which ended up sequestered for nine months.

The controversy over some of the jurors becoming romantically and sexually involved with each other during their sequestration was raised by juror William M. Zamora, who at the time was starting to write his book, **Trial by Your Peers** (renamed **Blood Family** for the 1976 Zebra paperback), about his experience on the jury and its sequestration. In Zamora's comment to the press right after the trial ended, he stated that: "In nine months people do give up and become what they are, and somehow they are promiscuous."

Zamora's statement was rebutted by jury foreman Herman Tubik, who was an undertaker/mortician when not a Manson juror. Tubik's comeback to Zamora's insinuation was: "We had our associations, we played around, but if anybody said there were sexual affairs that was very small of him."

Zamora's last word:

All I can tell you is this. I had two eyes. If [Tubik] wanted to close his eyes to reality, that would be fine, but it was a known fact among all of us. I felt that for my book it would be an asset to mention it on the TV interview and furthermore what I said was no lie. It was strictly the truth.

The tales told were of one juror, Mrs Evelyn Hines, becoming an alcoholic due to the stress of the trial, and another juror, William McBride getting a "Dear John" letter from his fiancée while in seclusion. McBride would later complain about the intrusive security measures imposed upon him, that made "intimate companionship" a problem

for him when trying to pick up pretty young things around the hotel pool, and being sent to his room, so to speak, by a large female bailiff. McBride later hooked up with "a pretty bank employee" who would visit him.

The article then questions what the trial really answered, other than handing down a guilty verdict.

Why had Charles Manson taken to killing when he had such a good thing going for him with his dune buggies and his girls? Why had the girls murdered strangers for a man who did no killing of his own? Why did the defendants giggle and sigh through the trial without attempting to save their skins?

Only the Shadow knew.

The end of the piece rehashes famous trials and the people who cashed in on them, such as the jurors in the Bruno Hauptman trial, the accused kidnapper and murderer of the Lindbergh baby. The whole jury went on the road with a "vaudeville act" that played a few small dates in New Jersey before bombing at New York's Academy of Music. Also mentioned is Kiki Roberts, one time Ziegfeld Follies girl and moll to the gangster "Legs" Diamond. Roberts wrote a book and did a "song and dance routine" to cash in on the fame of her gunned down gangster boyfriend.

ESQUIRE

☐ The cover of this issue of **ESQUIRE** is quite appropriate for the Manson article inside—*Charlie and the Devil* by Ed Sanders. The cover theme and blurb, "You Are What You Throw Away," corresponds to an article inside, *The Art of Garbage Analysis*—"Secret garbage reports on: Bob Dylan, Muhammad Ali, Abbie Hoffman and Neil Simon."

The Sanders article, subtitled "The Tate murders; Manson's vision; Death Valley days," is sometimes verbatim, and

at other times loosely taken from his book **The Family**, a work in progress at the time. The main text is on the murders of Sharon Tate and friends, then a brief explanation from Sanders of how he first became aware of, and interested in, the Manson case. He then relates the genesis of Manson's Family from the early days of the Summer of Love in Haight-Ashbury, to the move to LA in the summer of 1968, their stay at the Spahn Ranch, and eventual move to Death Valley.

There are two inset pieces within the article, one titled *The Influence of Satan*, the other *A Conversation on Human Sacrifice*, a couple of the building blocks for Maury Terry's later speculative orgy, **The Ultimate Evil**.

In *The Influence of Satan*, Sanders ponders the "sleazo inputs" that sent Manson on his death trip, and cites the Process Church, the infamous Solar Lodge of the Ordo Templi Orientis, and the Kirke Order of Dog Blood as contributing to Manson's philosophy.

A Conversation on Human Sacrifice is based on interviews Sanders conducted with a person who had "been hanging around on the edges of the family for about two-and-a-half years." This person:

> *alleged that certain members of the Process and others were involved with members of an obscure bike club in a ritzy hilltop commune not far from the Spahn Ranch. He alleged that the family was involved with this group. That they went there to score dope. That they participated with them in out-of-door filmed beach ceremonies involving sacrifices. That some of the family were in the films.*

Part of the interview is included in the text, during which the person describes a five minute "snuff movie" of a woman with her head already cut off, whose body lay there as black cloaked figures danced around "throwing blood all over."

NATIONAL BULLETIN

☐ "New Evidence Reveals...Charles Manson Is Illegitimate Son of Adolf Hitler" claims the incredulous cover of this tabloid. What better way to sell papers than putting Manson and Hitler together. Hitler seemed to work wonders for **THE POLICE GAZETTE**, as they used his image, along with Eva Braun and other assorted Nazis, for years on their covers.

The two page centerspread feature by Sam Pepper sports many pictures of Hitler and Manson, and claims this "revelation" came from newly discovered German documents taken by the Russians at the end of the war. It claims Manson's mother's real name was Greta Manich, "one of the many teenage girls whom Hitler used in his perverse sex games." It goes on to say that Hitler allowed these girls to live, but not in Germany, and they were shipped off to other countries. "Russian research reveals that there are over a dozen little Hitlers alive and well somewhere in the world today."

The article goes on to quote a Dr Alan Prospers, chairman of the Psychology Dept. at the University of New York: "Once you establish the historical validity of such a premise, and the Russians have surely done that, the whole thing fits together beautifully." It then examines Manson's

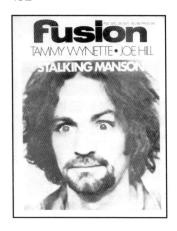

Above **FUSION (#69) Dec 24, 1971,**
had Manson's eyes printed in bright
red ink for the cover mugshot.

**FUSION
No 69 Dec 24, 1971,**
New England Scene Pubs, 909 Beacon
St., Boston, MA 02215 .50 56pp

**CONFIDENTIAL FLASH
Vol 36 No 2 (inside Vol 35
No 2) Jan 8, 1972**
Flash Publishing & Distributing
Company Ltd., 234 Eglinton Ave.
East, Suite 202, Toronto 315, Ontario,
Canada .25 20pp

**IT (INTERNATIONAL
TIMES)
No 127 Apr 6, 1972**
Bloom (Publications) Ltd., 11a Berwick
St., London, W1A 4PF 15p 52pp

anti-Semitism and dislike of blacks as be-
ing parallel to Hitler's. Another quote from
Harold Schoner, a historian who was in Nazi
Germany until 1936, reads as follows:

> *Everyone speaks of Manson's eyes,
> well, I've seen Hitler in person many
> times and the similarity is astounding.
> The eyes seem to burn into you and
> the words, the utter nonsense being
> spoken, takes on a magic meaning of
> its own.*
> *Hypnotic is not a strong enough word,
> it was beyond the trance state. You
> can't make people kill the way Hitler
> and Manson did through hypnotism—
> that's been proven. It is something bor-
> dering on the religious and it definitely
> had sexual overtones.*

FUSION

☐ **FUSION** had changed from its folded
tabloid format into a magazine format by
this issue, but the insides are still printed
on newsprint, and it was bi-weekly. By issue
#72, it had become a monthly.

The editorial that kicks off the issue
(again assuming it was written by Robert
Somma, the editor) is of as much interest as
the article. It talks about the criticism heaped
on Ed Sanders' book, **The Family: Charles
Manson's Dune Buggy Attack Battalion,**
in both the established and alternative
press at the time, stating the love ("A Bos-
ton reviewer nominated it for the Pulitzer
Prize") and hate ("**NEWSWEEK** described
it as insufferably dumb") it had inspired in
reviewers. Also mentioned is the lawsuit
brought against Sanders by the Process
Church, and Sanders making himself hard
to find for safety reasons.

The editor pats his own publication on
the back for discussing the questions the
Manson episode raised within certain seg-
ments of America, namely the communal
groups. The topic is dubbed "psychedelic

fascism"—also the theme of the book
Mindfuckers—and is concerned with how
charismatic personalities (such as Manson)
can so control a group that there is no free-
dom of thought within it. All was one, one
was all, all was Charlie.

FUSION did publish, prior to Sanders'
book, a piece about the Boston chapter of
the Process Church of the Final Judgement,
"which describes in rather mild fashion the
rather mild activities and viewpoints ex-
pressed by the members".

Boston had, at the same time, its own
Fort Hill community in Roxbury, headed by
Mel Lyman, another "psychedelic fascist"
whose communal cult of personality was a
topic of concern. **FUSION** had published an
essay by Lyman entitled "A Plea for Cour-
age" in an earlier issue that caused a stir
with the readers.

Stalking Manson—the Sanders Saga
by Nick Tosches is the article of interest,
written in Tosches' hip style. Tosches went
on to pen many books and an anthology
of his magazine articles has recently been
published.

Tosches tells of various personal en-
counters with Sanders in NYC—starting
a few days before Christmas 1969—as
Sanders began researching an article for
ESQUIRE magazine on the Manson case.
When Tosches next saw Sanders, a week
later, he had this to say about it:

> *He seemed by then to be fairly bub-
> bling over with interest in the Manson
> story. He had grim descriptions of Tate
> mutilations culled from the staff of
> the **NEW YORK POST** whom he had
> begun to rub elbows with at the Lion's
> Head Bar in his newly acquired aspect
> of Ed Sanders qua Sam Spade. It was
> while getting sloshed in some cavern-
> ous Bowery bar that I first heard him
> speak of expanding his Manson article
> into a book because there was so
> much to it. Shortly thereafter he began
> to utilize his plane trips to Warner*

Brothers in Los Angeles as scoop forays for the Manson book.

Not only did Sanders write the book, but he started over and rewrote it.

Tosches:

I think Sanders' initial beguilement with the whole Manson affair was a fairly logical extension of his basic preoccupations with the universe of Satanism, dope-nutsness, magick, long-haired maniacs, sexus, and the nitemare side of honk.

Tosches has praised Sanders' hip writing style, which got him criticism from other reviewers, and included comments like this:

But beneath the overall austere journalistic feel of **The Family** you can see Country Ed qua mutant popping in and out, as in those paragraphs where lethal gunfire is minimized to 'Bang.' Or when a mutilation victim is given an empathic 'ouch' by the author in the midst of his data-obsessed reportage. **The Family** is also possibly the first sociological casebook in which 'oo-ee-oo!' is used by its author to comment on any given incidents or phenomena.

The piece concludes:

Could you picture in about ten years or so Manson in a suit & tie with a little 'Pray for Rosemary's Baby' button on his lapel (so that people would remember who he was) filming a teevee commercial a la Willie Sutton: 'Yeah, heh-heh, I was pretty reckless in those days. But if I had to do it all over again, I'd still choose Volkswagen.' Fade.

CONFIDENTIAL FLASH

☐ "Now, Told For The First Time: How Charles Manson Programmed Tate Murders" is the cover headline. The one page article inside, *Manson's 'Zombie' was Programmed to Kill* by H. Johnson, concerns: "the weirdly twisted world of dope, sex and bizarre religious customs that prevail among the young in southern California." The piece has a definite Tex-as-victim slant to it.

It gives the obligatory biographical info and tells of Watson meeting Manson at Dennis Wilson's "luxury pad" after Watson picked up the Beach Boy hitchhiking and drove him home. Watson apparently got into harder drugs after hooking up with Manson and his tribe and claimed he was being programmed for murder. After admitting to the seven murders, Watson plead insanity, which he claimed was induced by the drugs he took at the time and Manson's mind control.

The last paragraph is a quote from Watson's attorney's opening statement to the jury: "[Watson] is a mere shell of a person. When the prosecution reads the list of Manson's victims, add one more to the list—Charles Watson."

IT (INTERNATIONAL TIMES)

☐ *The Family. Charlie Manson and the Hollywood Death Cult* is the transcript of an interview with Ed Sanders, author of **The Family**, illustrated with comix panels taken from **Legion of Charlies** by Greg Irons and Tom Veitch. **The Family** has been reprinted twice, and updated each time, the most recent printing having some rare photos.

The interview with Sanders is interesting because it was conducted not long after he finished his book and his experiences were still fresh in his mind. Sanders talks about how boring he wished the book would be, and mentions getting that very criticism about it, which he liked. He claims he

wanted to fill it with facts and figures, even including social security numbers, to make it dry reading on purpose, because that was what it was to him gathering the info. Having read the book not long after it came out, I found it anything but boring, in fact I've read it three times!

Sanders said:

See, my book isn't about Manson. It's about criminal behavior under patterns of suggestion. It's about fascism. It's about blind obedience, about people wandering around not knowing what they're doing without having plans and just willing to obey. It doesn't dig into their minds. It's purely existential; it's just what they did. It's a travelogue. See, I wanted to get that slow drive toward snuff. That slow, twisted path that led them from the counter culture to the crazy culture.

After pointing out that Manson's modus operandi was that of a pimp, Sanders says: "I just wanted to present him in a non-magical, non-religious, non-superstitious aura and do it as dryly as possible and one way to do it is to deliberately create boredom."

When asked why he took that approach, Sanders gives the interesting response:

Because it creates this tedious boredom and that's what it really was. Even though they killed them, everything they did was unaesthetic. There was nothing about them or the series of events that was esthetic [sic]. At the Spahn ranch all you see are the horse flies swarming above this huge pile of manure and the sway backed horses and the filthy buildings and just how pathetic it all was. And even the way they killed and everything they did was just sleazy, icky, junky, you'd have to go back to the words children use. Mushy and uck. And one way of doing it was to bore people to death—to life;

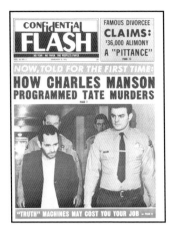

Above **CONFIDENTIAL FLASH was
a Canadian tabloid from Toronto
with a reasonable US readership.
The Jan 8, 1972, issue has on
the cover a diminutive looking
Manson flanked by escorts.** Right
and Opposite **IT (INTERNATIONAL
TIMES) Apr 6, 1972, has an interview
with Ed Sanders, illustrated with a
drawing from the US underground
comic** *Legion of Charlies* **by Greg
Irons.**

DAILY PLANET
Vol 2 No 7
Apr 13–26, 1972
Gargoyle Publishing Corp., PO Box
3316, Merchandise Mart, Chicago,
IL .25 24pp plus 24pp Special Audio
Supplement

to bore people to life.

On Manson's use of the women:

*It was really pathetic that his indoc-
trination of some of these young
women, teenagers, and some in their
late twenties, should have left their
minds so completely restructured. He
used females as a kind of tool. If he
wanted to impress somebody he just
said 'send four of them in' as a kind of
masseuse squad. I had heard he had
them gobbling dogs, just every form of
hideous kind of submission.*

Concerning the Manson "snuff" related
movies that Sanders alludes to in the
book:

*I can't go into it, I can't even talk
about it. I do not possess any of those
movies, so all those people who are
paranoid about it can rest at ease. I do
not know where any of them are.*

Sanders ends by stating that if he had
to write the book over, he wouldn't do it—he
would rather play music in a band.

Other highlights of the issue include: *He
Not Busy Being Born is Busy Dying…*, about
the White Panther Party; and *Assassination,*

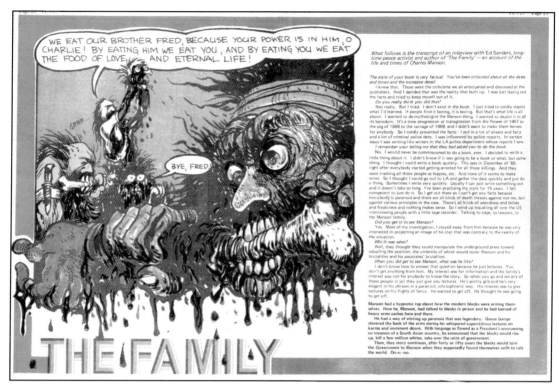

WE EAT OUR BROTHER FRED, BECAUSE YOUR POWER IS IN HIM, O CHARLIE! BY EATING HIM WE EAT YOU, AND BY EATING YOU WE EAT THE FOOD OF LOVE — AND ETERNAL LIFE!

BYE, FRED.

THE FAMILY

What follows is the transcript of an interview with Ed Sanders, long-time peace activist and author of 'The Family' — an account of the life and times of Charles Manson.

The style of your book is very factual. You've been criticized about all the dates and times and the excessive detail.
I knew that. Those were the criticisms we all anticipated and discussed at the publishers. And I decided that was the reality that built up. I was just laying out the facts and tried to keep myself out of it.
Do you really think you did that?
Not really. But I tried. I don't exist in the book. I just tried to coldly depict what I'd learned. If people find it boring, it is boring. But that's what life is all about. I wanted to de-mythologize the Manson thing. I wanted to depict it in all its boredom. It's a slow progression or transgression from the flower of 1967 to the pig of 1968 to the carnage of 1969, and I didn't want to make them heroes for anybody. So I coldly presented the facts: I put in a lot of aliases and facts and a lot of criminal police data. I was influenced by police reports. In certain ways I was writing like writers in the LA police department whose reports I saw.
I remember your telling me that they had asked you to do the book.
No. I would never be commissioned to do a book, ever. I decided to write a little thing about it. I didn't know if it was going to be a book or what, but something. I thought I could write a book quickly. This was in December of '69, right after everybody started getting arrested for all those killings. And they were trashing all those people as hippies, etc. And none of it seems to make sense. So I thought I could go out to LA and gather the data quickly and just do a thing. Sometimes I write very quickly. Usually I can just write something out and it doesn't take so long. I've been practising my style for 15 years. I felt competent to just do it. So I get out there an I can't get any facts because everybody's paranoid and there are all kinds of death threats against not me, but against various principles in the case. There's all kinds of weirdness and bribes and freakiness and nothing makes sense. So I wind up travelling all over the US interviewing people with a little tape recorder. Talking to cops, to lawyers, to the Manson family.
Did you get in to see Manson?
Yes. Most of my investigation, I stayed away from him because he was very interested in projecting an image of his clan that was contrary to the reality of the situation.
Which was what?
Well, they thought they could manipulate the underground press toward adopting the position, the umbrella of which would cover Manson and his brutalities and his associates' brutalities.
When you did get to see Manson, what was he like?
I don't know how to answer that question because he just lectures. You don't get anything from him. My interest was for information and the family's interest was not for anybody to know the story. So when you go and see any of those people in jail they just give you lectures. He's pretty glib and he's very elegant in his phrases in a paranoid, schizophrenic way. His interest was to give lectures on his flights of fancy. He wanted to get off. He thought he was going to get off.

Manson had a hypnotic rap about how the modern blacks were arming themselves. How he, Manson, had talked to blacks in prison and he had learned of heavy arms caches here and there.
He had a way of stirring up paranoia that was legendary. Goose bumps shivered the back of the arm during his whispered superstitious lectures on karma and imminent doom. With language as flawed as a President's announcing an invasion of a South Asian country, he announced that the blacks would rise up, kill a few million whites, take over the reins of government.
Then, they story continues, after forty or fifty years the blacks would turn the Government to Manson when they supposedly found themselves unfit to rule the world. Oo-ee-oo.

U.S.A., an interview with lawyer and JFK conspiracy theorist Mark Lane.

DAILY PLANET

☐ This paper was a semi-underground, local area bi-weekly from the North Side of Chicago. The cover photo, credited to Tem Horwitz, is printed in purple ink and is a great portrait of a young lady hawking Process literature on the streets of Chicago in the rain, with the banner headline, "The Final Judgement."

The young lady's cloak is reminiscent of the Manson girls, Squeaky Fromme and Sandra Good, in their respective Red and Blue cloaks. She is pictured clutching a stack of magazines wrapped in plastic bags, on the back of which you can see the Process symbol underneath her gloved pinky.

The Process 'As It Is, So Be It…' by David Witz, is an article with one photo, the caption to which reads "Worshipping Christ and the Devil," and depicts some kind of Process gathering, with a large cross on the wall in the background. The person presiding, facing the camera, is wearing a cross around his neck. The heading on the second half page, reads *Cloaks, Satan & Marshall Field*.

The article opens:

One of them approaches you on a downtown street, and with the grace of a full Chicagoan you veer curbward, out of the way of this black-cloaked… person…but in a voice ever so soft and British, he asks you if you'd care to buy the magazine. You mutter and shake your head and trundle on, staring at the sidewalk.
And, although you keep walking, you've seen it. A hint of gray cloth under the black cloth, a silver cross around the neck, an impossibly

manicured beard and…this smile…not exactly the lacquered toothy grimace of the teevee weatherman or the blank, humorless look of the beggar…but a nice beatific, loving knowing and unnervingly maddening smile, the smile that your chess partner smiles before he demolishes you in a five-hour game. And in that split-second when your bleary heathen eyes make contact with the crystalline, piercing eyes of this…maniac…that smile is seared onto your memory with your own immediate question right next to it…'What is he grinning for?'
And that smile, that shy, knowing smile, will stay on his face underneath his alert orbs after all the books are sold, and he'll keep faintly smiling as he walks to the bus stop and boards the Broadway bus (sure, he found the bus stop okay and he knew what the exact change was so he can't be stu-

SPECIAL SOUNDS OF TOMORROW PULL-OUT
Exclusive: Murder and Music at Puerto Rican Rockfest, P.12
Special Team Report On U.S. Housing Scandal,P.5

Daily Planet

APR 13-26, 1972　THE NORTH SIDE'S BIWEEKLY　25 CENTS

The Final Judgment, P.3

Above DAILY PLANET was a local underground paper from the North Side of Chicago. The Apr 13–26, 1972 issue sported a female follower of the Process Church on the cover hawking their papers on the street in the rain. Opposite **The only photo in the DAILY PLANET article on the Process Church.**

REAL DETECTIVE
Nov 1973
G. C. London Publishing Corp.,
PO Box 58, Rockville Centre, NY
11571 .60 68pp

CONFIDENTIAL SEX
REPORT
Vol 1 No 5 Jun 1975
National Mirror, Inc., 257 Park
Avenue South, New York, NY
10010 1.00 68pp

pid, but those cloaks on the bus…and that smile)…and the smile will stay as the cloak gets off at Deming and glides down the street, acknowledging glances, and into 602 West, a big brick house in the Flamboyant Bungalow school of architecture with a very mystic sign on the front, over the door. And, if that faint, almost-a-smirk got you right in your paranoia, don't look into this house, because there's fifteen or so other delicate, uniformed young men and women inside and each and every one of them has that same, identical fanatical grin!
Welcome to the Process Church of the Final Judgement.

This is the way almost all references to the Process Church read in the anecdotes from the various books they are mentioned in. Dark clad figures on the street with strange silver symbols around their necks, selling magazines, booklets and pamphlets, always given a sinister slant by the writers who encountered them. This article goes on to say, "the first impression could easily be of a quiet group of parakeet-slaying devil-worshipers ghoulishly waiting for the apocalypse for their own degenerate reasons."

Ed Sanders' take on the Process is briefly mentioned, but was eventually excised from his book after a lawsuit brought against it by the Process for libel. Some of the Process chapter of that book has been reprinted in the Nov 71 issue of **ESQUIRE**.

The article gives a brief history of Robert de Grimston and his Scientology spin-off cult, the Process. It explains that cults fall into two categories. The "internal system is closed and self-sufficient" and the "external system" (which it claims the Process was, at least by 1970) is "in the world," involved in free kitchens, halfway houses, residential homes for the mentally ill, children's hospitals, and so on.

An explanation of the Process theology of the unity of Christ and Satan is included, with

a quote from Processean Brother Reuben: "Salvation is the resolution of conflict."

Each of the four Process Gods, Jehovah, Lucifer, Satan, and Christ, and their respective personality types relating to humans are explained, with examples of the positive and negative aspects of each.

The humans listed as the positive and negative examples of the four gods are as follows:

Jehovah—Winston Churchill and Mayor Daley of Chicago
Lucifer—Martin Luther King and JFK
Satan—Janis Joplin and St. Paul
Christ—Buster Keaton and Florence Nightingale

It mentions a Process proverb: "And man carries a candle in hell, so that he can pretend he's in heaven." The writer, Witz, ponders the Process and its beliefs, coming to the conclusion that, "If reality is jelly, the Process is a bismark [sic]."

REAL DETECTIVE

❑ Although Manson and Tate are both in this highly bizarre juxtaposition of photos and blurbs on the cover, and probably helped to boost sales, the article inside, called *California's Gruesome Massacre in the Mansion*, is about the murder of Dr Victor M. Ohta, his wife, two children and secretary by John Linley Frazier.

Frazier had taken some mescaline and had a revelation to get back to nature and take his wife with him into the woods to start a commune. He left by himself and ended up murdering the Ohta family, leaving a written rant about the environment under the windshield wiper of the Ohta's Rolls Royce. The note was signed by the four Knights of the Tarot.

The intro blurb explains the supposed connection between the two cases:

Not long after the Sharon Tate murders made nationwide headlines, California was shocked again by what seemed another ritualistic mass killing. Five persons were slain in both cases and officials wondered whether there was any connection between the gruesome crimes.

Other features in the issue: *She Peddles Hot Drugs, Cleveland's Butcher of Kingsbury Run, Show Me to the Hot Seat,* and the *Fiery Death for the Four Teen-agers.*

CONFIDENTIAL SEX REPORT

☐ **CONFIDENTIAL SEX REPORT** is a revelation in, and a perfect specimen of—*extreme sleaze*—something that is not easy to find these days in print. The numbering suggests there are four earlier issues of **CONFIDENTIAL SEX REPORT** issued under the title **CONFIDENTIAL REPORT**. One is a special issue called **CONFIDENTIAL REPORT: JACKIE ONASSIS** and another, **CONFIDENTIAL REPORT: THE PRIVATE LIFE OF PATTY HEARST**. Both were written by John Thomas Church, and published in 1975 by National Mirror, Inc., the publishing company that had also published Myron Fass' sleaze tabloid the **NATIONAL MIRROR**.

A topless Jackie O on the cover is always a good way to start things off, especially when the accompanying blurb reads: "Kidnapper Planned To Snatch John-John and Demand Jackie's Body As Ransom!"

"Manson Sex Slave Was Going To Castrate Dick Burton and Slit Tom Jones' Throat While Having Sex With Him"—"Sex Freak Is Half Man, Half Woman"—"Did JFK and Bobby Shack Up With Marilyn Monroe?"

These are the screaming blurbs on the cover of this incredible piece of yellowing pulp from the heyday of Myron Fass' publishing career. The editor is listed as Bryant Hall, seemingly a pseudonym for Myron Fass, as

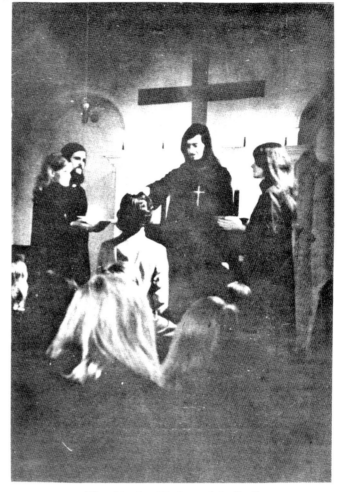

Worshipping Christ and the Devil

the rest of the staff are the same as in other Fass pulps.

The uncredited writing in the *Manson Sex Slave* article is just as sleazy as the subject matter, and sounds as if it came right out of a tabloid ten years earlier. For example:

Both Burton and Liz Taylor have since gone their separate ways to splitsville but while they were still a twosome, they headed the grisly Manson death list and Susan Atkins, one of the bandy-legged little runt's sex slaves, has

described in detail how she planned to get her kicks killing them.

The article proceeds to explain Atkins' gruesome plans to "hack off the actor's penis" and disfigure Taylor's face with a hot knife blade, pluck her eyes out, and send the disembodied penis and eyes in a jar to Eddie Fisher!

The captions and blurbs that accompany the photos are bizarre. Under a picture of Burton it reads, "Dick Burton's sex organ was to be sent to Eddie Fisher." Under a picture of Atkins: "Susan Atkins, an acid

Above This early issue of
CONFIDENTIAL REPORT (1975)
was a Jackie Onassis special. Later
issues were titled **CONFIDENTIAL
SEX REPORT** and, alongside his
TRUE SEX CRIMES, were the
epitome of Myron Fass sleaze mags.
Opposite A quintessential bad
mag, **CONFIDENTIAL SEX REPORT**
(v1 #5) Jun 75.

NATIONAL EXAMINER
Vol 12 No 41
Nov 17, 1975
Beta Publications Ltd., 1440 St. ,
Catherine St. W., Suite 625, Montreal,
H3G 1S2, Canada .30 28pp

HOLLYWOOD SEX SCANDALS
No 1 1976
Sterling's Magazines, Inc., 355
Lexington Ave., New York, NY
10017 1.00 68pp

OUI
Vol 5 No 8 Aug 1976
Playboy Publications, Inc., 919
North Michigan Ave., Chicago, IL
60611 1.25 132pp

head who got turned on by the taste of
blood." And the blurb across the bottom of a
picture of the three female defendants—At-
kins, Krenwinkel and Van Houten—reads:
"Brides of Satan...the smell of death was
their perfume."

The descriptions of Atkins' plans for
the likes of Tom Jones (to slit his throat
while he was having an orgasm) and Frank
Sinatra (to skin him alive and turn his skin
into hippie pouches) are related in detail,
redundantly so.

A good example of the article's flavor:

*What kind of a girl would want to hack
off a man's penis, gouge out his wife's
eyes, kill another man while having
sex with him, and enjoy skinning a
third? The same kind of zonked-out
butcher who wanted to cut open the
swollen belly of Sharon Tate and take
out her unborn child. The kind of sex
freak who liked to orally stimulate
dogs, drink blood, and switch hit with
both men and women, an acid head
who had quit school at fifteen, ran
away at sixteen, and became a fugitive
from the law at eighteen. For a while
Susan worked as a topless waitress.
Then she moved in with a couple of
small-time heistmen as community
property until deciding to cut out for
the northwest woods in a stolen car.
Finally, on September 12, 1966, she
was arrested by the Oregon police and
held in jail for three months.*

Speaking of the Family "orgies" and
blood lust:

*One of the highlights of an evening's
entertainment was a ritualistic killing
of a cat or dog. The girls would
masturbate the dumb brute or take his
penis in their mouths. Then they would
butcher him, draining the blood and
drinking it.*
Susan was later to describe the taste

*of Sharon Tate's blood after sticking
her finger into one of the sixteen stab
wounds. She licked the hot sticky fluid
from her fingers and got so charged up
that she almost flaked out.*

The rest of the mag is one long sleaze
fest of naked women, couples engaged in
sex, S&M pics, a "half man, half woman",
and so on.

The features *not* mentioned on the
cover are equally strange: *Exposed: Tor-
ture for Sale*, *Rape: It could happen to your
Mother, your Sister, your Wife, and even to
you*, *Africa's Black Hitler Charges Female
Foreign Minister turned Airport Toilet into
Passion Pad*, and *Body Carriers use their
Vaginas to Smuggle Dope*.

And there are of course the multitude of
ads in the back for all manner of sexually re-
lated devices, books, films and magazines.

The next issue was **CONFIDENTIAL
SEX REPORT** v1 #6 (Aug 75), and possi-
bly the last. The insanity continues with the
cover blurbs: "Maria Schneider Says She's
Bi-Sexual—Gets Turned On By AC-DC Sex,"
"Jet Set Playboy Paid 50G's To Shack Up
with Marilyn Monroe," and "Richard Burton
Wants To Rent A Womb." The back cover of
the mag is for "Sex Mates—Judy & Susan,
two tantalizing love-dolls."

The list of contents gives more descrip-
tive and elaborate titles to the features such
as: *Burton Wants to Rent a Womb...Black
Stripper Offers hers for Free*; *Kidnapped
Girls being Sold to Oil-Rich Arabs—Your
Wife or Sweetheart could end up in some
Sheik's Harem*; *Black Brides for Sale*; *Warn-
ing to Dog Lovers...Your Pooch could end
up on somebody's Dinner Table—Dognap-
pers Sell Bargain Basement 'Hamburger'
to Butcher Shops*; *Will Jackie's New Hubby
Agree to Separate Bedrooms like JFK and
Ari?*

The issue is illustrated with generic sex
shots from girlie mags, artwork, photos of
celebrities, criminals, victims, etc., not like
the previous issue.

NATIONAL EXAMINER

❑ *Exclusive! Lynette Fromme tells all! Secrets of Charles Manson's Satan Cult— She Reveals Shocking Devilish Rituals* by Stephen Kazan is the same old, same old, claiming that Manson still controlled followers from behind prison bars. A case in point is Squeaky Fromme and her attempted assassination of then President Ford. The one page article boasts some rare photos of Fromme and Sandra Good looking very cult-like in their hooded cloaks.

The strangest claim the piece makes is that Sandra Good's mysterious son by Manson, called Chosen, was being raised in secret at a California commune, and indoctrinated into Manson's philosophy so he could one day assume Manson's role as leader of the cult!

In the 1994 *Afterword* to his book **Helter Skelter,** Vincent Bugliosi states: "Little is known of Sandra Good's son, Sunstone Hawk, except that he went to college on a football scholarship and was a lineman on the team."

Good's son is variously referred to in different articles as Ivan, Ivan Satan Manson, Chosen, and Sunstone Hawk.

HOLLYWOOD SEX SCANDALS

❑ *The Sharon Tate Murders—Manson Family's Gory Bloodbath! How they still plot today!* is the five page lead feature in this one-shot mag. The uncredited article is on the sensational side, still reporting—six years later—the original inaccuracies and rumors of dismembering at the crime scene. But it also gives updates on Manson and crew in prison as of 1976; Terry Melcher's run of bad luck; and Squeaky Fromme's attempted assassination of President Ford. It ends: "So, the evil wrought by Manson and his band may just be beginning."

There are twenty-eight scandalous photo packed articles in the mag, including:

Sal Mineo—Knife Slain in Dark Alley; *Joan Bennet—Shot in the Groin*; *Jayne Mansfield—Her Grisly Last Ride*; *Wallace Reid—Hollywood's Pretty Boy Junkie*; *Diane Linkletter—Her Acid Trip to Eternity*; *Unsolved! Two Hollywood Starlet Murders! Black Dahlia & Thelma Todd!*

OUI

❑ *Meeting Manson—The Acid Apostle and the Prophet of Doom Discuss Life and Fear and Death* by Timothy Leary juxtaposes the minds of Leary and Manson. Their paths crossed, together on the same stage—

maximum security at Folsom Prison—for a moment in time and space. It was enough to make one pause and think—was it just a cosmic coincidence, or were strings being pulled by the powers that were?

Leary, the psychedelic non-guru of neurology, psychology, and intelligence—being questioned by Manson, beatnik con man pimp, psychedelic tripster hipster, and maestro of many acid drenched orgies—makes for a very strange article indeed.

Not mentioned in the article is that in 1970 Leary escaped from a prison in California, and ended up in Algeria with Black Panther Party leader and fugitive from justice, Eldridge Cleaver, who suspected Leary and

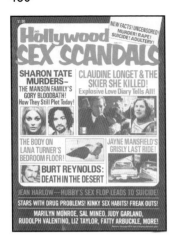

BEST OF THE SAN FRANCISCO BALL

Vol 3 No 2 (No 7) 1976
Jaundice Press, Inc., 17620
Sherman Way, Suite 9, Van Nuys, CA
91406 1.50 84pp

DRACULA CLASSIC 1976

Eerie Publications, Inc., 257 Park
Avenue South, New York, NY
10010 1.00 68pp

his wife Rosemary of being CIA operatives, and put them under "house arrest." The real extent of Leary's involvement with the CIA has never been disclosed.

A couple of years later when Leary returned to the US (he claimed the CIA kidnapped him), he landed in Folsom Prison, which was where this encounter took place.

The article starts with Leary writing as if in a sci-fi espionage novel:

Commodore Leri, Agent from Central Intelligence assigned to earth, third planet of the G-type Star, sits on the bench of the holding cell of Soledad Prison, dressed in the white jump suit worn by transferees. On his left, John O'Neill, a slick good-looking big-city Irishman down for ten to life for murder two. To his right, a tall, slim, pretty cowboy named Ted with Indian cheekbones and a deep tan. Ted babbles evasively. He has been in and out of the joint for years and has the reputation of being a professional fuck-up. ('He ain't playing with a full deck,' whispers O'Neill. 'He's one of the girls and a snitch, too.') The three hold one-way tickets to the Dark Tower, and that has formed a bond among them. The Dark Tower is Folsom, a trans-Einsteinian Black Hole in the Earth Galaxy from which nothing ever escapes but feeble red radiation.

In any case, Leary expounds on "the neurology of human fear" and the use of it by the state, the government, the prison system, Charles Manson, and the Bible. The article quotes Bugliosi as being puzzled on Manson's philosophy of fear and Paul Watkins explaining it.

Leary writes:

The power and politics of fear are, unfortunately, beyond the experience of middle-class electroids, who let

televised actors get their kicks for them. Only the cop, the prisoner and the ghetto veteran know the primal exhilaration of total alertness—which they must maintain in order to survive.

Leary calls prison "the academy of fear" and points out that Manson left that academy in 1967, "brandishing a book that cites the highest ethical authority to justify ritual murder, a 3,000 year-old text loaded with prescription and pronunciamento designed to strike fear into nonbellevers: the **Book of Revelation**."

Leary was on his way to 4A, an "adjustment center" where the prisoners who were either too violent for the main line, or snitches being protected from it, ended up. As one black convict explained to Leary, "Folsom is the bottom of the prison system, and 4A is the bottom of *that*."

On the bottom tier of 4A, in the last cell, sat "a small man on the floor in the lotus position, smiling benevolently." Tim Leary—meet Charles Manson.

As Leary got accustomed to his new living quarters, a trustee of the tier poked his head in to ask Leary if he smoked; Leary replied, "Yeah. And is there anything to read?" The trustee left and returned with tobacco, rolling papers, and four paperback books—**The Teachings of the Compassionate Buddha**, **In Search of the Miraculous**, **The Teachings of Don Juan**, and **The Master and Margarita**. He told Leary, "These are from Charlie. He's in the next cell."

As a Neurologician Leary defines black and white magic through "neurological techniques" and tells the reader how he used a Buddhist mudra, or hand movement, meaning "have no fear," to battle "black-magic reality takeovers."

It apparently served Leary well in his "first-and-only reality skirmish with Charles Manson."

Manson told Leary he had been wanting to talk with him for years, and that he could never figure out why Leary didn't choose to

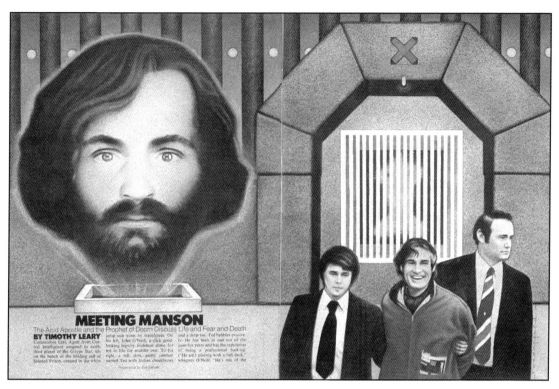

MEETING MANSON
The Acid Apostle and the Prophet of Doom Discuss Life and Fear and Death
BY TIMOTHY LEARY Commodore Leri, Agent from, Central Intelligence assigned to earth, third planet of the G-type Star, sits on the bench of the holding cell of Soledad Prison, dressed in the white jump suit worn by transfeees. On his left, John O'Neill, a slick good-looking hippety Irishman down for ten to life for murder two. To his right, a tall, slim, pretty cowboy named Ted with Indian cheekbones and a deep tan. Ted babbles passively. He has been in and out of the joint for years and has the reputation of being a professional fuck-up. "He ain't playing with a full deck," whispers O'Neill. "He's one of the

lead all the turned-on acid-dropping heads he had spawned. Leary explained that was the point: he didn't want to "impose [his] realities" and everybody had to take responsibility for their own nervous system.

Manson, of course, didn't seem to get it, or didn't want to, as he told Leary: "That was your mistake. Nobody wants responsibility. They want to be told what to do, what to believe, what's really true and really real." Manson claimed all the answers he had gotten were from the Bible, and that the Bible laid all evil at the feet of women.

When Leary asked, "How do you feel, Charlie?" Manson told him he felt bad about getting the rawest deal in 2,000 years.

Leary concluded of his meeting: "Manson should not be feared, lest he be made fearful," feeling pity for him. Another convict informed Leary that Manson's main problems in prison stemmed from his small size and the fact that he was a "head fucker" who believed his own Bible claptrap.

BEST OF THE SAN FRANCISCO BALL

☐ The feature *Manson Girls* is two pages appealing to prurient interests and includes three pictures—one of Sandra Good and Squeaky Fromme together on a bed topless, and one nude solo pic of each. The paragraph of text informs us that the accompanying pics originally appeared in the Oct 6, 1975 issue of the **L. A. STAR**, a local sex tabloid.

The **SAN FRANCISCO BALL** was the West Coast equivalent of **SCREW**, and like the New York skin tabloid, they published "Best of" mags on newsprint with glossy color covers. This particular issue, besides the above article, included fascinating features on: penis piercing, amputees, water sports, teen enema clubs, and "Patty Hearst" nude, actually an anonymous woman naked except for a pair of shades and a beret, holding a gun in various poses.

DRACULA CLASSIC

☐ **DRACULA CLASSIC** is an excellent little obscurity from Myron Fass' Eerie Publications (yes, the same people who brought you **WEIRD**, **HORROR TALES**, **TALES OF VOODOO**, etc.) who also published **FRANKENSTEIN CLASSIC** and **REVENGE OF DRACULA**, two other mags in the same vein.

DRACULA CLASSIC is filled with great photos and illustrations from vampire related sources. The whole magazine was apparently written by John Thomas Church, with the exception of *Dracula's Guest* by Bram Stoker.

John Thomas Church was reportedly an old-time pulp writer who would on occasion write whole magazines for Fass.

The reason for **DRACULA CLASSIC**'s inclusion here is that in the feature *A History of Vampires* it lists Manson, and particularly his female disciples or "sex slaves" as real

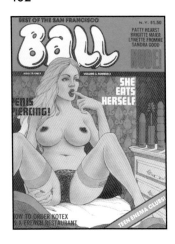

Above **BEST OF THE SAN FRANCISCO BALL (#7) 1976** reprinted pics of Squeaky Fromme and Sandra Good topless together. Opposite *The CrawDooDah Gazette* back section of CRAWDADDY (#66) Nov 76 featured Ed Sanders writing about Manson conspiracy theories.

CRAWDADDY
No 66 Nov 1976
Crawdaddy Publishing Co., Inc.,
72 Fifth Ave., New York, NY
10011 1.00 84pp

SWANK
Vol 23 No 12 Dec 1976
Swank Magazine Corp., 888 7ᵗʰ Ave.,
New York, NY 10019 2.00 112pp

life vampires! It illustrates this with a full page pic of Charlie giving the heebie-jee-bies stare he was so famous for; a picture of Red (Squeaky Fromme) and Blue (Sandra Good) in hooded capes; and a pic of Susan 'Sadie' Atkins in a miniskirt on her way to or from court. Ms Atkins did admit in her early testimony that she had tasted Sharon Tate's blood, which of course made the headlines of newspapers around the world.

The text relating to Manson is a mere paragraph in length:

Perhaps the most famous murder cult in America is the Manson Family. No one will ever know how many people they killed and buried in the desert wastes. However, it is known that they practiced satanic rites, drinking the blood of cats and dogs that they slaughtered and also drinking the blood of their human victims. One of the killers, Susan Atkins, has admitted that, after stabbing Sharon Tate, she dipped her finger into one of the gapping wounds, and then licked the warm blood of the dying girl.

Obviously the writer takes Ed Sanders' wild conjectures and mixes them with the possibly true/possibly false statement by Susan Atkins concerning her tasting Tate's blood.

CRAWDADDY

☐ *Manson's Helter FBI Skelter* by Ed Sanders can be found in *The Craw-Doo-Dah Gazette*—"All the news, all the doo-dah day"—in the back of this issue of **CRAW-DADDY** which features "Fleetwood Mac Confidential!" as the main feature.

Sanders' paranoia comes to the fore in this piece on J. Edgar Hoover's hatred of, and Cointelpro operations against, the Black Panther Party in 1968 and 1969. Sanders asks the question, could the FBI

be so "scummy" as to have enlisted Manson and his Family to help in the effort to create dissention in the BPP? Sure they could! But whether that was the case is another story.

Manson had a fear of the Black Panthers retaliating for his shooting of black drug dealer Bernard Crowe on July 1, 1969. Manson thought he had killed Crowe and that he was a Black Panther member, neither of which was true.

Paul Krassner also explored the theory of Manson as puppet as well as puppet-master in his **REALIST** mag, and took conspiracy theorist Mae Brussel's work to heart in thinking that naval intelligence was controlling Manson.

Sanders says in his last paragraph:

So you would have thought that some federal agency—Army Intelligence, the FBI, Charles Colson, Naval Intelligence (which Paul Krassner believes actually manipulated the Family), Air Force OSI, the CIA, the Birch Society, the American Volunteer Group—someone would have become hip to the Manson Family's willingness to confront the Panthers. Maybe someday, when the jubilant partisans of libertarian socialism surge into the computer rooms and start punching in the right questions, we'll find out.

There are also pieces by William S. Burroughs and Paul Krassner. *Time of the Assassins* by Burroughs is of interest and states at the start:

*This essay was originally written to accompany a screening of **Street Film Part Zero**, a film composition for five projectors and saxophone by Robert E. Fulton. The screening took place in Boulder, Colorado, on August 3, 1976.*

SWANK

☐ "Is Helter Skelter Really, Finally Over?" reads the heading on the article, *Checking in with the Manson Family*, an interview by **SWANK** editor Ben Pesta with a person who lived with the Manson Family, off and on, since the 1967 Haight-Ashbury days until June 1969, when he split right before the murders. He was still in touch, in 1976, with members both in and out of prison.

For anonymity's sake, the person is referred to as "Ari Ben Canaan," the name of a character in Leon Uris' novel **Exodus**. 'White Rabbit' (aka Larry Allen Melton) was the Family name, given to him by Manson because he "fucked like a rabbit." According to this interview, Squeaky Fromme and Susan Atkins were just a couple of the women he rabbitized. He claimed to love Atkins, even though he admitted she was "kinda schitzy," but says she was the "best fuck."

Ari Ben Canaan also says the first Manson related murders, which took place on Oct 13, 1968, were those of Clida Delaney and Nancy Warren in Ukiah, California, where both had been beaten and strangled with leather thongs. They were supposedly killed because they were wise to the Family's credit card rip offs, and although no one was ever charged with the crime, the police believed that some "Mansonoids" were in the area at the time.

The second Family murder he claims was Marina Habe, kidnapped on Dec 30, 1968 and found dead from multiple stab wounds on Jan 1. She also was supposed to have known about the Family's credit card schemes. Both of these cases were mentioned by Bugliosi in his book **Helter Skelter**, cited in the "editor's notes" of this article. All in all, he attributes twelve murders to the Manson Family: the three mentioned above, as well as Gary Hinman, the Tate/LaBianca victims, Shorty Shea, and John Philip Haught, aka "Zero," who the Family claimed killed himself playing Russian Roulette.

THE CRAWDOODAH GAZETTE

compiled by Greg Mitchell 'All the news, all the doo-dah day' *No Cents Whatsoever*

MANSON'S HELTER FBI SKELTER
by Ed Sanders

Maybe it's not so much of a police state as we have feared. Take the FBI's Cointelpro operations in Southern California in 1968 and 1969, which were "successful" in stirring up murder and shootings among black political groups such as the Black Panthers and the US organization. If only the Bureau had known about the Manson Family's preparation for dune-buggy warfare and about its total paranoia about an impending black Armageddon it called Helter Skelter! Then the FBI could have hired Manson and cohorts to stir up trouble. But, of course, the Bureau would never have done anything so gross as to hire the M-ites, now would it?

Some of the FBI's activities in countering the legitimate rise of the Black Panthers are enough to make one puke one's guts out. Literally. Take for instance the plan devised in 1970 by the New Jersey FBI office to send fruit contaminated with disease-causing microbes to a Panther convention in Jersey. Why were the feddie weddies doing this? To counter some great violent plot? Ha! Not at all—the germy fruit was to be sent to disrupt one of the Panther's most positive programs, its Free Breakfast Program. The Bureau later assured the Senate Committee On Intelligence that it first approved, then cancelled, the germ program, not because of harming innocent blacks, but because the germs, which reportedly caused cramps, diarrhea and severe stomach aches, might have zapped employees of the U.S. Postal Department. Where did the FBI get its microbes: from the CIA through its Fort Detrick or Dugway, Utah germ farms? Only the ghost of J. Edgar Hoover or the spectre of Richard Helms knows for sure.

The point of this vignette is to show that the FBI was just scummy enough to have done something so low as to have hired

Was the FBI scummy enough to have hired Manson? UPI

someone like the Mansonites to attack the Black Panthers. The chronology is indeed tantalizing.

Around November of 1968, J. Edgar Hoover sent instructions to 14 FBI offices, including Los Angeles, for the Bureau to create "dissension" in the Black Panther Party by exploiting certain tensions that existed between the Black Panthers and the United Slaves (US) group, headed by Ron Karenga. In the words of Eddie Hoover: "In order to fully capitalize [Hoover was a shitty writer] upon BPP and US differences as well as to exploit all avenues of creating further dissension in the ranks of the BPP, recipient offices are instructed to submit imaginative and hard-hitting counter-intelligence measures aimed at crippling the BPP."

The offices, ordered J. Edgar, were to report to him every two weeks with a detailed description of their disruption ac-

tivities. Just weeks later the murders started. On January 17, 1969, Bunchy Carter and John Huggins, both leaders in the Black Panther Party, were shot to death at a meeting on the UCLA campus.

Around February '69, J. Edgar Hoover personally approved a group of bogus cartoons to be sent to US and to the Panthers. "These are clever cartoons which belittle the Panthers and should create further differences among BPP leaders and members," J. Eddie wrote. Among the cartoons the FBI sent to the Black Panthers was one showing US leader Ron Karenga holding a pencil and a paper titled "things to do today." Checked off were the names of the slain Huggins and Carter and below them were listed two other Panthers—who presumably were next to become debilitated with fright.

There was a great amount of violence in San Diego too, spurred on by the Bureau.

November 1976 61

Ari Ben Canaan shores up peripheral Manson lore with his stories from the front line, as it were. Such as his theory of the motive behind the Tate and LaBianca killings: apparently the result of an MDA dope burn by Frykowski on a lot of people. He claims Leno LaBianca was a bookie who owed the payoff on a bet, which Manson wanted to collect. Ben Canaan repeats the oft-told story of Shorty Shea's murder, or how he reached "Now" by having his head cut off at the point of orgasm whilst tied to a tree and orally attended to by the girls. That account has since been discounted by more recent revelations that claimed only Manson, Clem, Tex, and Bruce Davis were

present when Shea was murdered.

Ben Canaan also talks of Manson's connection to the white prison gang, the Aryan Brotherhood, who would relay messages from Manson to his girls on the outside in return for sexual favors and help in armed robberies.

The most bizarre story he tells, that I have not heard elsewhere, is that the Family wanted him to go to San Francisco with a couple of the girls and commit Tate/LaBianca "copy-cat" murders, so that once Ben Canaan was caught he would confess to the Tate/LaBianca murders also, freeing Manson and crew. He said he would think about it and then left as quickly as possible.

Top Myron Fass' Eerie Publications
DRACULA CLASSIC from 1976
equated Manson and his girls
to vampires, particularly in light
of Atkins' revelation that she
tasted the blood of Sharon Tate.
Opposite Splash page artwork by
Edwin Herder for *Checking in with
the Manson Family,* SWANK Dec 76.

REAL DETECTIVE
Jul 1977
G. C. London Publishing Corp.,
PO Box 58, Rockville Centre, NY
11571 .60 68pp

POLICE DETECTIVE
1977
Annual–Winter 1977
G. C. London Publishing Corp.,
Box 38, Rockville Centre, NY
11571 .75 68pp

HEADQUARTERS
DETECTIVE
Vol 32 No 2 Mar 1978
Globe Communications Corp., Box 0,
Pittsford, NY 14534 .75 68pp

The piece ends with Ben Canaan talking about his continuing contact with some of the women, such as Susan Atkins, Sandra Good, Squeaky, Leslie Van Houten, and other anonymous friends of Manson.

The last lines of advice from Ben Canaan:

They recruit. They picked up a bunch of people since the murders. They got more since the assassination attempt, too. So, I mean, that cancer is still growing. Don't for a minute believe it's all over.

REAL DETECTIVE

☐ *Bombing Murder of the Ten Love Cultists—Ventura County, Calif.* is about the events that led to the bombing of the Fountain of the World monastery on Dec 10, 1958. It is included here because of the cult's connection to Manson's commune through philosophy, lore and location. Manson himself showed up in LA in 1955, but when he became aware of the Foundation of the World is not clear. It was also rumored that Manson had given money to the Fountain of the World when he was living at Spahn Ranch.

This article is probably a reprint from an earlier detective mag of unknown date and origin.

The article starts with the Dec 9, 1958 activities of Ralph Muller, thirty-three, and Peter Kamenoff, forty-two. Leaving their home in Joshua Tree, California, they made their way to Los Angeles by noon. They had purchased twenty sticks of dynamite, three detonating caps and ten feet of wire. They drove to the branch office of the California Attorney General. Kamenoff—a Russian immigrant with broken English—told Special Agent James H. Mulvey: "We want to complain of the immorality of Krishna Venta. When we go to fight forest fires, he sleeps in the car. He takes one of the sisters and sleeps with her."

Mulvey listened to the strange complaint from the just as strange pair, then asked, "Is there any special religious significance to this?"

"[Krishna Venta] stated he has cold blood and poor circulation, so he needs someone to keep him warm," Kamenoff explained.

After the two ex-cultists rattled off more allegations, they asked Mulvey that if they got a confession from Venta would he prosecute him? Mulvey told them he would, but he had to leave for an out of town trip, so they should come back in a few days.

They went on their way, stopping in the San Fernando Valley somewhere to buy a tape recorder and rent a motel room. The pair produced lengthy taped messages and written notes explaining their mission. They then built a bomb that they put in a canvas bag, and headed out at midnight to the twenty-nine acre Fountain of the World, located in Box Canyon and consisting of fifty-nine cultists and thirty children.

The cult, headed by Francis Pencovic, aka Krishna Venta—the target of Muller and Kamenoff's hate—was a one-time boilermaker, shipyard worker, dishwasher, and petty criminal. As a cult leader, Krishna Venta was of the flashy variety, not the ascetic school. He "loved luxury, dressed in a golden robe, drove a high-powered car, and, in a Southern California touch, wore dark glasses constantly."

That night a few of the cultists saw and heard Krishna Venta arguing with someone in front of the monastery just before it blew up at 1:29 am, raining debris on the living and the dead. The explosion started a fire that spread through 150 acres of brush. Krishna Venta was never seen again, in one piece anyway. The bomb-toting Muller and Kamenoff were killed along with eight cult members.

The police found the taped statement of the two in their motel room and learned that Muller blamed Venta for breaking up his

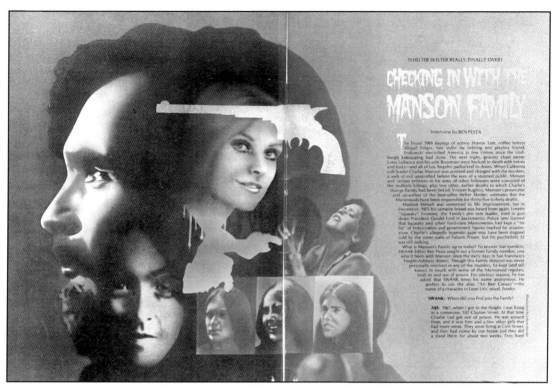

marriage to a woman who belonged to the cult. Muller had quit and rejoined the cult more than once since 1949 and felt "called" to kill Krishna Venta.

Kamenoff blamed Venta for persuading his wife to move to the cult's Alaskan monastery.

One biblical similarity between the Fountain of the World and Manson is that Venta "claimed he would have 144,000 followers (the 144,000 elect of the Book of Revelations) and would assume United States leadership in 1975, ten years after a Red revolution had swept the country." If you substituted "Black" for "Red" revolution you had Manson's belief in Revelations, but of course with his followers constituting the 144,000 elect.

Some in the cult believed that Krishna Venta did not die, including his wife who was at the Alaskan monastery when the bomb went off in Box Canyon. This disbelief might have had something to do with the fact that

all that was left of Venta to identify him was a piece of his dental bridgework.

POLICE DETECTIVE 1977

☐ *When Charlie Manson Looked at a Girl, She Became his Love Slave!* was originally published in **REAL DETECTIVE** Nov 70, above, and this is a word for word, picture for picture reprint. It is again reprinted in **REAL DETECTIVE** Jan 77.

This mag sports an incredible cover though, the Manson inset looking as though he is staring up at the blonde cover model, bound to a radiator and gagged, dress unzipped to expose a bra-clad breast. The cover blurb above Manson pertains to the picture of the bound woman, reading "Have torture kit…will travel…," the title of one of the features which opens with a pencil drawing of a manic-looking man leaning over an unconscious blonde with her blouse open,

as he takes a double edged razor blade from its holder.

These detective mags published by Rostam, and later G.C. London Publishing, are all reprinted from earlier mags, but are different from the higher-end detective mags of the time, in that these ran adult ads in the back for such necessities as crotchless panties, rubber sex dolls, porn films, sex toys, aphrodisiacs, Tijuana Bible grab bags, pellet guns, cheesy reproductions of exotic knives, and so on.

HEADQUARTERS DETECTIVE

☐ "First Time Revealed! Manson's Manic Plot To Destroy America! Straight From The Lips Of Helter Skelter's No.1 Killer" says the cover of this rarity from 1978. The article inside is by Chet Starkey, and starts with an editor's note informing us that Starkey was an ex-con who served one year for rob-

From top **REAL DETECTIVE Jul 77** has an article on the bombing of the Fountain of the World cult in Box Canyon, down the road from the Spahn Ranch; The **POLICE DETECTIVE 1977 Annual** reprinted a Manson-as-svengali article from an earlier issue. Opposite **HEADQUARTERS DETECTIVE (v32 #2) Mar 78** has an article written by Chet Starkey, who served time with Tex Watson.

ADAM
Vol 22 No 11 Nov 1978
Knight Publishing Corp., 8060
Melrose Ave., Los Angeles, CA
90046 1.75 96pp

bery in the California Men's Colony at San Luis Obispo and had become a confidant of Charles 'Tex' Watson. The article is "an account" of what Watson revealed about Manson's "master plan" to Starkey during his year in prison.

Starkey had first become aware of Watson when going to the prison chapel where Watson had been preaching as a born again Christian. A fellow inmate told Starkey that on occasion women would go to the chapel services, but when Starkey attended instead of meeting women, he met Tex Watson. After Watson's sermon, Starkey asked who he was, and found out Watson had been largely responsible for the murder of the seven people in the Tate and LaBianca homes in 1969, supposedly under the spell of Charles Manson.

One day, while working in the Clothing Distribution Department in the prison, Starkey got a call from Watson who requested laundry carts for baptizing convicts who had become born again. Discovering that Watson got what he wanted in prison, and that he was on the same "quad" as himself, the two became friends and saw each other on an almost daily basis.

Eventually, Starkey asked Watson about Manson and Helter Skelter and what he was told, if true, was rather bizarre.

Watson got "a vacant look" in his eyes and stared off into space as he explained to Starkey:

A lot of guys in the prison think they're bad. Some of them are, but when it comes to being bad in every sense of the word, I have been bad before and can play the role pretty good. When I killed those people, especially that foreign guy, Frikowski [sic], or whatever his name was, they didn't exactly stand there and not do anything. I stabbed that guy fifty-one times in the chest, and I didn't think before I was done that I was going to be able to make it.

I stabbed him so many times in the chest that my hand was sinking into it up to my elbow. I stabbed him so hard that the handle of the knife broke off. These people don't know what bad is. I wrote the book on bad, and I did it more than once.

It helps to remember this is Starkey's version, from memory, of Watson's statements to him, not directly quoted from Watson.

Starkey claims Watson told him something he had told no one else—that Helter Skelter was "an overall plan" and that the Tate/LaBianca murders were tests.

Watson, he claims, said that Manson wanted to orchestrate simultaneous raids on three major California cities by killing prominent people in their homes in the manner of the previous murders. There were also supposedly plans for four of Manson's chosen to board a plane, take it over and kill people, one at a time, until their demands were met.

Tex went on to tell Starkey that Leslie Van Houten didn't kill anyone and that she was so freaked out he had to throw her down next to Rosemary LaBianca's already dead body and make her stab the corpse to make sure she would "do her part."

When asked if he would "help her out," Watson replied: "What! If I brought that kind of attention down on me, I'd never get out. No way am I going to blow my chance to get out just to testify in Leslie Van Houten's behalf."

Tex then hinted that Bruce Davis and Squeaky Fromme were the ones that would have benefited from the unsolved death of Ronald Hughes, Van Houten's lawyer.

When a big name Southern evangelist visited the prison in 1976, toting along semi-famous ex-cons and a "former Hollywood actor," Watson made it his business to impress the preacher in the hope he could pull some strings with politicians to eventually get him out. The evangelist told him that to get the ball rolling he should write his "life story," a

book that would encompass his crimes and subsequent prison conversion to Christianity. This became **Will You Die For Me**, as told to Chaplin Ray Hoekstra, published in 1978.

Starkey ends by being appalled at the thought that this murderer of seven people, who apparently had little remorse, had the possibility of walking free someday and implementing Manson's plans for terror.

ADAM

☐ *Interview: Paul Watkins* is by Guillermo Soledad, who co-authored **My Life with Charles Manson** with Watkins, a rare paperback published in 1979 by Bantam Books. In this pre-publication article, the book is referred to as "**With Flowers in their Hair** by Paul Watkins, with Guillermo Soledad, Bantam Books." The Watkins interview is nestled inbetween "Nanette," a full color girlie layout, and the *Adam Sex Clinic* on "Cunnilingus: Problems and Pleasures."

The late Paul Watkins is said to have been Manson's second-in-command for about a year and the main chick magnet for the Family. As Watkins pointed out, he was eighteen then, Manson was thirty-five, and the young ladies were initially more attracted to Watkins. Watkins walks the fine line between giving Manson and the Family credit for their pre-Helter Skelter lifestyle and philosophy and deriding them for the eventual slaughter. This he does by making the point that he knew them all prior to the murders as people, before some turned into monsters. He goes so far as to say that because he and Manson were the same size physically, he mirrored Charlie as his "flowerchild:" his younger, positive side. When Watkins left the Family a couple of months before the murders, he claims it caused a "psychological split in Charlie" and left him with the knowledge of what he really was: "an aging ex-convict with a lot of bitterness and rage."

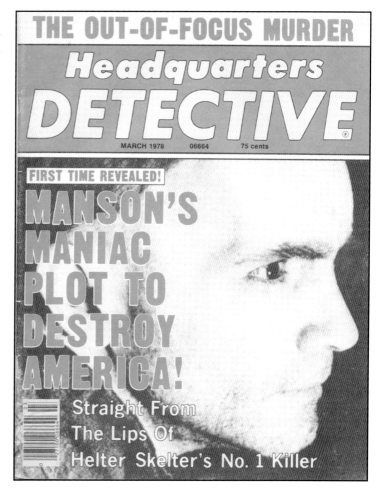

THE OUT-OF-FOCUS MURDER

Headquarters

DETECTIVE

MARCH 1978 06664 75 cents

FIRST TIME REVEALED!

MANSON'S MANIAC PLOT TO DESTROY AMERICA!

Straight From The Lips Of Helter Skelter's No. 1 Killer

Watkins' main point about the Family and Manson is a valid one: that in the beginning it was only about love, music, sex, getting high, and losing your ego. The Helter Skelter trip didn't start:

> ...until we moved from Spahn's Ranch to Death Valley, then back to L.A. again, that things got heavy—about six months before the Tate-La Bianca murders, at about the time the Beatles' **White Album** came out and Charlie started spouting Helter Skelter. By then, we were committed to helping promote the revolution through music, hoping to program the young people to come to the desert. That's when

> we started buying dune buggies and tied in with the motorcycle gangs and ex-cons.

The much ballyhooed orgies of the Family are put in a more realistic light by Watkins who was there, as he describes why having that many people, with more girls than guys, trying to achieve simultaneous orgasms together when some hadn't even gotten past the awkwardness of being naked together, was just plain funny. As an example, Charlie once gave them instructions on the location of the clitoris by having one of the girls spread her legs so he could show them. Family Sex 101 with Professor Manson on board.

Top Paul Watkins relating his experiences in the Manson Family with "Guillermo Soledad," the pseudonymous co-author of Watkins' as yet unreleased book at the time. ADAM Nov 78. Above and Opposite **Bill Dakota's HOLLYWOOD STAR CONFIDENTIAL was a magazine version of his gossip rag, the HOLLYWOOD STAR.**

BILL DAKOTA'S HOLLYWOOD STAR CONFIDENTIAL
Vol 1 No 1 1979
The Hollywood Star Press, 314 S. Alexandria Ave., Los Angeles, CA 90020 2.50 84pp

BILL DAKOTA'S HOLLYWOOD STAR CONFIDENTIAL

❑ First a bit of history: William Kern aka Bill Dakota started out his checkered and interesting career in the late fifties when, as a teenager, he became fascinated with James Dean and took a trip to Los Angeles in order to find out more about the icon. While there he met and befriended actor Nick Adams ("Johnny Yuma" in the 1959 TV series **The Rebel**) and became his secretary. Dakota also worked at the Apollo Theatre in Hollywood where he met a man named Mr Federici, who told him a story about Adams and James Dean sharing an apartment together in their struggling, unknown days in the early fifties. Federici claimed he overheard the two arguing over who would wear a pair of jeans they owned to hustle on the streets of LA. It was also rumored that Adams and Dean had been lovers at the time, a claim disputed by others.

Dakota and others, such as artist/sculptor Kenneth Kendall, writer John Gilmore, and Dean's co-star Sal Mineo, all helped turn Dean into a cult icon for the bad boy bisexual.

By the early sixties Dakota had gone back to Ohio where he opened several gay bookstores and theatres, as well as a club in Michigan.

In 1964 the Sheriff's Dept, without a warrant, busted Dakota's state chartered, non-alcoholic gay club Studio D in Flint, Michigan. Forty-seven people were arrested and brought in for questioning. One of the arrested was on probation and told he would be jailed unless he gave them something on Dakota. So he claimed to have had sex with Dakota six months earlier. Dakota was arrested for "gross indecency with a minor," and protested it was a set up. After being held in jail for six months awaiting trial, in which time he lost his Le Stag Shoppe bookstore, Dakota was eventually convicted and spent four years at the Southern Michigan Correctional Facility in Jackson.

On his release Dakota again opened a string of adult bookstores and theatres in Ohio and reopened his club, Studio D, in Lake Fenton, Michigan, getting the locals up in arms because it was a gay club. He also encountered more legal problems in Ohio with his adult bookstores. Dakota had had enough by that time and moved back to Los Angeles where he started his two tabloids, the **HOLLYWOOD STAR** (1976) and **GAYBOY** (1977).

Dakota wrote as "Bill Kern" and "Bill Dakota" as editor and gossip columnist/investigative reporter for the **HOLLYWOOD STAR**, a scandal rag that loved exposing stars in Hollywood who were rumored to have had homosexual affairs. The paper was sold exclusively by vending machines according to a rubber-stamped message found on the cover of many copies, which states: "This copy sold in vending machines only. If bought some other way, this is a stolen paper." The message also gives a twenty-four hour phone number to call to report any illegal sales.

Besides its shock value headlines, the **HOLLYWOOD STAR** is noted for antics like running full page nude photos of stars such as Jan-Michael Vincent, or a photo of would-be Presidential assassin John Hinckley dressed in a Nazi uniform. Other Dakota favorites were printing autopsy reports of dead stars such as Sal Mineo, Sharon Tate and Freddie Prinze, as well as articles and pics of young male actors like Robbie Benson.

The newspaper **HOLLYWOOD STAR** ran for nine issues, sporadically, and stopped publishing in 1977, until Dakota decided to revive it in 1979 in a magazine format, adding "**CONFIDENTIAL**" to the title. Only two issues of the magazine were published that I'm aware of; the second features Robert Mitchum on its cover.

The **HOLLYWOOD STAR CONFIDENTIAL** mag was just as wacky as the paper had been. It carried the subtitle "Movie Gossip For Adults," and the blurb, "This is not a

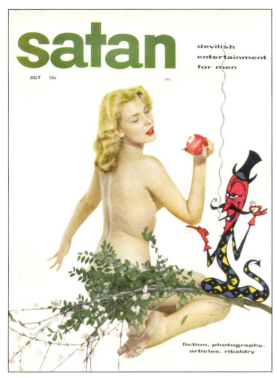

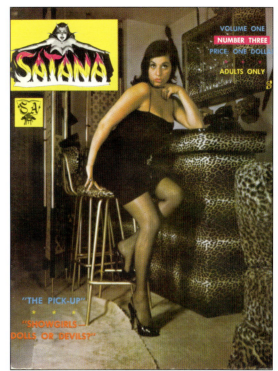

SATAN v1 #4 Jul 1957 Stanley Publications

JAYBIRD JOURNAL #10 Oct/Nov/Dec 1967
with Anton LaVey on cover

SATANA v1 #3 1962 Selbee Associate, Inc.

BITCHCRAFT v3 #2 Spring 1973 Eros Publishing Co., Inc/PN
with Rene Bond in red cape

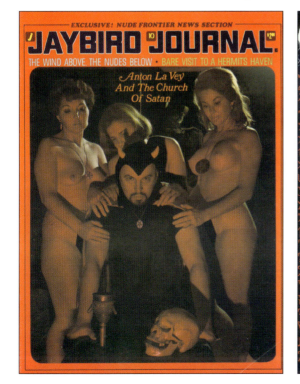

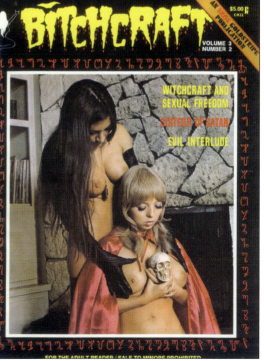

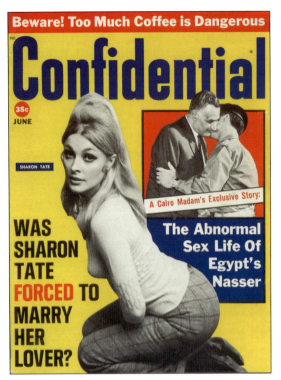

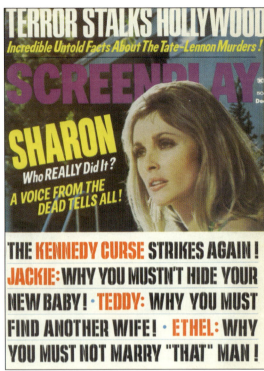

CONFIDENTIAL v16 #6 Jun 1968 By-Line Publications
INSIDE DETECTIVE v48 #3 Mar 1970 Detective Publications, Inc

SCREENPLAY v71 #12 Dec 1969 Smifty, Inc.
ASTROLOGY TODAY v1 #2 Dec 1970 Hewfred Publications, Inc.

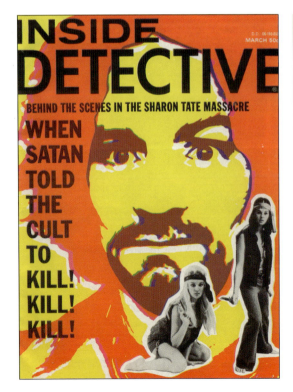

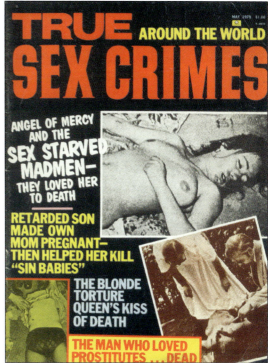

WEIRD DETECTIVE Apr 1971 Jalart House, Inc. with Titus Moody

TRUE SEX CRIMES v1 #1 May 1975 Tempest Publications, Inc.

HOMICIDE DETECTIVE v1 #2 Jan 1978 Stories, Layouts & Press, Inc. with still from *Snuff* on the cover

THE GODFATHERS v1 #4 Jul 1978 Stories, Layouts & Press, Inc.

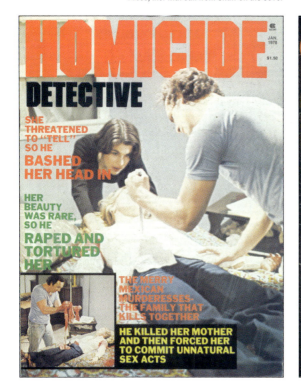

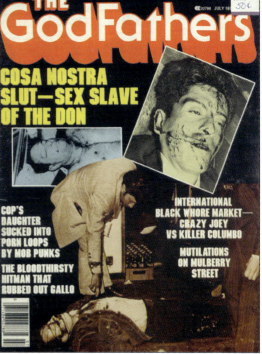

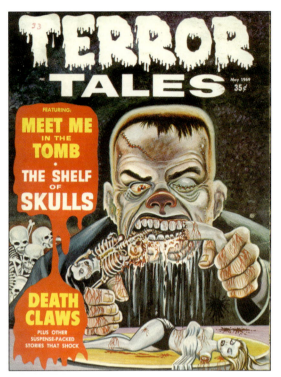

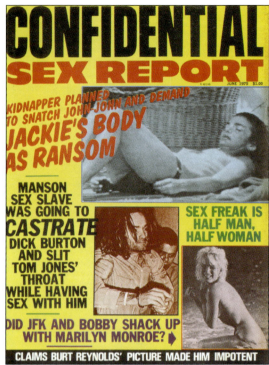

TERROR TALES v1 #8 May 1969 Eerie Publications, Inc.

JAWS OF HORROR v4 #2 Summer 1978

CONFIDENTIAL SEX REPORT v1 #5 Jun 1975

National Mirror, Inc.

PUNK ROCK v2 #2 Apr 1978 Stories, Layouts & Press, Inc.

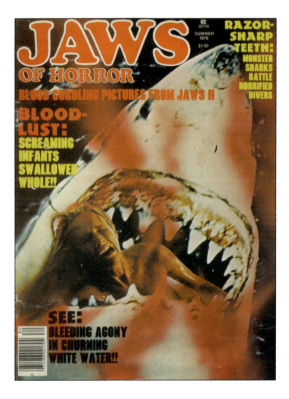

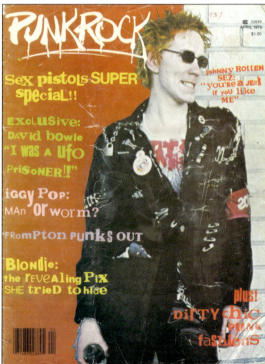

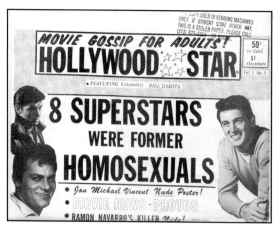

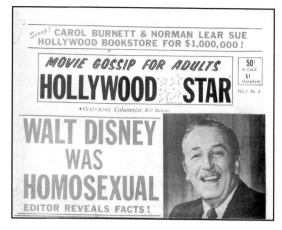

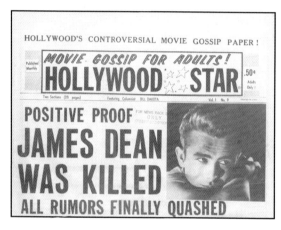

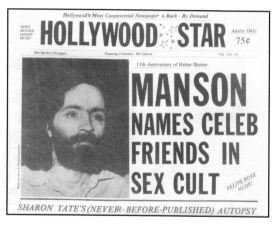

pornographic publication but…written in an adult manner." The first issue has a picture of Elvis on the cover and announces: "Exclusive!—Elvis Was Bi-Sexual—Nick Adams Was His Lover!," with the smaller blurb at the bottom: "Manson talks about Celebs in Sex Cult—Sinatra makes phone threat."

If in fact Nick Adams was gay, Dakota would have been the one to know, as mentioned above he became Adams' secretary. Adams died mysteriously in 1968, supposedly from an overdose of anti-psychotic medication. Some, including the police, believed it to be murder; others thought it a suicide.

In spite of the fact that **HOLLYWOOD STAR CONFIDENTIAL** is printed in b&w on newsprint guts, has questionable reportage of gossip, strange layouts packed with text of varying type styles and carries numerous photos of young male actors—it is interesting reading! The word scurrilous does come to mind though. But, as editor Bill Kern (Dakota) has written in his editorial for the first issue:

Just what is the **HOLLYWOOD STAR**? *It's a combination of the exposé magazines of the fifties such as* **CONFIDENTIAL**, **WHISPER**, *and* **HUSH-HUSH** *and a movie type of magazine but aimed at the adult reader as opposed to the ones for teens. If you are tired of boring magazines, perhaps those which bear Rona Barrett's name, then the* **HOLLYWOOD STAR** *is a viable alternative. We warn you that if you are easily shocked by descriptive wording describing sexual activity, you may not like our format. This is for you to decide. It's your money. You will find the* **HOLLYWOOD STAR** *campy, yet factual. We first published three years ago as a newspaper. Although we published on an irregular basis it created a mild sensation, here on the west coast, especially among Hollywood's elite, who knew our exposés were true and feared the day when they too, might be exposed individually.*

Dakota claimed his involvement with Manson began three years earlier, when his friend John Gilmore interviewed Manson and wrote **The Garbage People** (Omega Press 1971; Amok Press 1995). Manson had never received a copy of the book so Dakota

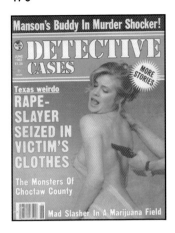

Above **DETECTIVE CASES (v1 #1) Jun 83** had an article on convicted murderer Perry "Red" Warthan who had been peripherally connected to Manson.

HOLLYWOOD STAR
Vol 1 No 10 1980
The Hollywood Star Press, 314 S. Alexandria Ave., Los Angeles, CA 90020 .75 24pp

DETECTIVE CASES
Vol 33 No 3 Jun 1983
Globe Communications Corp., PO Box 51 , Rouses Point, NY 12979 1.25 68pp

HIGH SOCIETY
Vol 10 No 1 May 1985
High Society Magazine, 801 Second Ave., New York, NY 10017 3.95 100pp

mailed him one after receiving permission from the Vacaville Medical Facility, where Manson was incarcerated at the time. That started their correspondence. Gilmore's book on James Dean, **The Real James Dean** (1975) had been advertised in the **HOLLYWOOD STAR** paper.

Charles Manson Writes from Prison is taken from a ten page letter Manson sent to Dakota. For those who can't find a copy of this mag, but are interested in reading Manson's letter, it can be found—in slightly edited form—in the Amok Press book **The Manson File** (1988) by Nikolas Schreck.

The piece starts with Dakota contacting Frank Sinatra's daughter, Tina, by phone to ask questions relating to Manson's letter in which he had mentioned Sinatra's daughter partying with him down at a beach house. Dakota met with her the next day, at her request, with her boyfriend and lawyer in tow, only to receive the same advice Frank Sinatra himself would later give him—don't call anymore! Dakota claimed he had offers from **NATIONAL ENQUIRER** for the story. He surmised that the story must be true if they were willing to go to that much trouble to cover it up.

In Manson's infamous letter concerning the sexcapades of the rich and famous when rubbing shoulders with him, he tells of the time he was living at "Tom Mix's old house on Sunset out by the beach." Manson drops names right and left, including Neil Diamond, Mike Love, Jane Fonda, Terry Melcher, Dee Dee Lansbury, Dennis Wilson, Peter Sellers, Yul Brynner, Peter Falk, James West, and even Elvis. As usual, what Manson has to say is not always easy to follow, but always interesting.

Charles Manson's First Phone Call from Prison is apparently Manson's first call to Dakota in the nine years since he went to prison, taped by Dakota as prison personnel monitored the conversation. Manson talked about his plans for an organization for a clean environment, the not yet named ATWA (Air, Trees, Water and Animals). Da-

kota asks him about a TV/VCR that someone had sent to him in prison, but Manson didn't get it, explaining that a prisoner had taped a guard's conversation with a tape recorder and soured the guards on letting recording devices through. Manson is asked if he knew Jerry Rubin and Abbie Hoffman to which he answers:

> *Yeh, Jerry Rubin. Them guys who said, 'Raise [sic] up and do it now. Take a knife and go home and kill your Mom and Dad,' all that kind of stuff? I got the blame for all that. That's why I'm so damned mad, see.*

For the most part, the interview is not that long, or interesting, but the next one page feature is about the threat Dakota reportedly received from Frank Sinatra whilst on air at radio station KABC broadcasting the Manson call. Sinatra tried to get a straight answer out of Dakota about where he got Tina Sinatra's phone number, which Dakota never answered. Sinatra then told him: "I don't care what the attorney said. I'm her father, and I'm telling you to tear up her phone number and don't call her again or *I'll break your fuckin' arm.* You got that? I'll break your arm."

By the time Dakota could ask Sinatra, "What's this all about?," Frank had hung up.

HOLLYWOOD STAR

❑ As the banner blurb on Dakota's reincarnated paper states: "Hollywood's Most Controversial Newspaper Is Back—By Demand." Dakota continued with the **HOLLYWOOD STAR** in newspaper format once again, picking up the numbering from its first newspaper go-round with v1 #10, that has a large photo of Manson on the cover.

The issue includes a reprint of the Manson article *Charles Manson Writes a 10 Page Letter from Prison. Names Celeb*

Friends in Sex Cult! from the **HOLLYWOOD STAR CONFIDENTIAL**, above. But the added feature is *Sharon Tate's Never-Be-fore-Published Autopsy Reports!*, disproving the rumors of her baby having been cut from her, or her breast cut off. The piece explains why Tate's autopsy had not been released:

> The Sharon Tate autopsy reports were never before printed because there was a gag order given by the court which prevented the press access to them. The trial lasted so long, that when it was all over the autopsy reports were forgotten. They are still inaccessible to the public.

The front and back wound charts illustrate Tate's eighteen stab wounds; also reproduced is the three page coroner's report from Dr Thomas Noguchi.

DETECTIVE CASES

☐ "Manson's Buddy In Murder Shocker!" is the cover blurb for the article *Manson Disciple Linked to Teen Killing* by Henry Radner, which has little to do with Manson, but does include a rare picture of him standing next to neo-Nazi murderer Perry "Red" Warthan, the main topic of the piece.

At the age of twelve, Perry Warthan was diagnosed as "a psychopathic delinquent" for burning a house down in Stockton, CA, and starting two other blazes. He was sent to Napa State Hospital where he acquired a reputation for violence and eventually strangled to death another schizophrenic, a ten year old boy. Warthan was shuffled around to both Atascadero State Hospital and the California Medical Facility at Vacaville, found insane by a judge and escaped prosecution for the child's murder. Two years later, he was deemed sane enough to be let out on the street.

The caption under the picture of Warthan and Manson together reads, "Place and time

of photo unknown." The article only mentions that Warthan made "several visits to Vacaville state prison to see mass-murderer Charles Manson," but doesn't mention that Manson had also been incarcerated at Atascadero, and that this was where he might have met Warthan originally.

Warthan had been married in what he termed a "Satanic wedding" but had divorced from his wife and moved to Oroville, California with his young son and was living in squalor in a two bedroom house. The neo-Nazi den was cluttered with books on Hitler and the Nazis and rife with garbage.

Warthan had gathered a small cadre of dope-smoking, beer-drinking "stoner" teenagers around him through his "Dial-A-Nazi" phone service which spewed neo-Nazi white supremacist propaganda with a background of German marching music like the Horst Wessel song. Teenagers who hung out at the local video arcade had made a habit of calling the number, and a few were reeled in by Warthan. As he told them tales of the coming race war with the non-whites and impressed them with his photo taken with Manson, some of the kids got hooked and started joining him on military-like maneuvers in the woods while getting high and drinking.

The police finally took notice of Warthan after an incident at the high school where all the student lockers had been leafleted with anti-black propaganda. The community demanded someone be held responsible and one of Warthan's young adherents ratted him out as the source of the material. The teenager who snitched went missing, along with some of his buddies.

A body was found and identified as that of the teenage informant, but when the police went to find his friends they learned they were also missing. One of them was located at his grandmother's house in another town and told police he left Oroville for his own safety. He feared he would share in his friend's fate at the hands of Red Warthan, who he claimed had shot the other boy in

the head.

Warthan had in fact shot the boy in the head eight times. At first the police thought it was a single shotgun wound, because the wounds were in a cluster. Police got one of the fearful teenagers to testify against Warthan and as of the writing of this article (in 1983), Perry Warthan was sitting in jail waiting to be sentenced.

In Adam Gorightly's encyclopedic book on the "Manson Mythos," **The Shadow over Santa Susana**, he mentions that Manson initially sent Squeaky Fromme to check out Warthan and gave Manson the thumbs up on the neo-Nazi. Gorightly also links Warthan to the Universal Order, another neo-Nazi organization headed by James Mason in Ohio, who saw Manson as a modern day avatar in the same vein as Hitler.

HIGH SOCIETY

☐ **HIGH SOCIETY**'s "9th Anniversary Collector's Issue" contains *Interview—Part 1—Charles Manson* conducted by Linda Franischelli. The piece starts with an intro by Franischelli that is a quick rundown of the highs and lows of 1969, briefly relating the facts of Manson's early life, the murder of Gary Hinman and the Tate/LaBianca murders, and the subsequent trials.

The interview was held at the California Medical Facility in Vacaville, when Manson was fifty years old. It starts with Franischelli asking about the incident in which another inmate, Hare Krishna follower Jan Holstrom, dowsed Manson with paint thinner and lit him alight, then attacked him with a prison-made knife. Manson explained that Holstrom took something he had said the wrong way, which enraged the pseudo-Krishnaite. In some of the photos red blotches can be seen on Manson's forehead and hands from the flaming paint thinner incident.

Most of the interview is typical Manson, treading familiar territory. He does give a few

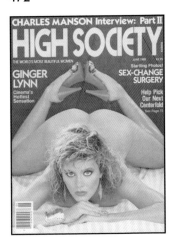

Above **HIGH SOCIETY (v10 #2) Jun 85** carried the second and final part of Linda Francischelli's interview with Manson. A sultry Ginger Lynn on the cover. Opposite **CALIFORNIA (v10 #5) May 85** used a close-up of Manson at fifty on its cover. Inside was an interesting interview with Manson conducted by Keven Kennedy, a reporter for KALX radio in San Francisco.

CALIFORNIA

Vol 10 No 5; May 1985
California Magazine, Ltd Partnership.,
11601 Wilshire Blvd., Los Angeles, CA
90025 2.00 138pp

HIGH SOCIETY

Vol 10 No 2 Jun 1985
High Society Magazine, 801
Second Ave., New York, NY
10017 3.75 100pp

unique anecdotes on such topics as his connection to Krishna Venta and the Fountain of the World, and the Gary Hinman murder.

When asked if he ever claimed to be Satan, Manson replies, "Well, now [laughter], I used to ride around with a motorcycle group, and we used to call ourselves the Straight Satans."

Instead of taking that statement to task with more questions, Francischelli moves on and asks him to explain Helter Skelter. According to Manson, it was a nightclub in the desert.

After being asked to discuss the Hinman murder, Manson starts getting esoteric:

I can tell you simply that Hinman was killed because of a bagpipe. It comes to music, a French whorehouse and the three numbers 666. Aleister Crowley from Ireland died in a French whorehouse. The French owed Scotland money in the occult, spiritual world, or whatever you want to call it.

This leads into a convoluted paragraph on Bobby Beausoleil, Hinman, bagpipes, Scottish clans and the occult, ending with Manson stating that he sliced Hinman's ear off.

Francischelli gets a crazy-as-a-fox response when she asks, "You cut it clear off?" Manson replies, matter-of-factly, "Yeah, almost, but I put some scotch tape on it." Surprised, Francischelli says, "Scotch tape? Charlie, you can't scotch tape an ear back on." To which Manson comes back with: "Sure you can. Scotch tape is as good as any other kind of tape."

It makes one wonder whether Manson was just playing with her or making another occult reference to the Scottish. Part one of the interview concluded with the murder of Hinman.

CALIFORNIA

☐ *Manson at 50* is an interview by Keven Kennedy with Manson, again conducted at the California Medical Facility in Vacaville.

Kennedy was a staff reporter for the small Berkeley radio station KALX, broadcast from a church basement. Manson himself liked the station for its "open-mindedness" and Kennedy said he was contacted by "friends" of Manson to do the interview, and to talk with him about his music. After the interview was recorded, it was broadcast on KALX on the eve of the issue's publication. **CALIFORNIA** is the monthly where-to-go-and-what-to-do-while-you're-there magazine for the state, with listings for entertainment, dining and sight-seeing in the front half of the mag, called *The Best of California*.

The interview covers far more than just Manson's music though, and is a long piece that wends its way through the second half of the magazine, with several golden Manson moments included.

The feature starts with two mugshots of Manson, taken in 1981 and 84, and one of Manson's more oft-quoted statements, made in court just before his conviction in November 1970:

I have stayed a child while I have watched your world grow up. I've lived in your tomb that you built...wishing I could go to high school and go to the proms, wishing I could go to the things you could do, but oh so glad, oh so glad, brothers and sisters, that I am what I am.

The intro by Kennedy gives a brief rundown of Manson's biographical and criminal histories.

Kennedy starts the interview by asking Manson about his interest in music and making the point that it seems to be the only professional interest he has in his life. Manson then clarifies his relationship with Alvin "Creepy" Karpis and says Karpis

taught him a few tunes on the guitar, but not how to play, as Manson had been playing since 1943 and didn't meet Karpis in prison until 1959.

Manson then states he is not a hippie, but "a beatnik down in Venice pounding on bongos and reciting poetry in the fifties, 54 and 55." It must be remembered that Manson was in prison from 1957 until 67, a stretch of time in which the country saw significant changes, including the birth of the hippies.

There are many exchanges where Manson corrects Kennedy's questioning concerning who got in touch with whom; when Kennedy states that Manson sent a tape of his music to the punk band Black Flag, Manson answers: "You look at everything backwards. Terry Melcher came to me. I didn't go to him."

The subject matter covered in this long interview includes Manson's childhood, music, Terry Melcher, Timothy Leary, Jerry Rubin and Abbie Hoffman, Krishna Venta, prison life, the Tate/LaBianca murders, Spahn Ranch, and more. Kennedy asks interesting questions which elicit interesting responses from Manson. Anyone interested in Manson and his point of view is urged to search out this interview.

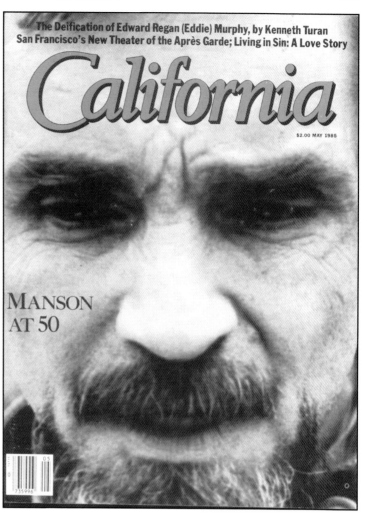

The Deification of Edward Regan (Eddie) Murphy, by Kenneth Turan
San Francisco's New Theater of the Après Garde; Living in Sin: A Love Story

California

$2.00 MAY 1985

MANSON AT 50

HIGH SOCIETY

☐ *HIGH SOCIETY Interview—Part 2—Charles Manson* is the continuation of the interview by Linda Francischelli. This time around Manson shares the spotlight with eighties porn queen Ginger Lynn, who is the covergirl and centerfold layout; Samantha Fox, called "Bunny" in her layout; and the young Traci Lords in a girl/girl layout! There is also an article on sex change operations with color photos of the results of both female-to-male and male-to-female operations.

In the intro to the second part of **HIGH SOCIETY**'s Manson interview, Francischelli

tells of her trip to Vacaville and the foreboding look it had at dusk, and being stopped by a guard for taking photos of the prison/medical facility, for fear that prisoners could get a hold of the pictures to plan escape routes! She learns the real nature of the contents of her purse during the search before the interview. Open packs of cigarettes, credit cards, postage stamps and emery boards are all forbidden. The long wait for Manson to show helps calm her "anxieties" at meeting the legendary and notorious Manson, who, her friends had warned her, used mind control on people.

Manson makes the interviewer jump

through hoops to get her questions answered, some of which he never ends up answering with a straight explanation. He explains how he met Terry Melcher through Gregg Jakobson and how Melcher had sent a truck with recording equipment out to Spahn Ranch, but the person sent to record Manson's unique music freaked out because, according to Charlie: "The music was too much for him, he couldn't deal with it. He had never heard music like that before, and he went crazy. In the weeds, we play some pretty wild music, music that you ain't heard on the radio."

Next Manson claims that when the murders happened he was in San Diego

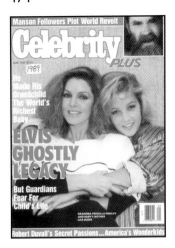

Manson Followers Plot World Revolt

Celebrity PLUS

1989

He Made His Grandchild The World's Richest Baby

ELVIS GHOSTLY LEGACY

But Guardians Fear For 'Child's Life

GRANDMA PRISCILLA PRESLEY AND BABY'S MOTHER LISA MARIE

Robert Duvall's Secret Passions... America's Wonderkids

Top CELEBRITY PLUS (v3 #5) May 89 had on its cover a smiling Priscilla and Lisa Marie Presley overlooked by a scowling Manson. **Opposite** Extreme close-up of Manson's face—count the crow's feet—on the Sunday supplement magazine of the LOS ANGELES TIMES (v5 #20) May 14, 1989.

LOS ANGELES TIMES MAGAZINE

Vol 5 No 20 May 14, 1989
Los Angeles Times, Times Mirror Square, Los Angeles, CA 90053 Section of the Sunday paper 44pp

CELEBRITY PLUS

Vol 3 No 5 May 1989
Globe Communications Corp., 441 Lexington Ave., New York, NY 10017 1.95 60pp

MEMORIES

Vol 2 No 4 Aug–Sep 1989
Diamandis Communications, Inc., 1515 Broadway, New York, NY 10036 1.95 100pp

driving around in a milk truck with a girl named Stephanie who he had picked up in Big Sur.

When asked if Danny DeCarlo, a member of the Straight Satans MC, was his bodyguard, Manson laughs and tells an amusing anecdote about how DeCarlo would hide behind Manson when his wife came to the Ranch looking to retrieve him!

Manson talks about his attitude towards drugs—but marijuana, LSD and peyote he didn't consider drugs! He also discusses Dennis Wilson, the Beatles, John Lennon's assassination and God.

The interview ends on an interesting yet funny note when Manson is asked what he thinks about President Reagan, and surprisingly he liked him. Having grown up watching him in Westerns and the TV program **Death Valley Days**, he cites Reagan, along with Roy Rogers, Gene Autry and Gabby Hayes as being a "straight shooter.'" Manson ends his presidential critique stating that Nixon, "was one of the best presidents this country has ever had."

To which Franceschelli replies: "Maybe you are crazy, Charlie."

The very last exchange in the piece is interesting for various reasons, and reads as follows:

HS: Charlie, if you could get out of prison right now, what would you do?
CM: I'd get a girl and get her in the bushes.
HS: After sex, then what?
CM: There is no after, that's what I'd do all the time, and try my damnedest to get rich, then I wouldn't have this happen anymore—jail and all.

LOS ANGELES TIMES MAGAZINE

☐ A close-up of Manson's face (not quite as close up as the same photo on the cover of **PRISON LIFE**, see page 477) adorns the

cover of this **LOS ANGELES TIMES** supplement mag. The photo is *so* close up that you can count the crow's feet around Manson's eyes, the inked-in swastika on his forehead rising from the creases between his brows.

Keeping Manson Behind Bars by Martin Kasindorf is mostly about Stephen Kay, LA County Deputy DA, and his long fight to keep Manson and fellow defendants behind bars. In fact, the first page of the article is taken up by a full page color photo of Kay standing in front of a chainlink fence outside San Quentin prison before Manson's 1989 parole hearing. On the following page is a small, color, prison mugshot of Manson, taken on March 20, 1989.

The article is long, covering Kay's life and career, his involvement in the case, and the many parole hearings of Manson and other defendants in the Tate-LaBianca murders.

CELEBRITY PLUS

☐ "Manson Followers Plot World Revolt" claims the banner blurb on the cover, with an inset pic of an ornery Manson, strangely juxtaposed by the main photo of Priscilla and Lisa Marie Presley. The uncredited article inside has the title and subtitle *Manson Cellmates Talk—Tell How Cult Killer Still Controls Followers & Vows World Revolution*.

The piece is unusual in that it only gives a brief history of the crimes but starts from the premise that Manson was controlling a small army of newfound followers outside prison from his solitary cell. Quoted is a "Manson family insider who asked not to be named" who claimed:

Charles runs his 'family' the same way he always ran them. He plays mind-control games and uses just about every occult trick known to man. The Manson method is a strange and terrifying mixture of pop psychology, black

magic, Nazi hatred and age-old su-
perstition. And it works, because there
are more Manson followers today than
there were twenty years ago!

Cult specialist Steve Hassan (author
of **Combating Cult Mind Control**, 1988)
claims that there were Manson fanatics
awaiting his parole, who asked Manson
for advice via letters and believed Manson
would lead a societal revolution upon his
release. He also claims Manson, in his dia-
tribes, used 'love' as a metaphor for 'hate.'

A German journalist is quoted saying
that in her country, Manson was "praised to
the hilt" by certain underground Nazi-minded
youths, who read his every word and col-
lected Manson memorabilia which they
got from American fanatics. Manson had
become a God-like father figure to cultists
and neo-fascists around the world.

The article claims:

CELEBRITY PLUS learned that there
is also a secret society of Manson 'sex
slaves.' Naturally, none of the Manson
groupies involved have ever had sex
with Manson, as he is firmly incar-
cerated, but they indulge in strange
sexual rituals in Manson's name.

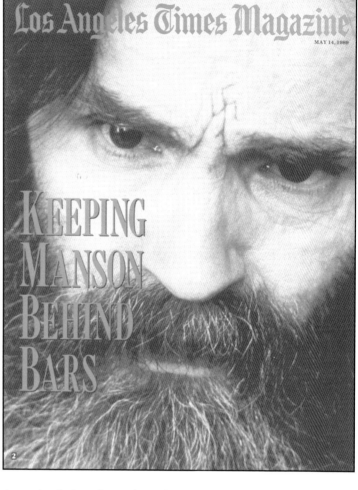

Los Angeles Times Magazine

MAY 14, 1989

KEEPING MANSON BEHIND BARS

The writer claims their inspiration
came from a passage by Susan Atkins in
The Killing of Sharon Tate by Schiller,
in which she describes Manson's use of
forbidden fantasies in sex orgies.

The piece lapses into tabloid-like
incredulity with: "Some Manson experts
predict that several thousand girls, calling
themselves by colors—because that's what
Manson did—will surface and begin staging
demonstrations for world revolution."

The remainder of the article goes
through all the parole rigmarole of Manson
refusing to go to his hearing, the other
defendants feigning born again status,
Watson's conjugal visits, etc. This is pep-
pered with Doris Tate's (Sharon's now

deceased mother) reactions to the parole
hearings and bids for freedom. Also briefly
mentioned, is that at the time Bobby Beau-
soleil and Watson were incarcerated in the
same prison, they had both married while
there and enjoyed conjugal visits with their
wives, who apparently knew each other.
Barbara Beausoleil is quoted:

Tex's wife is pretty, she's a real girl-
next-door type. It's obvious she and
Tex are crazy about each other,
because they're just like a real family.
She brings the kids to visit all the time,
and Tex is a kind and caring father.

Doris Tate found this "horrifying."

The article ends on the note that, twenty
years down the line, there may be copycat
crimes perpetrated by the current crop of
Manson followers, so beware!

This issue of **CELEBRITY PLUS** also
has articles on Elvis Presley's grandchild,
horror films, James Woods, Sigourney
Weaver and Bob Crane's unsolved murder.

MEMORIES

☐ The Manson Murders by John Kendall
is a twentieth anniversary retrospective on
the Tate-LaBianca murders and their after-
math. Kendall, a twenty-five year employee
of the **LOS ANGELES TIMES** in 1989, had

Above **Charles Manson sharing MEMORIES (v2 #4) Aug/Sep 89.** Opposite, from left **NATIONAL EXAMINER Sep 11, 1990,** helped to fuel paranoia about a potential Manson release; In their issue dated Mar 19, 1991, he was attempting to team up with international terrorists.

NATIONAL EXAMINER
Vol 27 No 37
Sep 11, 1990
Globe International, Inc., 5401 N.W.
Broken Sound Blvd., Boca Raton, FL
33487 .79 48pp

NATIONAL EXAMINER
Vol 28 No 12
Mar 19, 1991
Globe International, Inc., 5401 N.W.
Broken Sound Blvd., Boca Raton, FL
33487 .85 48pp

PRISON LIFE
Vol 1 No 1 Jan 1992
Prison Life, Inc., 111 S. Ninth
Street, Suite 3, Columbia, MO
65201 3.95 100pp

GLOBE
Vol 40 No 7 Feb 16, 1993
Globe International, Inc., 5401 N.W.
Broken Sound Blvd., Boca Raton, FL
33487 .99 48pp

originally covered the Manson trial for that same newspaper.

The article is a straightforward account of the events, giving all the appropriate facts and figures accurately. The highlight of the piece is the use of a color picture of the female defendants at the time, sporting red, freshly carved X's on their foreheads. While the photo is not that uncommon in b&w, the color somehow makes a difference to its impact. The picture is inset with two smaller color pics of Charles 'Tex' Watson and Linda Kasabian at the time of their trials. Also used is a b&w picture of Manson with a wide smile, standing between rows of pews in the prison chapel, sweeping up.

This issue of **MEMORIES** also contains a look back at Woodstock, the so-called defining moment of the peace and love sixties, which took place a week after the Tate-LaBianca murders: an event that gave the decade one of its final mortal blows, finished off by Altamont in December that year.

NATIONAL EXAMINER

☐ The headline "Fury Over Manson Release," with the additional blurbs "Gets out on weekends—Date set for full freedom—New identity planned," makes it sound, to the uninformed, as if Manson would soon be walking free! Which of course was exactly the desired effect: to stir up indignation and outrage and boost sales. The truth is, Manson was no closer to being released in 1990 than he was in 1971 or for that matter in 2006. But then again, the **NATIONAL EXAMINER** was not known for either its journalistic excellence or accuracy at the time.

There are actually two short articles within a two page spread. The title of the first is *Outrage as Manson Walks Free,* by Linda Decker, again making it sound as though it had already happened! The premise is ridiculous: Manson was gaining too much popularity as an antihero

and martyr in prison, therefore the federal government was planning to put him in the federal witness protection program, get him plastic surgery and a job, and forbid him to grow a beard or long hair once he was out! This, we are told, would effectively stop the adoration given to Manson by some, as he would effectively cease to exist. Doris Tate checks in with quotes stating that she hoped this "human scum" was never released. The last sentence of the article is a disclaimer of sorts: "Prison authorities, however, are keeping tight-lipped and deny the existence of any plan to free Manson." The article is based on interviews with Manson's fellow inmates who reported that he was "given weekend passes on two occasions." The rest is someone's fantasy extrapolation of what that meant.

The lesser item at the bottom is called *LaBianca Daughter wants her Parent's Killer let go,* by Glenn Troelstrup, a piece on Rosemary LaBianca's daughter, Susan LaBerge, who was fighting to get 'Tex' Watson released on account of his being a born again Christian and father of three—thanks to conjugal visits. Both Doris Tate and Bugliosi were incredulous at the thought that the daughter of a murder victim who had been stabbed forty-two times in the back would consider Watson's release—*ever.*

NATIONAL EXAMINER

☐ "Charles Manson promises Saddam: I Will Help You Destroy America!" exclaims the cover blurb next to a color picture of Manson making a face, swastika included. Inside, the article's title informs us that *Charles Manson Begs Saddam...*

Pictured with Manson in the piece are Saddam, Carlos the Jackal, Moammar Gadhafi, and Hitler. The article, by John Turner and Mark Carlisle, claims that Manson had gone on a letter writing campaign supporting Saddam Hussein after he invaded Kuwait.

It claims he tried to contact John Hinckley, Squeaky Fromme, and Sirhan Sirhan, but his letters were intercepted and confiscated. Manson was also supposed to have offered his aid to international terrorists Moammar Gadhafi, Abu Nidal, Carlos the Jackel, Abu Abbas, and Ahmed Jibril.

The sources quoted include "a prison source," "prison insiders," "a government anti-terrorism official," "secret government reports and memos," and "a government investigator assigned to monitor both Manson's incoming and outgoing mail."

In the letters, Manson apparently calls for a worldwide revolution against "the evil forces of oppression." This entailed freeing him to gather and align his followers, or "cult members," to help in "uniting terrorists worldwide for a concentrated attack on establishment rule" and "establishing a new 'clean' world that would operate 'directly through divine guidance.'"

The piece claims that Manson believed Hussein to be the reincarnation of Hitler.

PRISON LIFE

☐ *The Inequities of Prison Parole* by Joe Strahl, the publisher of **PRISON LIFE**, uses Manson's hopeless parole hearings, and the one man show they sometimes turned into, as a springboard to talk about parole boards and their quirky judgment calls on who should be released and under what circumstances.

Using sex offenders as an example of people who were let out, without any counseling, to offend again, Strahl cites his failed attempt at visiting Manson after receiving a letter from him stating he wanted to talk about his parole. After three days attempting to see Manson at Corcoran State Prison in California, Strahl was told that Manson refused to come out to see him. The real story is that Manson was being told to "cuff-up" for visits, which other inmates weren't required to do, and therefore he refused in protest at the unfair treatment. Strahl informs us that he was told Manson's own son was denied a visit.

Strahl's advice is that the "entire system should be scrapped and rebuilt from the ground up." Strahl also advocates alcohol and drug rehabilitation, family support, sex counseling, making sure parolees are employable, and handling each parolee as an individual case.

One full page color photo is of Manson at a parole hearing.

Other features in this first issue of **PRISON LIFE** include: *Mothers Behind Bars*, *White-collar Criminals* and *Herb's Body Shop,* about an inmate selling body parts to pay his legal fees.

PRISON LIFE lasted for several years. Joe Strahl was the editor and publisher for the first two years, and has since tried to get **PRISON LIFE** started again as an e-zine.

GLOBE

☐ The half page piece, *Angela Lansbury's wild daughter was Manson family drug zombie!* by Claire Thomas, concerns the revelations in Angela Lansbury's book, in which she relates how her daughter Deirdre hooked up with the Manson Family in 1967 when they were living in Topanga Canyon,

Above **Premiere Issue of PRISON LIFE Jan 92** with the familiar Manson close-up on its cover.

Right **An article in NATIONAL EXAMINER Jan 21, 1997,** juxtaposed a crazy looking Manson with insets of Polanski and Tate, and Deputy DA Stephen Kay. Opposite **Infamous Manson mugshot closes the century on the cover of US NEWS & WORLD REPORT Dec 9, 1999.**

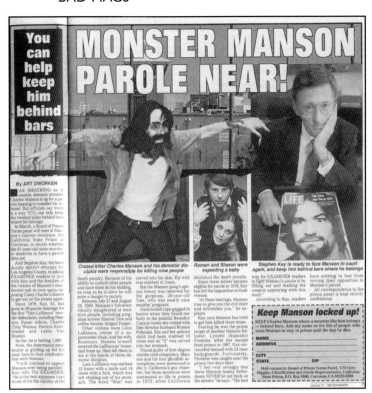

Crazed killer Charles Manson and his demonic disciples were responsible for killing nine people

Roman and Sharon were expecting a baby

Stephen Kay is ready to face Manson in court again, and keep him behind bars where he belongs

NATIONAL ENQUIRER
Vol 68 No 33 Mar 8, 1994
National Enquirer, Inc., Lantana, FL
33464 1.25 56pp

SPIN
Vol 10 No 6 Sep 1994
Camouflage Associates, N.Y. ,
Advertising Office: 6 West 18th St.,
New York, NY 10011 2.95 164pp

SECONDS
No 32 Jun 1995
24 Fifth Ave. Suite 405, New York, NY
10011 2.95 92pp

down the road from Lansbury's Malibu home. She even went so far as to write a note for her daughter giving her permission to hang out with Manson at the age of thirteen. Lansbury also informs us that another of her children, Anthony, was using drugs at that time.

By 1970, Deirdre and Anthony were both addicted to heroin; that same year the Lansbury's home in Malibu burned to the ground. This gave the parents the opportunity to decide to pack up, move to Ireland and take the kids with them. Lansbury credits this move with saving her children from both Manson and drugs. Deirdre, thirty-nine at the writing of this article, was living in Santa Monica and owned a restaurant there called Positano.

NATIONAL ENQUIRER

❑ *Sharon Tate's Angry Sister Charges: Top TV Newswoman Diane Sawyer wants Manson Girls Freed* by John Blosser is a piece

related to Diane Sawyer's ABC TV program **Turning Point**, which aired their premiere show on the twenty-fifth anniversary of the Tate murders and was the highest rated debut of a news magazine program ever. The show included interviews with Bugliosi, Van Houten, Krenwinkel and the angered Patti Tate, Sharon's sister, among others. Patti Tate's beef with the program, and Diane Sawyer, was that she was afraid the interviews with Van Houten and Krenwinkel would show them in a sympathetic light and aid their release on parole. The Tate family, Bugliosi, and his sidekick, LA Deputy DA Steven Kay are all quoted on their opposition to ever releasing any of those convicted of the Tate-LaBianca killings.

The article goes on to state that: "In 1993, **ENQUIRER** readers deluged authorities with 40,000 letters urging that they keep Krenwinkel, Van Houten and other Manson Family members behind bars."

The cover's main pic of Sawyer is inset

with a smaller pic of Manson seemingly pointing his finger at her.

SPIN

☐ The cover blurb reads: "1969 Revisited—Manson vs. Woodstock by Mike Rubin," and the cover uses a red, reversed version of the infamous Manson mugshot featured on the cover of **LIFE** magazine Dec 19, 1969.

The article inside is titled *Summer of '69* and is a remembrance of that summer. The piece kicks off quoting the first few lines of the Stooges song, 1969, which, as Rubin points out, was anything but "Another year with nothin' to do" for many.

It was a summer that included the Stonewall Inn gay rights riots on June 28; the Ted Kennedy/Mary Jo Kopechne/ Chappaquiddick incident on July 19; man landing on the moon on July 20; the Tate–La-Bianca murders August 9–10; the "Woodstock Music and Art Fair" on August 15–17, and ended that winter with the concert at Altamont Speedway on December 6.

Rubin rightfully comments: "1969 flickers as a schizophrenic year full of contradictory messages. Of course, the number '69' visually resembles a yin-yang symbol, so a sense of duality does seem implicit."

The fact that both Manson's and Woodstock's legends have carried through twenty-five years and become mythologized by present youth cultures is Rubin's concern here. He runs down Manson's songs covered by the likes of Guns 'n' Roses, Redd Kross and Psychic TV, with odes to the Manson mythos by Sonic Youth, Marilyn Manson, the Lemonheads, Nine Inch Nails, and even Funkadelic's quoting of Process Church literature on the liner notes for two of their albums.

One of the strangest manifestations of Manson marketing mentioned is the Manson t-shirt fad, capitalized on by Zooport Riot Gear in California, with whom Manson had

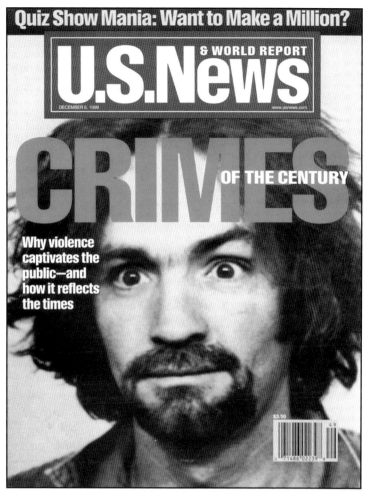

signed a marketing agreement. Slogans such as "Support Family Values" and "The Original Punk" adorning shirts with Manson's mugshot, and Axl Rose sporting a Manson tee on stage throughout Guns 'n' Roses' 1993 tour, helped sell 30,000 shirts, and a lawsuit was brought against Zooport by Voytek Frykowski's son, Bartek, after they cut Manson a royalty check for $600. Zooport's owners, the Lemmons brothers, who are fundamentalist Christians, then donated the profits to Operation Rescue, the fanatical anti-abortion group, instead of letting the money go to "a drug dealer's son."

Rubin concludes that the younger generation's adoption of Manson as a bogeyman hero is in some part because their

baby boomer parents co-opted the likes of Woodstock as one of their "counter-cultural milestones." Ultimately, Rubin states Manson is a loser, a zero, a convicted murderer and a bigot, and asks the question, "So, if only figuratively, why can't we kill him?"

SECONDS

☐ On the cover of this issue of **SECONDS**, the extraordinarily hip music zine, Manson is seen in a small inset pic, playing a colorfully painted guitar. Inside he is interviewed by Michael Moynihan, who later co-authored **Lords of Chaos** with Didrik Søderlind; the photos in the article are taken by Nick

NATIONAL EXAMINER
Vol 34 No 3 Jan 21, 1997
Globe International, Inc., 5401 N.W.
Broken Sound Blvd., Boca Raton, FL
33487 1.39 44pp

U.S. NEWS &
WORLD REPORT
Vol 127 No 22
Dec 6, 1999
U.S. News & World Report, Inc., 450
West 33rd Street, 11th Floor, New York,
NY 10001 3.50 112pp

Bougas. Highlights of the feature are two drawings by Manson, one being a full page in color, a smaller one in b&w. Again, Manson lays it on the line for all to read, as only he could.

Moynihan starts off with an introduction that had a turn-about-is-fair-play attitude concerning Manson's "twenty-six years of bad press." After pointing that out, he rightfully states Manson's name "commands attention—and a healthy bit of fear—around the globe." Moynihan goes on to say that he wishes to avoid reinforcing "the spoon-fed opinions of the imbecilic **Geraldo** nation." Moynihan likens Manson's media image to that of Aleister Crowley, deemed "the wickedest man in the world" by the press of his day.

The lion's share of the intro though is taken up evaluating Manson's quirky discography over the years. Manson's recording career started after his 1967 release from prison when another released inmate and cohort, Greg Jacobson, recorded Manson and some of the girls singing Manson tunes, which eventually became the **Lie** album. After that, most all of Manson's output, both musical and spoken word, has been recorded in prison with varying degrees of clarity, and has limited release on small independent labels. Recordings of the Family at the time of the trial, *sans* Manson, have also been released, as well as other pre-arrest Manson studio recordings.

In the interview itself, Moynihan keeps to the subject of Manson's music throughout, with occasional tangential stories and rants by Manson.

Manson claims he was cheated out of a house and a Rolls Royce promised to him by Dennis Wilson, the now deceased Beach Boy. He also claims that Neil Young gave him a motorcycle, then veers off into a story about living at Elvis' house, in which he calls Elvis "an idiot, an egotistical fucking punk."

Manson also says of Frank Zappa: "he's a no good, thieving motherfucker!"

All in all, as with any interview with Manson, he comes across as insightful, rambling, spiritual, and crazy—sometimes all at once!

NATIONAL EXAMINER

❏ This is another "Panic Over Manson Parole—Help Keep Him Behind Bars" piece, as the cover states. The article inside by Art Dworken, *Monster Manson Parole Near!*, includes a coupon petition for readers to clip, fill in and send to the Board of Prison Terms Panel, California State Prison. It reads:

Keep Manson locked up! Keep Charles Manson where a monster like him belongs—behind bars. Add my name to the list of people who want Manson to stay in prison until the day he dies.

Stephen Kay, Deputy DA for Los Angeles County and the families of the victims, not surprisingly instigated this. Kay had crusaded against the release of all accused of the Tate-LaBianca murders since they first came up for parole in 1978. Kay claimed Manson had tried to have him killed three times. When Squeaky Fromme escaped from prison in 1987 Kay hired twenty-four hour protection.

The article ends: "According to Kay, readers have nothing to fear from voicing opposition to Manson's parole."

U.S. NEWS & WORLD REPORT

❏ This more recent national mag closed out the century, and millennium, with Manson's infamous mugshot on the cover. *Crime Stories of the Century* by Angie Cannon is the article it pertains to—an overview of the most infamous and well-publicized crimes from each decade of the twentieth century.

The article covers: Harry Thaw's shooting

of Stanford White in 1906, because he had an affair with showgirl Evelyn Nesbit, who became Thaw's wife; Joe Hill's controversial trial in 1914, eventually made a martyr by the Industrial Workers of the World; Capone's 1929 St. Valentine's Day Massacre; the 1932 Lindbergh baby kidnapping; the 1949 Ethel and Julius Rosenberg spy case; and the 1955 lynching of fourteen year old Emmett Till by racists. The 1960s are represented by Manson, "psycho killer" as the heading reads, ending with a quote from Vincent Bugliosi: "Manson has become a metaphor for evil." The 1970s looks at Son of Sam (also mentioned are Ted Bundy and John Wayne Gacy). Jeffery Dahmer cannibalized the 1980s; and O.J. Simpson's media circus in the nineties rounds out the century.

The most haunting sentence in the article comes in the last section ("Millennial madness"): "Crime experts worry that some-day we might see the frightening brand of overseas terrorism that has so far eluded us: suicidal fanatics bent on destruction."

Which makes me wonder, if "crime experts" knew about this in 1999, where was the CIA on Sep 11, 2001?

HUMANS ACTUALLY EATEN BY MONSTER SHARKS

JAWS OF HORROR

SPRING 1978 $1.50

SEE:
BLEEDING VICTIMS
RIPPED IN HALF
BY FRENZIED
SHARKS

READ:
FIGHT
TO THE
DEATH—
SHARKS
VS KILLER
WHALES

REAL
PICTURES:
RAZOR-SHARP JAWS
MAIM DIVERS FOR LIFE

WHEN WILL YOU
FACE THE JAWS
OF HORROR?

MYRON FASS, WITH OCCASIONAL help from his brothers, Irving and Leo, and a cast of many other characters including his son David from the late seventies onwards, published hundreds of magazine titles from the late fifties through to the early nineties, using various company names and sometimes a pseudonymous, even fictitious, staff. Staff whose names pop up consistently in the credits through the years include Robert Greene, Mel Lenny, Arnie Schnitzer, Joseph D'Amato, and Bob Nesoff.

In 1976 Fass hired the twenty-one year old Jeff Goodman, who was fresh from writing porn paperbacks for Star Distributors under the pseudonym "Wulf Fleischbinder." Goodman quickly became the editor of many of Fass' girlie mags such as *Jaguar*, *Flick* and *Erotica*, and then ended up as the editor-in-chief of many of Fass' other titles, nearly overnight. Goodman then gathered a nucleus of other co-conspirators around him—namely his brother Kevin Goodman, Buddy Weiss and Stan Bernstein—in the lunacy that was about

to be unleashed on the magazine racks of the world. Myron's teenage son David helped to edit the multitude of rock mags they published in the late seventies and also joined Goodman's crazy crew. With Myron's blessing they began putting together some of the craziest mags ever to hit the newsstands. On the rare occasion when Goodman thought he might have gone overboard with the stories in *Official UFO*'s later issues, Fass would tell him to make the stories even crazier! And Goodman and his team were up to the challenge as can be seen from some of the cover blurbs.

Myron Fass is best known as the publisher of Eerie Publications' illustrative horror mags from the sixties and seventies. But that story really started in the fifties with the Iger Shop, an independent art house cranking out stories and artwork for the lower end, pre-code crime and horror comic book companies, in this case namely Ajax, and their titles *Voodoo* and *Haunted Thrills*. The pages would later be reprinted in b&w in Myron Fass' early Eerie Publications illustrated horror titles in the sixties—occasionally with panels redrawn, or added blood and gore to make them more shocking. Gore was non-existent in the comic books after the Comics Code Authority had its way in 1955.

William Gaines' *Mad* thumbed its nose at the code, and bypassed it by evolving from a color comic book to a b&w magazine. In 1964 Warren Publications published their first illustrated horror magazine, *Creepy*, again bypassing the Comics Code Authority. It has been rumored that Myron Fass was the reason that Warren's first issue of *Eerie* was a small "ashcan-sized" affair due to legal problems stemming from Myron's plan to use that name for his own illustrated horror mag. Jim Warren had been planning to publish a sister mag to *Creepy* called *Eerie*, and had advertised the fact in *Creepy*. Warren had got wind that Fass was planning to use that as the title for an illustrated horror mag of his own and quickly had a small "ashcan-sized" *Eerie* #1 printed and distributed

to a few newsstands so as to legally claim the title for Warren Publications in court. Whether or not Fass was going to use the title for a mag, or just his publishing company, is not clear. In any case Warren won the right to the *Eerie* title, and Fass published his first illustrated horror title—*Tales of Terror* #1, Summer 64—using the company name of Eerie Publications. *Tales of Terror* comprises reprints of fifties pre-code horror comics, and is a one-shot mag a hard to find collectible.

But at the time, *Tales of Terror* had also been a cause of concern for *Mad*'s publisher William M. Gaines, whose EC Comics had published a comic with the same title in the fifties; Gaines didn't want to be associated with the shlocky fifties reprint output from Eerie Publications.

A few years later Eerie Publications decided to pay homage to, or tweek, Gaines again, and issued another one-shot illustrated horror mag, *Tales from the Crypt* v1 #10, Jul 68 (another rare collectible), again the title of a popular EC horror comic from the fifties. In this case, Gaines told them to cease using the title and Fass complied.

But Eerie Publications took things to a level of graphic gore that Warren didn't. Beheadings, disembowelments, impaling, dismemberment, cannibalism, and buckets of blood and guts spilled across the covers in vivid, mind-numbing color. Eerie Publications eventually added some newer artwork, mixed in with the reprints, around 1970 when their cover price rose from thirty-five to fifty cents.

It should be noted here that Eerie Publications' numbering of volumes and issues has helped contribute to a lot of confusion, as first issues were usually numbered as volume 1, #10 (the second issue being v1 #11, and so on).

When Eerie Publications published the first issue of *Weird* v1 #10, Jan 66, it started the ball rolling, although the first few covers were rather tame, featuring the likes of Frankenstein's monster and Dracula, but their covers moved into the realm

of vivid gory scenes not long after. Eerie Publications added more horror titles: *Horror Tales, Tales from the Tomb, Tales of Voodoo, Witches' Tales, Terror Tales, Weird Worlds* and *Strange Galaxy*.

Fass also published the mag *Great West*, comprising text with photos and illustrations and utilizing the same artists for its gory covers as for his horror titles.

Keeping track of the addresses Eerie Publications emanated from was a cause for confusion, considering their long history and seemingly convoluted path through the canyons of Manhattan.

In 1966, when Eerie Publications started the title *Weird*, their first longrunning title, they were located at 315 West 70th Street, just west of Central Park.

The second address Eerie Publications inhabited was 150 Fifth Avenue and they published from that address until mid to late 1969 (the Aug 69 issues were the last from that address), then moved operations to 222 Park Avenue South (starting with the Sep 69 issues through to the Feb 74 issues), a block east of Fifth Ave.

In early 1974 (starting with the Mar 74 issues) they moved again, across the street and a block north, to 257 Park Avenue South, into the Gramercy Park Building located between 20th and 21st Streets. This is the address from which Fass, Goodman, and the rest of the crew would work as Countrywide Publications at the height of their publishing popularity.

Eerie Publications moved one last time to 79 Madison Avenue, in late 1977 or early 78 (Feb 78 is the first issue I've seen with this address). This address seems to have been related to Stanley Harris when he moved out of Fass' proximity at the Park Avenue abode, which is where Fass stayed as Countrywide Publications. In 1980 Eerie Publications ceased publishing, as far as I can tell, with *Weird* v13 #3, Sep 80, being the last issue from this illustrious publishing company. Modern Day Periodicals then published a few issues of *Weird Vampire Tales* and *Terrors of Dracula*, more illustrated horror, from the Madison Avenue address in 1980–81.

Actually, the three addresses Eerie Publications published from the longest are all within a block or two of each other, and only a few blocks north and east of 33 Union Square West, where Warhol had his second Factory in the late sixties. And just a hop, skip and jump down the street was the famed Max's Kansas City located at 213 Park Avenue South, off Union Square.

The illustrated sci-fi sex mag, *Gasm*, was the brainchild of Myron's editor Jeff Goodman, lasting five issues and published by Stories, Layouts and Press in 1977–78. Apparently Goodman wanted to do a quality illustrated sci-fi mag along the lines of *Heavy Metal* but Myron would only agree to it if it had plenty of sex in it. Goodman then solicited the artwork with that stipulation and *Gasm* was born.

Frankenstein Classic was published in 1977 by Modern Day Periodicals and is similar to the two magazines, *Dracula Classic*

(see Manson chapter) and *Revenge of Dracula*, published by Eerie Publications. They are not illustrated with artwork, but utilize movie stills, old woodcuts, and illustrations.

Myron Fass—Demon God Of Pulp

❑ Myron Fass sat at the top of a pulp magazine publishing empire in the seventies that sometimes published as many as fifty titles a month, including such diverse mags as **OFFICIAL AMERICAN HORSEMAN**, **HALL OF FAME WRESTLING**, **TRUE WAR**, **OFFICIAL UFO**, **SHOW DOGS**, **TERROR TALES**, **HORROR TALES**, **HARD ROCK**, **SUPER ROCK**, **PUNK ROCK**, **ACID ROCK**, **GROUPIE ROCK**, **SON OF SAM**, **SHOTGUN JOURNAL**, **HOMICIDE DETECTIVE**, **MURDER SQUAD DETECTIVE**, **WEIRD**, **SHOOTING BIBLE**, **.44 MAG**, **JAGUAR**, **LED ZEP VS. KISS**, **CLOSE ENCOUNTERS OF THE FOURTH KIND**, **CLONES**, **SPACE WARS**, **SPACE TREK**, **MOVIE TV SECRETS**, **TV PHOTO STORY**, **PHOTO TV LAND**, **THE WORLD OF SHERLOCK HOLMES**, *ad infinitum*. But it hadn't always been that way.

There isn't much information available on Myron Fass and what follows has been pieced together from several specific sources: notably, the one article I was able to find on him: *I, Myron* by Mark Jacobson, published in the Oct 23, 1978, issue of **THE VILLAGE VOICE** when Fass was on top of his game. Conversations with Jeff Goodman and material from various internet references, usually by former employees or colleagues, have also been woven in to complete the picture.

Myron (born March 29, 1926, died September 14, 2006) grew up in Brownsville, a section of Brooklyn, NY; his father was an orthodox Jewish immigrant who worked in the sewers of NYC for the Work Projects Administration (WPA). The following is a description of Brownsville from the **1939 WPA Guide to New York City**:

Brownsville extends from Ralph Avenue to Junius Street, between Liberty and Hegeman Avenues. With more than two hundred thousand people dwelling in its 2.19 square miles, it is the most densely populated district in Brooklyn. The population is predominantly Jewish. A group of Negroes lives on Rockaway Avenue, Thatford Avenue, Osborn Street between Livonia and Sutter Avenues. The only Moorish colony in New York is on Livonia Avenue between Rockaway and Stone Avenues. Italians live in the northern section of Brownsville; and on Thatford Avenue near Belmont is a small Arabian and Syrian quarter.

Myron first gained attention with his drawing skills, but during

This page, from top **Myron Fass, Demon God of Pulp, at work; Al Goldstein and Myron Fass, who is seen giving King Kong a "dong;" An animated Fass on the phone, sporting a handgun at his waist. Photos courtesy of Jeff Goodman.**

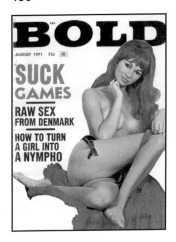

From top **BOLD (v6 #7) Aug 71,** a digest-sized Fass mag that Al Goldstein had briefly written for in 1968 before starting SCREW; **CLONES (v1 #1) Summer 78.**

Opposite, clockwise from top left The houses of Eerie: close-up of the front door of 257 Park Avenue South, aka the Gramercy Park Building, the fourth address for Eerie Publications; 222 Park Avenue South, the third address for Eerie Publications; and 150 Fifth Avenue, the second address for Eerie Publications. All photos: Tom Brinkmann, 2002.

WWII his talent and "ideas" got him public relations jobs at an early age. After the war—starting about 1948 until the Comics Code Authority began in 1955—he got work drawing pre-code western, crime, horror, romance, and jungle girl comics, illustrating many covers, as well as stories. Companies such as Atlas, Trojan, Gleason, Toby, and others paid for his artwork to use in diverse titles like **TALES OF HORROR**, **ADVENTURES INTO TERROR**, **ASTONISHING**, **UNCANNY TALES**, **GREAT LOVER ROMANCES**, **BLACK DIAMOND WESTERN**, **CRIME SMASHERS**, **WESTERN CRIME BUSTERS**, **ATOMIC SPY CASES** and so on. Jeff Goodman has accurately assessed Fass' stature in the realm of comic book history, saying: "[Fass] was a competent minor illustrator who found his forte in other publishing venues."

It was after the Comics Code Authority took effect in the mid fifties that Fass started his publishing odyssey.

He was greatly influenced and inspired by **MAD**'s William M. Gaines and his maverick approach to publishing, particularly the fact that Gaines had turned **MAD** into a magazine format in 1955 to escape the control of the Comics Code Authority.

This led Myron to find backing for **LUNATICKLE**, the "Lunatic's Home Companion," one of the earliest **MAD** imitators with Myron as editor. Other contributors were Joe Kubert, Russ Heath, and Theodore S. Hecht, who was later the editor for Stanley Publications' horror story mags **ADVENTURES IN HORROR** and **HORROR STORIES**. Myron said of **LUNATICKLE**: "[it] sold a million first issue, was dead by the third." The third issue never materialized and only two issues were published. Whitestone Publishing, a subsidiary of Fawcett Publishing, published **LUNATICKLE**'s first satire-filled issue in 1956. Whitestone also published the scandal and satire mags **COCKEYED**, **SHHH**, **CUCKOO** and **EXPOSED**—their longest running title.

FOTO-RAMA was another mag Fass

edited in the fifties, "full of panties crotch shots," as he put it. Mel Lenowitz was listed on the staff as researcher, and was the "Mel Lenny" who was the advertising manager of the later Eerie Publications. According to Jeff Goodman, Mel Lenny died in the 1990s from a blood clot.

Myron Fass never rejected his origins in sleazy pulp magazines; in fact he turned them into an art form. The formula for Myron seemed to be cheesecake, gore, horror, shock and opportunism, printed on the cheapest newsprint available, and it worked. Utilizing a combination of young hack writers and artists, fresh out of college, some of his immediate family, and old-time pulp magazine writers, Fass published multitudes of pulp mags, which put plenty of money in his pocket. He has accurately referred to his magazines as "Masterpieces on cheap paper."

Myron published **SHOCK TALES** in Jan 59, riding the coat tails of the new monster mag, **FAMOUS MONSTERS OF FILMLAND**, although **SHOCK TALES** isn't about films and doesn't utilize film stills. **SHOCK TALES'** contents were geared toward a more adult audience, as was **THRILLER**, also published by Tempest Publications in 1962. Tempest Publications would again be used as the publisher for sixties pin-up girlie mags **PIC**, **BUCCANEER**, **POORBOY**, **JAGUAR** and so on.

Another Tempest Publications mag is 1964's **QUICK**, "The Original Newspaper Magazine," which boasts "70 Photo Stories" on the cover, even though they are single and half page items that include sexy and shocking pics. Myron was also the publisher of **COMPANION,** a digest that claimed it was formerly **LADIES HOME COMPANION**, whose publishing company was given as Ladies' Coronet, Inc., located at 150 Fifth Ave., the second home of Eerie Publications.

At the end of 1964 Myron started his tabloid paper **NATIONAL MIRROR**, that ran until 1973. The **NATIONAL MIRROR**

used the wackiest, most eyecatching cover headlines, sometimes with images collaged together of women and animals. In the early months of 1968 Al Goldstein answered an ad in the **VILLAGE VOICE** and ended up working for Fass for ten months. In the last months of 1968 Fass started another tabloid title called **HUSH-HUSH NEWS,** a title he took from the defunct fifties and sixties gossip mag. Al Goldstein worked on both of Fass' tabloids, sometimes writing a story an hour, and also worked on a few of Myron's digest-sized girlie titles like **PIC** and **BOLD**. Goldstein says he liked working for Fass as there were few restrictions put on his writing where sex and violence were concerned; this is apparent when looking at the headlines alone.

When Goldstein started his own sex review paper, **SCREW**, in Nov 68, he was still working for Fass, but at the end of the month when he asked for a raise, Fass fired him. Goldstein readily admits that working for Myron was his introduction to the wonderful world of publishing and he learned a lot. Goldstein remained friends with Fass, and later on Fass even became a recipient of the "Al Goldstein Award."

National Mirror, Inc. was also the name of another publishing company Fass used for some of his sleazier magazine efforts in 1975, publishing titles such as **CONFIDENTIAL REPORT**—which turned into **CONFIDENTIAL SEX REPORT**—**TRUE SEX CRIMES**, and a shortlived resurrection of the scandal mag **UNCENSORED**.

Another of the many publishing companies Myron ran was aptly named M. F. Enterprises, utilizing his initials; many of his detractors claim there was never a more appropriate name for a company run by Myron Fass. In 1966 Fass tried to enter the comic book market in an ill-fated attempt with Carl Burgos—creator of Captain Marvel and the Human Torch for Marvel Comics—to reinvent Captain Marvel. M.F. Enterprises published five issues before calling it quits after bad sales and bad reviews by Captain Marvel fans, as well as some problems with copyright infringement. Another Fass comic from the same time period is an **Archie** rip off called **Henry Brewster**, which had the same life span as his Captain Marvel title.

From top **ANCIENT ASTRONAUTS** (v4 #9) Dec 78 had then NYC Mayor Ed Koch on the cover; **THE ONLY WOMAN ELVIS EVER LOVED** 1977-78 was one of the many Elvis titles Fass published. Opposite Splash page spread from **OFFICIAL UFO** v3 #5, with Buddy Weiss morphing into Mel Lenny.

One-shot magazines were Myron's favorites, in which he could use his "gift for mass psychology and bullshit." The three biggest events that Myron cashed in on were the Beatles invasion, the Kennedy assassination—on which he claimed to have made $4 million—and the death of Elvis Presley.

Myron's theory on the Kennedy assassination was:

it made people feel good. When someone dies, no matter what you thought of him, no matter how much you might have loved him, there's part of you that's going to feel good. Because you're superior to him. Doesn't matter if he was better than you in life; now he's nothing. That's what Kennedy was about. It was a chance for everyone to feel superior to the president of the United States.

To illustrate Fass' gumption to be the first on the newsstands with a magazine on Elvis, right after the King's untimely death, he had editor Jeff Goodman take a late night flight to St. Louis to the printer to hand deliver the boards for the Elvis mag, so as to beat all other publishers to the stands!

LARRY FLYNT OF HUSTLER is a title Myron put out shortly after the **HUSTLER** publisher was shot and it is chock-full of pics of Flynt's bullet-riddled body. It also engages in the same type of scatological humor that **HUSTLER** specialized in, this time aimed at Flynt. As Myron explained, "I just wanted to give Flynt a little bit of what he gives everyone else. I thought he'd appreciate it…but I guess he didn't think it was funny. Some people can't laugh at themselves."

LARRY FLYNT OF HUSTLER is now a Fass rarity, as a horrified distributor reportedly destroyed many copies.

Putting pictures of himself in his own mags on occasion was another of Myron Fass' wonderful quirks. In the Fall 78 issue of **.44 MAG**, Myron is seen standing next to a picture of Wild Bill Hickock with the caption: "Several nostalgia buffs have said Myron Fass bears a striking resemblance to Wild Bill Hickock." Myron also shows up on the cover and inside of **OFFICIAL UFO** (v3 #8 Oct 78, see page 497).

Fass commuted from his house in New Jersey, where he resided with his first wife Phyllis, his Mercedes, customized Cadillac and Corvette. Hanging in his Manhattan office was a portrait of himself as the crucified Christ and a painting of the Pied Piper of Hamelin, as well as numerous drawings of his own (some of which can be seen in the background of the photos in the **OFFICIAL UFO** feature).

On the door into his office he had the Dun and Bradstreet report stating his company, Countrywide Publications, had grossed $25 million in 1977; in 1978 he bragged it would double. At that time he was the single largest "multi-title" newsstand publisher in the country. His magazines usually had little, if any, advertising, and he didn't care about selling subscriptions. His break-even point was selling thirty-five per cent of a title's print run; if a magazine did much less than that, it was canned and replaced with another title.

Myron's philosophy on this: "As long as you can keep the circulation above 20,000, I don't care what it's on, you could do one on toilet seats," he explained to Howard Smuckler, editor-in-chief of two of Myron's national magazines, **ANCIENT ASTRONAUTS** and **ESP**.

ANCIENT ASTRONAUTS, the one that bordered on the ridiculous more often than not, was doing exceedingly well, with a circulation approaching 30,000. It was **ESP** that was falling, with a circulation of only about 18,000. "For heaven's sakes," Smuckler would say, after returning from a meeting with Myron to plead for yet another issue of **ESP**, "**SHOW DOGS** is doing 27,000, can't we do better?" Myron did not want to continue with the losing title, but Smuckler argued to combine circulations, and so **ANCIENT ASTRONAUTS** kept **ESP** afloat.

Ken Landgraf, one of the artists working for Countrywide Publications in the late seventies, recalls:

Myron was a publisher who knew what he wanted, and got it. Jeff Goodman made sure that everything ran smoothly. They were extremely professional. Jeff received the artwork and would show it to Myron for his approval; I think Myron trusted Jeff's judgment. [Myron] always paid me on-time for artwork, which was unusual for free lance artists at the time, we used to get stalled by other publishers a lot.

Myron's partner in the publishing business was Stanley R. Harris, whose father had made a fortune from the invention of the Harris Press, a printing press still in use today. Fass and Harris did not see eye to eye on certain aspects of the publishing business, namely dealing with the distributors. Harris accused Fass of "unilaterally dealing with distributors…and threatening employees if they communicated with the plaintiffs." Harris also claimed:

Mr. Fass…threatened my life and made menacing gestures. On other occasions in recent weeks Mr. Fass has come into my office wearing a loaded gun in a holster…It is a ploy of Mr. Fass to so display this gun when he is in an argument. I am informed that many of the employees are intimidated by his wearing a loaded gun about the office.

Mr Fass explained this by stating: "We publish several gun magazines and are constantly receiving guns and ammo in our office, so no one should be intimidated by the presence of a gun."

Jeff Goodman said: "The MOST infamous incident was the one where Myron shot a gun through a wall, almost killing his partner, or the severe beating of Stanley Har-

ris by Myron in front of the whole office."

The gun incident started with Myron setting up cardboard and pillows in his office to get in some target practice. When he fired into the padding it didn't stop the bullet from passing through the wall separating Myron's office from Harris', nearly hitting Harris who was in the office at the time. A near miss.

Later, Fass had a fist fight with Harris, and Harris lost. According to Jeff Goodman, who was a witness to the fracas, Myron and Harris emerged from Myron's office: Myron had Harris in a headlock while punching him in the face. Harris then went from one employee to the next asking that someone take a photo of his bloodied face for proof in court against Fass; no one was willing to comply as Fass was waving a gun around threatening anyone who did. The incident terrified many of the old timers in the office who left not long after.

Harris left too, taking his secretary who eventually became his "right-hand-man," and started his own Harris Publishing, which in turn churned out more of the same type of mags in the 1980s. Harris continued publishing mags as Countrywide Publications into the 1990s. Harris Publications is still going strong today, publishing a multitude of mags such as **REVOLVER**, **GUITAR WORLD**, **EXERCISE AND HEALTH**, **TACTICAL**

KNIVES, **COMBAT HANDGUNS**, **BOW-HUNTING**, **CELEBRITY HAIRSTYLES**, **COUNTRY COLLECTIBLES**, **QUILT** and many more.

Myron on the other hand kept publishing, eventually as S.J. Publications from an address in Fort Lee, New Jersey. S.J. Publications' mags were reprints of earlier Fass mags like **MURDER SQUAD DETECTIVE**, **CHIEF OF DETECTIVES**, **HOMICIDE DETECTIVE**, and so on, with rearranged stories and covers, occasionally slapping a new cover together. Other rare S.J. titles are **UFO CONFIDENTIAL**, **UNIDENTIFIED FLYING OBJECTS**, and the hilarious **CONFIDENTIAL & UNCENSORED**. The last Fass mags published from New Jersey were dated early 1982. Whether Myron was putting these together from his home, I don't know, but it wouldn't surprise me.

Although Fass made a mint with his mags during the sixties and seventies, he also spent a mint, and by the early eighties was heavily in debt to printers and distributors. That's when he moved to Florida. Jeff Goodman said Myron was running a gun shop in Florida in the mid eighties and by the nineties had become paranoid and would not talk to anyone.

Dean Speir, who runs "The Gun Zone" website recalls:

Above Page from SHOCK TALES
(v1 #1) 1959. **Right** An excited
Myron Fass. Photo: Jeff Goodman.
Opposite SHOCK TALES (v1 #1)
Jan 59. The vampiress on the cover
would show up again on the covers
of THRILLER #2 1962 and the
NATIONAL MIRROR in 1966, both
published by Fass.

SHOCK TALES
Vol 1 No 1 Jan. 1959
M. F. Enterprises Inc., Room 1128,
342 Madison Ave., New York 17,
NY .35 68pp

*Fass, who I knew as 'Chief Merion
Riley-Foss,' was in Ocala, Florida in
the mid-'80s when I sold a story to one
of his cheaply-produced gunzine titles,*
USA GUNS, *and found it published in
another one,* **GUNPRO.** *Both titles were
under the aegis of 'CFV Publishers.'
Some years later I learned from Phat
Phil Engledrum that 'Chief Merion
Riley-Foss' was in reality one Myron
Fass, with whom he'd worked in NYC
in the late 60s at Harris Publications.
Apparently, Fass, upon moving to
Central Florida, decided that he would
be handicapped with a Jewish name,
and since he'd always wanted to be a
'Police Chief,' he created something
called 'Bureau of Criminal Investiga-
tions,' appointed himself the head of it
with the title of 'Chief' and assumed the
name of 'Merion Riley-Foss.'*

Goodman claimed a lot of these later gun-
zines comprised material from brochures that
Myron received free from gun manufacturers
and reprinted verbatim.

Another former employee of Myron's was
Angi Moyer, who informed me that Myron and
son David were still at it in Florida in 1994, pub-
lishing mags such as **GADGET WORLD** and
PEOPLE TODAY, as well as several gunzines,
under an umbrella company called Creative
Arts. Myron's name was not listed on the mast-
heads and David Fass was listed as "David
Harvard." Myron was still wearing a loaded gun
to work according to Moyer. She says: "There
were rumors that [Myron] and David had had a
standoff in David's office, pointing loaded guns
at each other. I even heard that one of them
had fired a shot into the ceiling."

Moyer worked for Fass from January
through to November 1994, and was a friend
of David Fass until June 1995. Moyer says of
her last contact with David Fass:

*The last time I spoke with David over
the phone, he said that Myron had
been 'forced' by the local authorities*

*into some kind of 'facility' because he
was shooting his gun off in the tennis
courts of his condo in Deerfield Beach.
David sounded like a real mess and
said he was working as a 'sex opera-
tor' but had some 'big projects in the
works.'*

David Fass died on June 11, 2000 in
Deerfield Beach, Florida, from what exactly I
do not know, but everyone who knew him con-
curs that he had a long term drug/substance
abuse problem.

I'm also sad to report that Myron Fass died
on September 14, 2006 at the age of eighty in
Ft. Lauderdale, Florida.

Below are three mags Myron published
at different points in his long career—**SHOCK
TALES,** an early Fass endeavor; **STRANGE
UNKNOWN** from 1969; and **OFFICIAL UFO,**
from the later days. They are all fascinat-
ing—or Fasscinating, if you will.

SHOCK TALES

☐ This early Myron Fass one-shot had
low distribution and is a rarity, and seems
almost a blueprint for the **SEX TALES** mags
published by Gallery Press thirteen years
later (see page 269), or even Stanley Pub-
lications' horror titles like **ADVENTURES IN
HORROR,** etc. So much so, that it led me to
wonder if Ed Wood had possibly picked up
a copy of this campy classic in 1959, kept it,
or remembered it, then possibly suggested
to Bernie Bloom to do the **HORROR SEX
TALES** mag using this sort of format: a
mixture of photos and artwork to illustrate
short horror stories.

The editorial, by Myron, is even similar to
the later **SEX TALES** intros:

*Don't Read This Magazine Unless You
Enjoy Being Scared To DEATH!
Dear Reader: This is not a magazine
for readers with weak hearts. It is a
magazine guaranteed to thrill you, chill*

you, amaze you, frighten you—and above all, to entertain you.

In a world rapidly filling up to the brim with maudlin, weak-kneed entertainment, this magazine raises a beacon of light out of the past for readers who prefer their stories strong, well muscled and full-blooded.

Tales of horror are well-rooted in the past of literary tradition. 'Frankenstein' and 'Dracula' and 'Dr. Jekyll and Mr. Hyde' and 'The Fall of the House of Usher' are classics of English literature. Every language has its own library of classic horror tales. We build upon this foundation.

This is a magazine dedicated to shock and horror in the classic tradition. For, you see, we believe in such things as vampires, ghosts, witches and werewolfs!

Take our dare. Read. You, too, will wonder. And perhaps believe with us.
—Myron Fass, Editor

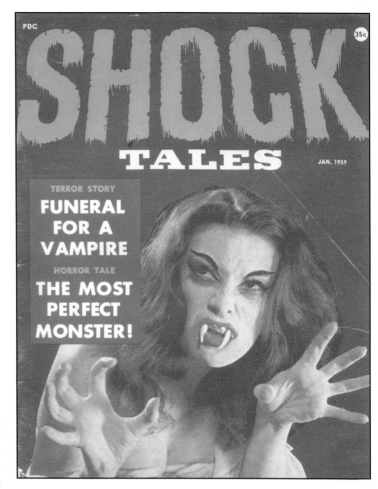

Other similarities to the 1972 Gallery Press **SEX TALES** titles are the use of posed photos (credited to Don Snyder). These usually involve scantily clad women, blood, and on occasion strange effects that make the images look slightly psychedelic, even in b&w: fairly odd for 1959.

There are twelve features in the mag, with only two ads, one for learning hypnotism, and one that claims you could "Cash In Quick On The New Shoe Craze!" and earn $960 a month selling the "Mason Kampus King", ankle high shoes with a colored panel on the sides that you could choose an initial letter to put on!

The writers credited below are almost certainly pseudonyms.

In the first story *Blood is Thicker than…,* by Robert J. Cassiday, photos of the vampire woman from the cover are used. In the two page opening spread, she is hunched over the corpse of a man in a graveyard, blood dripping from the corner of her long-fanged

mouth (a color version of this photo was used on the cover of **THRILLER** #2 from 1962, published by Fass' Tempest Publications). In other photos she attacks a couple of lovers kissing. Some of these photos were reportedly posed for by the staff of the mag. The story is a basic vampire tale, set in New York City, written in the first person by a man in a mental hospital, relating his discovery that the rest of his family are bloodsucking vampires! When he grows older, and realizes it was not all a bad dream, as his sister tries to pretend, he sets out to kill the lot of them, with stakes through their hearts. The police don't believe his story of vampires, and he is locked away in the looney bin, where he writes his story, trying to convince the doctor to believe him.

The Most Perfect Monster, by Bernard L. Elliot, involves a psychopath killing women to collect various parts from each, which he sews together—Frankenstein-like—to make his perfect female. After he gives her life, she takes his, killing her creator.

How to be Horrible! is a two page feature on monster movie makeup, that uses photos of George Sawaya having his makeup applied by Volpe and George Bau, for his role as "K-6" in **The Black Sleep** (1956). **The Black Sleep** also starred Basil Rathbone, Lon Chaney, Jr., Bela Lugosi, John Carradine and Tor Johnson.

I Ain't Got No Body! by Thomas O'Connor is a strange tale of a soldier who has all four limbs amputated, and one eye removed, due to shrapnel wounds.

Above **STRANGE UNKNOWN**
(v1 #1) May 69. Opposite **Surreal
photo montage for the opening
spread of** *I Dream I Dream* **in
SHOCK TALES 1959.**

He becomes proficient at hypnotism to control those around him, namely beautiful women. When he tries and fails to hypnotize his nurse, she picks him up, dumps him in a full bath, and leaves him to drown. The copy editor must have been out to lunch when this story crossed his desk, as at the beginning of the story it tells of one of the soldier's eyes being removed, yet by the end of the story he is hypnotizing women with "glittering eyes!" The mag as a whole has not been proofed well either, as there are numerous typos throughout, as well as seemingly missing text.

I Dream I Dream, by Robert J. Cassiday, is a weird, surreal tale about David, a man who continually wakes from nightmares, only to find he is in another dream. He continues to wake from one dream into the next, on and on, never really sure which dream is reality.

The Girl in the Gilded Coffin by John Jones is a murder story involving a love triangle, and death by suffocation from being enclosed in a coffin, inside a mausoleum. "Birdie vomited and choked, deep down in the depths of her casket…"

Bored to Death, by Ted Lee, is a twisted tale of a cannibalistic cult, that begins:

His screams for mercy chilled me as few things have in my forty-odd years of life. They were all the more terrifying because he knew, that nothing in the world could prevent him from being butchered alive and then calmly eaten by cannibals. I found it hard to adjust the scene before me to reality—this was happening in the heart of New York City, in a weirdly torch-lit soundproof sub-basement of Greenwich Village. And the cannibals were American citizens!

Bored to Death is one of the goriest stories in the mag, with ritual murder, dismemberment, cannibalism, and roasting a woman alive on a spit over a bed of white

hot coals. It is told by a wealthy, world weary dilettante, who joins the cult out of boredom and gets more than he bargained for.

The Harlot Wouldn't Die!, by Willy Hunter, is your basic tomb-raiding archeologists battling reanimated Inca harlot mummies!

The Werewolf Rapist by Geoffrey Dickens is a werewolf tale that would have warmed Ed Wood's heart. The werewolf that rapes and disembowels its female victims turns out to be a transvestite werewolf named Henry/Henrietta. The writer offers this theory in the last paragraph:

But instead of considering the problem purely as a demonic, supernatural phenomenon, I prefer to think of it as my brother did, the influence of a powerful schizophrenic mind over matter. Better yet—I prefer not to think of it at all.

A Funeral for a Vampire is the "grisly facts on how to protect yourself from the living dead."

And Baby Makes 3 is listed on the contents page as, "Something evil in their home threatened to drain their life blood!" It is a ho-hum vampire story about a couple bringing home their newborn infant from the hospital, which just happens to coincide with the two parents becoming overly tired. The inevitable holes on the neck are discovered, and they realise they have a vampiric baby, which crawls across the floor, baring its sharp teeth.

Eye Photograph Death is an uncredited piece at the back of the mag that tells of a rape/murder in Yugoslavia. The crime is solved on the premise that the retina of the eye is like a camera, and will record the last image a person sees before their death. In this case, after a sex maniac rapes a woman in her home, he "performed various perverse acts, torturing her body with his teeth and drawing blood, biting her severely more than fifty times on every part of her body, laughing as her warm, red blood dripped from his fiendish mouth." After he finishes assaulting

STRANGE UNKNOWN
Vol 1 No 1 May 1969
–Vol 1 No 2 Jul 1969
Tempest Publications, Inc., 150 Fifth
Ave., New York, NY 10011 .50 68pp

the woman, he shoots her in the head with a pistol. His image is recorded on her retina, and as one pull quote reads:

The dead woman's eyes were removed, the retina disattached, and the image developed; much as a photographic negative might be developed, the picture which was made from this weird 'negative' was evidence enough to convict the sex-crazed killer and send him to swing from the gallows.

The four page article is illustrated with hokey looking photos of a "doctor" examining the retina under a microscope. The final image, an enlarged retina, reveals the murdering rapist pointing a gun at his victim.

The magazine's stories might seem particularly perverse for 1959, but then, considering what EC comics depicted in the early fifties, they don't seem all that odd.

STRANGE UNKNOWN

☐ **STRANGE UNKNOWN** was Myron and crew's attempt to cash in on the occult fad of the late sixties, but the title only lasted two issues. The covers, particularly that of the second issue, look very similar to the horror fiction mags, **ADVENTURES IN HORROR** and **HORROR STORIES**, which Stanley Publications put out later in 1970–71.

The first issue covers the usual occult subject matter: witchcraft, voodoo, UFOs, astral travel, vampires, the Loch Ness Monster, Atlantis, Tarot cards, astrology and reincarnation. Bylines are given for the articles, but you can bet that some, if not all, are pseudonyms. It is illustrated with photos, drawings, and old woodcuts and etchings from various sources.

The opening article, *Witchcraft*, is by Elijah Hadynn, a self proclaimed warlock. Hadynn is also interviewed in the second issue; this article though, is on the history of the craft of being a witch.

One of the stranger articles in the first issue is *I Received Bobby Kennedy's Last ESP Message* by a "Mrs M." The piece starts with an editor's note:

When Mrs. M. sent her story to us, we had to admit that it was one of the most unusual cases we had ever come across. In addition to describing a moving ESP experience, we felt that her story had an important message for all of us. For that reason we are presenting it exactly as Mrs. M. sent it to us—in her own words, just as it happened!

Apparently Mrs M. went to bed after watching the results of the California Presidential Primary, happy that Senator Kennedy won, but too tired to stay up for his speech, figuring she would catch it on the morning news. While lying in bed, she heard the words "Learn…learn" loud and clear, and sat up immediately. She checked her husband next to her, who was sound asleep, then the children, who were likewise. When she got back into bed, an inexplicable deep sadness overcame her, to the point of tears. Mrs M. received longer messages, such as "This had to happen. But don't cry. But learn…learn from it." She felt paralyzed

and started getting mental pictures of people and scenes, and heard more:

Tell them…they musn't be sad. They must realize that it all had to happen again…like this…so that they all would understand. This killing…this violence…for God's sake—let it stop with me. My child…my unborn child will grow up in a world without this senseless…with peace and understanding.

Mrs M.'s husband woke up and asked her what the matter was; when she told him of the voices, he told her she was having a dream. She was insistent, and her husband told her he would prove to her that nothing had happened to Senator Kennedy by turning on the TV. And, as the set warmed up, and the picture appeared, they heard the reports of the Senator's attempted assassination. Her husband was then a believer in her visions and voices. Mrs M. wonders:

Why had I been the one who had been contacted? Had the bullet, as it moved through his brain, triggered some wavelength of thought that matched mine? Had I perhaps, actually been living the experience simultaneously with the Senator?

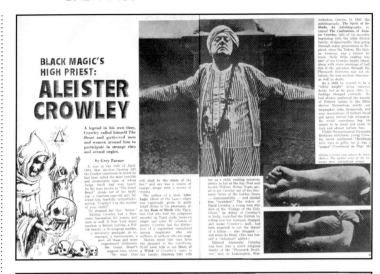

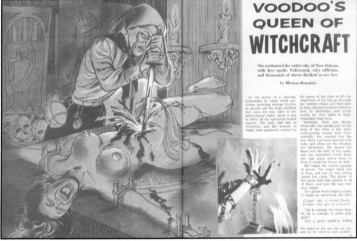

Wondering what she should do about her experience, she figured if she could talk to the Senator to confirm it with him, then people would believe her. Then she heard Kennedy had died from his wounds, which nixed her plan. She writes: "When I learned about **STRANGE UNKNOWN** magazine, I decided that at last the moment had come to tell my story."

Interestingly, inside the cover is an ad for back issues of two magazines from 1968, which it claims are "A Must For Every American." One is **ROBERT FRANCIS KENNEDY MEMORIAL ISSUE** and the other a **MARTIN LUTHER KING MEMO-**

RIAL ISSUE. The former has sixty-eight ad-free pages that focus on "The Kennedy Curse," including the gory pics of Kennedy dying on the floor of the Ambassador Hotel in LA and an unnamed Sirhan Sirhan. M.F. Enterprises published these two mags, but the coupon in the ad was to be sent to Countrywide Publications.

The second issue of **STRANGE UN-KNOWN** is of more interest than the first, and therefore more collectible. It advertises itself as being a "Complete Witchcraft Special" and includes features on Anton LaVey, the Church of Satan, and Aleister Crowley. It uses artwork for the opening pages of some

of the features, which the first issue lacked.

The first article, *The Curse of the Witch-finders*, starts with a painting that looks as if it could have been used on one of Eerie Publications' horror titles, and doesn't seem to have anything to do with the subject matter. The rest of the piece is illustrated with woodcuts and drawings of the torture and murder of witches, along with some photos of thumbscrews, a heating chair, and so on.

Another article *Are You A Witch? How Can You Tell?* starts with a drawing of a rotting witch's head and two photos, one of Maxine Morris (Sanders), "Queen of the Witches," and the other of Hitler reviewing troops, with the caption: "Many believe that Hitler inspired crowds through the use of Black Magical Arts."

In a feature called *Interview with a Warlock*, Elijah Hadynn informs us that he was born in the hills of Kentucky and claims to have been born a warlock. When asked his view on black magic, after a moment of silence, Hadynn says:

> *Magic is magic, and I like to think that the sort that I practice has beneficial effects. When you study the history of witchcraft you find that most of the witches who were tortured and burned alive for supposed pacts with the devil were actually good people. They healed the sick, cured their neighbors of mental ills, and made life easier for them in many ways. The fact that they were able to do these things made many people jealous and the church and government conspired to execute them. Black magic is seldom, if ever, practiced. A true witch unless he or she is crazy, is not an evil person. Of course magic, like any other power in the hands of the wrong person can be used for evil purposes.*

As well as photos of Hadynn, there are woodcuts of witch burnings and a witch being sawn in half.

The LaVey feature, *The Church of Satan*, is a four page pictorial, the only text being the photo captions and opening blurb: "Is the Prince of Darkness seeking converts? Did you know that he has established a church? Perhaps he wants you to join his congregation!" The photos are the basic publicity shots the Church of Satan released to the press, of a Satanic wedding, funeral, rituals, etc., all of which could be found elsewhere.

Black Magic's High Priest: Aleister Crowley by Grey Turner (who also contributed to the first issue), is typical of the articles published on Crowley's life. The problem with Crowley is that his life, work, and personality were so complex and diverse it is impossible to boil it down to an accurate portrayal in a magazine article. There are also several inaccuracies in the piece, such as the date of Crowley's birth, incorrectly given as October 12, 1897 (as opposed to 1875). It also claims that Crowley started the Ordo Templi Orientis (OTO), which he did not.

STRANGE UNKNOWN has the look and feel of many of the books published around that time which are compendiums, or encyclopedias, of witchcraft and the occult, mixing older engravings and woodcuts with photos and newer artwork on the subject. The same formula was used for the later Fass publication, **DRACULA CLASSIC**, in 1976 (see page 461).

From top **OFFICIAL UFO (v2 #5)**
Jul 77 before Goodman started
to edit it; OFFICIAL UFO (v3 #1)
Jan 78 with the cover blurb "UFO
Editor Jeff Goodman Kidnapped
to Squelch Secret Information."
Opposite **OFFICIAL UFO (v3 #8)**
Oct 78 with inset of Buddy Weiss
being manhandled by Myron Fass.

OFFICIAL UFO
Vol 3 No 8 Oct 1978
Countrywide Publications, Inc.,
257 Park Ave South, New York, NY
10010 1.50 68pp

OFFICIAL UFO

❑ Myron Fass appears on the cover of this bizarre issue of **OFFICIAL UFO**, and inside. The cover blurbs are enough to clue you in to the insanity that is **OFFICIAL UFO** under the editorship of Jeff Goodman. They read: "Insensibly Drugged: How Aliens Control Our Youth"; "Beware: Polyester Fabrics Are Driving You Insane"; "Outer Space Aliens Are In Your TV Set"; and "Super Exclusive: Official UFO Goes To War! Protect Yourself Against The Dark Aliens."

In the bottom left of the cover is an inset pic of Myron Fass and "new arrival" Buddy Weiss, with the caption: "Publisher Myron Fass Examines New Arrival." Myron, grinning, is seen grasping the head of Mr Weiss, who is wearing a name tag that reads "Hello! My Name Is Buddy Weiss." Could it get any weirder? Yes it could—and it does. But first a bit of **OFFICIAL UFO** history is in order.

OFFICIAL UFO launched its first issue in May 75, and was filled with "real" UFO stories and articles by known people in the field, with lots of photos. At first edited by Bernard O'Conner, it boasts articles such as *Did Betty and Barney Hill Really Meet Aliens?* and *Does the Physical Evidence Prove UFOs?* It was then edited by Dennis William Hauck—a studious ufologist—and got stranger still but with a serious ufology bent to it with cover stories like *I Lived on a UFO—How it Changed Me* and *Space Probe Lands in New Hampshire*. Eventually Myron physically assisted Hauck out the door in favor of Jeff Goodman, after Hauck had gotten upset with the less serious direction Myron wanted the mag to take. With Goodman taking over the helm at the end of 1977, **OFFICIAL UFO** started its purposefully insane course in earnest.

But, by the time this issue came out, in Oct 78 (the same month as **THE VILLAGE VOICE** article on Myron), the mag was in the midst of full-blown psychosis. Fass, and particularly Goodman and his staff, were having fun with it, squeezing out another issue. Sanity was tossed out the window. This later issue has more artwork than the earlier ones, as there are many full page "Official UFO Bonus Posters" drawn by Gene Day, with a message to "Join the Anti-UFO Army," an attempt by Goodman to mimic WWII posters.

The editorial is as screwy as anything else in the mag. Uncredited (the author could have been Jeff Goodman, editor-in-chief, or Buddy Weiss, editor), it reveals the following:

Unfortunately for us, but enormously fortuitous for mankind as a whole, we've come across an astounding story. The aliens are likely to attack the earth at any time!! This is no hoax. The government, while not wishing to alarm the general public, is apparently taking the alert seriously—seriously enough to draw up and implement a blueprint for defense. We know—we've seen the plans and visited the installations.

After that revelation, it advises that, "Every home should have at least two copies of **OFFICIAL UFO** on hand as the definitive guide to defense and preparation."

The editorial concludes:

Two problems of modern day society that have greatly troubled us (and we're sure you also) are the rampant use of drugs and the oppressing presence of jabbering idiots on our nation's streets. These two reports will keep you informed of the latest developments in these areas.

The one problem with the mag—in a good way—is that everything in it, from the editorial to the articles, and even the ads, are all hilariously insane! Most all the photos—scientists in laboratories, gadgets, people fooling around with technological looking crap, televisions, etc.—were reportedly clipped out of Russian science mags that

Goodman and staff had picked off a foreign magazine rack, saving Myron the cost of paying for any photos, and he loved it.

The captions to the pics are fun too. For example, next to a picture of some anonymous machine the caption reads: "Complicated equipment is being put into operation in order to intercept any alien messages that are being broadcast through the average television set." It almost seems that this mag's purpose was to either push the existing "jabbering idiots" over the edge or add to their population.

The article *OFFICIAL UFO Secret Origins: The Buddy Weiss Story* as told to Kevin Goodman, opens with a photo of Myron and Buddy Weiss. In the background is a painting of a younger Myron Fass as Jesus hanging on the cross. The caption to the photo: "Publisher Myron Fass assures Buddy, 'We model our philosophy after Jesus.' Buddy was so moved by the Publisher's great gestures of kindness that he felt surges of inspiration run right through him."

Another photo of Myron and Buddy, on the opposite page, has the caption, "'I'll treat Buddy like I would my own son,' assures Publisher Myron Fass." Of course Myron's own teenage son, David Fass, was one of the assistant editors.

The article's intro starts: "**OFFICIAL UFO** is more than just a magazine; it is a way of life." It goes on to say that this was the first in a series of staff life stories. Of Buddy Weiss's story it added:

> It dramatically demonstrates how a brave and gallant individual can overcome the most horrible of life's cruelest obstacles and rise to become the Editor of one of the most prestigious publications in our nation today. In a way, it can be called, 'The American Dream Come True.'

The story itself begins with Buddy Weiss showing up at the door of **OFFICIAL UFO**, unable to speak, with a sign pinned to the

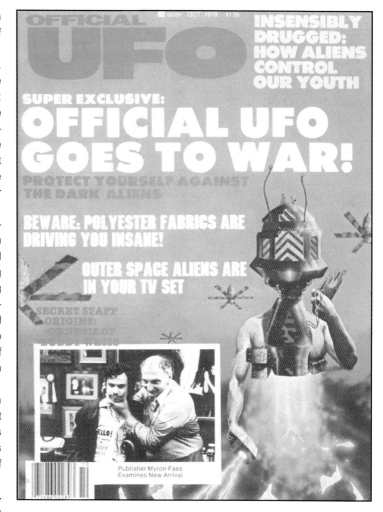

Publisher Myron Fass Examines New Arrival

front of his shirt that read, "Hello, My Name Is Buddy Weiss. I am unable to care for myself. Please see that I am taken to **OFFICIAL UFO** headquarters [the address followed]."

After a short intro on how he was adopted by the staff, Buddy Weiss tells his own story, of being raised in a dungeon-like cell with only hay to sleep on, bread and gruel to eat, and a toy horse with wheels for his only amusement, other than eating bugs and killing rats. He claims to have not known how to speak and knows nothing of the outside world.

One day, as an adult, he was knocked unconscious and dressed, then thrown into the trunk of a car, and let out in knee-deep

snow in NYC, with the aforementioned note attached to him. He wended his way through the canyons of New York City, having encounters with muggers and police in Central Park, finally being brought to "**OFFICIAL UFO** headquarters" by an unknown woman dressed in black.

The staff took him in and taught him how to speak; he then became the editor of the mag! The article is loaded with photos of Buddy Weiss, Myron Fass, Jeff Goodman, Kevin Goodman, and other members of the staff at **OFFICIAL UFO**.

The article *Beware: Jabbering Idiots might actually be Talking to Space Beings* is a prime example of the fun-filled crazi-

From top **The mayor of Chester, Illinois, reading OFFICIAL UFO as depicted on the (v3 #3) Apr 78 cover; Buddy Weiss and Jeff Goodman.** Right **Anti-UFO Army recruiting poster by Gene Day.** Opposite, from left **The staff at Countrywide Publications were featured in OFFICIAL UFO v3 #8 (L-R): Kevin Goodman, Buddy Weiss, unidentified and David Fass; Myron Fass wheeling and dealing, in OFFICIAL UFO ENCYCLOPEDIA v1 #2.**

ness that was **OFFICIAL UFO**. The article's premise is stated in the opening blurb:

Have you ever noticed someone sitting on a train mumbling some sort of incoherent nonsense to themselves? Or perhaps it makes perfect sense, but it's obvious there's no one listening. Maybe not! The latest findings have shown that such people might actually be engaged in conversations with beings from other worlds.

The article quotes people who had suffered from this phenomena, relating their experiences to "investigators from **OFFICIAL UFO**." One woman claimed to have been overheard using strange words like "Ashtar, vernion and zarelle" which, she says, "don't make any sense at all to me." Dr Kurt Seiger, Director of the Institute for Paranormal Research, is consulted throughout the article. In one case Dr Seiger comments: "This communication is in most instances strictly by mental telepathy, but in some cases we have documented the person is actually talking to an *invisible* UFO alien which is physically present!"

Another topic of concern was aliens targeting people who worked in the "highly

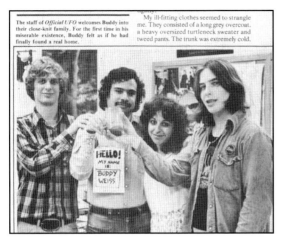

The staff of *Official UFO* welcomes Buddy into their close-knit family. For the first time in his miserable existence, Buddy felt as if he had finally found a real home.

My ill-fitting clothes seemed to strangle me. They consisted of a long grey overcoat, a heavy oversized turtleneck sweater and tweed pants. The trunk was extremely cold.

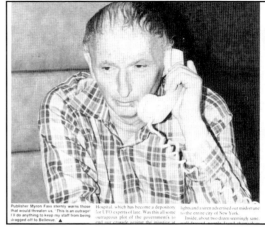

Publisher Myron Fass sternly warns those that would threaten us. "This is an outrage! I'll do anything to keep my staff from being dragged off to Bellevue. ▲

advanced scientific and defense industries." After hearing voices in his head while flying a jet, an Air Force colonel by the name of Dickinson stated:

I suddenly developed an intense interest in UFOs, which isn't too good if one wants a career in the Air Force. Yet I couldn't control myself, and started buying and reading every UFO book and magazine I could find. It was after reading such magazines as **OFFICIAL UFO** *and* **ANCIENT ASTRONAUTS** *that I realized that my problems could be connected in some way with alien mind-control experiments.*

Just as troubling was "evidence that many persons who have been committed to mental hospitals for hearing voices may not be insane but rather merely in the grip of alien forces!" The article quotes Dr Igmar Freunse, of New York's Center for Experimental Psychoanalysis:

I realize now the cure lies in changing the individual's environment. If the individual was hearing voices and talking to himself, it was because the person was engaged in some activity that was of interest to the space aliens. The only cure was to cease whatever activity interests them.

Dr Seiger concludes:

It could be that the aliens might be interested in using you for some sinister purposes—just look at all the people who have killed others throughout history simply because they have heard voices in their heads. If the space beings want to use you for such a purpose, you are helpless to fight back.

The crazy antics of the staff of **OFFICIAL UFO** appear ongoing and are documented throughout, as in the Jan 78 (v3 #1) issue, with stories such as *UFO Editor Jeff Goodman Kidnapped to Squelch Secret Information* and *Saucers Loot and Burn Chester, Illinois: Story Suppressed by Officials* in which the staff report on the destruction of Chester, Illinois, a real town singled out by Goodman by randomly placing his finger on a map of the US. Chester was also the birthplace of Elzie Segar, the creator of "Popeye." The story was subsequently reported on the front page of the Dec 21, 1977 issue of the **WALL STREET JOURNAL** as never having happened, which sent Myron into untold paroxysms of opportunistic joy.

Fass then sent Bob Nesoff, a retired police reporter and friend of his, out to Chester to report back from the town. The follow up, *Illinois City Destroyed*, was reported in the Apr 78 (v3 #3) issue, a cover story that

pictured the Mayor of Chester reading **OFFICIAL UFO**. The Mayor's central photo is surrounded by b&w pics; the claim: "Here are the actual photos of the burning and resurrection of Chester, Illinois, by UFOs. Proved true under computer analysis!" Apparently Nesoff was not well received by some of the populace and flew back to NYC upset by the experience. Nesoff is listed as publisher/editor of some of Fass' later true crime titles like **MURDER SQUAD DETECTIVE** and **THE GODFATHERS**.

OFFICIAL UFO includes ads for back issue magazines; in one ad, the discontinued **GASM** is touted as "Berserk Computers, Naked Wenches, Crazed Robots, Lurid Lust-Crazed Lunatics, Insane Aliens, and much more." Another ad is for **CLONES**, and another for **SPACE WARS**. The detective mags put out by Stories, Layouts and Press, such as **MURDER SQUAD DETECTIVE**, **HOMICIDE DETECTIVE**, **VICE SQUAD DETECTIVE**, **THE GODFATHERS** and **MOBS AND GANGS** (see next chapter), are also advertised, the ads offering a "25%-off student discount," which was Myron's idea! Editor-in-chief Goodman paraphrased Myron on the student discounts as saying: "Those assholes will all say they're students. Let them lie. It will make more people subscribe. They're all fuckin' liars—I hope everyone asks for the goddamn discount."

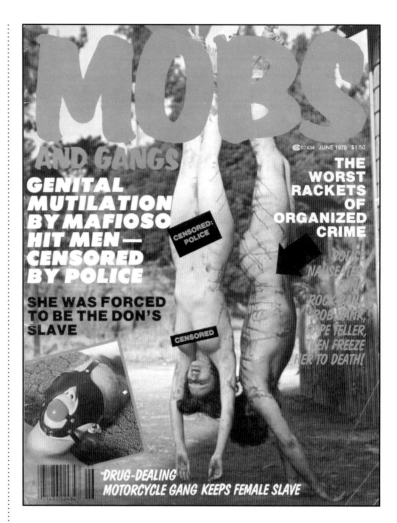

MOST OF THE TABLOIDS that once had the goriest covers, most warped, violent, shocking and disturbing images and stories, had, since the late sixties, "cleaned up their act" and moved into either the sex or gossip business. The exception was *The National News Exploiter* and its second incarnation as *National News Extra,* which kept gore and weirdness in the tabloids until 1973.

The realm of the Hollywood scandal mags was eventually replaced by the tabloid titles. Following the *National Enquirer*'s lead in the late sixties these had stopped the freak and gore shows that had been their bread and butter in order to get into the supermarkets. The scandal and gossip mags had pretty much died out by the late sixties, although some, such as *Whisper, Confidential* and *Uncensored,* hobbled on into the early seventies under new publishers.

A few publishers kept the cheesecake, gore and shock alive by putting out mags filled with bloody, grotesque images from around the world, or tales of good old, home-spun gangsters with girls and

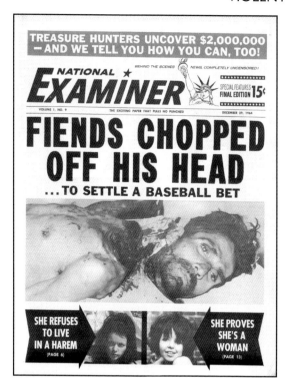

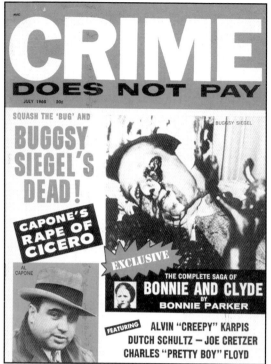

gore. This was the publishing world's equivalent of the *Faces of Death* shockumentary film series. Their covers added some color to the magazine racks in the seventies, even though their insides were printed in b&w on cheap newsprint.

The detective mags, which had their start in the twenties, had a long history of lurid and suggestive covers, but by the late sixties their covers were headed in the direction of bondage porn. Magazines with titles like *Detective World, Weird Detective, Real Detective, Deadline Detective, Strange Detective* and *Confidential Detective* used sensational stills from sixties "roughie" flicks, or posed models trussed in ropes being threatened by maniacs.

In the seventies, publisher Myron Fass started several true crime titles that brought the whole genre to a new, sleazy level. His titles *Mobs and Gangs, The Godfathers, Murder Squad Detective, Homicide Detective, Chief of Detectives, Vice Squad Detective,* and particularly the earlier *True Sex Crimes* and *Confidential Sex Report* were the epitome of sleaze: "Masterpieces on cheap paper" as Fass rightfully admitted.

Previous page **Jeff Goodman claims to have written the insane blurbs and done the layout for this in your face cover of MOBS AND GANGS (v2 #3) Jun 78.**
This page, from left **NATIONAL EXAMINER (v1 #9) Dec 29, 1964, with beheaded loser of a baseball bet. The first crime mag I bought was CRIME DOES NOT PAY (v1 #12) Jul 68, the third issue.**

CRIME DOES NOT PAY

CRIME AND PUNISHMENT

☐ I had just turned thirteen when I discovered the magazine rack that would become my favorite as a teenager, and **CRIME DOES NOT PAY** Jul 68 was the first crime mag I bought (along with **FRONT PAGE DETECTIVE** Jul 68; see Outlaw Bikers chapter in **Bad Mags** Vol. 1). The cover had a gory b&w close-up of Bugsy Siegel's head, dripping with blood, having been shot through his left eye. Although the sensational cover undoubtedly attracted my attention, I bought it for *The Complete Saga of Bonnie and Clyde*: the poem originally sent to newspapers by Bonnie Parker.

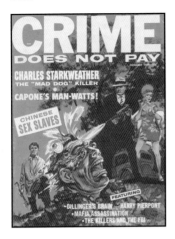

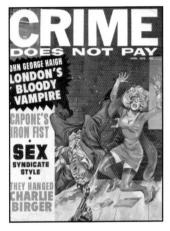

Fatty Arbuckle behind bars, a rare picture done by Lehrman, who was quick to spot his faults. Here while his trial dragged on.

From top **Gory cover of CRIME DOES NOT PAY (v2 #7) Dec 69, reminiscent of Eerie Publications' illustrated horror titles; CRIME DOES NOT PAY (v3 #1) Apr 70.**

Right **Opening spread for Fatty Arbuckle article, CRIME DOES NOT PAY (v1 #10) Jan/Feb 68.**

Opposite **Torture cover and dramatic opening spread, CRIME DOES NOT PAY (v3 #4) Oct 70.**

CRIME DOES NOT PAY
Vol 1 No 10 Jan 1968

CRIME AND PUNISHMENT
M. F. Enterprises Inc., 150 5th Ave., New York, NY 10011 .50 68pp

CRIME DOES NOT PAY, and its sister mag **CRIME AND PUNISHMENT**, took their titles from the 1940s crime comics of the same names, in turn inspired by the titles of 1930s movies. These mags ran articles, mostly uncredited, on a variety of crimes and criminals, more often than not gangsters from the 1920s to 1950s, focusing on the gangster heydays of the twenties and thirties, with the likes of Al Capone, John Dillinger, Bugsy Siegel, Baby Face Nelson, Dutch Schultz, Pretty Boy Floyd, Lucky Luciano, Machine Gun Kelly, Bonnie and Clyde, Ma Barker and her gang, and so on.

These mags also covered crimes from the early 1900s, illustrated with drawings, engravings and old photos, not unlike the old days of the long running **POLICE GAZETTE**. They always managed to include images of scantily clad gun molls, prostitutes, dope addicts, and corpses, or sometimes all of the above. They occasionally ran articles on various psychopaths through the ages, such as Bluebeard, Lizzie Borden, Charles Starkweather, William Heirens, Caryl Chessman, John George Haigh, and John Christie; Fatty Arbuckle even got his own feature.

The credits are interesting in that Myron Fass is not listed, though it was published by his M.F. Enterprises, Inc. Alfred Barton is listed as the publisher, and apparently was "formerly with the C.I.A." Marc Peters was the editor, and there are six names given as "consultants" who are all listed as detectives and investigators. There are also five investigation bureaus credited: National Investigation Service, Rawlsons Detective Bureau, Burton Detective Agency, Eagle Investigation Service, and Alton's Detective Bureau. Both the staff and the investigative bureaus changed slightly with time, but Alfred Barton was listed as the publisher until both titles folded.

The body count for the Jul 68 issue (v1 #12, probably the third issue) is high, with eighteen photos of corpses, some laying in pools of blood where they were murdered, others in morgue photos with bullet holes, autopsy stitches, and toe tags. In fact the whole back cover of this issue is a morgue photo of Ma Barker and her son Fred, laid out on morgue gurneys next to one another, keeping it in the family even in death, with some very ghoulish looking attendants hovering around them. In *The Rogue's Gallery* is a full page head shot of a very much alive "Public Enemy No. 1, Alvin 'Creepy' Karpis," a member of the Ma Barker gang who supposedly taught Charles Manson to play guitar in prison. Manson claims that Karpis only taught him a few tunes.

Both **CRIME DOES NOT PAY** and

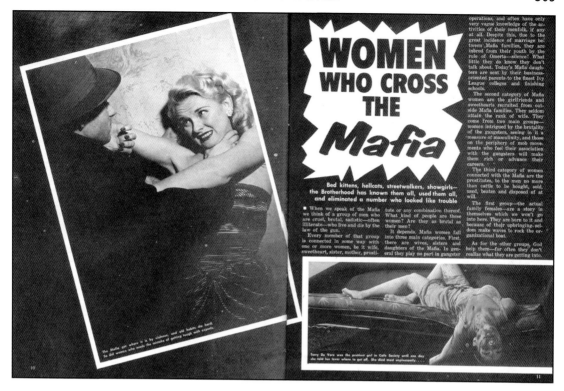

CRIME AND PUNISHMENT seem to have had a policy of one corpse per cover, not usually quite as prominently displayed as the Bugsy Siegel photo (**CDNP** Jul 68), but always there nonetheless. That was until the Sep 69 issue of **CRIME DOES NOT PAY** (v2 #6), which features the first painted cover (**CRIME AND PUNISHMENT** seems to have folded around the same time and never had painted covers), depicting the sadistic torture of a man, bloodied and tied to a chair, as a gangster burns his neck with a blow torch, and a cigar-chomping mobster and laughing gun moll look on. From that issue on, until its demise (v3 #4, Oct 70 is the last issue I've been able to find), the covers are all painted, violent and sadistic, and most seem to be painted by one of the same uncredited artists (possibly Bill Alexander, see **MURDER TALES** below) who was also doing some of the covers for Eerie Publications' horror titles, such as **WEIRD**, **HORROR TALES**, **WITCHES TALES**, **TALES FROM THE TOMB**, etc.

CRIME DOES NOT PAY and CRIME AND PUNISHMENT undoubtedly started with their first issues numbered as v1 #10, not unlike the illustrated horror mags from Eerie Publications. By 1969 M.F. Enterprises had moved to 222 Park Avenue South, from the address above, then later moved again to 257 Park Avenue South, something else they had in common with Eerie Publications.

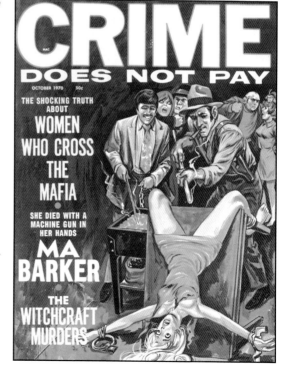

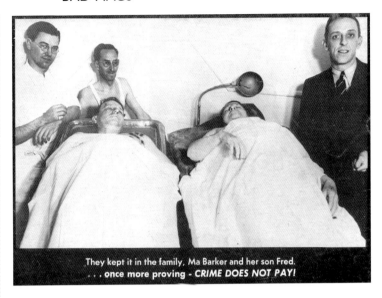

They kept it in the family, Ma Barker and her son Fred.
. . . once more proving - *CRIME DOES NOT PAY!*

Above **TALES OF THE KILLERS (v1 #11) Feb 71.** Right Morgue photo of Ma Barker and her son Fred, surrounded by ghoulish looking morticians, from the back cover of **CRIME DOES NOT PAY (v1 #12) Jul 68.** Opposite **MURDER TALES (v1 #11) Jan 71.**

MURDER TALES
Vol 1 No 10 Nov 1970

TALES OF THE KILLERS
Vol 1 No 10 Dec 1970
World Famous Periodicals, Inc.,
67 Park Ave., New York, NY
10016 .50 52pp

WEIRD DETECTIVE
Apr 1971
Jalart House Inc., PO Box 175
Port Chester, NY 10572 .50 76pp

DEADLINE DETECTIVE
Apr 1971
Jalart House Inc., PO Box 175, Port
Chester, NY 10572 .50 76pp

MURDER TALES

TALES OF THE KILLERS

☐ Both **MURDER TALES** and **TALES OF THE KILLERS** lasted only two issues each, and reprinted the artwork and stories from the original **CRIME DOES NOT PAY** comic book of the 1940s, published by Comic House and later by Lev Gleason. **CRIME DOES NOT PAY** #22, Jun 42, is credited as being the first crime comic book (#21 being **Silver Streak Comics**).

The inside front cover of **MURDER TALES** (v1 #10, the first issue) is a reprinted page by Frank Frazetta, an anti-dope message "Prepared through the cooperation of New York City Youth Board," called "We Can Stop the Enemies of Youth."

The inside, badly reproduced from color comic book pages in b&w and on cheap newsprint, are at best shaky, and in some cases downright muddy. At least one story in each issue is an illustrated tale of a famous gangster, such as Alvin "Creepy" Karpis, John Dillinger and Dutch Schultz.

I've included these two titles here mainly because of the cover artist, who is listed on the contents page as being Bill Alexander on all four mags. Whoever painted these

covers appears to be the same artist who painted some of the even more sadistic covers of the above mentioned later issues of **CRIME DOES NOT PAY** magazine—and who did some of the gore-fest covers for Eerie Publications' horror titles!

WEIRD DETECTIVE

☐ Jalart House published strangely titled detective and true crime mags which were mostly antiquated looking reprinted articles from earlier detective mags. In the indicia for this issue of **WEIRD DETECTIVE** it says: "Please note that portions of this issue have been reprinted from past issues of **STRANGE DETECTIVE**." Other Jalart House titles included **WOMEN IN CRIME**, **DEADLINE DETECTIVE** (see below), **STRANGE MURDER STORIES**, **TRUE MYSTERY DETECTIVE**, **BEST TRUE FACT DETECTIVE**, and so on, published in the sixties and seventies. The photo content of these mags is not gory: in fact there is an absence of real or even faked corpses. They did, however, include crime scene photos and mugshots.

The cover of this **WEIRD DETECTIVE** is interesting in that the picture used is

from a sixties sexploitation movie, with a bearded Titus Moody and his usual cohort in film crime, Hondo Rio, loading a woman's bloody body into a tub; the still has also been used on the covers of **OFFICIAL POLICE DETECTIVE**'s Oct 73 and **NIGHT AND DAY** (v3 #10) Aug 67 (see page 22).

Photos from the same flick can be found in **JAGUAR** (v3 #4) Mar 68 from Jaguar Publications, yet another publishing company of Myron Fass'. In a feature called *Nu-Art in the Cinema*, where the movie is **Girls who Work at Night**, the text relates the scenario as follows:

It is about a poor young girl who has to work nights in a shipping room. On one particular night two second-story men break into the office and rob the safe. On the way out they notice her and decide to torture and rape her. It is a shocking and hard-to-take film, but at the same time it holds interest. This is because of the fine work that the director and the actors do. It, as was expected, cannot be shown in this country. Directors felt it should be made, anyway.

These publications were obviously not looking for the approval of feminists. Other stills from 1960s sexploitation movies used as covers include **WOMEN IN CRIME** Oct 70 which incorporates a still from the popular Nazi sleaze flick, **Love Camp 7** (1968). It is a side view of a woman dressed in garter, panties and nylons, pointing a handgun. States the blurb: "The Queer Lady in Room 66." The Nov 70 issue of a mag called **STRANGE DETECTIVE** also features a still from **Love Camp 7** on its cover.

The two cover blurbs on this issue of **WEIRD DETECTIVE**—"Bizarre Sex Crimes" and "Witchcraft! Mystery!"—help round out the bizarre quality, including the articles such as *Bride of the Brute!*—"Why do women become attracted to ugly men? This gorilla-man had plenty of women…and

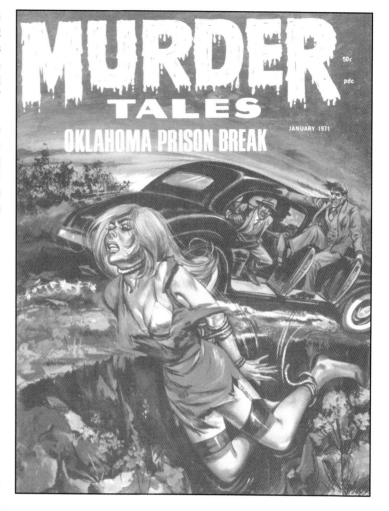

did some pretty ugly things to them!"

There are two interesting ads in the back; amongst others, one for a "Life-Size Inflatable Loveable Doll For Playful Adults 37"-23"-36"." The three pictures in the ad are bizarre because they depict a guy posing with a *real* woman. Two smaller pics at the bottom had the captions: "For cocktails…For company…" There is even a doll called "Susan (Negro Doll)" advertised as an alternative to "Judy," the white doll!

The other ad, of trivial note, is a Joe Weider body building ad starring a young Arnold Schwarzenegger hefting a bikini clad babe in one arm, while flexing the other. No girlie men in sight.

DEADLINE DETECTIVE

☐ Another Jalart House detective mag that reprinted articles from **BEST TRUE FACT DETECTIVE** is **DEADLINE DETECTIVE**, again included here for its bizarre cover photo from a sixties sexploitation film. It has a strange quality to it, because the pale wrist-bound woman, with chains around her neck, is totally nude, being beaten by a fully clad man on the lawn of a house in broad daylight! The cover blurb offers: "Variety In Sex Was the Spice of Death!" Another photo from the same flick, with the same actor, was later used on the cover of the Canadian published **DETECTIVE WORLD** Oct 75.

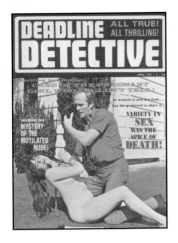

From top **DEADLINE DETECTIVE** Apr 71 with a sexploitation still on its cover. *Right* **Titus Moody** and Hondo Rio on the cover of **WEIRD DETECTIVE** Apr 71 (an image later used on the cover of **OFFICIAL POLICE DETECTIVE** Oct 73). *Opposite, from left* **TRUE CRIME DETECTIVE** Jul 74, and splash page from that same issue.

TRUE CRIME DETECTIVE
Jul 1974
Jalart House, Inc., PO Box 642, Scottsdale, AZ 85252 .60 68pp

TRUE SEX CRIMES
(Vol 1 No 1) May 1975 —Vol 1 No 2 Jul 1975
Tempest Publications, Inc., 257 Park Avenue South, New York, NY 10010 & National Mirror, Inc., 257 Park Avenue South, New York, NY 10010 1.00 68pp

Other photos from the same film can be found in **MIX MATES** and **WHIPPET** #1, both from 1968 (see pages 85 and 87).

All the articles reprinted in **DEADLINE DETECTIVE** look to be from the fifties, or early sixties, and are rather ho-hum, with titles like *The Mystery of the Mutilated Nude* and *God and I are Tired of Men who Take Advantage of Women*.

The ads in the back are actually of more interest: everything from fishing lures to burial insurance could be purchased. Ads of an increasingly sexual nature show up inbetween the usual body building and technical school ads. There is also a page of ads for mail order brides and lonely hearts clubs, rather disconcerting given the cover of this mag.

TRUE CRIME DETECTIVE

☐ **TRUE CRIME DETECTIVE** is a later Jalart House detective mag, this time published in Arizona. The cover adds the info, "Every Story New! Every Story True!" It is visibly different from the earlier Jalart House titles above, as this one has posed pics of bound and gagged women inside.

Another added feature is *Legal Laffs*, "A

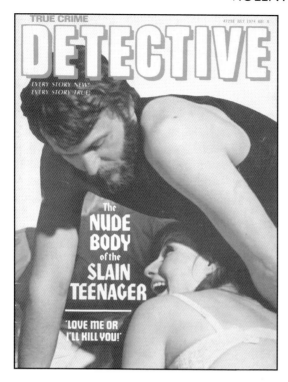

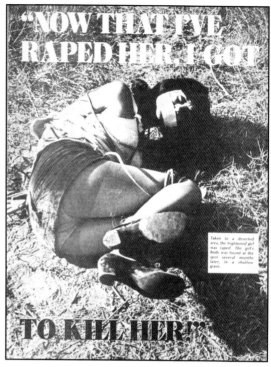

Review Of The Past Month's Screwball Robberies, And Other Odd Happenings From The Police Blotters!" This is one long litany of strange robberies from around the world. Things reported stolen range from a pipe grabbed from a passing motorist's mouth by a pedestrian, a 1,000 brick sidewalk, 544 bushels of beans from a sixteen acre crop, a rack of coin operated bubblegum and toy machines, and a staircase. It also tells tales of crooks with a conscience, who returned money, gave back sets of keys from stolen pocketbooks, and were polite in the commission of burglary.

There are also the typical articles on murder, rape, and mayhem, like *Did a Goblin get 'Miss Valentine?', The Nude Body of the Slain Teenager, Now that I've Raped her–I got to Kill her, Love Me or I'll Kill You, Was it a Colorado 'Thrill Killing?'*, and more.

There is even a *Crime Anagram* with the last names of twelve of "The World's Master Criminals" scrambled for your solving pleasure:

Can I, Lou?
I'm no dad
Leo's colt
Al cut Herb
One cap
Her tot's in
I spark
Thump, Anna!
I lend, girl
Old pole
Demand
Eve's gone

The ads are a pot pourri of everything from fishing lures to rubber sex dolls—with porn, karate, muscles, mail order brides, jewelry, burial insurance, vibrators, spy-eyes, sex club directories, fake badges, hair and scalp treatments, and lazy men's ways to riches featured.

TRUE SEX CRIMES

☐ Although the editor of **TRUE SEX CRIMES** was John Thomas Church—an old timer who wrote some of the Fass magazines—this was another Fass production even though he is not mentioned in the credits. Mel Lenny is listed as "Advertising Manager," as per usual, and Irving Fass as the "Executive Director." Jeff Goodman has described Myron's brother Irving as:

> [looking] sort of like a disheveled Orthodox Jew, with a really big nose and a horrible wig. The wig was always greasy and never on completely straight, and he was forever adjusting it. He was a weird sort of guy, in some ways crazier than Myron.

It is interesting to note that sleaze fests like **TRUE SEX CRIMES** or **CONFIDENTIAL SEX REPORT** (see Manson chapter) give the publishing company as National Mirror,

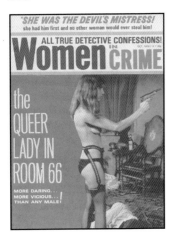

'SHE WAS THE DEVIL'S MISTRESS!
she had him first and no other woman would ever steal him!

ALL TRUE DETECTIVE CONFESSIONS!

Women CRIME

the QUEER LADY IN ROOM 66

MORE DARING...
MORE VICIOUS...!
THAN ANY MALE!

Above **WOMEN IN CRIME Oct 70 with a still from** *Love Camp 7* **on its cover.** Opposite, from top **Another quintessential bad mag was TRUE SEX CRIMES published by National Mirror, Inc. in 1975. This is the cover and opening spread for an article in the second issue.**

Inc.: the title of Fass' sleaze tabloid between 1965–73, where again there was no mention of Myron Fass in the credits, the publisher being listed as "Bryant Hall," a popular Fass pseudonym.

The unnumbered first issue of **TRUE SEX CRIMES AROUND THE WORLD** (May 75) has a cover that is a montage of three crime scene photos with the blaring blurbs: "Angel of Mercy and the Sex Starved Madmen–They Loved Her to Death," "Retarded Son Made Own Mom Pregnant–Then Helped Her Kill 'Sin Babies,'" "The Blonde Torture Queen's Kiss of Death," and "The Man Who Loved Prostitutes...Dead." Other sordid articles to be found inside are: *Pimps Tortured and Burned Vico King to Death, One-Eyed Pervert couldn't keep his Hands off Little Boys, Lesbian Love behind the Walls of Women's Prisons, Rapist Shot to Death by Fathers of Girls he Attacked,* and *Lesbian Couple Posed as Prostitutes to Lure 17-Year-Old Boy to his Death.* The mag is illustrated with graphic photos of corpses at crime scenes, criminals and their victims, and anonymous girlie pics. Some of the photos show both male and female nudity with pubic hair and genitals uncensored, an uncommon thing for a non-girlie mag at the time, and made all the sleazier by being printed on cheap newsprint that almost seems to yellow in your hands. The back of the issue has sleazy one-inch ads for 8mm movies of Linda Lovelace, hardcore stills, sex aids, pellet guns, love dolls, and an ad for three of Fass' girlie titles, **STUD**, **DUKE** and **JAGUAR**. The inside back cover is a full page photo of Patty Hearst as "Tania" in the infamous pic where she clutches a gun, wearing a beret, against the background of the SLA's seven-headed cobra symbol. The text across the top of the photo reads: "Wanted By The FBI—Patty Hearst."

The second issue of **TRUE SEX CRIMES**, Jul 75, was published by National Mirror, Inc and dropped the "Around the World" subtitle. Not unlike **THE GODFATHERS** mag below, the address is listed as

Englewood Cliffs, NJ, and, again, the credits do not list Fass. What this means to me is that Fass did not want his name associated with these mags, for obvious reasons.

As with his line of illustrated horror mags from Eerie Publications, Fass—or someone working for him—was a master of using keywords to give an overall horrific and sleazy flavor to the covers of his mags. On the cover of **TRUE SEX CRIMES** alone there are the words: Naked, Stripper, Hanged, Raping, Satan, Exorcism, Orgy, Sex, Blood, and Murder, enough to hook any budding young psychopath for sure. Titles like this from Fass and crew may well have been the inspiration for the later **VIOLENT WORLD** mags listed below, even though **VIOLENT WORLD** was more serious about its content.

Inbetween ads for a life size "4 Way Party Doll," "Undie-Exposures" from Lili St. Cyr, and "The Electronic 'Everything' Doll," the contents page reveals the twisted concerns of this mag, listing articles on necrophilia, incest, murder, rape, suicide, torture, and other things that go squish in the night.

All the uncredited features in the mag are heavily illustrated with a combination of crime scene photos, mugshots, photos of victims before and after death, softcore pics lifted from porn and girlie mags and a few painted illustrations. Which all adds up to heavy-duty weirdness when mixed together into the grisly stew that is **TRUE SEX CRIMES**.

Although the contents of this mag wouldn't cause much of a stir these days, in 1975 you didn't see this level of gore and sex together often, especially on the newsstands, since the tabloids largely stopped running it in 1967 or so, with a few exceptions.

The following excerpt of the opening feature, *39 Stab Wounds was all the Redheaded Stripper Wore*, provides a good taster of the mag. The sordid tale of the murder of a Munich stripper begins:

When Burlie queen Jetta Bachman was on the stage gyrating to the pulsating sound of the music, and slowly peeling down her G-string, she was a sight to behold. Her mammoth breasts were enough to pop the eyes of all the near-sighted senior citizens crammed into baldheaded row, and her voluptuous body, covered with a thin film of perspiration was enough to turn an impotent bishop into a sex maniac...
That was while she was alive. Dead, Jetta Bachman was just another grisly corpse, her once lovely face blackened by the scarf that was tightly knotted about her neck. Her eyes bulged from her head, and her mouth was twisted grotesquely in what might have been a last desperate plea for mercy.
The body that had once teased and aroused countless men was sprawled on a blood-soaked sofa, its soft flesh punctured and pitted with deep knife wounds. After strangling the stripper, the vicious killer had apparently gone berserk, slashing at the naked body of his victim, and plunging his knife into her at least thirty-nine times. One of her breasts was almost severed from her body in the frenzied attack."

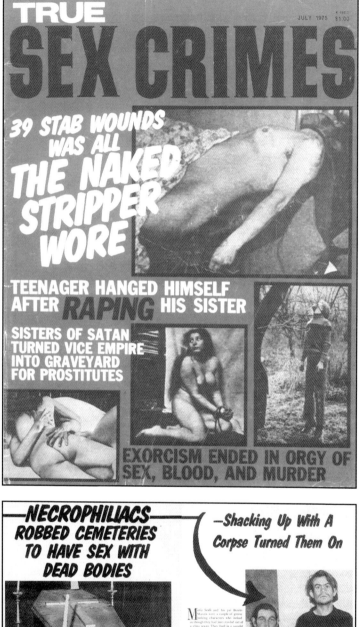

As the story unfolds, the medical examiner reported that the "well stacked peeler" was murdered by two men, not one, ruling out a jealous lover. The detectives discovered that Bachman had worked in a massage parlor and performed live sex acts in a private club before becoming a stripper, on her way to her ultimate goal of porn star.

The police finally got a tip that led them to two pimps who had been hassling Jetta to join their stable of young hookers; she told them to get lost and had them tossed out of the club. The pimps were identified as Clevon Williams and Clarence Trainor, "two black former American soldiers booted out of the army with bad conduct discharges." It said of the two that they were, "hard cases

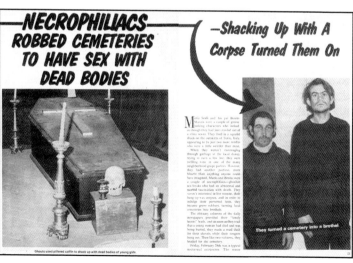

Above and Opposite **A tough cookie smoking in bra, panties, garters and packing heat from UNDERGROUND DETECTIVE May 76; An ice pick in her breast—the cover of that same issue.**

UNDERGROUND
DETECTIVE
May 1976
G. C. London Publishing Corp.,
PO Box 58, Rockville Center, NY
11571 .60 68pp

who lived by their wits shaking down store owners, blackmailing homos, and forcing young girls to hustle."

The two pimps admitted knowing Bachman, but not her murder. The case against them was weak until one of their young hookers, Ute Koch, came forward with damning info.

Koch stated that the two had bragged about "'offing' a white bitch who thought she was too good for them." She knew that the two were vicious as evidenced by another incident she related to the police, when the pimps had picked up a "drunken housewife" and brought her back to their apartment to rape her. They had found some sauerkraut in her shopping bag that they shoved in her vagina as she pleaded with them. The woman's cries awoke Koch who went to see what was going on, but after she saw the two stuffing the woman with pickled cabbage, she kept silent to keep them from doing the same to her.

Koch related another story of Williams and Trainor picking up a "fairy" and what they did to him, which helped her believe that they had murdered the stripper.

Eventually the two pimps fingered each other as the killer in attempts to save themselves from murder charges. The article gave both their versions of the horrifying rape, murder and mutilation of Jetta Bachman. Williams and Trainor had both raped her and stabbed her. One then strangled Bachman with her scarf, while the other got his kicks from her death struggle while raping her.

The article claims that the two pimp/rapist/murderers, "operating on the fringes of the Munich underworld," were awaiting trial at the time the article was written.

The writer tries to give the story a moral by stating at the end: "[Bachman's] torrid bumps and grinds had ended in a macabre struggle for life as the breath was choked out of her body, and the sensuous music of the burlie stage had become a dirge of death."

A two page spread called *The Price of*

Murder around the World contains pictures of a beheading in Yemen, Ugandans being clubbed to death, and Mexican desperados hung from a tree. Other articles include: *Sisters of Satan Charged with 127 Murders*, *Color the Sexy Art Teacher Dead*, *Necrophiliacs Robbed Cemeteries to have Sex with Dead Bodies*, *Teenager Hanged himself after Raping his Sister*, *Husband and Wife both 'Raped' by AC-DC Pervert*, *Exorcism ended in Orgy of Sex, Blood and Murder*.

UNDERGROUND DETECTIVE

❑ This oddly titled mag doesn't have much in the way of gore content, but I have always thought the title and cover strange. The cover photo of a 'dead' girl, lying on a fur, limply holding a phone in one hand, with an ice pick protruding from her breast, blood running down her side, is shocking by itself, but the thing that makes it even stranger is the lit candle in the foreground, which is out of focus. It somehow makes for a visually confusing cover. It is hard to tell which of the three cover blurbs the photo is supposed to pertain to, if any: "Snare for the Knife Slayer," "'I Was Sex Bait For Truck Looters,'" or "Don't Fool With Fate." A different angled, less confusing photo from the same shoot was used on an earlier cover of **REAL DETECTIVE** from Mar 74.

There is no volume or number on **UNDERGROUND DETECTIVE** and I suspect it might have been a one-shot. There is no editorial, or clue as to why the word "underground" has been chosen for the title. Ah, but the indicia does state: "Portions of this magazine have been reprinted from past issues." This did not negate its possible one-shot status of course, as the "past issues" were probably other detective titles all mixed together, as in the Jalart House mags mentioned above.

Another thing that sets **UNDERGROUND DETECTIVE** apart from a lot of the other detective mags at the time is that

it uses posed pics, or film stills, of scantily clad women as well as the usual crime scene photos and mugshots. And, a sure sign of a truly sleazy detective mag, is that it carries ads for porn in the back! There are two full page ads for sex dolls, one of which is called the "Electronic 4 Way Action Lolita Teenage Play Girl" as well as little ads for hardcore 8mm films, X-ray specs, pellet guns, and a full page ad for **The Adventures of Sweet Gwendoline** by John Willie.

The articles have titles such as *Cold Java and Hot Bullets*, *Fleeing Madman's Trail of Blood*, *Rape and Murder*, *The Nympho Doctor who Bought a Bordello*, and so on.

The one article of interest is *I was Sex Bait for Truck Looters*, which starts with a pic of a woman lying on a bed, in bra and panties, looking into the camera, with the caption: "Hitching rides proved duck soup. But it was the truckers who paid the big price at the showdown." The blurb under the title is even more fun, with its intended or unintended double entendre: "Girls who hitch rides can expect men to make passes. I was counting on it to hijack their load." The article is the only one in the mag without a byline and supposedly written by a woman who ran away from home at sixteen and learned early on, from being raped, that by hitchhiking rides with truckers and other men, she had to dispense sexual favors to get from one town to the next. Because it gave her a sense of freedom, she said, "If that was the price of travel, I was prepared to pay it." She worked as a waitress in "hash houses" to keep herself fed and clothed, until she had a problem or got bored and would move on via the truckers passing through. She makes the observation:

> It's surprising, but the same trucker who'll step on the gas and roll away when he's faced with a hitch-hiker on the open highway, will never even raise an eyebrow if a girl requests a lift. I suppose that having met her, talked to

her and joked with her, he feels that he knows her. And the thought of getting a little free sex from a girl he's picked up, helps his ego.

She hooked up with Big Will Forester after three years of moving around, as he had a wad of money he flashed around, and made no bones about what he wanted from her. She was a game gal, so when Big Will came up with the scheme of hijacking loaded trucks, using her as "sex bait," she didn't have to think twice. After six months of looting trucks successfully, she, Big Will and crew figured they could retire after a few

more heists—as she points out, a few too many. The cops got wise and set a trap, the truck looting ring was stopped, Big Will was put away for a long time and she felt lucky she only received ten years, six with good behavior, supposedly writing the article from prison. The article is interesting as it uses a lot of trucker/hooker lingo that makes for a fun read. Its quirk is the third and last photo in the story, of a woman who looks to be from the 1940s, and seems to have nothing to do with either the first two photos or the story itself!

From top **Son of Sam in CRIME May 76; BRUT (v1 #10) Apr 76 was a Fass publication that used kink photos from other Fass mags. It later became BRUTE.** Opposite **CRIME (v3 #2) May 77 with Vito Genovese and a corpse.**

CRIME
Countrywide Publications Inc., 257 Park Avenue South, New York, NY 10010 1.25 68pp

BRUT
Vol 1 No 10 Apr 1976
Tempest Publications, Inc., 257, Park Avenue South, New York, NY 10010 2.00 92pp

CRIME

❑ In the mid seventies some of the exact layouts from the magazines **CRIME DOES NOT PAY** and **CRIME AND PUNISHMENT** surface in **CRIME**. At first **CRIME** was published by Countrywide Publications from 257 Park Avenue South. The covers are montages of old gangster photos, but they still have the same feel as the early **CRIME DOES NOT PAY**, with the added element of porn ads this time around.

Al Capone is popular as subject matter; out of the five issues I've seen, Capone is on the cover of four of them, as well as having features inside.

CRIME Jan 75 (v2 #1), "Collector's Edition," features Clyde Barrow, John Dillinger and Al Capone on its cover.

In the Feb 76 (again v2 #1) issue they have added a "told for the first time" article on Capone's sex life in prison.

The cover of the May 77 (v3 #2) issue has Al Capone and pal Elliot Ness, along with Vito Genovese and a bloody corpse. Bizarrely, the back cover has an ad for women's "Natural Look Capless Stretch Wigs!"

CRIME Nov 77 issue (v3 #4) was published by Harris Publications Inc., from 10 East 40th Street, NYC. The inside front cover has an ad for an inflatable sex doll.

CRIME May 78 issue (v4 #2) was published by Harris Publications, but from 79 Madison Avenue, and they threw a new element into the mix by putting the recently arrested David Berkowitz, aka Son of Sam, on the cover, and inside an uncredited eleven page feature on the case. On page five of the same issue, opposite the contents, is a full page of one-inch porn ads advertising such things as: "Authentic Stag Movies Showing Actual Screwing," "Hooker's Handbook," "Deviant Sex Movies of Nasty Women," "Swinging Texas Girls," "8 Inch Rubber Dildo As Our Get Acquainted Gift", etc.

CRIME continued into the early eighties; the last issue I know of is Aug 81.

BRUT

❑ **BRUT** was a Bryant Hall (read: Fass) published, kinky S&M girlie title. It was published in that relatively short window of time in the late seventies when it was alright to show nipples on the front covers of newsstand girlie mags in the US. **BRUT** is typically filled with offbeat fetish artwork, X-rated film reviews, sometimes of 8mm loops, tid-bits of strange info related to the world of fetish, S&M, B&D, and anything else with any kink value.

This issue features sexual drawings by the talented Rene Moncada Perez, gory stills from sexploitation films, and an article on Barney Steel, the underground comix artist who had done three issues of **ARMAGEDDON**, a future-sex-fantasy comic. And the issue is filled with Ilsa.

The first of the three—yes, three—articles concerning **Ilsa, She-Wolf of the SS** is in the "Bruiting Section" which is called *Ilsa Fascinates, Horrifies*. In it, the writer starts with concern that **Ilsa** might give S&M a bad name with its extreme torture scenes, not what many S&M "devotees" engaged in. But it then goes on to say: "On the other hand, many S&M devotees will adore the film, as it was evidently made by someone who was highly aware of some of our dearest fantasies." Accounts of some of the scenes in the film relating to various kinky fantasies are given. One underlying theme in the movie is Ilsa's theory that women, "properly trained," could endure more pain than men. To prove her theory Ilsa utilizes Anna, a defiant "pain queen," who is eventually reduced to a bloody mess. The reviewer admits that the characters are one dimensional because the film is "more a gallery of assorted tortures than a story with a central theme." The section also reviews underground comix with sexual themes, the book **Do-It-Yourself Sado-Masochism** by James Hartwell, the movie **Swept Away**, and so on.

Sex & Fascism in America, the second **Ilsa** article, by Peter Wolff, is labeled a

"review/analysis" of the sexploitation/gore classic **Ilsa, She-Wolf of the SS** in which Wolff analyzes the movie's effects on different sexual personality types. The first page of the article is taken up by an uncensored version of the shocking color still used on the Jun 78 issue of **MOBS AND GANGS** (see page 522). Wolff starts out by saying that: "the seductiveness of the concentration camp experience…represents a fantasy of such powerful efficacy that it titillates even those who might be appalled by it." But then asks the question:

Why now, some 30 years after the holocaust, have we welcomed back the most awful moment in our history as the scenario of a sexploitation movie, as a source of revelation and amusement, as a spur to our own vicious pent-up sadisms, and as another hallowed moment in our experience that can be easily merchandized?

Wolff proceeds to partially answer his own question by saying that the interest in **Ilsa** is a "harbinger of a new era in sexual politics" and, "A groundswell of backlash against the egalitarianism of women's lib and a reaction against the behavioristically salubrious aspects of the sexual revolution in general." Ultimately Wolff thinks **Ilsa** "an important work of art and fancy" that should not be censored or ignored.

Along with the above article is the third **Ilsa** related article, *Dyanne Thorne: Metaphysician–Turned–Torturess*, in which "New Zealand-raised metaphysician-comedienne" Thorne's "monumental anatomical presence" in the flick is given as the reason for its limited success. Apparently when Thorne was first given the script for **Ilsa**, she declined the part and her Jewish actor husband, Howard Cain, threw the script across a room. Obviously, Thorne thought better of the part and reconsidered, and her husband would co-star with her in the second **Ilsa** movie. Quotes from an interview

with Thorne are included in the last part of the piece, in which she relates there was a technical director on the set "who seemed to be an expert on torture." In a moment of understatement, Thorne says: "In many ways it's ironic that two people—like my husband and myself—living their lives in a world of comedy and metaphysics, trying to better humanity—end up in one of the most controversial films of our time."

Other features of interest in the issue are: *The Art (???) of Stan Grossman*, a well known bondage photographer referred to in the short article as "the Rembrandt of Rope;" *Cuntbanquet: The Visual Metaphors of Gerard Damiano*, including many stills and

covering Damiano's latest flick, **The Story of Joanna**; and *Fucky–Sucky on the Boob Tube*, an article reprinted from **The Village Voice** in which porn star Carol Conners (**Deep Throat**) is interviewed by Al Goldstein on **Midnight Blue,** the X-rated public access late show in Manhattan.

BRUT's later issues are "pick-ups," i.e. reprinted features from earlier issues and other Fass published sex mags. There were fourteen or more issues in the first volume; by v2 #1 (Feb 77) it was retitled **THE NEW BRUTE** with the added "e" to distinguish from previous issues.

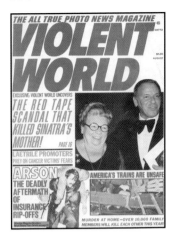

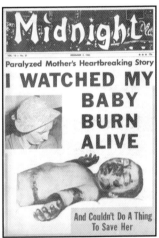

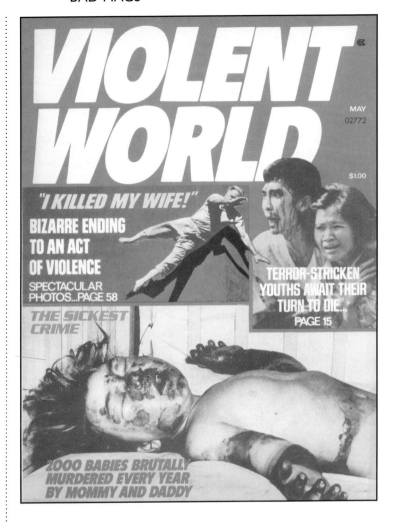

VIOLENT WORLD
Vol 1 No 1 May 1977
Violent World, Inc., 208 43rd St., New
York, NY 10017 1.00 84pp

VIOLENT WORLD

□ **VIOLENT WORLD** is the epitome of the gore shocker mags that hit the stands in the mid seventies. It starts on a shocking note with the first issue's cover sporting a b&w photo of the bruised and bloodied corpse of a child, with the caption, "The Sickest Crime—2000 Babies Brutally Murdered Every Year By Mommy And Daddy." It is one of the more disturbing magazine covers presented here, rivaled only by the color cover of **MOBS AND GANGS**, Jun 78 issue, below. In fact the picture of the battered, or burned, child on the cover was originally used fourteen years earlier.

It appeared on the cover of the Canadian tabloid **MIDNIGHT** v10 #21, Dec 2, 1963, with the background deleted, the child's hair cropped short and the headline: "I Watched My Baby Burn Alive!" **MIDNIGHT** did on occasion swipe pics directly from the pages of the **NATIONAL ENQUIRER**, and this could very well be the case here. The photo looks as if it could be a victim of the atomic bombing of Hiroshima or Nagasaki.

HUSTLER magazine, in their infamous Aug 77 issue, which boldly proclaims on its cover: "First Time Ever Scratch 'N' Sniff Centerfold," contains a short item called *Overkill*, **HUSTLER**'s take on new mag **VIOLENT WORLD**. With **VIOLENT WORLD**'s

first issue pictured, the article claims that **HUSTLER** only ran photos depicting violence as satire or as social commentary and were therefore "upset" when **VIOLENT WORLD** hit the stands! But being the First Amendment advocate that it was, **HUSTLER** didn't think **VIOLENT WORLD** should be taken off the stands. Instead the article points out that publisher Jules J. Warshaw made a profit from a "meaningless display of violence" available to children. The writer points out the irony of **HUSTLER** publisher Larry Flynt having been indicted for printing Vietnam War atrocity photos in his beaver mag and sending them through the mail—it was deemed harmful to minors—but Warshaw and his **VIOLENT WORLD** had ducked under the radar because there were no girlie photos in it. Not mentioned is that the editor of **VIOLENT WORLD**, Jesse James Leaf, was also editor of **GENESIS** magazine at the time.

All issues of **VIOLENT WORLD** were printed on newsprint with b&w photos, but colored ink was used for some titles, blurbs, word boxes, backgrounds, etc. It was filled with news items and photos from around the world and always started with a section called *'Our' Violent World*, with up to five items per page, and photos.

VIOLENT WORLD only lasted five issues, but they were five jam-packed issues indeed! It did not consist of fictional articles made up in the minds of the writers like some of the tabloids; on the contrary, they were rather well researched.

One of the stringers who wrote articles for **VIOLENT WORLD** was ufologist Timothy Green Beckley, a long time contributing writer and editor to such mags and tabloids as **FATE, BEYOND, SAGA, FRONT PAGE DISASTERS, ADULT CINEMA REVIEW** (editor for three years), **HUSTLER** (movie review critic), **SLUTS & SLOBS, BEAVER, THE NATIONAL TATTLER, GLOBE, UNSOLVED UFO SIGHTINGS, CONSPIRACIES AND COVERUPS, UFO REVIEW** (publisher), and myriad others that

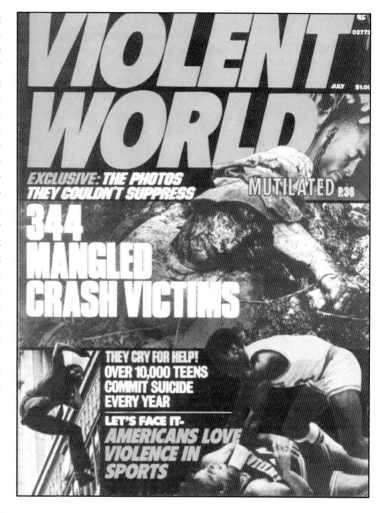

include many of Myron Fass' Countrywide Publications. Beckley's book, **Men in Black**, was advertised in the Fass mag **ANCIENT ASTRONAUTS**; in fact, Beckley met Jeff Goodman the first week Goodman worked for Countrywide Publications. Goodman was one of Myron's later editors who upped the insanity ante on countless mags.

Beckley started out his offbeat odyssey at the early age of fourteen when he purchased a mimeograph machine and published a UFO newsletter called **Interplanetary News Service Report**. Since then he has authored many a book on UFOs and the occult sciences, as well as articles for magazines and tabloids. As "Mr.

Creepo," Beckley also occasionally does films and videos, such as **Skin Eating Jungle Vampires, Sandy Hook Lingerie Party Massacre, Barely Legal Lesbian Vampires**, and is responsible for the porn spoof of Michael Jackson's **Thriller, Driller**, featuring a horny werewolf.

VIOLENT WORLD's first issue (May 77) has features on: *America's Baby Massacre*, infanticide in the USA; *Butcher* on Adi Amin; *The Cruel Blade*, a history of the guillotine; *Gary Gilmore wanted to Live*, the untold story; *I Ate Human Flesh*, on cannibals and hippie cannibals; *The Manson Curse* (see below); *Chinatown's 'Yellow Hand' Gangs*, deadlier than the Tongs; *Killer Packs*, stray

dogs banding together, and lots more. All in all, the eighty-four pages of the mag are packed, from its brutal cover to the last page, with thirty articles, sensational gory pics, and no advertising.

The Manson Curse—Securely Locked Behind Bars, His Evil Genius Still Controls the Minds of His Murderous Cult is an un-credited two page piece on the unsolved deaths of Laurence Merrick, producer of the documentary movie **Manson**, and Ronald Hughes, defense attorney for Leslie Van Houten. The caption under a photo of Manson (the **LIFE** cover shot) describes him as "the cruel guru of death." The other pics are of Merrick, Hughes, Van Houten, Squeaky Fromme and a police sketch of the gunman who shot Merrick.

The piece starts with Manson's courtroom threat, "You are next, all of you!" It then recounts the sending of death threats by "Manson zombies" and the attempted assassination of President Ford by Squeaky Fromme.

It goes on to relate the details of Ronald Hughes dying during the trial of Van Houten in what was deemed a "fishing accident." His body was found face down in a stream, his head having been crushed by a boulder.

"A young, heavy-set man wearing denim coveralls and a bright yellow hat" shot Merrick through the chest outside his LA acting studio. Merrick did not die instantly; he made it into his acting class to show his fatal wound to horrified students before expiring. Strangely enough, Sharon Tate had once been a student of his.

The article ends:

Charles Manson will be eligible for parole in a few short months. And even if his petition is rejected this time, he can always try again…and again…and again. Until, finally, he wins his release, and gets to laugh his last jeering laugh. Once Charles Manson is freed, his boasting curse—a slow, evil cancer today—may very well explode into a virulent epidemic of bloody revenge.

Another article in the first issue is *Boston's Legalized Pleasure Zone Haven for Pimps, Pushers, Muggers and Killers*, a short exposé on Boston's "Combat Zone," a small section of the city set aside in the early seventies for porn theatres, massage parlors and adult bookstores, so they would not mar Boston's areas of historical interest. The 'Zone' was contained mostly on Washington Street and spilled over onto Tremont Street with a few adult bookstores.

I personally find this feature interesting and funny. It starts with a photo of the lit up nighttime marquees outside the infamous porn palaces, the Pilgrim and the World Famous Two O'Clock Showcase of Stars. The Pilgrim's marquee ballyhooes: "On Stage Burlesk Chesty Morgan 73-24-36 Seeing Is Believing." The reason I find it amusing is that I occasionally went there with friends in the early to mid seventies and have seen firsthand its sleazy side.

The text, written by Stanley Hartnett, is hilariously sensational! It starts out quoting a cop on the beat:

It's the worst place in the world. Frankly, the Devil wouldn't be safe here. There's just so much violence that it staggers the imagination. If you manage to walk away alive, you're certain to at least get mugged, pick pocketed or hassled by some two-bit con artist or punk. Every kind of human vermin on earth has found its way here, and it's turning one of our greatest cities into a cesspool. If I had my way, I'd line 'em up and blow their heads off!

One would think that was sufficient, but there is more:

…the Combat Zone has become a hell-hole for the most brutal, sadistic criminal element. Located less than a

Opposite **One million battered wives in VIOLENT WORLD (v1 #2) Jun 77.**

block from the Boston Common, the zone is the meeting place for pimps, dope pushers, murderers and the criminally insane, who pry [sic] on unsuspecting citizens in an orgy of violence that never stops.

I must have missed the "orgy of violence that never stops," although I have to admit it did have a violence-prone atmosphere that I felt was more a result of Boston's racial problems at the time. Most all of the pimps and hookers you would see were black, with few exceptions, and could be seen outside the Sugar Shack, an infamous seventies Boston club not far from the Zone. These were the stereotypical black pimps right out of central casting: long, double breasted fur coats, big wide brimmed fur hats with a feather in the band, crushed velvet bell bottoms, platform shoes, pink Cadillacs and all the original players. Then there were the drunken white college kids and yahoos from surrounding rural areas (I was a drug addled hippie yahoo myself) who would gravitate to the Zone, which made for a volatile mix. The article attributes the violence to drug pushing, and cops on the take who looked the other way and took sexual favors from the hookers, who complied to avoid being arrested. But, not unlike NYC's 42nd Street or "Deuce," Boston's Combat Zone has been cleaned up, sort of, though there are still a few porn stores there.

VIOLENT WORLD's second issue (Jun 77) has some equally bizarre features: *Ripped to Shreds by Frenzied Sharks*, *Kids on Death Row*, *Cultists who Worship Death*, *Hostage Fever Sweeps America*, *Severs his own Arm with a Jackknife*, and *The Chair of Horrible Death*. One article has the title, *1,000,000 Battered Knifed Beaten Chained Whipped Shot Punched Imprisoned Burned Stabbed Choked Stomped...Wives a Year.*

There is a strange two page feature on Patty Hearst that starts: "What turned this All-American cutie pie into a deadly revolutionary and now an emaciated sacrificial

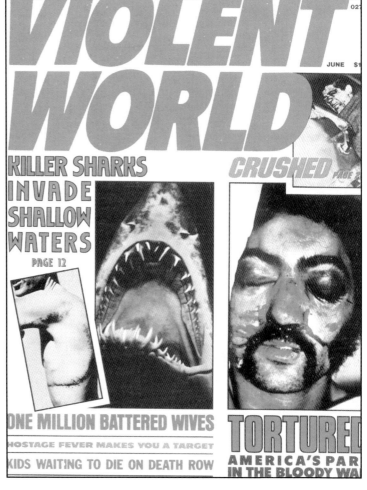

lamb?" The two photos that accompany the blurb are of Patty as a smiling cheerleader with pom-poms, and as a sad looking young woman after her arrest. The opposite page reveals a Symbionese Liberation Army's propaganda pic of Patty with beret and gun in front of the seven-headed SLA cobra symbol. It reads "Target For Assassination?" across the top, the supposed concern of the article. Apparently, Ms Hearst was constantly threatened by radical revolutionary groups, and moved around with three large bodyguards. The gist of the piece is that even the bodyguards and a large, well trained German Shepherd could not keep a sniper's bullet, Molotov cocktail or even poison from reaching the doomed

Hearst. As the last paragraph reads: "Political zealots who had the criminal savvy to bomb the Pentagon could very easily murder a young woman living in the radical hotbed of Southern California. A piece of cake..."

The main pic on the cover of the third issue (Jul 77) is the mangled victims of a plane crash: a Turkish DC-10 jet plane took off from Orly airport in Paris in 1974, and crashed minutes later in the French countryside after a cargo door blew out and the plane lost control. The majority of the passengers, 300 of 346 (the cover says 344), were British citizens returning to England after a rugby match in France. The corresponding article inside, *A Violent World Exclusive: Grisly Aftermath of a Hor-*

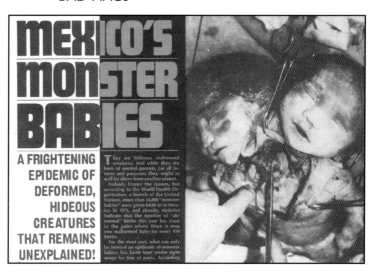

rible Crash, has more grisly photos of the victims and what was left of the plane.

The fourth issue (Aug 77) uses a pic of Frank Sinatra and his mother as its main cover photo, and the blurb, "Exclusive: Violent World Uncovers The Red Tape Scandal That Killed Sinatra's Mother!" The banner blurb above the title reads: "The All True Photo News Magazine." Of interest in the issue is a piece on the then uncaptured *.44-Caliber Woman Hater* who later became known as the Son of Sam. An article called *Blood Rock* starts with a pic of Iggy Pop, though he is not mentioned in the article, only in a caption. The caption dubs him "the star of agony rock" and mentions him rolling in broken glass on stage.

The cover of the fifth issue (Sep 77) has a couple of photos pertaining to their respective articles, along with the fanned out covers of mags titled **NUDIST MOP-PETS** (apparently a children-as-nudists mag) and **LITTLE GIRLS TOGETHER** (adult women with pigtails), with the blurb, "Child Pornography—**VIOLENT WORLD** Denounces Sadist Parents and Promoters Who Sexploit Children." The corresponding article is called *The Tragedy of Child Pornography*: there are more pics of magazine covers and a photo of Sergeant Lloyd Martin

of the LAPD holding up a copy of a mag called **LOLLITOTS** while testifying before the House Select Education Subcommittee hearing. He informed the congressmen of a twelve year old boy in LA who earned $1,000 a day posing for porn. As well intentioned as the piece might have been, it seems to veer off into sensationalism and fantasy with reports of child porn "stage moms" in control of their jaded child porn stars.

Tim Beckley has said that his article in the fifth and last issue of **VIOLENT WORLD**, *Mexico's Monster Babies*, was partially responsible for the mag's demise as horrified wholesalers took it off the stands early and killed what few sales the mag had generated with the first four issues. The New Jersey horror-punk band The Misfits, Glenn Danzig's first band, recorded the song Violent World, whose lyrics referred to the article.

A sixth issue, promised in issue five, failed to materialize.

VIOLENT WORLD dredges up some dark places in the psyche that were the domain of the sleaze tabloids, which hadn't used violence and gore in such amounts since the late sixties. **VIOLENT WORLD** owes a tip of the hat to the **Mondo Cane** variety of films, as it seems to be a print version of them.

I AM THE SON OF SAM
A PSEUDO AUTOBIOGRAPHY

❑ "The Most Vicious Murderer Since The Boston Strangler And The California Zodiac Killer" reads the subtitle on the cover of this "Pseudo Autobiography," which uses the same font for the title as the Myron Fass **SON OF SAM CAUGHT** mag below, and on Fass' other related detective mags such as **HOMICIDE DETECTIVE**, **VICE SQUAD DETECTIVE** and **MURDER SQUAD DETECTIVE** (see page 526).

I AM THE SON OF SAM does not have any credits or list any staff, and the indicia, if it can be called that, is one line with Popular Publications' name and address. A short editorial reads:

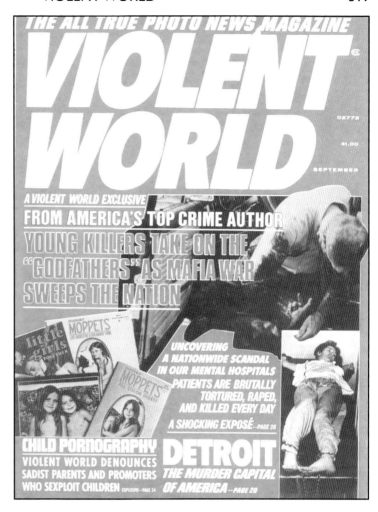

The front cover of this magazine clearly states that the text on the inside pages is a pseudo autobiography. That is exactly what it is and is not an attempt to mislead or defraud readers. It is written in the first person in an attempt to look at the tragic events that gripped New York City with fear over the past year as the Son of Sam might have seen them as he lived through this nightmare. As he is awaiting trial for the murders he is charged with, this magazine is presented as a public service in recording the biggest manhunt the city has ever had. It is our sincere wish that New York, or any other city, will never be subjected to such a wave of terror again.

I AM THE SON OF SAM is printed on a higher grade of newsprint than the Fass published mags, and starts out with a page that gives the specs of the .44 caliber Special, five shot, double action handgun used in the murders. The next page lists the eight victims and dates of the shootings chronologically with the addresses where they occurred.

The magazine is illustrated with police sketches, which look nothing like Berkowitz; crime scene photos, maps, and clip-art of .44 caliber handguns. Newspaper headlines and items pertaining to the story are reproduced across the tops of the pages. There are only three photos in the whole mag of Berkowitz himself.

The pseudo-autobiographical text runs throughout the whole mag and incorporates some of the letters Son of Sam sent to **NEW YORK DAILY NEWS** columnist Jimmy Breslin, as well as editorials that ran in that newspaper and on the front page of the **NEW YORK POST**—pleas to the killer to give himself up.

The text also gives a lot of info, in the form of speculation by the killer, that seems just as believable as had it come from the homicide detectives working on the case. A sample of the pseudo-autobiography reads (the "Dowd" referred to is Deputy Inspector Timothy Dowd):

I'm the guy they wanted, but they didn't know where to look for me. That's why Dowd and his staff listened to any telephone call or any theory. One call he received was from a retired policeman. He told Dowd that he felt that I worked in a funeral parlor. He came to that conclusion because I mentioned in my letter to Breslin

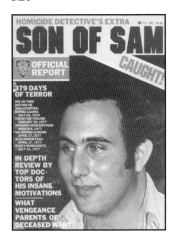

Above **Myron Fass' SON OF SAM CAUGHT!** from 1977. Right Full page ad for SON OF SAM CAUGHT! from a Countrywide Publication. Opposite **I AM THE SON OF SAM**, circa 1977, was a "pseudo autobiography."

First Time Limited Issue Offer

THE CRIME OF THE CENTURY
THE CRIMINAL OF THE CENTURY
APPROVED BY POLICE ALL OVER THE WORLD

SON OF SAM CAUGHT
OFFICIALLY SANCTIONED

THIS LIMITED EDITION WILL BECOME MORE VALUABLE AS TIME GOES ON. CONTAINS COMPLETE PICTURE COVERAGE FROM VICTIM TO ARREST TO THE BATTLE TO SEE JUSTICE DONE.

OFFER LIMITED TO FIVE COPIES OR LESS PER CUSTOMER. NO WHOLESALERS OR RETAILERS PERMITTED.

STUDENTS AND POLICE OFFICERS RECEIVE A 25% DISCOUNT. STATE NAME OF YOUR SCHOOL OR DUTY JURISDICTION TO QUALIFY.

STUDENT/POLICE OFFER

YES! I am a student or law enforcement official and I want _____ copies (limit is 5) of SON OF SAM CAUGHT at a 25% discount. My school or duty jurisdiction is listed below. I understand that you will pay the postage. Send the copies to:
Name_____
Address_____
City, State, Zip_____
School/Jurisdiction _____
$1.13 - One Copy
$2.25 - Two Copies
$3.38 - Three Copies CLIP AND SEND TO:
$4.50 - Four Copies COUNTRYWIDE PUBLICATIONS,
$5.63 - Five Copies 257 PARK AVE. SOUTH,
 NEW YORK, NEW YORK, 10010.

REGULAR OFFER

YES! Send me _____ copies (limit is 5) of SON OF SAM CAUGHT at $1.50 per copy. I understand that you will pay the postage. The copies are to be sent to:
Name_____
Address_____
City, State, Zip_____
$1.50 - One Copy
$3.00 - Two Copies
$4.50 - Three Copies
$6.00 - Four Copies CLIP AND SEND TO:
$7.50 - Five Copies COUNTRYWIDE PUBLICATIONS,
 257 PARK AVE. SOUTH,
 NEW YORK, NEW YORK, 10010.

SON OF SAM CAUGHT!
1977
Stories, Layouts and Press, Inc., 257 Park Avenue South, New York, NY 10010 1.50 68pp

MOBS AND THEIR GANGS
Vol 1 No 1 Nov 1977

MOBS AND GANGS
Vol 2 No 3 Jun 1978
Stories, Layouts & Press, Inc., 257 Park Ave. South, New York, NY 10010 1.50 68pp

'handiwork and coffins and blood and gutters.' The caller pointed out that on an embalming table there are gutters that enable the blood to run down.

SON OF SAM CAUGHT!

☐ **SON OF SAM CAUGHT!** is a Stories, Layouts and Press mag from the "Publisher and Former Press Relations Consultant to N.Y.P.D.—Myron Fass." According to his entry in **Who's Who in America**, the fortieth edition, Myron had actually been a member of the NYPD public relations department

from 1962–71. But, as has been pointed out to me, the entries in **Who's Who** were often written by the entrants themselves.

The full title of the mag is **HOMICIDE DETECTIVE'S EXTRA—SON OF SAM CAUGHT!**, while the cover reads "Official Report," with a picture of an NYPD badge. Myron had been fascinated by both the Clint Eastwood movie **Dirty Harry** (1971), which co-starred the .357 magnum handgun, and the Son of Sam case. So, true to form, Myron published the shortlived title **.44 MAG** and this special issue on Berkowitz's capture.

SON OF SAM CAUGHT! came out not long after Berkowitz's arrest, and is a good

source of info and rare photos concerning the case. It starts with uncredited quotes from, I assume, the parents and families of the victims. Many describe the nature of the retribution wanted: "He should have his hands cut off and his eyes taken away. It would be too quick to shoot him down like a dog." On the same page are quotes from Jimmy Breslin and Peter Hamill, writers with the **NEW YORK DAILY NEWS** at the time. The last quote is from "Sam's Mother" who says: "Leave me alone. I don't want to talk about it."

The magazine is packed with photos of the victims, their families, various police sketches, crime scenes, detectives working on the case, funerals, the gun, and Berkowitz's capture and arrest. The Son of Sam case got the city's attention, and had the public's imagination working overtime, as well as the police working to capture him. Berkowitz was ultimately brought down by a parking ticket he received near one of the crime scenes, that led the NYPD to his car and apartment in Yonkers where he gave up peacefully, grinning like some insane celebrity in the limelight. The magazine reproduces the parking ticket in a two page spread. The ticket was issued on July 31, 1977 and the police arrested Berkowitz on August 10, 1977, just in time to stop a massacre he had planned for a disco out in the chic Hamptons on Long Island. The city breathed a collective sigh of relief as the local newspapers had a field day, and the magazines and books started to appear.

After Berkowitz's arrest, the police searched his apartment and, amongst the squalor, they reported finding stacks of magazines, most of which were pornographic in nature. I've always wondered what magazines they were. Could there have been a few Stories, Layouts & Press mags in the stacks? Maybe a copy of **TRUE SEX CRIMES**? It is a definite possibility. It would be interesting to know what specific mags some of the sick and infamous have had in their possession. What issues of

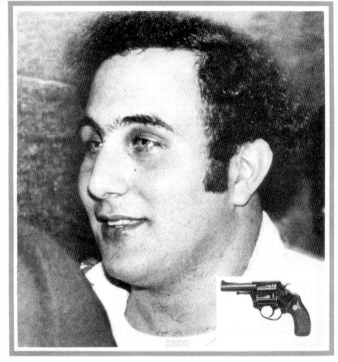

STARTLING DETECTIVE did Ed Gein have in his kitchen? What mags were in Ted Bundy's closet that he claimed warped him to such a degree? Some things, I guess we'll never know.

MOBS AND THEIR GANGS

MOBS AND GANGS

☐ MOBS AND THEIR GANGS is loaded with pics of old school mobsters, both dead and alive. The cover of the first issue from Nov 77 is reminiscent of its predecessor

CRIME DOES NOT PAY, but with the added attraction of a color photo of a woman in distress, with the blurb: "Sex Gangs: They're On The Prowl For Your Woman!" The articles are the usual gangster pieces with titles like *Beware the Violent World of the Wah Ching 'Fobs', You and the Hooker-Hood Terror Alliance, Wolf Packs: They get their Kicks from Wanton Murder, Capone: Was he the Leader or was it Jake 'Greasy Thumb' Guzik?*. Although there are a couple of pics of scantily clad women, the first issue has next to no porn ads, only a full page ad for male and female sex dolls.

The title was eventually shortened to

Above **First gangster filled issue of MOBS AND THEIR GANGS (v1 #1) Nov 77.** Opposite **MOBS AND GANGS (v2 #2) Apr 78.**

VICE SQUAD DETECTIVE
Vol 1 No 1 Dec 1977
Stories, Layouts & Press, Inc., 257
Park Ave. South, New York, NY
10010 1.50 68pp

MOBS AND GANGS, and the much used photos of gangsters dropped in favor of color pics of S&M and torture.

MOBS AND GANGS' Feb 78 (v2 #1) issue is fairly tame with posed shots of a black gangster, and a stripper who looks like a Vanessa Del Rio clone, with the blurb ,"She Had To Submit To The Gang Or Die." Featured articles include: *Assassination Mafia Squads are Deadlier than Ever, Girl Gangs are on the Prowl, Old Creepy Meant Death (Alvin Karpis)* and *Hot Ice and Cold Bodies*.

In the Apr 78 (v2 #2) issue the cover gets weirder still, with the blurbs: "Female Screw Savages," "Intimate Medical Details of Rape Victims," "Living Sacrifice Murders of the Devil Cults." Like the covers, the articles inside use a mixture of sixties sexploitation film stills and posed photos as well as mugshots and bloody crime scene pics. For example, in the article *Why Gangs Commit Sex Crimes* by Dr Richard Kahn, Police Medical Examiner, the layout starts with a two page spread using a much used still of Titus Moody and Hondo Rio with chained women and cannibal pot. Some of the posed photos have blood painted on them, which has not been done very well.

The cover of the Jun 78 (v2 #3) issue takes the cake as far as shock value is concerned, with its full cover color photo of a naked man and woman, hung by their ankles, with bloody lash marks covering their bodies—I presume dead. Black boxes have been placed over their genitals and the womans' nipples, proclaiming "censored." The blurb pertaining to the photo says: "Genital Mutilation By Mafioso Hit Men—Censored By Police." The photo is actually a still from **Ilsa, She-Wolf of the SS** (1974) a Canadian sexploitation "kinkie" produced by David F. Friedman that made a reputation for itself on 42nd Street. Jeff Goodman, Fass' editor-in-chief at the time, claimed this cover was his choice and layout, 100 per cent. As Goodman stated: "At Countrywide, we had a huge file of old press photos, handouts, un-sorted stills, plus there was a guy from UPI who

would steal photos by the thousands and sell them to Myron for a couple of hundred bucks." The same still was used in the Fass S&M girlie mag **BRUT** (v1 #10 Apr 76) (see page 513).

I found an issue of **BEST TRUE FACT DETECTIVE** Jul 77, published in Canada, that has a very similar, and obviously posed, photo of a woman in her underwear hanging upside down from a tree with a knife protruding from her bloody chest. The blurb: "The Case of the Butchered Nude."

The inset pic on the cover of **MOBS AND GANGS**, Jun 78 issue, of a woman's head in a leather blindfold and ball-gag mask, is accompanied by the blurb, "Drug-Dealing Motorcycle Gang Keeps Female Slave", and helps to complete the disturbing nature of the cover—as if the main photo (mentioned above) wasn't enough. There is an interesting anecdote about this cover in **The Village Voice** piece on Myron Fass from Mark Jacobson:

Myron is defensive about his baser output. If he sees you looking at the cover of one of his detective books—the ones with the women covered with whip marks hanging upside down from a tree branch—he'll rip it out of your hands. 'You only want to see the bad stuff. You're looking to take a cheap shot.' Then he gives you some other magazines, saying 'Here, why don't you look at some of the cute stuff?' Among the mags he gives you are **CLONES** *and one called* **LARRY FLYNT** [**OF HUSTLER**], *which came out soon after the publisher was shot.*

VICE SQUAD DETECTIVE

☐ **VICE SQUAD DETECTIVE** is the manifestation of a type of magazine I knew had to exist out there somewhere, and finding this issue confirms my suspicion. It breaks from the mold of the other detective mags, with

its mixture of posed girlie shots, bondage, S&M, and softcore porn pics from various sources and time periods, which in places actually show both male and female genitals, a first I'd bet for a detective mag. Some of the photos have been taken from the girlie mags published by M.F. Enterprises, such as **EROTICA** and **JAGUAR**.

The articles/stories are enigmatic in that it is hard to tell whether they are supposed to be true accounts or fictionalized stories. The mag itself doesn't give us a clue. It is filled with ads for 8mm hardcore porn, sex aids, counterfeit guns, fake police badges, male and female electronic sex dolls, X-ray specs, and other assorted essentials.

VICE SQUAD DETECTIVE is a unique piece of sleaze that publisher Myron Fass slipped onto the newsstands to test the waters for such a thing; it might be his version of **UNDERGROUND DETECTIVE** (page 511), which was similar in nature. The associate publisher was Irving Fass and the editor Robert Greene.

This mag is different from the other Stories, Layouts & Press titles below, in that its focus is the activities of the vice squads, giving them a good excuse to fill the mag almost exclusively with sexual photos.

The header on the short editorial reads: "Making Vice Pay For You." It is not so much an editorial, but a plea for readers to send in written accounts of their local vice squad's adventures in viceland to be used in the next issue, as the editor explains:

> Vice squads are active in almost every community throughout the nation. Their jobs entail the investigation of prostitution, pornography, gambling, etc. **VICE SQUAD DETECTIVES** is looking for true stories about the Vice Squad in your community. If there has been some good action, write it up and let us know about it. Each issue of **VICE SQUAD DETECTIVES** will choose up to three articles from our readers for publication. Cash awards

of $100, $75 and $50 will be made for the three best articles.

The seven features include: *Undercover Pimp, Massage Parlor Rip Off, Wetback Wanda, She Liked Sex Better than Common Sense,* and so on. One article of note is *Long Haul Hustlers,* drawing on the CB (Citizen Band) radio craze of the seventies. A similar article, although it doesn't mention CBs, is *I was Sex Bait for Truck Looters* in the above **UNDERGROUND DETECTIVE**.

Long Haul Hustlers is as good an example of the contents of this mag as any, and involves "Eager Beaver" and "Easy Gal," two CBing, motor home driving, *long*

haul hookers! The piece incorporates CB slang in the dialog and gives the meaning of certain phrases:

> This is Charlie Brown and that's a big 10-4 (message acknowledged and understood) on the 10-16. We be moving south on the concrete ribbon (highway) at about 106 over six (mile marker 106.6). What's your cover (vehicle) and 10-20 (location)?

The story is about the two mobile hookers plying their trade on the interstate highways of New Jersey, eluding police efforts to arrest them. That is until the cops send

Above Recycled bloody corpses adorn the cover of HOMICIDE DETECTIVE (v1 #3) Jan 80. Right Opening page spread for *Long Haul Hustlers* in VICE SQUAD DETECTIVE (v1 #1) Dec 77. Opposite HOMICIDE DETECTIVE (v1 #2) Jan 78. On its cover were two stills from the tagged on end scene from the movie *Snuff*.

HOMICIDE DETECTIVE
Vol 1 No 2 Jan 1978
(inside Dec 1977)
Stories, Layouts & Press, Inc., 257 Park Ave. South, New York, NY 10010 1.50 68pp

an undercover officer on the road posing as a trucker to take the eager gals up on their offer. With the back of his semi filled with cops, he locates the mobile home that the CB transmissions lead him to, off the interstate, and onto a side road. The two willing, entrepreneurial pitstop hookers are arrested and the highways are safe again, filled with a few more horny and frustrated truck drivers.

One point of note is that the four photos used for the feature all seem to be from different decades! The two opening pics, of a guy and girl rolling on a bed, and a woman lying on the floor in panties and stockings, holding up a bottle of booze, both seem to be of sixties or seventies vintage. The next photo, of a woman sitting on the edge of a bed undressing, looks like it is from the forties or fifties. The last photo of a woman and man standing together, the woman's coat open revealing her naked bod underneath, is again sixties and looks like it might have been taken in another country due to the man's attire.

VICE SQUAD DETECTIVE v1 #2 (Feb 78) has a bizarre cover photo of a nude man with two naked smiling blonde females and an inset pic of a long-haired cop and a woman; both cover pics are juxtaposed with the cover blurbs: "Rural Teens Forced Into Sex Ring," "Pervert In Skirts," "Ex-Con Rapes and Kills 20 Women–and the Law Can't Touch Him."

VICE SQUAD DETECTIVE's Jun 78 issue has these edifying cover blurbs: "Bleeding Agony! Homo Castrator Snips Off Organs of Pleading Captives," "Vice Lord Gangs! Bull Dyke Cop Works Over 4 Pimps with Blackjack," "Sex Monsters! The Slut Hitchhiker's Last Ride to Doom," "Perversions! Got Hot for Dead Broads," "Pretty Fraulein's Butt Plugged by Drunken Burgomeister."

There is at least one other issue of VICE SQUAD DETECTIVE, dated Apr 78.

HOMICIDE DETECTIVE

❑ The first issue of HOMICIDE DETEC-TIVE (unnumbered, Oct 77) appears to be an actual crime scene photo of a woman's bloody, disheveled corpse lying on the floor. The cover blurbs read: "He mutilated their vaginas, then shotgunned his victims to death," and, "Murder spree of the knife-wielding rapist," which sandwich the main blurb, "NYPD Manhunt: The .44 Killer: *I Love to Shoot Women*." This is an article on the Son of Sam killings before he was caught, and Myron was on the case.

The just as sensational cover of the second issue and its gory inset pic—of intestine fondling—are stills taken from the tacked on, obviously faked, "snuff" footage from the film of the same name, **Snuff** (1976), the Michael and Roberta Findlay film which helped perpetuate the urban legend of the snuff film. Which also begs the question—if this controversial scene has appeared on the cover of a national magazine, why are people still arguing for its reality years later? There is no acknowledgment of the cover's origin inside, and no mention of "snuff movies" or crimes of that nature. The photo's appearance on this cover came after a previous Fass girlie mag called **EROTICA** (v1 #5, Dec 76) published a four page article on the making and faking of **Snuff**, the movie, referred to as "The greatest rip-off in Porn history! The inside story of how to dupe the public!" And of course paying for sexploitation film stills is cheaper than hiring models to pose for a photographer.

The inside of the mag is the usual mixture of articles, with bloody crime scene photos and posed pics of nude or semi-nude women, some with blood on them. The eleven features include: *Never Late until she Died—He Reached out like a Snake*; *Death of a Cheerleader—Returned to Prison on Rape Charge*; *Murder was the Blue Plate Special for the Pretty Waitress*; *Death was a Night Visitor—Sex Fantasies Drove him to Murder*; *Girl Scout Cookies Meant Death—She was a Scout doing a Good Deed*, and so on.

One ad, opposite the contents page, announces "We Quit!:" "Because of recent court decisions, we're throwing in the towel…closing out all our inventory. Our bulging warehouse is loaded with $1,250,000.00 worth of sexually oriented merchandise which we are offering at 85% to 90% off list price." It advertises "Superstars of Porno In Big Screen Films," and lists eight 8mm films and a handheld viewer which holds 200ft. of film, and is offered for those without a projector. The description next to the first

film, **Talented Tongue**, says:

*If you have seen **Deep Throat** you'll recognize this star instantly. Watch her now, nude and more passionate than ever, perform for you privately, doing things with men that have made her the queen of hardcore. If one of her acts turns you on…stop the action and replay it again. You can't do that when you watch in the theater!*

Another sexploitation movie still, of a big-breasted, blood covered brunette from **Ilsa, She-Wolf of the SS**, kicks off the article

The Merry Mexican Murderesses.

Again there are ads for all manner of porn, sex dolls, mail order brides, fake police badges, counterfeit guns, and other scary crap. Two one page features are of interest, one for the continuing "Murder Story Contest" and the other for a future "Detective of the Month" page. The copy for the "Detective of the Month" query reads: "**HOMICIDE DETECTIVE** is dedicated to the thousands of policemen who labor daily in the dregs of the earth searching for killers. Their lives are on the line every waking moment." It proceeds to ask for stories and newspaper clippings concerning detectives or detective squads that had "done an exceptional job in

solving a particularly vexing murder."

HOMICIDE DETECTIVE's Jul 78 (v2 #4) issue uses another still from the same scene in **Snuff** as the January issue, but with an inset of a woman's bloody head with an ax sticking out of it. The main cover blurb reads: "Fort Laudy Sex Butcher Goes Berserk with Coeds." Inside are articles such as: *Child Molester Killed by Dyke Rapist*, *Pervert Boiled Alive in Cesspool Drum by Irate Dad*, *Drunk Cops Work Over Insane Pimps*, and *The Pimp who Murdered Priests*.

There were at least two other issues of **HOMICIDE DETECTIVE** published by Stories, Layouts & Press for Mar and May 78. In the early eighties the title was continued by S.J. Publications from Fort Lee, New Jersey, and doesn't *seem* to have any connection to Myron Fass, as the staff names listed in the mag are all pseudonyms. However, another S.J. publication from 1981, **UFO CONFIDENTIAL**, does list Myron and Irving Fass as the publishers.

S.J. Publications' Nov 81 issue of **HOMICIDE DETECTIVE** includes such features as: *The Helpless Murderess and the Monster*, *Murder at the Five and Dime*, *The Sadist who Preyed on Old Women*, and so on.

HOMICIDE DETECTIVE's Jan 82 (v1 #3, S.J. Publication's numbering) issue is in fact a reprint of **THE GODFATHERS** v1 #4 from 1978 with the title changed and layouts rearranged. It contains such gems as: *Slut-Sex Slave of the Don*, *Cop's Daughter Sucked into Porn Loops by Mob Punks*, *Mutilations on Mulberry Street*, and *International Black Whore Market*. The issue is probably one of the last mags that Myron Fass published from NJ before his move to Florida where he published his gunzines.

MURDER SQUAD DETECTIVE

☐ Another obscure detective mag from Nesoff Media—named after the listed publisher-editor, Bob Nesoff, a retired police reporter and friend of Myron's—had many of the same staff on hand as the titles from Stories, Layouts & Press, namely Irving Fass, Robert Green, Joseph D'Amato, Arnie Schnitzer, and Mel Lenny.

The first issue contains a "Murder Story Contest" that asks readers to send in stories on homicide cases, the first prize being $100. It is interesting to note that all entries were to be sent to the editor at 257 Park Ave. South, not the Oradell, New Jersey PO Box listed in the front of the mag.

The cover is a bizarre shot of a man digging a grave in the woods for a trunk containing a dead girl. The same cover shot is re-used on the Spring 80 issue of **CHIEF OF DETECTIVES**. The contents page, opposite an ad for porn films, has a line that informs the reader: "Some pictures may be posed by professional models." In the first article, *Murder—A Way to Pay Debts,* the full page photo is yet another still from **Ilsa, She-Wolf of the SS**, of a very bloody, naked woman. The second photo in the same feature is another still from the last scene in **Snuff**. Looking through these mags and trying to figure out where the photos came from is half the fun!

Of the nine articles in the first issue, *Killing for Kicks* by Wayne T. Walker is the weirdest by far, its focus being "homicides committed for illogical reasons." It is a pot pourri of bizarre, short news items strung together with a mixture of movie stills and actual photos of some of the criminals mentioned.

The second issue, v1 #2, Mar 78, was also published by Nesoff Media but lists Myron Fass as editor. It features a still from the sexploitation movie **Rawhide '69** (1969) on its cover. **WILDEST FILMS** v3 #4 from 1969 also uses a still from the same scene on the cover and features a review of the film.

With cover blurbs like "Cops Question Two-Year-Old Girl In Killing" and "Bullets & Bagels: A Fatal Combination," much of the second issue is one or half page features labeled "Under Investigation," which read

Opposite **Splash page for the story** ***The Merry Mexican Murderesses*** **in HOMICIDE DETECTIVE (v1 #2) Jan 78 using a still from *Ilsa, She-Wolf of the SS*, with a page of sex ads next to it.**

MURDER SQUAD
DETECTIVE
Vol 1 No 1 Jan 1978
Nesoff Media, Inc., PO Box 104,
Oradell, NJ 07649 1.50 68pp

THE GODFATHERS
Vol 1 No 1 Jan 1978
Nesoff Media, Inc., PO Box 104,
Oradell, New Jersey 07649 1.50 68pp

like newspaper items on local crimes.

There are a few full length articles, such as *The Helpless Murderess and the Monster*, which relates the story of a crime spree in Seattle, Washington, in the summer of 1966, instigated by "professional virgin" Ginny Farlowe. In the wake of the spree were four dead and mutilated college students, two others seriously wounded, a raped and strangled burlesque queen, and a dead and mutilated eleven year old girl. It seems Ginny had a serious problem with people thinking they were better than her—a *big* problem. Apparently, she was so convincing when she played the innocent maiden that men would murder, rape and mutilate strangers for her when she felt she had been slighted.

The ads in these two issues vary greatly. The first issue has one inch porn ads, male and female sex dolls, 8mm porn, sex aids, etc. The second issue has no porn or sex

related ads at all. But there is a higher page count of ads of various kinds from different companies around New York state, and for mags from Countrywide Publications.

The third issue of **MURDER SQUAD DETECTIVE** (May 78) was published by Stories, Layout and Press with Robert Greene as editor, and has a naked woman sandwiched between two naked men on its cover. The features inside are: *Queer Cannibal Eats Female Breasts*, *Diseased Gypsy Rapes Girl with Boyfriend's Bleeding Head*, *Madman Stuffs Rocks into Girl's Anus*, and *Black Panther Keeps Nude White Slave*.

THE GODFATHERS

☐ The first two issues of **THE GODFATHERS** were published by Nesoff Media, in Oradell, New Jersey, while the third issue was published by Stories, Layouts and

Press, giving no address. The fourth issue is also a Stories, Layouts and Press effort that lists their address as 191 Middlesex Avenue, Englewood Cliffs, New Jersey.

As can be expected, **THE GODFA-THERS** is cover to cover mobsters and naked women, with photos of dead bodies, blood streaming from bullet holes, corpses in pools of blood, morgue photos, and so on—a staple of the gangster mags. The articles seem to have been written specifically for this mag and not reprinted from the earlier gangster titles.

The first issue of **THE GODFATHERS** (Jan 78) lists Ben Stone and Tony Manza as the editors, undoubtedly pseudonyms. The mob bosses pictured on the cover are Carlo Gambino, Carmine Galente, Sam Giancana, Joseph Bonanno, Joseph Columbo, and last but not least Frank Costello. Of the nine articles in the issue, *How the Capos Import their Personal Sicilian Whores* probably has the

From top **The St. Valentine's Day Massacre on the cover of THE GODFATHERS (v1 #2) Mar 78; THE GODFATHERS (v1 #4) Jul 78.** Right **Bizarre cover of MURDER SQUAD DETECTIVE (v1 #1) Jan 78 that was used again for CHIEF OF DETECTIVES (v1 #1) Spring 80 (see page 532).** Opposite, from left **WILDEST FILMS (v3 #4) 1969 and MURDER SQUAD DETECTIVE (v1 #2) Mar 78, both with stills from** *Rawhide 69* **on the cover.**

strangest title, with *A Mafia Don Says: Look for Wholesale Slaughter in the New Coke War!* coming a close second.

The second issue (v1 #2 Mar 78) lists Robert Nesoff as publisher and Robert Greene as editor. It uses the infamous sepia close-up of the St. Valentine's Day Massacre as a cover background, screaming: "Mafia Assassination Squads—They Take Care of Their Own First." Other cover blurbs are: "Mob Soldier Helps Rent Teen Boys," "Ex-Agent Says FBI Set Up Its Own for Murder," and "The Hit Squad Wore Badges." The two insets on the cover are headshots of dead mafiosi with blood oozing from facial bullet holes. There are fifteen articles in the issue

but their titles aren't as sensational, with *Gambling and Sex in Prison, The Luciano Nobody Knew, The Black Godfather,* and so on.

The third issue (v1 #3, May 78) gets sleazier than the first two issues with lots of sexy girlie pics thrown into the gory mix. It contains articles like *America's Death Dealers, The Mob is Muscling into Atlantic City, Popeye—New York's New Capo Di Tutti Capo, L.A. Strangler—Caught?* and *The Black Godfather,* a one page story about the arrest of Leroy "Nicky" Barnes, drug kingpin of Harlem and the Bronx, reprinted from the previous issue. Of course there is an occasional nude female amongst the mugs of

gangsters, hoods and mafiosi. On the center pages are two photos of near naked blondes lying on beds, with the caption: "Play-for-pay girls rarely refuse an offer of a night of sex with the Mafia's powerful leaders. High-priced call girls are among the prerequisites of every well-heeled Mafia chieftain."

In Chicago—Heroin Means Herrera! is about a "2000-member Mexican crime family monopoliz[ing] 'Windy City' dope traffic." There are a couple of pics in the mag of a woman supposedly shooting dope into her arm, but she is holding the needle at an unnatural vertical angle.

There is one article that stands out as particularly bizarre, *Death is the Payoff* by Charles Downing, subtitled "When the mob moves in on the lucrative wetback racket." This little ditty is on the mob's control of the "highly profitable alien smuggling racket." It is complete with a photo of two dark haired women, in bra and panties, on a bed with their hands tied behind their backs, a man grabbing one by the hair. There is also an inset pic of a bare breasted *mamacita*, and accompanying blurb, "Fornicating wetbacks in action."

Reports of vehicular homicide in LA, body parts in NY subway lockers and vanishing people in Florida all add up to a vast trade in displaced aliens from south of the border, whether it was Mexican laborers or

wealthy Cubans escaping Castro.

There is a full page ad for back issues of **OFFICIAL UFO**, **ANCIENT ASTRONAUTS,** and one for **SON OF SAM CAUGHT!** which offers a twenty-five per cent discount to students and police officers for five copies or less—Myron's idea.

The fourth issue of **THE GODFATHERS** (v1 #4, Jul 78) has a staff list that seems to be all pseudonyms, or at least the editor-in-chief, "Wulf Fleischbinder" is: a pseudonym used by Fass editor Jeff Goodman since his days of writing porn paperbacks for Star Distributors. Goodman's hand in the mag may explain its crazier look than the previous three issues; he takes credit for the cover

layout and blurbs.

The ten articles inside sound more over the top than before, with titles like *International White Slave Torture Ring, Cosa Nostra Slut Wars, Mutilations on Mulberry Street, Gallo-Colombo Bloodbath,* and the mother of all titles, *Mafia Sucks Cop's Daughter into Porn Loop Ring.* Whether or not the last article inspired the likes of the film **8mm**, I can't say, but it certainly reads like it. The piece is by Randy Saunders and concerns the sordid story of "Sally B.," twelve year old daughter of "Frank," an Irish cop on the beat in Detroit. It seems that Frank has gone on the take to a mobster named "Lucky Louie," informing him of any police raids in the offing so his

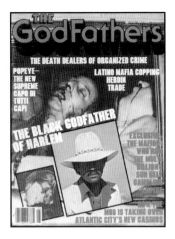

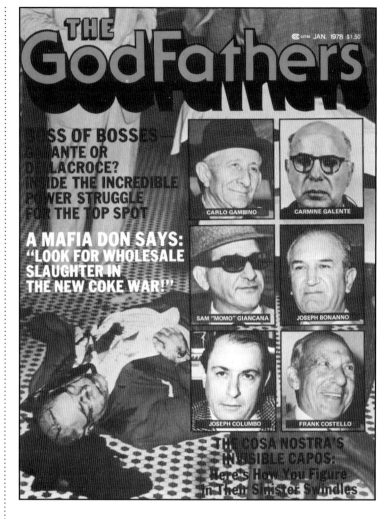

Above "The Black Godfather of Harlem" on the cover of THE GODFATHERS (v1 #3) May 78. Right THE GODFATHERS (v1 #1) Jan 78. Opposite Splash page spread from THE GODFATHERS (v1 #3) May 78.

CHIEF OF DETECTIVES
Vol 1 No 1 Apr 1978
Countrywide Publications, Inc., 257 Park Avenue South, New York, NY 10010 1.50 68pp

cronies could escape beforehand. One day Frank has had enough of Louie's business and feels he is in too deep, so threatens to go to his superiors, even at the cost of his job. Lucky Louie threatens to break every bone in his body, and then later has the brilliant idea to kidnap Frank's daughter Sally and force her into porn loops so he can become rich. She is kidnapped and brought to Louie's warehouse where she is raped by a German Shepherd and a teenage boy with a "large organ," while the cameras roll. There is no happy ending to the story; Sally finds out she likes performing degrading sex acts for a living and goes on to "turning hundred-dollar tricks." Frank, on the other hand, un-

der threat of the films of his daughter being shown to his betting buddies, keeps giving inside info to Lucky Louie.

On the last page of the piece are two photos, one of a child in his coffin and another of a badly burnt or abused child; it is hard to tell. The caption states: "Younger and younger children are violated by unscrupulous flesh merchants who cater to the growing population of sickies who get off on child-abuse films."

As mentioned previously, the cover of the issue—in fact the whole magazine—was eventually reprinted for **HOMICIDE DETECTIVE**'s Jan 82 issue by S.J. Publications.

When the mob moves in on the lucrative wetback racket.

By Charles Downing

To the tight group of stoney-faced homicide detectives gathered around the subway locker at Eighth Avenue and 42nd Street, the possibility was there. The woman whose dismembered hands and limbs now lay before them was of undetermined age and nationality. That her skin was black meant little in the identifying process. She could have been native born, an African national or a former resident of some Latin American country.

illegal alien who had refused to play the game by the mob's rules. As one veteran N.Y.P.D. plainclothesman put it, "You have a lane Doe.' Any theory is as strong as another. We don't rule out anything.

In Tampa, Florida, the same type of situation has homicide men working on their own time, as they try to develop a link between the violent deaths and disappearances of at least 12 people over the course of the last few months.

Out of Hand

Los Angeles police sources say the situation among Chicanos there has virtually gotten out of hand. The exploitation of Mexicans who have made it to the United States under the cover of night but are actually tied

Illegal aliens trying to lose themselves in major U.S. cities frequently become extortion victims of organized crime.

CHIEF OF DETECTIVES

☐ A crime scene photo of a nude woman's spreadeagled body, colorized pink for this cover, is seen along with seven other photos of the L A strangler's victims. This first "Collector's Edition" of **CHIEF OF DETECTIVES** has the subtitle "L.A. Strangler" displayed more prominently than the title. Inside the mag is a bizarre assortment of articles with a just as bizarre selection of photos to illustrate them. Not unlike Fass' other detective mags this one uses a hodge-podge of crime scene photos: full page photos of the victims while alive, posed stills, photos and drawings lifted from girlie mags, police sketches, anonymous pics of prostitutes on the street, and so on. It is another Fass published excursion into the depths of human pathos that focuses on the murders of eleven young women and prostitutes in LA whose bodies were dumped out in the open, some

on hillsides (as can be seen on the cover). This later led the media and police in LA to dub the perpetrator "The Hillside Strangler." This magazine was published at least nine months before the killer was arrested.

As it turned out, two men were responsible for the killings, Kenneth Bianchi and his cousin, Angelo Buono. Since both were still at large when this mag was published, it makes one wonder whether they saw a copy of it on the newsstand. Bianchi had moved from LA to Bellingham, Washington and was arrested in January 1979 as a suspect in the murder of two young women there. Later, when claiming to have multiple personalities, Bianchi implicated his cousin in the LA murders.

The opening article is *L.A. Killer in the Mold of 'Son of Sam' says Retired New York City Chief of Detectives, Albert Seedman.* Seedman— pictured on the cover with the blurb, "Official Advice From Chief Seedman

To the L.A. Police," and throughout the rest of the mag—was a retired Chief of Detectives from the NYPD. Seedman's article likens the LA strangler to the Son of Sam murders in NYC, still fresh in everybody's mind in 1978. The Chief of Detectives badge reproduced on the cover is that of the NYPD, not the LAPD as would be expected, mainly because Fass had friends in the NYPD. Jeff Goodman says Seedman was someone whom Myron admired and got in touch with, asking him to lend his name and rank to the mag to give it an air of authenticity.

The editor's note on the opening page of the article reads:

Albert Seedman is the former Chief of Detectives in New York City, perhaps the toughest beat for any cop in the country. He has earned a reputation for being one of the most astute murder investigators in criminal history. We are

Above **A familiar looking cover for CHIEF OF DETECTIVES (v1 #1) Spring 80.** Opposite **CHIEF OF DETECTIVES (v1 #1) Apr 78 was a special LA strangler issue with his victims displayed on the cover.**

THE UNTOLD STORY
OF THE JONESTOWN
MASSACRE
Vol 1 No 1 1979
Histrionics Publications, 21 West 26th
St., New York, NY 10010 1.50 84pp

pleased that he is a special consultant for this magazine.

Seedman's article is short and the only time he connects the two cases is when he writes: "That there is a degree of imitation of the Son of Sam here is also obvious. Although Son of Sam didn't sexually attack his victims, he did seek publicity for his actions. The Los Angeles killer is apparently looking for the same notoriety." A confusing statement considering the two cases seemed to have nothing in common other than murder.

The second article, labeled an "Exclusive," is *L.A. Strangler a Homosexual, Police Official Speculates*, throughout which the writer refers to the mag as **HOMICIDE DETECTIVE**, not **CHIEF OF DETECTIVES**. The piece starts on a prescient note stating: "The L.A. Strangler, that modern-day 'Jack the Ripper,' who has been on a murder spree in Los Angeles, may very well be more than one person, according to police." In the article the only mention of the homosexual angle is Lt. Dan Cook of the LAPD's comment: "It has not been uncommon for a homosexual to commit such crimes against young people, but rare for the perpetrator to have been a heterosexual." A statement which makes one wonder what planet the Lieutenant was on.

The other articles that help flesh out the mag are: *Terror Grips Los Angeles as Police Fail to Stop Strangler-Rapist Preying on Young Girls and Prostitutes, Killer is a Respected Citizen, says Noted Psychiatrist, Women Learning Self-Defense to Protect against the L.A. Strangler, L.A. Residents Outraged at Vulnerability to Killers*, and *The L.A. Strangler and the Copycat Killings*.

The last piece in the mag, *Medical Report why the L.A. Strangler Rapes,* by Dr Richard Kahn, police Medical Examiner, does not mention the LA strangler/rapist. It is a general article on rape, examining three cases and the aftermath of rape on the victim's physical and psychological health. The

piece ends with ten "rules to observe if you are approached by a rapist."

The last page has a full page photo of an outdoor crime scene with a blurry inset photo of a woman who appears to be naked except for her panties, with the caption, "Exclusive—The last known photo of one of the L.A. Strangler's victims. She was a hooker who appeared at a stag party a day before she was killed. This picture was taken by a guest at the party."

As mentioned above, the title **CHIEF OF DETECTIVES** was minimized on the covers of the first few issues and the subtitles became predominant. The second issue is subtitled "Insane Murders," with the cover blurbs: "Eyes Gouged Out With Butter Knife," "Rapist Castrated By Angry Dad With Blowtorch," "Blonde Model Anally Raped By Hot Lunatics 'They Were Like Apes'," and "Torture - Whores Whipped and Spiked By Fake Priest: Big Sinners." The cover of the "Insane Murders" issue also has an inset close-up of a woman's hand, a finger cut off and bleeding onto a bedspread: yet another still from **Snuff**.

Starting with the Spring 80 issue (again v1 #1), **CHIEF OF DETECTIVES** was published by S.J. Publications in Fort Lee, New Jersey, a town right across the Hudson River from the Bronx. The staff listed seem to be all pseudonyms: Kelly Doge, publisher; Dick Rodman, editor; Chrissy Zap, art associate; and Len Melvin (aka Mel Lenny aka Mel Lenowitz), advertising director. Fass' name does not appear.

The cover photo used can also be found on the earlier Jan 78 issue of **MURDER SQUAD DETECTIVE** (see page 528). The cover blurbs have been changed of course: "FBI Report Rape Up 100%" and "Punks: The Ultimate Thrill—Killing For Kicks."

In 1981 S.J. Publications also published a mag that combined the titles of the two most infamous scandal mags in its title, **CONFIDENTIAL & UNCENSORED**. It is not filled with gory photos, rather with screwy articles and news items like: *Elvis*

Taken on Board a UFO before he Died, *Inherits $10,000,000 if she Marries Gorilla*, and *Castro was Castrated!*

There are ads throughout **CHIEF OF DETECTIVES** for such things as mind control courses; US government surplus items; do-it-yourself auto repair manuals; gun collecting books; how to make your own synthetic fuel; real estate investing; "Goddess In Flight" hood ornaments for your car; a "Lucky Power Card," and books for war buffs. All the ads have one thing in common: the Countrywide Publications, 257 Park Avenue South address.

In the article *Murder—A Way to Pay Debts*, there is again a still from **Snuff**. The issues published by S.J. Publications are just as filled with mayhem and sex as **HOMICIDE DETECTIVE**, **MURDER SQUAD DETECTIVE** and **MOBS AND GANGS**.

CHIEF OF DETECTIVES' Winter 81 issue has a cover photo of the bloody corpse of a female murder victim and boasts the features: *Bound Raped and Sodomized*, *Rural Teen Forced into Sex Ring*, *Exposed: Torture for Sale*, *The Elderly: Victims of Young Punks*, *Rapist Shot to Death*, *Sex-Starved Madman*, and more.

THE UNTOLD STORY OF THE JONESTOWN MASSACRE

☐ This instant magazine, published by Histrionics Publications and Adrian B. Lopez, hit the stands only a couple of months after the tragedy at Jonestown. Similar to the above mentioned Son of Sam mags, it is a time capsule/collector's item of the late seventies. The caption on the cover for the larger pic of Jim Jones reads: "Jim 'Dad' Jones…The speed freak who played god." For Congressman Leo Ryan, it reads, "The do-gooder who came to a tragic end." The other pics that make up the cover are of Larry Layton ("charged in eight counts of murder"), Jacqueline Speier ("Congressman Ryan's aide who survived

her gun wounds"), the Jonestown dead and the corpse of Jones.

THE UNTOLD STORY OF THE JONESTOWN MASSACRE contains many rare photos and is a must for anyone interested in the Jim Jones story.

"Rape of the Innocents" is the banner blurb above the title of the mag. The insides are printed on newsprint and there are many typos in the text, but nevertheless it dispenses interesting info and photos. The mag contains six features and a list of the 914 names of those who died at Jonestown, Guyana on November 18, 1978.

The first section, *Death Strikes Swiftly in the Guyanese Jungle*, relates the causes

that led to fifty-three year old Congressman Leo Ryan's ill-fated trip to Jonestown. It details the guarded first contact Ryan had with Jones upon arrival, and the subsequent weird visit at the commune in the jungle, during which notes from a handful of the commune's residents reached Ryan asking him to take them with him when he left. This was the beginning of the end as it caused Jones much concern and paranoia. The tale of the Congressman taking sixteen members of the cult with him and the slaughter at the Port Kaituma Airport which precipitated the mass suicide is recounted. One of the most curious facts is that Jones' lawyers, Mark Lane (**Rush to Judgement**

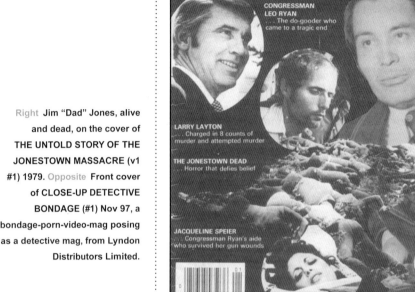

Right **Jim "Dad" Jones, alive
and dead, on the cover of
THE UNTOLD STORY OF THE
JONESTOWN MASSACRE (v1
#1) 1979.** Opposite **Front cover
of CLOSE-UP DETECTIVE
BONDAGE (#1) Nov 97, a
bondage-porn-video-mag posing
as a detective mag, from Lyndon
Distributors Limited.**

**CLOSE-UP DETECTIVE
BONDAGE**
No 1 Nov 1997
Harmony Concepts, Lyndon
Distributors Ltd., 15756 Arminta St.
Van Nuys, CA 91406 9.00 48pp

1966) and Charles Garry (who defended both Huey Newton and Angela Davis), were allowed to escape into the jungle so as to be able to tell the world what had really transpired at Jonestown. Lane had been hired by Jones because he believed Lane's theory that the CIA were behind the Kennedy assassination—he wanted to prevent the CIA from infiltrating Jonestown. It has been speculated by others that what happened at Jonestown was part of MK/ULTRA, the CIA's mind control experiment gone awry.

Master of Coercion and Perversion: Jim 'Dad' Jones—Both God and Devil to his Followers is the second section and reports on Jones' bisexuality, general horniness when it came to his congregation, and his sadistic streak. It goes into his childhood and his mischievous reputation with the townspeople of Lynn, Indiana, where his parents raised him. His father had been a member of the Ku Klux Klan and died when Jones was fourteen. Jones parallels Manson in many respects: the god/devil duality he represented to his cult, his roles as beneficial father and stern father, and his control over the commune's sex lives, which included Jones having sexual relations with both male and female cultists. A favorite expression of the Jonestown cultists: "Dad knows best."

'Hurry! It's your time to go!' is reportedly what the guards told the befuddled followers as they helped forcefeed them poison, according to Stanley Clayton, a twenty-five year old cook who escaped into the jungle. The section is made up of statements from survivors of the mass suicide, including cultists and reporters alike.

Life at the People's Temple: Be Sure to Leave Poison within Reach of Children relates Jones' history of "punishing" transgressors, usually with torture and humiliation. The children were not exempt from abuse at the hands of Jones' goons either, in spite of a pamphlet advertising Jonestown which read: "... the laughter of children rings through the air. Our children are our greatest treasure." But when the time came for Jones to orchestrate the mass suicide he reportedly ordered, "Bring the babies first," which they did, and poison was squirted down the infants' throats with syringes. This piece explains that one of Jones' main reasons for the move to Guyana was that he could keep his flock under tighter control as they had no place to escape except the jungle.

Of the six chapters in the mag the most interesting for me is *Can it Really Happen Again?—Cults are Thriving on the American Scene.* The piece starts out with a photo of a grinning Charles Manson, and includes pics of a Satanic ritual in Louisville, Kentucky; Father Divine, whom Jones had met and fashioned himself after; a Unification Church rally in Washington, DC; five members of the Fountain of the World cult in Chatsworth, California, including Peter Kamenoff (one of the two men who blew the cult sky high); and rattlesnake-handling fundamentalist Christians. It ends with another pic of Manson being escorted by an officer of the LAPD down one of the halls of forever.

Could Jonestown have been Prevented? compares the Jonestown suicides with the Jewish Zealots of Masada in 73 AD and the suicide of Japanese civilians who jumped from the cliffs of Saipan as US troops neared

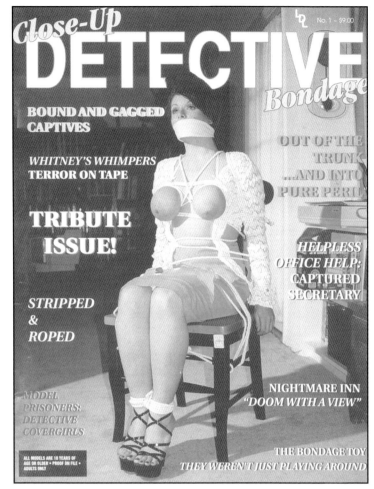

at the close of WWII. But the main gist of the article is whether or not the US government could have somehow prevented the mass suicide at Jonestown. The similarities between the People's Temple and other cults (Aimee Semple McPherson's Church of the Foursquare Gospel, the Children of God, Jehovah's Witnesses, the Amish, Mennonites, and even the Mormons with their Church of Latter Day Saints) are also examined.

The List on the last two pages is the names of those who died in the mass suicide as released on December 17, 1978 by the US State Department, and is divided into two categories—"Kin Were Not Notified" and "Kin Were Notified." Given are the names,

ages, states of birth (when known) and the last known town of residence.

CLOSE-UP DETECTIVE BONDAGE

☐ Whether the bondage mags influenced the detective mags, or vice-a-versa, is hard to say. If anything, it was probably a mutual admiration. In the late sixties and throughout the seventies the covers of a lot of the sleazier true crime detective mags heavily used photos of bondage and the simulated torture of women on their covers. These types of true crime detective magazines command

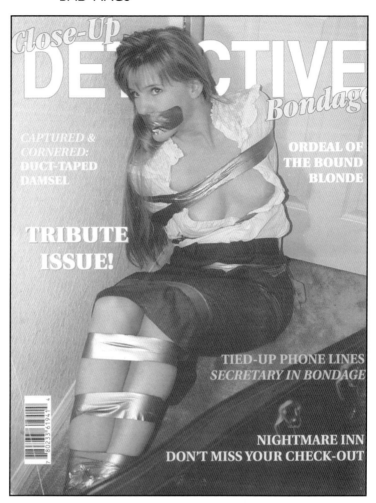

high prices with collectors of back issues these days, as well as with aficionados of B&D. **CLOSE-UP DETECTIVE BONDAGE** is a B&D porn version of those detective mags, verifying that "imitation is the sincerest form of flattery."

Resembling a detective mag, **CLOSE-UP DETECTIVE BONDAGE**, is of course a bondage mag, which features stills from bondage videos for sale through ads in the mag: Videos with titles like **Detective Covergirls**, **Out of the Trunk**, **Captured & Subdued**, **She Asked For It**, available from Close-Up Concepts, Inc., in L.A.

Detective Bondage Fantasies, the title of the statement at the beginning of the mag, reads, "A successful relationship is maintained and strengthened by honesty, willingness to share, and the ability to laugh and play together. Sexual fantasy and role-playing require communication, listening, and sharing of personal secrets....The journey of intimacy is empowered by open-minded sexual exploration."

The layouts are several pages each and mostly photos, in both b&w and color, from the videos, with a few sentences on the scenario running along the top of the pages, presented as "cases". The first one, **The Bondage Toy** for example, has been summed up in four sentences; it reads, "Innocent Tina was handcuffed, blindfolded,

tape-gagged, and forced into the car. Bryan and his gal Angel drove Tina to their hideout. When Angel dropped her guard, Tina tried to escape! Bryan, displeased, tied up both captive and cohort. All was forgotten as Angel and Tina explored sensual bondage with each other. CASE CLOSED;" in other words, you get bondage pics and lesbianism.

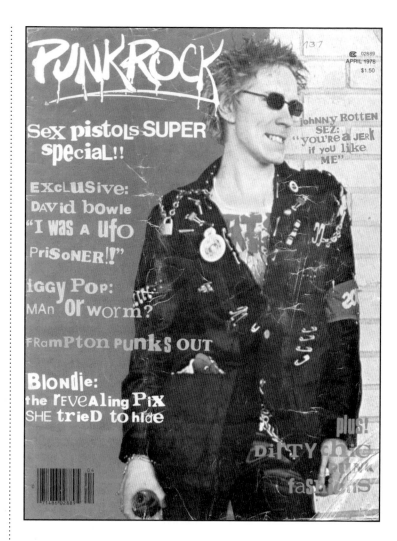

LATE IN 1975 A SMALL HANDBILL was pasted all over the Lower East Side and Greenwich Village announcing, "Watch Out! Punk is Coming." *Punk* magazine launched their first issue from the Bowery in NYC in January 1976, and it was the first, best, and therefore seminal magazine—or more appropriately zine—for what could loosely be called a "movement."

The New York Rocker premiered two weeks later, a local NY rock tabloid that was the brianchild of Alan Betrock, and one of the earliest publications to chronicle the punk scene on the Lower East Side of NYC. Betrock had produced an early demo for Blondie before the band signed with a major label, and also published *The Rock Marketplace*, a tabloid for collectors of rock memorabilia. As Shake Books in Brooklyn, Betrock wrote and published zines and books on cult magazines, sleazy tabloids and pop culture of the 1950s and sixties, all of which were inspirations for *Bad Mags*.

Punk magazine was published sporadically until 1979 when it went belly up with issue #17. John Holmstrom, *Punk*'s editor, went on to become the editor/publisher of *High Times* after the suicide of Tom Forcade, *High Times* founder and ardent supporter of *Punk* magazine. Holmstrom also published a great, but shortlived, rock gossip mag in the early nineties called *Nerve*, that had *Punk* magazine's "resident punk" Legs McNeil on board again as editor-in-chief. *Nerve* had the same sort of irreverent punk feel to it as the original maverick *Punk*. *Punk* has been well covered elsewhere, and is undoubtedly familiar to most reading this, and didn't even cash in on itself. In recent years *Punk* has had a compilation volume of material published in book form, and in 2001 issued an anniversary issue—*Punk* v2 #0. *Punk* magazine seems to be back, and on a regular schedule, as in 2007 they published issues #19, #20, and #21.

Also a part of the times were the punk rock "specials" published by Myron Fass and edited by Jeff Goodman, mags such as *Super Rock* and *Punk Rock*. Many of the staff that helped Goodman put these satiric pulp versions of *Punk* magazine together became well known later on in their own right, such as writer Michael Musto and photographer Ebet Roberts. Goodman himself went on to edit and write for many adult girlie mags such as *Velvet*, *High Society*, *Beaver*, *Screw*, *Sluts & Slobs* and *Penthouse*.

The punk attitude could be likened to the anarchic antics of Bugs Bunny, Woody Woodpecker or Heckel & Jeckel, married to garage band musical tastes and talent. It was something that had really started a few years earlier with the release of Patti Smith's *Piss Factory* (Jun 74) and Television's *Little Johnny Jewel* on independent 45rpm singles. The Dictators, a Bronx band led by the charismatic Handsome Dick Manitoba, released what is in my memory the first punk album, *The Dictators Go Girl Crazy* in mid 1975. Then, Smith's debut album, *Horses* in late 1975, exposed punk to the public at large. In 1976 the Ramones' first LP was released on an apathetic rock world, and the publication of *Punk* magazine both helped give it a name and gain followers on both sides of the pond.

Basically, you either loved it or hated it. The mainstream musical media picked up on it by 1977 because of the outrageousness associated with the Sex Pistols and the English punk scene. A year later it became almost fashionable, the nemesis of established rock and the disco fad. Or, to quote from the fairly perceptive article in the below mentioned *Punk Sex*:

Within a few years, punk had been legitimized by feature pieces in Time and Newsweek. It was chic, it was 'in,' it was a salable, profitable commodity. And don't think nobody noticed! No, siree. Ask anyone who shops at Bloomingdale's or Macy's. Punk started out in the streets, but it ended up mutilated between the glossy pages of slick fashion magazines.

Which is interesting, as some of the mags mentioned below have their own "punk fashion" pages.

Rock'n'roll, fashion, and porn seem to have gone hand in hand in the past few decades, so punk also showed up as a theme in porn mags, just as disco was to be found in the titles and themes of hardcore porn mags back then. Punks in porn is sort of ironic because a lot of punks, for the most part, claimed boredom with sex or asexuality, in spite of their usage of bondage gear, which was introduced through the English punk scene via Vivienne Westwood and Malcolm McLaren's shop, Sex.

The article in *Punk Sex* also attributes the NY punk scene, specifically Blondie and Annie Golden of the Shirts, with being more sexual than the English. In any case, it put dollar signs in the eyes of certain publishers on the lookout for something to grab hold of to churn out another magazine.

Here, I focus on the "punksploitation" mags published by Fass and others to make a profit, using the word "punk" and what they perceived to be the look of punk. They knew that the actual punks on the scene probably weren't the main audience they were selling to anyway. This is not to say that these magazines didn't hire some people on the edge of the punk milieu to write for them, hiring college kids who would work cheap and get a chance to see their names in print.

These types of mags were published into the early eighties, by which time punk had been digested by the mainstream and was shit out as a parody of itself, a stereotype.

**Page 538 Excellent cover on
PUNK ROCK (v2 #2) Apr 78, a Fass
published and Goodman edited title.
This page, above New York Dolls
on the cover of ROCK SCENE
(v2 #1) Mar 74. Opposite, from
top SUPER ROCK (v1 #2) Aug 77
featured the Dead Boys on its cover.
Inside they appeared in the non PC
photo set, *The Dead Boys starring
in Abduction!!* The first issue of
SUPER ROCK had Peter Frampton
on its cover.**

ROCK SCENE
Vol 2 No 1 (sixth issue)
Mar 1974
Four Seasons Publications,
Inc., Fairwood Rd., Bethany, CT
06525 .75 84pp

SUPER ROCK
Vol 1 No 2 Aug 1977
Modern Day Periodicals Inc., 257
Park Ave. South, New York, NY
10010 1.95 100pp

ROCK SCENE

❑ Until the early months of 1976 when Holmstrom's **PUNK** and Alan Betrock's **NEW YORK ROCKER** tabloid appeared on the scene, the main rock mag to regularly feature photos and items on the early punk bands and CBGB scene was **ROCK SCENE**, which premiered in Mar 73 with Bowie on the cover. It was one of the few rock mags in b&w and printed on newsprint between glossy color covers. When punk became a media phenomena between 1977–79, **ROCK SCENE** had featured covers with the likes of the Ramones, Television, Patti Smith, Keith Richards, and Iggy Pop.

ROCK SCENE billed itself on its cover as "The Alternative to the Alternatives," and they weren't lying. Its editorial offices were located in NYC, even though the publisher was in Connecticut and the staff boasted none other than Richard and Lisa Robinson as managing editor and society editor, respectively. The staff photographer was Lee Black Childers and together they put out one of the hippest on-the-scene mags to chronicle the infancy of punk rock in the Bowery of New York.

ROCK SCENE's Mar 74 issue is a prime example of what it was about, and as far as I know was the only appearance of the New York Dolls on an American magazine cover while still an active band. There is also coverage of Iggy and the Stooges, as well as the Dolls, and articles on Bowie, Lou Reed, Wayne County, and the back room at Max's Kansas City, mixed in with articles on more commercial bands.

In the *More New Bands* section the intro blurb says: "We've said before that New York City recently has been like Liverpool in the mid-1960s, or maybe Rome before the Fall…" There are four bands featured, including Kiss, who went on to superstardom. Another, Twisted Sister, a local band from Long Island, eventually had a moment in the limelight with their We're Not Gonna Take

It rock-angst anthem over a decade later. The two more obscure bands featured are Street Punk and The Harlots of 42nd Street. Street Punk, who had played Max's and the Mercer Arts Center, looked like straightlaced guys with long hair. The Harlots, on the other hand, looked like a tarty imitation of the New York Dolls.

So **ROCK SCENE** helped set the stage for magazines like **SUPER ROCK**, below, and even **PUNK** magazine itself.

SUPER ROCK

❑ **SUPER ROCK**'s first issue sports a full cover pic of Peter Frampton, but **SUPER ROCK** v1 #2 is dubbed a "Special Punk Rock Issue" on its cover. The mag was unleashed from 257 Park Avenue South with Myron and Irving Fass publishing, and Jeff Goodman as editor, under the Modern Day Periodicals name. It was the precursor of **PUNK ROCK**, which came from the same publisher a few months later, although **PUNK ROCK** would be minus the top forty type features carried in **SUPER ROCK**. Some of the magazine's staff—Jeff Goodman, Perri Chasin, Hannah Spitzer, Glenn Brown, and Ebet Roberts—would also pop up again in **PUNK ROCK**, mentioned below.

I bought this mag off the rack when it came out and was surprised to see on the "Editors Page," below a photo of Jeff Goodman holding a picture of Fatty Arbuckle, a photo of two girls, one of whom had been in my college art classes the previous year. This seemed to be a non sequitur, as the purpose of the pic was not revealed in the caption or editorial. Recently, when questioning Goodman about these magazines, I asked him about that picture. It was interesting to find out the girl in question had been Goodman's girlfriend at the time and that he had a habit of putting pictures of his current squeezes into the various mags he worked for, undoubtedly to impress them.

SUPER ROCK was a thick mag and was

all b&w on newsprint except for the center section which contained sixteen color pages on slick paper. Undoubtedly Fass realized he couldn't compete with the all color, slicker rock mags that dealt with the more popular rock acts, so he decided to go with the punk fad, which seemed more suited to the newsprint format. The cover was not far removed from the cover of **PUNK SEX**, an adult slick mentioned below. Here, the cover features the Dead Boys menacing a punkette, with an inset pic of Willy and Mink DeVille. The articles inside are an incongruous mix of punk acts such as the Dead Boys, Television, the Ramones, and Iggy Pop, alongside popular acts of the day like Linda Ronstadt, Natalie Cole, Lynyrd Skynyrd, Fleetwood Mac, Bay City Rollers, and so on. Maybe they weren't yet sure if an all punk issue would sell well.

The color section starts off with a full page pic of a crazed looking Keith Moon wearing a Nazi uniform, leaning on a wasted Joe Cocker, also wearing a Nazi cap. The color section continues with split page pinups of Peter Frampton, Keith Richards, Linda Ronstadt, Debbie Harry, Ian Anderson, and others. This is followed by six pages, in color, of a layout entitled, *The Dead Boys: Starring in Abduction!!*, with photos by Glenn Brown, also responsible for the cover pic. It starts out with the band threatening a streetwalker with fists and a stiletto. Turn the page, and they are on stage belting out one of their tunes, and on the last two pages are joined on stage by the streetwalking punkette, minus some of her clothes.

One of the better pieces in the mag is a six page feature called *Photos from the Underground—A Portfolio of Photographs from the Underbelly of New York* by Ebet Roberts, who also supplied the Mink DeVille inset pic on the front cover. The WeeGee/Diane Arbus feel and look of these portraits—in b&w on pages with a black background—make them stand out from the rest of the mag: they capture the moment perfectly. After chronicling the CBGB punk scene, Roberts went on to

become a noted professional photographer, taking portraits of such influential artists as Bob Marley, Bob Dylan, Iggy Pop, Miles Davis, REM, The Cure, etc.

Even though this mag was some kind of weird hybrid of a punk magazine crossed with popular rock acts that seemed diametrically opposed, it had value in that the articles and interviews were unique, and the better known bands of the day helped put the punk bands in context, and vice versa, producing a more rounded picture of what was going on back then.

Above **Debbie Harry of Blondie on
the cover of PUNK ROCK (v2 #1)
Feb 78.** Opposite, from left **PUNK
ROCK spoof of a Harvey Kurtzman
MAD magazine ad; Patti Smith
feeling herself on the cover of
PUNK ROCK (v1 #1) Dec 77.**

PUNK ROCK
Vol 1 No 1 Dec 1977
—Vol 2 No 2 Apr 1978
Stories, Layouts and Press Inc., 257
Park Avenue South, New York, NY
10010 1.50 68pp

PUNK ROCK

☐ The cover logo of **PUNK ROCK** was a close approximation of the logo of John Holmstrom's original **PUNK** mag. Obviously good old Stories, Layouts and Press were trying to tap the trend and snare the unwary who might have thought this was Holmstrom's mag because of the similar logo. Even though Myron Fass was at the publishing helm, editor Jeff Goodman was really the genius behind the mag. Goodman explained that he and others had seen some bands at CBGB and other clubs, thought the fans worshipping these "idiots" were a good source of humor, and decided to give them a mag that was part tongue-in-cheek, part on-the-scene reporting.

PUNK ROCK, make fun of themselves while pointing the finger at others, with a cartoon in v2 #2 that parodies the original Harvey Kurtzman, "Don't Buy Imitations" ad from the back of **MAD** comics. The full page cartoon, opposite the editorial, depicts a newsstand with the obligatory cigar-chomping, tattooed news dealer taking money from a kid who clutches a copy of **PUNK ROCK**, the stand filled with magazines bearing the titles: **GOOD PUNK**, **BAD PUNK**, **SUNK PUNK**, **MONK PUNK**, **PUKE PUNK**, **PUNK SOCKS**, **PUNKY PUNKS**, and so on, with one oddly enough just called **PUNK**! The caption reads, "Kids: Beware of imitations!!! Buy only the geniune [sic] **PUNK ROCK**!" I can't say whether "geniune" is misspelled on purpose so as to imply it wasn't the genuine punk mag, or merely a typo. The cartoon is signed "Hurvey Klutzman '57."

PUNK ROCK was printed in b&w on newsprint except for eight pages of color pin-ups in the center. The first issue (Dec 77) had features on the Sex Pistols, Dead Boys, Blondie, Devo, DMZ, Television, The Stranglers, Flamin' Groovies, an interview with Patti Smith, and a "Fireside Chat" between Iggy Pop and Hannah Spitzer, amongst other features.

The most prevalent design elements throughout the mag are ripped edges, fingerprints, pins, needles and safety pins. The type styles used are the ransom note jumble of type and stencil; in many cases the titles to layouts are hand lettered in another attempt to mimic the totally hand lettered Holmstrom mag. The editorial is also hand lettered and promises to bring you, "the nastiest pictures, the hottest features, and all the punk trash we can haul out…," and also offers an undetermined prize to anyone who sends in a picture of the "rattiest outfit." The gossip/news section, after the editorial, is *Needles and Pins* by Paul Reitz, and dishes the gossip on NY bands and CBGB.

The feature on Television is an interview of sorts conducted by David Koepp with Tom Verlaine in which the magazine interviewing him is referred to as **SUPER ROCK**, so it might be something that had been slated for a future issue of **SUPER ROCK**, which then turned into **PUNK ROCK**, or just a **SUPER ROCK** leftover.

The first issue ends with its strangest act, the little known and fast forgotten Skafish. The name came from the last name of the band's singer-songwriter, Jim Skafish. The blurb under the title: "Here's a thoroughly disgusting little piece of business that passed over our desks. We've been saving it up just for you!"

Then a name/birthday/favorites list follows for each of the five band members, Skafish's being the only one of any interest:

Born Aug 29, 1956; Instruments are piano, voice and guitar; Favorite TV shows are **Mass for Shut-Ins** *and* **Roller Derby***; Ambition is to fulfill all his needs and desires regardless of the outcome. To have many hit singles and be featured in* **16 MAGAZINE***; Favorite colors are paisley and stewardess plaid; Hobbies are grocery shopping and gardening; Favorite foods are pizza and cake; His childhood memory is hearing his parents*

KIDS! BEWARE OF IMITATIONS!!!
BUY ONLY THE GENUINE PUNK ROCK!

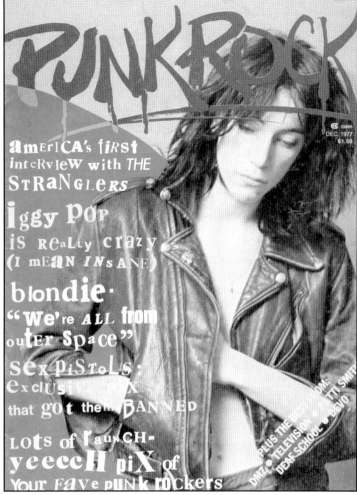

complain because he wasn't popular or on the football team; Favorite clothes babushka; Former occupation is dressmaker; Musical influences are Johnny Mathis, Lesley Gore, Johnny Ray, Connie Francis and Little Richard; Favorite sport is soccer; His idol is Little Richard; Family background of no father figure—an overbearing mother—one older brother who is a doctor—one older sister who is married; Has no friends.

PUNK ROCK's second issue (v2 #1 Feb 78) sports a Debbie Harry/Blondie cover and the inside front cover advertises Beatle magazines published by Countrywide Publications. The mag starts with an editorial thumbing its nose at the readers, and the competition:

Ha, Ha, Ha…You spoiled rotten brats! So, you think you're "PUNKS", do you? Well, you can take all this "NEW WAVE" crapola and SHOVE IT! That's right! SHOVE IT UP YOUR ASSES! You are now a punk with $1.50 LESS in your pocket. Now you can't buy DRUGS with your father's hard earned dough for another day…and WE go

out and eat and smoke stinky cigars! And oh yes, all you little girly punkers…Why doncha come up here and DO SOME STUFF…Huh? And as for our competition, you DUMB ASS J.H. who's no doubt reading this right now…you're mag stinks and that's why it don't sell.
THANKS A WHOLE LOT, you all, and go out and punk till your eyes fall out! Ha, Ha, Ha! —The EDITORS

How to be a Punk: A Complete Guide for the Meek by Hannah G. Spitzer is subtitled: "From gold lame pedal-pushers to the correct placement of safety pins, Hannah helps

you put your newfound punkdom together perfectly!!" It comprises fashion do's and don't's for punks, and was reprinted in the **PUNK ROCK SPECIAL** below.

Learn to be a Punk at Home in your Spare Time by Robert Romanoli is a four page feature that really looks like the layouts in Holmstrom's **PUNK** magazine: a neatly hand lettered mixture of photos with word balloons, comics, lists, diagrams, etc. It starts with a parody of "The Insult That Made A Man Out of Mack" ads that ran in the back of numerous comics and mags, with the beach bully kicking sand in the face of a wimpy guy, only here it was "The Insult That Made A Punk Out of 'Runt'"; the

Above *Punk Fashions* from PUNK ROCK. Right Debbie Harry and Andy Warhol pin-up from PUNK ROCK. Opposite PUNK ROCK SPECIAL JOHNNY ROTTEN AND THE SEX PISTOLS (v1 #1) Spring 78.

CHERI
Vol 2 No 6 Jan 1978
Cheri Publications, Inc., 208 East 43rd St., New York, NY 10017 1.95 100pp

PUNK ROCK SPECIAL JOHNNY ROTTEN AND THE SEX PISTOLS
Vol 1 No 1 Spring 1978
Stories, Layout and Press Inc., 257 Park Ave. South, New York, NY 10010 1.50 68pp

sand at the beach replaced with spilled beer at CBGB.

There are two articles by Michael Musto, *Blondie: the Bombshell with Style* and *The Spirit of the Sex Pistols*. Musto now writes a NYC gossip column for **THE VILLAGE VOICE**.

There are articles on the Dictators, Devo, Iggy Pop, The Jam, Sirius Trixton and the Motor City Bad Boys, the Weirdos, Mink DeVille, Voidoids, Sylvain Sylvain and more! It is interesting to note the cover and contents list an article on the Criminals not in the magazine. It seems to have been replaced with a four page comic strip written by Jeff Goodman and drawn by Ned Sontag, basically an ad for "Handsome" Jeff Goodman, editor-in-chief, to meet girls. The back cover is the same "Punk Rock T-Shirts" ad found in the back of **PUNK ROCK STARS** (page 547), but with a different address.

The third issue of **PUNK ROCK** (v2 #2 Apr 78), has an extremely toxic looking Johnny Rotten on the cover. The renamed gossip/news column by Hannah G. Spitzer, is now called *Nocturnal Emissions (she only comes out at night…)*. This is followed by features with titles like *Wreckids and Stuff, Sex Pistols Squirt, Eddie and the Hot Rods*

get Totaled, David Bowie—I was a UFO Prisoner, Iggy Pop—Man or Worm?

One of the pin-ups depicts a member of the Dead Boys, only a NY heartbeat away from burning the bare butt cheek of a groupie with a cigarette. Another pictures Stiv Baters with a fly on his outstretched tongue, posing with a strip of very used flypaper. In the section called *New Wave On Vinyl!* (a record review of **New Wave**, a compilation album of tracks from the popular punk/new wave acts), a picture appears of the two women from the *Groupies Revenge* layout in **PUNK SEX** (see page 549)! What this means, if anything, I don't know.

The *Punk Fashions* feature in the issue is "favorite photog" Glenn Brown at the Manic Panic punk boutique on St. Mark's Place, with pics of owners Snooky, Tish and Gena.

These secondary punk mag efforts are of interest to anybody into the heyday of the punk phenomenon. In spite of their look and rips from the original **PUNK**, they stood on their own.

CHERI

☐ **CHERI**, another New York based girlie mag like **HIGH SOCIETY**, took advantage of the burgeoning punk scene by finding good looking punkettes willing to pose in semi-nude layouts, Bowie publicist and rocker Cherry Vanilla being an example.

"Nude Punk Superstar: Meet Tish of the 'Insalubrious Intercourses'" is how the cover blurb deals with the name of the punk band the Sick Fucks; the article inside is *Tish is a Sick Fuck.*

Tish and her sister, Snooky Bellomo, were the entrepreneurial proprietors of the Manic Panic boutique in New York City, opened in 1977. It was a place where fashion conscious punks could acquire unique clothes to show off their non-conformity. One of their unique fashion statements at the time was a ".44-Caliber Killer" t-shirt which featured bullet holes, blood stains, a note from Son of Sam reproduced on the front, and the message "Cops: .44 Killer Is Taunting Us."

Before joining the Sick Fucks as "Fuck-ettes," the Bellomo sisters were backing singers for Blondie and had been singing since their early teens. Tish and Snooky eventually started selling their hair coloring and cosmetic products under the brand name Manic Panic; the East Village shop closed down and morphed into a warehouse in Queens.

In this article the writers Michelle Craven and Elda Stilletto are in the audience as they await the Sick Fucks' appearance on stage at CBGB. Dick Manitoba, frontman for the Dictators, announces the Sick Fucks' arrival to the stage and they are off and running with songs including Fags On Acid, Chop Up Your Mother, Jerk-Off Blues, My Baby Needs A Teenage Abortion, and their hit Ride The New Wave, which was filled with profanity, a challenge to record company execs who might want to sign them. The Fuckettes dressed up as nuns wearing nylons, garters, and veils with swastikas on them while

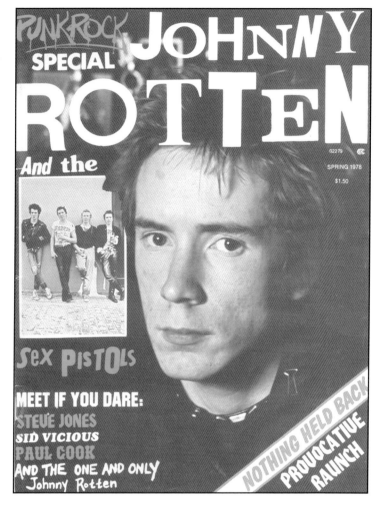

wielding props such as coat hangers and toilet plungers. The key to the Sick Fucks' act was comedy, according to Tish who is quoted in the piece, claiming that most of the Bowery bands lacked a sense of humor and took themselves too seriously.

PUNK ROCK SPECIAL JOHNNY ROTTEN AND THE SEX PISTOLS

☐ A special issue of the above **PUNK ROCK** mag was devoted to the notorious Sex Pistols, who by 1978 had eclipsed all other punk bands as far as general notoriety

went. 1978 was the year of the Sex Pistols American Tour (January 5–14) that ended in a fiasco in San Francisco, after which the band called it quits. Tom Forcade, then editor of **HIGH TIMES** magazine, went on the tour with producer/director Lech Kowalski and a film crew to capture its chaotic highlights and lowlights for posterity. The documentary film was released as **D.O.A.** (1981) with a tacked-on interview with Nancy Spungen and Sid Vicious, in the throes of a junkie twilight zone at the Chelsea Hotel in NYC, not long before Spungen's murder. (Vicious, wearing a Nazi flag t-shirt, repeatedly nods out with lit cigarettes, which he drops on himself and Nancy.)

From top **There is no mention of the Sex Pistols' US tour in the Sex Pistols PUNK ROCK SPECIAL; Full page ad for the Fass/Goodman illustrated sci-fi mag GASM.** Opposite **Stiv Bators doing two things at once. All pages from PUNK ROCK SPECIAL Spring 78.**

PUNK ROCK STARS
Collector's Issue No 8
Jul 1978
Ideal Publishing Corp., 2 Park Ave.
New York, NY 10016 1.50 68pp

Dated Spring 78, **PUNK ROCK SPECIAL** is copyright 1977, and whether it came out before or after the Sex Pistols' US tour I don't remember. It doesn't mention the tour anywhere in it, and a good portion is reprints of Sex Pistols articles from **PUNK ROCK** mentioned above.

The staff banner says that the "perpetrators" that put this mag together are as follows:

> Myron Fass [Publisher]
> Irving Fass Assoc Publisher [Myron's brother]
> Jeff Goodman [Editor-in-Chief]
> Hannah G. Spitzer [Editor]
> Dave Fass Assoc Editor [Myron's son]
> Clare Ultimo [Designer]
> Shirley Barland [Production Director]

In the editorial the Sex Pistols are described thus:

> *In case you don't know...the Sex Pistols are a new band from England, where everything is falling apart. Ever since the Blitz, the economy there's been on the downslide, and weirdness and maniacs have been breeding and increasing.*
> *Besmeared with vomit, dripping with obscenity, and talking about anarchy and everything else, the Sex Pistols are the newest thing this side of Armageddon. They're the model for almost all the other punk groups on both sides of the Atlantic.*
> *The Sex Pistols...images of exploding orgasms...slime...decadence and decay. They say they don't like all the publicity that they just want to play. This is something that's debatable, but you can be sure that they're not the Beatles. This new British invasion is something else altogether.*

The first five articles are titled *Who are the Sex Pistols?*, *Johnny Rotten: Rotten to the Core*, *Sid Vicious: You're so Vicious*, *Paul Cook: The Master Beater*, and *Steve Jones: The New Load*, and seem to have been written by an uncredited Jeff Goodman, as he mentions being the editor of **ACID ROCK** magazine at one point. The Sex Pistols are associated with **A Clockwork Orange** more than once in these articles, as the Rolling Stones were before them. Some of the captions for various photos of Sid Vicious are pretty funny, such as, "Sid Vicious: He looked like an idiot," and "Sid Vicious can't play bass for shit."

In the middle of the mag is a twelve page feature called *Anarchy in the UK*, which looks like someone's punk scrapbook pages, with photos of the Pistols and others, and handwritten captions on ripped paper strips. In actuality, it is the reproduced cover and pages of a UK punk zine of the same name.

Other articles in the mag are reprints from the previous **PUNK ROCK** mags: *Letter to the Colonies* by Perri Chasin, a report from the UK by the punk club hopping Chasin; *How to be a Punk: A Complete Guide for the Meek* by Hannah G. Spitzer who also wrote for girlie mags like **HIGH SOCIETY**; and *The Spirit of the Sex Pistols* by Michael Musto.

The only ad in the mag is a one page subscription ad for **GASM**, an illustrated sci-fi sex comix mag from Stories, Layouts & Press. Some of the copy reads: "**GASM** is a fantastic new comix magazine with the most brilliant stories and artwork that's ever been printed." And "It's sexier, weirder, more stupendous than any other!" The address given is 257 Park Ave. South, 12th floor, the kingdom of Fass!

So these slapped together, mostly newsprint mags actually did capture the feel of punk to a certain degree: printed on the cheapest newsprint available and looking rather unprofessional compared to **PUNK** magazine's better designed effort, on heavier, higher quality paper.

PUNK ROCK STARS

☐ **PUNK ROCK STARS** fits firmly into the punksploitation category, but mercifully doesn't try to look punk by incessantly using the stereotypical ransom note type. I'm pretty sure that the rest of this "Collector's Issue" series, of which this was #8, were not punk issues. **PUNK ROCK STARS** is short on text and heavy on pics, mostly in b&w with some color pin-ups, and printed on glossy paper. The features are one and two pages with photos and a few short paragraphs on the bands. Again, there is a four page *Punk Fashion* feature.

VIBES magazine, another "Hot New Magazine" from Ideal Publications, is advertised in the back. Ideal also published numerous low-end women's mags, like **MOVIE LIFE** and **PERSONAL ROMANCES**.

One of the funniest pieces in this mag is a two page feature called *Punk Etiquette* with a list of ten punk "Do's & Don'ts!" This is accompanied by three photos, one a much reproduced pic of an English punk wearing shades, sticking out his tongue and sporting a large safety pin through his cheek. This now seems passé with the current fad of piercing every available body part, but back then it still had shock value.

DO'S:
1. A punk does just about anything he or she feels like doing.
2. A punk drinks just about anything available, but prefers beer.
3. A punk puts other people in their place—and is not particularly polite about it.
4. A punk dyes his or her hair. Red is the best dye because it resembles blood.
5. A punk wears T-shirts, black leather jackets, sneakers, and torn clothing. A female punk might check out a short, tight skirt with a rip up one side.
6. A punk knows how to say 'no' and says it quite frequently.

7. A punk hangs out wherever he isn't thrown out.
8. A punk knows how to pogo.
9. A punk puts on plenty of eye makeup for special punk occasions.
10. A punk prefers punk company.

DON'TS:
1. A punk does not ask his mother for clean clothes or an allowance.
2. A punk does not take his little sister out.
3. A punk does not carry a comb or have much use for a toothbrush.

4. A punk does not ask who The Brats are.
5. A punk doesn't play the jukebox in a bar: he makes his own music.
6. A punk does not get pushed around: he does the pushing himself.
7. A punk does not "date"; he hangs around until the right chick happens by.
8. A punk doesn't call in sick—he crawls in sick, that is, if he has a job in the first place.
9. A punk does not buy records unless he plans to chuck them out the window.

The Voidoids:
Richard Hell's Hot Rock Dream

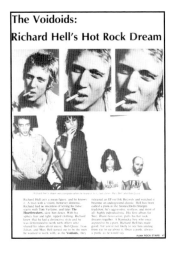

Blondie

Sex Fantasies Of A Hot Punk Mama

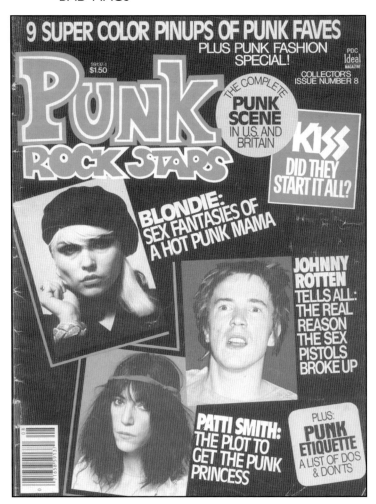

Above and Right **Voidoids and Blondie articles from Ideal Publishing's PUNK ROCK STARS Collector's Issue #8 Jul 78.** *Opposite, from left* **More *Punk Fashion* and a bizarre t-shirt ad from the pages of PUNK ROCK STARS.**

PUNK SEX
Vol 10 No 1 Summer 1978
Maverick Publishing Co. Inc.,
Wilmington, DE. Distributed by
Parliament News 4.50 48pp

10. A punk doesn't pretend he's having a good time: if he is, he groans loud.

My only question is, who the hell were The Brats? The above typifies the idiocy of what was written by some, even though it had to be tongue-in-cheek, or safety pin in cheek as the case may have been. One "don't" they seem to have overlooked is—punks don't waste time making "do's and don'ts" lists.

There is also a half page of book reviews in this mag called *Punks in Print*. This comprises a short description of two then current books: **1988—The New Wave Punk Rock Explosion** by Caroline Coon, and **Punk** by Glenn O'Brien. It starts out with this little quip: "Although most punks are too busy doing nothing to pick up a book and read, a few punks have discovered that a couple pages of a good paperback go down quite well on occasion."

The magazine's ads are for "The Magic Power of Witchcraft", "Super Groups Super T-Shirts", "Poster Riot", "Ready To Use Mystic Chants", "Star Wars T-Shirts", "Automatic Mind Command", "The Official Teen Star Directory" and "Punk Rock T-Shirts," all of which have Ideal House order coupons. Talk about in-house!

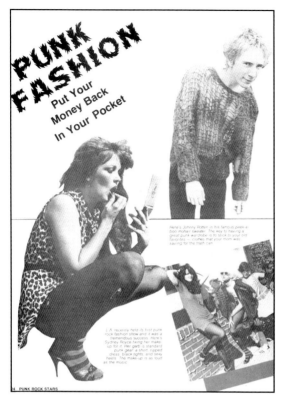

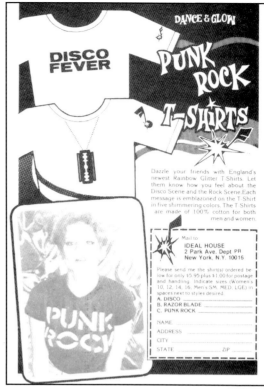

PUNK SEX

☐ This adult slick is interesting for a couple of reasons; it was published at the peak of punk's popularity and some of the photos, and the one article, actually refer to real punk bands and places such as CBGB. The editorial is a short paragraph underneath the table of contents:

Punk Sex—The Slits, The Pistols—they are the new breed of outrageous rock and roll. Defying the establishment, attacking the sensibilities, they represent the iconoclastic revenge of the young, determined to whip it out and shake it loose in front of the staid and shocked faces of the corporate state. Their legacy comes from the likes of Morrison, Joplin and Hendrix—legends who planted the seed of outrageous defiance known as punk rock!

I would have replaced those three references with the MC5, the Stooges and Alice Cooper, but to each his own.

The mag consists of two pictorial layouts with blurbs and one article. The first pictorial, *Susie and the Spider Punk Rape*, from which the cover photo is taken, reads as follows:

Susie P., the queen of the punk groupies comes to town! And Sleaze, Grit, Snot and Heavy Chains are ready! They call themselves Spider! Heavy Chains and Grit begin spinning their slimy web. Snot and Sleaze make it a quartet. Susie P. pleads with Spider for mercy. They love it. The harder they cry, the harder they fall! And little orphan Susie is primed for her punks. Susie P. has fallen for the leathered and nasty Snot. She fondles and feels the snake skin as the serpent begins to rise. Snot regards her with the usual punk disdain. Ripe meat ready for the

taking. Heavy Chains gets off on the soft touch of a finely tuned switchblade against an erect nipple. Susie P. likes it down, dirty and nasty. Her pink, budding flesh is throbbing with desire. The punks like their bitches in pained heat. Spider digs the low down quartet action. In the punk underground, it's dark, nasty and hard. Susie P. gets down the way she and the punks dig it. Soft, fleshy tongue against dirty, grimy leather. The chick will go to any length to stir the hard blood of the punks. Spider knows no limits—any orifice will do 'cause they know you get what you need. The dirtier the better. On tour and nasty, Spider makes sure all the little girls in America know why they call themselves backdoor punks …Susie P. joins the rear door set. You don't need leather to bind the punk groupie when the quartet wants to play. Virgin sacrifice and punk rape

From top **Page from PUNK SEX (v10 #1) Summer 78; Sharon Mitchell, *Porn Star of the Month*, in HIGH SOCIETY (v6 #6) Nov 81.** Opposite **Bizarre adult slick PUNK SEX (v10 #1) Summer 78.**

HIGH SOCIETY
Vol 6 No 6 Nov 1981
High Society Magazine, 801
Second Ave., New York, NY
10017 2.95 100pp

PUNK DOMINATRIX
Vol 1 No 1 1981
Holly Publications, Hollywood,
CA 5.00 48pp
[info taken from US edition; no details
listed on UK edition]

on the gleaming hood of a British sports car. Susie P. shows what she is made of—a real punk's lady! The Spider's web is tightened, the punks play in 4/4 time. Remember, this girl is somebody's sister!

The above comprises all the blurbs from the layout, strung together in the order they appear. The last photo in the layout is four punks receding into a darkened background, looking over their shoulders at the naked and supine Susie P., either passed out or dead.

The second pictorial, *Groupies Revenge*, is almost a reversal of the first one. Two groupies, "Kinky and Squirm," take revenge on "Erwin the Straight" who is new in town. The interesting thing is the first shots of the layout are in front of CBGB, the seminal punk club. The people in this layout actually try to imitate the punk look, and succeed to a small degree.

The article *Punk Rock: A Fantasy of Sex and Violence* is uncredited; it begins with all the dictionary definitions of the word "punk". It is interesting in that it refers to punk in the past tense throughout, like it only took place in 1977, or to let the text speak for itself: "…we've got a pile of nostalgia on our hands. Two-year-old nostalgia? Time is lightning, man. Get with it." While the writer has some knowledge of the bands and attitude, it is a jumbled mix of reminiscence, rock as sexual metaphor and espousing of punk "philosophy," for want of a better word. A very sexual description of the Dead Boys on stage reads:

Heavy metal and steel throbbing music. A huge, gaping, wet pussy on the back of each guitar. Ah, ram it in! A long prick, hard and erect, shooting out the side, strung with bulging veins, corded sperm. Hands sliding up and down the shaft, harder, harder, getting it off. Raping every frenzied fan in the audience with the music. Banging them hard and fast till they're scream-

ing in painful ecstasy, rioting and writhing in the aisles.

Stiv and the boys would have been proud.

In one place, the writer lapses into "a personal report about a slice-of-bigger-than-life happening at an unnamed department store in New York City." A fifty year old matron is engaged with women who are battling over the newest fashion fad—punk, off the racks—until a real "mean-looking-son-of-a-bitch" punk shows up and gets a blow job from the woman in the middle of the store!

After this the article goes back to longing for the good old days of punk, and ends on this note:

Ah nostalgia…remember when punk bands used to crash chic London society parties and gross out the high-brows? Remember the famous vomiting act in the middle of Heathrow Airport or the belching and farting orgy at an Andy Warhol movie premiere in London? Remember when Johnny Rotten, lead singer of the Sex Pistols, was moved to comment, 'What a fuckin' dump' during his first (and presumably last) visit to EMI, Britain's largest and traditionally most conservative record label? Remember Iggy and the Stooges, who's [sic] I Wanna Be Your Dog and Search And Destroy became punk classics? Iggy, sweating and flailing about on stage, pausing to put out a cigarette on his bare nipple. The fans went wild. The performance was raw, stark, savage. The performance was pure Iggy. A rubber man, tough boy, crawling around on all fours, sniffing crotches, flipping over the microphone. He dove head first into a pool of screaming fans and smeared them with peanut butter, took on the whole of them, dukes up. He flushed amplified toilets on stage, shredded his chest with slivers of glass, bled,

died, and was resurrected before thousands…Ah, yes. Remember when fantasies of sex and violence almost became reality?

Punk and porn. Well, to quote Debbie Harry, "Sometimes music can make you come…I don't know if people jerk off to my music. I hope so." If not, they could go to the local porn shop and buy a copy of **PUNK SEX**!

HIGH SOCIETY

☐ This punk infested issue of **HIGH SO-CIETY** features an excellent cover with the late, great Wendy O. Williams, while inside we find a feature titled *All Choked Up*, an interview with The Stranglers by Dean Belmont with photos of them posing with Cherry Vanilla at Bonds Disco in NY. To round out the punk feel of the issue, porn star Sharon Mitchell has a layout that starts with a pic of her in a little punk-like outfit with shades.

In the *Nudes Real* section there are two pages devoted to Wendy O. in which she displays her tits, ass and pussy in pics from her pre-Plasmatics porn career. The text informs the reader of her stage antics smashing TVs, dynamiting Cadillacs and exposing her breasts, the latter of which got her into scrapes with law enforcement in Milwaukee and Cleveland. In Milwaukee the cops took to fondling her breasts and butt, eliciting a slap in the face to one, that brought down five officers on her slight frame who proceeded to beat her and kick her in the face. Wendy was eventually acquitted of all charges in both cases. At a record signing for New Hope For The Wicked she challenged a fan to pull his pants down and show her what he had, which he did, hesitantly. Wendy then jumped on the table, pulled up her shirt and fondled her breasts! Wendy was, without a doubt, a hot potato. The Plasmatics eventually broke up and Wendy O. released a few solo albums

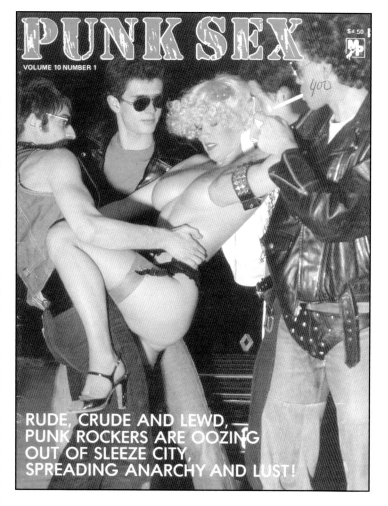

RUDE, CRUDE AND LEWD, PUNK ROCKERS ARE OOZING OUT OF SLEEZE CITY, SPREADING ANARCHY AND LUST!

to little fanfare. She retired to Connecticut and on April 2, 1998 took a stroll into the woods near her house and died of a self-inflicted shotgun blast to the head, making the cover of this issue perhaps slightly eerie in hindsight. For those interested in a look at the raw, loud, sweaty, bump and grind that was her solo act, it can be seen on the DVD **Bump 'N' Grind**, from K-Tel, which was a September 1985 performance at Camden Palace in London, with an onstage cameo from Lemmy and Wurzel of Motorhead.

Also in the *Nudes Real* section, following Wendy, is a page on Nina Hagen, the crazed looking German punk diva.

PUNK DOMINATRIX

☐ **PUNK DOMINATRIX** reminds me of a digest fetish mag from the late sixties/early seventies called **BONDAGE HIPPIES** (no publisher info), whose story focuses on a hippie chick and her square flatmate, and the tussles that erupt following an altercation one day regarding household chores. The hippie chick tries to eschew philosophies of peace and understanding while the flatmate starts to tie her up and beat some sense into her. By the end of the story everyone has found their own space, courtesy of a little bondage. The mag's statement of intent: "An entire generation is turning onto the joys of

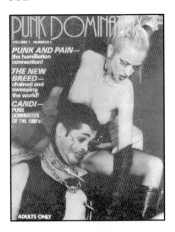

PHOTO FICTION – 40 BEAUTIFUL PHOTOS

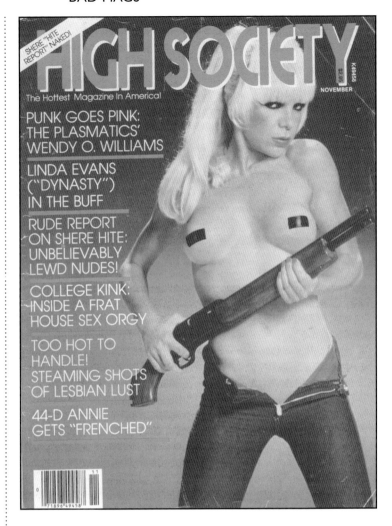

Top and Opposite **Zero Jim and Candi** in PUNK DOMINATRIX (v1 #1) 1981. Above **BONDAGE HIPPIES** (undated). Right **HIGH SOCIETY** (v6 #6) Nov 81 with Wendy O. Williams of the Plasmatics wielding a shotgun. She committed suicide in 1998.

NOTE As far as representations of punk fashions go, **PUNK DOMINA-TRIX** isn't that bad. It's quite sombre, and relatively free of the zany makeup and crazy-color nonsense usually associated with the adult slicks, such as **PUNK PUSSY** (see page 556).

pain. Their bizarre and unusual movement is called 'punk', and it's sweeping the world with its outrageous brand of sex."

In keeping with the pornographically prohibitive times, **BONDAGE HIPPIES** made no attempt to be sexually explicit. The girls in the photographs—despite their compromising situations—all maintain items of underwear, and the text never ventures beyond words as coarse as "breasts" and "bum."

It is unlikely that the **BONDAGE HIP-PIES** readership was composed of the free loving fraternity itself, but of guys outside that culture, completely removed from it.

Indeed, the **BONDAGE HIPPIES** readers probably viewed hippies with some disdain, outwardly at least; the magazine most certainly appeared at a time when factions of American youth were rebelling against the war in Vietnam, and hippies were synonymous with the breakdown of the 'American way'.

It is interesting that punk rock, the most notable youth culture to emerge since the hippies, should also have been regarded as a damaging influence on the social order. Just as interesting is the fact that, as with **BONDAGE HIPPIES**, there also existed a branch of pornography dedicated to this

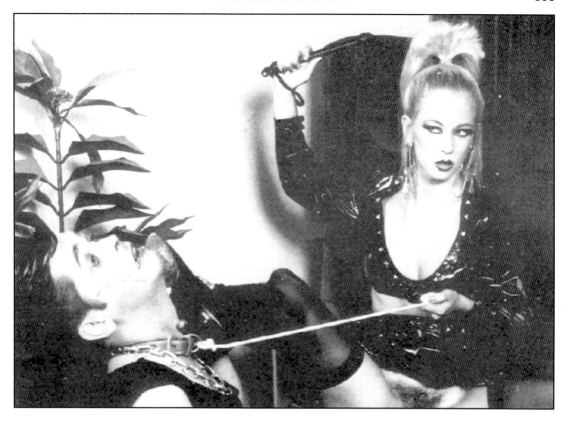

particular youth phenomenon. The title in question: **PUNK DOMINATRIX**.

PUNK DOMINATRIX was published in 1981 by Holly Publications, a kink and fetish imprint of American Art Enterprises in Hollywood. Two other popular Holly Publications titles at the time were **SATAN IN HIGH HEELS** and **SPIKES**. **PUNK DOMINATRIX** bills itself as v1 #1 on the cover and is undoubtedly a one-shot. The copy appears to be a poor quality British reprint and the murky quality of some of the photographs suggests they are b&w lifts of color images. The text has also undergone some rather clumsy censorship, which I will discuss in more detail later.

PUNK DOMINATRIX is not dissimilar to **BONDAGE HIPPIES** with its themes of subjugation and discipline. We are introduced to Candi, the "queen of leather," who one day realises there is more to punk than "short

hair, safety pins and dancing to the music of Devo." Motivated by a desire for domination and discipline, ideals that she believes are intrinsic to punk sexuality, Candi leaves her friends and moves onto the streets in search of "action." Haunting the Boulevard sporting studded leathers, dark eye makeup, a hefty industrial earring and carrying a whip, she gets a reputation for her ability to turn any man into her sex slave.

Enter Zero Jim, a cocky young soul with a fifties quiff, leather dog collar and cosmetic zigzag down his left cheek. [SEE NOTE.]

"You think you're ready for me?" Candi asks Zero Jim.

"Hey, baby, I've been with the worst," Zero replies. "I've been beaten, whipped, chained and forced to crawl through mud. Ain't nothing you can do to shake me."

Candi plays along with Zero Jim and the two go down a back alley. Zero pulls his

penis out and begins to masturbate, thinking Candi is swooning at its size (it is in fact quite tiny). When Candi invites Zero back to her apartment things quickly change. On her own turf Candi asserts herself and Zero Jim, "a punk, arrogant and blinded by his own image," soon crumbles, powerless.

The text and photographs in **PUNK DOMINATRIX** run parallel to one another meaning that, surprisingly, the (unaccredited) author had access to the images prior to writing the story. His descriptions of the characters match the descriptions of the people we see in the photos, and the scenarios in which they find themselves. However, none of the images show an erection or any penetration, and in parts a censorious hand has obliterated certain words, passages and sentences. The fact that offensive aspects of the text have been whitened out, leaving gaping holes, further

place on the sensitive flesh. She knew how to play the potentially metal and take her victim to the limits of his own pain endurance. Suddenly, Candi withdrew th

ain endurance.
Suddenly, Candi withdrew the prod. She lay on the mattress and spread her thighs.

onto his flanks, straddling him.
She held a pair of in her hands and showed them to Zero Jim. "No! Please no!" Zero Jim

eft! Nothing!"
The nightmare of pain began as Zero Jim felt the heat between his thighs. That heat grew more intense wit

Above **Censored passages from the UK edition of PUNK DOMINATRIX (v1 #1) 1981.** Opposite **Cover of Swedish Erotica's hardcore LEATHER PUNKS #167.**

NOTE This offering from Swedish Erotica has three dots on the upper left hand corner of its cover; these can also be found on some of the uncredited mags in the Ed Wood checklist.

LEATHER PUNKS
Swedish Erotica No 167
no date
Swedish Erotica, no address
listed 15.00 32pp

fuels the suspicion that this copy of **PUNK DOMINATRIX** is a page-for-page lift of the US version—quite possibly a special import for the British market or a bootlegged version censored for legal distribution in the UK.

(Closer inspection reveals it as a copy: reproductions of the *original* staple holes can be seen just above and below the staples on the center pages. I don't usually examine pages of smut mags in such detail, but my interest was piqued after the centerspread in **PUNK DOMINATRIX** fell free, and I was left to ponder whether this rather common facet of loose center pages in pornography was down to natural wear and tear, or by design courtesy of some masturbation-crazed previous owner, eager to scatter as many dirty pictures around the house as possible.)

Back in the apartment, Candi thrashes Zero Jim with her whip, whereupon Zero feels "a sudden loss of power, a sudden reeling sensation within himself." The reader need only look at the images to figure what else transpires: almost every picture shows Zero Jim with his Levis wrapped around his ankles, his face frozen in a ridiculous expression of abject horror. Candi, topless, snarls as she subjects Zero to a barrage of physical torment.

"There will be no mercy until you satisfy me!" she yells, tugging hard on the rope that Zero fashionably wears around his neck.

"Please! Stop it! I'll do anything, anything!!!" Zero cries.

Candi laughs: "You little prick! You arrogant stupid fool! You think that just because you are a punk in leather that you know it all! You are stupid, and you will pay for that stupidity!"

With what looks like a car aerial, Candi threatens Zero Jim's genitals. It is here we find the first instance of censored text (missing words have been re-inserted, courtesy of the US edition):

"She knew how to play the potentially [lethal] metal and take her victim to the limits of his own pain endurance."

Followed by: "Suddenly, Candi withdrew

the [dangerous] prod."

Words aplenty are missing as Zero Jim is menaced with a pair of pliers. Indeed, the text completely lacks any reference to the tool. If not for the accompanying pictures, which clearly show Zero's limp member hanging between the pliers in Candi's hand, it would be entertaining to try and figure what barbaric apparatus lay at the heart of this latest torment: "She held a pair of [pliers] in her hands and showed them to Zero Jim."

The final and most severe punishment is left to last, but whole paragraphs have been cut and not even the pictures give anything away. The only suggestion as to what the source of anguish is as follows: "The nightmare of pain began as Zero Jim felt the heat [of the flame] between his thighs."

The tale ends with Zero Jim a broken man, a common sight on the punk streets apparently, no longer walking upright but "chained and on all fours next to his master, the punk dominatrix Candi."

Filling the remaining pages of *Punk Dominatrix* is a picture spread of Candi on her own ("the new breed") and "Punk and Pain;" a supposedly factual article on the meaning of punk and its parallels with other cultures. Here it claims that punk dress sense indicates a "churning, violent reaction against motherhood." Want to hear why punks lean towards S&M? It's because "many of the young people now involved within the [punk] movement carry a deep sense of guilt over what they are doing."

However tenuous, the article does make for an entertaining read and tries admirably to convince the reader that all "punksters" are closet sadomasochists.

… the punks are not as oriented to traditional methods of expression, and therefore seek to create their own system. In essence, many of the punks turn themselves into "slaves," whether that state be within the industrial society or within the world of sex. They

shave their heads, don the metal bracelets of sexual slavery, and literally chain themselves into a state of bondage. Since they are rebels, they cannot accept the formal ministrations of a dominatrix. The leather mistress is from another world, a world which they have left.

The photos accompanying the piece reveal a variety of models in 'punk' poses. Some of these, naturally, are rather embarrassing: the middle aged woman in studded leathers, for instance, who wears a buckle on her belt inscribed "EVIL."

[Review by David Kerekes. Additional info concerning the uncensored US edition of **PUNK DOMINATRIX** by Tom Brinkmann.]

LEATHER PUNKS

☐ "The blonde groupie boldly offered the punk musician her body." So reads the cover blurb on **LEATHER PUNKS**, one of a long line of all color, hardcore porn mags from Swedish Erotica, I would guess from the early eighties [SEE NOTE]. It follows the basic formula of porn: a few pics of the clothed couple in a recording studio, before genitals are unfurled and things get hot, heavy and inserted.

The rather erratic dialog makes you wonder if anybody ever took the time to proof it. The text runs throughout the mag and is fairly typical: a tale of musician Denny Danger, wearing a Union Jack t-shirt and leather pants, and a groupie named Monica, who looks more akin to Olivia Newton John than a punk. The intro refers to the "heavy metal musician"—heavy metal and punk being synonymous to the writer. We are informed that every recording studio has a "Studio B": B standing for bed, a room in the back decked out for the muscians to "do" their groupies in, and this studio is no exception. After cooing over being so close to Denny Danger, Monica starts shedding her skimpy

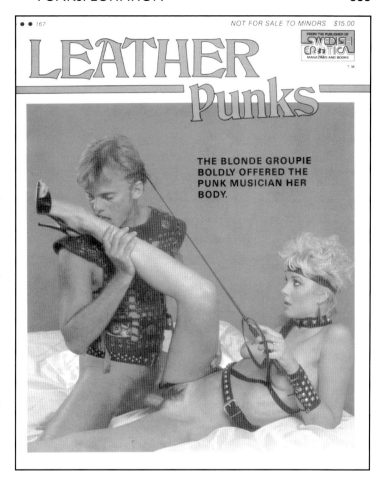

THE BLONDE GROUPIE BOLDLY OFFERED THE PUNK MUSICIAN HER BODY.

outfit. A sample of the dialogue:

"Oo-wee!' the guy yelped at the sight of her clefted cuntal mound, lightly fuzzed with fine blond hairs. "That's some little twat! Look, if you really want me to help you start a singing career, show me how you can vocalize…on my dong."

The fucking and sucking goes on and on, with nothing in the text that refers back to punk rock, or anything else for that matter.

Denny then decides to break out the "paraphernalia": leather straps studded with metal, a leather vest with brass eyelets, a leather paddle and a riding crop. The text

breaks away from sexual description for a few lines:

"Wow. I've never seen stuff like that," the chick said, as Denny got back to the bed. "You Britishers are into some pretty heavy stuff. The English curse and all that!"

"What makes you think I'm English?" he asked, settling onto the bed beside her.

"Your shirt," she came back quickly. "Union Jack. Where are you from Denny?"

"Livermore. We're all from there."

"You mean Liverpool. You're Liverpudlians."

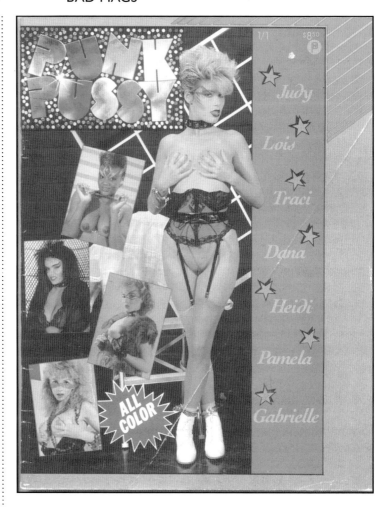

Right **PUNK PUSSY (v1 #1)**
1987… or Pee Wee's Playhouse?
Opposite **Splash page spread for**
the inane Traci Lords feature in that
same issue.

"No, Livermore. California. They call us Livermorons. We're not too smart."
The girl giggled uncontrollably.
"You're smart enough to get your cock sucked," she was finally able to say.

And that he does. In the last paragraph, Monica passes the test and becomes a certified rock groupie: "prime fucking stuff for every guy in the band."

PUNK PUSSY

☐ This is a much later hardcore solo girl slick, ten years after the fact but still cashing in on the punk trend. It features seven all color layouts of different women, each with text—not of much interest unless you are into dumb blurbs or Traci Lords, who happens to be one of the seven punkettes. The style and look of the women's costumes are more akin to Cyndi Lauper and **Pee Wee's Playhouse**, both popular at the time. In fact, the editorial makes reference to Madonna and Lauper, using "living in the material world" and "girls just wanna have fun" in the text. The layouts are posed shots with several showing the insertion of dildos, vibrators and fingers.

The text with the Traci layout is typical of the rest:

PUNK PUSSY
Vol 1 No 1 1987
American Art Enterprises Inc., PO
Box 3959, North Hollywood, CA
91609 8.50 64pp

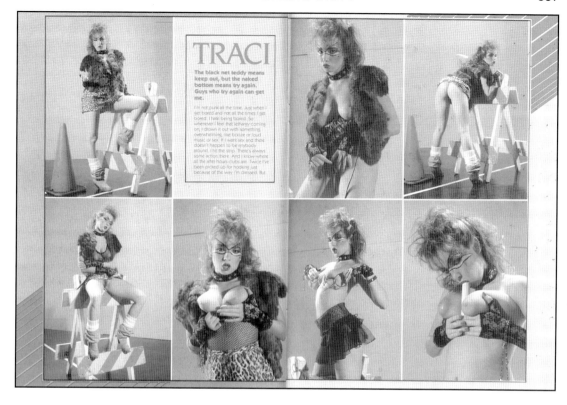

The black teddy means keep out, but the naked bottom means try again. Guys who try again can get me.
I'm not punk all the time. Just when I get bored and not all the times I get bored. I hate being bored. So whenever I feel that lethargy coming on, I drown it out with something overwhelming, like booze or loud music or sex. If I want sex and there doesn't happen to be anybody around, I hit the strip. There's always some action there. And I know where the after-hours clubs are. Twice I've been picked up for hooking just because of the way I'm dressed. But once they find out I give it away, they don't have a case. Isn't that weird? You can have all the sex you want but if somebody gives you money after, you're a criminal. Weird. I'm into punk for the fun of it. I like the furs and lace and satin and beads and paint and everything all gobbed together like this. It's so much more imaginative than the way people used to dress. And you can tell a person's personality by the things they put together. Like this fur jacket means I'm soft like a kitten, but notice it doesn't close down the front. That's because I'm also a voluptuous sex creature who wants her tits fondled and stroked.

I'm into persistence. Shows confidence and self-esteem. I don't dig men who come on strong and then don't back it up with anything.

This adult slick is not alone in its use of punk as a theme. I have seen several others from the eighties that have followed the same format, using solo layouts of girls with wild makeup, hair and clothes that look more circus-like than punk-like.

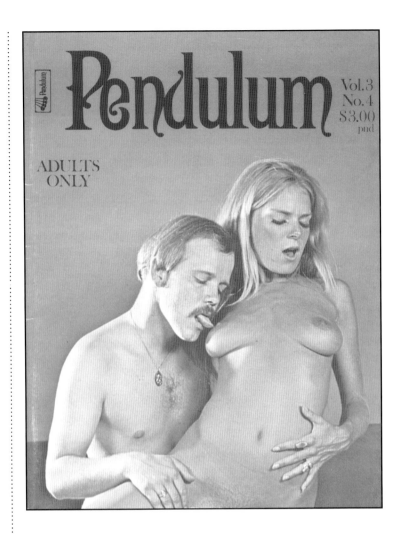

1. Working at Pendulum

☐ Below is the account of the pseudonymous "Frank Leonard" on his employment at Pendulum's 5583 West Pico Blvd. address in Los Angeles. This information was amalgamated from several emails from Leonard. Initially, I questioned the authenticity of some details, namely the fact that Leonard claimed he wrote **A Study of Sexual Practices in Witchcraft and Black Magic**, not Wood. Well, the answer to this is that there were two volumes; Frank Lennon (with Dr T. K. Peters) wrote Book One (1970 SECS Press SP 111), and Ed Wood (as Frank Lennon with Dr T.K. Peters) unquestionably wrote Book Two (1971 SECS Press SP 112).

Through author Rudolph Grey (**Nightmare of Ecstasy**), I contacted Dennis Rodriguez, who had also worked at Pendulum as a writer and editor between 1970–73. After reading the story below, Rodriguez wrote that Leonard's description of Pendulum was "100 per cent" correct and he thought he remembered him.

Tom Brinkmann
August 26, 2007

Frank Leonard's Years at Pendulum

I was one of the staff at Pendulum for about nine months (very young and foolish) between fall 1970 and early summer 1971. The others and I were expected to write all the copy for the magazines. It's possible I knew Charles Anderson, Dennis Rodriguez and Scott Raye but the names don't mean anything to me today. If I remember correctly, and it was a long time ago, my co-writers were Robin (Redbreast) Eagle—crazy name, I know, but that really is what I remember— Bill Jones and, of course, Ed Wood. I can't remember a fifth [writer] but it may be that he came in after my time. I do remember Phil Cambridge, nice guy who was one of the layout artists in the Art Department. We writers were off to one side of the West Pico building, down a corridor cut off from the rest of the building by an electric lock. Pendulum was set up just like a factory. We all had time cards and we were required to clock in and out every day; Bernie Bloom used to say that he hired his writers to write, which meant that as he was paying for eight hours, that's how long he expected us to write. We young Turks would be out of our cells (the windowless offices where the writers lived) in the corridor, playing 'push-pins' (our version of darts) when we'd hear the 'click' of the electric lock and immediately scurry back to the typewriters and start banging away. Often it was Bernie, ushering some visitor through with the sweeping introduction, "these are my writers." Woe betide us if he didn't hear all four typewriters clattering away in unison on such occasions.

What do I remember about Bernie Bloom? Not too much. He was the boss, and I'm sure we paid him the same attention as any boss. We knew there was another bigger boss (Mike Thevis) somewhere in the background but I don't remember ever meeting him. Bernie's wife Blanche was often around. In fact, she may have worked there some of the time.

My period at Pendulum (actually I think its official business name at the time was Calga Publishers, although many of the magazines came out under the Pendulum title) was one of those strange periods one falls into when young and wandering the world. I'd left the UK in 1969 for Mexico and lived there until my money ran out, then hitched into LA in 1970 flat broke with just a couple of phone numbers for people I'd met in Mexico. One was a writer from San Miguel Allende who made money on the side writing books for Bernie. He knew I needed a job and set up an introduction. Bernie asked if I knew how to edit magazines (I didn't but of course said I did) and he promptly hired me. For a green kid pretty fresh out of the UK, working for Pendulum was like Alice having just fallen down the rabbit hole.

My job, like all the writers, was to write the 'case studies' that went with the picture layouts. I think there were four per magazine. In addition we had to write one or more articles and a piece of fiction per magazine. Since we knew nobody was interested in the fiction (they only bought the magazines for the pictures), most of us would have fun with the stories. I was into sci-fi at the time so I wrote a lot of straight sci-fi short stories, totally out of keeping with the magazine but nobody ever complained. In fact, Phil Cambridge drew some really nice illustrations to accompany them.

I've read elsewhere that "Dr T.K. Peters" is supposed to be one of Ed's pseudonyms. Not true, the poor guy actually existed. Bernie had bought this serious though very boring—and excruciatingly long—scientific study of sexuality from Dr T.K. Peters. It was an unpublished manuscript that the guy had probably labored on for years without finding a buyer (he was a Kinsey-style researcher). I hate to think what Bernie paid him for it; I'm sure it was peanuts, but he was very old (semi-senile was the word around the office) and he'd let it go without realizing what use would be made of it. This manuscript gave Bernie a sort of 'semi-legitimacy'

for the magazine articles and we were all encouraged to make use of it whenever and wherever possible. Adding Dr Peter's name as co-writer was also supposed to add a sort of legitimacy.

There were many different publishers' names that were used at this time. The only ones I recall were Pendulum, Calga and, of course, Dansk Blue Books (one of the book imprints). The softcore and hardcore magazines came out under different names but I can't remember what they were. The mists of time have closed in over so much of this period but the Edusex magazines were probably part of the hardcore magazines for which we were expected to write 'socially redeeming' copy.

I mentioned the electric lock on the door that led to the writers' corridor. There was also one on the door that led into the main building from the entrance. If you entered the front door on West Pico Blvd., there was a receptionist window/hatch but you couldn't go on into the main building until the receptionist tripped the switch. I remember there was a police raid one day (the only one I remember from my time at Pendulum) and the police refused to wait until the receptionist opened the door, even though she was about to do so. They just climbed in through the hatch. We all kept our heads down in the back. Whenever things got a little hot (some court decision always seemed to be changing the ground rules), Bernie and Blanche would leave town and we would be told they were away at some adult publishing convention.

What do I remember about Ed Wood? The tragedy is, not nearly enough. He was at least twenty years older than the rest of us writers and that's a huge gap when you're in your twenties. Yes, he sometimes wore miniskirts around the office and he often wore his trademark angora sweaters; he was certainly the first transvestite I'd ever met. But he was something of a figure of fun to us. We liked him but we didn't take him seriously; he was just a washed up old

Page 558 **PENDULUM (v3 #4) Nov/Dec 71.**

This page, from top **The second volume of** *A Study of Sexual Practices in Witchcraft and Black Magic* **Book Two written by Ed Wood; the first was written by "Frank Leonard."** Above **Gallery Press' first logo, and the Pendulum logo.** Opposite **PARTY TIME (v2 #3) Aug/Sep 73.**

NOTE For Pendulum and Gallery Press titles and publisher information, see page 58.

drunk. However I do remember he was kind and gentle and he'd often help out when one of us was stuck on a story or article. He seldom joined us out in the corridor for our pushpin tournaments; he'd just be writing away. I suspect he disapproved of the lack of seriousness with which we took our job.

He certainly disapproved of our attitude towards the books. I've mentioned elsewhere that on top of the magazine writing (for which I was paid the princely sum of $200 per week), we were also encouraged to write a book a month in our spare time, for which we were paid an additional $800-$1,000. These could be fiction but what they really wanted was pseudo-scientific factual books that could be illustrated with hardcore pictures (in such books, the Dr T.K. Peters manuscript found heavy use). Since none of us (except Ed Wood) wanted to spend more time than necessary writing these books (again, people only bought them for the pictures), the young writers had developed a unique shortcut. We'd dip into the files for magazine articles that had been written a year or more before, collect seven or eight together, rewrite the first paragraph of each to fit a new generic title, and then send the 'new' manuscript down to typesetting. I think the record for 'writing' such a 'new' non-fiction book was an hour. Good pay for an hour's work! Ed used to disapprove strongly and always wrote his manuscripts completely, although he too culled heavily from the Dr T.K. Peters material.

Initially I took the book writing seriously too. My first book for Pendulum was **Sexual Practices in Witchcraft and Black Magic**. And no! Ed Wood didn't write it. My usual pseudonym was "Frank Leonard"—often changed to "Frank Lennon." Of course we all borrowed each other's pseudonyms but—strangely enough—I was quite proud of the writing in **Witchcraft and Black Magic**. It was before I'd been inculcated into the 'fast book-writing group' and I took that particular writing gig seriously, spending long Saturdays doing research in the downtown LA

library. After that, my books tended to be the usual rubbish. I remember hearing that the scam was discovered some months after I'd left Pendulum and at least one of the other writers was fired.

But getting back to Ed Wood, he certainly talked about the movies he'd made, and about working with Bela Lugosi. I'm ashamed to say I didn't believe him. After all, how could this old 'failure' have made films with such a star? Youth can be very cruel. In fact for years I couldn't even remember his name. Years later, when I talked about my time in LA, I'd often tell stories of 'this old drunk' who used to wear mini-skirts and angora sweaters and say he'd worked with Bela Lugosi but it was just party chatter. It was only when Tim Burton's film came out and everyone started talking about Ed Wood did I wonder: "Could this be the same guy?" Then I tracked down Rudolph Grey's book and was amazed to see the Pendulum period so well documented. It makes me think of that quote in Grey's introduction: "The really funny thing is that here is this alcoholic, this old bum that I really liked, and all the time I never knew that he was something special."

Knowing what we know now, how I wish I'd spent more time with him, asked him all those questions one wishes one could have asked. I find it amazing to think he was only in his mid forties when we worked together. Since I was twenty-six, the mid forties must have seemed ancient, and the booze was definitely taking its toll. None of us socialized too much outside the office, although we writers often went to lunch several days a week (there was a little dive just up the road on Pico that had the best Spanish hot dogs I've ever tasted) and we'd sometimes meet for a drink in the evening. I definitely went to Ed's home at least once since I have a memory of his wife cooking dinner and I recall being surprised that she was so nice and normal. I also remember once going shopping with Ed. He needed a new bra and for some reason I was tagging along. What surprised me most was that when Ed wanted

to try on various sizes, the salesgirl seemed totally unphased. I guess LA salesgirls in the early seventies were far more used to transvestites than I was.

I left Pendulum in the early summer of 1971 to return to San Miguel Allende in Mexico. My time in LA had restocked my finances sufficiently to give me almost a year down there while I tried to write 'the great British novel' (it was a great period to be living in Mexico). I took a couple of fiction commissions from Dansk Blue Books down to Mexico with me but once I'd delivered those, had no more contact with Pendulum. When publishers weren't as excited about the 'great British novel' as I was, I went back into TV, which is how I've earned my honest crust for the bulk of my career (however my time at Pendulum was a youthful folly that will sound great in my autobiography if I ever get around to writing one).

So that's the story of my relatively peripheral contact with Ed Wood. Unfortunately I have no memorabilia from that period. After leaving LA I lived in Mexico, Texas, the UK, Greece and Portugal before returning to the US in 1980 and things vanish over so much time and so many moves. I managed to hold onto one of my novels (I think it was a Dansk Blue Books paperback) titled **Beauty for Brutes** until about ten years ago when my wife threw it out (my son was old enough to start looking through bookshelves in my office).

"Frank Leonard"
January 17, 2005

2. The short story & magazine articles of Ed Wood

☐ This is by no means a complete list of Ed Wood's published short stories and articles—there are some titles listed for which only sketchy info was available—but I have tried to include as much as possible. All the entries are followed by Wood's name or pseudonym as it appears in the publication; when not followed by a byline, it is a Wood story but there is no pseudonym listed. I deduced some uncredited stories to be the work of Wood, on occasion concurring with Rudolph Grey on a few whose origins I was not sure about. The entries are listed chronologically by the date given in the mag. There are some titles at the end of the list whose dates I do not know.

There are also a myriad of girlie mags and slicks that ran stills from Wood's movies, particularly the Apostoloff-Wood film **Orgy of the Dead**, too numerous to list here.

Recent film mags **CULT MOVIES** and **OUTRE** have both featured lengthy articles on Ed Wood's life and work in film, as well as articles on, and interviews with, Vampira, Tor Johnson, Criswell, Titus Moody and Rudolph Grey.

ADVENTURES IN HORROR
v1 #1 Oct 70 Stanley Pubs
Stills from **Orgy of the Dead** have been used to illustrate *The Devil of Denham Swamp!* by Howard Cherna. It has been incorrectly written elsewhere that Ed Wood wrote some of the stories in these Stanley Publications horror titles. **ADVENTURES IN HORROR** used stills from sexploitation flicks and horror movies though, and the **Orgy**

From top **THE WILD-CATS
(v5 #2) May/Jun 71; SWAP (v5 #4)
Oct/Nov 71.** Opposite **SWAP
(v6 #2) May/Jun 72.**

of the Dead stills in this issue may have sparked the rumor of Ed having contributed stories. However, the stories do not read like Ed Wood and Ed seems to have dealt only with local LA mags from all indications. Stills from sexploitation flicks with Titus Moody in them have also been used in both issues of **ADVENTURES IN HORROR**.

THE WILD-CATS
v5 #2 May/Jun 71 Pendulum
The Fright Wigs by Donna D. Dildo.

TWO PLUS TWO
v3 #2 May/Jun 71 Pendulum
Out of the Fog by Joe Baga.

GARTER GIRLS
v5 #2 Jun/Jul 71 Pendulum
So Soon to be an Angel uncredited Ed Wood.

SWITCH HITTERS
v2 #2 Jun/Jul 71 Calga
The Devil and the Deep Blue-Eyed Blonde uncredited Ed Wood.

MALE LOVERS
v? #? Jun/Jul 71 Pendulum
Closet Queen uncredited Ed Wood.

SWAP
v5 #3 Jul/Aug 71 Pendulum
Where did Charlie get on the Train? uncredited Ed Wood.

PENDULUM
v3 #3 Aug/Sep 71 Pendulum
Into my Grave by Edw. D. Wood, Jr.

AN ILLUSTRATED STUDY OF VOYEURISM
v2 #2 Aug/Sep 71 Calga
The Day the Mummy Returned by Ed D. Wood, Jr.

GOLD DIGGERS
v3 #3 Sep/Oct 71 Pendulum

Missionary (Position) Impossible by Edw. D. Wood, Jr.

GARTER GIRLS
v5 #3 Oct/Nov 71 Pendulum
Never Up — Never In! uncredited Ed Wood.

SWITCH HITTERS
v2 #3 Oct/Nov 71 Calga
Morbid Curiosity by Dick Trent.

SWAP
v5 #4 Oct/Nov 71 Pendulum
Taking Off by Edw. D. Wood, Jr.
Bedroom Scene by Edw. D. Wood, Jr.

SUCK-EM-UP
v1 #2 Oct/Nov 71 Pendulum
Try, Try Again by Ann Gora.

BODY & SOUL
v5 #3 Oct/Nov 71 Pendulum
The Movies and Sex by Edw. D. Wood, Jr.

DYNAMIC FILMS
v5 #3 Oct/Nov 71 Pendulum
Necromania: A Tale of Weird Love is featured on both the covers as well as inside this Pendulum mag, which has several other points of interest. The issue contains an uncredited article called *The Product is the Answer*, which was undoubtedly written by Ed Wood. The article concerns the difference between the cheaply produced "nudie quickies" and the newer crop of films which went "out into the field to hire the experienced personnel who have been around the conventional motion pictures and know their business," i.e. Ed Wood. Giving an example of one of the "new" films Wood has written:

> One such film soon to hit the screen
> is Necromania which was produced
> by Cinema Classics. This film is in
> full, brilliant color filmed by two of Hol-
> lywood's best cameramen has a hard
> line story and well acted by the prin-

cipals. It has a director who has more than twenty years in the business and an editor who has done more features than he cares to count. But it will be a sure fire winner at the box office, and will set a new trend to the sexploitation type of films. In Necromania most of the emphasis is placed on the basic story. Although the sex sequences are what the public wants and demands, they are also being treated to a well balanced story line which is sure to get rave notices in the publications which outline such films. And there is nothing offensive to the viewer. His intelligence is not insulted by bad performances from any of the on or behind the scene operations. And it is truly a sound film. The actors know their lines and [they] are delivered with the professionality of a good Independent production.

Ric Lutze, the male star of **Necromania**, and Rene Bond's paramour at the time, is also featured in another layout in the mag, *A Handful of Cherries*, with two young ladies. In the accompanying text he is referred to as "Tommy Hart." The fourteen page *'Necromania'—A Tale of Weird Love*, is a feature packed with stills from the flick and includes a synopsis of the story written by (an uncredited) Ed himself. As in the film, all the credits in the article are pseudonyms. It lists the director as "Dick Trent," Wood's most common pseudonym, while "Larry American" is credited for the screenplay.

FLESH & FANTASY
v4 #4 Nov/Dec 71 Pendulum
From Birthday Suit to Shrouds by Edw. D. Wood, Jr.
Mandy's Mistake uncredited Ed Wood.

ORGY
v3 #4 Nov/Dec 71 Pendulum
Prostitutes as Wives by Dick Trent.

PENDULUM
v3 #4 Nov/Dec 71 Pendulum
Like a Hole in the Head by Dick Trent.

WILD COUPLES
v3 #3 Nov/Dec 71 Pendulum
Turn off the Lights! by Edw. D. Wood, Jr.
The Rabbit by Art Carlysle.

YOUNG BEAVERS
v5 #4 Nov/Dec 71 Pendulum
Come Inn by Edw. D. Wood, Jr.
The Roots of Sexual Desire uncredited, possibly Wood.

HIT & FUN
v2 #2 1971 Calga

There are no Atheists in the Grave by Edw. D. Wood, Jr.

BELLY BUTTON
v2 #2 1971 Calga
Final Curtain by Edw. D. Wood, Jr.

ECSTASY
v3 #3 Nov/Dec 1971 Pendulum
Megalopolis by Edw. D. Wood, Jr.

AN ILLUSTRATED STUDY OF VOYEURISM
v2 #3 1971 Calga
Florence of Arabia by Edw. D. Wood, Jr.
The Documentary by Dick Trent.

From top **SWITCH HITTERS (v2 #3)**
Oct/Nov 71; TWO + TWO (v4 #1)
Jan/Feb 72; PASSION (v2 #2)
Mar/Apr 73. Opposite **FANTASTIC**
(v2 #1) Feb/Mar 73.

HORROR SEX TALES

v1 #1 1972 Gallery Press
Hellfire by Edw. D. Wood, Jr.
Gore in the Alley by Shirlee Lane.
Scream Your Bloody Head Off by Edw. D. Wood, Jr.
Bums Rush Terror by Ann Gora.
Bloodiest Sex Crimes of History uncredited, taken from the paperback of the same title by Ed Wood.
Cease to Exist by T.G. Denver.
Witches of Amau Ra by Dick Trent.
Rue Morgue Re-Visited by Dick Trent.

TWO + TWO

v4 #1 Jan/Feb 72 Pendulum
Test of Time by Ann Gora.
The Price of Jealousy possibly uncredited Wood.

ONE PLUS ONE

v4 #1 Jan/Feb 72 Pendulum
Hitchhike to Hell by Edw. D. Wood, Jr.

ROULETTE

v6 #1 Jan/Feb 72 Pendulum
The Saga of Rance Ball by Dick Trent.

BODY & SOUL

v6 #1 Feb/Mar 72 Pendulum
Filth is the Name for a Tramp by Ann Gora.
Not So Easy, This Life unsigned Ed Wood.

SAVAGE SEX

v4 #1 Feb/Mar 72 Pendulum
The Gay Details by Edw. D. Wood, Jr.

GARTER GIRLS

v6 #1 Feb/Mar 72 Pendulum
The Hazards of the Game by Dick Trent.
When the Topic is Sex by Edw. D. Wood, Jr.

SKIN & BONES

v4 #1 Feb/Mar 72 Calga
Pray for Rain by Ed D. Wood, Jr., this story was reprinted in the undated **LUSTY LOVERS** listed below.

FLESH & FANTASY

v5 #1 Mar/Apr 72 Pendulum
Blood Drains Easily by Dick Trent.

SWAP

v6 #1 Mar/Apr 72 Pendulum
Spokes of the Wheel by Dick Trent.

ONE PLUS ONE

v4 #2 Apr/May 72 Pendulum
The Movie Queen by Ann Gora.

TWO + TWO

v4 #2 Apr/May 72 Pendulum
Another Insight to Women's Lib by Ann Gora.
Last Laugh by Shirlee Lane.

PENDULUM

v4 #1 Apr/May 72 Pendulum
How NOT to get Trapped into Marriage by Dick Trent.
The Exterminator by Ann Gora.

BLACK & WHITE

v2 #1 Apr/May 72 Pendulum
Enough Bread for Everybody by Edw. D. Wood, Jr.
To Kill a Saturday Night by Ann Gora.

SWAP

v6 #2 May/Jun 72 Pendulum
Time, Space and the Ship by Dick Trent.

GARTER GIRLS

v6 #2 May/Jun 72 Pendulum
Detailed in Blood by Edw. D. Wood, Jr.
Who Wants to get Involved, uncredited Wood.

ROULETTE

v6 #2 May/Jun 72 Pendulum
The Ant Hell by Ed D. Wood, Jr.

GOLD DIGGERS

v4 #1 May/Jun 72 Pendulum
Not so Freewheeling by Edw. D. Wood, Jr.

GOLD DIGGERS

v4 #2 May/Jun 72 Pendulum
Breasts of the Chicken by Edw. D. Wood, Jr.
Let's Swap Spits by Dick Trent.

ECSTASY

v4 #2 Jul/Aug 72 Pendulum
Exotic Loves of the Vampire by Ann Gora.
Those Hidden Happenings, uncredited Wood.

YOUNG BEAVERS

v6 #1 Mar/Apr 72 Pendulum
That Damned Faceless Fog by Dick Trent.
A Thought to Fetish Love Objects uncredited, probably Wood.

YOUNG BEAVERS

v6 #2 Jul/Aug 72 Pendulum
In the Stony Lonesome by Edw. D. Wood, Jr.
Youthful Boobs by Ann Gora.

WEIRD SEX TALES

v1 #1 Jul/Aug 72 Gallery Press
Ant Hell by Alvin Tostig.
Rapist from Outer-Space by Cornelius Castor.

MONSTER SEX TALES

v1 #1 Aug/Sep 72 Gallery Press
Castle of Dracula by Chester Winfield.
Voyage of Dracula by Roy Hemp.
Lust of the Vampire by Dudley McDonly.
Night of the Moon by Jason Streek (most likely Ed Wood).

COUPLES DOING IT

v1 #1 Aug/Sep 72 Gallery Press
Cannon Fodder by Edw. D. Wood, Jr.

SAVAGE!

v1 #2 1972
Interview with a Sadist and a Masochist by Dick Trent.

VOL. 2 NO. 1
FANTASTIC $3.50
ATLAS

lots of color and special features
ADULTS ONLY

LEGENDARY SEX TALES

v1 #1 Sep/Oct 72 Gallery Press
Cleopatra's Sex Slave, by Dudley McDonly, is thought by some to have been written by Ed; he used the pseudonym in **MONSTER SEX TALES** with a spelling variation. It doesn't read like Ed Wood to me, and it is questionable that Wood wrote any of the other stories in the magazine. Although one source claims Wood *had* appeared in all four of the Sex Tales mags, it seems doubtful in this case.

GARTER GIRLS

v7 #1 Nov/Dec 72 Pendulum
Those Long Winter Nights by Ann Gora.

SWITCH HITTERS

v3 #3 Nov/Dec 72 Calga
Let's Talk about it by Dick Trent.

GODDESS

v1 #2 Nov/Dec 72 Gallery Press
Hooker by Choice by Ann Gora.
Climax Needed by Dick Trent.

FIG LEAF

v2 #1 Jan/Feb 73 Gallery Press
Never Look Back by Ann Gora.
Sex Oddities and the Newspapers by Dick Trent.

GALLERY

v2 #1 Jan/Feb 73 Gallery Press

From top **FANTASTIC (v2 #2)**
May/Jun 73; MENAGE (v1 #2)
Jun/Jul 73; LESBIAN LIFE (v2 #3)
Jul/Aug 73. Opposite **SAVAGE!**
(v2 #2) Jun/Jul 73.

Blood Splatters Quickly by Edw. D. Wood, Jr.
Turn On or Keep Out of the Sex Business by Dick Trent.

PASSION

v2 #1 Jan/Feb 73 Gallery Press
The Big Kill by Ann Gora.
Male + Female = Life by Dick Trent.

CHERRY

v2 #1 Feb/Mar 73 Gallery Press
It's Time to Let Go Love by Edw. D. Wood, Jr.
The Strange Life of a Prostitute by Dick Trent

LESBIAN LIFE

v2 #1 Feb/Mar 73 Gallery Press
All the Way by Shirlee Lane.
Lesbian Happenings by Ann Gora.

PARTY TIME

v2 #1 Feb/Mar 73 Gallery Press
Necrophilia—Love of the Dead by Dick Trent.
Two x Double by Ed D. Wood, Jr.

SPICE N' NICE

v4 #1 Feb/Mar 73 Pendulum
Flowers for Flame LeMarr by Edw. D. Wood, Jr.
Sex around the World by Dick Trent.

FANTASTIC

v2 #1 Feb/Mar 73 Gallery Press
Never a Stupid Reflection by Edw. D. Wood, Jr.
Pain + Pleasure = Sado/Masochism by Dick Trent.

PASSION

v2 #2 Mar/Apr 73 Gallery Press
Captain Sin by Edw. D. Wood, Jr.
More Oddities in the News by Dick Trent.

WANTED WOMEN

v2 #2 Mar/Apr 73 Gallery Press

Confessions of a Dance Hall Prostitute by Dick Trent.

FIG LEAF

v2 #2 Apr/May 73 Gallery Press
Super Who? by Ann Gora.
Sex is Not a Hazard by Dick Trent.

GALLERY

v2 #2 Apr/May 73 Gallery Press
Tank Town Chippie by Ann Gora.
The Sweater Girl by Edw. D. Wood, Jr.

BI

v1 #1 Apr/May 73 Gallery Press
As they Like it by Dick Trent.
Rout Loneliness for Sexual Joys by Shirlee Lane.

SENSUAL CINEMA

v2 #1 Apr/May 73 Gallery Press
Interview with a Skin-Flick Writer by Dick Trent.
Two + One = Lust uncredited Ed Wood.

LESBIAN LIFE

v2 #2 Apr/May 73 Gallery Press
Just a Conversation by Ann Gora.
Color her Red by Dick Trent.

BOY PLAY

v2 #2 May/Jun 73 Pendulum
Zeus and his Lovers by Edw. D. Wood, Jr.
Never Too Late—Never Too Soon by Dick Trent.

FANTASTIC

v2 #2 May/Jun 73 Gallery Press
Changing Lifestyles by Dick Trent.

FETISH

v1 #1 May/Jun 73 Gallery Press
Letters by Ann Gora. Wood wrote the letters column of the mag concerning fetishes, he may also have written the entire mag.
A Look at the Fetishist by Dick Trent.

GODDESS

v2 #2 May/Jun 73 Gallery Press
Thor and his Magic Hammer by Edw. D. Wood, Jr.
Girls who have to watch their Periods as well as their Commas by Dick Trent. Rene Bond on cover and in the layout, *A Beautiful Body*.

SAVAGE!

v2 #2 Jun/Jul 73 Gallery Press
The Beacon by Stanley John.
The Movement by Dick Trent.

WOMAN'S WORLD

v2 #3 Jun/Jul 73 Gallery Press
The Fantastic Four by Ann Gora.
That Different Girl by Shirlee Lane.

WANTED WOMEN

v2 #3 Jun/Jul 73 Gallery Press
What about those Sex Surveys? by Dick Trent.

MENAGE

v1 #2 Jun/Jul 73 Gallery Press
The Greeks had a Word for it by Edw. D. Wood, Jr.
Three is Desired by Dick Trent.

LESBIAN LIFE

v2 #3 Jul/Aug 73 Gallery Press
A Taste of Honey by Ann Gora.
The Lesbian Today by Shirlee Lane.

MAN TO MAN

v1 #2 Jul/Aug 73 Gallery Press
The Return of Captain Fellatio Hornblower by Edw. D. Wood, Jr.
The Female Impersonating Prostitute by Dick Trent.

HELLCATS

v2 #3 Jul/Aug 73 Gallery Press
Baiting Millie by Edw. D. Wood, Jr.
Prostitution and the Lesbian by Shirlee Lane.

FIG LEAF

v2 #3 Jul/Aug 73 Gallery Press
Gimmick Prostitution by Dick Trent.

GALLERY

v2 #3 Jul/Aug 73 Gallery Press
The Fleabag Prostitute by Dick Trent.

PARTY TIME

v2 #3 Aug/Sep 73 Gallery Press
Sex Star by Edw. D. Wood, Jr.
Did You Ever Know…? by Dick Trent.

TROIS

v1 #1 Aug/Sep 73
Take it out in Trade by Ed D. Wood, Jr.
Clothes and the Body by Dick Trent.

WOMAN'S WORLD

v2 #1 1973 Gallery Press
Try It You'll Like It

WOMAN'S WORLD

v2 #2 1973 Gallery Press
Wanted: Belle Starr

DEUCE

v2 #1 1973 Gallery Press
Ever Hear of a Dingbat? by Edw. D. Wood, Jr.

GEMINI

v2 #3 Jan/Feb 74 Gallery Press
Lesbian Progression by Shirlee Lane.
Dyke Hooker by Ann Gora.

WOMAN'S WORLD
v3 #1 Jan/Feb 74 Gallery Press
The Educator by Ann Gora.
Strange Desires by Shirlee Lane.
Rene Bond on the cover in a blonde wig.

BOY PLAY
v3 #1 Jan/Feb 74 Gallery Press
There are Different Words by Dick Trent.
The Autograph by Edw. D. Wood, Jr.

SEX STARS
v2 #1 Aug/Sep 74 Gallery Press
In the Stony Lonesome

LESBIAN LIFE
v3 #3 Aug/Sep 74
Another Insight to Women's Lib by Ann Gora
Last Laugh by Shirlee Lane
These two pieces were reprinted from **TWO + TWO** v4 #2 Apr/May 72.

LEZO
v4 #1 Aug/Sep 74 Gallery Press
The Hooker by Ann Gora.

GARTER MAGAZINE
v1 #1 Sep/Oct 74 Gallery Press
Whorehouse Horror by Edw. D. Wood, Jr. in some copies, while in others the insides comprise of **GARTER GIRLS** v6 #2 (May/Jun 72) and include Ed's short horror story *Detailed in Blood*. Some copies reputedly have yet another Wood story: *A Touch of Terror*. These were re-covered mags, also referred to as "four staples." The insides belonged to returned, unsold mags, whose covers had been ripped off and replaced with **GARTER MAGAZINE** covers, four staples showing in the center of the mag and two on the spine.

VUE
v29 #1 Jan 75 Allarry Enterprises
Private Girl by Edward Wood Jr.

BI-SEX
v2 #1 Apr/May 75 Gallery Press
Flowers for Flame Lemarr by Edw. D. Wood, Jr.

GOLD DIGGERS
v7 #1 1975 Gallery Press
(reprint of v4 #1 1972)
Not so Freewheeling

COUPLES
v5 #1 Apr/May 76 Gallery Press
Turn off the Lights uncredited Ed Wood.
The Rabbit by Art Carlyle.
Both of the above were reprinted from **WILD COUPLES** v3 #3 with new intro-page artwork.

LESBIAN CASE HISTORIES
v1 #2 date unknown Gallery Press
A First Time for Everything by Ann Gora.
Interview with a Lesbian Prostitute by Shirlee Lane.
Rene Bond was one of the "lesbians" on the cover.

LOVERS ANNUAL
Undated
Blood Spatters Quickly by Edw. D. Wood, Jr.
Turn On or Keep Out of the Sex Business by Dick Trent.
Both reprinted from **GALLERY** v2 #1 with new opening page artwork.

ORGY ANNUAL
Undated, Pendulum
Florence of Arabia by Edw. D. Wood, Jr.

PUSSY WILLOW ANNUAL
Undated, Pendulum
Red is for Blood uncredited Ed Wood, Jr.

BLACK AND WHITE
v2 #2 1972 Pendulum
Dial-A-Vision by Dick Trent.
Yes or No—The Candidates and Busing uncredited, probably Wood.

THE ORIGINAL TOM OF FINLAND'S CIRCUS

Three dots on cover, no publisher listed, undated, circa early eighties

As best as I can figure, this is a later edition of the original Tom of Finland illustrated short story called *Circus*, written by Edw. D. Wood, Jr. The first edition was the fourth in a series of Tom's books on a blonde lumberjack named "Pekka."

The text of the Wood story has been included in this version, while the rest of the mag is basically a portfolio of Tom of Finland's iconographic gay male artwork. The cover claims that it is, "The American version of the international best-seller featuring a full-length story of Pekka at the circus!" The cover's other blurb claims: "All pictures suitable for framing plus a fantastic centerfold!" There is no publisher or date listed.

In the biography **Tom of Finland**, by F. Valentine Hooven III, Tom speaks of the story *Circus*, but instead of clarifying how Wood came to write it for him, he adds to the mystery by claiming: "Unfortunately, the author of the story had no sense of humor at all (he was British) and felt my drawings *ruined* his very serious literary work. I won't say what I thought, but I decided then never again to illustrate somebody else's writings."

The publisher of this mag, and other titles such as **LUSTY LOVERS**, **MISTRESS** and **WEIRD COUPLES**, have used three black dots or "bullets" at the top of the cover as the only identifying marks, along with the price and the words "Not For Sale To Minors," all in the same type style. This leads me to believe they were all published by Swedish Erotica. None are dated.

LUSTY LOVERS

Three dots on cover, no publisher listed, undated, possibly reprinted or re-covered by Swedish Erotica.
Pray for Rain by Edw. D. Wood, Jr.

This mag seems to made up of Pendulum/Gallery reprints.

WILD DYKES

Three dots on cover, no publisher listed, possibly Swedish Erotica, undated.
The Fantastic Four by Ann Gora.
That Different Girl by Shirlee Lane.
This was a reprint of **WOMAN'S WORLD** v2 #3 Jun/Jul 73.

FREAKED OUT

No info, could possibly be from the same three dots/Swedish Erotica publisher as mentioned above, **LUSTY LOVERS**.

The Wave Off

FAMOUS MONSTERS OF FILMLAND

#201 Fall 93

This issue of **FMoF** contains Ed's short story, *Gemeni* (a misspelling of Gemini). The original manuscript was owned by Forry Ackerman, which he eventually auctioned off.

CULT MOVIES

#10—13 1994–95

*Starting in issue ten, **CULT MOVIES** printed Ed Wood's first written work, *Casual Company*, written in 1948. It continues in four parts, ending in issue thirteen.

Bibliography and Suggested Reading

Barger, Ralph "Sonny" *Hell's Angel: The Life and Times of Sonny Barger and the Hell's Angels Motorcycle Club*. William Morrow: NY, 2000

Betrock, Alan *The Illustrated Price Guide to Cult Magazines 1945–1969*. Shake Books: Brooklyn, NY, 1994

— *Sleazy Business: A Pictorial History of Exploitation Tabloids 1959–1974*. Shake Books: Brooklyn, NY, 1996

— *Unseen America: The Greatest Cult Exploitation Magazines 1950–1966*. Shake Books: Brooklyn, NY, 1990

Boulware, Jack *Sex American Style: An Illustrated Romp Through the Golden Age of Heterosexuality*. Feral House: Venice, CA, 1997

Collins, Max & Hagenauer, George *Men's Adventure Magazines*. Taschen: Koln, 2004

Ford, Luke *A History of X: 100 Years of Sex in Film*. Prometheus : Amherst, NY, 1999

Friedman, Josh Alan *When Sex Was Dirty*. Feral House: Los Angeles, 2005

Gabor, Mark *The Illustrated History of Girlie Magazines*. Harmony: NY, 1984

Garson, Paul and the editors of *Easyriders* *Born To Be Wild: A History of the American Biker and Bikes 1947–2002*. Simon & Schuster: NY, 2003

Gilmore, John *Laid Bare: A Memoir of Wrecked Lives and the Hollywood Death Trip*. Amok: Los Angeles, 1997

Gilmore, John *Manson: The Unholy Trail of Charlie and the Family*. Amok: LA, 2000

Gray, Michael *Mother! The Frank Zappa Story*. Plexus: London, 1994

Greene, Doyle *Lips Hips Tits Power: The Films of Russ Meyer The Persistence of Vision Volume 4*. Creation: London, 2004

Gorightly, Adam *The Shadow Over Santa Susana: Black Magic, Mind Control and the "Manson Family" Mythos*. Writers Club Press: Lincoln, NE, 2001

Grey, Rudolph *Nightmare of Ecstasy*. Feral House: Portland, OR, 1992 and 1994

Hanson, Dian (ed.) *Naked As A Jaybird*. Taschen: Germany, 2003

Hayes, David C., editor *The Horrors of Sex: Short Fiction by Ed Wood Jr.* Wood Pile Press: Louisiana, 2000

Hayes, David C. *Muddled Mind: The Complete Works of Edward D. Wood, Jr.* Ramble House: Louisiana, 2001

King, Greg *Sharon Tate and the Manson Murders*. Barricade: NY, 2000

Kostelanetz, Richard *SoHo: The Rise and Fall of an Artist's Colony*. Routledge: NY, 2003

Landis, Bill & Clifford, Michelle *Sleazoid Express*. Fireside: NY, 2002

Lipkin, Robert "Bob Bitchin'" *A Brotherhood of Outlaws*. FTW Publishing: Redondo Beach, CA, 1981

Overstreet, Robert M. *The Overstreet Comic Book Price Guide 30th Edition*. Gemstone / HarperCollins: NY, 2000

Parfrey, Adam (ed.) *It's A Man's World: Men's Adventure Magazines, the Postwar Pulps*. Feral House: LA, 2003

Peck, Abe *Uncovering the Sixties: The Life & Times of the Underground Press*. Pantheon: NY, 1985

Reynolds, Tom *Wild Ride: How Outlaw Motorcycle Myth Conquered America*. TV Books: NY, 2000

Rotsler, William *Contemporary Erotic Cinema*. Penthouse/Ballantine: NY, 1973

Schlosser, Eric *Reefer Madness: Sex, Drugs, and Cheap Labor in the American Black Market*. Mariner: NY, 2003

Schwarz, Ted *The Hillside Strangler*. Doubleday: Garden City, NY, 1981

Sennitt, Stephen *Ghastly Terror! The Horrible Story of the Horror Comics*. Critical Vision: Manchester, UK, 1999

Silke, Jim *Bettie Page: Queen of Hearts*. Dark Horse: Milwaukie, Oregon, 1995

Sloan, Bill *"I Watched A Wild Hog Eat My Baby!"*. Prometheus: Amherst, NY, 2001

Stevenson, Jack (ed.) *Fleshpot: Cinema's Sexual Myth Makers & Taboo Breakers*. Critical Vision: Manchester, UK, 2000

Thompson, Hunter S. *Hell's Angels: A Strange and Terrible Saga*. Ballantine: NY, 1966 and 1996

Vale, V. & Juno, Andrea *Re/Search #10: Incredibly Strange Films*. Re/search Publications: San Francisco, 1986, 5th printing 1990

Watkins, Paul with Soledad, Guillermo *My Life With Charles Manson*. Bantam: NY, 1979

Who's Who In America 40th ed. 1978–79, Volume 1, A–K, Myron Fass entry

Wolfe, Tom *The Kandy-Kolored Tangerine-Flake Streamline Baby*. First published in 1965. Bantam: NY, 1999

Periodicals

Copner, Michael "Titus Moody: The Only Ed Wood of the '90s": an interview with Moody by Copner, *Cult Movies* #17, 1996

Grey, Rudolph "Titus Moody: Those Who Are Dedicated Are Indestructable": an interview with Moody by Grey. *Psychotronic Video* #12, Spring 1992

Heflin, James "Riding With the Outlaws" *The Valley Advocate*, Jan 22, 2004

Jacobson, Mark "I, Myron" article in *The Village Voice*, Oct 23, 1978

Kingsley, Vance "Friends, Kindred Spirits Honor The Late Moody's Iconoclastic Spirit" in the "Boneyard News" section of *Adult Video News* v17 #5, May 2001

LaVella, Mark & Jones, Kirk "Robt. Williams The Gearhead Interview: 'Personal Impressions from Bondo Bob'" in *Gearhead* #10 Fall 1999, 2nd printing Fall 2000

Normanton, Peter "The Comic Book Art of 'Insane' Myron Fass" in *From the Tomb* #11 Halloween 2003

Pennyworth, Humphery & Hunter, Tod "Titus Moody Remembered: Longtime Adult Industry Veteran Dies of Colon Cancer" in the "Boneyard News" section of *Adult Video News* v17 #4, Apr 2001

Web

Gertz, Stephen J. "Earthlings Beware! A Galaxy of Porn in San Diego" http://www.efanzines.com/EK/eI4/ 2002

Resnick, Mike "How I single-handedly destroyed the sex-book field for five years and never even got a thank-you note from The Legion of Decency!" http://jophan.org/mimosa/m26/resnick.htm

Index of magazines and tabloids

VOL 1 pages 1 – 311
VOL 2 pages 312 – 570

U

V

W

X

Y

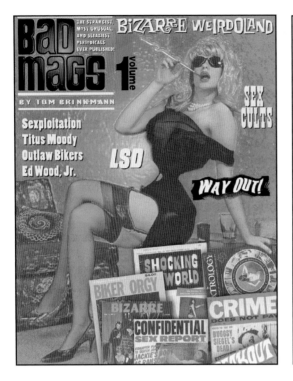

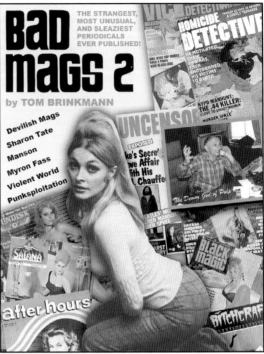

BAD MAGS
"revealing the forbidden"

VOLUME ONE
9781900486651
312pp + 8pp colour

VOLUME TWO
9781900486705
272pp + 8pp colour

These books and more are available from

www.headpress.com

A Headpress Book

HEADPRESS
the gospel according to unpopular culture
www.headpress.com

Contents for Bad Mags Volume One

plus colour plates